THE DEMOCRATIC ART

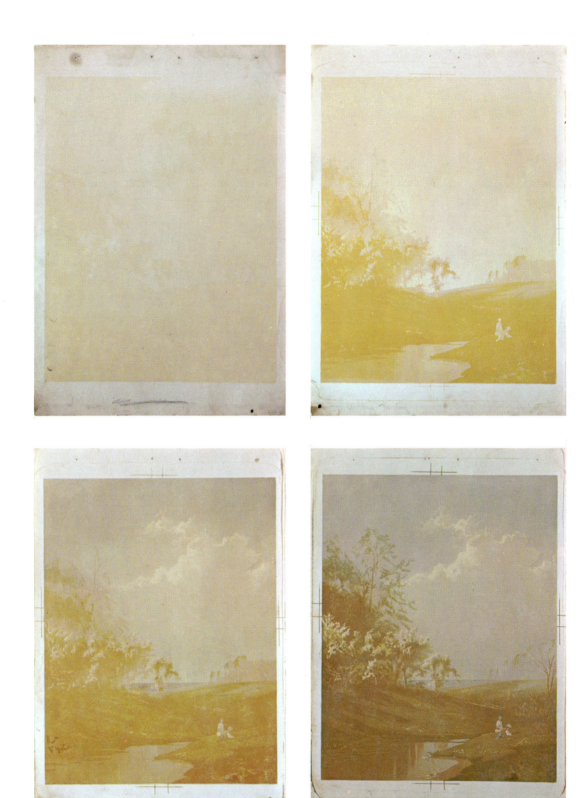

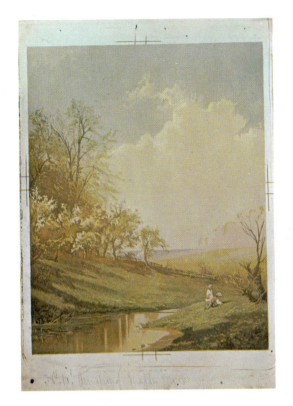

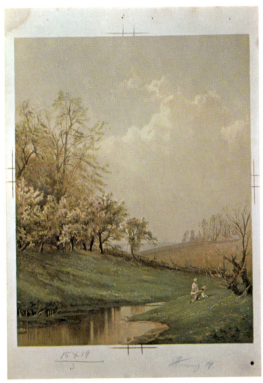

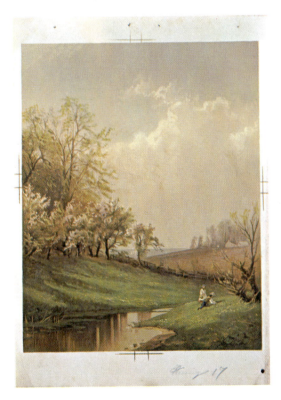

FRONTISPIECE:
Seven progressive proofs for
"Spring." Artist, William Harring.
After a painting by Alfred Thompson
Bricher. Printed by L. Prang and
Company, Boston, 1869. 16 × 12¾
inches. Location: American
Antiquarian Society.

 THE DEMO

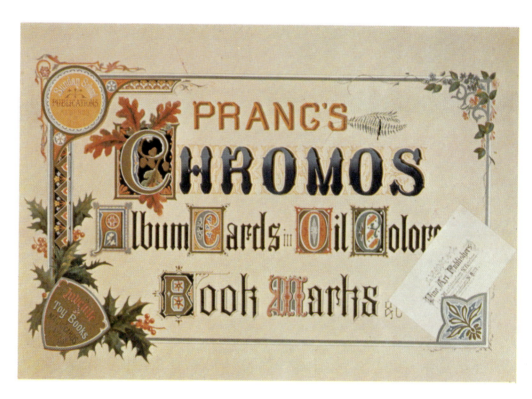

Chromolithography 1840-1900

CRATIC ART

Pictures for a 19th-Century America

Peter C. Marzio

David R. Godine, Publisher Boston

in association with the Amon Carter Museum of Western Art, Fort Worth

First published in 1979 by
David R. Godine, Publisher, Inc.
306 Dartmouth Street
Boston, Massachusetts 02116

ISBN: 0-87923-290-0

LCC NO: 79-84494

Printed in the United States of
America

TITLE PAGE:
Advertisement for *Prang's Chromos*.
Artist unknown. Printed by L. Prang
and Company, Boston, n.d. 9½ ×
15½ inches. Location: Print
Department, Boston Public Library.

TO MY MOM & DAD

CONTENTS

xi

PREFACE

I

CHAPTER I.

The "Chromo-Civilization"

23

CHAPTER 2.

The "Automaton Artists" in the City of Brotherly Love

41

CHAPTER 3.

New York and Düsseldorf: Mecca and Inspiration

49

CHAPTER 4.

The Giants of New York Lithography

64

CHAPTER 5.

Tools, Techniques, and Tariffs

94

CHAPTER 6.

Louis Prang: Pragmatic Idealist

107

CHAPTER 7.

Bundles of Natural Wonderment

116
CHAPTER 8.
What Shall We Hang on the Walls? And Why?

130
CHAPTER 9.
The Chromo Comes to the Queen City

149
CHAPTER 10.
Growth and Specialization

176
CHAPTER 11.
Novelty in a Chromo World: From Art to Advertising

191
CHAPTER 12.
Advertising

201
CHAPTER 13.
Familiarity Breeds Contempt

212
EPILOGUE

221
APPENDIX 1

224
APPENDIX 2

227
NOTES

265
BIBLIOGRAPHY

277
PLATES

345
INDEX

PREFACE

THIS BOOK tells a simple story: from 1840 to 1900 original paintings were being reproduced lithographically in color and sold in America by the millions. These copies were called chromolithographs. According to many observers, they were the best means of disseminating fine art throughout the broad middle class. Most of the following pages aim at nothing more than providing examples and documentation of that cultural phenomenon.

To the reader who is uninitiated in chromolithography, the subject will seem at first narrow and antiquarian. But, as a student of printing technology can tell you, the opposite is true. Billions of pictures and words were chromolithographed in nineteenth-century America: during the chromo period millions of gallons of colored inks, tons of lithographic stones, and hundreds of printing presses were consumed in the public's voracious hunger for images in color. The more the printers made, the more the people wanted, and technology forged ahead to meet the demand. At the peak of America's Victorian age, the mass-produced color lithograph waved unchallenged as the flag of popular culture. Its pervasiveness has led some historians to see the fifty-year period following the Civil War as the "chromo civilization." To be sure, the chromolithograph was not a freak development, pursued as an idle pastime—it was at the core of American life.

The most compelling aspect of this story, in my opinion, is that the chromo civilization was marked by a faith in fine art, a belief in the power of art to enrich the life of anyone. This attitude embraced the notion, heretical to some, that fine art should be reproduced, packaged, and offered to the masses. The chromo embodied this attitude—it was the democratic art of the post–Civil War decades.

Chromolithography was a technological accomplishment with a vibrant social presence. Born and nourished in Europe, it traveled as a youth to the United States, and here it led an exciting and varied public life. It worked as a broadside, a trade card, a label, a job sheet; it had scores of other occupations, not the least of which was fine-art reproduction. It became the princi-

pal color medium for advertising and an important tool for the teaching of art. Toward its twilight years, the chromo fused its two main functions—advertising and art reproduction—into a hybrid that would evolve into modern-day commercial art.

Until very recently, the American chromolithograph was viewed as something of an embarrassment by the keepers of America's printed fine art. For reasons that will be discussed in the following chapters, museums and libraries throughout the country have paid much more attention to "art prints"—etchings, copper engravings, and the like—than to chromolithographs, and if these institutions admit to having any chromos at all, they keep them out of sight—chromos are the unwanted leftovers of early collection policies. One result of this neglect is that our knowledge of the birth of modern American advertising is scandalously shallow, and our understanding of middle-class taste in art has been based on the conclusions of decorative-art historians and researchers more interested in literary criticism than in public imagery. Meanwhile, the artifact that most plainly documents popular aesthetics has been ignored.[1]

What were the materials used to produce this artifact as it developed in America from 1840 to World War I? What were the machines, the investment, the profit? How were chromos distributed? Who were the lithographers? Who were the buyers? And finally, what role did the chromo play in American life? These are the questions that this book addresses.

As first stated, my focus is on the chromo as a medium for the reproduction of fine art. This approach is narrower than the field deserves, for it does not begin to reach into the myriad cubbyholes of chromo activity. It does, however, serve the broadest goals of inquiry into the history of American chromolithography. The most important technological and business factors are surveyed, and most of the major lithographers are identified. Moreover, my treatment of the chromo as an element in the pursuit of art for all will, I hope, be of use to general historians, who might not otherwise think of consulting the print as a cultural indicator. I also hope that the art historian will find interest in the fact that so many of America's important nineteenth-century painters were involved in the creation of a popular medium, the chromo.

My deepest wish is that this book will help students to see the field of American lithography as worthy of research. There are innumerable doctoral dissertations crying to be written on the chromolithographers alone. Approached from the multifaceted discipline of American studies, the work of such lithographic firms as Strobridge and Kurz and Allison could be dissected for a rich piece of social, cultural, and technological history. The chromos, the advertisements, and in some cases the company records survive. What is needed? Sensitive students willing to climb out of academic ruts and wrestle

with material from unfamiliar—commercial—sources to uncover an illuminating view of our past.

Indeed, if an interest does arise and research is set in motion, it will doubtless disclose errors and misjudgments contained in this book. But that is all to the good. It will further my mission of rediscovering a subject that has been ignored and even ridiculed by scholars. I will feel that I have succeeded in sparking a desire for knowledge of the chromo, and this will result in the examination and organization of a wealth of material.

Every historian has his or her personal lens, and my book is not comprehensive. I have found it difficult to leave out some facts that have little to do with my topic but that fascinated me, and I have chosen to write about only a fraction of the chromolithographers whom I studied. I am also acutely aware that, owing to lack of information, this work seems to overlook such important lithographic centers as St. Louis, Milwaukee, and New Orleans, as well as most of the West; I hope in the future to be able to tell a coherent story of the contribution of these places.

I have purposely avoided the approach of earlier studies of lithography, such as that of Harry T. Peters, whose work on black-and-white and hand-colored lithographs has been eminently useful. Peters's books generally lack a central thesis, serving in aggregate more as an index than as a history. My approach, by contrast, is much more individual, and I take full responsibility both for the main ideas in my book and for any mistakes in it.

I am, however, deeply indebted to the contribution of a list of colleagues who, despite their own hectic schedules, found large blocks of time to donate to my cause. To the Amon Carter Museum of Western Art, in Fort Worth, Texas, which supported so much of my research, I am infinitely grateful. Its late director, Mitchell Wilder, showed such a high degree of co-operation and encouragement from the earliest stages of my project to the finished book that he was the model of a faithful friend. I deeply regret that he was unable to see this project completed.

The historian at the Amon Carter, Ron Tyler, has supported my study in countless ways, working continually in my behalf. Throughout the rest of the country, curators and librarians responded with enthusiasm to my research needs. Among those to whom I owe the greatest thanks are: Georgia B. Bumgardner, of the American Antiquarian Society; Sinclair Hitchings and Paul Swenson, of the Boston Public Library; Clifford Ackley, of the Museum of Fine Arts, Boston; Frances Silverman, of Harvard's Peabody Museum of Archaeology and Ethnology; Elaine Evans Dee, of the Cooper-Hewitt Museum, the Smithsonian Institution; David Kiehl, of the Metropolitan Museum of Art; Joseph Noble, of the Museum of the City of New York; Wendy J. Shadwell, of the New-York Historical Society; Elizabeth Roth and Robert Rainwater, of the New York Public Library; Kirstin L. Spangenberg, of the

Cincinnati Art Museum; Laura L. Chace and Edward Rider, of the Cincinnati Historical Society; the entire print staff of the Public Library of Cincinnati and Hamilton County; Mary Frances Rhymer and Julia Westerberg, of the Chicago Historical Society; Anselmo Carini, of The Art Institute of Chicago; the keepers of the J. Francis Driscoll Collection at the Newberry Library; John Lentz, of Sarasota, Florida; John Hurdle, of the Ringling Museum of the Circus; R. L. Parkinson, of the Circus World Museum; Karen Dewees, of the Amon Carter Museum; Milton Kaplan, Stephanie Munsing, and Bernard Riley, of the Library of Congress; Martina R. Norelli and Lois Fink, of the National Collection of Fine Arts, the Smithsonian Institution; Herman J. Viola, of the National Anthropological Archives, the Smithsonian Institution; Lillian Miller, of the National Portrait Gallery, the Smithsonian Institution; James Spears, John H. White, Jr., Robert M. Vogel, Rodris Roth, and Anne Serio, of the National Museum of History and Technology, the Smithsonian Institution; Robert Looney, of the Free Library of Philadelphia; Edwin Wolf II, of the Library Company of Philadelphia; and Whitfield Bell, of the American Philosophical Society.

My manuscript benefited enormously from critical readings by Anne C. Golovin, Sinclair Hitchings, Ron Tyler, Elizabeth Harris, J. Clifford Harden, and David Godine. Special assistance was provided by Luna Lambert, Lucy Leitzel, and Frances Heinrich. Each of these people generously contributed his or her invaluable point of view. I also thank the manuscript's typists, Ellen Ballanger and Carol McDowell, who patiently saw the work through several drafts.

Judy Hu, the managing editor of the book, has organized its diverse aspects with a high level of efficiency and professionalism. Hilary Douglass Horton, the editor, is as good at her craft as anyone I have ever encountered. Her knowledge of the English language and her respect for my writing style made working with her a real joy. The book was effectively designed by Richard Hendel, who also oversaw all stages of its production.

The idea for *The Democratic Art* germinated in 1968, while I was writing a doctoral dissertation at the University of Chicago. My advisers, Daniel J. Boorstin and Joshua C. Taylor, encouraged me to pursue the topic in my own peculiar way. Their guidance in those early years has had a deep impact on this book.

THE DEMOCRATIC ART

THE 'CHROMO-CIVILIZATION'

ON SEPTEMBER 24, 1874, *The Nation*, a thirty-five-cent weekly, pub-lished an editorial describing the decline of morals in America. The specific subject was a sex scandal and trial involving the famous clergyman Henry Ward Beecher and the wife of a former associate, Theodore Tilton. It was a controversial topic, with many Eastern journals, including *The New York Times*, calling for a verdict of innocent; Western papers, denouncing Beecher as a snob and a tool of the privileged classes, wanted him jailed or hanged. There was a tide of conflicting testimony and unsubstantiated charges, and in the end the jury was unable to reach a decision. In the meantime, it had been a public picnic: making front-page newspaper copy, the trial elicited hyper-bole and self-righteousness; reputations were barbecued to a crisp.

The Nation,
September 24, 1874

When *The Nation* joined the feast, it pompously tried to raise the table talk from sensationalism to social philosophy. Citing the Beecher case as a vivid example of the decay of morals in public figures, *The Nation* admitted that the causes of the decay were "numerous and generally obscure." This did not stop the editor, however, from printing what he must have felt was a powerful headline. To Edwin Lawrence Godkin (1831–1902),[1] one hy-phenated word conveyed all that was ugly and false: CHROMO-CIVILI-ZATION. Although only a small number of people probably read the article, the term stuck. The 1870s, '80s, and '90s became, in the minds of contempo-rary observers and latter-day historians, decades conspicuous for their low morals, particularly in business and politics, and materialism.

The irony is that chromolithography was not mentioned, not even once, in *The Nation*'s editorial. Although the weekly had in earlier issues denounced chromolithographic copies of paintings, it had not previously used the chromo as a symbol of social decline. Why now? And why with so much vehemence?

In the opinion of editor Godkin, the chromolithograph was the quintes-sence of the democratization and, therefore, debasement of high culture. It represented a "pseudo-culture," being one of a plethora of evil media—news-

papers, magazines, lyceum lectures, small colleges—that "diffused through the community a kind of smattering of all sorts of knowledge, a taste for 'art'—that is, a desire to see and own pictures—which, taken together, pass with a large body of slenderly-equipped persons as 'culture', and give them an unprecedented self-confidence in dealing with all the problems of life, and raise them in their own minds to a plane on which they see nothing higher, greater, or better than themselves."

As a cheap copy of a beautiful oil painting, the chromolithograph destroyed for the viewer the specialness of the original. Compounding this sin, in Godkin's opinion, was the superficiality of most art appreciation, which was based on the study of printed copies of art. The chromo also led to the creation of a "pick-up" culture, a tyranny of the masses by external appearances. In contrast, said Godkin, a strong, healthy civilization was less concerned with the dissemination of culture and more dedicated to the pursuit of truth: it was the product of an internal force, "the result of a process of discipline, both mental and moral." It was something spiritual and intellectual, formed by labor and self-denial. It affected a "man's whole character," not just the trappings of everyday life. (It was, in fact, elitist.) Thus, in the minds at *The Nation,* any culture that was packaged and ready for purchase was by definition deeply suspect. Homes decorated with chromos instead of original designs were environments destined to breed nothing higher than a smug society of ignoramuses. With characteristic righteous indignation, *The Nation* pulled no punches: "A society of ignoramuses who know they are ignoramuses, might lead a tolerably happy and useful existence, but a society of ignoramuses each of whom thinks he is a Solon, would be an approach to Bedlam let loose. . . . The result is a kind of mental and moral chaos. . . ."

Today it is easy to write off the moralism of *The Nation.* In its time, however, the publication must have been an awesome enemy to chromolithographers, who knew it was an unusually influential magazine, particularly popular among intellectuals and politicians; an English observer, James Bryce, described it as the "best weekly not only in America but in the world."[2] And Victorian as Godkin may sound to us, the object of his anger was a very real set of social upheavals that were transforming America from a small agrarian society to a giant of the twentieth century.

I. The Popularization of Science and Art

The chromo civilization is a broad idea that does not submit to simple definition. My interest is that the chromo, a color lithograph, could be raised to such soaring heights. Could this be attributed merely to the growth of lithog-

raphy during the late 1800s? In 1860 there were approximately 60 firms in America, employing 800 people, with a capital investment of about $445,250. The census of 1880, even with its conservative figures, showed an enormous leap: 167 companies, 4,332 employees, wages amounting to $2,307,302, and work valued at $6,912,338. By 1890 the growth was even more astounding, as 700 lithographic establishments employed 8,000 people, with a yearly production valued at $20,000,000. When Godkin's editorial appeared, the chromo was hanging on walls everywhere and its future was assured.

Growth of Lithography

One reason for the exponential growth of a form of printing helps clarify the concept of *chromo civilization*. This modest color print represented a means of bridging the gulf between artists and intellectuals and the common people. It symbolized the American pursuit of democracy—the democratization of culture as well as of government.[3] It was the realization that the chromo was not an isolated phenomenon but in fact the indicator of a profound social movement that impassioned E. L. Godkin.

From 1840 to 1900 the United States saw a popularization of intellectual life. In natural science, for example, periodicals such as *Popular Science Monthly,* started in 1872, publicized new discoveries, and its founder, the lecturer Edward Youmans, spearheaded a movement to make the scientific classics of Europe available to Americans in inexpensive books. Inspired speakers such as John Fiske traversed the country, spreading the latest scientific word (Fiske's word was, of course, "evolution").

Natural Science

State universities and agricultural schools became part of the landscape as a result of the Morrill Land-Grant College Act of 1862, and university extension courses materialized for those who could not devote full time to higher education. The public-school movement pushed ahead. Insisting that universal education was essential for a democracy, reformers made use of the pre–Civil War arguments of Horace Mann and others to establish high schools, libraries, and Chautauquas.

Education

The faith in popular education was also expressed outside the schools. First Y.M.C.A.'s in the 1870s and then Y.W.C.A.'s offered a variety of day and evening self-improvement courses, which combined general education with religious instruction for "Christian well-being"—much of the movement to democratize culture marched to the uplifting tunes of Protestant salvation.

There were industrial fairs, state exhibitions, and even larger-scale events, such as the international expositions in Philadelphia in 1876 and in Chicago in 1893—all dedicated to disseminating knowledge to the masses. The development of wide-circulation newspapers and magazines, some of which would boast a million copies per issue, made perhaps the greatest impact. By combining sensationalism and utilitarianism, as well as just plain news, periodicals such as *Ladies' Home Journal, McClure's, Everybody's,* and

Journalism

others launched a style of communication that expressed the self-help and democratizing impulses of the period from 1840 to 1900.

Demand for Art The demand for art came with this rush for culture, and the manufacture of objects of beauty was not confined to chromolithographic copies of paintings. Rather, the chromo was just one element in the movement to make the aesthetic available to everyone. Newly developed processes of mass production were applied to the decorative arts to turn out cheaply and in quantity terra-cotta facings for buildings, cast-iron fluted columns, iron details on stoves, cast and stamped parts for gas (later, electric) lights—the list is almost endless.[4] Just about anyone could now afford to live with art.

II. The Profit Motive

In the best of all possible worlds the energy devoted to the concept of self-improvement would have been expended for the good of humanity: the haves would have acted as selfless missionaries of culture to the have-nots. But in America commerce motivates most things. Correspondence courses enticed eager students with skills that often could not be delivered. Lyceums became part of high-pay lecture circuits. Journalism too often was a gaming table for the rich. The distribution of books, both cheap and expensive, was a spectacle of merchandising: mail-order houses such as Sears, Roebuck became conduits for low-priced titles, while agents invaded the countryside, pushing everything from leatherbound to paperback bibles, encyclopedias, biographies, popular histories, light literature, and classics. And, as we have noted, lithography was a big business.

The Chromo But while it is important to place the chromolithograph in the larger socio-*Business* cultural picture, one must recognize its uniqueness. Unlike most fads, which are short-lived, the chromo reigned for two generations. Its producers demonstrated an ability to survive bad economic times, maintain low prices, respond to and guide public taste, and deliver high-quality goods. These strengths are attributable to a simple fact: whereas most artists and art educators between 1830 and 1860 worked in sheltered environments, the printers of chromos and the publishers who paid for them were at home in the world of commerce. Chromolithographs made up only one aspect of their business, so that if popular demand waned, as it seemed to do in 1879, the workers and machines in the lithographic plants could turn to non-chromo-art items. This work covered the overhead and permitted printers to maintain competitive prices. When market interest resumed, the chromos could be printed again. The diversity of services of a nineteenth-century lithographer and a fine-art publisher allowed for profitable adjustment to popular whims.

As businessmen, the promoters of chromolithography had their fingers on the public pulse much more than did the pre–Civil War crusaders who had called for art unions, drawing schools, and free museums. An increasing amount of the lithographer's trade from 1865 to 1900 was in advertising— broadsides, package wrappers, labels, logos, and letterheads—so that intentionally or not, lithographers played an important part in public imagery, as they created vogues and shaped the popular taste. Theirs was a flexible philosophy: not bound to a single code of aesthetics, their aim was to make a profit. Insofar as that goal was consistent with the promotion of a democratic art, they served as art crusaders.

The competition in the marketplace benefited the product. A lithographer might be indifferent to the style of art being reproduced in his chromolithograph, but he was closely attentive to the print's quality. Modern critics who define the chromo as a "symbol of all that is most repulsive"[5] or a "stepchild of the arts . . . an outcast"[6] do not appreciate the historical role of the chromolithograph as a guide to the printing standards of the post–Civil War decades. Pride was strong among lithographers, and the nineteenth-century trade journals were filled with advertisements proclaiming the latest technical innovations. Chromolithographs displaying accurate registration and faithful color, sold at low prices, assured the lithographer's success.

Chromolithographs were distributed through all conceivable channels: *Distribution* premium systems, traveling salesmen, art galleries, museums, commission agents, furniture dealers, religious and fraternal organizations; they were offered as promotional giveaways and through direct mail order, and they even followed in the tracks of lyceum lecturers and the traveling bible salesmen. Anyone could buy one.

Is there any question why Godkin pointed to the chromo? What he feared in 1874 had by 1893 become fact. That year a spokesman of the National Lithographers' Association confirmed that

> . . . within a few decades, public taste has been lifted out of the sluggish disregard for the beautiful . . . and now seeks to adopt the decorative accessories, which beneficent enterprise has so cheapened as to place them within the reach of all, to the ornamentation of its homes. . . . [T]he depressing monotony of plain walls are [sic] now relieved by bright touches of color . . . awakening in some degree, however faint, the innate love of beauty which marks the scale of aspiration in the human soul. There is no place, high or low, where pictures are not now seen, for the campaign of popular education in art has been carried to the very utmost boundaries of ignorance, and the cost of reaping its advantages is next to nothing.

The business of art promotion, continued the *Lithographers' Journal*, was a crusade "stimulated by a few . . . enterprising exponents . . . who may justly be termed the vanguard of that army which marches toward the future under the banner of progressiveness. . . . The evolution upward has been steady. . . ."[7]

III. The Origin of the Chromolithograph

Alois Senefelder, Lithography's Inventor

It is difficult to say precisely when color lithography began. The German Alois Senefelder (1771–1834) had invented lithography, the first planographic printing process, in 1796. Early in the nineteenth century he tried his hand at chromolithographs. He provided many guidelines that served later printers; even as early as 1801 his English patent for "Printing Textile Fabrics" (patent number 2518) included a section on the mechanical application of color. In his famous treatise, *A Complete Course of Lithography* (English edition, 1819), he wrote: "The manner of printing in different colors is peculiar to the stone, and capable of such a degree of perfection, that I have no doubt perfect painting will one day be produced by it."[8] Less than ten years later, *The Franklin Journal and American Mechanics' Magazine* (December 1827) reported that Senefelder had invented a "new mode of copying oil paintings, by means of lithography."[9]

News of Senefelder and his work appeared regularly in the United States, where lithography had been practiced since the early 1820s. His name was found in polite magazines as well as professional journals, and it is difficult to overestimate the homage that American lithographers paid him. His portrait, his name, and his dates, invoked to bestow respectability, were printed on lithographers' trade cards, letterheads, and advertising leaflets:[10] like portable tombstones reminding us of the past (Figure 1), these images rendered Senefelder a saint. Whenever an article about lithography was published in a popular periodical, chances were good that a portion of it would redefine the genius of Senefelder, relate the facts and myths surrounding his great discovery, and provide a paragraph or two of biography. One of the earliest lithographic companies in America was the Senefelder Lithographic firm, of Boston (1828–34);[11] as late as the 1860s entire communities of lithographic printers and artists celebrated his birth; and in 1896 the centennial of lithography was greeted with a flurry of Senefelder festivals.[12]

Godefroy Engelmann

Charles Hullmandel

While German printers led the way in the development of color reproduction, it was a French printer, Godefroy Engelmann, and his son who coined the term *chromolithographie*, in a patent of 1837. Two years later an English lithographer, Charles Hullmandel, printed the color lithographs in Thomas Shotter Boys's *Picturesque Architecture in Paris, Ghent, Antwerp, Rouen.*

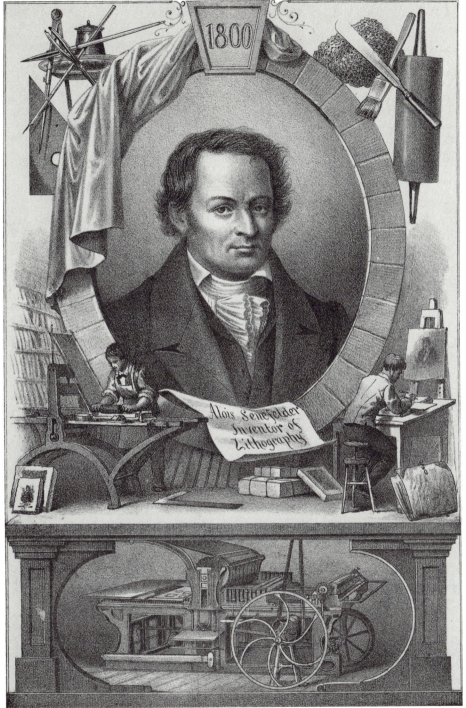

Figure 1. "Alois Senefelder Inventor of Lithography." Artist unknown. Illustration from J. Luther Ringwalt, American Encyclopaedia of Printing, 1871, preface. Printed by Duval and Hunter, Philadelphia. 8⅞ × 6 inches. Location: Division of Graphic Arts, National Museum of History and Technology, Smithsonian Institution, Washington, D.C.

Hullmandel called the process "chroma-lithography,"[13] probably the first use of the term in English.

Hullmandel's position in the history of English lithography is important, and he will appear again in the following pages. As London's *The Literary Blue Book* explained in 1830,

The perfection to which Lithography has been brought in this country, and the rapid progress made within these few years, by Artists or rising talent in the branch of fine art, have excited much public interest and Lithography has acquired not only present popularity, but a permanent place among useful and valuable inventions. It is twenty two years since the art was first brought into this country, but it was not until the year 1816 that a successful attempt was made to introduce it into general notice. Mr. Hullmandel, to whom Lithography in England owes so much, succeeded in establishing the art upon a sure basis. . . .[14]

First American Chromos In America, the first chromolithograph was printed in 1840, in Boston, by the English immigrant William Sharp. It was shortly followed by chromos produced by German-, French-, and Russian-born printers in Philadelphia and New York. By the end of the century the progeny of these printers were operating a multimillion-dollar business. Their story has not previously been told.

IV. A Problem of Definition

Lithographs are pictures that are printed from either finely polished limestones or specially prepared zinc or aluminum plates. (During the nineteenth century, limestones served as the dominant medium.) Lithography is a planographic process: the image to be printed is in neither relief nor intaglio, but at a level with the surface of the print plate.

To make a lithograph, an artist draws on the surface of the limestone with greasy crayons, pens, or pencils. No special engraving or cutting skills are required. When the drawing is completed a solution of gum arabic and dilute nitric acid is washed across the stone. This fixes the grease against spreading during the printing. The entire surface of the stone is then washed with water, and the stone is rolled up with printing ink. Since grease and water repel each other, the ink adheres to only the greasy image and does not stick to the clean portions of the stone. After the inking, print paper is laid across the stone and together they are sent through a special printing press. When the paper is removed from the stone a mirror image has been transferred from the stone to the paper.

There are many other details involved in making a lithograph, which are discussed at various points in this book, but the basic things to keep in mind are that lithography is planographic and that it works on the principle that grease and water do not easily mix.

As one might expect, there are different types of lithographs. For our purposes the following distinctions are useful:

Single-color lithograph
This is the type described above. It is made from one lithographic stone and one printing-ink color.

Hand-colored lithograph
This is a single-color lithograph on which a nonprinted color has been applied. In the 1820s monochromatic lithographs were colored freely by hand with crayons, chalks, and water paints. By midcentury the color was put on with stencils according to rigid formulas.

Tinted lithographs
Unlike the single-color and hand-colored lithographs, which require only one stone, the tinted lithograph involves two or three stones, though seldom more. The image is still printed from just one stone, but one or two tints that flood across the picture surface are printed from second and third stones. The tints thus create atmospheric effects but do not compose the image.

Chromolithographs
This is a printed-color lithograph in which the image is composed of at least three colors, each applied to the print from a separate stone. Unlike tinted lithographs, with their second and third colors casting hues across the print, the colors of a chromo make up the picture itself. As we shall see, chromolithography is technically very complex, because it requires perfect registration and a sophisticated understanding of color.

Today the definition of chromolithography is muddy. There are several reasons for the imprecision.

The first, though least important, cause of confusion is the dynamic evolution of the chromolithographic style. To generalize, there is what one might call the old-style and the new-style chromo. Most of the early German, French, and American chromos juxtaposed blocks of color or solid tints, without attempting to suggest gradations of tones. As lithographers gained experience, however, they aimed more and more at capturing the essence of the original works of art by overlaying colors and printing with a broad range of transparent and translucent inks; this was the new style. According to the London *Art-Journal* of April 1859, the new style of "Chromo-Lithography . . . offers the means of repeating the work of the artist in the artist's own best style." Among the early high-quality examples of the new style in Europe are the Hullmandel chromos in Boys's *Picturesque Architecture in Paris.* . . . The preface to that book, published in 1839, makes a point of differentiating between the old and new styles:

> The whole of the drawings composing this volume are produced entirely by means of lithography: they are printed oil-colors, and come from the

Two Styles of Chromolithography

Plate 1.

press precisely as they now appear. It was expressly stipulated . . . that not a touch should be added afterwards, and this injunction has been strictly adhered to. They are pictures drawn on stone, and reproduced by printing with colours; every touch is the work of the artist, and every impression the product of the press.

This is the first, and as yet, the only attempt to imitate pictorial efforts of Landscape architecture in chroma-lithography; and in its application to this class of subject, it has been carried so far beyond what was required in copying polychrome architecture, hieroglyphics, arabesques, etc., that it has become almost a new art. . . . [As compared with] mere decorative subjects, [in which] the colours are positive and opaque, the tints flat, and the several hues of equal intensity throughout . . . in these views the various effects of light and shade, of local colour and general tone, result from transparent and graduated tints.

From this "new" beginning in 1839 the chromolithograph grew rapidly, first in Germany, then in England and France, and finally in America. *Chromolithograph* in America at first meant any lithograph printed in color; by the early 1860s, however, it had come to carry a more specific definition: the color-lithographed reproduction of an oil painting or watercolor, or at least the full-color picture of some religious, heroic, or landscape subject. These chromo "paintings" might be glued to a stretched canvas, varnished, embossed with striations to simulate canvas, and framed. Or they might be incorporated into a calendar or some other commercial product. Either way, they were a middle-class medium for disseminating fine-art imagery.

Oleographs In Europe, particularly Germany, the varnished and embossed chromo came to be called an *oleograph*. The term was not unknown in America (the American Oleograph Company, of Milwaukee, existed for a number of years), but there was no consistent use of *oleograph*. Importers of foreign chromos occasionally applied *oleography* to large, expensive chromos: in *Phillips Business Directory* of New York City (1887–88), the firm Berger Brothers, at 304 Broadway, advertised "Main office for Germany. . . . importers of chromos. Oleographs 15 × 20, 20 × 30; sole agents for German factories; large stock at all times on hand; new designs daily. . . ." Several doors up Broadway, William Bruns, advertising in *Wilson's New York Business Directory* for 1883, was even more explicit: "Publisher and manufacturer of standard chromos, classic and 10 × 14 oleographs . . . fine chromo panels . . . art novelties. . . . Catalogues mailed free." When the Cleveland firm J. F. Ryder, best known for its chromo "The Spirit of '76," sent a batch of prints to London for review in *The Printing Times and Lithographer*, an editor defined them (July 15, 1875) as: "four oleographs, as they would be called in this country—being printed in oil and embossed to imitate the

irregularities of canvas." Nevertheless, *oleograph* failed in America. *Chromo* seemed more natural.

Striking though the new-style chromos were, it is important to realize that they did not supplant the old-style color prints. Broad areas of flat, opaque colors, juxtaposed with one another, remained part of the American chromo tradition throughout the nineteenth century. Thus, *chromolithograph* could apply to an 1860 reproduction of an Eastman Johnson oil painting and an 1890 version of a Winslow Homer watercolor, as much as to a title page made in the 1840s to look like a medieval manuscript or an art-nouveau illustration published at the turn of the century.

Another reason for the blurring of the definition of chromolithography is the appropriation by Louis Prang of the word *chromo* as a "sort of trade-mark for my best oil color prints."[15] However, when Prang—who would become America's most famous chromolithographer—began to claim authorship of "chromo," in the 1860s, the abbreviation had already been in use in America for at least twenty years. As early as 1847 William Sharp printed *chromo* on a chromolithograph entitled "The Floral Year," and the *Oxford English Dictionary* notes that the word was used shortly after 1850. P. S. Duval, a French-born Philadelphia lithographer, was putting it on his prints by 1852. By the 1860s *chromo* was also employed in compound terms, such as *chromo-facsimile*.

"Chromo"

Louis Prang had more than a touch of the advertising genius about him. In some of his broadsides from the 1880s he pictured a bust of Alois Senefelder, and below it he printed two astonishing claims: that Prang alone had led the effort to "Americanize the art of reproducing oil-paintings," and that he had "adopted and made popular" the word *chromo*.[16] He was dedicated to establishing his name in art history, in the hopes of making it synonymous with *chromo*. In part he succeeded; a few dictionaries call him the word's inventor.

A third, and most critical, factor in defining chromolithography has been the passionate determination of modern-day American art historians to distinguish "color lithographs" from "commercial chromolithographs" as "original works of art." It is a twentieth-century distinction that would have puzzled most nineteenth-century printmakers. Gustave von Groschwitz, an American observer, wrote in *Gazette des Beaux-Arts* in November 1954:

Commercial and Fine-Art Lithography

> In order to avoid confusion, a distinction must be made at once between color lithography and chromolithography. Etymologically and technically they are identical, but usage has assigned to chromolithography those unfortunately bad copies of paintings made by this process, which are popularly referred to as chromos. . . . To make the distinction, then, a *color lithograph* is an original, independent work of art

that does not seek to imitate a watercolor or painting, but, rather, competes with them as a picture in printed form.[17]

As the author notes, chromolithography is a technique for printing color. Whether it is performed by Toulouse-Lautrec or Louis Prang, it must follow the process outlined by Alois Senefelder. Why, then, is so much effort used to separate art and commerce? Numerous American chromolithographs were designed and put on stones by a single artist—but somehow they do not fit the modern aesthetic bias. Despite the fact that they are in every sense original works of art, their commercial use has made them second-class.

The result of trying to separate color lithography from chromolithography has been confusion. Print collections throughout the country are jumbles of terminology.[18] In the chapters that follow, the word *chromolithograph* refers to any print produced by the process of chromolithography. Be it a label for a can of tomatoes, a poster, a valentine, a copy of a Thomas Moran painting, or a portrait, it is still a chromolithograph. It may be an original design, it may be a copy. It may involve one artist or four. It may be printed on a press powered by hand or by steam. It is *still* a chromolithograph.

Commercial lithography is a term used *today* to describe the panorama of lithographic activity that exists outside the tiny sphere of artistic—"color"—lithography. It connotes a profit-motivated enterprise dealing in long printing runs of show cards, certificates, books, record jackets, advertisements—anything ordered, by an individual or a firm. Commercial lithography is printing for everyday life. It is the teacher, the entertainer, the advertiser.

Art and Commerce Before 1860

As much as commercial lithography is today distinguished from fine-art lithography, the two cannot be separated in mid-nineteenth-century printing. This lack of distinction was largely because lithography as a branch of fine art was not recognized. Painters—including Rembrandt Peale, John James Audubon, Bass Otis, Thomas Cole, William Morris Hunt, Thomas Doughty, John La Farge, and Winslow Homer—occasionally drew on stone, but their forays into this medium rarely matured into real efforts, for their interest, for various reasons, was seldom sustained. When one of these artists did produce a lithograph, it was in the shop of a commercial firm: for example, Homer was employed by J. H. Bufford, of Boston, in the 1850s, while more than twenty-five years earlier Rembrandt Peale had made use of the facilities of the Pendleton brothers, also of Boston.

Historic Prejudices

Because of this blurring of commerce and art in the 1800s, American art historians have traditionally dismissed the whole nineteenth-century heritage of lithography. Substantiating their stance, the French lithographer Godefroy Engelmann reportedly averred before the Civil War that lithography in the United States was solely commercial, "because there were no artists in the country." The American printmaker and illustrator Joseph Pennell, writ-

Joseph Pennell

ing from London at the end of the nineteenth century, looked back and characterized the American lithograph as being monopolized "by the cigar-box maker, the printer of theatrical posters, or the publisher of chromos and comic prints."[19] Dedicated to the advancement of art, Pennell detested "commercial" pictures, particularly the chromolithographs, because he thought them cheap works expressing little more than "inartistic primness of finish." In his opinion the repetition of clichés had vulgarized the lithograph: "when printed on canvas or an imitation of canvas, they are highly deceptive for a moment, it is but a matter of technical perfection: there is no artistic merit about them, and the real outcome is the chromolithograph of commerce, which did an enormous amount of harm to lithography." By the third quarter of the nineteenth century, lithographers were viewed as copyists, nothing more. Asserted Pennell, they "could put everything but art on stone." From 1870 to 1900 the "creative artist . . . had no place in the lithographic establishment."[20]

Pennell blamed the commercialism, the lithographers' unions, the gigantic scale of firms such as the American Lithographic Company (the "Trust," as he labeled it), and the naïveté of the public. He might also have added to his list of causes the cost of lithographic technology, the complexity and proportions of which seemed to demand an army of mechanics just to keep the plants running.

The present-day separation of art and commerce in lithography began at the end of the nineteenth century with a phenomenon known—inaccurately in America—as the "revival of artistic lithography." Original, limited-run lithographs started to be produced by such painters as James A. M. Whistler, Julian Alden Weir, Arthur B. Davies, Mary Cassatt, William Glackens, and several others. Often drawn on stone and sometimes even printed on a hand-operated press by the painters themselves, these lithographs were artistic firsts in America. Unlike in Europe, where the artists were rediscovering the older lithographs of Degas, Monet, and others, in the United States the movement did not *revive* anything; rather, it originated the twentieth-century style of artistic lithography. As the caustic Joseph Pennell moaned, "up to the present day [1914], lithography may scarcely be said to have existed as an art in the United States."[21]

Separation of Art and Commerce

The terms *artistic* and *commercial* in lithography are today emphasized for two reasons. First, they make it easy for researchers to define the subdivisions of the field. Art historians in particular favor the nomenclature, for such categorization spares them the eyestrain of poring over millions of pictures by placing all but several hundred lithographs into the commercial grab bag; it legitimizes their impulse to dismiss the nineteenth century with but a glance over their shoulders. Second, twentieth-century artists and printmakers have tried repeatedly to distinguish their original productions as

Twentieth-Century Terms

something more artistic than the deluge of images flooding the market since the development and improvement of photomechanical reproductive processes. One organization, the Tamarind Lithographic School and Shop, founded in the 1950s, calls an *artist's* lithograph an "original print." To qualify, a print must be the product of a two-step process:

> First an artist creates his image, rendering it on one of many kinds of supporting material—stone, metal, wood, silk, linoleum, etc. In the second stage, that image is inked and pressed against paper to bring the art work into being. . . . The artist always performs the first stage of the process himself. Sometimes he also performs the second part, or he may need the special equipment and services of highly trained artisans to print his image for him. But whether working alone or not, the artist is totally responsible for the original print, and his signature is proof of this approval.[22]

If we accept this definition, then numerous nineteenth-century chromos scorned as rubbish become bona-fide works of art. Prints considered commercial, such as the work of Currier and Ives, James Queen, Julius Bien, Louis Kurz—in fact, nearly all the major names—*are* original and thus, further complicating the terminology, qualify as fine art.

V. Practical Lithography

Nineteenth-century American lithography must be analyzed on its own terms, and not according to a modern vocabulary. For example, at the time of the Civil War and for a decade or more thereafter, the phrase "commercial lithography" was in fact used, but very specifically: it referred to the printing of business stationery and bill sheets in the style of copperplate-writing engraving, as well as to miscellaneous jobbing work—billheads, calling cards, tickets—in other styles.[23] It was a generally cheaper alternative to letterpress printing. The New York chromolithographers Sarony, Major and Knapp, for example, advertised in the 1860s: "show cards for manufacturers, views of cities and hotels, book plates, architectural drawings, music titles, maps, plans, labels, and COMMERCIAL WORK of every description."[24] As late as 1894 the *American Dictionary of Printing and Bookmaking* divided lithographs into nineteen categories, separating "commercial work" from such headings as "Christmas card," "music," and "chromos."[25]

A more inclusive term, closer to the modern definition of "commercial work," was "practical lithography"[26] (Figure 2). Regardless of the subject

Contract Work matter, "practical lithography" implied general contract work, and "terms

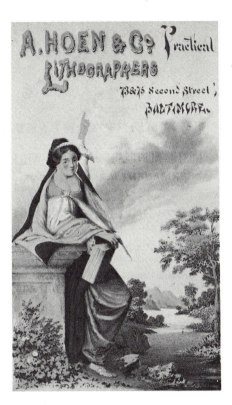

Figure 2. Advertisement of A. Hoen and Company, Baltimore, n.d. Location: Division of Graphic Arts, National Museum of History and Technology, Smithsonian Institution, Washington, D.C.

cash" was echoed throughout the period. J. Sage and Sons, of Buffalo, lithographed the phrase in 1¾-inch-high letters on their 1859 business cards. Other firms encouraged fast payment by hand-stamping special incentives on their cards: one such inducement was "Prompt Cash 2 Per Cent Discount on 30 Days Nett [*sic*]."[27]

Until the 1870s, when the chromo reached its height of popularity, practical lithography was not generally a speculative activity. J. H. Bufford and Sons, leading Boston printers, laid to rest any hope of credit with a bill of 1865: "Terms Cash.—No Goods Sold on Commission."[28] Many firms were aggressive, however, in their advertisement of both wholesale and retail orders. Joseph Hoover, a "steam power lithograph printer and publisher of fine chromos" in Philadelphia, was one of hundreds who offered wholesale prices for lot purchases.[29] A Philadelphia competitor, Theodore Leonhardt and Son (324–326 Chestnut Street), priced one thousand "*French Art Chromo Cards . . .* for Ten Dollars net."[30] The prices and lot sizes varied enormously, but all agreed on "terms cash."[31]

Practical lithography also meant fast service. When Thomas Sinclair and Company in the *Philadelphia Business Directory* (1854–57) promised maps, circulars, manufacturers' labels, and tags "printed on the shortest notice," they were repeating a phrase as natural as air to practical lithographers.[32] It was not hard to fulfill their promise, for much of this work was

Deadlines

routine: stones with images of checks, receipts, and show cards were stored on the shelves of lithographic shops throughout the country; when an order came in for one of these stock items, the stones were immediately pulled, inked, laid on the bed of the press, and, the order filled, reshelved.

But often practical lithography was more than an automatic process. Advertisements highlighted custom work, which required artists and lithographic draftsmen. Bingham, Dodd and Company, in Hartford, were typical: in 1860 they advertised, "Landscapes from nature.... Sketches made by competent artists, either in the city or country. *Original designs,* and *all work* connected with lithography attended to with promptness and punctuality."[33] Several decades later, Bigelow and Company advertised from their New York offices: "Artistic Productions in all branches of lithography."[34]

The dual service of providing original art and meeting deadlines could make hectic the life of a practical lithographer. The Strobridge company, of Cincinnati, for example, produced diplomas, and every year April and May must have been frenetic. Consider the correspondence between Strobridge and J. Fairbanks, superintendent of schools in Springfield, Ohio. On April 19, 1877, Fairbanks ordered a shipment of original diplomas that had to be prepared "at once"; as he explained, "Our school closes in *four weeks* and I would be pleased to get the Diplomas as soon as convenient." Despite several letters expressing semipanic, Fairbanks still had not received the shipment by May 17: "I am becoming alarmed lest our Diplomas will not be here in time. Our commencement is next Wednesday. Can it be they . . . have become lost in the mails?" No. Four days later the goods appeared: "The Diplomas came . . . all right. I am relieved and well pleased."[35] Quality work, low prices, tight deadlines made up the code of the practical lithographer.

Division of Labor Finally, "practical lithography" usually meant that a team of workers was responsible for a print's production. One person generally prepared the lithographic equipment, another drew the designs on the lithographic stones, a third operated the printing press, and a fourth managed the entire business. Many of the chromolithographs in this book carry as many as four different names: the publisher who paid for the reproduction, the artist who provided the original painting, the lithographic artist who copied it, and the firm that printed it. On rare occasions one person wore all four hats, but ordinarily the separate responsibilities were clearly divided.

This division of labor became increasingly specialized in the late nineteenth century. Instead of one printer, for example, there now were four: an apprentice, who fed paper into a press; a mechanic, who tended the steam-powered machinery; a prover, who checked for quality; and a foreman, who oversaw the work of the other three. And so it was with the artists and other chromo workers. As we shall see, this factory atmosphere was a

primary cause of the loss of respectability of the term *practical lithographer* and of the eventual desire of the artist to distinguish his work from the mass production common in the final decade of the chromo civilization.

VI. Boston and the Genesis of Chromolithography in America

The chromo civilization began, haltingly, in the lithography shops of Boston. The portrait of the Reverend F. W. P. Greenwood, printed in Boston in 1840 by William Sharp, is the first American chromolithograph.[36] The legend reads: "Drawn from Nature and on Stone, and Printed in Colours. . . . This plate executed at the request of the Congregation of Kings Chapel, is respectfully dedicated to them by their obliged & Obdt. Servt. Wm. Sharp." Although only two or at most three lithographic stones were used to print the image, the effect is distinctive enough to separate the portrait from the tinted lithographs of the time, in which one stone printed the image and a second cast a hue of light blue or tan across the whole page. In the Greenwood picture, the gray, tan, and light flesh tones compose the figure itself.[37]

Plate 2.

Born in England in 1803, William Sharp worked in London as a painter and drawing teacher, and by 1829 he was a lithographer with his own shop. The entry on Sharp in *The Literary Blue Book* for 1830 reads: "This artist is second only to Mr. Lane in the beauty and delicacy of his tints, and the fidelity of his delineations."[38] He emigrated to America in the late 1830s (probably 1839) and offered his services as portraitist to the people of Boston.

William Sharp

During his American career William Sharp entered into several partnerships, first with Francis Michelin, then Ephraim W. Bouvé, and finally with his son, Philip T. Sharp. Sharp's chromo portrait of Greenwood, an experimental effort, may have resulted from his acquaintance with Michelin.[39] According to an account written in 1902 by the chromolithographer Charles Hart, "Francis Michelin was considered an excellent printer . . . having learned the business in the establishment of the famous Hullmandel."[40] Conceivably, Sharp was not himself a lithographic printer, but simply the artist who drew the original designs on the stones.

Sharp's Partners

Sharp produced portraits,[41] botanical prints, sheet-music covers,[42] floral designs, and street scenes. Some of his work is classified as tinted lithographs,[43] but a certain number of prints are true chromos. When Sharp's chromolithographs for Morris Mattson's *The American Vegetable Practice* appeared in 1841, the author prefaced that they

> have been procured at great expense; and they were executed by a new
> process, invented by Mr. Sharp, recently of London, being the first of

the kind ever issued in the United States. The different tints were produced by a series of printed impressions, the brush not having been used in giving effect of uniformity to the coloring. Connoisseurs in the arts have spoken of them in terms of admiration, and Mr. Sharp will no doubt succeed in bringing his discovery to a still greater degree of perfection.[44]

Uneven Quality

But though some clients were excited about this new kind of color work, many lithographers and patrons were not eager to take a further step in the direction of chromolithography. The new process was experimental and financially risky, and the range in one artist's quality could be enormous. Some of Sharp's pieces demonstrate a subtle crayon style, such as the sheet-music cover "Blue Beard" (published by Boston's William H. Oakes; undated), which was printed from four stones, but other chromos show poor registration and weak color.[45] When Sharp's prints for the *Transactions of the Massachusetts Horticultural Society* of July 1847 were published, the editors pointed out "that chromos of the highest artistic skill . . . involved . . . an amount of labor and delay which could not have been foreseen, and the same may be stated with regard to the expense."[46]

Plates 3 and 4.

Plate 5.

But Sharp persevered. In contrast to New York and Philadelphia chromolithographers, who by the 1850s were increasingly reproducing existing works of art, Sharp mostly lithographed designs and drawings he had created specifically to be printed. Many of these chromos were made to illustrate books; his prints for John F. Allen's *Victoria regia; or The Great Water Lily of America* (1854) are extremely competent and at times spectacular. Sharp had in fact begun his career with a "hanging" print—a chromo designed to be framed—and though it seems he received few such commissions, one striking example is the "Chromo Lith" after "a portrait by F. Alexander" of the Reverend W. M. Rogers. Produced in 1852 by Sharp and Son, "chromolithographers,"[47] the portrait shows Rogers posed in a mirror image of F. W. P. Greenwood, but richer in color and firmer in form than his illustrious chromo predecessor. And although this image does not equal the lush portraits that were to be printed by Louis Prang in the 1860s and '70s, the print is definitely chromolithography imitating painting.

Sharp ended his career in chromolithography in the 1860s, having developed an interest in photography. This was a typical evolution. Numerous important chromolithographers, including Napoleon Sarony and Julius Bien, of New York City, either became photographers or else worked on techniques for reproducing photographs lithographically.[48] (Despite much experimentation, however, photomechanical printing was not refined until the 1890s.)

From William Sharp's shop in Boston, the chromolithograph moved to

Philadelphia and New York in the 1840s, then on to Pittsburgh, Buffalo, and Cincinnati in the 1850s. By 1875 most American cities boasted at least one chromo company.

Migrating from Boston, Francis Michelin became probably the first New York lithographer to have a background in color printing. A partner of Sharp's in 1840–41, Michelin may also have watched the color experiments of his English tutor, Charles Hullmandel, in the early 1830s. According to a man who apparently knew him, Michelin had a quirky, irritating personality and was also addicted to drink;[49] after leaving Boston to set up shop in New York, no later than 1844, he exhausted a number of partnerships.[50] Nevertheless, he achieved stature in his craft. City views, both chromolithographed and printed in tints,[51] were his specialty. One of his projects was a series ("printed in color") entitled "Whitefield's Original Views of American Cities." Created by Edwin Whitefield, an English artist who had come to America in about 1840, these chromos include "View of Brooklyn, L. I. From U. S. Hotel" (1846); "View of Buffalo, N. Y. from the Old Lighthouse" (1846 or '47);[52] and "View of Baltimore, Md. from Federal Hill" (1847). They were long, narrow chromos, printed to imitate watercolors.

Michelin's shop continued in New York throughout the 1850s. With book illustrations, portraits, and oddly casual group scenes[53]—such as "Encampment of 27th Reg.t National Guard, N. Y. S. A. at Camp Schuyler near Albany on the 4th of July, 1845"—he helped establish in New York the Boston-bred chromolithographic technology. Soon, a host of New Yorkers would follow his lead.

Shortly after Sharp's first chromo appeared, but before Michelin moved to New York, a New York lithographer settled in Boston. His name was J. H. Bufford, and he had in fact been trained in Boston, by William S. Pendleton. He was employed in New York by both George Endicott and Nathaniel Currier before he set up his own business there, in 1835.[54] His reputation was for producing fine hand-colored lithographic reproductions of paintings, to be either hung on a wall or placed in a portfolio. He was also a master illustrator of books, magazines, and sheet-music covers.[55]

It was in 1840 that Bufford returned to Boston, the town of his apprenticeship. He entered into partnership with his brother-in-law Benjamin W. Thayer and a lithographic artist named John E. Moody. They purchased the shop of Thomas Moore, another Pendleton-trained lithographer, who between 1836 and 1840 had employed at various times such artists as Benjamin Champney, Fitz Hugh Lane, and Eastman Johnson—all subsequent contributors to the democratic art. When Bufford took over, most of the art staff was dismissed, and Bufford assumed the artistic responsibilities. He is thought to be the first Boston lithographer not associated with Sharp to experiment with printing colors from several stones, which he did in 1843.[56]

Francis Michelin

Plate 6.

J. H. Bufford

Bufford in Boston

One sheet-music cover from this period, "Columbine Waltzes," appears to have been made from at least five stones: soft in surface like Sharp's "Greenwood," "Columbine Waltzes" is for its time an ambitious, sophisticated effort.[57]

In 1845 the partnership dissolved and Bufford joined A. G. Dawes to establish J. H. Bufford and Company. The firm existed briefly, and by 1851 Bufford was alone. He now called his business J. H. Bufford's Lithography.[58] The creation of framing prints after original drawings and paintings became his specialty, and his work was enthusiastically received. A reporter in the *Boston Evening Traveller* of March 18, 1864, wrote:

Bufford Alone

> Bufford's lithographs are sold wherever the flag of our country waves, and in foreign lands as well, and have carried into the homes of the people the rarest gems of modern art, transferred in a style frequently superior to the bright original. Engravings costing twenty, thirty, forty dollars a copy, or more, are reproduced in lithograph[y] at a quarter of their cost; and even the common prints, that used to disgrace the poor man's parlor, are now superseded by tinted or colored lithographs which, though cheaper, are true to the nicest details. . . .
>
> Through general agencies in all the large cities, and subordinate sales rooms in myriad towns and hamlets, tens of thousands of these lithographs have been sent broadcast over the continent. The result has been invaluable in educating the people up to a true taste, and in fostering their love for the beautiful.[59]

John Rubens Smith's Beacon Hill Views

Bufford drawing-room chromos include a set of five views of Beacon Hill that were copied from the watercolors of John Rubens Smith. The originals were produced in 1811 and 1812, the chromos in 1857–58.[60] While the prints are slightly heavier in appearance, more firmly drawn, and less lively, they remain faithful facsimiles of the watercolors, capturing Smith's skill as a draftsman, particularly his expertise in perspective.[61] Restrained in color and fairly accurate in registration, the Smith-Bufford Beacon Hill chromos are of extremely high quality, thanks both to Bufford's skill and to Smith's style, which relied on outlined forms and isolated colors. To reproduce a watercolor such as Smith's, a lithographic artist copied the drawing and each individual color on separate lithographic stones: the drawing was set on one stone, all the tan was set on another, the light pink on a third, and the brown on a fourth. So long as the registration was accurate, the image could be re-created by printing the impression from one stone over another on a single sheet of paper until all the components were reassembled.

Plate 7.

Bufford's business changed in form and in content during the decade of the Civil War. In 1864 his sons became his partners and the firm was renamed

J. H. Bufford and Sons; eventually they established branch offices in New York and Chicago.[62] Bufford himself left the company from 1866 to 1868 to serve as manager of the New England Lithographic Steam Printing Company—examples of his work from this period are of such low quality that it is hard to associate them with Bufford.[63] When he returned to his old house he renamed it John Bufford's Lithographic and Print Publishing Establishment. His chromo broadside, well designed and printed, promised "Lithography of all Descriptions executed in a style superior to any in the United States and not excelled by any European Productions." Historians disagree.[64] Bufford's quality declined. While the sheet-music cover "Chickering Waltz," made in 1867, is superb,[65] and prints of Benjamin Russell's five drawings of whaling scenes are accurate reproductions, Bufford and his partner sons were moving toward cheap chromo novelties, clichéd Christmas cards, and cut-rate prices.[66]

Bufford and Sons

Bufford's Decline in Quality

This commercialism definitively transformed the firm once the senior Bufford had died, in 1870. From the "oldest lithographic house in the United States," as one advertisement read in 1880, flowed such copy as "The finest lithographic power printing machines and the largest in New England"; "The strongest and most efficient corps of lithographic artists in the country"; and "Lithographic work of every description from the cheapest plan to the most elaborate Chromo executed at the lowest prices."[67] Typical of the level of work after 1870 was the "Twelve Temptations; Daniel in the Lions' Den," after a painting by H. Schoff. Used to illustrate—really, to advertise —a lecture given in Boston by the Reverend Henry Morgan, the chromo has none of the subtlety of the early Bufford works. It was sold complete with a key, enumerating and explaining the Twelve Temptations.[68]

Plate 8.

The Buffords remained in business until 1890, but, needless to say, their prominence as "artistic lithographers" waned. As they gave up their dedication to quality, two of their Boston competitors, L. Prang and Company and Armstrong and Company, rose in status. Prang (who will be fully discussed in a later chapter) became the leading chromolithographer in America. He did so by following in the early tradition of J. H. Bufford; by reproducing originals "precisely," Prang was to carry the Boston style of lithography, laid down in the 1840s, all the way into the twentieth century.

Bufford Set Pattern for L. Prang

Armstrong and Company was established in Boston in 1872 by Charles Armstrong, an English immigrant who had worked for several years as one of Louis Prang's principal lithographers. Known as producers of intensely sentimental genre scenes, portraits, sheet-music covers, reproductions of original paintings, and calendar illustrations, Armstrong and Company called themselves "Artistic Lithographers, Fine Art publishers." One of their specialties was chromo illustrations after paintings and drawings for books and folios on natural history and sports. Their work was commissioned for

Armstrong and Company

such publications as *Upland Game Birds and Water Fowl of the United States* (1877–78), after color sketches by A. Pope, Jr.; *Game Fishes of the United States* (1878–81), from paintings by S. A. Kilbourne; *The Celebrated Dogs of America: Imported and Native* (1880), after watercolors by Pope; *Celebrated Horses* (1881–82), "From paintings by the best artists"; *The Trouvelot Astronomical Drawings* (1881–82), after pastels by E. L. Trouvelot; and *American Yachts* (1884), from watercolors by Frederic S. Cozzens.[69] Of particular interest is *The Wild Flowers of America*, which was published in twenty-five parts, with two chromos and appropriate text for each part;[70] copied from watercolors by Isaac Sprague, the chromos appear remarkably faithful to the originals.[71]

Plate 9.

Armstrong and Company closed in 1897, the same year the more famous Louis Prang sold his firm, abruptly ending the era of the chromo in Boston. But the influence of the Boston chromolithographers did not end. As the following chapters will show, in addition to playing a critical role in the birth of American chromolithography, Boston's color printers were instrumental in the development throughout the United States of the democratic art.

THE 'AUTOMATON ARTISTS' IN THE CITY OF BROTHERLY LOVE

CHROMOLITHOGRAPHY made its first Philadelphia appearance in the 1840s, grew rapidly in the 1850s, and had matured by the start of the Civil War. Until the end of the nineteenth century Philadelphia was an important center for the chromolithographic reproduction of paintings.

Four companies ruled the early chromo life in Philadelphia: P. S. Duval, Thomas Sinclair, Wagner and McGuigan, and L. N. Rosenthal. Together they controlled half the presses, printers, and artists working in the city's lithographic trade in 1856.[1] The most prestigious chromolithographer of the group was Peter S. Duval.

I. P. S. Duval

Duval was born in France and in 1831 he was brought to America by the Philadelphia lithographic entrepreneur Colonel Cephas G. Childs.[2] Twenty-six years old, Duval was an expert pressman, trained in a nation renowned for its lithographic printing. He worked for Childs until the end of 1834, when, in lieu of cash payment of $750 Childs owed him, he assumed Childs's half of a lithographic business, which he then named Lehman and Duval.[3] The firm lasted until the end of 1837, when Duval's partner, George Lehman, withdrew, and the company became P. S. Duval's Lithographic Establishment. From then until his retirement in 1869, this French immigrant was the most important force in Philadelphia lithography.[4]

Beginning in 1842 Duval, in the pattern of William Sharp, was determined to produce a chromo. His earliest successes with printed color came in 1843 when he produced "lithotints," monochromatic lithographs printed in vari-

Duval's Partners

ous tones from a single stone,[5] and prints made from two stones with light tints.[6] Neither was a chromolithograph, but Duval was not hesitant to advertise in *Miss Leslie's Magazine* that his works were "Printed in Colours." By 1846 he was publicizing his skill as a chromolithographer in *The Mercantile Register or Business Man's Guide*.

French Lithographer and American Businessman

Duval achieved early significance for several reasons. First, he was the only lithographer in Philadelphia in the early 1830s who had been professionally trained; his experience in France allowed him to set lithography upon a proper technological and artistic course. Second, he had a flair for publicity —his storefront, his trade cards, and his occasional banquets promoted the image that he was one of Philadelphia's leading citizens. And third, Duval was an innovator in both color printing and steam-power presses.

Duval's Philadelphia competitors were not asleep. As early as 1844, Pinkerton, Wagner and McGuigan (later known as Wagner and McGuigan) received a silver medal from Philadelphia's Franklin Institute, a prestigious organization chartered in 1824 "for the promotion of the mechanic arts." The medal was given for "polychromatic lithography" and in 1848 Thomas Sinclair earned a "First Premium. Sinclair's works caused the judges to elevate chromolithography from the category of "stationery" to "fine arts."[7] Duval himself won his first of numerous Franklin Institute medals in 1849, for a chromo that exhibited "a decided advance surpassing anything we have seen in this country and equal to the best foreign productions in that line."[8] The same year he advertised "P. S. Duval's Lithographic & Color Printing Establishment"; his chromolithographed flier (Figure 3) reads in part: "The undersigned begs leave to inform his friends and the public in general that he has added to his Lithographic Establishment CHROMO-LITHOGRAPHY (printing in Colours), for all kinds of fancy & ornamental printing of which this Card is a Specimen."

Plate 10.

Printed in gold, green, red, and blue, this early Duval chromo isolated colors in the old style, that of illuminated manuscripts. Caught in the surge of the Gothic Revival, similar works appeared from numerous shops, most of them serving as illustrations for the polite periodicals and annual "gift-books" that were in vogue at the time. The technical demands of this genre were less stringent than those of the later reproduction of complex oil paintings: with virtually no color overlap, the lithographer was challenged neither by subtle color changes nor by transparent inks. Given the technical level of early chromolithography in America, this style was ideal.

Christian Schuessele

The Duval Gothic-style flier was designed and put on stones by Christian Schuessele. Born in Alsace in 1824,[9] Schuessele had studied under Paul Delaroche in Paris, where he worked for several years with one of the most advanced chromo houses in Europe, Engelmann and Graf. According to *Sartain's Union Magazine of Literature and Art* (1852), Schuessele specialized

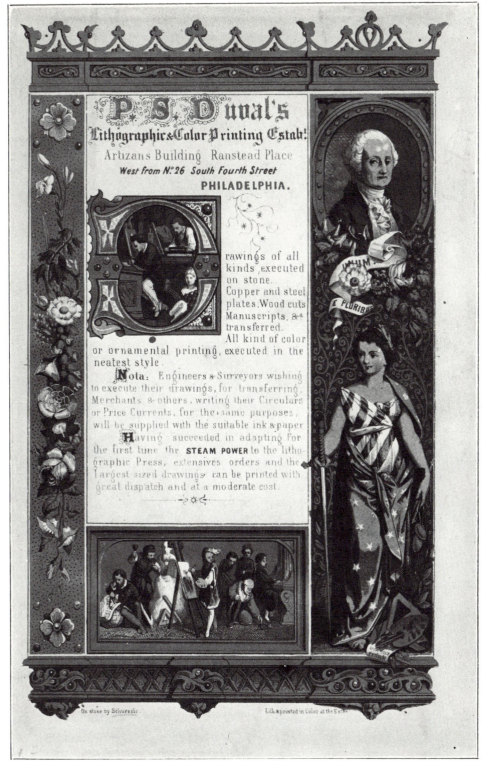

Figure 3. "P. S. Duval's Lithographic & Color Printing Establishment." Artist, Christian Schuessele. Printed by P. S. Duval, Philadelphia, c. 1849. Caption: "printed in Color." 8⅜ × 5¼ inches. Location: Prints Division, The New York Public Library, Astor, Lenox, and Tilden Foundations.

in designs for illustrations similar to the illuminated advertisement by Duval: "Some of these designs were executed in the very highest style of this beautiful art. In this department, Mr. Schuessele seemed to have reached almost

unrivalled excellence."[10] The same article also notes that Schuessele had been chosen to reproduce "all the pictures in the gallery at Versailles," a project planned by King Louis Philippe but terminated by France's February Revolution in 1848. In 1849 Schuessele was lured to America by his compatriot P. S. Duval.

Although Duval had been working with color, he regarded Schuessele's arrival as the real beginning of chromolithography in his shop.[11] *The Bulletin of the American Art-Union* of 1850 agreed. A Duval-Schuessele print suggested to that publication the wave of the future: ". . . for finish and richness of color, [it] rivals the best European work. . . . In a few years the most accurate copies in color of pictures, will be printed, and the great work of popularizing Art, which is one of the distinguishing characteristics of the age, carried nearly to perfection."[12] Similar comments appeared in some issues of the 1849 *Report of the Commissioner of Patents* (part one), which contained various plates illustrating the different stages of a chromolithograph. These progressives, too, were the work of Duval and Schuessele, whose technical competence led one author of the *Report* to predict: "In chromo lithography, automaton artists rival the finest touches of old masters, and shortly will multiply by millions, their most esteemed productions."[13]

Plate 11. Schuessele's work with Duval encompassed the designing of chromo title pages, advertisements, and illustrations, and the rendering of portraits. In 1851 his full-length chromos of Washington and Lafayette were printed from thirteen stones. The prints were highly praised by the Philadelphia *Public Ledger* as examples of the "new style of chromolithography." Instead of isolating every color, Schuessele overlapped the tones in each portrait, creating the range of subtle color variations found in oil paintings. His work proved to the *Public Ledger* that chromos were "capable of the finest expressions of coloring, as well as of light and shade." They were so unusual that, unlike the Gothic designs, which served as mere illustrations, these looked like "finished paintings." Moreover, they were available to everyone: "the cheapness of their production commends the art to universal favor."[14]

Duval's Fire, 1856 With Schuessele as lithographic artist and Duval as printer and impresario, the P. S. Duval firm was able to turn out large quantities of high-quality work;[15] it also served to train many apprentices. When a fire burned the business down on April 11, 1856, the losses were in excess of $100,000 (only $30,000 of which were covered by insurance).[16] Rebuilt by 1857, the company was expanded with the addition of a new partner, Duval's son Stephen, and renamed P. S. Duval and Son.[17] Schuessele left the firm apparently in the early sixties to pursue his own genre painting. Eventually he would serve as a professor of drawing at the Pennsylvania Academy of the Fine Arts.[18]

Shortly before the Civil War the Duvals printed for the publisher William

Smith "Washington's Triumphal Entry into New York," a print advertised as "the largest specimen of Chromolithograph ever executed."[19] Its measurements were extraordinary for the time: 34½ by 46⅞ inches. Sold with a numbered key for identifying the principal figures and an eight-page pamphlet of biographical sketches, the chromo was intended as a patriotic historical narrative. Its appeal was clear to all patrons of the democratic art, and it made a sensation. A second, similar version of the historic event was chromolithographed by Duval's competitor Thomas Sinclair in 1860. Published by George T. Perry, who had worked with William Smith on the Duval version, this chromo was copied by lithographer Alphonse Bigot "from an original drawing." It, too, was in the heroic style.

Joseph Pennell noted in his history of lithography that Duval had written "a book about lithography of which there is no trace."[20] There is an entry by Duval in J. Luther Ringwalt's *American Encyclopaedia of Printing* (1871), which Duval wrote shortly after retiring, in 1869. To this day a primary source on American lithographic history before 1870, this article may well be the "book" to which Pennell referred. Duval died in 1886.

The dean of his craft in the postwar years,[21] Duval had made the difficult transition from black and white to printed colors, and from printed colors in simple designs to printed colors that reproduced oil paintings. He even dabbled in photography. He did all this and his firm succeeded commercially. The importance of that fact cannot be overestimated. The democratic art required both an inventive approach to serious technical problems and a keen business brain, a duality Duval obviously embodied. Duval played an essential part in the establishment of the chromo, and his name appears repeatedly throughout the history of chromolithography.

Plate 12.

Plate 13.

Duval's "Book"
on Lithography

II. The Schoolcraft Project

Duval and his Philadelphia competitors offered the full range of lithographic services: "portraits from life and on stone," landscapes, anatomical and architectural drawings, machinery designs, music titles, maps, plans, circulars, checks, billheads, labels, and "transferring from Copper Plates, Steel Plates, Wood Cuts and Manuscripts." In contrast, some firms were intensely specialized. E. Ketterlinus, for example, became nationally known for its manufacturers' labels (Figure 4); as the Franklin Institute noted in 1858, "Much of this fanciful work was imported from England and France, but Ketterlinus can now supply the demand with an article just as good." All of these Philadelphia lithographers gathered from time to time at banquets and guild meetings, and there is little doubt that those who remained in business for a decade or more felt themselves part of a fraternity. So it was in

E. Ketterlinus

Figure 4. Trade card of E. Ketterlinus, Philadelphia, c. 1855. Location: Warshaw Collection of Business Americana, National Museum of History and Technology, Smithsonian Institution, Washington, D.C.

City Loyalty

Boston, Buffalo, New York, and elsewhere; in fact, American lithographers' loyalty to their own cities was so great that efforts to establish a national organization met with lack of interest or else suspicion until the 1880s, when a lobbying association became an economic necessity.

National Style

Each city may have had its peculiar lithographic style in the 1830s and '40s, but by midcentury Philadelphia, Boston, and New York were producing chromos whose style was very similar. All the major firms were trying to reproduce oil paintings. Many of them did outsized illustrations for reports for the federal government, which contributed to the rise of a national chromolithographic style; in the transitional years from hand-coloring to chromolithography, a government contract often determined whether or not a firm would commit itself to color printing.

Henry Rowe Schoolcraft's History of Indian Tribes

One vivid example of work done for the government was the production of volume one of Henry R. Schoolcraft's *Historical and Statistical Information Respecting the History, Condition and Prospects of the Indian Tribes of the United States.* Authorized by a Congressional bill of March 3, 1847, it was published in six volumes from 1851 to 1857, each volume measuring 9½ by 13 inches. Henry Rowe Schoolcraft (1793–1864) is generally considered America's first social anthropologist. Trained as a glassmaker, he developed interests in both geology and the American Indian and he published several important treatises before 1851, one of which correctly identified the source of the Mississippi River as Lake Itasca. Schoolcraft participated in several explorations and served from time to time as a liaison between the federal government and various Indian tribes. A man of practi-

cal knowledge and literary skill, he was the government's natural choice to collect material and write the essays for the six-volume history of the American Indian.

The primary illustrator for the Schoolcraft volumes was the soldier-artist Seth Eastman (1808–75). Entering West Point in 1824, Eastman was commissioned a second lieutenant in 1829. After teaching drawing at his alma mater from 1833 to 1840, he fought in 1841 in the Seminole War in Florida and eventually was stationed at Fort Snelling, Minnesota. There he became interested in recording the Indian's everyday life in a style that he described as free from romantic distortion and faithful to every detail. Before his appointment to the Schoolcraft project, he was hailed as an artist who "possesses more ability for such a task than any man in this country. It would be hard to find a man possessed of the same artistical ability, who combined with it a thorough knowledge of Indian character. Illustrate such a work by all means, set Capt. E. to work upon it, and our country will possess a history of its original inhabitants which will reflect credit upon the administration under whose direction it is produced."[22] And in Schoolcraft's preface to his first volume, Eastman is described as having returned from the West "with his portfolio filled with views of American scenery, and objects of Indian life and art, delineated on the spot, or drawn from specimens."

From 1849 to 1855 Eastman was stationed in Washington, D.C., churning out hundreds of drawings and watercolors of maps, landscapes, tribal ceremonies, artifacts, pictographs, tools, costumes, weapons, and musical instruments related to the American Indian.[23] He produced four types of pictures: paintings and drawings completed before going to Washington; copies after his own sketches and notes; original works produced in Washington; and copies of works made by others. In most cases he painted pictures in watercolors and inks, which measured about 9½ by 6½ inches. These were the "originals" the printmakers used—when reproducing either his own or the works of others, Eastman seldom made faithful duplicates; his biographer explains that in Washington Eastman often painted from memory because he did not possess the original picture.[24] But even when he could work directly from the original he sometimes altered his small watercolor in order to make the image more accessible to graphic reproduction.[25]

The Schoolcraft-Eastman project was a milestone in anthropology, and had the chromolithography been successful it could have served as a boon to color printing in both Philadelphia and New York. Volume one contained seventy-six plates: seventy-five lithographs and one wood engraving. Among the lithographs forty-nine were chromos. Early in the project it had been suggested that Eastman draw his pictures directly on stone, for according to one contemporary opinion, this would "cost nominally nothing" and save the government "some $5,000."[26] But instead, three lithographers were

Seth Eastman

Eastman's Originals

Volume One

hired to do the work. J. T. Bowen, the foremost producer of hand-colored lithographs in Philadelphia, received $1,896 for twenty-one lithographs (mostly hand-colored), twelve hundred copies each. James Ackerman, of 379 Broadway, in New York,[27] a chromo pioneer of whom little is known, printed thirty-one of the chromos and four black-and-white lithographs; for the edition of twelve hundred copies he received $1,900.[28] P. S. Duval, in the same edition, was paid $1,421 for nineteen lithographs,[29] seventeen "printed in color" and two monochromatic. Prices per copy varied tremendously, depending upon the lithograph's technical complexity. Ackerman's lithographs, which were the simplest, came to a little more than 4.5¢ a copy, Duval's to a little more than 6.5¢, and J. T. Bowen's to 7.5¢.

James Ackerman

Volume one was an unusual opportunity for Ackerman and Duval, the printers who provided most of the chromos. While each had produced chromos before 1851,[30] neither had had the chance to demonstrate his competence at meeting the standards and the variety of demands of the government project. Most of Ackerman's chromos for Schoolcraft are simple in design and neatly executed. As in "Wabeno Songs," the colors are isolated, bounded by black lines and seldom permitted to overlap; only in a few cases, such as "Copper Wrist Bands," do colors graduate from one hue to another. The isolation of solid colors also characterizes many of the Duval chromos. His "Symbolic Petition of Chippewa Chiefs," unique in the world of chromo imagery, is well suited to the separation of colors, as is his "Iroquois Picture Writing." His "Ruins of a Watch Tower," however, attempts to superimpose colors in imitation of an original work of art, and it fails, not coming near the feeling of the painting. The same flaw is found in the rare chromo "Indian Offering Food to the Dead," by J. T. Bowen.[31] The American chromolithographers of 1850 had not yet learned the skills of subtly combining colors; the blending of hues was still best done by hand, as in Bowen's fine "View of Itasca Lake, Source of the Mississippi River."

Plate 14.

Plate 15.

Plate 16.

Plate 17.

Plate 18.

Plate 19.

Although to modern eyes the plates in Schoolcraft's first volume are aesthetically appealing, it is most important to realize that they failed to make the grade in 1851. Eastman in particular appears to have been disappointed;[32] even the publisher, J. B. Lippincott and Company, told Schoolcraft that "Capt. Eastman's beautiful drawings suffer" as chromolithographs.[33] The number of color plates in subsequent volumes of the history was sharply reduced, and lithographs gave way to traditional black-and-white wood and steel engravings.

Throughout 1851 scores of letters were exchanged between Schoolcraft, the publisher, Seth Eastman, and the lithographers, complaining that the chromos were not being produced on time and that the entire project was missing its deadline. Typically, the publisher wrote to Schoolcraft on January 14, 1851: "... the book is at a complete stop for want of Mr. Ackerman's

Publishing Problems

plates."[34] Moreover, no one seemed capable of controlling the quality of the chromos. Lippincott and Company wrote, "We regret to notice that some of the plates are soiled in coloring and a number of them are printed without regard to the margin which tends to mar their symmetry and beauty, as well as the general appearance of the books. All this shows the necessity of placing the entire mechanical execution of such a book in the control of one who is familiar with the various branches, and who should be held responsible for any defect in its appearance."[35] Eastman found that virtually all the chromos needed to be, as he termed it, "corrected" before they could be printed. One lithographer seemed no better than another, in Eastman's opinion, even though to us Ackerman appears most competent.[36]

Reprinting the Schoolcraft volumes presented yet another problem. Unlike engravers, who often turned over their printing plates to customers once a job was completed, lithographers retained the stones, to be used again on other projects. Writing to the head of the Bureau of Indian Affairs, School- *Lithographers* craft noted the difference in procedures: *Own the Stones*

> There were many reasons why the chromolithography should be applied to the first volume . . . to portions of the forth coming parts the contract with the lithographers, were, [sic] however, made under some disadvantages, and, in future it is believed that the drawings relating to history, antiquities & pictography, could be, more appropriately, done on copper or steel plates, to be purchased and owned by the government. The expense . . . would be somewhat larger at the commencement, but in reprinting the work, it would be very little. The government, owning the plates, could, in that case, reproduce the work at its pleasure. Whereas, we are now in the hands of the lithographers, who own the stones, and must be paid the entire amount of the first cost for additional numbers before the drawing is obliterated.[37]

The changeover from lithographs to metal plates is dramatized in volume *Metal Plates* six. Here we can compare the same pictures printed differently, for many of *Replace Stones* the illustrations from the first five volumes were reissued in the last. In particular, Ackerman's chromolithograph "Ohio River, from the Summit of Grave Creek Mound" has been drastically altered as a steel engraving.

III. Thomas Sinclair

In the early 1850s, then, there were signs both of hope for the new print *Hope and Doubt* technology—as seen in the Duval-Schuessele portraits of Washington and Lafayette—and of an early death. When the Schoolcraft-Eastman project

turned its back on chromolithography it may have seemed to the public that lithographic color was just another of the many printing fads of the time.[38]

Unevenness in the quality of early chromolithographs can be seen in the work of numerous Philadelphia lithographers, as exemplified by that of Thomas Sinclair. The Scottish-born Sinclair, one of Duval's most persistent rivals in the broad field of practical lithography, was a frequent contributor to federal publications, including the *United States Pacific Railroad Expedition and Survey, 38th and 39th Parallels.*[39] He had begun in Philadelphia in about 1838 by purchasing the lithographic equipment of John Collins;[40] forty years later he claimed to own "the most complete facilities, and the largest exclusively lithographic establishment in the state."[41] The format as well as the quality of his work varied greatly. Although he won a Franklin Institute award for his chromolithography in the 1840s, he continued with hand-colored pieces throughout the fifties.[42] Some prints bearing his name dazzle with their color and three-dimensionality, but others created in the late fifties can be flat and uninspired. Many of his sheet-music covers, for example, anticipate the striking lithographic style of the humor magazines *Puck* and *Judge,*[43] but his smaller chromos of the late sixties project a cute, mawkish quality that exceeds even the saccharine Currier and Ives. As early as 1840 one of his workers protested against what he called "Sinclair's idea of caricaturing"; the frustrated lithographic artist, Matthias S. Weaver, decided after a stint with Sinclair, "I don't want anything to do with the business."[44]

Nevertheless, Sinclair was a major developer of the chromo in the 1850s. His landlord at 101 Chestnut Street, the Philadelphia *Public Ledger,* praised his work of the late forties and early fifties:

> No landscape produced by a skillful painter in water-colors could be much more finely executed. The colors are blended and softened down with the nicety of pencil work, and the most delicate atmospheric effects are produced in a style that would seem, at first sight, impossible to be performed with such unyielding substances as blocks. Mr Sinclair has acquired a skill in this kind of printing which it is doubtful if the best French artists can excel. There is certainly nothing out of France which goes beyond it.[45]

The *Public Ledger* was describing the transition from isolated colors, as seen in the Duval illuminated designs, to color mixing and overlap. In Sinclair's own advertising broadside from about 1860 the old style predominates, as it does in the membership certificate of the Improved Order of Red Men.[46] In the latter, however, dots of color were juxtaposed and thereby mixed in the viewer's eye to create varying intensities and shades in the vi-

Diversity of Sinclair's Work

Plate 20.

Plate 21.

gnette at the top and in the flowers in the borders. The splendid advertisement for H. P. and W. C. Taylor Perfumes shows the two styles brought together: the border and frame motif is in the style of the 1840s, while the central scene and the small bottom view had become typical by the 1860s. Produced in about 1850,[47] this advertisement is one of Sinclair's best works. *Plate 22.*

Throughout the late fifties and into the sixties the firm of Thomas Sinclair and Company (1854–59) and Thomas Sinclair and Son (seen on some prints after 1859) continued in its disparate production:[48] brilliant lithographs such as the "Union Volunteer Refreshment Saloon of Philadelphia" (1861, after the talented James Queen) one day, and silly chromo cards the next. Clearly, when called upon to produce a high-quality product, the Sinclairs were up to the task. In 1865 they chromolithographed Jasper F. Cropsey's *Jasper F. Cropsey* *Starucca Viaduct*, calling the print "American Autumn, Starucca Valley."[49] *Plate 23.* The print had been commissioned by Uranus H. Crosby, of Chicago, who had built an opera house that he intended to give to the city. Because construction costs had been heavy, however, he found himself in financial trouble and so decided to salvage some of his money by holding a lottery. He offered the opera house itself as first prize and other items, including the original Cropsey painting, as third prizes. The "Starucca" chromos were given away to anyone who purchased at least four tickets.

Cropsey's painting, destroyed in the Chicago fire of 1871, measured about eight by fourteen feet and had cost Crosby $3,000. There were also at least two smaller versions of the work, one of which probably served as the original for the Sinclair chromo.[50] Drawn on stones by William Dreser, "American Autumn" was technically demanding. The wide variety of colors called for many stones, and the absence of strong outlines meant that the colors had to define the forms. While the foreground and middle distances are fairly clear, the background begins to give way to atmospheric effects created by a gradual diminution of recognizable shapes. Cropsey's technique of applying paint was not unduly complex, but the different colors of his individual brush strokes had to be imitated in the chromo. Dreser pursued this detail work tenaciously, producing a print that conveys much of the feeling of the oil painting.

Cropsey's work was not chromolithographed by any other American. He did sell some of his paintings to the English lithographic firm E. Gambert and Company;[51] eight of these chromolithographs were offered in a series entitled *American Scenery*.[52] Whether Cropsey's paintings were viewed as too difficult for Americans to reproduce or as lacking in general appeal is unknown.

IV. Wagner and McGuigan and L. N. Rosenthal

Sinclair had two rivals in addition to P. S. Duval. Wagner and McGuigan and L. N. Rosenthal were expert, aggressive chromolithographers. Pinkerton, Wagner and McGuigan had established themselves in 1844, and that year they won a silver medal from the Franklin Institute for their color printing. The firm supplied fashion illustrations for *Godey's* and *The Ladies' Garland*. E. J. Pinkerton, a former lithographic artist in Duval's company, retired in 1845 and Thomas S. Wagner and James McGuigan dropped his name from the firm's title. Wagner, too, was a Duval artist. Virtually nothing is known of McGuigan.[53] The two remained together until 1858.

Wagner and McGuigan were considered expert color printers of Gothic-style illuminated pages and producers of a vast array of trade cards; they were also known as the unlucky inhabitants of fire-prone buildings. Wiped out and underinsured on several occasions, they nevertheless always bounced back to business life; their factory, in fact, was featured in their advertising. In the fifties they owned the building in which they worked, and after Duval's factory was gutted by a fire in 1856, they boasted the city's largest facility. They advertised with two different views of their pressroom (Figure 5), each showing "upwards of Forty presses" and each promising "illuminated color printing," including chromos in bronze and gold.[54]

Plate 24.

If the subjects, styles, and quantity of their prints are any indication, the midfifties was a happy time for Wagner and McGuigan. This spirit is conveyed in "Henry's United Silver Cornet Band at Niagara Falls": printed in colors in 1855 from a daguerreotype "taken on the spot," the small, quiet chromo seems out of step with the fifties' trend toward bigger and brasher pictures. Fire was to strike again, however, this time destroying the harmony that existed at Wagner and McGuigan. In 1857 everything was ruined,[55] and although the factory was rebuilt the partnership was not. Thomas Wagner stayed on alone at the old address, advertising early in 1859—with three white horses pulling a chariot—that he was "formerly" of Wagner and McGuigan;[56] he died in 1863. James McGuigan eventually established his own business in Philadelphia, with "oil color printing" as one of his specialties;[57] it does not appear that his firm survived for long.

Rosenthals: Russian Immigrants

The Rosenthal brothers, the fourth of the Philadelphia lithographic quartet, arrived in town about 1850. Russian immigrants with a sophisticated skill in chromolithography, they stepped right into the battles for business being waged by P. S. Duval, Thomas Sinclair, and Wagner and McGuigan. Before long their works began appearing in books and on fences and walls throughout Philadelphia.[58] Their rate of growth was rapid.

During most of its existence the company was called L. N. Rosenthal.[59] Lewis appears to have been the leader, but at least four other brothers played

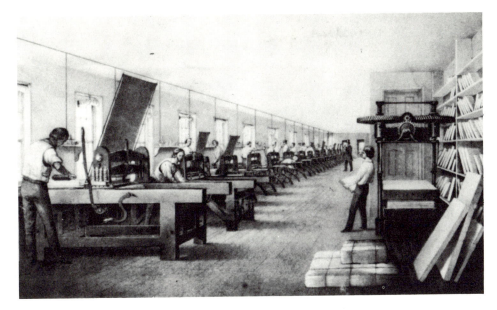

Figure 5. Advertisement of Wagner and McGuigan, Philadelphia, c. 1856. Location: Harry T. Peters "America on Stone" Lithography Collection, National Museum of History and Technology, Smithsonian Institution, Washington, D.C.

parts in the business.[60] As quoted in R. A. Smith's *Philadelphia as It Is in 1852*, the firm described itself as a "Chromographic and Zincographic Drawing and Printing Establishment" that produced the full range of practical lithography "in the latest European style."[61]

Max Rosenthal was the principal lithographic artist. He had studied lithography, engraving, and painting under an Alsatian, Martin Thurwanger, from whom he may have heard of the opportunities in Philadelphia, where Thurwanger immigrated sometime after 1848. Like Christian Schuessele and William Dreser, who drew a tremendous variety of subjects on stone, Rosenthal produced the plates for city views,[62] pictures of locomotives,[63] advertisements of every description,[64] and book illustrations. His earliest works are lean and somewhat disappointing compared with Duval's and Sinclair's. For example, in about 1852 L. N. Rosenthal produced chromos for C. W. Webber's *The Hunter-Naturalist:* copied from drawings by Alfred Jacob Miller, Max Rosenthal's chromos were described by Webber as a "first experiment in a novel field," and, while praising them as "unparalleled specimens of the art of Printing in colors upon stone," the author admitted that they left "much to anticipate." Nevertheless, Webber saw the involvement in the democratic art of this recent immigrant as part of a peculiarly American mission: "the art of printing in colors, which is yet in embryo in Europe, has been left for us to develope in this country."[65]

Subsequent chromos by Max Rosenthal are bolder, brighter, and overflowing with details. The Rosenthals' advertisement of 1856 (Figure 6) is itself a visual, as well as written, example of their chromo philosophy. Even placid scenes such as "Interior View of Independence Hall, Philadelphia" received the full chromo treatment.[66] Under Max's guidance the prints rarely

Max Rosenthal

Plate 25.

Plate 26.

Figure 6. Advertisement of L. N. Rosenthal, Philadelphia, 1856. Artist, Max Rosenthal, after his own design. 12⅜ × 9⅝ inches. Location: The Library Company of Philadelphia.

moved from the old style into the new, as illustrated by Sinclair's view after Cropsey; that is, instead of the blending of colors by minute applications, strong isolated colors were arranged to give the superficial appearance of a painting. Even a fast glance, however, reveals the Rosenthal method of treating almost every work as though it were a specimen composed of distinct color separations. The large number of Rosenthal chromos produced for Samuel Sloan's *City and Suburban Architecture* (1859) testifies to the persistence of the old style of chromolithography.

The Rosenthals remained in business for at least twenty-two years.[67] Today they are appreciated for the high-quality printing they occasionally achieved. Their designs, however, have lost aesthetic favor. Indeed, the work

of virtually all of Philadelphia's early chromolithographers seems garish to our eyes, with the significant exception of the lithographs of James Queen.

V. James Queen

James Queen produced some of the finest chromolithographs in America. A quiet family man whose career spanned much of the history of lithography as a popular art, he eschewed specialization, seeming to thrive on variety. He combined line and color at a time when many artists seemed bound to either the old or the new style.

Even the most basic facts and dates of Queen's career have eluded biographers.[68] Born in Pennsylvania in either 1821 or '22 (the best evidence makes it May 1, 1821),[69] Queen was apprenticed to Lehman and Duval on November 24, 1835, for "four years, five months, and six days . . . to be taught or instructed in the art, trade, or mystery of a Lithographic Draughtsman."[70] (Before the Civil War the apprenticeship system was strong in numerous crafts, and it helped train some Americans in lithography.) Completing his apprenticeship in 1840, Queen worked steadily as a lithographer for more than forty years. He was married in 1843 and he died on January 15, 1886.[71]

Apprentice of Lehman and Duval

Queen's lithographs cover a spectrum of time, subjects, and styles. His earliest pieces were black-and-white illustrations for periodicals such as the *U.S. Military Magazine* (1840) and for covers of popular sheet music. Sometimes in the lithographic production he was simply the middleman—the one who drew images on stones from someone else's designs. At other times, he served as both original artist and lithographic draftsman. He drew steamboat explosions and scenes of fairs, appealing to the public thirst for journalistic illustrations; he drew advertisements for a broad selection of goods and services; he drew certificates and diplomas; and he also drew portraits. His repertoire, if not always in the realm of high art, was diverse and, more often than not, injected with fresh ideas. His vision was filled with unusual compositions, and his works convey a singular personality, something all too often missing from the lithographs of his competitors.

Earliest Works

Queen worked on occasion for Wagner and McGuigan as well as for Thomas Sinclair, but his master teacher, the Duval firm, remained his principal employer until the 1870s: in 1864 Duval wrote to lithographer Albert Newsam, "James Queen is still with us and is now one of the best artists in the country. He is very useful to us and we have more work for him than he can do."[72]

Queen's earliest chromos appeared in the 1850s,[73] but his most distinguished pieces were published during the Civil War.[74] His "Volunteers in

Queen's Civil War Chromos

Plate 27. defence of the Government against usurpation" is notable in two respects. First, Queen published it himself, apparently seeing a money maker in the subject. Second, the foreground figures are unique in American chromolithography: simple, yet individual; stiff, yet believable. The broad, flat colors of red, white, and blue make a patriotic tapestry and repeat the feeling of the flag that occupies at least a third of the chromo surface. Queen's devotion to the Union was intense, and his chromos relay that commitment to the viewer.

Plate 28. "View of the Philadelphia Volunteer Refreshment Saloons" was drawn by Queen and "printed in colors" by Thomas Sinclair in 1861. Typical of at least half a dozen chromos by Queen, it depicts the Union troops in Philadelphia preparing to leave for battle. A series of vignettes showing mess halls and parade grounds are stacked one above the other and embraced by Queen's ubiquitous flags. Like the patriotism of "Volunteers in defence," the impact of this chromo is action for the Northern cause.

Plate 29. While some of Queen's chromos are composed of only a few people, his "Buildings of the Great Central Fair," printed by P. S. Duval in 1864, is quite complex. Once again, an enormous flag serves as a critical design element, an axis around which the scene revolves. The artist's control and self-confidence are evident: with very few colors he has created a chromatic richness.

One of the truly inspired American chromolithographers of the 1860s, Queen grew as the industry grew. Having been schooled in the linear artistic tradition of the 1830s, he matured during the experimental '40s, when color printing was first being tested: he added bold tones to his drawings just as *Queen Compared* the lithographic trade was learning to do the same. Queen's talent can be *with Schuessele* illustrated by comparing it with that of Christian Schuessele (the two worked for Duval at the same time).

Schuessele was a professional artist who had brought from France a great deal of knowledge of chromolithography. His thematic passion appeared to be academia. But, despite his background in chromolithography, he never really succeeded at it: his chromos look strained, with subject, style, and medium always apparently at odds.

In contrast to Schuessele, whose approach was that of the academic painter, Queen seems to have thought in lithographic terms. His focus was on the two-dimensional picture surface. His carefully chosen colors, generally broad and flat, simplified the problem of faithful registration. There is a seeming artlessness in his Civil War pieces, which is in fact a sophistication that would vanish from most of his postwar chromos. After 1866 clichés predominated: "Washington as a Mason,"[75] "The Dessert Table,"[76] and "Home, Sweet Home,"[77] which were only occasionally relieved by such unusual works as "A Breezy Day."[78] In "A Breezy Day" Queen employed a

few greens and browns and several well-chosen vertical, horizontal, and diagonal lines to create a chromo that is closer to a pencil-and-watercolor sketch than to an oil painting; simple and lean, it is atypical of his work in the late sixties and early seventies.

During this period Queen found himself involved with Joseph Hoover. A shrewd businessman, an art collector, and an uncanny taste maker, Hoover was not himself a lithographer but rather an entrepreneur who oversaw all aspects of the lithographic trade. One of the few native Americans to achieve prominence in the chromo world, Hoover was born in Baltimore on December 29, 1830. Trained in "architectural wood turning," he moved to Philadelphia and started his own business in 1856, in which much of his work involved the turning of oval frames on eccentric lathes for gilders and frame-makers. Sometime in the middle or late 1860s he began publishing pictures, selling many ready to hang.[79]

Joseph Hoover

Hoover was one of three American chromolithographers awarded medals for excellence at the Centennial Exposition.[80] His prints were at first subcontracted to established lithographic firms; Duval and Hunter, of Philadelphia,[81] for example, printed his award-winning Centennial chromos from images drawn on stones by James Queen. Although these chromos were the product of a group effort, it was Hoover who got the prize because, in addition to paying for the project, he had undertaken "the entire supervision, as to color, details and proofs . . . [and] thus made himself personally responsible for the success of the final result."[82]

From 1867 to 1872 Hoover was the main publisher of James Queen's chromos: "American Fruit" (1867), "The Young Rogues" (1869), "The Bright Little Teacher" (1869), "Live Woodcock" (1870), "The Veteran" (1870), "Early Winter in the Highlands of Upper Bavaria" (1872), and "Little Red Riding Hood" (1872) suggest both the diversity of Queen's subject matter[83] and the change in his art since his work for Duval in the early sixties. Sentimental three-dimensional picture stories that allude to a kind of social ideal, these chromos lack the two-dimensional power of the Civil War views. From art to anecdote was the course Queen took, and the subject matter that Hoover selected was only part of the cause of the change. The way the figures were molded with line and color indicates that Queen was deliberately shedding his earlier style.

Plate 30.

VI. The Later Years in Philadelphia Chromolithography: Joseph Hoover

The pioneer work of Duval, Sinclair, Wagner and McGuigan, and Rosenthal firmly established the chromolithographic industry in Philadelphia for the

period 1860 to 1900. The later career of Joseph Hoover is but one illustration of the result of that industry's foundation.

In the middle of the 1870s Hoover himself began printing some of the chromos that bore his imprint. By 1885 he had installed what was described by the *Lithographers' Journal* as a "complete lithographic plant . . . equipped with the best character of machinery. . . ." [84] Reportedly, all his chromos from the mid-1880s were printed in his own shop. By 1893 Hoover's firm was one of the largest chromolithographers of fine-art copies in America. Average annual production was put at between 600,000 and 700,000 pictures, with markets throughout the United States, Mexico, England, and Germany. Like Louis Prang, who selected the pictures to be chromolithographed, Hoover followed his own instincts, and he had a reputation for a keen sense of color. His purchases of art kept "a trained corps of lithographic artists . . . continuously engaged in putting new work upon the stones. . . ." [85] While many of his prints do not compare in quality with Duval's, professional contemporaries gave Hoover high marks. Made to look like watercolors, his chromos were praised as being "perfect in fidelity to the originals . . . there is a truth which almost defies detection of [the] original." [86]

Taste Maker Hoover became known in the trade as a chromolithographer who catered to the "tastes of the masses." [87] In the democratic rhetoric of the nineteenth century this was not necessarily a pejorative description. By 1893 Hoover was considered a successful reformer, who for approximately twenty-five years had sought to unite two influences: "one tending to gratify the popular craving . . . the other aiding to educate that craving to a demand for something a step higher." [88] This was a classic profile of the democratic-art reformer.

From when P. S. Duval advertised in 1848 that "Chromolithography is the coming thing" [89] until the end of the nineteenth century, Philadelphia manufactured a vast range of lithographic copies of original paintings. While Boston, New York, and Cincinnati soon equaled or surpassed the work of the "automaton artists" of the City of Brotherly Love, a great many Philadelphia firms during the second half of the century could echo the statement of printers Samuelson and Rogers. They claimed from their little office on Chestnut Street that they were "Fancy Job Printers," copyists of the highest order, "Imitators Nonplussed." [90]

NEW YORK AND DÜSSELDORF: MECCA AND INSPIRATION

ON THE EVENING of October 16, 1891, the new, struggling National Li-
thographers' Association held its fourth annual convention banquet in Phila-
delphia. Although President Julius Bien was too ill to preside, spirits were
high. The Association—finally formed after years of lithographic regionalism
—had lobbied intensely for a strong international copyright bill, and had
won. The lithography business was recovering from what was described as a
"long period of depression" (in fact, four years of stagnation), and the new
bill promised to protect against the hiring of foreign lithographic companies
to print materials covered by the United States copyright law: "the plates
or drawings on stone, zinc or other materials must be produced and the
printing done in this country on copyrighted pictures generally known as
lithographs or chromos, and on maps, musical compositions, engravings,
cuts, prints, etc."[1]

The menu greeting the jubilant diners was calculated to smother appetites
and expand waistlines. It announced, in succession, blue-point oysters,
green-turtle soup, *bouchées à la reine*, boiled salmon with cucumbers, beef
filet with truffles, cauliflower, French peas, potatoes, sweetbreads, and more,
ending with ice cream "à la Harlequin," fruits, cakes, coffee, liqueurs, and
cigars. There were six wines. Somewhere between the amontillado and the
Mumm's Extra Dry the toasts began. One stouthearted soul hailed "Our
Craft." Another cheered the site of the next convention, Boston. A third
apologized for his ineptness as a public speaker and then delivered several
thousand polysyllabic words. On and on, speakers as varied as the dishes
on the menu tried to outdo one another in gentility and rhetoric.

At one point in the toast making Edward Carqueville, of Chicago, stood
up, stated proudly, "I am a lithographer, but no public speaker, so hope you
will excuse me," and sat down. Twenty-seven speeches and one song later

this Chicago lithographer got back on his feet: "We are running twelve steam-presses from twelve to fifteen hours a day, but we look up to New York as the great pillar of lithography. The New York lithographers . . . have no superiors. They have always, since 1857, been the Mecca . . . of hope we have looked to and tried to equal."[2] Even if the wines and cigars had exaggerated Mr. Carqueville's good will, he spoke a truth everyone recognized in 1890: since the Civil War New York had become the lithographic center of America. It was estimated in 1890 that of the twenty million dollars invested in lithographic work, "more than fifty per cent" was spent within the state of New York.[3] Some of lithography's biggest names—names still recognized today—came out of New York: Currier and Ives; Sarony, Major and Knapp; Julius Bien. But in addition to these giants, there were numerous other important yet all-but-forgotten printers working in New York during its lithographic heyday. Their contribution to the democratic art must be examined.

I. Rediscovering New York Lithographers

Lithography began in New York City in the 1820s. George Endicott, one of the New York pioneers, first advertised his skill in 1828. From 1830 to 1834 he worked in partnership with Moses Swett, then withdrew and established his own firm, which survived in various forms until 1896.[4] During the forties his shop was a nucleus of New York lithography; by the time his son, William, joined the firm, in about 1845, Endicott, with his shoulder-length silvery hair, had attained the position of the revered "old man" of the New York lithographic community.[5] The first chromos Endicott produced, modest sheet-music covers, appeared between 1845 and 1849,[6] and throughout the fifties the firm (William Endicott and Company, 1849–52; Endicott and Company, 1852–86) worked to perfect the medium.[7] It also trained numerous apprentices, who later established their own firms.

As in most practical-lithographic shops, the Endicotts turned out a variety of both hand-colored and chromolithographic prints into the 1860s. While the "Plan of the Gettysburg Battlefield" (1863)[8] was composed of both printed and hand-applied colors, many other of their town and city views, battle scenes, pictures of hotel fronts, portraits, and maps were completely chromolithographed. In about 1861 one advertisement boasted that the Endicott lithographic materials and presses represented the "latest adopted improvements unsurpassed by any other house."[9] Nevertheless, unlike Sharp or Duval or Rosenthal, who enthusiastically publicized their printed colors, the Endicotts apparently did little to promote the word *chromo*, nor did they see their skills as instrumental in the reproduction of original works of art. The Endicotts were important because they helped establish and

maintain a lithographic tradition in New York, but they were of little consequence in the dissemination of fine art: it was the subject matter of their prints, not the education of the masses, that dominated their lithographic interests. In a letter dated April 11, 1865, the Endicotts displayed their approach to sales:

> Dear Sir: We wrote to you . . . in reference to our Chromo Lithograph of the Bombardment of Fort Fisher and having received no reply presume you have not rec'd it.
>
> We send you a sample copy by todays mail and as your vessel occuppied quite a prominent place in it we think the officers and men would like to have some copies. If you will make out a list of those who want them and send the money to us with the address to which the copies are to be sent[,] we will allow you an extra copy for every five names you obtain and will send them safely post paid by the following mail.
>
> <div align="right">Yours truly
Endicott & Co.</div>

Despite their perhaps amateur sales technique, the Endicotts were unquestionably highly skilled lithographers, and they maintained their standards into the 1880s. "[Albany] of the Hudson River Day Line" is typical of their post–Civil War work.

Plate 31.

Growth of New York Lithography

As early as 1854, more than sixty New York City companies were advertising themselves as lithographers.[10] By 1873 approximately ninety names made up the listing in the city's directories,[11] and in 1880 the number came close to a hundred thirty.[12] Not all of them were involved in chromolithography, but the total volume must have been nearly beyond count. Pelletreau and Raynor advertised in 1886: "Printing Fine Chromos with us forms a specialty, and we need no stronger evidence of our success, than the Million and upwards of Chromos we turned out during the last year."[13] It is amazing that today so few of these New York pieces exist: in less than a century the work of a lithographic army has almost disappeared.

Many of the once influential New York lithographers are now hardly even known. Henry R. Robinson, for example, who advertised himself as a "lithographer, publisher, and caricaturist," has defied historical research.[14] All we know of his life is that his tenure in New York is estimated to have been from 1831 to 1850.[15] His political cartoons from the 1830s and '40s are his best-remembered works but he must have been a multitalented man, for according to his trade card his business went well beyond satire. The card shows numerous different kinds of prints on display in his storefront window, at 52 Courtlandt Street, and some of these pictures might have been chromolithographs. He printed at least one extraordinary chromo, entitled

Henry R. Robinson

Plate 32.
Plate 33. "A View of the Federal Hall of the City of New York as it appeared in the year 1797," which reproduces a watercolor by the English-born theatrical scene painter John Joseph Holland.[16] Printed from apparently three stones, the chromo is a study in restraint. Not attempting to copy the watercolor precisely, the print relates to the original in much the same way that an oil painting relates to its preliminary sketches. The character of the Holland composition has been altered, and naturalistic "imperfections" and details in the original have given way to idyllic harmony. The printing quality is extremely high and bright, and the lithographic draftsmanship is firm. One can only hope that more Robinson chromos will be located.

Dominique C. Another obscure New York lithographer is Dominique C. Fabronius, who
Fabronius is shrouded in myth.[17] Apparently Belgian-born, he is in one version of his ancestry a relative of Alois Senefelder. His name appears in the lithographic circles of Cincinnati, Pittsburgh, Buffalo, and Boston, but New York City appears to have been his home.[18] Unlike Endicott and Robinson, who seem to have produced most of their lithographs with little thought of imitating original paintings, Fabronius printed chromos that were varnished and glued onto canvas and then sent through a special roller that scratched thin striations on the surface. This technique of "creating" oil paintings was commonly used by lithographers after 1870, but Fabronius employed it in the
Plate 34. late 1860s; his "Autumn Fruits," produced in 1868 after an original by W. M. Brown, could pass by many eyes as a genuine painting. So could his "chromo lith." portrait of Ulysses S. Grant, after a painting by Constant Mayer.[19] A skilled lithographic artist, Fabronius responded to the public's desire for chromos that could not be distinguished from paintings.

Another printer as difficult to research as Robinson and Fabronius is
Henry C. Eno Henry C. Eno, who during the sixties moved about New York City displaying some of the most sophisticated of the lithographs that were "printed in colors."[20] His chromo sheet-music covers extend from the gaudy[21] to the subtly refined.[22] At his best, Eno was unrivaled for quality. His colors are rich but not heavy, his figures glow without varnish, and his registration is as precise as any achieved by American practitioners. His early chromoed horse
Plate 35. portrait "Volunteer" (1864)—one of many such prints produced by numerous lithographers between 1850 and 1890—is far above average. This chromo was not equaled in style or quality until a decade or more later, when several prints by San Francisco's E. Bosqui and Company were produced,
Plate 36. "St. Julien" being a particularly beautiful example.

One of Eno's competitors, Colton, Zahm and Roberts, also displayed a wide range of quality and subject matter, depicting everything from Euro-
Plate 37a. pean masterpieces to simple American landscapes.[23] Their "View on Esopus
Plate 37b. Creek, N.Y." (1869) was poorly printed—particularly when compared with the Alfred Thompson Bricher version reproduced by Louis Prang—but this card-sized lithograph, 5⅛ by 7½ inches, was priced to sell, competing as it

did with many other such cheap prints.[24] Colton, Zahm and Roberts also produced "oil chromos" that were glued to a painter's canvas and framed.[25] A romantic view entitled "The Arrival of Hendrik Hudson in the Bay of New York, Sept. 12, 1609," after Frederic A. Chapman, is clearly an attempt to simulate the original. Another, a portrait of the founder of the Disciples of Christ, Alexander Campbell, was printed from at least fourteen stones to the order of R. W. Carroll and Company, of Cincinnati (the original artist is not known). A guaranteed money maker, it was advertised with as gross a sales pitch as one could encounter. An advance flier promised a "chromo portrait" that would project Campbell's "fireside look" and "best likeness . . . accessible to the public." In a hodgepodge of type sizes and faces, exclamation points and repeated phrases, the advertisement hammered its message into the eyes of even casual readers: The portrait was, without question, the "most correct," "most life-like," and most suited to the "Christian Public." Naturally, it was worth ten dollars, but it was being sold for only six, with large discounts available to agents. First come, first served. Appropriately, it was mounted, ready for framing, on a substance called "Junk Board."[26]

Plate 38.

Plate 39.

The imitation of original art was also pursued by Edmund Foerster and Company, New York "Importers and Publishers of French, English, German, and Italian Chromos."[27] Between 1871 and 1873 Foerster published six chromolithographs after Max Eglau's landscape paintings.[28] There is no evidence, however, that Foerster himself was a printer; he may well have hired another firm to reproduce the pictures.

Edmund Foerster and Company

Plate 40.

Among the important but now elusive New York firms was that of German-born Ferdinand Mayer, later known as Mayer and Sons, which was active in the late 1860s and throughout the '70s. Mayer's best work is exemplified in the "View of the East Dorset Italian Marble Mountain and Mills."[29] Reproduced from a painting by F. Childs, this chromo appears lighter than those printed by Fabronius but more substantial than Robinson's Federal Hall view.

Ferdinand Mayer

Plate 41.

A very unusual production from a New York "art publisher's" shop appeared in 1875. "The Bummers," chromolithographed by Bencke and Scott, shows six men on a hotel porch arranged in such a way that not a single face can be seen. Copied from a satirical painting attributed to Enoch Wood Perry and selling at $2.50 a copy, the lithograph had originally borne the biting title "The True American," which was later scratched out and replaced.[30]

Bencke and Scott
Plate 42.

Herman Bencke had begun as a New York lithographer in the mid-1860s,[31] and—if the collection at the Library of Congress is a fair gauge—he was prolific in the seventies. Produced from twelve or thirteen stones, extant copies of "The Bummers" reveal that the Bencke shop was experimenting with different printings. One copy (at the Smithsonian Institution) is pre-

Different "Bummer" Editions

dominantly gray in tone with little sunlight, but it has a strong three-dimensional feeling, especially as seen in the men's clothing. The other copy (at the Library of Congress) is more yellow than gray. It is bathed in sunlight and characterized by a feeling of airiness.[32] Although the Smithsonian copy is closer to the original painting (in the Metropolitan Museum of Art), the latter became the standard issue. To create the differences between the two versions, changes in color were made at the fifth, tenth, and eleventh printing impressions. Bencke's modification of the original and his tinkering with the two printed versions show how he was attempting to interpret popular taste in order to make "The Bummers" a best seller.

Enoch Wood Perry This is not to say that the work of the original artist needed much alteration. Enoch Wood Perry (1831–1915) was an ideal painter for chromo reproduction. Having studied with Emanuel Leutze in Düsseldorf for two and a half years in the early 1850s, Perry had imbibed the most influential aesthetics in the history of American chromolithography. The Düsseldorf style suited the technical needs and the standard of taste of the democratic art.

What was the origin of the Düsseldorf impact?

II. Düsseldorf: The Stylistic Wellspring

The golden age of Germany's Düsseldorf Academy began in 1826 and ended in about 1860.[33] Americans, first with Emanuel Leutze in 1841 and then with many other artists, studied there over a period of thirty years (eventually tiring of the Düsseldorf style, they moved on to Munich and Paris). In a two-year curriculum the students drew from plaster casts, copied drawings and paintings, and finally sketched from life. It was a thorough academic training, which demanded mastery of one level before graduation to the next. For some painters it was far too rigid. William Morris Hunt, for example, favored the more flexible approach in Paris; he rejected "the principle that the education of art genius, of a mechanic and of a student of science were one and the same thing—a grinding, methodical process for the accumulating of a required skill."[34]

Subject Matter For subject matter, the Düsseldorf Academy at first had a bias toward religious and historical themes, but by the late 1830s—just before the arrival of the Americans—genre, landscape, and portraiture had risen in status and popularity. In 1849 a show room of Düsseldorf work opened in New York City, well stocked with the sentimental genre pieces Americans prized. During the fifties fine-art patrons in America used "Düsseldorf" to categorize art of high style and technical competence.

The Düsseldorf style has not fared well with art historians. Most have written it off as an uninspired movement, lost in its detail and method. They

say it is anecdotal and too mechanical and static. The criticism began as early as 1867, when Henry Tuckerman wrote: "*Knowingness* may be considered the special trait of this class of artists; they are often excellent draughtsmen, expert, like all artistic Germans, in form and composition, but in color frequently hard and dry; they abound in the intellectual, and are wanting in the sensuous. . . . Skill prevails over imagination in the Düsseldorf artists. . . ."[35]

Maybe so, but the academy produced several first-rate American artists, including Emanuel Leutze, Worthington Whittredge, Richard Caton Woodville, Albert Bierstadt, and Eastman Johnson, as well as a larger number of lesser lights, who often found their way to chromo printing shops. Enoch Wood Perry, John Mix Stanley, Benjamin Champney are a few of the Düsseldorf-trained Americans who appear in this book. Sympathetic to the dictum that the "public always wants a picture that tells a story,"[36] these artists produced for chromolithographers idealized genre and landscape scenes. And while the subject matter benefited sales, the style of Düsseldorf art lent itself to the technique of chromolithography: all these artists worked, in the Düsseldorf manner, from line to color. Forms were outlined and colors clearly localized, so that a chromolithographer could disassemble the picture, separating each distinct element within a single lithographic stone, then print all the elements together at once. Unencumbered by overlapping colors or a sophisticated use of transparent pigments, chromolithographers, especially in New York, worked well with the artists trained in Düsseldorf.

One other aspect of the Düsseldorf style made it well suited for the American chromo: it embodied more than one artistic trend popular in the United States. First, there were the previously mentioned genre scenes and landscapes, all to our eyes a little too correct—the children too cute, the situations too well understood, the landscapes too perfect—but fulfilling the people's desire for romantic idealism. Simultaneously, the style betrayed a fascination with detail that appealed to the public: every leaf, button, window, or cow can be counted and classified. These elements, so exact that they show the viewer more than one would see as an eyewitness, are in fact super-real, and yet they are ordered in such a way as to make each scene appear absolutely true to life.

This combination of romantic composition and factual rendering forms what could be called chromo realism. To E. L. Godkin, of *The Nation*, chromo realism was at the core of the perversity of the "chromo-civilization." It was the ultimate in deception, the confusion of truth and romantic reconstruction, of fact and ideal, of real art and reproduction. It was life on stage, a play engrossing such a large audience that many felt themselves a part of the script.

As an example, Enoch Wood Perry, schooled at Düsseldorf, received

Americans at Düsseldorf

Style Ideal for Chromolithography

Chromo Realism

praise from critics for, as in *Art Journal,* July 1875, his ability to take a "lowly" subject and invest it "with a poetry of feeling and delicacy of expression which are not exceeded by any of his contemporaries." Despite its German precedent, Americans came to see this romanticization of common life as "distinctively" their own. Robert Weir, drawing teacher, lithographic designer, and painter,[37] wrote in a publication for the Centennial Exposition that Perry's pictures "are illustrative and pleasing, and evince a conscientious study of his subject."

Afterlife of Düsseldorf Art

The link between chromolithography and this particular style of German art gave Düsseldorf images a long afterlife in the mind of America, even though Düsseldorf's real influence was considered to have died by the early 1870s. While one historian noted that the "influence of the Düsseldorf Academy was marginal when compared to that of the community at large,"[38] the fact is the style was perpetuated among millions of people throughout the 1870s, '80s, and even into the '90s. Artists, critics, and upper-class patrons had turned in the seventies to new art movements from Paris, but average Americans were being advised in newspapers, magazines, and books to keep chromos of Eastman Johnson's *Barefoot Boy* and Albert Bierstadt's *Sunset* hanging on their living-room walls. Until new, reliable methods for color reproduction were developed, in the 1890s, the chromo industry continued to mass-produce the Düsseldorf-inspired prints that had been rejected by most of the artistic community almost thirty years earlier.

Thus it was that the New York business of lithography combined with the imported German style of art to usher in the halcyon days of the American chromo. Although we have lost all but the names of many of these important collaborators in chromolithography, their work deserves recognition as much as does that of New York's lithographic giants, to be examined next.

THE GIANTS OF
NEW YORK LITHOGRAPHY

I. Sarony, Major and Knapp

Napoleon Sarony (1821–96) is best known to collectors of American litho-graphs as a skillful draftsman who produced some of Nathaniel Currier's greatest prints.[1] But he also operated his own lithographic firm until the mid-1860s and then made his way into photography, where his camerawork won "fame on two continents" and he was described as a "master in composition, without a rival in the arrangement of subjects and settings."[2] A celebrity at the time of his death, his obituary earned a banner headline on the front page of *The New York Times*.

Napoleon Sarony was born of English parents living in Quebec. Having learned lithography from his father and emigrated to New York as a teen-ager, in about 1836, he worked for several lithographers, including Henry R. Robinson and Nathaniel Currier, eventually going into partnership with the lithographer Henry B. Major.[3] The company went through several some-what confusing overlapping incarnations: from Sarony and Major (1846–57) and Sarony and Company (1853–57) to Sarony, Major and Knapp (1857–circa 1864) to Major and Knapp (circa 1864–71). There were two Majors in the partnership, either father and son or brothers, it is not known which: Henry B. (1846–55) and Richard (1855–68).[4]

Trained in the tradition of lithographs as sensational news reports, the fledgling New York partners were fortunate to enter business during the Mexican War (1846–48), which created a demand for such prints. In keep-ing with other companies' black-and-white and hand-colored Mexican War views, those by Sarony and Major were a mix of fact and fantasy.[5] Their prints were generally popular, and one in particular was somewhat unusual: "The Storming of Chapultepec Sept. 13th 1847," "printed in colours" from at least four large stones, each measuring approximately thirty by forty inches. Appearing in 1848, the chromo was based on a painting by Henry Walke, an artist who had served as an executive army officer during the war;

Napoleon Sarony

Partnerships

*Mexican War
Chromos*

Plate 43.

having witnessed the Chapultepec confrontation, he made numerous sketches and quickly translated them into the painting.[6]

The colors in the chromo are tightly bound within the black outlines of the images, with only the blue tint in the sky pervading the open space. This elementary level of chromolithography did not, however, result in a simplistic picture, for the foreground is filled with active combatants, each figure meticulously defined by outline and precise color registration. The alternation of light and dark from the bottom to the top of the print creates the illusion that there are more colors than are actually being used and produces a great liveliness. The chromo is large, following the tradition of its hand-colored competitors, and it makes the most of its colors without becoming complex, almost as though Sarony and Major had felt compelled to give their print a hand-colored appearance. (By some unexplained agreement, Nathaniel Currier served as "sole agent" for this chromo.)[7]

Plate 44.
Fitz Hugh Lane

A similar kind of chromo is Sarony and Major's "View of Norwich, From the West Side of the River," after a sketch by Fitz Hugh Lane. Smaller than the Walke chromo, this lithograph appears to have been printed from just four plates. Nevertheless, the colors compose trees, water, people, animals, buildings, and boats into a bouquet of variety and harmony; delicate yet powerful, the print exudes a feeling of community life. A painter primarily of seascapes, Lane was also a lithographer, trained in the 1830s by William S. Pendleton. He published many of his own lithographs in the forties and fifties,[8] and may in fact have drawn the images directly on stone for his view of Norwich. Sarony and Major published at least one other Lane chromo, in 1850: "View of Baltimore From Federal Hill."[9]

Plate 45.

The Sarony and Major chromos appear technically less ambitious than either the Duval-Schuessele products or the later pieces of William Sharp. Indeed, many are close to being tinted lithographs, in which a second (and sometimes a third) color is superimposed on the printed images to cast an overall hue, instead of the colors' composing the images themselves. "Philadelphia from Camden" was produced in 1850 from black, brown, and blue inks, and although the brown is localized in the wharves at the bottom of the picture, most of the color is atmospheric, the forms being defined by black outlines. Sarony and Major distinguished this type of print from their earlier works by describing it as "printed in tints."[10]

While producing chromos and tinted lithographs Sarony and Major also sold both monochromatic and hand-colored works.[11] Their shop was continually experimenting in color combinations, and both their hand-colored prints and chromos vary substantially from piece to piece. The Sarony and Major peacock standing on a wall for the sheet-music cover "Pride Polka" (1850) noticeably changes his colors as he progresses through at least thirty editions: sometimes he is glorified with a blue tint, sometimes the tint is

absent.[12] Whether or not by choice, *exact* duplication was not a chromo hallmark.

In the 1850s Sarony and Major took on a new partner and renamed the firm Sarony, Major and Knapp; the newcomer, Joseph Knapp, would by the 1880s become the titan of New York lithographers, producing labels, business cards, and advertisements. Sarony, Major and Knapp also altered their chromo philosophy in two basic ways, stepping to the tune played by P. S. Duval and others. First, as seen in "Old Sachem Bitters," they ventured into the flamboyant style in vogue among their competitors; unfortunately, in bringing themselves up to date they forfeited the subtle artistry so evident in their work of a decade earlier. Second, they suddenly started to make imitation oil paintings, as their chromo of Rembrandt Peale's *Court of Death* demonstrates. Printed in about 1859, the chromo reproduced a vast canvas (twenty-four feet long) that for years had toured the country. Peale himself, normally haughty and querulous, provided a model of euphemistic endorsement of the lithograph, writing shortly before his death, "The Drawing is correct, and the Colouring (considering the difficulty of the process & its cheapness) gives a good general idea of the Painting."[13]

By the time Sarony left the partnership, in about 1864, the firm was square in the mainstream of middle-class art. A Major and Knapp calendar advertisement of 1866 displays a typically decorative post–Civil War chromo. It is interesting to compare it with an earlier Sarony and Major notice (Figure 7), which depicts their shop sign being carried out of James Ackerman's firm, presumably for disposition above their own door: the Major and Knapp chromo was a cliché even in 1866, whereas the earlier scene was creative, individualistic, humorous.

By the early 1870s, the firm had dropped fine-art chromos and moved into advertising. Eventually it became part of a conglomerate called the American Lithographic Company.

Joseph Knapp

Plate 46.

Rembrandt Peale
Plate 47.

Plate 48.

II. Julius Bien

Julius Bien (1826–1909), a lithographer and map engraver who arrived in the United States in 1849, was a contemporary of Napoleon Sarony. Born in Naumburg, Germany, he was schooled at the Academy of Fine Arts in Kassel and at the Städel Art Institute in Frankfurt am Main. He participated in the political upheavals of 1848 and was forced to leave his country after the movement was crushed, becoming one of the many talented German "forty-eighters" to begin life anew in America—these refugees included the politician and journalist Carl Schurz, the Union army officer Franz Sigel, and, coincidentally enough, the famous printer Louis Prang.

A Forty-eighter

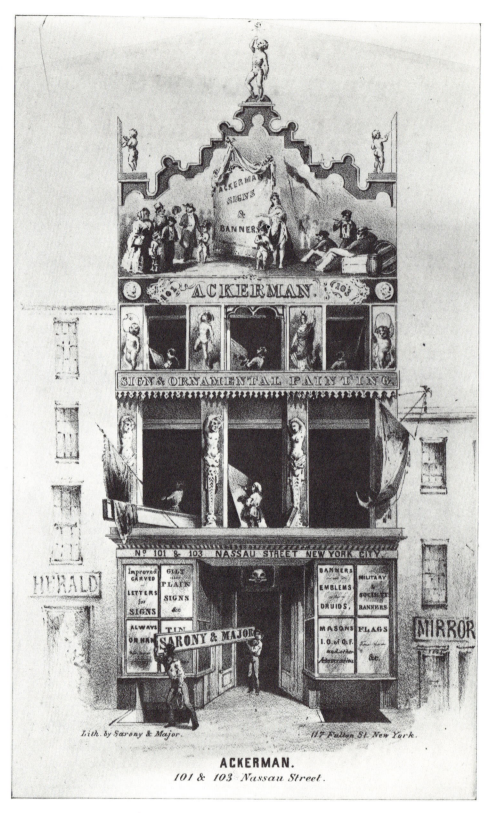

The life of Julius Bien reads like the self-made American prototype. From a tiny print shop in New York City, Bien built a hugely successful business that employed two hundred people and operated fifteen lithographic steam presses and related machinery.[14] He received numerous awards for the maps he engraved for the Pacific Railroad surveys, for several decennial census reports (1870–1900), and for many U.S. Geological Survey atlases and military field maps. He was also the first president of the National Lithographers' Association.

During Julius Bien's lifetime, chromolithography evolved into a highly specialized industry, requiring custom-built factories, a vast array of single-purpose machines designed to carry out just one stage of production, an army of skills, and a large capital investment. As explained in chapter five, this sophisticated and expensive technology was economically justifiable because chromolithography was the only print medium capable of delivering richly colored pictures at low prices.

When the first chromolithograph appeared from an American shop, in 1840, most lithographers were also producing wood or metal engravings, or sometimes both. But by the 1870s the situation had changed: wood engravings were then typically made in plants such as those owned by *Harper's Weekly* or *Frank Leslie's Illustrated Newspaper;* copper and steel engravings were becoming the exclusive products of shops devoted to fine prints; and chromolithographs were mass-produced in factories. Julius Bien was a major exception to this rule of specialization, but in order to comprehend his uniqueness the differences among the media must be understood.

The specialization of printmaking was caused by developing technology and the growing commercial demands of the nineteenth century. Wood engraving was a relief process. It required a skilled craftsman who with burins and other sharp tools removed those areas from the surface of the hardwood (usually boxwood) plate that were not meant to receive ink. It was a delicate, painstaking job. When completed, the engraved plate was similar to a large piece of type and could be printed on a regular type press. Thus, wood engraving became during the nineteenth century the common means of producing illustrated books, magazines, and newspapers.

Metal engravings, etchings, and aquatints were, on the other hand, intaglio processes: the image to be printed was cut or etched into a metal plate, and the ink was forced into the low areas, while the original surface was left clean—the opposite of wood engraving, in which the image to be printed made up the high area of the plate. The press used to print metal engravings, etchings, or aquatints had to apply more pressure than a type press because the print paper had to be forced into the low areas of the plate in order to absorb the ink: the prints, therefore, could not be produced along with type and gradually became known as fine, or artistic, of a higher quality than the

wood engraving. The metal (copper or steel) engraving became famous for its hard, clear lines, which gave strength and dignity to portraits or classical scenes; the lines were cut into the plate with a sharp burin. Etchings and aquatints, in contrast, gave softer effects, and both substituted the chemical reaction of hydrochloric acid and copper for the engraver's hand-cutting. In etching, a copperplate was coated with wax; those areas of the plate to be etched were cleared of wax, those meant not to print were kept covered. The plate was then put into an acid bath, which etched the exposed metal. The longer the acid acted on the metal, the deeper the "bite" and the darker the printed line. In producing an aquatint, acid was also used, but instead of wax, resin was deposited on the metal plate. The acid bit the tiny areas around the particles of resin, giving a subtle gradated effect, much different in character from that of metal engraving.

The important point is that each medium had its strengths and limitations, and as each became more technologically complex each went its separate way. By the 1870s, the planographic printmakers—lithographers—simply dropped intaglio and relief printing from their commercial offerings. Indeed, many lithographic shops were probably incapable of producing a wood or metal engraving.

Julius Bien, however, having apparently begun before the Civil War as a relief, intaglio, and planographic printer, continued to practice all these skills throughout the decades of the chromo civilization. Despite the increasingly specialized requirements of each medium, Bien became known as both a master engraver and a master chromolithographer.

Innovation appeared to be his way of life. As noted later in this chapter, in the seventies he produced photolithographs: by making the surface of a lithographic stone photosensitive, a photographic image could be applied and printed as easily as a line drawn on the stone by hand. Before these experiments, Bien took on his great Audubon project, with the goal of reproducing via chromolithography the expensive English *hand-colored* aquatints of Audubon's paintings that had done so much to popularize the naturalist's work. The Bien chromolithographs, according to the propaganda, would be cheaper and just as good. Challenge obviously stimulated Julius Bien.

With Bien came some of the most sophisticated lithographic knowledge and printing techniques to be transplanted from Europe to America. His pathbreaking chromolithographs, the product of his German training, exemplify the transfer of technology from the Old to the New World that was prevalent in the nineteenth century.[15]

John James Audubon Bien's magnum opus was his chromolithographic edition of John James Audubon's *The Birds of America*, which Bien began in 1858. Audubon (1785–1851) was a brilliant artist-naturalist, who dedicated much of his life to painting the birds and quadrupeds of North America. At the time of his

death he was considered a genius, much of his reputation resting on an extraordinary folio entitled *The Birds of America*. This tour de force consisted of 435 life-size hand-colored aquatints after Audubon's watercolors, and it took twelve years to produce. Printed on double-elephant-folio sheets of high-quality Whatman-brand paper, it was finally completed in 1838 by the English printmaker Robert Havell, Jr. The collection was sold by subscription in 87 parts, representing 1,065 birds, at an even $1,000 per set.[16] In short, the original publication of *The Birds of America* was a staggering accomplishment.[17]

Bien's undertaking, coming twenty years after Havell pulled the last print and seven years after Audubon's death, was no less challenging. Through the new medium of chromolithography, which more cheaply and more easily reproduced color than engraving or etching, Bien was commissioned both to reproduce the quality of Havell's aquatints and to capture the subtlety of Audubon's colors. It was a task demanding artistry and technical daring, and to accomplish it Bien needed solid financial backing—as was typical of such endeavors, this last requirement proved the most difficult to meet.

The project's financing came from two sources: John Woodhouse Audubon, Audubon's son, and the New York publishing firm Messrs. Roe Lockwood and Son. Although the terms are unknown, it is assumed that Bien was hired with a contract similar to Havell's. Beginning in 1858, the new edition of *The Birds of America* was to include the full number of Havell impressions but at half the original price. The print paper was to be double elephant folio in size (27 by 40 inches) and made of strong fibers. There were to be forty-four "numbers," or groups, of plates, each group to be composed of ten images on seven pages: two large images, two medium images, and six smaller images printed two on a page.[18]

A prospectus, published in 1859, promised all potential subscribers:

> This Edition, in softness, finish, and correctness of coloring, will be superior to the first, and every Plate will be colored from the original Drawings, still in possession of the family. . . .
>
> The first Number ["Wild Turkey Cock"] is considered superior in many respects to the same Plates in the first Edition, and it is confidently hoped that subsequent Numbers will exhibit still greater superiority as the Artists gain experience.[19]

The ambitious project was never completed. Only one volume of fifteen numbers—105 plates, showing 150 species—was published. Some historians blame the Civil War as the disruptive force, while others suggest that financial cheating scuttled the enterprise, but probably it was the death, in 1862, of John Woodhouse Audubon that terminated Bien's work.

The Challenge of The Birds of America

Financing

It is known from the correspondence between Lucy Audubon, the naturalist's wife, and the first secretary of the Smithsonian Institution, Joseph Henry, that the Bien project came at a time when the Audubon family finances were low. Two years after the death of her son John Woodhouse, Mrs. Audubon was forced to sell many of her late husband's paintings. It is unlikely that the straitened, elderly (seventy-four in 1862) widow could have assumed the cost of completing Bien's extraordinary assignment.[20]

Complexity of Birds

Few historians who have treated Audubon have examined the complexity of what Julius Bien was attempting to do. Fooled by early propaganda proclaiming lithography quick, cheap, and easy, and misled by endless articles in nineteenth-century periodicals that oversimplify the process (to the point where the craft appears the professional reserve of idiots),[21] most historians overlook the high degree of technical competence required for even good monochromatic lithography. When additional colors were called for, with the necessity for delicate separations and tonal balances, the job could be accomplished only by the most expert artists and technicians.

Bien's twofold task—to capture the subtlety of Havell's engraved lines and aquatinted tones and to reproduce Audubon's colors—was not part of American printmaking tradition. The reproduction of watercolors, as practiced in Europe since the start of the nineteenth century, had evolved a reciprocal standard of taste: that is, watercolors were considered best reproduced in aquatint, and the best aquatints were those that possessed the fluidity of watercolor. Audubon's praise of Havell makes this point: "the

Plate 49.

birds are Fac Simile of my Drawings—Soft and beautiful the colouring is clear transparent and true to nature."[22]

Bien's Technique

Bien's approach to reproducing the already reproduced watercolors, though untraditional, was not unique. He used the lithographic-transfer process to get the effect of the engraved lines and the aquatint tone on the stone, and then he printed a series of transparent colors to give depth and body to the work. The technique of transferring a printing image from one surface—copperplate, woodblock—onto a lithographic stone, and then printing that image in hundreds or thousands of impressions, had been known and used in Europe since the early nineteenth century.[23] By the time Bien was ready to do the Audubon folio, there were in America a generous array of transfer papers and transfer inks, and several manuals explaining the transfer process.[24] Bien inked the original copperplates used by Havell (they had arrived in America in 1839)[25] and covered them with a thin, dampened sheet of transfer paper. The copperplates and paper were then sent through a copperplate printing press to produce a sharp, accurate image on the paper. The paper in turn was laid face down on a prepared lithographic stone and sent through a lithographic press, thus transferring the image to the stone. After additional work on the stone, the stone was

inked, a piece of blank lithographic printing paper was laid on top of it, and both were sent through the press again.[26] The result? A sharp black-and-white Audubon bird that looked like the Havell copper engraving but in fact was an inexpensive lithograph reproduced from stone. A close look at the background in Bien's "Yellow Shank" shows the remarkable success Bien achieved: the effect of aquatint, the dream of nineteenth-century lithographers, is manifested throughout most of the 105 plates.[27]

Plates 50a and 50b.

Bien, as we have noted, printed some of the most important engraved maps in nineteenth-century America, and this experience with engraving surely aided him in the transfer of the Audubon images. Nevertheless, the reasons for his extraordinary success with printed color are difficult to establish, for before the Audubon job he had not attempted anything quite so challenging in its scope and complexity.[28] All we can conclude is that his German education had prepared him for the task.

By the 1840s, when Bien was a student, the lithographic houses in the German states were enjoying a remarkable success in reproducing color lithographs as "exact" likenesses of oil paintings and watercolors. These chromolithographs were the product of artistic sensitivity and technical know-how. Roughly, the approach to the problem of printing in color broke down into four categories: 1) how to divide the image into a particular number of color printings, 2) which inks to use, 3) how to register exact impressions with each successive color, and 4) how to decide the order of printing the colors. Judged by the standards of any American printing firm in the 1850s, the color theories Bien used to produce *The Birds of America* were sophisticated. Although he seldom employed more than six basic colors, Bien was able to capture the range of tones created by Audubon and hand-applied by Havell. Like a painter at his easel, Bien succeeded in producing new colors and varying shades by juxtaposing certain colors or by laying one color over another. It is not known precisely how many printing stages each of Bien's chromos underwent, or even how many times any one color was used, but the extant progressives of the three "Wild Turkey" cocks suggest the painstaking effort and the many steps these chromos demanded.[29] The difference between one impression and the next is almost imperceptible, yet each successive stage can be seen as essential to the richness Bien achieved.

German Chromos

Plate 51.

A number of the Bien chromos show evidence of color applied by hand after the final printing step. For example, the touches of red in the mouths of the "Jer Falcon" were painted with a brush, and the berries in the "Small Green Crested Flycatcher" appear to have been added to the branches with a printer's stamp or other tool. These bits of handwork on an otherwise complete chromo demonstrate that fully mechanized chromolithography was still as unusual in America in 1858 as it had been in Europe a decade earlier.[30]

Hand-coloring

Bien's work on *The Birds of America* has been criticized on several points:

the folio was never completed, the prints are "inferior in quality to the engravings in the original edition,"[31] Bien used low-grade paper (his reason for choosing this paper is not known), and he simplified the backgrounds and made other compositional changes. Yet his accomplishment cannot be ignored. The Audubon project helped put chromolithography on a solid technical and artistic foundation, substantially advancing the craft of color reproduction in America.

Later Career For more than forty years following the Audubon folio Bien worked in mapmaking, engraving, and photolithography; his papers—now scattered throughout the National Archives—show a particularly strong commitment to government jobs.[32] His interest in photolithography could have been
Lodowick H. stimulated by Lodowick H. Bradford, of Boston, who in 1858 patented a
Bradford photolithographic process that produced a positive print from a positive transparency, paving the way to modern photolithography.[33] (Bradford, too, was a chromo printer, who had mastered that craft in the 1850s:[34] his
Plate 52. broadside for "Pembroke Iron" is a superb example of the use of bronze and of the ingenious employment of blue under maroon to give a pervasive glow to the images.)

In addition to attending to his own firm, during the late 1860s Bien served as the superintendent of the New York Lithographic, Engraving and Printing Company. One photolithographed broadside (1868), which he signed, reads:

> This company is now prepared to execute all classes of work in the different branches of the graphical arts. . . . Its *Photo-Lithographic* process, the best and most reliable in practice, for the almost instantaneous reproduction of all kinds of writing, letter press, (especially such as rare and ancient books) woodcuts, line drawings, engravings, will recommend itself to all, who are interested in the publication and use of such works. . . . The undersigned, favorably known in connection with the Lithographing . . . business for nearly twenty years, gives his personal attention to all orders and invites you, to visit the establishment and examine the numerous specimens.[35]

From these simple line drawings of the 1860s Bien began producing tinted photolithographs in the seventies. His "Women's Pavilion" at the Centennial Exposition, for example, was printed in two stages: the black lines were put on one stone via photolithography and the color, tan, tints the picture from a second stone.[36] Many of Bien's lithographic maps were produced in the same manner. However, although the combination of photolithographic images and tints had been practiced in America as early as 1858—in the folio *Villas on the Hudson*—photolithography had little influence on the chromos produced between 1860 and 1890.

Julius Bien died in 1909. During the final two decades of his life he was known as one of America's greatest lithographers. In addition, his passion for social change, which had fueled his participation in the European revolutions of 1848, was always evident. First president of the National Lithographers' Association, he lobbied for high tariff legislation to protect the lithographic industry; he called for trade schools to replace the dying apprenticeship system; and he was active in numerous cultural and philanthropic causes in New York City. Some of these issues appear in later chapters.

III. Currier and Ives

Nathaniel Currier established his lithographic business in New York in 1834. In 1857 he was joined by James Ives, and the Currier and Ives firm survived until 1907. Despite its enormous success and overwhelming dominance during the middle decades of the nineteenth century, the firm has eluded the historian.[37] Except for the sales catalogues and the prints themselves, too few documents exist, and too many embroidered oral memoirs and anecdotes have been recorded as fact.

If there were a general history of American lithography, Currier and Ives would go down in it as the most important company of the nineteenth century. They produced more than seven thousand titles, many in lots of several hundred thousand copies. They charged low prices, maintained dealers in every large American city, and survived longer than almost all of their competitors. Their volume of business was larger than that of any other lithographic firm in America, and even to this day their pictures seem to embody the American popular taste of the nineteenth century. From sensational "news" prints to religious scenes to rural life to railway and horse prints, the Currier and Ives inventory touched all aspects of American life. It was a lucrative business enterprise, which many lithographers attempted to copy. None succeeded.

In chromolithography, however, Currier and Ives's rank is much more difficult to assess, both because the firm did not advertise its chromo technology and because most antiquarians have not accurately distinguished the hand-colored Currier and Ives lithographs from the chromos.[38] In volume one of Harry T. Peters's *Currier & Ives* (1929), the classic misunderstandings are demonstrated. First, Peters notes that the earliest chromolithographs "appeared in America about 1860"; he was off by twenty years. Second, he states that the first Currier and Ives chromo "was published in 1889," yet A. F. Tait's "American Speckled Brook Trout" is a chromo that was published by Currier and Ives in 1864—and it may not have been their earliest.[39] Third, according to Peters, Currier and Ives did not produce their own chromos, "since they did not have the necessary equipment"; the

Their Place in History

Harry T. Peters

Plate 53.

meaning is unclear but Peters seems to be saying that it was the steam-powered printing press that was lacking. The confusion is not unique to Peters. He himself observed, still in 1929:

> All the works of N. Currier and Currier & Ives that really interest us, were colored by hand. . . . It was a keen disappointment to me, when, some years ago, I heard and convinced myself of this fact. For years I had gone my way with the vague idea that they were somehow litho-graphed and printed in color. Many collectors of Currier & Ives still go merrily on with the same idea.[40]

What Peters says about the prints that most interested him is true: they *were* hand-colored. Unfortunately, collectors and antiquarians have parroted Peters's appraisal of which are the hand-colored—and which are the most interesting—Currier and Ives prints, making his bias gospel.[41] This remains the case despite the standard, accurate index of the work of Currier and Ives compiled by Frederic A. Conningham. In the 1949 edition of his reference list Conningham wrote: "Not all Currier prints were colored entirely by hand. Many of the large folios were printed partially in color—even in the early days of the firm."[42] He expanded on this revelation in 1950:

Frederic A. Conningham

> The first print I can recall having seen, printed in color, is *The Cele-brated Trotting Horse Trustee*, published in 1848. I own a number of prints in which only the sky and foreground are printed in color and have seen many others. . . . The small-sized prints, however, were all colored entirely by hand until the later days of the firm, when all their prints, large and small, were printed entirely in color.[43]

Currier and Ives were conservatives when it came to technological innova-tion. For example, they probably never used a steam press in their plant.[44] Yet by the late 1860s many prints with Currier and Ives's characteristic titles were appearing as the products—at least in part—of printed color: "The Alarm," a "Chromo in Oil Colors From the Original Painting by A. F. Tait," was published in 1868, as was "American Farm Life," after a painting by A. O. Van Willis.[45] That same year "By the Sea Shore," after Thomas P. Rossiter, and "Falling Spring, Va.," after Samuel Colman, also appeared.[46] In 1869 the painting *Early Autumn*, by A. T. Shattuck, was chromolitho-graphed,[47] and in 1876 "Night Scene at an American Railway Junction. Lightning Express, Flying Mail and Owl Trains 'On Time'" was published (it exists today in both an unfinished and a finished state, the unfinished one demonstrating an early stage of a chromolithograph).[48]

Plates 54a and 54b.

Plate 55.

The horse-racing prints, which became almost an obsession with Currier and Ives during the late seventies and the eighties, are often "printed in oil

colors": "Trotting Stallion Phallas," 1883; "A Brush with Webster Carts," 1884; "Head and Head at the Winning Post," 1884; "The Water Jump," 1884; and "The Futurity Race at Sheepshead Bay," 1889 (which the artist, Louis Maurer, erroneously claimed to be Currier and Ives's first chromolithograph).[49] Many of the ship and yacht lithographs were also chromos: "A 'Crack' Sloop in a Race to Windward" was "printed in oil colors" in 1882 after C. R. Parsons;[50] the "Thistle" appeared in 1887; and the "Armoured Steel Cruiser—N.Y.—U.S. Navy," 1893, resembled the chromos being sold simultaneously by Joseph Hoover, of Philadelphia.[51] There were others, harder to classify by subject, such as "The Grand Display of Fireworks and Illuminators at the Opening of the Great Suspension Bridge between New York and Brooklyn on the evening of May 24th, 1883,"[52] and two large Southern scenes after William Aiken Walker (1838–1921), who was a Düsseldorf-trained American painter of the Old South:[53] "The Levee —New Orleans," 1884, and "A Cotton Plantation on the Mississippi," 1884, were marketed as a pair,[54] the former being particularly close to its original.[55]

Plate 56.

Plate 57.

Plate 58.

William Aiken Walker
Plate 59.
Plate 60.

Neither in the city directories nor the single-sheet broadsides did Nathaniel Currier and James Ives emphasize either their chromolithographic technology or their ability to reproduce oil paintings and watercolors. While some advertisements do say "from original paintings by eminent artists" or "Works of Art to brighten the home,"[56] the Currier and Ives commercial thrust was low prices (prints cost from 20¢ to $4): "The Cheapest and Most Popular Pictures in the World"[57] is the way they put it. Their pictures were advertised as "most interesting and attractive features for Libraries, Smoking Rooms, Hotels, Bar and Billiard Rooms, Stable offices or Private Stable Parlors. Also, for display by dealers in Harness, Carriages, and House Furniture of all descriptions."[58] Currier and Ives banked on their name and on the sentimental subject matter in their "colored engravings for the people."[59] Their philosophy was devoid of fine-art pretension, which resulted in the divorce of Currier and Ives from the rest of the chromolithographic community.

Low Prices, Not Fine Art

This distinction is significant, because it helps to characterize the nature of the craft. Most chromolithographers were practical lithographers who worked to order; that is, customers came to them (Louis Prang was one major exception, Joseph Hoover and Hines Strobridge were partial exceptions, and there were certainly others). Currier and Ives, however, were cut of a different cloth. They were speculators, who printed their goods, loaded them on wagons, and gave their spiel. A lithographed hand-written letter addressed to their salesmen and wholesalers in the 1870s reflects the confidence, the business acumen, and the efficiency of the partners from Nassau Street:

Currier and Ives as Speculators

Dear Sir,

Herewith we enclose our new Catalogue of Popular Cheap Prints containing nearly Eleven hundred subjects, from which you can make your own selection of kinds wanted, you will notice that the Catalogue comprises, Juvenile, Domestic, Love Scenes, Kittens and Puppies, Ladies Heads, Catholic Religious, Patriotic, Landscapes, Vessels, Comic, School Rewards and Drawing Studies, Flowers and Fruits, Motto Cards, Horses, Family Registers, Memory Pieces and Miscellaneous in great variety, and all elegant and salable Pictures.

Our experience of over Thirty years in the Trade enables us to select for Publication, subjects best adapted to suit the popular taste, and to meet the wants of all sections, and our Prints have become a staple article which are in great demand in every part of the country.

To Pedlars or Travelling Agents, these Prints offer great inducements, as they are easily handled and carried, do not require a large outlay of money to stock up with, and afford a handsomer profit than almost any other article they can deal in, while at the same time Pictures have now become a necessity, and the price at which they can be retailed is so low, that everybody can afford to buy them.

Our price for the prints named on the list is Sixty dollars per thousand, and to accommodate those who cannot conveniently purchase a thousand at a time, we sell them at the same rate by the hundred, Six dollars per hundred, if you wish us to send them by Mail, enclose Sixty cents per hundred extra, as we have to prepay postage.

Our terms are strictly *Cash with the Order* and on receipt of same we carefully envelope and promptly forward Prints the same day that the order is received. Money should be sent by *Post Office Order* if possible, if a Post Office Order cannot be procured, send in *Registered letter*, and Money so sent may be at our risk, but do not send Bank bills in a letter without registering it, be careful to sign letter plainly with name of writer, Town, County, and State; we are sometimes much troubled by receiving letters containing Money without signature, or date of place whence mailed. Address letters plainly to

Currier & Ives,

123 & 125 Nassau St.

New York

Remember that on receipt of Six dollars and Sixty cents by post Office Order, or in a registered letter, we send by mail post paid so that you will receive without further expense One hundred prints such as we retail at Twenty cents each.

The majority of chromos published under the name Currier and Ives appeared after 1880, the year that Nathaniel Currier retired. Having been in the lithographic business since 1834, he had achieved great success with his black-and-white and hand-colored work and, understandably, he did not leap aboard the rolling chromo bandwagon. His interest was in newsworthy events and escapism from the disappointments of everyday life—he honed this genre to its sharpest edge. It was apparently his son Edward West Currier, who replaced him, who steered the firm toward oil reproductions. By that time, however, at the turn of the century, the chromo as defined by P. S. Duval and Louis Prang had passed its peak and was headed toward ridicule. Nevertheless, Currier and Ives produced its chromos until 1898, and the business was liquidated only in 1907.[60]

Currier Retires

Business Closes 1907

5

TOOLS, TECHNIQUES, AND TARIFFS

New York City: A Major Depot

NEW YORK'S RISE as the nation's business capital had much to do with its emergence as the leader in American lithography. For as New York, blessed with its spectacular harbor, grew to dominate American trade, the city became the natural depot for the lithographic supplies that, during most of the chromo civilization, had to be imported from Europe. It is understandable that New York's feverish commercial activity brought forth such lithographic giants as Sarony, Major and Knapp; Julius Bien; and Currier and Ives. That most American printers had to turn to New York for their presses, stones, inks, and papers augmented the stature of these New York lithographers, who came to set the style of their craft. Thus, ideas, techniques, tools, and even trade policies—a mix of creativity and commerce— all worked together to produce the democratic art.

As described earlier, throughout the nineteenth century the technological growth of American lithography depended upon European innovation; before 1840 even the supplies for printing were difficult to purchase in the United States.[1] Charles Hart, an apprentice with George Endicott during chromolithography's early days, later remembered: "There being no material stores, at that time, every thing used by the lithographer, except the Stones and paper for printing, was made by themselves."[2] By the 1850s, however, no fewer than six businesses in New York City specialized in the import of lithographic equipment, which included, in addition to stones and presses, "bronze powders and leaf metals, varnishes, papers and card boards, dry colors of every description, tools, French tympans, rollers, and printing inks."[3] Nevertheless, even after the Civil War most presses, papers, inks, and virtually all of the stones continued to come from western Europe, particularly from the large supply houses in Berlin, Bremen, Frankfurt am Main, and Hamburg.[4]

I. Lithographic Stones

The flat lithographic stone, the essential component in lithography, provides the surface on which the image is drawn and from which it is printed. The best lithographic stone was limestone from the Solenhofen (or Solnhofen) quarries in Bavaria, which was of an ideal texture, density, and purity for printing. However, to save shipping costs and to lessen their dependence on imported goods, many lithographers in different parts of the world searched their own areas for substitutes. Bass Otis, an American painter who was an early promoter of lithography, worked with limestone quarried from Dirks River, Kentucky; he may have learned of the stone from the editor of the *Western Review,* who wrote in 1820, "Fortunately we have in Kent., the peculiar sort of stone which is made use of by the German artist . . . and it has been found to succeed admirably." Kentucky limestone continued to be used in lithography until as late as 1874. The Troy Lyceum, in New York, owned a "compact limestone" from Indiana; and an anonymous lithographer noted with pride that his picture of a boy holding a dead rabbit was printed from "Vermont Marble." Francis Lieber's *Encyclopaedia Americana* advised that when German stones were too expensive, Americans could fabricate "artificial slabs" by commissioning any "intelligent potter," who could "easily imitate the density of natural stones." Stucco composed of lime and sand and "fastened with the caseous part of milk" was held to be a suitable substitute![5]

Solenhofen Stone

Alternatives to Solenhofen Stones

The search for lithographic stone in North America was pursued relentlessly throughout the 1800s. One explorer after another claimed to have struck a lode that would end the German monopoly.[6] To prove the worthiness of American stone, at the end of the century some firms (such as the North American Lithographic Stone and Asbestos Company and Robert Mayer and Company) published with fanfare handsome chromos printed from native rocks.[7] Samples of stones from different parts of the world were exhibited at various expositions, including the great Centennial Exposition of Philadelphia. But despite these efforts to replace the German material, most printers kept returning to the Solenhofen products.[8] Like many of the lithographers themselves, the stones were direct links between American lithography and its deeply embedded German heritage.

Huge chunks of subterranean Solenhofen rock were sawed into blocks, boxed, transported to Hamburg or Rotterdam or Antwerp, and thence carried across the Atlantic in ships owned by Norddeutscher Lloyd and numerous other companies. The volume exported to America from 1860 to 1900 was huge: on June 19, 1886, for example, C. Daeschler, specializing in the export of "Lithographie—Steine nach allen Teilen der Welt," sold 391 stones to the A. I. Uffenheimer Company, of Philadelphia (115 North Fourth

Export of Solenhofen Stones

Street). The precious stones in this shipment ranged in size from 10 by 12 to 34 by 48 inches,[9] and their total cost, minus shipping charges, came to a staggering 6,705.29 German marks: the price per stone was determined by size and quality, as indicated by color and texture.[10]

Stone Dealers Most American chromolithographers purchased their stones from dealers. Strobridge inventories of the late 1860s show that the majority of its Solenhofen stones were bought from H. Siebold and Company, J. Birkner, Willy Wallach, Gibson and Company, Hughes and Kimber, and Deutz Brothers, all of New York City.[11] But though New York was the center for lithographic equipment, middlemen in the port cities of Boston, Philadelphia, Baltimore, and San Francisco appear also to have prospered.[12] For the printer, it was more convenient to deal with these middlemen (who were often German-born) than to try to buy directly from the quarries in Bavaria. It was also safer, as the quality of each Solenhofen stone could vary considerably, and if stones from an American dealer did not please a lithographer, they could be returned for credit. This occurred in a transaction between Strobridge and Fuchs and Lang, of New York, in 1877. Fuchs and Lang wrote in apology: "Are very sorry you did not like 19 & 25 stones and shall certainly do better the next time. Sometimes stones are picked out in a rainy day & then it is almost impossible to pick them out thoroughly well."[13]

Delivery of Stones On rare occasions, however, lithographers skipped the middleman and ordered directly from Europe. One bill, dated April 9, 1888, shows thirty-eight stones being sent from Munich to Antwerp, from Antwerp to Philadelphia, then on to Pittsburgh.[14] The heavy rocks from Bavaria were then distributed to their purchasers in inland cities and towns. The early chronicler Charles Hart described a wagonload of Bavarian stones being transported in New York City in about 1835:

> I saw a truck . . . being loaded with . . . stones. . . . The novelty of the sight attracted a great crowd. Men went up and felt the stones, and the women, filled with wonder and curiosity, stood gazing at a little distance. Such an exhibition of lithographic picture stones had never been seen by New York before. . . . It took a good while to load the truck, but I waited patiently for the truck to start. . . . Down Broadway it went. Such an unusual sight excited the attention of the pedestrians; and the drivers of which would stop their horses to watch. . . . The truck proceeded very slowly for fear of breaking the stones. There was, at times quite a little procession.[15]

The trade in stones was vast and, given the stones' high cost, the business in secondhand pieces must also have been brisk. An advertisement of 1893

ran: "Wanted.—About 20,000 pounds of Second-Hand Lithographic Stones."[16] If any were slightly damaged, stone-planing machines could be used to remove a sixteenth of an inch or more from the printing surface.[17]

Because the stones, a major capital investment, could be recycled for many different prints, most chromolithographers made it clear that they, not their customers, retained the stones after a job was completed (in other printing media, such as copperplate engraving, the customer often kept the plate). J. H. Bufford's bill announced that the "stone used for this work remains the property of J. H. B. unless distinctly charged." J. Sage and Sons, of Buffalo, insisted in 1869 that their magic rocks from Bavaria would remain in their own shops to perform the printing miracles: "No charge is made for the Stone on which the Engraving is done; but it does not become the property of the party ordering unless a special agreement is made."[18] In addition to protecting the lithographer's capital goods, this arrangement also forced the customer to return for additional runs—he would request that his image be kept on the stone—instead of carrying the stone to another printer. P. S. Duval said as much to one of his customers on January 7, 1852: "I cannot consent to allow the stones to be printed at any other establishment for the simple reason that the establishment who would print them would have the credit of work which has been done at my expense."[19]

Stones Remain Property of Printers

By 1875 good lithographic stones could be purchased in the United States with ease. When a stone arrived in a lithographer's shop, it was first sawed to a proper size. The rule was that a stone twelve inches square should be at least one and a quarter inch thick, in order to withstand the weight put on it during the printing process—the stone lay flat with the paper on top of it, over which the scraper blade moved, applying the necessary pressure. After cutting the stone, the lithographer then leveled and smoothed the printing surface. The standard method is described in the *Lithographers' Journal* of 1893:

> The stone is powdered over with a very fine sand, passed through a sieve No. 100, and, after having moistened it thoroughly, a second stone of the same nature as the first is placed upon it, and a reciprocating or rotary motion is imparted to it, being careful that the second stone does not overlap the first one, as the stones would then be flat no longer.
>
> The last sand, which should form a very soft pulp between the stones, is used in this way.
>
> The stone is then washed with abundant water to remove the impurities and the little grains of sand that might have remained attached on the sides and which would scratch the stone during the subsequent operation.
>
> The polish is given with the pumice stone; the lithographic stone is

Preparing Stones for Lithography

moistened, and rubbed forward and backward, a pretty long time, with a piece of pumice stone, taking care to wet the latter through by dipping it rather frequently in a glass of clean water, in order to free it from the little fragments which become detached from it.[20]

Storage Delivered and prepared, the unwieldy stones then had to be stored. For the lone printer who made black-and-white lithographs, the single Solenhofen slab resting at a forty-five-degree angle from a table top served as a charming accoutrement to his print shop or studio (Figure 8). In the big chromo firm, however, where each print required twenty stones or more—one for each color—the rocks called for housekeeping on a huge scale. "Stonerooms" became part of lithographic architecture, and special shelves coded by job number or stone size were standard equipment. Surely more than one apprentice, pulling down and reshelving stones that could weigh a hundred pounds, cursed the day that Senefelder decided to experiment on rocks instead of feathers.

Expounding on the bulk of stones needed to print even a few chromos, two American publications cited the extreme example of Matthew Digby

Figure 8. Detail from an advertising sheet of W. H. Rease, described by Nicholas B. Wainwright, in Philadelphia in the Romantic Age of Lithography *(p. 78), as "Philadelphia's foremost trade card artist" before the Civil War. Probably late 1840s. Location: Warshaw Collection of Business Americana, National Museum of History and Technology, Smithsonian Institution, Washington, D.C.*

Wyatt's *The Industrial Arts of the Nineteenth Century*, which appeared in England in 1851: to produce the chromo plates for this book, 1,069 stones, weighing a total of 25 tons, were used.[21] Had the Strobridge account books been open to the public, an even more astounding figure would have made the news: from an inventory of stones (valued at $6.43 each) worth $2,837.01 in 1867, the holdings grew to $43,344.42 worth in 1886,[22] and in 1896 to $53,068.53.[23]

Because of the inconvenience and expense of lithographic stones, many experiments were conducted to find a lighter, cheaper, generally more manageable printing implement, just as the search continued for a native-rock substitute. Senefelder himself had experimented with zinc. These plates, which were relatively inexpensive and easily obtainable, could be drawn on with great facility. When roughened by graining with sand, zinc took on water much like a Solenhofen stone; when highly polished it rejected water. Zinc also proved easy to prepare for printing. When properly treated, the zinc yielded, according to estimates made in 1860, "6,000 to 8,000 good impressions."[24]

Zinc Plates as Stone Substitutes

Zinc plates, used in America as early as 1849,[25] were first promoted as the ideal medium for reproducing simple outline drawings of machinery and architectural designs.[26] By December 1884 the *Inland Printer* could write that "zinc plates as substitutes for lithographic stones are now in common use."[27] It was during the 1870s that the American transition from stone to zinc began. It was a gradual shift, not completed by 1880, and for many years thereafter most magazine articles, business inventories, and encyclopedia entries still used "stones" in their terminology. Until the final decade of the nineteenth century most presses continued to be designed with flat beds to accommodate stones—zinc plates had to be attached to blocks to print correctly. Then the Providence Lithographic Company opened a new branch: the Lithographic Plate Manufacturing Company, which produced zinc plates specially designed for the Huber Rotary Zincographic Printing Press.[28]

The standard lithographic hand press was made up of a flat bed, which carried the lithographic stone, and a stationary scraper blade. The stone was placed in the bed, inked, and covered with a piece of paper that would receive the image, and then a leather tympan was laid on top of the paper. The bed was then raised and pressed hard against the blade. Once set against the blade, the bed was cranked across the blade, thus transferring the image from the stone to the paper. Early steam-powered presses followed the same design, but—as we shall see—by the late 1860s a top cylinder began to replace the blade for the purpose of exerting pressure against the flat bed and the lithographic stone: this permitted quicker printing. The Huber Rotary Press took the principle another step by adding a second cylinder. Instead of

*Illustration 1.
Elements of a standard
lithographic press, made
up of a flat bed, which
carried the lithographic
stone, and a stationary
scraper blade.*

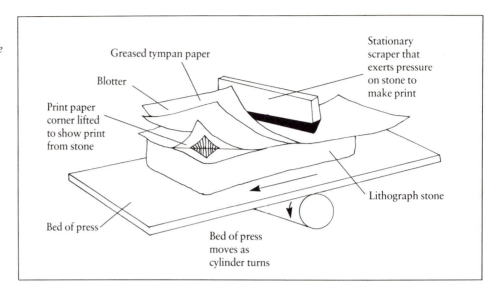

Greased tympan paper

Blotter

Print paper
corner lifted
to show print
from stone

Bed of press

Stationary
scraper that
exerts pressure
on stone to
make print

Lithograph stone

Bed of press
moves as
cylinder turns

employing a flat bed that moved back and forth under a top-rotating impression cylinder, the Huber method used a curved zinc plate that was attached to one cylinder at the top, while under it a second cylinder pressed against it. It was a fast, continuous rolling of the two cylinders, with the zinc plate and lithographic paper passing between them. But this is getting ahead of our period; as late as 1891 the Providence firm was being described as the pioneer "in rotary printing from zinc-plates in the United States."[29] And in October 1893 even a promoter of zinc, the *Lithographers' Journal,* wrote:

> A very great determination exists among lithographers to do away with the necessity of using the costly and bulky lithographic stones, and to adopt some material which will give equal results and reduce the space for storage that is requisite where the stones are used. The tendency is toward zinc. . . . Certain difficulties, however, have stood in the way, and results are not always as pleasing with the metal surface as with the stone, owing to the lack of knowledge as to what the zinc requires in treatment. Experiments are now going on with this material, and it will not be long before a new zinc plate will be offered to the trade, which will possess all the features of desirability, and will be economical, as well.
>
> Zinc plates are now being extensively used in England, and with no uncertain success, while their efficiency has already been demonstrated in this country by one of the best art-lithographers in the field.[30]

Problems with Zinc

The final reference may be to Louis Prang, known as a technical innovator, who had perhaps used zinc in his chromolithography since the early 1870s.[31] Certainly, his success with zinc when others had not unlocked its mysteries

would not be surprising. However, though the new technique was promoted by *Art Interchange*[32] on October 12, 1882, even the editors of that magazine believed that Prang still worked with stones.[33]

II. Lithographic Inks

The pigments used to print chromos in the 1840–90 period were ground in boiled linseed oil, which printers called varnish.[34] Except for black, which was lampblack, simply a form of carbon, all pigments were imported from England, France, and Germany;[35] although protective tariffs attempted to encourage a pigment industry in America,[36] that industry did not develop until World War I.[37] The pigments were all made from materials dug from the ground and then purified; their very names spoke of the earth: chrome yellow, cobalt, sienna earth, earth of Italy, indigo, zinc white, red lead, and, in various combinations, iron.

Linseed-Oil Base

Pigments

During most of the chromo era, the inks were prepared by the lithographers themselves.[38] While each printer had his secret recipes, his own preferred viscosity, his personal theory of color, all were bound by the laws of chemistry as well as the supply of the necessary ingredients. Ink production consisted of three steps: 1) preparing the varnish, 2) preparing the pigment, and 3) mixing the pigment in the varnish. Throughout the period dominated by the hand press, 1820 to 1870, P. S. Duval followed a standard procedure, which he described in 1871. He placed at least two gallons of pure aged linseed oil in a heavy iron pot equipped with a vapor-release valve on the lid. The pot was placed over a roaring fire and brought to a temperature that almost ignited the oil. Then something equivalent to a varnish fondue was cooked. Duval explained:

Ink Preparation

> When heated nearly to the point of ignition, slices of stale bread and onions are fried in it, one slice and two or three onions at a time, to avoid too much tumefaction. When the bread is fried brown, it is taken out, and another slice is substituted, until 1¼ pounds of bread and ¼ pound of onions for each gallon of oil have been used. The bread has the effect of absorbing certain oily or fatty substances contained in the oil, which, if allowed to remain, would be injurious to the drawings; the onions clarify the varnish, and give it a drying quality.[39]

Having fried the bread and onions, Duval increased the temperature and ignited the oil. As he understated, "From that moment the operation must be conducted with great care." The pot was then removed from the flame, and the oil continued to blaze until the proper thickness was reached. "When

sufficiently burned," Duval described, the varnish will stick between the forefinger and the thumb, and "when the fingers are parted it will produce threads and a light crackling sound." In Duval's time it was "customary to make three different degrees of thickness of varnish, to suit different classes of work; greater or less thickness is produced by more or less burning."[40] Ink production was a risky business. Small wonder that chromolithographers seemed to mark their tenth or fifteenth year in business by seeing their factories burn down.

Fires

Rise of Ink Industry in America

Between 1870 and 1900 the manufacture of lithographic ink and varnish became an independent and sophisticated enterprise. By 1890 there were major producers and purveyors in San Francisco, Chicago, Cincinnati, Buffalo, Philadelphia, New York, Boston, and St. Louis.[41] There were many variables in this industry, for every development in the lithographic technology called for changes in lithographic inks. Steam presses required a new variety of thinner varnishes. Coated papers needed colors, particularly whites, that would not cake. Faster production procedures necessitated faster-drying inks. The new demands kept coming. Like the rising chromolithography factories that compelled large-scale specialization, lithographic-ink and varnish complexes sprang up, complete with smokestacks blowing black venom across the landscape.[42]

In 1885 George Mather's Sons, of New York, claimed to be the oldest ink manufacturer in America, having started in business in about 1816. In that firm each step in the production—"varnish making," "color grinding," and "ink mixing"—was carried out by a separate department. The first and most dangerous step, judging from illustrations in the *Inland Printer*, was always performed by black workers. As Duval had warned in 1871 and a reporter echoed in 1885, the process demanded the "greatest skill and technical discernment."[43]

Although many of the ink manufacturers, such as Sigmund Ullman (who advertised in 1884 the "largest and most complete assortment" of lithographic inks in America),[44] sold their inks already mixed, it appears that much of what they sold even to large chromo companies was varnishes and pigments in fairly small quantities,[45] which the printer then mixed when needed. This was advised by the *Lithographers' Journal* as late as February 1893, because "Newly crushed colors have more glow, cover more, and can be more easily printed than those prepared in advance and kept in stock."[46] While Duval ground his pigments and mixed his inks by hand, various grinding and blending machines, some even steam-powered, were available by the late 1870s.[47]

Silver and Bronze

A feature of chromolithography during its heyday was the showy use of silver and bronze. Far more expensive than the colored inks, these powdered metals were considered a drawing card, irresistible to the chromo taste. But

they were also troublesome to work with, toxic to the printer, and somewhat unpredictable. Applying the metallic glitter with a pad of cotton wool was the oldest and best-known procedure,[48] but bronzing, the application of bronze powder, was apparently done by rubbing, dusting, or rolling the fine particles on an adhesive ink printed on the chromo.[49] By the 1880s enclosed "dusting machines" offered both a more even bronzing and safer air to breathe.[50]

III. Drawing on Stones

Polishing the stones, preparing the printing surface, grinding the pigments, boiling the varnishes, blending the inks, and applying the metallic colors were the physics and chemistry of chromolithography; the drawing of the image and the printing of the colors, in the correct sequence while maintaining close registration, were the art. To conduct this most delicate operation, chromo print shops employed color specialists called *chromistes*. These professionals drew the separate color plates (stones), determined the order of printing, and checked the finished pieces for their reproductive quality. They were starred in the popular press as craftsmen-geniuses. An account published in America in 1869 reads:

Chromistes

> The hand that reproduces on stone the painting to be copied must be that of a true artist. No dauber or botcher can do this work, which demands in him who does it not merely manual skill and fine artistic vision, but a thorough understanding and an earnest sympathy with the purpose of the painter, whose work is before him, strong powers of analysis and rare knowledge of colors.[51]

Similar praise carried into the twentieth century. A writer for England's *Strand Magazine* wrote in 1904 that chromistes were "master-lithographers . . . whose chromatic perception is so acute that they can tell you at a glance what the great Turner himself did not know—how many colours go to the making of one of Turner's pictures." [52]

The ladies' magazines and intellectual journals wrote that lithography was not as difficult as other printing processes: drawing directly on the stone with crayons, pens, and pencils, a lithographer supposedly did not need the special skills required for engraving.[53] This was not, as we have noted, the case. The procedure involved expertise in preparing the stones and experience in preparing ink, as well as a highly sophisticated knowledge of printing.

After the drawing was completed, the entire stone was covered with a solution of gum arabic and dilute nitric acid. This fixed the drawing against

Fixing the Drawing on Stone

spreading, by desensitizing the clean portions of the stone to crayon grease, pencil lead, or drawing ink. The printing surface was then washed and the damp stone was rolled up with printing ink and sent through the press. Inking was the most crucial step, for a precise amount of ink had to be applied, and this was learned only by experience.[54]

Senefelder had developed the entire process by 1818, and throughout the nineteenth century his *A Complete Course of Lithography*, translated into English in 1819, served as the standard text for all lithographers. To this day, those who draw on stone follow Senefelder's formulas. Other European manuals elaborated on Senefelder, but no American wrote a treatise to equal even these secondary works.

Registration To insure the proper registration of colors, the lithographic artist first drew an outline of his subject on a lithographic stone and then printed as many impressions as he intended to print colors. These impressions, while still wet, were powdered with red chalk and transferred to other stones, the ones to be used in the printing of each individual color. The chalk lines, now on the stones, would not appear in the final print; their purpose was only to serve as a guide for the drawing on the stones of each new color. The challenge was to make every sheet of paper fall on every stone in exactly the same position. Then the printing began.

IV. Printing

P. S. Duval wrote in 1871 that "the artist proceeds with his work, commencing with the lightest color."[55] Maybe so in Philadelphia, where Duval ruled in the 1850s and '60s, but too many exceptions exist. Standard print references at the end of the chromo era called for bronzing first, followed in order by blues, reds, yellows, outline, and, sometimes, a final color.[56] Even these texts, however, are contradicted by the surviving examples of proofs in different stages from 1865 to 1880.

Chromo proof sheets now located in the Boston Public Library, the American Antiquarian Society, the Smithsonian Institution, and the Library of Congress demonstrate that most shops followed their own color theories. Nevertheless, several universal rules did seem to govern the sequence of color printing:

1) The bronzing was done first, because if another color preceded it, that ink might require days of drying time to insure that the bronze powder would not stick to it.
2) Opaque colors preceded transparent, because the latter were generally used to modify the former.

3) Different shades of a color required different sequences of printing. If a lithographer wanted a dark green, for example, he would print chrome yellow first and follow it with Prussian blue; but a warmer, lighter green demanded the reverse order of color application.

The writer James Parton vividly described the chromo printing process in *The Atlantic Monthly* of March 1869. The painting being reproduced was Eastman Johnson's *Barefoot Boy*. The lithographic firm was L. Prang and Company.

It is a small picture,—about thirteen inches by ten,—but to reproduce it in chromo-lithograph requires twenty-six slabs of stone, weighing not far from two tons, and worth fourteen hundred dollars. The time occupied in preparing these stones for the press is about three months; and when once the stones are ready, an edition of a thousand copies is printed in five months more. And yet, although the original is worth a thousand dollars, and the process of reproduction is so long and costly, a copy is sold for five dollars,—a copy, too, which, to nineteen-twentieths of the public, says as much, and gives as much delight every time it is looked at, as the original work could. It may be possible, in a few words, to convey some idea of the manner in which this particular boy, standing barefoot upon a rock in a brook, with trees, a grassy bank, and blue sky behind him, is transferred from a thousand-dollar canvas to whole stacks of five-dollar pasteboard.

As far as possible, the chromo-lithographer produces his copy by the method which the artist employed in painting the original. One great difference between painting and printing is, that the printer puts on all his color at once, while the painter applied color in infinitesimal quantities. One crush of the printing-press blackens the page; but a landscape grows and brightens gradually under the artist's hand, as the natural scene which he is representing ripens and colors under the softer touches of the sun, the warm winds and gentle showers of April and May. As far as possible, I say, the chromo-lithographer imitates these processes of art and nature by applying color in small quantities and by many operations. He first draws upon a stone, with his pencil of soap and lampblack, a faint shadow of the picture,—the outline of the boy, the trees, and the grassy bank. In taking impressions from this first stone an ink is used which differs from printers' ink only in its color. Printers' ink is composed chiefly of boiled linseed oil and lampblack; but our chromo-lithographer, employing the same basis of linseed oil, mixes with it whatever coloring matter he requires. In taking impressions from the first stone in laying, as it were, the foundation of the boy, he prefers a

Parton Describes Chromo Printing

browned vermillion. The proof from this stone shows us a dim beginning of the boy in a cloud of brownish-red and white, in which can be discerned a faint outline of the trees that are by and by to wave over his head. The face has no features. The only circumstances clearly revealed to the spectator are, that the boy has his jacket off, and that his future trousers will be dark. Color is placed, first of all, where most color will be finally wanted.

The boy is begun. He wants more vermillion, and some portions of the trees and background will bear more. On the second stone, only those portions of the picture are drawn which at this stage of the picture require more of that color. Upon this second stone, after the color is applied, the first impression is laid, and the second impression is taken. In this proof, the boy is manifestly advanced. As the deeper color upon his face was not put upon the spots where his eyes are to be, we begin to discern the outline of those organs. The boy is more distinct, and the general scheme of the picture is slightly more apparent.

As yet, however, but two colors appear,—brown-vermillion and white. On the third stone the drawing is made of all the parts of the picture which require a blue coloring,—both those that will finally appear blue and those which are next to receive a color that will combine with blue. Nearly the whole of the third stone is covered with drawing; for every part of the picture requires some blue, except those small portions which are finally to remain white. The boy is now printed for the third time, a bright blue color being spread upon the stone. The change is surprising, and we begin now to see what a pretty picture we are going to have at last. The sky is blue behind the boy, and the water around the rock upon which he stands is blue; there is blue in his eyes and in the folds of his shirt; but in the darker parts of the picture the brown-vermillion holds its own, and gains in depth and distinctness from the inter-mixture with the lighter hue.

Stone number four explains why so much blue was used upon number three. A bright yellow is used in printing from number four, and this color, blending with the blue of the previous impression, plasters a yellowy disagreeable green on the trees and grass. The fifth stone, which applies a great quantity of brown-vermillion, corrects in some degree this dauby, bad effect of the yellow, deepens the shadows, and restores the spectator's confidence in the future of the boy. In some mysterious way, this liberal addition of vermillion brings out many details of the picture that before were scarcely visible. The water begins to look like water, the grass like grass, the sky like sky, and the flesh like flesh. The sixth stone adds nothing to the picture but pure black; but it corrects and advances nearly every part of it, especially the trunks of the trees,

the dark shade upon the rocks, and portions of the boy's trousers. Stone number seven gives the whole picture, except the figure of the boy, a coat of blue; which, however, only makes that bluer which was blue before, and leaves the other objects of their previous color, although brighter and clearer. The eighth stone merely puts "madder lake" [red] upon the boy's face, hands, and feet, which darkens them a little, and gives them a reddish tinge. He is, however, far from being a pleasing object; for his eyes, unformed as yet, are nothing but dirty blue spots, extremely unbecoming. The ninth stone, which applies a color nearly black, adds a deeper shade to several parts of the picture, but scarcely does anything for the boy. The tenth stone makes amends by putting upon his cheeks, hands, and feet a bright tinge of blended lake and vermillion, and giving to his eyes a somewhat clearer outline.

To an inexperienced person the picture now appears to be in a very advanced stage, and many of us would say, Put a little speculation into that boy's eyes, and let him go. Trees, rocks, grass, water, and sky look pretty well,—look a thousand times better than the same objects in paintings which auctioneers praise, and that highly. But we are only at the tenth stone. That child has to go through the press sixteen times more before Mr. Prang will consider him fit to appear before a fastidious public.

Stones number eleven, twelve, thirteen, fourteen, fifteen, and sixteen all apply what seems to the uninstructed eye mere black. The colors are, indeed, extremely dark, although not pure black, and the chief object of these six impressions is to put into the picture those lines and shadows which the eye just mentioned cannot understand, but only enjoys. It is by such minute applications of color that a picture is raised from the scale of merit which escapes censure to that which affords delight. The last of these shading stones gives the boy his eyes, and from this time he looks like himself.

The seventeenth stone lays upon the trees and grass a peculiar shade of green that corrects them perceptibly. Number eighteen just touches the plump cheeks, the mouth and toes of the boy with mingled lake and vermillion, at which he smiles. The last seven stones continue the shading, deepening, and enriching of the picture by applying to different parts of it the various mitigations of black. It is then passed through the press upon a stone which is grained in such a way as to impact to the picture the roughness of canvas; after which it is mounted upon thick pasteboard and varnished. The resemblance to the original is then such that it is doubtful if Mr. Eastman Johnson could pick out his own boy if he were surrounded with a number of copies.

It is not every picture that admits of such successful treatment as this,

nor does every chromolithographer bestow upon his productions so much pain and expense. A salable picture could be made of this boy in ten impressions; but, as we have seen, he receives twenty-six; and the process might be prolonged until a small quarry of stones had been expended upon him. Some landscapes have been executed which required fifty-two stones, and such pictures advance to completion by a process extremely similar to that employed by an artist. That is to say, color is applied to them very much in the same order, in the same minute quantities, and with an approach to the same intelligent delicacy of touch.

The frontispiece of this book shows examples of progressive proofs for a single chromo.

V. Lithographic Paper

According to Duval, good paper was difficult to find in America in the 1820s, and for some time it was a "great drawback to the progress of the art" of lithography. Thomas Gilpin, of Brandywine Mills, made the first American paper that was acceptable to Duval, of "very fine texture, firm and

Calendering well calendered." [57] Calendering is the process of passing paper through rollers to give it a smooth or glossy finish. In pressing the paper, the rollers cause it to expand before it is printed upon.[58] The expanding of printing paper when it is moistened was always a problem, but it was most severe in chromolithography. Unlike black-and-white lithography, in which the paper was printed slightly damp and only once, chromos were printed dry and numerous times. Thus, every time the chromo paper received another impression it expanded and then contracted when it dried, so that the system of register was repeatedly upset. For this reason, calendered paper that was

Sizing sized—coated with a glaze or glue to reduce stretching—was the preferred stock of printers. Before the Civil War, a lithographer such as Duval would do his own sizing, using a variety of gelatinous or glutinous substances, but by the late 1870s a broad variety of machine-"coated," "glazed," and "enamelled" lithographic papers were sold by American firms. These papers were guaranteed to hold together under the strain of the twenty or more impressions required by some chromos, and, according to Duval, they were "equal to any manufactured in Europe." Sometimes the paper came on rolls, but generally it was sold in sheets (called plate paper), varying in weight from 40 to 120 pounds.[59]

Temperature and The instability of paper forced printers to struggle to maintain in their
Humidity Control shops a constant temperature and level of humidity.[60] It was for the lithographic shop where the chromo covers for *Judge* magazine were printed that

Willis H. Carrier designed a machine in 1902 for controlling temperature and humidity—[61] this was the first successful centrally air-conditioned building in America.

VI. Lithographic Presses

Although a memoir-history of the Hoe printing-press company notes that "Hand Lithographic Presses" were being made in that shop as early as 1834, not a single Hoe press, nor any other American model from that time, has survived. Pictures of early lithographic presses in America are few and imprecise (Figures 9, 10, and 11).[62] From what we can see portrayed in the cuts on letterheads and advertisements, all but one of the presses appear to be side-lever machines, which cranked the bed carrying the lithographic stone

Hand-Operated Presses

Figure 9. Detail from a billhead of Case and Green, Hartford, 1850. Location: Warshaw Collection of Business Americana, National Museum of History and Technology, Smithsonian Institution, Washington, D.C.

Figure 10. Detail from a billhead of F. F. Oakley Lithographic Company, 1857–60. In the fore-ground a lithographer is inking a stone, which is sitting on a lever press—a modern kind for the 1850s. At the middle distance a printer is cranking a star-wheel press. The background shows lithographs dry-ing on lines. Location: Warshaw Collection of Business Americana, National Museum of History and Technology, Smithsonian Institution, Washington, D.C.

EATLY EXEC

under the scraper blade, the pressure applicator. The scraper had to be ad-justed to the proper height, so that when the bed was raised just the right amount of pressure was applied. After the stone had been inked and the paper laid across it, a cover called the tympan was lowered. The bed was then raised against the scraper, thus applying pressure, and a handle or star wheel was cranked to move the stone beneath the scraper. When the entire print was completed, the pressure was released, the bed drawn back, and the tympan lifted from the stone. The print was then peeled off the stone and the entire operation was repeated.

This was a cumbersome process, even more awkward and slow than working a letter press, and the most efficient lithographers sometimes pro-duced only 200 to 250 impressions in a twelve-hour workday. As one writer noted, lithography "will never supersede printing with types for books and papers . . . the work has been and is a very slow business."[63] In 1860 *The New American Cyclopaedia* condemned the apparatus used in making litho-graphs as having the "appearance of clumsiness and imperfection."[64] By contrast, when the letter press was linked to the steam engine in the early 1800s, it made the lithographic machines appear antediluvian.

In 1818 Alois Senefelder perceived the problem:

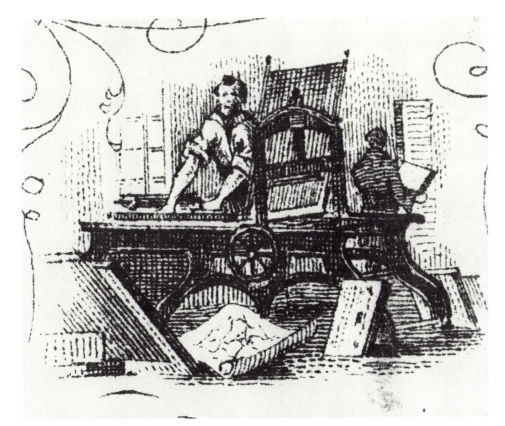

Figure 11. Detail of a hand-operated lithographic press from the business card of Snyder and Black, "Practical Lithographers," 92 William Street, New York, c. 1850. Location: Warshaw Collection of Business Americana, National Museum of History and Technology, Smithsonian Institution, Washington, D.C.

I am only too well aware . . . of a great defect in lithography, which is that the beauty and even the number of impressions depend mainly on the skill and industry of the printers. A good press is necessary, to be sure; but even with the best a poor workman will produce nothing but trash, because in this respect lithography is far more difficult than any other printing-process. I shall not admit that lithography has made a great step toward the utmost perfection until the erring work of the human hand has been dispensed with as much as possible and the printing is done almost entirely by machinery.[65]

Senefelder on Problems of Hand Presses

The inking and printing of lithographs required great care and skill. There was only one correct procedure, and the test of a good printer was if he made one print from a stone look like every other print from that stone. But, because the hand-operated press required so much human—as opposed to mechanized—labor, even the best printer's lithographs varied in quality. An automatic machine was called for, to correct the "erring work of the human hand" and to meet the quantity demands of the art promoters, who sought to mass-distribute the prints.

Numerous steam-powered lithographic machines were invented during the 1840s in Europe, but they all proved impractical.[66] One of the first

Steam Power

commercially successful lithographic steam presses was patented on May 30, 1851, in Austria, by a man named Sigl, and it was subsequently improved by a French engineer, a Monsieur Engues. The Sigl-Engues press operated with lithographic stones, mechanical inking and damping devices, and an automatic system that delivered and removed the paper. The Engues patent was eventually sold to the London press builders Hughes and Kimber, who, according to Ringwalt's *American Encyclopaedia of Printing* (1871) and the *American Dictionary of Printing and Bookmaking* (1894), introduced it to the United States in 1866.[67] Victor E. Mauger, a lithographic supplier, was the principal Hughes and Kimber agent in New York.[68]

The use of English and French lithographic steam presses in New York, Boston, Philadelphia, Chicago, and Cincinnati is documented for the period 1867–75,[69] and these contemporary references may well be describing the Engues–Hughes and Kimber machine. Unfortunately, the story of the steam press in the United States before 1870 is a web of contradictions. More than twenty American patents registered between 1861 and 1873 deal with some aspect of power for lithographic printing, and the claims of those who first invented, used, or promoted these steam devices are maddeningly confusing.[70]

P. S. Duval's Early
"Steam Press"

Edwin Freedley, in his enthusiastic history *Leading Pursuits and Leading Men* (Philadelphia, 1856), stated that P. S. Duval was operating a steam press as early as 1846. However, neither the Philadelphia directories for 1846 and 1847 nor the advertising blurbs in local newspapers corroborate Freedley. Duval himself wrote in 1871, in the *American Encyclopaedia of Printing:* "In 1850 the writer of this notice, by a simple combination, added the steam-power to his hand-presses, but only so far as to save muscular labor, while the steam-presses in use at the present time do the work on the same principle as the typographic presses."[71] Duval's statement is vague, and his advertisements from the 1850s are not much clearer: "The spacious location which he is now occupying has enabled him to make the most important improvements to his presses by adapting them to *Steam Power,* a process which facilitates the printing of Drawings of a larger size than those previously done by hand presses."[72] Perhaps the steam hookup eased the cranking of the bed or permitted the application of greater pressure from the scraper blade.

Even as late as July 25, 1852, the *Scientific American* lamented that all "lithographic presses are worked by hand; not one has been made, so far as we know, self-acting, to be driven by steam power. The man who invents an improvement in the lithographic art, whereby the printing press will be self-acting and capable of being driven freely by steam power, will confer a benefit upon a most beautiful branch of the printing art, for which he should be highly honored and richly remunerated."

Shortly before the Civil War a printing contest was held that is reminiscent of the man-against-machine folk tale of John Henry. The chromolithographer Charles Hart, who was famous for his printing skills, recorded the incident:

> In the year 1859 a press to print lithographic stones was invented in Germany. A certain man in the German office made drawings of the machine, brought them to America, and sold the plans to an enterprising firm in Boston.
> In due course of time, a press was built from these plans, with such improvements as Yankee ingenuity could supply.
> The press was brought to New York city . . . and placed on exhibition in William Street on the Seventh of June 1859. . . .
> The press worked with a scraper and tympan (evidently copied from the hand press.)
> On my arrival . . . I found the press in operation, and the room filled with an excited crowd of lithographic printers, of all nationalities.
> The place was a perfect Babel. All were talking in various languages at once, wildly gesticulating and denouncing the steam press, as well as condemning its work.

Beside the steam machine was a hand press, printing the same image. Although Hart judged the prints, hand- or steam-executed, indistinguishable from one another, his fellow lithographers disagreed,

> asserting that there was no comparison between the two. The handpress work being, in their estimation infinitely the better. The excitement was increasing every moment and each new comer added fuel to the fire. . . .
> They then came up to the table, by the windows, where the steam press and hand press work were lying side by side, and while the excited printers were pointing out the superiority of the hand press work [the operator of the steam press] . . . placed his hands, one under each pile of work, and lifting them suddenly mixed both lots of work in one indistinguishable mass upon the table. "Now gentlemen" [he said]. . . . "Separate, if you can, the hand press from the steam press work." That was an impossibility. Great indeed was the indignation of the printers. . . . But they still declared the hand press work was the better.[73]

Anti-steam-press forces argued that powered machines would crack the precious lithographic stones (in 1860 some cost more than $500) and that the inking would be too light or too heavy, particularly on stones with heavy masses of crayonwork.[74]

While in retrospect steam power seems inevitable, skeptics of the time could point to all the false starts. Hart told of one steam press that was imported by Victor E. Mauger and sold to a lithographer on New York's Fulton Street. Nicknamed the Monster Lithographic Press, it could not be carried through either the doors or the windows, so a hole was cut in the roof, through which the machine, hoisted from the street, was deposited on the top floor. Once installed, the press proved a worse than useless investment, because it kept breaking the large stones it was designed to print from.[75]

In 1860 the hand press still predominated. As one writer observed, "Other results are . . . attained . . . by the use of machinery worked by steam, which to some extent is applied to this process."[76] Not a single patent was issued in the United States for a lithographic steam press before 1861, and though during the next thirty years many steam-related patents were granted, no patentee claimed the basic idea of harnessing steam for lithography. The American patents were for improvements on the lithographic press, such as automatic inking and damping devices, special carriages that adjusted to various-sized stones, and speedier printing methods.

Major and Knapp's Attempt at Monopoly

In the midsixties Major and Knapp, of New York City, tried to monopolize the power-press business. They owned a number of these machines by 1866 and, according to Hart, "controlled for a while, all the large orders for lithographic printing."[77] The firm went so far as to declare that it had the sole power-printing rights in New York and "elsewhere," which was undefined. One circular, dated October 15, 1867, reads: "All persons are cautioned against buying or using, within the territory of this Company, any of the . . . Imported Lithographic Power Printing Presses, which are direct infringements upon the Patents held by this Company." Major and Knapp did not, of course, have a legal leg to stand on, and their warning was ignored. In the 1870s and '80s advertisements for steam presses flooded magazines and broadsides. Manufacturers such as Walter Scott and Company, of New Jersey, C. B. Cottrell and Sons, of New York, Campbell Printing Press Company, of Massachusetts, and Babcock Manufacturing Company, of Connecticut,[78] all claimed unique qualities and enthusiastic patrons.

R. Hoe and Company

Advertisements, however, are not proof of which presses were actually being used. Strobridge purchased five number-3½ Hoe steam presses[79] in the early 1880s; the first two cost a total of $10,000, installed and running—$3,000 down, with the balance due in equal payments at three, six, nine, and twelve months.[80] This model is described by Stephen D. Tucker, for many years an employee of Hoe's, in his *History of R. Hoe and Company: 1834–1885* (edited by Rollo G. Silver):

All lithographic printing was formerly done on hand presses, the impression being taken from the stone by a scraper. Attempts had been

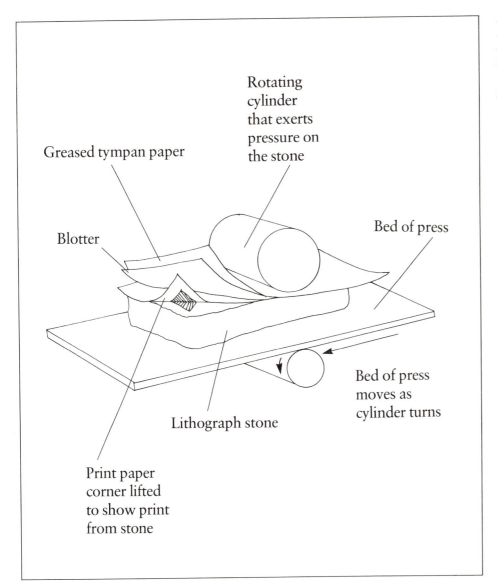

Greased tympan paper

Rotating
cylinder
that exerts
pressure on
the stone

Bed of press

Blotter

Bed of press
moves as
cylinder turns

Lithograph stone

Print paper
corner lifted
to show print
from stone

Illustration 2.
By the late 1860s a top
cylinder began to replace
the stationary scraper
blade on lithographic
presses. The cylinder
exerted pressure against
the flat bed and the
lithographic stone and
permitted quicker
printing.

made for several years, both in this country and in Europe, to build a
suitable machine press for lithographic printing with more or less suc-
cess. The older attempts generally retained the scraper for taking the im-
pression, but in some of the later ones an impression cylinder was tried
with promising result. Mr. R. M. Hoe, who was in Europe at that time,
saw a machine of the latter description made by Mr. H. A. [*sic*] Mari-
noni, a press builder of Paris, and he was so pleased with its perform-
ance that he proposed to Mr. Marinoni that he, as the inventor, should
make an application for a United States patent, and for a certain con-
sideration, assign the application to him, Mr. R. M. Hoe. This proposal
was accepted and carried out, and a patent was granted to R. M. Hoe,
March 16th, 1869.[81]

Hoe and Marinoni

Figure 12. Figure from patent number 87,950 (March 16, 1869) of A. H. Marinoni. The operation of the Hoe-Marinoni steam press and its special features were described:
OPERATION.
The operation of the machine will be as follows:

The lithographed stone Z is laid upon the bed-plate C, which rests upon the travelling carriage C, and is properly adjusted for a perfect register, by the screws Q, as shown in fig. 4, and the ink-fountain and rollers are properly adjusted to supply the ink. The sheets to be printed are then fed from the table V to the impression-cylinder F, when they are seized by the gripers and carried forward with the impression-cylinder and printed, and then delivered to the gripers on the receiving-cylinder, which carry the sheet to the cords or tapes and rollers that deliver it to the fly, as plainly shown in fig. 5. The fly is then operated through the medium of the cam O, and rod N, and segment-arm P, which works in a pinion on the fly-shaft, as shown in fig. 1.

The rod N, which operates the fly, is reacted by a spring, applied in any proper way for the purpose.

The receiving-cylinder G is provided with grooves for the tapes to lie in, so they will not come in contact with the impression-cylinder, and all the tape-rollers are grooved for the tapes, excepting the roller

Auguste Hippolyte Marinoni was one of the most celebrated press builders in Paris, holding more than "forty-five patents . . . for inventions in typographic and lithographic presses."[82] According to Tucker, a Marinoni press and a set of mechanical drawings were brought to the Hoe factory to be copied. "It was a stop cylinder press," wrote Tucker;

the bed ran on a six wheel truck and was driven the same as our "Railway" press. As the stone became thinner from use the stone platform was raised by a screw near each corner until the stone came in proper contact with the impression cylinder. At one end of the bed was an inking table, and at the opposite end a water table covered with felt, to which water was applied by hand from time to time, and this supplied the water rollers for the stone. The sheet was flown by a delivery cylinder with tapes leading to a sheet-flier. This press was put in operation here, but it soon became evident that it was entirely too lightly built for its work.

In building our machines we adopted our latest stop cylinder style as far as possible. The bearings of the impression cylinder have a slightly elastic packing above them, so that by yielding a trifle it will prevent a stone from breaking in case its surface should be a little uneven. A water fountain and rollers automatically dampen the stone, and if desired, the bed can make two runs to each sheet printed. This machine was built in 1868 and put in operation early in 1869, and at once became a great favorite with the trade and so remains to this day. Marinoni's sheet delivery arrangement was an improvement on any previously made and was adopted by the firm on both lithographic and typographic machines.[83]

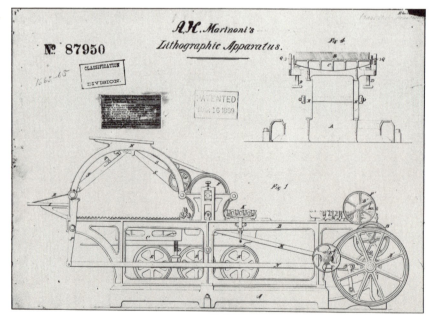

The long-time Hoe employee was perhaps prejudiced, but the Marinoni model was one of the workhorses of the industry (Figures 12 and 13). Charles Hart wrote that "Robert Hoe & Co. manufactured a lithographic steam press which, by its superiority in every respect, soon banished all the foreign presses from the American establishments."[84] Another writer agreed that lithographic steam presses of the 1865–85 period were "sedulously copied from the original machines of Messrs. Hoe & Co."[85]

Hoe sold five other Marinoni models,[86] ranging in stone size from 22 by 28 inches to 37 by 53, the weight of the presses varying from 5 to about 12½ tons. Advertised to print a maximum of 1,310 sheets per hour, the Hoe

which is above the receiving-cylinder.

The roller located near the fly, is also grooved to receive the blades or arms of the fly, so that they may be on a plane with the tapes, as the sheet is delivered to them to be piled upon the table I.

The importance of the adjustable bed for lithographic printing will be apparent. The stones are of variable thicknesses, and a perfect impression is of the utmost importance. This is readily attained by me, by the means described.

Having thus fully described my invention,

What I claim, is—

1. The combination, with the reciprocating carriage of a cylinder lithographic press, of an adjustable bed, for adjusting the stone, both vertically and laterally, substantially as described and specified.

2. The T-shaped lifter, and its mechanism for lifting the inking-rollers from the stone and inking-table, substantially as described and specified.

3. The combination of the sheet-flier with an impression-cylinder without tapes, and a receiving-cylinder, provided with both gripers and cords or tapes, substantially as described and specified.

Center for Polar and Scientific Archives, National Archives and Records Service, Washington, D.C.

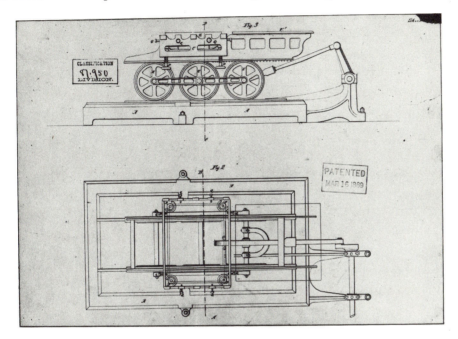

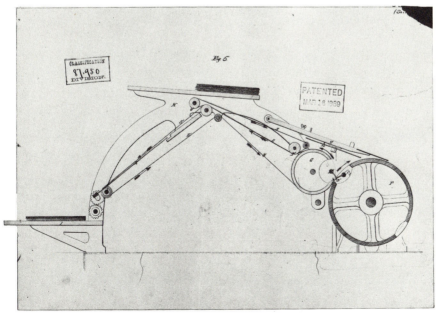

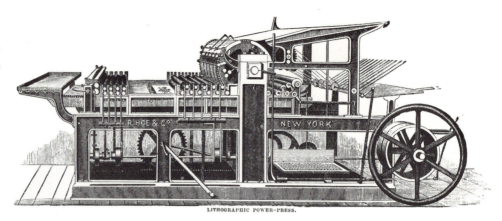

LITHOGRAPHIC POWER-PRESS.

presses, as well as others, in fact printed at a much slower rate. A Strobridge efficiency committee reported in 1877: "A thorough examination into the work of the [Hoe] steam presses places the average number of impressions for each daily at 2600, so that the average cost of each impression to insure a fair profit will be 1½ cts, varying from 1 to 2 cents."[87] Like most of its competition's machines, which came with several practical attachments, the Hoe press sported an automatic damping apparatus; a patented delivery cylinder, featuring tapes that took the sheets from the impression cylinder and transferred them to a self-acting fly, "with perfect certainty and without smutting"; a patented clamp that permitted the impression cylinder to stop "without jar and stand without tremor"; and—in case an image required extra printing—a bed that could be run "once, twice or three times to each impression."[88]

Steam Power and "Progress"

By the 1870s chromolithography was generally steam-powered. Advertisements for presses were replete with horsepower statistics, impressions-per-hour, and claims of easy maintenance. The lithographers themselves used "Steam Power" as proof of their modern business philosophy, printing it on trade cards and billheads and in newspaper ads; they even lettered it on the sides of their factories. The decennial government reports on manufacturing from 1870 to 1900 encouraged this attitude by reporting on total steam-power statistics for the industry,[89] and trade journals made steam appear more important than the lithography itself. City boosters, in their promotional literature and imaginative historical accounts, highlighted those lithographic firms with the greatest commitment to steam.[90]

Survival of Hand Presses

The advertising blurbs of chromolithographers have made it difficult to realize that steam power did not immediately drive hand presses out of the practical-lithography shops.[91] In the 1880s, for example, Hoe sold six different hand-press models (Figure 14), ranging modestly in price from $175 to $485. As late as the 1890s other manufacturers, too, still produced the reliable hand press: among these companies were Howard Iron Works, of

HAND LITHOGRAPHIC PRESS.

Buffalo, Kidder Press Manufacturing Company, of Boston, and H. P. Feister, of Philadelphia, who proclaimed that his "Bronstrup . . . Press is an old favorite of forty years' standing" (Figure 15).[92] Even into the twentieth century the hand press continued to be used, to proof lithographs before committing them to power. Between 1870 and 1890 most shops had both kinds of presses,[93] as they gradually made the transition from hand to the much more expensive steam. Statistics include P. S. Duval's count of 450 hand and only 30 steam presses in America in 1871, and in 1888 the Strobridge Company inventoried 17 steam presses against only 4 hand-operated ones.

With the transition from hand to steam came the metamorphosis of chromolithography from a handicraft to an industry. The relatively small runs of chromos in the 1850s and the technical difficulties of proper registration made the pre–Civil War chromo a hand-tooled object. By contrast, Louis Prang in 1868 used twelve steam machines to print his first-class *American Chromos*. An account in the *Commercial Bulletin* of Boston explained:

Prang Uses Steam

If we should say that out in Roxbury a twenty horse-power Corliss engine was turning out oil paintings at the rate of hundreds per day, the public would think that a modern Munchausen was writing this article;

Figure 15. H. P. Feister's
Bronstrup Lithographic
Hand Press. Source: Li-
thographers' Journal,
October 1891, p. 58.
Location: Division of
Graphic Arts, National
Museum of History and
Technology, Smithsoni-
an Institution, Washing-
ton, D.C.

but when we say that such an engine is turning out pictures so soft,
so spirited and so accurately reproduced, that the average observer can-
not distinguish them from oil paintings, we should be stating a simple
fact.[94]

And, apparently, by 1870 *all* of Prang's work was produced by steam.[95]

VII. Tariffs

Because in nineteenth-century America virtually all of the lithographic stones,
much of the ink, and many of the presses and papers—as well as numerous
prints themselves—were imported from Europe, tariffs play an important
role in the chromo story. The early import tariffs by and large omitted any
specific reference to lithography, but as of the late 1870s the United States was
in real competition with Europe, so that American lithographers lobbied for
protective high rates on foreign prints and low duties on essential raw
materials.[96]

"Ad Valorem"
Duties
Most of the tariffs enacted from 1842 to 1909 charged an "ad valorem"
duty on lithographs and lithographic equipment. The Walker Tariff, of
1846, first defined its use of ad valorem, and the concept was sharpened by

an amendment in 1851:[97] "The actual market value or wholesale price there-of, at the time of exportation to the United States, in the principal markets of the country from which exported . . . including the value of all cartons [etc.] . . . and all other costs, charges and expenses incident to placing the merchandise in condition, packed ready for shipment to the United States. . . ."[98]

Stones without images ("not engraved," in tariff terms) were placed on the free list in 1872 because Americans had no way of producing them at home; the Solenhofen quarries were a natural monopoly.[99] Before 1872 lithographic stones do not appear on tariff schedules, meaning that they were probably taxed according to the general duty: twenty percent ad valorem from 1842 to 1857, fifteen percent from 1857 to the early 1860s, then back up to twenty percent. For example, a bill of lading from James McGuigan, of Philadelphia, notes that "eight cases lithographers stones," processed at the port of Philadelphia in April 1867, entered at the general duty of twenty percent ad valorem. If, however, the stones came with images already prepared on the surface, the law was far different. Until 1862 they were taxed the general duty, and then until 1909 the ad-valorem rate of twenty-five percent was assessed. In 1909 the rate was doubled.[100]

Blank Stones Tariff-Free after 1872

Domestic inks, colors, and varnishes were also protected by the tariffs enacted between 1842 and 1909. The ad-valorem rates ranged from twenty-five to thirty percent, although some tariffs levied duty by weight or volume.[101] The purpose of these high rates was, of course, to encourage the development of American industries.

Inks

The foreign lithographic prints themselves were taxed during the entire chromo period: twenty percent ad valorem from 1842 to 1846, ten percent from 1846 to 1862, twenty percent from 1862 to 1864, twenty-five percent from 1864 to 1872, ninety percent of twenty-five percent from 1872 to 1876, and twenty-five percent from 1876 to 1890.[102] The tariff of 1890 refined the general term "all printed matter," under which unbound lithographs were usually classified,[103] and raised the duty by ten percent: "lithographic prints from either stone or zinc . . . and all articles produced either in whole or in part by lithographic process . . . thirty-five per centum ad valorem."[104] The revised definition and higher tariff reflected the work of the newly formed National Lithographers' Association, whose stated purpose was "to cultivate, by personal intercourse, a closer acquaintance, and by such an act, endeavor to overcome the abnormal conditions that have been a detrimental feature of the lithographic business in the United States."[105] The tariffs of 1894 and 1897 were even more precise and favorable to the industry.[106]

Prints

National Lithographers' Association

Throughout the chromo period there were some foreign lithographs that were imported duty-free. The tariff of 1909 clearly defined the category: ". . . lithographic prints . . . specially imported . . . not more than two copies

Some Prints Duty-Free

in any one invoice, in good faith, for the use and by order of any institution incorporated or established solely for religious, philosophical, education, scientific, or literary purposes, or for the encouragement of the fine arts . . . in the United States . . . and not for sale. . . ."[107] Less explicit but granting essentially the same exemption were all the tariffs from 1872 to 1909.[108]

At the end of the century lithographs to be used as samples by salesmen were also imported duty-free. "Various samples of litho printed . . . of no value" appears on numerous bills of lading of the 1890s, although the tariff laws were silent. Presumably, if the pictures had not been bought they had no value; hence, there was no ad-valorem figure to tax.[109]

Presses Printing presses are not specified until the tariff of 1909 (thirty percent ad valorem),[110] but they were covered by a clause dating from 1842. The wording varies from tariff to tariff, but in most cases it reads much like the tariff of 1897: "Articles . . . not specially provided for in this Act, composed wholly or in part of iron, steel, lead, copper, nickel, pewter, zinc, gold, silver, platinum, aluminum or other metal, and whether partly or wholly manufactured, forty-five per centum ad valorem."[111] From 1842 to 1857 it was thirty percent ad valorem; 1857 to 1861, twenty-four percent; 1861 to 1862, thirty percent; 1862 to 1872, thirty-five percent; 1872 to 1876, ninety percent of thirty-five percent; 1876 to 1894, forty-five percent; and 1894 to 1897, thirty-five percent.[112]

Duty-Free Equipment Finally, a little-known law permitted immigrant lithographers to bring into the country their own tools and other equipment duty-free, although the exemption did not include "machinery or other articles imported for use in any manufacturing establishment."[113] This appears to mean that foreigners could bring enough materials into the United States to work in an established shop, but not enough to set up their own businesses.

Rise of High Tariffs The tariff was a major concern of printers in the early 1890s, when foreign competition appeared invincible. The *Lithographers' Journal* called for protective rates against "increased competition of foreign manufacturers,"[114] while petitions to both the Senate and House were sent by workers "depending on the lithograph business for a living."[115] Julius Bien, president of the National Lithographers' Association, blamed the economic slump of the early nineties on the atmosphere "of distrust and fear for the future, owing to a renewed agitation of the tariff question."[116] Lithographers debated the merits of specific versus ad-valorem duties,[117] and in March of 1894 they sent Congress a proposed schedule of tariff rates, which came to make up most of the lithographic duties in the laws of 1897 and 1909.[118]

It was estimated that at least three quarters of the lithographic businesses in America were formally involved in lobbying for a high tariff. There was, however, a conspicuous minority, and the famous Louis Prang was among *Louis Prang: Free Trade* them. His belief in free enterprise and free trade must have seemed suicidal

to fellow lithographers, but he was adamant: "I fully and honestly believe that an entire abolition of every shred of tariff on importation would . . . revive general business in this country within six months to such an extent that with all possible competition from abroad a comfortable share of trade would turn my way, so that I could welcome the people at large to all the benefits to be derived from the products of my foreign competitors."[119] Smack in the face of massed opposition Prang argued that high tariffs devalued the dollar, raised the price of imported raw materials, and caused economic retaliation throughout the world. He also insisted that while American labor was much more expensive than European, it was characterized by "superior energy, ingenuity and pluck. . . ."[120] This old German forty-eighter was ready to fight for his adopted fatherland:

> We must rise to the height of our greatness as American citizens! We are giants annoyed by pygmies irritating us with straws. Instead of trying to protect ourselves by shielding . . . it would become us to discard all encumbering . . . protection and to stand forth in our full gigantic stature, determined to conquer the world by the power of faith in justice, in humanity, and in our own strength.[121]

It was one of the few battles that Louis Prang ever lost.

6

LOUIS PRANG:
PRAGMATIC IDEALIST

LOUIS PRANG (1824–1909) became rich on chromolithography. But in achieving the American dream he also served to advance the budding cause of art in the United States. He recognized and patronized American artists and he devoted his life, in his work and his writings, to the concept of art for all, as embodied by the chromolithograph.

I. Forgotten Patron of Contemporary American Art

In February of 1892 Louis Prang, in closing his career, auctioned more than 440 paintings. According to the catalogue, "all schools of American art" were represented. The selection of watercolors was particularly rich, comprising a "complete exposition of the progress and development of American watercolor art, illustrated by the ablest work of the ablest masters of aquarelle."[1] Held at the American Art Galleries, in New York (6 East Twenty-third Street), the sale included works of Alfred Thompson Bricher, John G. Brown, Benjamin Champney, Asher Brown Durand, Martin J. Heade, Thomas Hill, Eastman Johnson, John Ross Key, Thomas Moran, A. F. Tait, and seventy-five others, both American and European. It was the third of four auctions Prang held during his career. The earliest, in 1870, had included at least 150 paintings; the second, in 1875, was made up of 205; and the fourth, held in 1899, was a clearance sale of 1,515 pictures, including small oils and watercolors for calendars, valentines, and general designs. This last auction, conducted in Prang's city of Boston, at Copley Hall, featured three watercolors by Winslow Homer: *Eastern Shore*, *North Woods*, and *Blue Point Oysters*.

In buying and employing the works of these many painters, Louis Prang served as a leading patron of contemporary American art. Between 1882 and 1892 it was estimated by the *Lithographers' Journal* that he had paid out to

artists "who have originated the subjects of his works, upwards of $500,000 in cash."[2] This sum was made up of small and moderate prices. Thomas Hill's *Birthplace of Whittier* brought $225 at Prang's 1870 auction, while Eastman Johnson's *Boyhood of Lincoln* was purchased for $700 and his *Barefoot Boy* for $420. Other prices at the first sale included $375 for John G. Brown's *Queen of the Woods,* $305 for his *Little Bo-Peep,* and $105 for his *Playing Mother;* $550 for Thomas Hill's *Yosemite Valley;* and $140 for A. F. Tait's *Group of Chickens* and $65 for his *Group of Ducklings.* As these figures add up to only $2,885,[3] the monumental volume of Prang's purchases can well be imagined.

The paintings were bought by Prang for many purposes: large hanging chromolithographs, business-card decorations, greeting cards, book illustrations—in most cases, Prang purchased a picture for a specific use. As owner of the original he could copyright the chromo made from it without paying royalties to the artist[4] and at the same time protect himself from plagiarism by competing artists and lithographers. *Use of Paintings*

Once a picture was copyrighted, not only were other lithographers forbidden to reproduce it, but the original artist, too, had to watch himself. If an artist sold a picture to a chromolithographer or publisher who then copyrighted it, the artist, obviously, could neither sell it to another printer, nor reproduce his own design. Frederick Stuart Church must have had this on his mind when he wrote on May 8, 1886: *Copyright Protection*

> Dear Mr. Prang
> In the Prize Exhibition just opened . . . I have a little oil painting 14 × 16 entitled *The Enchanted Monarch.* Representing a sorceress with wand in her hand and a lion looking up in her face. The picture is copyrighted. I had no idea of publishing it [,] only selling it as a picture.
> . . . [It] occurred to me that you might see it and think perhaps I was infringing somewhat on the *Lion in Love*—and so I write. It is not the same in composition or color although similar in subject—*and I will not allow any publication of same,* but I want you to be perfectly satisfied of this fact which only occurred to me the other day.[5]

Louis Prang viewed painting and chromolithography as allies. His philosophy about their relationship was clear: "Chromolithography is in itself an art to *reproduce, to imitate, not to create* . . . [it is] for the painter what the type is for the writer,—it is the brush and the pallet [*sic*] of the nineteenth century."[6] His craft was the "Handmaiden of Painting." Writing in the late 1880s or early '90s, he observed: "there are a number of artists whose work I cannot obtain for reproduction, they fearing the influence upon their sales. My experience tells me that the versatile artist has nothing to fear by *Prang's Philosophy*

reproduction, to the contrary it will bring his name and his work before the public and make him popular." [7]

II. In Praise of Louis Prang

The Aldine

Louis Prang received his share of negative criticism, but of all the chromo-lithographers in America, he also received the best reviews. Early in his career, for example, the elegent *The Aldine*—a journal devoted to typographic art, featuring lavish pages measuring 19¼ by 13¼ inches—made Prang a hero of the common man:

> If chromo-lithography is not an art, it is in one sense better, since it goes where pure Art cannot go, [into] . . . popular aesthetic culture, which the latter could never accomplish. . . . Mr. Prang has made possession [of art] an easy sequence of desire. For ten dollars the working man may glorify his house with one of Correggio's masterpieces; for the same sum he may delight his eyes and his soul with the harmonious richness of Bierstadt's "Sunset in California;" he may warm his patriotism and feed his ambition by contemplating "The Boyhood of Lincoln;" or he may renew his youth in gazing on the inimitable portrait of Whittier's "Bare-foot Boy." [8]

James Parton

Historian and journalist James Parton, writing in *The Atlantic Monthly* of March 1869, called Prang a major force in the popularization of art in America. "The art of chromolithography," noted Parton, "harmonizes well with the special work of America at the present moment, which is not to create, but to diffuse; not to produce literature, but to distribute the spelling-book; not to add to the world's treasures of art, but to educate the mass of mankind to an intelligent enjoyment of those we already possess."

During the 1890s Prang was regarded as the dean of his craft, the intrepid pioneer who had discovered and tamed a wilderness in his own lifetime. [9] Heralded as a taste maker, a mechanical genius, and an intuitive business-man with a nose for the future, he was the first to be featured in the "Prominent Art Lithographers" column of the *Lithographers' Journal*. In the January 1892 issue the editor chanted his praise:

> From the outset of his publishing career, Mr. Prang has been a leader. Not alone, or simply, as a business man of sagacity, a worker of dis-criminating enterprise and tremendous energy, but equally as an origi-nator and pioneer in the paths he has chosen to tread. Conscientiousness has been a distinctive feature in all his efforts, and, although he has be-

come a man of wealth, riches of this sort were never in any sense for him a chief end or aim. The true artistic ideal has always been present with him, as the ruling incentive in his work, and the results of his labors in every respect justify this assertion.

III. L. Prang and Company

Like Julius Bien and so many other German-American chromolithographers, Louis Prang was pushed to America by the reactionary forces following the European revolutions of 1848. According to an autobiographical account, written in pencil, Prang was a political activist and the leader of one of the "so called Democratic Clubs, in Herschberg, Silesia." As he remembered that time, *Forty-eighter*

> This was an era of ideals for me, I [wished] to wrench freedom for a nation hungrey [sic] for it, but found soon that the world was not of one mind, and that there were too many satisfied with conditions as they were and ready to march against us idealists and to prepare for us a chance for contemplation behind prison bars. Conquered, I left with many others in the same predicerment [sic] to seek safety in other lands.

A two-year odyssey ensued. Prang traveled south to Bohemia, ending up in Prague, on to Zurich, and finally sailed from Le Havre on February 28, 1850, for America.[10]

Twenty-six and eager for work, he arrived in New York City on April 5, 1850, and headed for Boston. For the next six years he moved from job to job. He worked as a publisher of architectural books, teaching himself to draw on stone, then as a manufacturer of fine moroccowork and fancy boxes for jewelry, then as a self-taught wood engraver, and finally, in 1856, as a lithographic printer and publisher. This varied background better prepared him for his eventual success than he realized at the time. *Prang's Arrival in United States*

Prang's education in Germany had given him a sound base from which to spring. His father was part owner and manager of a calico-printing house at Breslau, and he trained his son in the physical sciences and their practical applications. By his eighteenth birthday Louis had mastered the principles of chemistry, particularly as they related to the cotton industry—bleaching, color mixing, and dyeing—as well as the designing and engraving of printing plates and the techniques of printing. He then worked as a trainee in a large mercantile firm, learning the rudiments of commercial life. This was followed by a four-year tour throughout Europe to study the best methods of calico printing. He also learned to speak English and French. *German Training*

On the eve of the revolutions of 1848, Prang's training was complete. He understood the calico business as an art, a technology, and a commercial enterprise, having studied the accountant's book, the chemist's laboratory, the printer's ink bucket, and the common laborer's toil.

Prang applied his German-craftsman's knowledge to his new-found American trade as a lithographer. Together with his partner, Julius Mayer,[11] he began to produce chromolithographs sometime in 1856–57,[12] but where he learned the skills of this art is unknown. Prang later wrote that at that time he was an absolute "stranger to the work," although in the same context he described himself as "Stonegrinder, Draftsman, Bookkeeper and Financial man all in one."[13]

From one hand-operated press and a few stones in 1856, the business grew, as in all good nineteenth-century success stories, to seven presses in 1860, to a "printory," or print factory, built in 1867 to contain fifty presses.[14] It was in 1860 that Prang bought out Mayer and renamed the firm L. Prang and Company. The change was completed by the start of the Civil War, which called for a whole new line of products. Instead of chromos for ladies' magazines, maps of battle sites, such as the "Harbor of Charleston with Fort Sumter," were clamored for, as well as simple monochromatic lithographs showing scenes of army life and portraits of Union officers.[15] Only gradually, wrote Prang, could "I . . . return again to my old love—the printing in color. Album cards representing Birds, Butterflies, flowers, autumn leaves headed the list, followed by larger work of similar subjects, decorative and otherwise—until 1865 I reached the ideal work which I never lost sight of, the reproduction of oil and water color paintings."[16]

L. Prang and Company

Prang's repertoire of chromolithographs was extensive. His world-famous fine-art reproductions ran from Robert D. Wilkie's still lifes, landscapes, genre scenes, and a series of Yosemite Valley views apparently based on photographs by Carleton E. Watkins[17] to the work of one of the original Hudson River painters, Asher Brown Durand, whose *An Old Man's Reminiscences* was the model for one of Prang's largest landscape chromos, which measured 21½ by 32½ inches.[18] And beyond this range of beauty, Prang tilled numerous fields. In fact, his long-run financial success never rested on large reproductions, but rather on smaller, less pretentious pieces.

Reproductions

Album cards, for example, were a mainstay of his business from the middle of the Civil War into the eighties. They were not attempts at oil or water-color reproductions, but simple designs of what Prang referred to as "great sweetness."[19] They were "beautiful art bits," in Prang's words, used by businessmen as calling cards or pasted in albums by women and children, or mailed from one person to another as gestures of friendship.[20] Their popularity, according to Prang, skyrocketed after he distributed "twenty or thirty thousand floral business cards" at the Vienna International Exhibition in

Album Cards

1873.[21] "These cards pleased so well," remembered Prang, "that after returning home I had to fill orders for other business houses, and I conceived the idea to print quite a variety of designs with blank spaces to receive the firm name of any one who would buy the blank cards by the hundred or thousand."[22] At about the same time many other lithographers began publishing these chromolithographic novelties. "All over the civilized world," noted Prang, practical-lithography firms "were built up on this particular production." Prang's claim of invention of the cards was false, but they did indeed become a fad. He was not exaggerating when he wrote: "Millions upon millions . . . of the most varied designs were thrown on the market and the mania among children for collections of these . . . helped to exhaust the supply. Hardly a business man in the country has not at one time or another made use of such cards to advertize his wares."

A second pillar of his business was erected when Prang entered the greeting-card field, in which he was to earn the title "Father of the American Christmas Card."[23] In the late 1860s Prang had printed Christmas chromos, to be hung on the wall. These pictures came in various sizes (11 by 27, 12 by 16, 8 by 22 inches) and carried a Christmas greeting.[24] According to Prang, it was Mrs. Arthur Ackermann, the wife of Prang's London agent, who suggested the idea of a card for Christmas,[25] and he published his first one in England, in 1873, the following year bringing one out in America.[26] These proved a bonanza for almost twenty years. By 1881 Prang was printing close to five million copies for a single Christmas season, as well as, in lesser amounts, cards for Easter and other holidays. One observer wrote: "Chromo cards have become so common that they are thrust upon the purchaser of the veriest trifle of dry goods or grocery."[27] Right from the start, Prang wrote, "I could not manufacture them fast enough. . . . From this time onward the Xmas card became the leading article of manufacture in my establishment."[28]

The early cards, usually 3½ by 2 inches, predominantly pictured flowers, with an occasional butterfly or robin's egg. Flowers eventually made way for children, snow scenes, penguins, and humorous animal pictures, as the cards grew in the 1880s to as large as 7 by 10 inches.[29] According to Prang, most of the designs were created by "trained artists who worked to my orders."[30] Augmenting the work of the hired designers were the entries in a series of public competitions Prang held in the 1880s, for which he offered prizes ranging from $200 to $1,000. The judges included such painters as John La Farge and Samuel Colman and the architects Stanford White and Richard Morris Hunt. When Elihu Vedder won the second competition, in 1881, the New York *Evening Post* quipped, "It is easy to see that art is advancing in this country, when Elihu Vedder makes our Christmas cards."[31] Third prize for the 1884 competition went to landscape painter Thomas Moran.

Greeting Cards

The big prizes, the famous judges, the celebrated winners, and Prang's pronouncements about the improvement of public taste added up to good advertising. As a means of generating great art, however, the competitions flopped. Looking at them with a cold eye, Prang reported that they "resulted in calling forth . . . very crude efforts."[32]

Prang's success did not go unchallenged. English and German chromolithographers entered the greeting-card market and beat Prang at his own game. After "3 or 4 years," he wrote, "the usual competition began to press in upon me." The foreign cards were cheaper. Prang noted: "the much higher wages for labor in our country . . . and the higher cost of raw material made it impossible to battle successfully against foreign competition in the same line."[33]

Prang's phrase "the usual competition" appears repeatedly in contemporary accounts. American printers would create a market, say, for album cards or Christmas greetings, and then foreign lithographers would steal the business with their low prices—or so went the wisdom of the day. This was particularly true for Louis Prang. "One after another he produced his specialties," wrote the *Lithographers' Journal* in 1892, "—war maps, colored album pictures, chromos, chromo business cards, Christmas cards, etc., each to be supplemented by some new creation, whenever the cheap competition from Europe—he never had any worth speaking of in America— required him to push into new fields of enterprise."[34] With prices higher than those of almost any other lithographer, he had to bank on novelty and quality for sales; when either was challenged he simply moved on.

Versatility
This ability to shift from one commercial field to another is one reason for Prang's reputation, and the *Lithographers' Journal* believed he had prescient powers. Prang, wrote the *Journal*, "employed thousands of dollars in anticipating the wants of coming decades, and making provision for demands which he must first educate communities to make." He knew his markets, both present and future. He went about his business without the aid of market-research reports or consumer-buying profiles. He relied on his judgment as "implicitly as though such a thing as failure to rightly apprehend the popular mind and instincts was among the impossibilities; he trusted the people and the people endorsed his actions, as his business so conspicuously shows."[35] Even Prang's risky ventures seemed to turn a profit, and his success was the model and envy of everyone.

Book Illustrations
As an example of Prang's good business sense, during his career he printed the color plates for numerous publications, some of which are now classics. Among these are A. C. Hamlin's *The Tourmaline* (1873), G. T. Lau's *Greek Vases: Their System of Form and Decoration* (1879), Clement C. Moore's *A Visit from St. Nicholas* (1864), Charles S. Pratt's *Babies' Lullaby Book* (1888), and the monumental *W. T. Walters Collection of Oriental Ceramic*

Art, featuring 116 chromos that were rated by collector-historian Whitman Bennett as comparable to the very finest European work.[36]

Prang also published, in 1871, a little-known book by the German-born artist-lithographer Theodore Kaufmann, entitled *Kaufmann's American Painting Book: The Art of Painting or of Imitating the Effects of Color in Nature.* Dedicated to William Wilson Corcoran, the art patron who had recently opened his free gallery in Washington, D.C., the book contained seven chromos and five monochromatic lithographs designed "to reduce to a few principles . . . the effects of color, as seen in all the inexhaustible variety of nature." In 1876 Prang published, complete with chromo plates, Sylvester Koehler's translation of Wilhelm von Bezold's advanced *Theory of Color* and in 1879 he produced Jakob von Falke's *Art in the House,* a work that Prang himself probably had not read, as it cautioned readers not to buy chromolithographs![37]

Art education at the elementary- and high-school level also occupied an enormous amount of Prang's energy. Beginning in the 1870s and continuing through the '90s, a myriad of drawing-book titles emerged from Prang's plant, in the Boston district of Roxbury.[38]

IV. The Development of Prang's Chromos

Today Prang's reputation rests on his fine-art chromos. He himself observed in the final decade of his career: "I have succeeded to raise the standard of . . . public taste and public appreciation for the beautiful."[39] In his advertisements and personal writings he hammered at the theme, and the effect of his publication of chromolithographs of original paintings was a renaissance of popular culture.

Prang's pursuit of the democratic art began in 1864 with a trip to various lithographic firms in Europe. He aimed on that tour to discover the latest technology and to lure at least one skillful technician back to Boston. He succeeded. The Englishman William Harring, "an all round artist in lithography," as Prang described him in his unpublished autobiography, produced Prang's first chromo copy of a painting. This was in 1865, when Harring drew the separate color plates for two of Alfred Thompson Bricher's landscapes. (The frontispiece of this book shows progressive proofs for Bricher's "Spring.") Printed in oil colors, varnished, and embossed to give the appearance of paint on canvas, they were priced at an extraordinarily high six dollars. At first, they did not sell. As Prang recounted more than twenty years later, "The picture dealers pronounced them too costly for the American picture buyer. . . . I was importuned by my salesmen to stop the experiment of producing high cost prints, nothing over 50¢ would sell."[40]

Hires William Harring

Plate 61.

Plate 62.
A. F. Tait and
Prang's First
Chromo Success

Harring then went to work on A. F. Tait's *Group of Chickens*. The chromo appeared in 1866: "Success," wrote Prang; "$5.00 was not thought too high to gratify a desire for a good picture to decorate a bare wall and to make a living room more cozy." The *New York Daily Tribune* called the "Chickens" chromo a "clever little picture. . . . We shall not quarrel with him [Prang] as to methods of interesting people in art. He has our cordial thanks for what he has already done, and our trust that he will do his best to educate the class he works for in the love of what is true and beautiful."[41] During two years thirty thousand copies of this print were distributed,[42] Tait receiving ten percent of the sales, with a two-year renewable contract.[43] Moreover, as Prang recorded, once the buyers accepted this latest chromo, the earlier Bricher "landscapes which had previously fallen flat on the public were sought for, it was a revelation to the trade . . .—everything sold."[44]

Tait's Appeal

Harring's technical competence alone could not account for these phenomenal sales. The right subject and a certain style were needed to win popular acceptance, and the painter Arthur Fitzwilliam Tait (1819–1905) was a happy choice for Prang. Already well known to the public eye through numerous hand-colored lithographs, printed and published by several companies, including Nathaniel Currier and Currier and Ives, Tait's images were proven sales items.[45] More important, Tait's pictures were ideally suited to chromolithography: his colors were strong and pure, and he seldom employed color overlap or blending. One reason for this was that, back in his native England, Tait had been trained as a lithographer. His English lithographs from the 1830s and '40s had focused on architectural subjects, although in 1842—still in England—he drew on stone a picture of a bull for *Agnew's Repository of the Arts;* this, according to one account, was probably his first "animal commission,"[46] subject matter that was to make his fame. He then worked on other lithographic projects until 1850, when he emigrated to the United States.[47] While he did not publish a lithograph on his own after 1850, Tait's paintings, as of 1852, became standard fare for America's two most successful lithographic companies, Currier and Ives and L. Prang.

In addition to being easily reproduced, Tait's paintings contain elements that were to make the works of Norman Rockwell and Walt Disney twentieth-century best sellers. First, Tait's pictures have an intense realism: the artist does not exist—just the event. The story, complete in every detail, stands before our eyes. Secondly, his animals—particularly his ducks, quail, chickens, and deer—evoke a tender reaction. Tait rarely challenges his viewer, preferring instead to present a scene that is at once sympathetic, sentimental, and blissful.[48]

Range of
Prang Chromos

"Group of Chickens" marked the real beginning of Prang's career in the democratic art. From that first success in 1866 until 1897, Prang published

approximately eight hundred chromolithographic copies of oil paintings and watercolors. His most expensive color lithographs, generally printed from twenty or more stones, he called "chromos," while the prints made from fewer plates were tagged "half chromos." As part of his promotion, he published his philosophy, his inventory, and his prices in a short-lived (1868–69) quarterly entitled *Prang's Chromo: A Journal of Popular Art* ("Mailed Free to any address"). The publication carried blurbs from such personages as James Parton, Harriet Beecher Stowe, Henry Wadsworth Longfellow, Frederic E. Church, John Greenleaf Whittier, Wendell Phillips, Edward Everett Hale, and Louisa May Alcott, and when newspapers wrote favorable reviews Prang published those, too. His journal offered "Hints on Framing" and popularized accounts of the chromolithographic technology. The inventory in his Christmas 1868 issue included *Prang's American Chromos*, which ranged in size from 4½ by 9 inches to 23¾ by 15¾ inches, and in price from $1.50 to $15.00.[49] The popularity of these prints was so great that other lithographers and dealers imitated not only Prang's artistic style, but also his public-relations rhetoric. When in 1873 a lithograph of Yosemite Valley was published by Philadelphia's Joseph Hoover, it was advertised as part of *Hoover's American Chromos* series.[50]

Prang's American Chromos

The *American Chromos* became a symbol of Prang's firm. Although he produced all kinds of lithographic work, in the popular mind *American Chromo* meant L. Prang and Company—and "Prang" meant "chromo." Shortly after the "Chickens" appeared, *The Nation* reported (January 10, 1867) that Prang probably did a much larger business in fine chromos than any other American firm, and that the prints were sold nationally, being "as common in Chicago as in Boston."

By the end of 1868, *Prang's American Chromos* numbered forty-six. These were full chromos, primarily of American subjects and intended to be framed. The series did not comprise all of Prang's work, but it included his most famous pieces. The list grew until by the time of the Centennial Exposition it contained more than a hundred color lithographs. Landscapes were a major item, as were genre scenes and animals, but Prang was also interested in portraiture.

Like Strobridge, of Cincinnati, who began the chromo business during the Civil War with "oil portraits," Prang issued small cards carrying images of officers from both the North and the South, Cabinet officials, Senators, Presidents, and wives of famous men, as well as miscellaneous figures. The 1871 catalogue contains 120 different cards. There were also large chromos of such celebrities as George and Martha Washington, Abraham Lincoln, Charles Sumner, Ulysses S. Grant, and Henry Ward Beecher, which usually came in two sizes, 28 by 22 inches and 19 by 14, and cost from $3 to $20.[51] All were respectable and some were dazzling.

Portraits

Plate 63.

Plate 64. Two of the most spectacular of the large Prang portraits were issued in 1870. One was of Hiram R. Revels, the first black United States Senator, drawn by Theodore Kaufmann. It was widely publicized as an "exact imitation of an Oil Painting, and hardly to be distinguished from it,"[52] and Prang made it news. Writing in September 1870, he noted the irony of Revels's holding the seat previously occupied by Jefferson Davis, and then pointed out that the "excellent full chromo" filled a great national want, "grown partly out of admiration, partly out of curiosity."[53] He also sent a copy of the chromo to Frederick Douglass, who responded with some poignant observations.

Frederick Douglass Comments Douglass wrote that the chromo "strikes me as a faithful representation of the man," and that it was not demeaning. "We colored men so often see ourselves described and painted as monkeys, that we think it a great piece of good fortune to find an exception to this general rule."[54] Douglass went on to discuss how the democratic art was for blacks as well as whites: "Heretofore, colored Americans have thought little of adorning their parlors with pictures.... Pictures come not with slavery and oppression and destitution, but with liberty, fair play, leisure, and refinement. These conditions are now possible to colored American citizens, and I think the walls of their houses will soon begin to bear evidence of their altered relations to the people about them."[55]

Plate 65. The second striking Prang portrait of 1870 was chromolithographed in honor of the hundredth anniversary of the birth of Ludwig van Beethoven. The reproduction of a painting by Ferdinand Schimon at the Royal Library in Berlin, the chromo was "certified ... a *fac-simile* of the original." It came in two sizes, 23¾ by 18 inches and 14 by 11, costing respectively $20 and $5.

European Reproductions Prang had reproduced other European paintings both before and after the Beethoven portrait. These included Correggio's *Reading Magdalen*,[56] Joseph Cooman's *A Family Scene in Pompeii* and *The Roman Beauty*,[57] C. Spitzweg's *Sunny Day* and *Golden Evening*,[58] Adolphe William Bouguereau's *The Baby*,[59] Alphonse Mucha's *Rêverie du Soir* and *Éclat du Jour*,[60] and Arturo Moradei's *La Primavera*.[61] While they never dominated Prang's list, the European images lent breadth and a sophisticated tone to his offerings.

In addition to this variegated subject matter, during the 1870s and '80s Prang chromolithographed Civil War scenes by the Americans Thure de Thulstrup,[62] Julian O. Davidson,[63] and Julian Scott;[64] sporting scenes by Henry Sandham;[65] and many advertisements and novelties. He seemed willing to give almost any kind of sentimental, heroic, or novel image a try.

V. Prang's Critics

It is easy to be swept away by Prang's rhetoric, his infectious optimism, his extraordinary promotional blurbs—parroted so frequently by the press—but it is important to remember that he faced a continuous blast of criticism. Before examining Prang's landscapes and his "dining room" chromos, it will be good for our perspective to listen to his critics.

One of the loudest was E. L. Godkin, editor of *The Nation,* who believed that the only use for chromolithography was as an aid to the industrial arts. He cited as the perfect example Owen Jones's masterful book, *Grammar of Ornament,* in which the chromos were employed to represent the decorative arts. The reproduction of A. F. Tait's *Group of Chickens* was just the kind of chromo Godkin hated. He wrote in 1867: "One thing only, quite unnecessary and quite inexcusable, throws discredit on the whole matter and makes the pictures merely merchandise . . . [they] are made to look like oil-paintings on canvas, by printing them all over with indented lines to imitate the effect of the threads of the canvas, and by giving them a varnished surface."[66] The Tait chromo was condemned for its lack of subtlety: there was no "brilliancy or purity or noticeable softness of color." This flaw was intrinsic, *The Nation* asserted, to the technology of chromolithography. "Good color, that is, delicately gradated color, is not to be produced by the printing press." To the question "Will not the art become so much improved that such pictures will be good?" the answer was blunt: "What the brush of a skilful painter does at every touch in gradating, softening, and blending tints, leading one color into another, breaking one color over another, until there cannot be found two grains of color the size of a pin's head that shall be really the same; this is beyond the reach of any mechanical contrivance."[67]

Until Godkin's statement about the technical limitations of lithography was published, in 1876, popular wisdom in this country had supported a more generous point of view. In 1850 the engraver John Sartain wrote that the success of the chromo would "depend . . . on the skill of the operator; on his degree of acquaintance with those laws which govern the harmonic relations of one colour to another and as modified by either *light* or shadow. . . ."[68] But the influential *Nation* closed the door on hope. Taking the position of John Ruskin, who throughout most of his life (1819–1900) believed that all chromos should be burned, *The Nation* damned Prang's work with the opinion that anyone "who enjoys these chromos and wants to study art to purpose, may begin when he has put them well out of his sight."[69]

Prang looked about for allies. He tried converting the art critic Russell Sturgis by sending him several samples of chromos. Politely and succinctly, Sturgis put the Boston taste maker in his place:

E. L. Godkin and The Nation

John Ruskin

Russell Sturgis

I should not be willing to hang up any American chromolithograph that I have seen, for, seeking to give color, it does not give it well. . . . I do not deny that your chromos are capable of doing good, by leading people slowly on to better things. But they will do this good only as people find out that there may be better things. If people believe that these chromos are as good as original paintings, & that, as they stand, they are in themselves pictures of great merit, more harm will come of your labors than good.[70]

Coming just when Prang was putting his business into high production, the barbs of Sturgis and *The Nation* stung.[71] In the late 1880s and the '90s Prang still looked back in anger, writing in his autobiography, "my work was sharply criticized . . . as mischievous in the extreme. The people were misled into the belief of buying real art works, their taste was led into a wrong direction, they were made accustomed to accept them in place of the real."

The People and the Intellectuals

But Prang countered: "The people were on my side."[72] From the publication of the very first picture in *Prang's American Chromos* one fact stood out: the chromo civilization was a time of divergence in taste between the broad middle class, which supported the burgeoning chromo industry, and the intellectual connoisseurs, who told the people not to waste their money on trash. This dichotomy is explored in chapter thirteen.

BUNDLES OF
NATURAL WONDERMENT

I. Prang and <u>The Yellowstone</u>

When *The Times* of London reviewed Louis Prang's fifteen chromolithographs for F. V. Hayden's folio-book *The Yellowstone National Park,* in 1875, it gasped in admiration: "no finer specimens of chromo-lithographic work have been produced anywhere."[1] Each chromo was a reproduction of a watercolor by Thomas Moran, who had accompanied the geologist Ferdinand Vandeveer Hayden on a U.S.-government exploring expedition to the Yellowstone Valley in 1871.[2] Hayden, too, was ecstatic. Although photographs and drawings in books and magazines had to some extent publicized the Western scenery, such pictures were generally black and white, which to Hayden's mind was like watching "Hamlet with the part of Hamlet omitted."[3] Color on a grand scale was the essence of Yellowstone, and Moran and Prang both worked to express it. They succeeded so completely that Hayden warned: "So strange, indeed, are the freaks of color which nature indulges in habitually in this wonderful country, that it will no doubt require strong faith on the part of the reader in the truthfulness of both artist and writer to enable him unhesitatingly to accept the statements made in the present volume by the pen as well as by the brush."[4]

Prang had begun to produce the Moran chromos in about 1874, and they appeared as a full folio in 1876. One thousand sets were printed and sold, for sixty dollars each.[5] According to Hayden, L. Prang and Company had, of its "own accord and . . . risk, determined to carry out" the project.[6] It was one of Prang's finest works and Hayden rightfully saw it as a magnificent American achievement. He anticipated *The Times* when he wrote, "It is a just subject for national pride to see a work of this character, which takes equal rank with anything of the kind ever undertaken in Europe, produced wholly on American soil."[7]

II. Thomas Moran

Thomas Moran was born in Bolton, England, in 1837 and he emigrated to America with his family in 1844. Beginning as a wood engraver's apprentice in Philadelphia,[8] he produced throughout the 1860s, '70s, and '80s an extraordinarily broad range of works: designs for wood engravings, large dramatic oil paintings, small quiet watercolors, and delicate etchings. He was regarded as a superb printer of etchings, a skillful technician, an "experimentalist."[9] And, like his fellow Englishman A. F. Tait, who also worked for Prang, Thomas Moran was an accomplished lithographer. Two prints done in 1868–69 put him at the top of the list of artist-printmakers: "Solitude," printed by James McGuigan, of Philadelphia, is black and white with a full spectrum of grays, and the "South Shore of Lake Superior" has been described as strong and picturesque; Moran rated it his finest.[10] Thus when Prang wrote to Moran in 1873, asking him to paint "12 or more watercolor pictures of the Yellowstone country," he was dealing with an artist who understood the nature of lithography and the peculiar problems involved in reproducing original paintings.

The two men had met before, and Moran was not honored by Prang's attention. On December 22, 1873, Moran wrote: "In reply I would intimate that my previous transaction with you in a similar business was anything but satisfactory to me inasmuch as I made to your order three illustrations from American poets for which you were to pay me $75. When I sent them to you, you returned them merely saying that you had concluded that the publication of the work would prove too expensive."[11] Prang mended the relationship, however, and Moran fell to work making the watercolors.

Whether Prang gave instructions to Moran regarding the Yellowstone subject matter is not known, but the two had obviously reached some sort of agreement, for in a letter of November 8, 1874, Moran referred to peaks and chasms as though Prang had been an original member of the exploring party: "Since you were here I have made but one drawing of the series. . . . I have the designs ready to work on of Donner Lake, Twin Lake, Pikes Peak, Summit of the Sierras, Great Salt Lake & the Azure Cliffs of Colorado. Will send on two the latter part of this or the beginning of next week."[12] Moran's use of the word "designs" should be noted: it indicates his painting technique, which was ideal for chromolithography. The initial Moran sketches often look like a chromolithographer's key plate, with colors written inside the pencil drawings, similar to a paint-by-numbers picture before the colors have been applied. By isolating reds and blues and greens, Moran structured a painting that could be easily taken apart and reassembled to resemble the original.

Plate 66.

While Moran's large oils, such as *The Grand Canyon of the Yellowstone,*

are bold, dramatic gestures, his Prang watercolors are tight and understated. The *Lower Yellowstone Range* is composed of light blues, light browns, and tans, accented in the foreground with darker areas of brown, blue, and green; the effect is a balance of dark and light, a counterpointing of the heavy mass of the mountains and the buoyancy of the delicate colors and the other-worldly atmosphere.[13] One also senses a play between sketchy, nervous lines and the colors that the lines often circumscribe. There is in this painting a meticulous attention to detail, a feeling that Moran is replacing geological survey with artistic documentary. Yet the portrayal is not coldly analytical, for Moran conveys an awe, which communicated to Americans the natural wonder that they possessed in Yellowstone. As H. M. Chittenden wrote in 1900, "They [the paintings] did a work which no other agency could do and doubtless convinced everyone who saw them that the regions where such wonders existed should be carefully preserved to the people forever."[14]

In Moran's watercolors, then, there is a synthesis of high art, documentation of nature, and propaganda, presented in a form that chromolithographers could understand. Prang certainly understood it. The product of Moran's style combined with Prang's expertise caused the Boston lithographer's head to swell to the extreme: "All our Chromos are fac-similes of oil or watercolor paintings by the best artists, in most cases equal to the originals."[15]

III. A Question of Accuracy

The intellectual debate surrounding the chromo's social value involved many issues, not the least of which was the precision of reproduction. Accuracy of detail has always been a popular strain in the American taste. John Trumbull discovered this preference when the public objected to his elimination of factual details from his Revolutionary War paintings, and more than one nineteenth-century American artist packed his or her bags for England, Italy, France, or some other part of Europe, grumbling that the American client wanted nothing more (or less) than an inventory of nature's holdings.

The publishers of chromolithographs were quick to see a sales pitch. Whenever possible, they guaranteed, first and foremost, that the painting they were reproducing was "faithful" in likeness and in detail to the subject matter; secondly, they hailed their chromo as an exact copy of the painting. Critics, of course, were skeptical, and so they should have been.

F. V. Hayden called Moran's watercolors "exceedingly correct renderings of their subjects, interesting alike to the man of science, the lover of art, and the admirer of nature."[16] Yet Moran had frequently written that his goal was to capture the essence of nature and not to be distracted by a fanaticism

for exact detail. He was a lover of Turner and a student of Ruskin (particularly of volume four of *Modern Painters*), and while he occasionally painted out of doors he preferred the studio, where he could work from photographs and his own eyewitness pencil sketches.[17] "Grandeur" and "color," not photographic accuracy, were the shibboleths of his aesthetic fraternity: "I place no value upon literal transcripts from Nature. My general scope is not realistic; all my tendencies are toward idealization."[18] Was Hayden thus knowingly stretching the truth when he encouraged scientists to accept Moran's work as "exceedingly correct," or was he merely using a vocabulary that his readers would understand?

Technical Limitations of the Chromo

The inability of even the mastermind of chromolithography, Louis Prang, to reproduce an image *exactly* like the original compounded the problem of portraying Yellowstone as advertised. A comparison of the *Lower Yellowstone Range,* which Moran painted for Prang's folio, with its chromolithographic reproduction points to numerous changes not only in detail but also in total composition. The chromo is heavier in feeling, far less subtle. The play of nervous lines and light colors that Moran used to create a sensation of liveliness has given way in the chromo to outlines circumscribing colors. The mountains have lost their fairyland quality, appearing now as huge chunks of earth with curious color striations. A brown cast, in part created by the excessive use of brown inks and in part the result of varnish, pervades the foreground and middle distances. Only the farthest mountains and sky— where the least amount of color work was necessary—are faithful to Moran.

Plate 68.
Plate 69.

There is in addition a lack of consistency from folio to folio. A comparison of two chromos of the *Lower Yellowstone Range* in the Smithsonian Institution shows that one seems to have been printed with an extra stone or two, while the copy at the Amon Carter Museum of Western Art, in Fort Worth, Texas, is decidedly darker than either. The Texas copy also has a very distinct background, with the snow and ice clearly visible. Naturally, time—a hundred years of it—and environmental conditions have altered the colors of the chromos in various ways, but the differences are too fundamental to be charged entirely to poor maintenance.[19] The color intensity varied with the amount of ink applied to the plates, the different drying times of the inks were a function of changing temperature and humidity in the print shop, the registration of colors inevitably shifted, and so on. Despite all Prang's claims to the contrary, the degree of control needed to make hundreds of exactly repeated color pictures was impossible to achieve in the 1870s.

Most Beautiful Chromo Set in America

Nevertheless, the Yellowstone folio established the highest standards for chromo artistry in America. Perhaps its greatest praise came when the avowed enemy of chromolithography John Ruskin ordered a copy.[20] The fifteen "sensation landscapes," as they were called, brought into the chromo

world new colors and new patterns of colors.[21] "The Great Blue Spring of the Lower Geyser Basin," "The Castle Geyser," and "Yellowstone Lake" *Plate 70.* combine vivid tones and an unusual low horizon to give a pleasing jolt to the eyes of the 1870s. So, too, did "Grand Canyon of the Yellowstone," "Mos- *Plate 71.* quito Trail," and "Hot Springs of Gardeners [*sic*] River," which all intro- duced liberal amounts of white ink into a medium that had been built on rainbow hues. While the surfaces of these chromos were less tactile than the original watercolors, they retained a sensuousness lost in most chromos by the early 1880s. Compare Moran's "Cliffs of the Upper Colorado River," *Plate 72.* copyrighted by Prang in 1881, with any of the Yellowstone chromos, and the difference in feeling is striking.[22] The 1881 chromo is harder and flatter, the result of the more cost-effective use of fewer printing plates or color separa- tions, faster-running presses, new coated papers, and a different kind of ink. For Prang, the pinnacle of chromolithography as both a high-quality form of art reproduction and a commercially viable medium was reached with *The Yellowstone* in the mid-1870s.[23]

IV. Other Chromo Landscapes

Thomas Moran was not the only American artist being reproduced in Prang's *American Chromos* series in the 1870s: Western views by Albert Bierstadt, Thomas Hill, John Ross Key, and others,[24] and New England–type scenes by Benjamin Champney were all being chromoed simultaneously. Although the quality of the prints varied enormously, depending upon the suitability of the original painting and the skill of the lithographic artist, they all bespoke Louis Prang's dedication to the American landscape.

Before Moran's name appeared on a chromo label, Prang had lithographed *Albert Bierstadt* German-born Albert Bierstadt's (1830–1902) *Sunset: California Scenery,* in *Plate 73.* 1868. This chromo closely resembled the German oleographs published by Breidenbach and Company in Düsseldorf—the city of Bierstadt's training. *Plate 74.* Breidenbach had published chromos after Bierstadt in the 1860s, and had marketed them in both Europe and America.[25]

"Sunset" sold for ten dollars.[26] Heavier than the Moran chromos, it at- tempted to reproduce the dense forms and spectacular atmospheric effects Bierstadt had created. Prang's advertisement described the chromo as one of the "best reproductions" ever brought out: "It represents a rocky California valley, where nature has remained undisturbed in her grandeur and solitude. The rays of the setting sun have bathed the river, and the rocks on its bank, in a flood of golden light, while impenetrable darkness already hovers over the forest in the foreground."[27]

Bierstadt was new. The dramatic light and majestic qualities of this chro-

mo were a radical change from the quiet landscapes that Prang had published after Bricher. Henry T. Tuckerman, in *Book of the Artists,* stated flatly: "One reason [for] . . . the marvelous success of Bierstadt is that the Düsseldorf style was a novelty here, though familiar abroad."[28] "Sunset" remained a standard item on Prang's list for more than a decade.

Thomas Hill

Plate 75.

Western landscapes must have been irresistible, for Prang published a great many of them. An example is his chromo of English-born Thomas Hill's *Yosemite Valley,* published in about 1869.[29] The painting, measuring approximately six by ten feet, had been very popular: Robert Weir's *Official Report of the American Centennial Exhibition of 1876* described its success in Philadelphia.

> Mr. Thomas Hill exhibited his "Yosemite Valley," a large picture, and superior to anything of the kind in the Exhibition, in the way of attractive and realistic representation of scenery strikingly grand in its own elements. Such representations have held a place in American landscape art. They appeal with force to the popular taste, and while they are very distinct in their aim from the ends sought in more mature art, which is less dependent on novelty of material, they are not without decided power when treated with the ability displayed by Mr. Hill, or as formerly rendered by Mr. Bierstadt.[30]

Prang ordered a small painted copy, which Hill himself produced, from which the chromo was then made.[31]

John Ross Key

Hill's landscape contributions were followed by those of the grandson of Francis Scott Key, John Ross Key (1837–1920), who in the 1870s painted numerous Western and West Coast views. He had worked as a draftsman for the U.S. Coast and Geodetic Survey and fought for the Confederacy during the Civil War. According to one source, he was "practically self-taught," so that when he won a first-class medal for his art at the Centennial Exposition his success was deemed extraordinary. In 1877 he exhibited a hundred paintings and drawings in Boston, and many of these were undoubtedly ones that had been chromoed by Prang.[32]

Fourteen Key chromos—primarily half chromos—were produced, apparently as a set. Their dimensions were 7 1/16 by 14 1/16 inches, with four composed as verticals and ten as horizontals. Priced at $3 each, they aimed at capturing the beauty of California: "The Golden Gate, Looking West," "Cliff House, San Francisco," and "Harvesting Near San José, California" are three examples. In addition, there were two chromos priced at $10 each: "Santa Clara Valley, California" and an East Coast companion, "The Glade, Allegheny Mountains, Maryland."[33] But, despite his success, Key was no match for Moran or Bierstadt. Although he enjoyed a high reputation for

Plate 76.

draftsmanship,[34] his chromos pale beside Moran's particularly, and they seem superficial.

Contemporaneous with the Western scenes of the 1870s were Prang's more genteel Eastern landscape views: nine by Alfred Thompson Bricher (in addition to his pair of "Early Autumn" and "Late Autumn"), with six selling for $9 per set[35] and three at $6 each;[36] at least five by James M. Hart (1828–1901), including "Pastoral Scene," which was put on stones by William Harring;[37] six views of the Hudson River after Max Eglau;[38] six of Central Park in New York, by Henri A. Ferguson (1842–1911);[39] a host of Adirondack chromos;[40] idyllic snow scenes;[41] coastal views;[42] lakes;[43] harvest pictures[44]—the Eastern images were best sellers. If we can believe Prang's promotion, even the artists who produced the originals were deeply impressed. After M. F. H. de Haas's *Sunset on the Coast* was chromolithographed (13¾ by 24 inches, $15), de Haas congratulated Prang: "In imitation of oil colors, and without having been re-touched by the artist, I think I have seen none so good as yours. The modulation of the different tints in the sky and water is very much like the original. I do not doubt but that this publication will add greatly to your already so well established reputation."[45]

Of Prang's Eastern scenes, six views after Benjamin Champney (1817–1907) seem the most impressive today.[46] All published in about 1871, they are entitled "Mount Kearsarge," "Mount Chocorua," "Artist's Brook," "North Conway Meadows," "Pumpkin Time," and "Haymaking in the Green Mountains."[47] These chromos depicted places of summer retreat for the artists of Champney's generation, and the scenes held a magical fascination. "North Conway [New Hampshire] is one of the most charming places in the world to me," wrote Champney. "I have seen valleys both in this country and in Europe, but I do not recall one where more beauty is centred than there. The valley is broad, the mountains are high, but not too high or near to shut out the sunlight. The meadows or intervales are bright and fresh, broken with fields of grain and corn, giving an air of fruitfulness and abundance. Elms and maples are scattered here and there in picturesque groups, breaking the monotony of broad spaces."[48] His criterion for a good work was that it be "clear, sparkling and brilliant with a superabundance of detail," and his chromos, selling at nine dollars per copy, met these standards. Like the Bierstadt "Sunset," the prints are relatively heavy in color, with each figure firmly defined. Steeped in the Düsseldorf style, Champney was perfect for Prang's needs.

Variety of Prang Landscapes

Plate 77.

Benjamin Champney

Plate 78.
Plate 79.

V. From Oil Painting to Watercolor: The Later Years

The popular style of Bierstadt's and Champney's oil paintings did not blind

Prang to the future. By the late 1870s it was clear to him that a brighter, looser watercolor style was on the rise, and he acted accordingly.

Until the early 1880s few American chromolithographers, including Prang, could produce a tolerable imitation of watercolor. The German tradition carried out in American lithography had not demanded it, putting its emphasis on the reproduction of heavy oil. But the Moran chromos, with their liberal use of white, marked a new phase, and throughout the eighties lithographers worked to lighten their prints to meet the growing desire for airy, "tasteful" chromos. The magazine *Art Interchange* urged them on. The December 8, 1881, issue compared various national chromo styles: "German work has heavy, strong colors. French is in fine, delicately modelled tints, and English has soft effects and broad contrasts. In America, until very recently, brilliancy of color was the one object, now soft tones are forcing their way into use." The magazine charged, however, that "lithographers oppose [the new style]. . . . Even Mr. Prang, who must be credited with genuineness in his art efforts, shows how deep a root the glaring style has taken. . . ."[49]

The watercolor facsimiles led the trend away from precise reproduction toward *illustration* of original art, in the spirit of Moran's impression of Yellowstone. It was similar in concept to the use of black-and-white wood engravings to represent oil paintings—the mood and impact of the work, not its details, became the reproductive goal.

A great number of watercolor chromos after Louis K. Harlow and others were printed by Prang in the 1880s and '90s. Harlow, one of Prang's most reproduced artists, was typical. His watercolors were of idyllic New England scenes, and they were flat, much like present-day illustrations for Christmas cards.[50] At the same time, they have a photographic realism about them, drawn in a tighter style than one associates with watercolors, which made his works both popular and readily reproducible.[51]

Winslow Homer's (1836–1910) works for Prang suffered a different fate. Prang had reproduced his *Campaign Sketches* and *Life in Camp* series as black-and-white lithographs in 1863–64, and since that time the two men had apparently become good friends.[52] As recorded in their correspondence, Prang was after Homer in the late eighties and early nineties to produce paintings for his list. It was a shrewd request, but it proved too difficult to carry out.

Even before the end of the century, Homer was recognized as an American genius. His fresh vision, his firm graphic design, his sense of balance between artistic and natural values, could breathe new life into any reproductive medium. Moreover, Homer understood both the techniques and the aesthetics of the various graphic-art processes used in nineteenth-century America. Having begun his career in the lithographic shop of Boston's John H. Buf-

New Styles and New Standards

Winslow Homer

ford, he moved on to draw wood engravings for *Ballou's Pictorial Drawing-Room Companion* and *Harper's Weekly,* and then he worked in etching, briefly in the 1870s and in the late 1880s, after moving to Prout's Neck, on the Maine coast.[53]

It was during this etching phase that Louis Prang began his campaign to chromolithograph Homer's paintings. Letters between the two men show the aggressive Prang asking for an invitation to Homer's hideaway, the retiring Homer replying demurely that his rough surroundings did not make it "convenient to receive a visitor."[54] Somehow, Prang got his way: *The North Woods* was chromoed in about 1894 and *The Watch,* or *Eastern Shore,* in 1896.[55]

Prang and Homer

Plate 80.
Plate 81.

The prints were ambitious "Water Color Facsimilie[s][*sic*]" that symbolized a synthesis of Homer's great artistry in watercolor, his interest in graphic art, his love of rural outdoor life (particularly the sea), and his desire to popularize his paintings.[56] Unfortunately, however, the effort failed, and after a few impressions were made, the images on the printing plates were destroyed. Precisely what happened is unclear, but Prang—like many other lithographers—was working with delicate pastel ink washes to produce the low-intensity colors of water paint, and the images spread and blurred very quickly. Although the copy of *The North Woods* in the Metropolitan Museum of Art is a remarkably accurate chromo of the original (located now in the Currier Gallery of Art, in Manchester, New Hampshire),[57] most of the prints did not succeed, and the project was a commercial loss.

Homer Chromos Fail

Thereafter, Homer was left in splendid isolation, producing the watercolors that he believed would form the nucleus of his reputation. As he wrote to Prang at the end of 1893, "No other man or woman within half a mile & four miles from railroad & P. O. This is the only life in which I am permitted to mind my own business. I suppose I am today the only man in New England who can do it. I am perfectly happy & contented. Happy New Year."[58]

Prang, in turn, said good-bye to Homer's brand of complex landscapes. For his last great work, finished in 1899, Prang avoided tricky washes and subtle hues, instead producing the chromos for S. W. Bushnell's ten-volume classic, *W. T. Walters Collection of Oriental Ceramic Art,* which he called his "Monument." This last effort employed chromolithography to reproduce designs and images from industrial art and handicraft, a use recommended by Prang's enemy E. L. Godkin thirty years before! The printing, registration, and overall design are beautiful, but these chromos were not meant to imitate paintings: they are pictures of other things. And, perhaps most significantly, they were not published to be framed and hung. While the democratic art was aimed at the walls of the modest home, *Oriental Ceramic Art* belonged on the shelf of a gentleman's library.[59]

Prang's Last Masterwork

WHAT SHALL WE HANG ON THE WALLS? AND WHY?

I. The Chromo and Interior Decoration

If Louis Prang had a unique genius, it was his ability to understand popular taste. He knew his audience, and for us to appreciate him and his competitors we too must know that audience. To be sure, chromo buyers were heterogeneous, far-flung, and—at times—unpredictable. But evidence tells us that middle-class women constituted the primary object of Prang's sales pitch. These women were caught up in reading about good taste, as explicated in a growing body of how-to books, annuals, magazines, and religious tracts, and the chromo appears frequently in this literature. The classic treatment of the chromo is to be found in *The American Woman's Home*, by Catharine Esther Beecher and Harriet Beecher Stowe.

The American
Woman's Home

Catharine Beecher was the eldest of clergyman Lyman Beecher's and Roxana Beecher's eight surviving children, many of whom she helped raise. In the course of her life, which began in 1800 and ended in 1878, she founded several women's schools and colleges and wrote at least seven books.[1] None of her writings, however, surpassed in impact the volume she wrote with her sister Harriet Beecher Stowe (author of *Uncle Tom's Cabin*) in 1869, entitled *The American Woman's Home*. Revised in 1873 and reissued for years afterward, this book was a popular guide to home planning throughout the time of the chromo civilization.[2]

The purpose of *The American Woman's Home* was to explain and illustrate the proper system of running an efficient, happy Christian household, without a retinue of servants. Loaded with moralistic dos and don'ts, the book is very much like the chromo itself: technically it represented the most advanced form of its medium, while socially and culturally it found security in old-fashioned standards. A woman's "great mission," wrote Beecher in the opening paragraphs, is "self-denial." As chief minister of the family, a woman was called to train "its members to self-sacrificing labors for the ignorant and weak: if not her own children, then the neglected children of

her Father in heaven. She is to rear all under her care to lay up treasures, not on earth, but in heaven. All the pleasures of this life end here; but those who train immortal minds are to reap the fruit of their labor through eternal ages."[3]

If woman's work was the home—her reward held in escrow in heaven—then man was assigned to outdoor labor: "to till the earth, dig the mines, toil in the foundries, traverse the ocean . . . and all the heavy work, which most of the day, excludes him from the comforts of a home." But the home was man's reward: "the great stimulus to all these toils, implanted in the heart of every true man, is the desire for a home of his own, and the hopes of paternity." Thus the home was both workshop and oasis, a school and a haven of human tranquillity.

Today the ideals of *The American Woman's Home* are easy targets. Historians can compare the goal of Beecher's book with the reality of the times and find a distinct incongruity.[4] Nevertheless, the effect of the book on the nineteenth-century American woman was weighty. Beecher's work became a housekeeper's bible for more than one generation,[5] and indeed, some of her ideas on efficiency hold true to this day.

Written in a lucid, common-sense style, *The American Woman's Home* was based on the theory, modern at the time, that the home's physical environment helped mold human character. Designed to be "healthful, economical, and tasteful," every detail of the Beecher house was aimed at "economizing time, labor, and expense by the close packing of conveniences."[6] In this way it was rather a prophetic book. Numerous innovations appeared in it that are now standard in the American home: "scientifically" organized laundry and kitchen facilities (arranged in the style of a cook's galley on a steamship), artificial ventilation systems, movable partitions, as well as clean exterior architectural lines. The add-on jigsaw gingerbread decorating the Victorian house was condemned, because it made the house "neither prettier nor more comfortable"—it was "curly-wurlies" and "whigmaliries."[7] Beecher's creed was functionalism addressed to the needs of everyday life. It was a philosophy of living for a middle-class democracy.

Health, Economy, Taste

And chromos, particularly those by Louis Prang, were part of her scheme. They conveyed an appropriate sentiment, an atmosphere of education and growth. Repeating an idea that had survived for no less than fifty years in American art promotion, Beecher noted that proper chromos helped instill healthy attitudes: "Surrounded by such suggestions of the beautiful, and such reminders of history and art, children are constantly trained to correctness of taste and refinement of thought, and stimulated—sometimes to efforts at artistic imitation, always to the eager and intelligent inquiry about the scenes, the places, the incidents represented."[8]

Beecher specifically recommended the chromolithographs of Louis Prang:

"Eastman Johnson's 'Barefoot Boy,' ... $5.00 ... Newman's 'Blue-Fringed Gentians,' ... $6.00 ... Bierstadt's 'Sunset in the Yo Semite Valley,' ... $12.00." But chromos by others were also suitable: "By sending to any leading picture-dealer, lists of pictures and prices will be forwarded to you. These chromos, being all varnished, can wait for frames until you can afford them."[9] Besides American prints, there were "German and English chromos," as well as "French chromos," that could be "had at prices from $1 to $5 including black walnut frames." For chromos without frames Beecher provided illustrated instructions for making "pretty rustic frames." If one wonders why chromos have not survived in abundance, the framing and matting directions in *The American Woman's Home* may be partly to blame:

Frames for Chromos

> Take a very thin board, of the right size and shape, for the foundation of "mat;" saw out the inner oval or rectangular form to suit the picture. Nail on the edge of a rustic frame made of branches of hard, seasoned wood, and garnish the corners with some pretty device; such, for instance, as a cluster of acorns; or, in place of the branches of trees, fasten on with glue small pine cones, with larger ones for corner ornaments. Or use the mosses of the wood or ocean shells for this purpose.

Beecher also noted that a new frame "should ... be varnished, then it will take a rich, yellow tinge, which harmonizes admirably with chromos. . . ."[10]

Beecher's instructions did not mesh with the ideas of Louis Prang, warmly though she supported him. Expressing a doctrine of simplicity, Prang's "Hints on Framing," which had appeared in *Prang's Chromo* of January 1868, contains good advice even for today: 1) "the picture should decide the character of its frame," 2) "reject all frames that have obtrusively ornamented panels near the picture," and 3) "it is always safe to select a gold frame, because gold is suitable for every kind of picture."

Beecher and Prang

The matter of framing proved to be the only published difference of opinion between Prang and *The American Woman's Home*. The Boston lithographer by and large applauded Beecher's prescriptions for beautification. If her concept of the "charm of color" and the choice of subject matter associated with the "best class" of chromos seemed vague, she made her point of view vivid by warning against architectural frills and arguing that a chromo could, in some cases, be a more wholesome investment than that grand American invention, the front porch: "We would venture to say that we could buy the chromo of Bierstadt's 'Sunset in the Yo Semite Valley,' and four others like it, for half the sum that we have sometimes seen laid out on a very ugly, narrow, awkward porch on the outside of a house!"[11]

II. A Chromo for Every Room

As part of their merchandising, chromolithographers often categorized their pictures according to the room of the house in which they were to be placed. Mark Twain alluded to this in 1889, when his Connecticut Yankee, after finding himself in a dark, cold Arthurian tower, longed for his favorite "*little conveniences.*" The Yankee described his medieval lodgings:

Mark Twain

> There was no soap, no matches, no looking-glass—except a metal one,
> about as powerful as a pail of water. And not a chromo. I had been
> used to chromos for years and I saw now that without my suspecting
> it a passion for art had got worked into the fabric of my being, and was
> become a part of me. It made me homesick to look around over this
> proud and gaudy but heartless barrenness and remember that in our
> home in East Hartford, all unpretending as it was, you couldn't go into
> a room but you would find an insurance-chromo, or at least a three-
> color God-Bless-Our-Home over the door—and in the parlor we had
> nine.[12]

Landscapes, mottoes, and religious chromos in the living room, still lifes of fruit, fish, and game in the dining area ("Dining-Room Pictures," the 1878 Prang catalogue called them). As early as 1868 Prang advertised: "Our fruit and flower pieces are admirably adapted for the decoration of dining-rooms and parlors. We intend to issue still other pictures of this character; and we venture to predict that the set when complete will be unrivalled either in Europe or America."[13]

Dining-Room Chromos

He began the parlor and dining-room series with "Cherries in a Basket" and "Strawberries in a Basket," after oil paintings by Virginia Granbery. Later her "Currants" and "Raspberries" were added to the list. Granbery (1831–1921) was a prolific artist, who worked during most of her life in New York City. Her style, as art historians William H. Gerdts and Russell Burke have noted, was ideal for Prang's chromos: the bright, hard colors, with little blending or graduating of tones, made the printing separations relatively easy and economical to produce.[14]

Virginia Granbery

Plate 82.

The same style characterized "The Kitchen Bouquet," by William Harring. Chromolithographed in time to make Prang's Christmas list of 1868, Harring's piece sounds like an advertisement for tomatoes:

Plate 83.
William Harring

> *The Kitchen Bouquet* after W. Harring shows tomatoes in their glory of
> full ripeness,—luscious, bright in color, ready for the cook, to be served
> in one of the thousand different styles which he, as other cooks, in-
> vented. An American cook could miss a good many other things before

he would do without tomatoes—easy to serve and always acceptable. It is well-handled as a picture, and shows that even the most familiar and seemingly vulgar subjects can be made poetical if treated by a man of ability. For dining-rooms, for restaurants, for vegetable and provision dealers, for seed-stores and others it will make an attractive picture.

There were Prang dining-room chromos after paintings of dead game hanging by their feet, of trout, pickerel, lobsters, and of grouse. Selling in *Plate 84.* profusion were "dessert" chromos, of ice cream, grapes, lemons, peaches, pears, wine, and pound cake. Today the idea of eating at a table surrounded by visions of sweets and a menagerie of dead animals may seem bizarre, but the Victorian dining room was a veritable zoo of imagery. Even the furniture carried relief carvings of dead birds and fish on a platter, along with fruit in a bowl. It was a style that dominated from about 1860 to 1890.

Currier and Ives To be fair, Prang did not invent the genre. Fruit and flower lithographs (mostly hand-colored) had been popularized by Nathaniel Currier for a brief period in the late 1840s and again by Currier and Ives in the early '60s.[15] Most of these lithographs were published unsigned, but some from 1862 to 1867 carry the name of Fanny Palmer, an English-born artist. Currier and Ives usually shunned game birds, but fish were quite fashionable.[16] What may be their first chromolithograph, published in 1864, was entitled "Amer*Plate 53.* ican Speckled Brook Trout," copied from a painting by another English-*A. F. Tait* American, A. F. Tait. Currier and Ives had purchased the picture and assigned one of their premier artist-lithographers, Charles (or C. R.) Parsons, the task of producing a chromo copy.[17] Tait was one of Currier and Ives's favorite artists, they having lithographed and hand-colored at least forty-eight of his earlier paintings, but the "Trout" marked the beginning of the end of the relationship. One source suggests that in 1864 Tait thought of terminating their association because he believed the lithographic copies hurt the sale of his paintings, but several years later Currier and Ives chro*Plate 54a.* moed Tait's *Alarm,* and indeed, as noted in chapter six, it was the work of this very artist that pointed Louis Prang in the direction of success.[18] Tait did eventually stop working with Currier and Ives, but he did not abandon lithography.

J. Sage and Sons Dead birds for dining rooms were probably first popularized and sold in sets by the lithographers J. Sage and Sons, of Buffalo. Their series *Game Birds of America* appeared in 1861. It included a set of four oval lithographs, "Woodcock," "Snipe," "Quail," and "California Quail," all reproduced from the work of Hugh M. Clay, better known later as a partner in the Buffalo lithographic firm Clay, Cosack and Company. Other firms entered the field, but few developed the varied inventory and the smooth advertising rhetoric of L. Prang and Company. In addition to chromos after A. F. Tait and Virginia Granbery, Prang's dining-room specialties were copied from

paintings by a number of competent artists. George Nelson Cass (circa 1831–82), a student of George Inness, supplied several game and fish pieces,[19] while Carducius Plantagenet Ream, G. Bossett, C. Biele, and Robert D. Wilkie provided a variety of still-life motifs.

Three of Prang's flower and fruit painters were among America's best: George Cochran Lambdin, Martin Johnson Heade, and Lilly Martin Spencer. Lambdin (1830–96) was one of the first Americans to specialize in flowers;[20] his own garden, in Germantown, Pennsylvania, was a floral paradise. From this home base he supplied paintings for Prang's mill and became known in his own time as America's finest flower artist. Though he was foremost a painter of flowers, especially roses, his "Wild Fruit" became famous when it was billed as a companion to Eastman Johnson's "Barefoot Boy." Unlike the overly sentimental works of other Prang artists, such as O. E. Whitney, Lambdin often combined austere, dark—sometimes black— backgrounds with lush light-colored blossoms.[21] The effect is one of both drama and solidity—an intense three-dimensional illusion, very strong in the original oils and maintained to a large degree in the chromos.

George Lambdin

Martin Johnson Heade (1819–1904) differed from Lambdin. He excelled in an extraordinarily broad range of subject matter, but he never in his lifetime won the fame his talent deserved. Portraits, genre scenes, and landscapes dominated his painting from 1840 to 1860, then delicate marshes and haunting seascapes. Sometime in the sixties he began a series of flower pictures, and in the seventies he continued with rose and apple-blossom subjects.[22] These paintings had a special attraction for Louis Prang, who published the chromo "Flowers of Hope" in 1870.

Martin Johnson Heade

It is interesting to note that Heade had flirted with chromolithography six years before his work with Prang. In 1863 he visited Brazil and painted some twenty pictures of flowers and hummingbirds, which he planned to have "chromolithographed by the best artists"[23] in London under the series title *Gems of Brazil*.[24] The *Bucks County* [Pennsylvania] *Intelligencer* for August 9, 1864, reported that the work was planned as a "magnificent . . . chromolithographic album . . . in the first style of the lithographic art."[25] It never appeared. Only four of the projected twenty prints are known to exist. They seem to have been lithographed from five colors and one tint stone, with touches of oil paint hand-applied for details and highlights.[26] A contemporary news account said, "Mr. Heade has several chromos of hummingbirds whose brilliant colors harmonize with the rich tropical scenery in the background and which he has touched up and made nearly as good as original pictures."[27] In all probability these prints were intended as artist's proofs, which Heade found unacceptable. Historians surmise that the project died because of "difficulties experienced in the proper execution of the chromos,"[28] but the key was most likely inadequate financing.[29]

Gems of Brazil

Lilly Martin Spencer (1822–1902) was America's most famous woman

Lilly Martin Spencer

artist in the 1850s and '60s.[30] Like so many American painters, she was born in England, coming to the United States in 1830. By the fifties she was known for her paintings of children, dogs, home life, and still life, and more than a decade before Louis Prang published her *Blackberries in a Vase* (1868)[31] she was deeply involved in the dissemination of fine art for the middle-class household. Her paintings were often bought as lottery prizes by the popular art unions of the late forties and early fifties in both New York and Cincinnati, and later by the Cosmopolitan Art Association. (These organizations, charging an annual subscription fee of five dollars or so, gave members free admission to art exhibitions, several reproductive prints, and lottery tickets for a chance of winning an original painting. Popular institutions, they were eventually declared illegal, because of the lottery.) More pertinent to the story of chromolithography, throughout the 1850s and '60s Spencer sold paintings to William Schaus, an American representative of the French Goupil, Vibert and Company, which lithographed and hand-colored her works—most often Jean Baptiste Adolphe Lafosse did this—and then shipped the prints back to America.[32]

Print Dealers Schaus was one of a proliferating breed of New York print dealers and publishers who served as middlemen between artists, chromolithographers, and what Louis Prang called that great "art-loving public."[33] Prang alluded to these agents when he advertised his *American Chromos* as being "for sale at all Art Stores everywhere."[34] Sometimes the dealers gambled by underwriting the publication of their own chromos. Schaus apparently did this in *Plate 85.* 1868 with a print after John G. Brown entitled "Maud Muller," on which neither the lithographic firm nor the lithographic artist is credited; the only important fact seemed to be that it was a reproduction of a painting.

Such middleman distribution, as practiced by Schaus in the 1850s, gained enormous popularity by the end of the century. In a New York business directory of 1876 only three chromo publishers—as opposed to printers—were listed, whereas in 1900 there were fifty-six.[35] The new system marked the beginning of the modern division in roles between production and sales.

Meanwhile, Lilly Martin Spencer contracted to work for the chromolithographer Herman Bencke, as well as for Louis Prang. In about 1868 Bencke chromolithographed her *Ain't She Pretty?* and supposedly sold up to 1,500 copies. He also printed *Dandelion Time*, offering Spencer a ten-percent royalty on all sales. The deal sounded fair, but Spencer later complained that the royalties were too small and difficult to collect.[36]

In fact, as early as 1856 the business of reproducing her paintings for the home had disillusioned Spencer: "I had expected that after having so many of my pictures engraved that I should have had plenty to do but it is not so, the publick tast [*sic*] runs so little that way, that private orders, or purchasers are not to be had for fancy pieces, when once publishers have got what they

want."[37] Nevertheless, for more than another decade Spencer continued to deal with both lithographers and publishers as a source of income.

III. Good Taste as Subject Matter

The mass appeal of dining-room chromos is not difficult to appreciate in an intuitive way, but it is nearly impossible to explain in a rational discourse. Here Beecher and Stowe can be of help. In one passage the authors noted "the great value of pictures for the home would be, after all, in their senti-*The Value of* ment. They should express the sincere ideas and taste of the household and *Sentiment* not the tyrannical dicta of some art critic or neighbor." Reproductions of Italian Renaissance works, such as those being distributed in England by the Arundel Society, were not suitable. Most American genre scenes and still lifes, very sweet, even saccharine, to our eyes, were. Why?

"Sentiment" is the quality stressed by *The American Woman's Home.* Defined by *The American Heritage Dictionary* as "susceptibility to tender, romantic, or nostalgic feeling," sentiment has little to do with chromos as representations of works of art.[38] Critics of painting held a low position in the Beecher value schema—Stowe called them all by a single name: "Don Positivo." Compared with the stuff of debates in the rarefied art world, the subject matter hailed by the co-authors bordered on the mawkish. Chromos, they wrote, should be visual equivalents of polite novels: they should express "sincere ideas and taste of the household." Nothing offensive. Nothing shocking. At their best chromos provided "a host of simple, inexpensive ornaments . . . that are bringing beauty and pleasure to so many thousand homes that otherwise poverty would keep bare."

The emotional content of any era is difficult for later generations to comprehend. It grows out of the course of daily life. When the tenor of the times changes, the older sentiments seem outmoded and fall to ridicule. Homely truths of one generation become the jokes of the next. The high level of sweetness and romance embodied in the hanging chromos of the 1860s, '70s, and '80s must have responded to fundamental needs of the many Americans who embraced them. These chromos elicited a common feeling that presumably helped people relate to one another and was an essential ingredient in the chemistry of Victorian life. Those who condemn this feeling as sentimentality are comparing it with high, abstract ideals of emotion. The nineteenth-century sentiment did not pretend to be an elevated philosophy or a universal aesthetic; it was simply a component of everyday life.

As a purveyor of this sentiment, who was better than one of Catharine Beecher's favorites, Eastman Johnson (1824–1906)? A genre and portrait *Eastman Johnson* artist who began his professional life in the lithographic shop of John H.

Bufford, Johnson traveled to Düsseldorf to work with Emanuel Leutze in 1849, and in 1855 he was offered the position of court painter to The Hague. He declined and returned to America, where he established his fame with *Old Kentucky Home,* which was first exhibited at the National Academy of Design, in New York, in 1859. During the next twenty years he was immensely successful, producing paintings such as *The Cranberry Pickers, Corn Husking Bee, New Bonnet,* and *Embers,* which were reproduced in a variety of media and widely discussed in the genteel magazines.[39]

Johnson was a storyteller, a Norman Rockwell, with the same sharp eye for detail. He celebrated the bright side of life, those positive social values that seem to be at the core of the American spirit. All his people are good-humored, hard-working, honest, and happy. Their world was the promise of American life. The Beecher sisters saw this promise in *The Barefoot Boy,* as did thousands of others. First offered as a Prang chromo in 1867, the *Boy* lived as a potent image well into the nineties, appearing as late as 1897 in the Prang catalogue.

Johnson's *Barefoot Boy* was based on John Greenleaf Whittier's poem:

> Blessings on thee, little man,
> Barefoot boy, with cheek of tan!
> With thy turned-up pantaloons,
> And thy merry whistled tunes;
> With thy red lip, redder still
> Kissed by strawberries on the hill;
> With the sunshine on thy face,
> Through thy torn brim's jaunty grace.
> From my heart I give thee joy.—
> I was once a barefoot boy! . . .[40]

Advertised by Prang as the personification of the American character, the boy "in homespun clothing, barefooted," was meant to symbolize "that self-reliant aspect which characterizes the rural and backwoods children of America." It was so successful that other lithographers copied the genre. One competitor even made his own copy of *The Barefoot Boy* and lifted for its promotion Whittier's praise of Prang's print. Writing on May 25, 1873, to his "Dear Friend," Whittier alerted Prang to the Rhode Island newspaper that was publicizing the bogus chromo. Whittier was miffed: "It seems to be hazardous to praise anything. There is no knowing to what strange use one's words may be put . . . I don't think I should dare speak favorably of the Venus de Medici, as I might expect to find my words affixed to some bar-room lithograph of the Bearded Woman."[41]

"The Barefoot Boy" bred a host of similar Prang chromos. *The Doctor,*

American Spirit

Plate 86.

John Greenleaf Whittier

Plagiarism

painted in 1867 by Henry Bacon (an American living in Paris)[42] and reproduced in 1869, shows a seated boy spoon-feeding a reluctant cat, while in the background a hairy dog peers out from inside a huge wooden barrel. Eighteen sixty-nine also saw the "Young Commodore," after B. F. Reinhart, and in 1870 Prang chromoed "Little Bo-Peep," after John G. Brown.[43] There seemed to be innumerable variations on the theme of childhood, including Johnson's second success with Prang, "The Boyhood of Lincoln."[44] Priced at $12 a copy, this chromo, 21 by 16¾ inches, was larger than "The Barefoot Boy." The advertising copy spoke directly to *The American Woman's Home:* "This great national picture . . . teaches that in America there is no social eminence impossible to the lowest youth, who, by perseverance, study, and honesty of life and purpose, shall seek to reach the ranks of the rulers of the people."

Plate 87.

IV. "Women . . . Patronize and Influence the Arts"

In focusing on women in instructing the public on how to buy pictures, Catharine Beecher and Louis Prang were acting in concert with the times. Beginning in the 1840s and continuing through the 1890s an army of do-good social reformers tried to correlate the influence of art with the character of women. The writer and editor Nathaniel Parker Willis observed in the 1850s that it was the "women who read, who are the tribunal of any question aside from politics or business . . . patronize and influence the Arts, and exercise ultimate control over the Press."[45] Popular art was considered the expression of feminine taste. In the Reverend George W. Bethune's essay "The Prospects of Art in the United States," the mass consumption of lithographs is applauded: "The lithographs may be rude and gaudy but you will rarely find, in a humble family, a taste for these ornaments unaccompanied by neatness, temperance, and thrift. They are signs of a fondness for home, and a desire to cultivate virtues, which make home peaceful and happy." The purpose of this popular art was to "soften the harsh features" of life in America, to give "a moral scope and bearing" to the "industrial and commercial spirit."[46] Art was a firm but gentle hand; it was, to the nineteenth-century mind, female.

Women as Taste Makers

Art as Female

 This line of reasoning recurs throughout the chromo civilization. As late as 1893, the *Lithographers' Journal* insisted that chromos had softened the "bareness of hard angles" in the homes of "the lower and many of the middle classes in the United States," and they served as a "powerful agency for civilization." The editor wrote in terms that Catharine Beecher and Harriet Beecher Stowe would certainly have praised:

The love for the beautiful . . . acts upon the individual and forces him to unconsciously idealize the scenes of his daily life. So habitual does this become . . . that new avenues of refinement and true culture are continually being opened by its unseen activity. The individual thus becomes an added power to the nation, which, if collectively comprising such factors, soon becomes the general possessor of a culture which was formerly the attainment of a favored few.[47]

Women's Periodicals

It was largely the illustrated magazines and women's publications of the 1840–60 period that established the popularity of inexpensive printed color pictures. Editors quickly discovered and exploited the public's taste for newfangled illustrations. Certain media offered colored mezzotints, others sported scenes that had been embossed for a three-dimensional effect, and still others published images that could be cut out and stood on a table top. It was a riot of gimmicks designed to conjure up the world of domestic refinement.

Most of the popular-magazine prints were frivolous, but some of the pictures had historic or artistic significance. For example, the April 1843 issue of *Miss Leslie's Magazine* published the first American lithotint, "Grandpapa's Pet," by P. S. Duval and John H. Richards.[48] And some of the earliest chromos in America were produced as illustrations, covers, and title pages for annual "gift-books," beautiful publications of the 1840s and '50s aimed at women readers. *The Iris* was such an annual, published by John Seely

Plate 88.

Hart in order to stimulate interest in printed pictures.[49] The 1851 issue contains four fully "illuminated pages," each reportedly printed in ten colors, "with a degree of brilliancy and finish certainly not heretofore surpassed." Designed and drawn on the stones by Christian Schuessele and printed by Duval, the chromos are replete with angels, nymphs, flowers, and gold borders.

The following year *The Iris* came out with twelve chromos: "gorgeous illuminated pages, all from original designs and all printed in ten different colours . . . in the style now so deservedly popular." This style was inspired

Gothic Romanticism

by Gothic romanticism, then on the rise in America, and many early chromos —particularly those published in popular literary periodicals—attempted to imitate the illuminated pages of medieval manuscripts. Such "gems of art" were a "heavy expense," wrote John Hart, but worth it—even Queen Victoria praised one of the later editions. *The Iris* did not dominate the field, but it was representative of the chromo-book fad. Similar illustrations by Wagner and McGuigan appeared in *Leaflets of Memory* in 1846 and in the *Ladies' National Magazine*, which boasted that its chromos were the "best imitation of the illuminated style in America." And more than one gift-book reiterated *Miss Leslie's* theme of marrying art and technology for the good

of humanity: "[chromos displaying] that advanced stage of mechanical skill which is nearly allied to art, have been here brought together . . . in rainbow hues."[50]

The gift-book pictures were advertised as tiny paintings for everybody. When *The Iris* published chromos from drawings by Captain Seth Eastman in its 1852 issue, it trumpeted: "The happy blending of the colours in these pictures, the disposition of the light and shade, and the skill with which they are printed, give them the appearance of paintings rather than of prints."[51] By the midfifties the women's press had succeeded in promoting the chromo to its ready audience. Described as a technical wonder, the chromo promised to reproduce accurate likenesses of art ranging from gold-leaf manuscript illumination to sophisticated oil paintings. It was a flexible technology, yet it was also inexpensive and *tasteful,* winning praise from educators and ministers, as well as journalists. It was ideal for middle-class democracy.

Plate 89.

V. The Chromo as Lure

For the next thirty years, 1860 to 1890, Americans covered their walls with chromos. In an 1879 editorial entitled "Art in the House," *The New York Times* remarked on the phenomenon: "American art is getting into the house. . . . When fine pictures are too costly . . . chromo-lithographs . . . prove the growing taste for beauty of form and color." The editors did not understand why this was happening, but they heartily supported the trend. "It is not so clear what the cause of the change is, and to say that it is a fashion only puts the question one step further back, and compels us to ask why fashion takes that turn and has taken it for so many years."[52]

"Art in the House," The New York Times

American businessmen put "art in the house." Not only as editorial features but as advertising come-ons, the chromo got its biggest push from the periodicals. As mentioned earlier, after the Civil War, magazines and newspapers used chromos as promotional premiums to lure subscribers. Women's and family magazines led the way, with farm journals, religious sheets, and regional periodicals following closely behind. Landscapes, portraits, genre scenes, bouquets of flowers, baskets of fruit, chubby children, and fluffy kittens were all distributed by the premium system. The Strobridge Lithographing Company, of Cincinnati, a major supplier of chromos to periodicals, received a variety of requests from its customers. The *Farmer's Home Journal* wrote the firm on March 15, 1877: "We would be glad to offer some of the chromos as premiums and would like to know if we may order as we receive orders from our subscribers. If so we will make the announcement & would be glad to have two or three more specimens that we can have framed to hang in conspicuous places in the country."[53]

Subscription Premiums Plate 90.

The *Christian Monitor,* of Indianapolis, had a more basic demand: "I must get cheaper pictures some way—What have you got that will be enticing to subscribers and at the same time lower in price [?]"[54] On occasion the journal proprietors asked the printer for suggestions. The *Aurora Beacon* queried in 1877:

> Gents: You will remember that a year ago, we bought from you several hundred copies of "Perry's Victory" for Premium purposes. What have you that we can use this year? We wish something that will be "popular"—and as good as we can get for about the same price as we paid last year. Please answer as soon as convenient. . . .
> P. S. We used about a thousand last year—hope to use more this.[55]

While the dean of magazine historians, Frank Luther Mott, noted that the chromo-premium system peaked in the early eighties,[56] it nevertheless continued to function as an important conduit of the democratic art throughout the 1890s. In 1892 *Demorest's Family Magazine* proclaimed its greatest promotional coup: "an event of a century," the acquisition of the rights to a painting of orchids by the wife of President Benjamin Harrison.[57]

A GIFT BEYOND PRICE.
MRS. HARRISON'S SUPERB PAINTING OF ORCHIDS,
EXECUTED IN THE WHITE HOUSE, FROM AN
ORCHID GROWN IN THE WHITE HOUSE.

———————

Presented FREE with the October Number
of DEMOREST'S FAMILY MAGAZINE.

———————

THE ONLY PICTURE EVER PAINTED BY A PRESIDENT'S
WIFE TO BE PRESENTED TO THE PUBLIC.

*Criticism of
Hanging Chromos*

To some critics this distribution method was a prostitution of the serious objectives of the pre–Civil War art crusaders. *Art Interchange* on July 19, 1883, begged readers not to clutter their homes with pictures: "there appears to be a prejudice on the part of women, against leaving any considerable portion of the wall space uncovered. . . . every conceivable object . . . is impressed in the service of decoration. No lithographed advertising plaque is too atrocious in design or coloring to prevent its being used in a beribboned state to disfigure house walls."[58] Others simply did not like chromolithography. The *Art Amateur,* which itself was often illustrated with color litho-

graphs, argued against the hanging chromo, as produced by Prang. "A Correspondent says he is a New York bachelor," noted the magazine in 1881, "with a few hundred dollars to spend in pictures for the walls of his rooms, and wants advice as to how to lay out his money to best advantage. . . . [It] would be best for him to buy engravings or photo-gravures. These are much more desireable than chromo-lithographs . . . [which] are too mechanical to be artistic." [59] No matter. Chromos still sold by the millions.

9

THE CHROMO COMES
TO THE QUEEN CITY

The "Queen City" of Cincinnati, early a western outpost of commerce and culture, contributed a special impact on the democratic art. In a seemingly endless stream of prints springing from southwestern Ohio, Americans found new directions for their taste in chromolithography.

I. The Poster Industry

Barnum and Bailey

The most famous of the Cincinnati chromolithographs were the vast numbers of theatrical and circus posters produced from the 1870s until the start of World War I. The work by the Strobridge firm for Barnum and Bailey became legendary as the "Greatest Show on Earth" toured the nation, but in addition there were nearly a hundred companies in Cincinnati turning out posters for road shows of every description. The city's influence—particularly that of Strobridge, the "Tiffany of lithographers"—was such that a critical contemporary, printmaker and historian Joseph Pennell, admitted: "The great Cincinnati firm of [Strobridge] was a sort of cradle for many of the more distinguished younger American artists, who as journeymen lithographers received their first training [there]. It is not easy to trace their individual designs, for names never appear upon the gorgeous, or rather gaudy, Barnum . . . posters, in which for a period Americans found most of their art."[1]

The posters from the mid-1870s until the new century were often printed in eight colors or more. By the late seventies they had grown in size beyond the capacity of the biggest chromo printing press, so that they were manufactured as multiple-sheet posters. When pieced together on walls they depicted fanciful floats, freaks, rare animals, side-show stars, any feature the circus mind could dream up—most bigger than life.[2] Weeks before a show arrived, towns all over the country were wrapped in chromos that had been designed and printed in Cincinnati.

While high-minded critics saw this as democratic art with a vengeance, more liberal commentators viewed it as a sign of hope. As D. J. Kenny's *Illustrated Cincinnati* philosophized in 1875, "It is almost impossible to estimate too highly the value of the work done by lithography in popularizing art among the people.... nine-tenths of the illustrations we see placarded in railway waiting rooms, hotels, and other places.of public resort, are the product of lithography."[3] The editor of *Art Age* called it (December 1884) "Street Lithography," and he insisted that "Every . . . lithographer who sends out well drawn, well colored, well composed . . . posters to adorn the streets of a large American city is materially assisting in the art education of a Nation."[4]

"Street Lithography"

Public art or public pollutant, the Cincinnati poster was ubiquitous. Today it is the object of the chromo collector's passion.

II. Cincinnati Chromos Precede Posters: The Early Lithographs

It is important to remember that Cincinnati's great era of the poster rested on a foundation of forty years' experience.[5] The first Cincinnati lithograph was probably the "Galt House," produced in 1836 by Emil Klauprecht (1815–96).[6] Klauprecht was a German from Mainz, who is said to have sailed to America in 1832. It is not known where or how he learned the lithographic art. He arrived in Cincinnati in the midthirties, when the city was an optimistic upstart of about 34,000 inhabitants—within thirty years its population would increase sixfold.[7]

Emil Klauprecht

Throughout the 1840s Klauprecht worked in partnership with Adolph Menzel. In 1843 they published a lithograph-illustrated German newspaper, *Fliegende Blaetter*. By the midfifties Klauprecht's name disappeared from the ranks of lithographers in the city directories and found its way onto the mastheads of several German-language newspapers, including *Deutsche Republikaner*, *Westliche Blaetter*, and *Volksblatt*. In 1864 President Lincoln named Klauprecht American consul in Stuttgart, and he remained in his homeland the rest of his life.[8]

All the Cincinnati work that survives from the period 1836 to 1852 is black and white, hand-colored, or tinted with a second stone. As early as September 17, 1850, however, George Gibson and Company ("a few doors from Main, opposite the Galt House") advertised in the *Daily Cincinnati Commercial:* "lithographic Printing in Gold and colors, executed in a superior style, samples of which may be seen at all times at the office."[9]

George Gibson

George Gibson was an English immigrant who had arrived in Cincinnati sometime about 1850, with a wife, seven children, and a French-made

lithographic press.[10] He obviously came with lithographic training and could probably print in color, as advertised, although no specimens of his early color work survive.[11]

The oldest surviving chromo from Cincinnati dates from 1852. Produced by Middleton and Wallace, it is a certificate for the Cincinnati Independent Fire Engine Hose Company.[12] Although the print is covered with a thick gum varnish, the color and registration still show high-quality workmanship; indeed, this does not look like a first attempt.[13]

Middleton and Wallace

Strobridge

The firm of Elijah C. Middleton and W. R. Wallace was established in 1849, and in 1854 it was joined by a third man, Hines Strobridge. By the early 1860s, both Middleton and Wallace had stepped down. The firm's name went through several evolutions before becoming, in 1867, Strobridge and Company and finally jelling, in 1880, as the Strobridge Lithographing Company.[14]

W. R. Wallace, according to a letter written in 1932 by his son, was an English-born practical lithographer who had moved from Philadelphia to set up shop in Cincinnati.[15] If this letter is accurate, he could very well be the printer who introduced the chromo skills to Cincinnati. Several fine examples of his work from before the Civil War survive,[16] one, signed "Middleton, Wallace, and Company," appearing in 1858 in the third edition of *Hooper's Western Fruit Book:* "Rodman's Red Cling—Natural Size" is notable for two reasons. It is probably the first chromo to appear in a book published in Cincinnati, and, more important, it is one of the earliest instances in Cincinnati of the "new style" of tonal color.[17] This chromolithographed peach substantiates their claim that Middleton, Wallace, and Company "embraced all kinds of lithographing . . . in one or more colors."

They also claimed an annual business of $25,000 and a payroll of twenty workers. While Middleton, Wallace, and Company was a front-runner in the race for the perfection of the chromo, another Cincinnati firm was hot on their heels. Ehrgott and Forbriger's "Ansicht von [view of] New Ulm, Minnesota," published in 1860, is a finely finished chromolithograph by a company that had been in business for approximately four years.[18] Peter Ehrgott was a practical lithographer, Adolph Forbriger an artist. Like the Audubon chromos that Julius Bien was producing that year in New York, the New Ulm view contained colors and shades created by the overlapping of four basic inks: red, yellow, blue, and black. The green, for example, was made by printing blue over yellow, while orange was the result of red over yellow, and some of the browns were produced by a mixture of black, yellow, and red.

Ehrgott and Forbriger

Approximately a year before "New Ulm" was published Charles Cist had emphasized in a book about Cincinnati that Ehrgott and Forbriger, "practical lithographists," were prepared to accept any kind of work "on

stone, plain and in colors." Their repertoire included "landscapes, portraits, show cards, diplomas, music titles, book illustrations, maps, bonds, checks, drafts, notes, bill and letter heads, cards, labels, machines, etc., etc." The enthusiastic description concluded: "The establishment of Messrs. Ehrgott & Forbriger is in a great state of completeness, and those who may require lithographic work cannot do better than give them a trial. They guarantee their work to be equal to any executed in the country, and at the most reasonable cost. They are experienced workmen, and strive to excel in their department."[19] In short, "New Ulm" was probably not Ehrgott and Forbriger's first venture into the chromo world, but it was the print that established their high standard of chromolithographic craftsmanship. This standard was maintained during and after the Civil War, in sheet-music covers and unbound chromo views.[20] "Edmund Dexter's Residence" is one example. Printed between 1861 and 1868, it is a five- or six-color chromo that combines skillful drawing and pastel hues to create a placid scene of gentility. Unlike many chromos displaying bright inks and lavish designs, the Dexter-house print is cool and restrained, in the tradition of Sarony and Major.

Plate 91.

Ehrgott and Forbriger is also notable for installing one of Cincinnati's first steam-powered lithographic presses—the firm claimed, in fact, to have the first one west of New York. According to one account, albeit unsubstantiated, this press was a "clumsy English model" that was replaced within a year by a press from France, which, unfortunately, "proved to be even clumsier than the first."[21]

The work of these various early lithographers set the stage by the start of the Civil War for the big business of chromolithography in Cincinnati. At least two of the six leading companies had begun to print colors lithographically in this boom town, where the new and untried energized the commercial life. According to an eyewitness, the lithographic firms of Cincinnati had grown from one in 1840, employing four men to produce $4,000 worth of lithographs, to four companies in 1850 and six in 1859. By 1860 the six lithographic businesses totaled about sixty-six workers and grossed $165,000. As a Cincinnati booster pridefully wrote, the twenty years before the Civil War saw a "continued advance in the art as respects taste in design and excellence in the finish of what is now executed here. It requires a good judge to distinguish some of our Cincinnati lithographs from steel engravings."[22]

Growth of Lithography by 1860

III. The Strobridge Firm

The 1860s brought both color lithography and steam printing to Cincinnati,

and over the next four decades millions of chromo reproductions were sent out from the Queen City to every region of the nation. While Cincinnati lithographers called themselves printmakers for the West and Southwest, the surviving records show that much of their business was in fact oriented to the East and Northeast. Writing about Gibson and Company, Charles Cist noted that in 1859 the business was spread "to a much greater distance than would be generally supposed; filling orders from points as distant as Canada and Nova Scotia."[23] This was also true of Cincinnati's other big chromo companies: Strobridge, Ehrgott and Forbriger, Krebs, Donaldson, and F. Tuchfarber.

"Oil Portraits" Middleton, Strobridge and Company led the way with its famous "oil portraits" of the 1860s. Washington, Lincoln, Grant, Webster, and other heroes were lithographed in "warranted" colors, designed to simulate oils.[24] Seldom technically comparable to the best of Louis Prang, the prints were nonetheless enormously popular until the early 1880s. They were at first intensely promoted by Elijah C. Middleton, who subsequently, in 1861, left the company to start business as a "Portrait Publisher" (1862). In 1863 he publicized himself as owner of a "Fine Art Gallery and Piano Room," then as a "Portrait Publisher and Dealer in Oil Paintings" (1864–68), and finally as the force behind "National Oil Portraits and Sacred Landscapes" (1873). Middleton operated by purchasing wholesale lots of his former

Duval on Middleton firm's chromos and selling them as art suitable for framing. P. S. Duval recorded: "In 1859, Mr. Middleton, a lithographer of Cincinnati, produced very fine portraits of Washington and a number of other eminent personages of the United States, which had great success; his agents represented him as the only one in the country who possessed the secret of this style of picture, ignoring what had been produced previously."[25] This last reference was to Duval's own chromo portraits of Washington and Lafayette, drawn by Christian Schuessele.[26]

*Growth of
Strobridge* The oil-portrait reproductions formed the foundation of a chromo empire. After a fire had destroyed the former Middleton-Wallace business, in 1866, the firm was rebuilt the next year, when it was named Strobridge.[27] New steam-powered presses were then imported from Europe, along with tons of Bavarian stones. All the usual products of a practical lithographer were turned out, as well as a few oddball items. The most extreme was a "Syn Chronological Chart or Map of History," which diagrammed the history of humankind, complete with names, dates, portraits, vignettes, and references to manners and customs from Adam and Eve to Rutherford B. Hayes. In its revised printing of 1878 this lithographic novelty measured twenty-two feet long and twenty-seven inches high, and was put on rollers to be wound in the style of an Oriental scroll.[28]

During the early 1870s Strobridge was most strongly identified with the

chromo oil portraits; for a time the firm used its Washington chromo as a logo on its stationery. After Washington followed a long list of chromolithographs, first the oil portraits mentioned earlier, then a line of products very similar to that of Louis Prang. The "Strobridge Co. Chromo Publishers and Lithographers" catalogue, published sometime between 1876 and 1880, is a rich index, eighty-two pages long. Measuring only five and a half by three and a half inches, it was printed in gold-colored inks on fine thin paper, with each chromo illustrated alongside an order number. Strobridge used these high-quality sales pieces for mass mailings, but today they are quite rare.[29]

Strobridge
Stock Chromos

The Strobridge catalogue mirrored the popular taste. It was made up of chromos of seascapes, desserts, women and flowers, the Founding Fathers, animals, rural scenes, holy sayings, quaint cottages, battles, landscapes, ships, children at play, people fishing, religious scenes, horses. All, of course, could be hung in the "chromo frames" that Strobridge advertised. The chromos were often promoted as exact reproductions of oil paintings, one best seller, for example, being a copy of *Three Celebrated Dogs—Don, Peg, & George*. The popular appeal of its subject matter was enhanced by the advertisement that the scene was "painted by C. Bispham, N. Y. The original painting in possession of Dr. Stracham of the N. Y. Kennel Club." Most of the Strobridge chromos were both of American subjects and originally painted by American artists; the company had its own version of the omnipresent *Esopus Creek,* which two other firms—Colton, Zahm and Roberts and Louis Prang—had also published. Occasionally Strobridge printed such exciting European subject matter as chariot races and the like: an example is "The Gladiators" (13 by 25 inches), after the popular painting *Pollice Verso* ("thumbs down") by the French artist Jean-Léon Gérôme. The chromo was enjoyed both for its drama and its pretense to classical high art.

Plate 92.

The Strobridge catalogue did not include prices, apparently because they varied according to the size of the order. To be found on separate lists, the Strobridge prices were strikingly lower than Prang's. In 1877 200 of the Gérôme "Gladiators" were sold to the New York agent of Jacoby, Max, and Zeller for $38, an average of 19¢ per copy![30] The buyer was a publisher and importer of chromos with an office in Berlin,[31] which shows that Cincinnati prints prospered even in a highly sophisticated market. Pairs of portraits of George and Martha Washington cost 10¢, while others were even cheaper.[32] A price list of bulk rates of 1877 gives the entire inventory:[33]

Low Prices

PRICE LIST

		Per 100
Gathering Primroses,		
	17 × 22,	$30 00
In the Woods,		
(From English Water Colors.)		
Brother Jonathan,	16 × 22,	20 00
Chariot Race,		
	13 × 25,	35 00
Gladiators,		
Perry's Victory		
	16 × 22,	25 00
Putnam at the Plough,		
Blush Rose,		
	16 × 20,	30 00
Two Doves,		
Morning on the Mountains (sheep),		
	11 × 16, . . .	25 00
Mid-day (cattle),		
(After celebrated German Paintings.)		
A Foggy Morning on the Banks,		
	14½ × 25, . . .	30 00
Off Boar's Head, Hampton Beach,		
(Copies of the much admired Marine Views, by D. Weber.)		
Esopus Creek, near Kingston, N.Y.		
	14 × 18,	25 00
Mt. Tom, from the Northampton Meadows,		
Feeding the Pigeons,	13 × 16,	25 00
Cross and Crown,	14 × 18,	25 00
Cross and Flowers,	13 × 16,	25 00
Early at the Cross,	13 × 16,	25 00
Monarch of the Glen,	13 × 16,	25 00
Maternal Affection,	13 × 16,	25 00
Cascade Falls,	13 × 16,	20 00
Fruit Piece,	13 × 16,	25 00
The Young Navigators,		
A Country Stile,		
	11 × 15,	25 00

English Cottage,
The Darling Babe,
 (After celebrated Water Colors, by Birket Foster.)
Blessings Attend Thee,

 10 × 14, 25 00

Joy be with Thee,
 (From E. D. Grafton, Designs beautifully executed and suited
 for placing in the oval any favorite photograph.)
Nature's Lessons,

 11 × 14, 25 00

L'Esperance,
 (From E. D. Grafton. Beautiful representation of Natural
 Flowers, for presentations.)
Flower Piece, 13 × 16, 25 00
 (Natural Flower Composition, by Miss Spencer.)
The Young Hunter, 10 × 13, 15 00
Winter Sunday in the Olden Time, 16 × 22, 25 00
The Wanderer, 12 × 15, 15 00
Feeding the Ducklings,
Angling,

 11 × 14, 15 00

The Water Lilies,
Sharing the Meal,
Polly want a Cracker, 11 × 14, 10 00
Pacing Abdallah, 16 × 22, 50 00
Planet and Asteroid,

 22 × 28, each, 2 00

Celebrated Alexander Horses,
Garden of Gethsemene,

 10 × 13, . . . per 100, 15 00

Mt. of Olives,
Christ Blessing Little Children, 10 × 12, . . each, 50
Asking a Blessing, 10 × 12, " 50
 (From F. O. J. Darley.)
Last Supper, 16 × 22, . . . per 100, 20 00
Bouquets, Nos. 1, 2, 3, and 4, . . . " 5 00
God's Acre,
Playing Doctor,
Little Domestic,
Little Grocer, 8 × 10, . . . per 100, 3 50
Good Brother,
Attention,
Monarch,

The Lord is my Shepherd,
Praise the Lord, 9½ × 25, $15 00
God Bless our Home,
Speak the Truth,
 10½ × 27, 30 00
Search the Scriptures,
George and Martha Washington, 10 × 12, square pictures,
 . . per 100 pairs, 10 00
George and Martha Washington, 10 × 12, . special, each 50
Mats for do., do., 20 × 26, . . . " 25
Blind Man's Buff, 19 × 24, . . . per 100, 25 00
 (A beautiful copy of David Wilkies' celebrated
 painting, in black only.)
Illustrated Floral Designs, for Rewards of Merit,
 Calling Cards, or Advertising purposes, . . per 100, 1 00
Limited number of the following beautiful Oil
 Portraits, oval, 14 × 17, . . . each, 50
LINCOLN, WEBSTER, CLAY,
 DOUGLASS, ANDREW JACKSON,
 GEN'L. GRANT, GEN'L. SHERMAN,
ROBT. E. LEE, STONEWALL JACKSON,
 JEFFERSON DAVIS, BEAUREGARD,
PRINCE ALBERT AND QUEEN VICTORIA,
 JOHN WESLEY, etc.

Small Orders It is unclear whether these low prices were available in lots smaller than a hundred, but numerous letters in the Strobridge files show that customers assumed they were. George W. Vore, of Henia, Indiana, ordered the following on May 11, 1877:

	Sizes	Prices
Christ blessing little children	10 × 12	½ ct.
Polly wants a cracker	11 × 14	10 cts.
Missing	18 × 22	1 ct.
Found	18 × 22	1 ct.
Bouquets No. 1, 2, 3, and 4	10 × 22	20 ct.
The Monarch	8 × 10	3 ½ ct.
The little grocer	8 × 10	3 ½ ct.
The two doves	16 × 20	[no price]
Putnam at the Plow	16 × 22	20 ct.

The Water lilies	11 × 14	12 ½ ct.
Angling	11 × 14	12 ½ ct.
Fruit Piece	13 × 16	20 ct.
Cross and crown	14 × 18	20 ct.
Cascade Falls	13 × 16	15 ct.
Drowning of Pharoah	10 × 12	5 ct.
Asking a blessing	10 × 12	½ ct.

As confirmation of the prices he quoted, Mr. Vore appended: "I expect you have almost forgotten about me. Writing to you but I have been delayed in getting the Money but I will send you the Postal Card that I received from you to show what you Promised me."[34] There are hundreds of similar letters.

The chromo years 1867 to 1880 brought great technical and commercial sophistication to Strobridge. Confidence in dealing with public taste became a Strobridge trademark. Reliability as a wholesale supplier was also established. As the company proudly advertised in 1877,

Strobridge's Expertise

> We respectfully invite the attention of Publishers, Art Dealers, Agents, and Canvassers, to . . . our popular Chromos. Our facilities for publishing Chromos are now unsurpassed by any house in the country, and as we carry our own Publications only, we are enabled to furnish them at lowest prices.
>
> Publishers or Art Dealers using Chromos in large quantities can have originals produced exclusively for their own use, or can secure the control of such as we publish, on specific agreements.[35]

The custom-made chromo was a common article of the 1870s. P. S. Duval, Julius Bien, Louis Prang, virtually all the American lithographers printed them to order. Many were commissioned by chromo dealers such as William Schaus, of whom, unfortunately, we know very little. As reported in chapter eight, he and others—Joseph Hoover in Philadelphia, F. Gleason in Boston, A. H. Eilers in St. Louis—often speculated on the public's taste by financing chromos they believed they could sell.[36] George Munro, of New York City, offered forty-nine chromos for forty cents each, all guaranteed to be "first class works of art" (see appendix two). The Strobridge chromo entitled "Distinguished Masons of the Revolution" was created in 1876 for J. Hale Powers and Company, "Fraternity & Fine Art Publishers"; Powers obviously saw the combination of the American centennial and the Strobridge hero images as irresistible to Masonic passions. It is one of Strobridge's masterpieces.

Chromos Made to Order

Plate 93.

In gambling on the public such middlemen ran risky businesses, and it

Plates 94a and 94b.

F. Gleason

is not always clear what their arrangements with printers were. One chromo, "Winter Sunday in Olden Times," offers some clues. The reproduction of an 1853 painting by George Durrie entitled *Going to Church,* "Winter Sunday" was first copyrighted in 1874 by Strobridge and Company. At the lower left-hand corner of that edition was printed "Strobridge & Co. Chromo Cin. O." and at the lower right the copyright date. One year later, however, the lower left was changed to read "Winter Sunday in Olden Times," while the right corner carried "F. Gleason, Boston," telling us that Strobridge probably sold Gleason the rights to the print after having first produced it for its own inventory.

At the time of the transfer, Gleason was advertising a "picture gallery," where he exhibited "over a million of most [*sic*] elegant and costly Oil Chromos. They are all of large size, and embrace some of the most magnificent works of art ever produced either in Europe or America."[37] Yet he proved to be an unlucky dealer to do business with. On May 31, 1877, Gleason notified Strobridge of his intention to file a petition in bankruptcy: "I regret being obliged to inform you that the terms of my composition with my unsecured creditors cannot be carried out."[38] Hines Strobridge thus found himself overstocked in Sunday snow scenes. He tried to unload some of them on another Boston dealer, J. Latham and Company ("publisher of popular chromos"), but Latham held the upper hand: "There is a large lot of his [Gleason's] goods under mortgage, and can no doubt be bought very low; they may possibly be thrown upon the market, and if so, it will be at a very low figure. We could not use Winter Sunday at 17¢, and do not think we could at 12¢ but perhaps could at that. We are somewhat afraid of these goods in [*sic*] account of this large lot under mortgage."[39] Having bought the prints, Latham within one month would also write a letter of regret: "we were unable to meet your note yesterday. We have had heavy payments and very little cash...."[40]

During the 1870s and '80s these chromo dealers operated in every large American city: Gleason and Latham in Boston; Joseph Hoover and the National Chromo Company in Philadelphia (Figure 16); Jacoby, Max, and Zeller in New York; J. F. Ryder in Cleveland.[41] Often they competed for exclusive rights to particular chromos. Chicago's Albert Durkee and Company (Figure 17), of 112 Monroe Street, contracted with Strobridge to sell the popular "Three Celebrated Dogs" in the Chicago area, but one of Durkee's competitors, William W. Kelly (Figure 18), won it away. Kelly had written Strobridge, "Let me know if you are yet free from your contract with Durkee concerning *3 Dogs,* if so we want some." A wounded Durkee agonized: "I have advertised and circularized your chromos far and near and here is Kelly advertising to supply agents with the same kind."[42]

The sale of chromo prints appears to have attracted a sleazy subset of

Figure 16. Storefront of the National Chromo Company, Philadelphia, as depicted on its 1877 letterhead. Location: Strobridge Papers, Cincinnati Historical Society.

Figure 17. Storefront of Albert Durkee, Chicago, as depicted on his 1877 letterhead. Location: Strobridge Papers, Cincinnati Historical Society.

Figure 18. Storefront of William W. Kelly and Company, Chicago, as depicted on its 1877 letterhead. Location: Strobridge Papers, Cincinnati Historical Society.

Chromo Peddlers peddlers—the job was open to anyone. Continually badgering the chromo companies for higher discounts on wholesale prices,[43] safer shipping containers, free of damaging nails (wooden boxes the exact size of the prints were used to crate big orders), and faster service, these salesmen traveled door to door with sample books, always attempting to extract advance payments from customers. It was an unstable job that could promise high rewards one week followed by failure the next. The turnover rate among salesmen must have been high. The Strobridge files bulge with letters of hope from novice agents.

From Aaron Ihantz[?], February 26, 1877:

> Gents enclosed please find $1.00 for chromos Perrys victory, Putnam at the Plow, Bouquet nos. 1, 2, 3, & 4 and "fruit", that is if you will let me have them at wholesale prices. . . . I want them for canvassing purposes. I intend to frame them [,] then go canvassing. I am a carpenter by profession. I can make my own frames.[44]

From John R. Fletcher, December 5, 1877:

> . . . You will probably remember me as formerly with . . . Smith & Co.; I am now in the medicine business alone and will probably use quite a quantity of chromos: will run teams in the country.[45]

From L. W. Fishe, October 25, 1877:

> . . . if I should take up the business of canvasing with some nice chromos I think I could sell a good many but I must buy them very low or I could not afford to travel.[46]

From William Fryer, February 26, 1877:

> We met one of your agents on Saturday (for your chromos). We were thinking of going into the business and he recommended us to write to you telling us you would deal fairly with us and the best of any he knows.[47]

Chancy Business And so it went, high hopes, profits, and bankruptcy, courtesy and cutthroat competition: the chromo world was a game of chance. It is not surprising that an enormous amount of money was spent in lawyers' fees to try to wring payments from reluctant customers.[48] Even such businesses as the aggressive Kelly's in Chicago (self-advertised as the "most extensive picture and frame establishment in America") often had difficulty paying its

printers' small as well as large bills. Names, partnerships, and addresses changed with the seasons, rendering city directories out of date the day they were published. Would-be chromo tycoons soon grasped the necessity of having a sixth sense for deciphering, anticipating, and molding public taste. Firms that remained in business for ten years or longer tended to be multi-staffed organizations with diversified product lines, and most depended on at least one prosperous customer who regularly settled his account. Though headquartered in one city, successful companies also had some form of business presence in other cities.

The Strobridge firm typifies the successful chromolithographer. Based in Cincinnati, with offices in New York and, for a time, in London, it produced posters for some of America's largest circuses; a thriving list of fine-art chromos; and a healthy variety of practical-lithographic products. A well-established, stable company by the mid-1870s, Strobridge seemed capable of surviving slumps in demand for any of its goods. Nevertheless, even this firm had its share of problems.

The gremlin was the capricious taste of the American audience, which made the production and distribution of chromolithographs a chancy proposition even for men with savvy and nerves of steel. By the 1870s most firms could print a picture that, from a technical point of view, would satisfy a broad sector of the public: stock popular subject matter combined with printing proficiency made up two thirds of the ticket to solvency. It was the third factor that proved to be the crunch: the unit cost. As in all publishing, short runs and limited orders sent prices up, while long runs lowered the price of a print. But long runs also demanded a larger investment. They were a risk, a high-stakes gamble that wrenched more than one chromolithographer from his rose-colored world to the black and often red reality of a balance sheet.

Risks in Dealing with Customers

Witness Strobridge's experience with one customer. Among that company's papers at the Cincinnati Historical Society lie numerous letters from the office of P. O. Vickery, "publisher of *Vickery's Fireside Visitor* and dealer in jewelry and watches." The letters are requests for large orders of chromos to be used as premiums for Vickery's periodical. Because Vickery was based in Augusta, Maine (the home town of mail-order catalogues), the Strobridge chromos had to travel northeastward more than fifteen hundred miles;[49] Vickery apparently found the Strobridge prices more appealing than those of Prang or Armstrong, or other large Boston printers. Throughout October, November, and December of 1877, Vickery bombarded the Cincinnati lithographer with orders:

P. O. Vickery

October 15, 1877—We shall have to send you a dispatch tonight for
1000 each of the new chromos as those by freight will not get here

before the 25th. You had better ship 5000 of the Ascension of Christ and 5000 of Spring Beauties by freight. . . . Also 500 of Queen of Flowers. . . . We shall give you heavy order [*sic*] in the course of a month and we hope you will keep a good supply on hand so all order[s] will be filled promptly.

October 16, 1877—. . . I wish to assure you, in the strongest *possible* terms, that our demand for chromos . . . will be *very far ahead* of anything we have ever had. We are fitting out *twice* the agents that we ever did before, and you *must* push along editions so as to get 25 or 30 thousand of each ahead. . . . Now, do the work well—*as well* as you have started, and I will give you a larger trade than any one firm ever did: but if you slight them, make them muddy or imperfect, it will damage my trade, and consequently yours. You may take this letter for an order for 25,000 of each *all* to be delivered before Feb. 1st. Don't think that number will near do it; but I state this to show you that I know what I shall want, so that you may prepare for it, & not disappoint me in any demand that I may make. . . .

Dec. 3, 1877—*All out* of chromos and orders *waiting—hurry up*. . . . Keep up the quality—some look bad—cannot send out poor ones— ruinous to you and me.

Dec. 3, 1877—Six thousand behind and growing worse. Send very much faster.

Dec. 12, 1877—Push those chromos along just as fast as possible. We are almost about 10,000 behind.

The P. O. Vickerys of the world are colorful characters, but doing business with them must have been harrowing! The calm, conservative Strobridge company found it difficult to believe Vickery's requests. Surely, when he ordered a thousand of this and a thousand of that, he meant one thousand *in all*. At one point Strobridge had written for verification, and Vickery exploded:

. . . If you cannot at once, push out enough to supply the 12,000 on back orders, and still give us not less than 2,000 per day to fill orders coming in, will you allow me to duplicate them at Armstrong's in Cambridge. . . . Please let me know *at once* if you *cannot* make arrangements to give us at-least 3,000 per day for 50 days—after that, perhaps 2,000 per day will do. . . .
 You see my needs *now*, if you have the capacity to help me out: do so: if not,—give me a chance to do so myself before my business is ruined.[50]

Strobridge chose the former. To supply Vickery's army of salesmen—he claimed nine thousand agents—the Cincinnati presses ran full steam. It was a gamble Strobridge lost. In 1878 Vickery's chromo balloon burst. Having originally hesitated to print too far ahead of demand, Strobridge suddenly found its warehouse flooded.

The Strobridge board in January 1879 reported the experience in a slightly defensive tone:

> The business of the past six months has not turned out to be as favorable as was expected owing mostly to the failure of P. O. Vickery to take and pay for the large amt. of chromos we had assurances from him he would want. In anticipation of these orders and our being required to print enough in advance we accumulated a large number of chromos which he failed to order, as had been his custom for several previous years. We have made at this date upwards of 50,000 of his Chromos.[51]

Nevertheless, in spite of problems of this kind, Strobridge retained its position as a leader in American chromolithography into the twentieth century.

IV. Strobridge's Competition

The growth of the lithographic industry in the Queen City was phenomenal. *The Industries of Cincinnati* reported in 1886 that cash value for one year's production totaled $650,000. By 1901 the figure stood at close to $2,000,000.

To compete with Strobridge, the other Cincinnati companies engaged in diverse activities. Ehrgott and Forbriger, printers of "Edmund Dexter's Residence," followed a typical path: Civil War and national-hero lithographs in the 1860s, reorganization in 1869, then huge chromolithographic success in the 1870s. Their "President Lincoln Writing the Proclamation of Freedom, Jan 1st, 1863" was chromolithographed in 1864 after a painting by David G. Blythe.[52] It does not match the chromo standards of the Dexter print, but it appears to have been a popular reproduction. A second chromo, "Our Father,"[53] was in the mode of the Strobridge religious prints.

After Adolph Forbriger died in 1869, the dynamic Adolph Krebs joined the company. Born in Germany in 1831, he had landed in New York in 1847 and then migrated to Cincinnati, where he learned the lithographic business from one of Cincinnati's earliest firms, Rowse and Scherer. Krebs then moved to Pittsburgh in the early fifties, where he established his own company, with his brother Otto, in 1855.[54]

The story of lithography in Pittsburgh in the early fifties was similar to

that of Cincinnati in the preceding decade. A fire had gutted Pittsburgh in 1845, after which the lithographic business got its start. Brought in by French and German immigrants and stimulated by the demand that came with the Civil War, lithography became an arena for brisk competition—particularly between the Krebs brothers and the practical lithographer William Schuchman. When Adolph Krebs returned to Cincinnati in the sixties, Otto stayed on in Pittsburgh, bidding for jobs against the city's other practical lithographers, J. B. Duff, A. Hani, William G. Armor, and Charles Gillespie. In 1871 Otto published a giant view, "Pittsburgh & Allegheny," which appears to have been printed with four stones and then finished by hand in watercolor. In this instance he was assisted by one of his competitors, William Armor, an artist and lithographer who deserves a much broader reputation than he has.[55]

Meanwhile, back in Cincinnati, Adolph Krebs had entered into a growing lithographic partnership with Peter Ehrgott. Together they featured their talents in chromolithography.[56] In 1873 they produced one of their more unusual chromos, "Pork Packing in Cincinnati," which was made up of "the Cartoons exhibited by the Cincinnati Pork Packers' Association, at the International Exposition at Vienna." A year later Ehrgott resigned from the partnership. Renamed the Krebs Lithographing Company, the firm continued to grow. A Cincinnati booster described the business in 1875: ". . . Krebs Company occupy two . . . large floors. . . . [They have the] best lithographing . . . machinery and their work includes every variety of lithographic and chromolithographic productions. . . . In fine color printing the firm ranks second to none in America."[57] Among many different kinds of jobs that Krebs performed were 110 illustrations "in oil colors" for George Moerlin's[58] *A Trip Around the World* (1880). With a branch office in Chicago, the company reportedly had a work force of 135, and the capital stock at the time of incorporation, 1882, came to $100,000.[59]

The use of chromolithography in Cincinnati to reproduce oil paintings and watercolors declined in the mid-1880s, but it did not cease until the turn of the century. *Williams' Cincinnati Directory* for 1888 contains an illustration of the Krebs building with "CHROMOS" emblazoned on it, and the listing under "Chromos" in that directory has the names of ten companies, as well as the Queen City Varnishing and Mounting Company, "mounters & framers of . . . chromos." The chromo category was maintained in the city directories until 1895, if not longer.[60]

During this later period the firm F. Tuchfarber was producing some of the most outstanding chromos in Cincinnati's history. Kenny's *Illustrated Cincinnati* described Tuchfarber as being "engaged in the manufacture of Enameled Iron Show-cards and publishing works of art."[61] The book continued:

These signs and show-cards have become so popular on account of the

superior finish imparted to them that the firm is fairly overwhelmed with orders from almost all of the large cities of the United States. . . .

The beauty of some of the show cards, railway and other placards . . . is so great as fairly to entitle them to rank among works of art. Many of them are, in fact, not merely ordinary placards, but carefully executed copies . . . of the designs of talented artists. . . .[62]

Among these works were two extraordinary chromos, "The Old Violin" (1887) and "A Royal Flush" (circa 1899). Frank Tuchfarber purchased the oil painting *The Old Violin* in 1886 from its creator, William Harnett, at the thirteenth Cincinnati Industrial Exposition.[63] Such industrial shows commonly exhibited paintings—often their own chromo posters are artistic gems. Tuchfarber must have been deeply impressed by the popularity of Harnett's painting. As the Cincinnati *Commercial Gazette* explained, "It is hung upon the north wall, but visitors need no guide-post; they will find it by following the crowd." He must also have made an early visit: *The Old Violin*, noted one reporter, was "sold as soon as it was unpacked, and at his [Harnett's] own price"—$250.[64] Part of the picture's charm was the juxtaposition of subject matter: the barn door, the huge iron hinges, the violin, a letter in an envelope with a foreign address, and a news clipping all seemed down-home yet were incongruous. But what the public really loved was the painting's three-dimensional reality. Spectators would bet with one another, Is the bit of newspaper real? An elderly musician supposedly tried to take the painted fiddle down from the wall to play it. A reporter for the *Commercial Gazette* confessed, ". . . the newspaper clipping is simply a miracle. The writer being one of those doubting Thomases who are by no means disposed to believe their own eyes, was permitted to allay his conscientious scruples by feeling of it, and is prepared to kiss the book, and s'help me, it is painted." [65]

The Old Violin symbolized several of Tuchfarber's interests. First, of course, it served his business needs, since the chromo he made from it could be used as both a sign and a fine-art reproduction, to be sold profitably. But it was the subject matter that personally intrigued him. Tuchfarber had worked to found the Cincinnati Grand Orchestral Company (later, the Cincinnati Symphony Orchestra) and, according to one account, he experimented for years with violin varnishes.[66]

Tuchfarber's chromos were often printed on metal, though no metal versions of *The Old Violin* are known to exist. He also printed brightly colored lithographs on glass, which is one way "The Old Violin" was lithographed; copies of this version are extremely rare.[67] Large chromolithographic copies on paper are more common. While doing research for his excellent book on William Harnett, Alfred Frankenstein discovered:

Plate 97.
Plate 98.
William Harnett and The Old Violin

Popularity of Violin

Tuchfarber's Interest in Violin

Different Printing Media of "Violin"

Today [1969] in thousands of American homes, barrooms, restaurants, music stores, barber shops, and amusement parks hang copies of the magnificent chromolithograph of this painting produced in 1887 by its first purchaser, Frank Tuchfarber of Cincinnati. I have seen the Tuchfarber chromo in Vermont junk shops, in the proudly modern office of the president of the Musicians' Union in Detroit, and in the Rosicrucian Library at San Jose, California; for some inexplicable reason, it seems to be particularly prevalent in Colorado.[68]

Different Editions of "Violin"

The surviving paper prints, made from a minimum of seventeen plates, were glued to canvas.[69] In some copies the more-real-than-real newspaper clipping carries the name of Tuchfarber's lithographic artist, "Gus Ilg: An.," but the absence of the name on most copies shows that it was rubbed away from the stone before the majority of the prints were made. Also, some of the "Violin" chromos do not carry the Tuchfarber name at all, reading rather, "Donaldson Art Sign Co. Publishers, Cov., Ky." The date, 1887, is the same on both editions. Did Tuchfarber print the chromo for Donaldson? Did Tuchfarber sign the prints for one run, then change the credit line? Did Donaldson purchase the right to the stones from Tuchfarber after Tuchfarber had run his own first edition? Did Donaldson or even Tuchfarber intend or actually use Harnett's picture as an "art sign"? The questions remain.[70]

As in the Prang chromolithographs, the Tuchfarber print is very close to the original—but it is by no means a precise copy. Many of the music notes in the lithograph are incorrect; played, they would sound like nonsense. Harnett, however, knew music, so that his painted notes *are* correct. This change made by Tuchfarber is a useful way to determine if a subsequent "Violin" chromo, or painting, has been copied from Tuchfarber or from the original painting.[71]

"A Royal Flush"
Plate 98.

The other remarkable Tuchfarber chromo, "A Royal Flush," was printed sometime in the late 1890s, but little else is known about it. Its title does not fit the typical chromo genre. A vivid collage of odd objects, it looks like an advertisement for a company calling itself "Fine Art Publishers." But how was it used? What did it really mean? Why the depiction of Confederate money? It is one of Cincinnati's contributions to the myriad of chromo mysteries.[72]

10

GROWTH AND SPECIALIZATION

CHROMOLITHOGRAPHY STARTED as a handicraft and ended as a corporate industry. In this it followed the path of most manufacturing in the nineteenth century, and the ramifications of such growth bear examining.

I. Specialists, Factories, and Corporations

In most nineteenth-century crafts as well as industries the growth in output brought a rapid increase in specialization. Lithography was no exception. From the multitalented artist-lithographer of the 1820s to the narrow technician of the 1890s, the trend was clear: in 1902 Charles Hart, a New York lithographer who had served his apprenticeship under George Endicott in the late 1830s, defined the early lithographer as "one who could do everything in the business, from the grinding and the graining or polishing of the Stone, to the making and printing of the drawing and lettering."[1] Producing black-and-white lithographs in limited runs, the generalist in his small shop could survive, but chromos churned out by the tens of thousands required a factory of machinery operated by specialists. Thus, the generalist had disappeared, and not until the revival of so-called artistic lithography after World War II would it be typical again for one person to carry out every stage of the lithographic art. As the *American Dictionary of Printing and Bookmaking* observed in 1894, "There are many subdivisions among the workers, and the tendency is more and more to make each a trade, the man employed at one knowing nothing of other work."[2] In the late 1880s H. T. Koerner, secretary of the infant National Lithographers' Association, outlined sixteen broad divisions of labor within a lithographic firm: "artists' foremen, artists, provers and provers' assistants, transferrers and transferrers' assistants, power-press printers, power-press feeders and power-press assistants, stone grinders and grainers, ink-grinders, drying-room help and stock-room help, paper handlers and cutters."[3]

Generalists in the 1820s

Sixteen Divisions of Lithography Specialists by 1890

Figure 19. Detail from a billhead of F. F. Oakley Lithographic Company, 1857. The worker, who is standing, is drawing on a lithographic stone; the gentlemen seated appear to be discussing the picture on the stone before them. Location: Warshaw Collection of Business Americana, National Museum of History and Technology, Smithsonian Institution, Washington, D.C.

Shop Designs Reflect Specialization Views of lithographic-shop interiors are rare, but even the few idealized illustrations that do exist demonstrate the logic of Koerner's classification. Details from the billhead of the F. F. Oakley Lithographic Company, of Boston, depict printers in a pressroom in the foreground, with sheets of paper drying on lines in the background (Figure 10); a second vignette presents lithographic artists at work on the stones and discussing their drawings (Figure 19). Printed in 1866, these scenes show that even as early as then the design of lithographic shops was being conceived—akin to the assembly line—to serve the successive stages of print production. Compared with an older, 1836 view of a lithographer's shop in Edward Hazen's *The Panorama of Professions and Trades* (Figure 20), in which there is no ordering of the various lithographic procedures, the Oakley scene attests to a dramatic step taken toward specialization.

But, evolved though it was, the Oakley shop was only a rudimentary beginning. A factorylike atmosphere had already emerged in a view of the shop of Wagner and McGuigan, as portrayed in a broadside of 1856 (Figure 5).[4] This Philadelphia firm employed up to forty pressmen,[5] all working on similar presses, and the scene shows young workers, presumably apprentices, wheeling the heavy stones on little cars to and from the art rooms. Eighteen years later, in 1874, Louis Prang published a chromo from his *Trades and Occupations* series entitled "Lithographer" (Figure 21). Here we see specialization even more clearly delineated. One man is grinding a stone, a second is drawing an image on a stone, a third is inking a stone on a hand-operated

proofing press, and a fourth, deep in the background, is tending a steam-powered press.[6] Such division of labor is carried yet a further step in a detail from the 1875 advertisement of the Krebs Lithographing Company, of Cincinnati: a foreman, a printer, and an assistant each has his individual duties in the operation of the press (Figure 22). By the 1890s many of the

Figure 22. Detail from a billhead of the Krebs Lithographing Company, Cincinnati, 1875: a steam-powered lithographic press, complete with belting. The three men apparently have distinct tasks: 1) a foreman-printer, 2) a feeder (standing on the platform), and 3) a young man, perhaps an apprentice, receiving the finished work. Location: Warshaw Collection of Business Americana, National Museum of History and Technology, Smithsonian Institution, Washington, D.C.

large lithographic companies comprised several self-contained departments, each with its own foremen, journeymen, and assistants. As four halftone interior views of Philadelphia's Ketterlinus Printing House demonstrate in the *Lithographers' Journal* of February 1894,[7] each such department was arranged and operated like a little business in its own right.[8]

Wages The wages of the lithographic specialists are difficult to determine. Statistics are scarce for the pre–Civil War period, and for the years 1865 to 1900 the data are inconsistent, confusing, and often unreliable.[9] There are federal decennial census reports that give manufacturers' aggregate yearly wages paid (which are extremely low) that can be used to figure trade averages:[10] in 1850 162 lithographic workers earned $51,288, averaging a little more than $6 a week; in 1860 786 workers earned $338,868, averaging between $8 and $9 a week; in 1870 all printmakers (lithographers, engravers, et al.) were classified together, totaling 8,894 workers earning $3,438,089, an average of almost $7.50 a week; in 1880 4,322 lithographic workers earned $2,307,302, averaging more than $10 a week; and in 1890 lithography and engraving were combined for a total of 10,599 workers, who earned $7,147,174, a weekly average of almost $13.[11]

These statistics can provide only a general impression and must be used cautiously. First of all, they are based on information supplied by only a

portion of the firms; in 1880, for example, there were at least 400 lithographic companies in America, but that year's census reports only 167. Secondly, wage averaging does not indicate the ranking of specialists within a trade. In 1894, for instance, the National Lithographers' Association reported the following schedule of average wages paid to specialized lithographic workers in New York City:

	Weekly wages	Hours per week
Crayon artists	$28.00	47
Transferrers	$28.00	53
Provers	$26.00	53
Printers	$25.62	53
Feeders	$ 9.00	53
Boys and apprentices	$ 6.00	53
Foremen	$52.60	53[12]

Although these figures average at $25.03, almost double those of the 1890 decennial report, they do not reflect the varying individual circumstances that this list reveals. Furthermore, each wage listed is itself only an average, so that the best artists—usually the highest-paid lithographic workers— would have laughed at a salary of $28 a week. As early as 1881 Matt Morgan, an artist who had joined Strobridge in 1878 after a stint with the magazine publisher Frank Leslie,[13] enjoyed a weekly income of $200.[14] Even lesser artists were then paid by Strobridge as much as $100 a week.[15] Some lithographic workers were paid for "piece work,"[16] and others received special compensation not recorded on either the census or the National Lithographers' report. Adolph Rimanoczy, for example, a portrait painter living in England, was hired in 1883 by the Strobridge company: in order to get him to Cincinnati the board of directors had had to agree to "enter into a contract for 3 years at 125 per week for regular hours, extra time to be paid for at same rate . . . to pay ½ the expense to New York of himself, wife and five children, & to employ his oldest son [Otto] at a salary equal to that which we are paying for equally good work." (Rimanoczy's requests for one-half sick pay and two weeks' paid vacation were refused.)[17] Since Strobridge doubtless paid competitive wages, Rimanoczy's contract must not have been atypical of those drawn up by other companies with their star artists.

Artists' Wages Highest

During the entire chromo civilization, wages in America were much higher than in western Europe. Chronicler Charles Hart saw the pay scale in the United States as a magnet for ambitious European lithographers: "There was a time when not one German printer existed in New York . . . [but] a short time before 1850, the knowledge that lithographic printers in New York

American Wages Higher than European

were securing two dollars a day against forty and fifty cents a day in Germany had attracted many German printers to the United States."[18] By the start of the Civil War the migration across the Atlantic had become so large, Hart remembered, that many lithographers "could not speak or understand English."[19]

Departments of a Lithographic Business

The specialists in the big, well-established lithographic businesses were usually organized into three sections: production, bookkeeping and general business, and sales.[20] (A variation on that three-part structure is humorously depicted in a cut by the Dickman Jones Company in *Langley's San Francisco Business Directory* of 1888: we see "our artist" at the easel, "our

Sales

printer" at the press, and "our hustler" out hustling chromos.) In sales the turnover rate, just as with the independent peddlers described in chapter nine, appears to have been great. The company salesman's topsy-turvy life of new promotional campaigns almost every day, of trying to sell nonutilitarian goods to practical, frugal Americans, of riches one day, empty pockets the next, kept the want ads filled with notices for "lithographic solicitors." A typical classified in 1893 read:

> WANTED . . . Two first-class representatives who are well connected, thoroughly experienced, and have an established trade in fine art color lithography and art publications, one as superintendent of sales for Eastern territory, and the other for a similar position in Chicago and contiguous territory; also three first-class experienced and reliable general solicitors in the same line; also an experienced salesman in the same line who has an established trade among Eastern brewers, especially in New York. . . .[21]

The talented salesmen eventually wound up in management, sometimes even in the owner's seat. There is a tone of regret in Otto Heppenheimer's letter to a friend in 1879: "Alas," he wrote from the New York headquarters of lithographers Heppenheimer and Maurer, ". . . I am now bound to the office and my brother Charley has taken my place on the road."[22]

General Business and Bookkeeping

The structure of the business and bookkeeping staffs varied greatly among the companies. In fly-by-night outfits, one person seems to have handled all correspondence and filling of orders, as well as the paying and receiving. By contrast, more prosperous companies employed fairly large office staffs. Louis Prang in 1885 had about a hundred fifty women and girls examining, sorting, mounting, and mailing his chromos.[23] Letters written to the Strobridge firm during the late 1870s (now in the Cincinnati Historical Society) suggest a huge correspondence that demanded personal attention, and at Strobridge packing and shipping were also specialized. (By the 1870s wooden boxes were used, custom-made to the size of the chromos; as mentioned

earlier, the fit was so precise that, in the case of Strobridge, the nails anchoring the lid to the sides occasionally punctured the borders of the prints.)[24]

Linked inevitably to the growth and specialization of the lithographic business was the depersonalization of the firms. Trade cards and letterheads from the 1830s, '40s, and '50s show that firms were predominantly named for individuals: P. S. Duval, E. B. and E. C. Kellogg (Figure 23), Sarony, Major and Knapp. But, while many of these company names survived throughout the postwar decades (Figures 24 and 25), more and more firms were being incorporated under geographic or "poetic" labels: the Providence Lithographic Company (Figure 26), New England Lithographic Company

Incorporation and Depersonalization

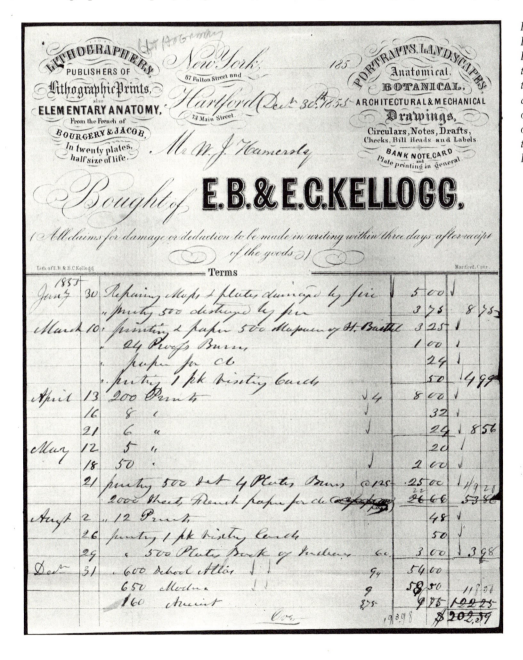

Figure 23. Billhead of E. B. and E. C. Kellogg, Hartford, 1855. Location: Warshaw Collection of Business Americana, National Museum of History and Technology, Smithsonian Institution, Washington, D.C.

(Figure 27), Phoenix Lithographic Company (Figure 28), American Chromo Company,[25] National Chromo Company. Expanding rapidly, some firms outgrew their regional identity as they sought to broaden their market; Strobridge went as far afield as New York and London, particularly in the area of circus and theatrical posters—as an indication of its expansion, in 1876 Strobridge declared a profit of approximately $12,000, ten years later clearing close to $50,000.[26] Other firms lost their individuality by absorbing their competitors in the same survival of the fittest that governed railroads, oil, and banking. Partners changed as in a country square dance, each firm attempting to call the steps of the trade. In short, company names had ceased to carry much personal connotation.

*American
Lithographic
Company*

The establishment of the American Lithographic Company serves as a prototype. On Friday, February 5, 1892, the New York *Herald* announced that the Knapp Company, of New York, had bought out much of its Eastern competition and now issued stock in the name of the American Lithographic Company. The *Herald* phrased it aptly when it wrote, "The firms that will . . . lose their identity are. . . ." Personal names were devoured by the new corporation: George S. Harris and Sons, of Philadelphia, F. Heppenheimer's Sons, of New Jersey, Donaldson Brothers, of Brooklyn; New York City's Giles Company, Linder, Eddy and Clauss, Witsch and Schmidt, G. H. Bulk and Company, and Schumacher and Ettlinger now made up the trust that

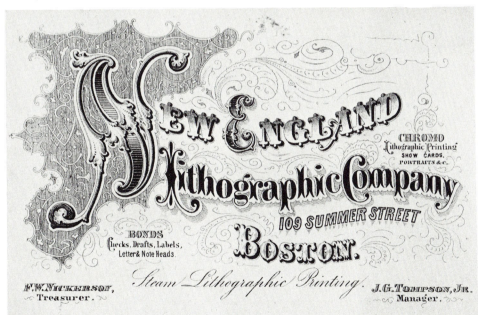

Figure 25. Billhead of Henry Seibert and Brother, New York, c. 1863. Location: Warshaw Collection of Business Americana, National Museum of History and Technology, Smithsonian Institution, Washington, D.C.

Figure 26. Trade card of the Providence (R.I.) Lithograph Company, c. 1893. Location: Warshaw Collection of Business Americana, National Museum of History and Technology, Smithsonian Institution, Washington, D.C.

Figure 27. Advertisement of New England Lithographic Company, Boston, c. 1868. Location: Warshaw Collection of Business Americana, National Museum of History and Technology, Smithsonian Institution, Washington, D.C.

was capitalized at $11,500,000. Although this happened late in the chromo story, the formation of the American Lithographic Company serves as a compelling example of the direction the printing business took in the nineteenth century.[27]

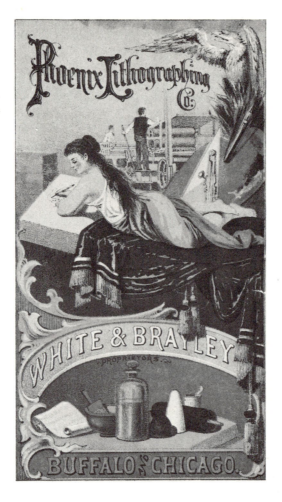

As early as the sixties the print shops of the chromolithographers, a far cry from artists' ateliers, were large factories, so called.[28] Pelletreau and Raynor, of New York City, described their establishment as a "Chromo Lithographic Manufacturing Company."[29] Many firms, proud of their three-, four-, and five-story facilities, featured the buildings as logos on letterheads, trade cards, and fliers (Figures 29, 30a–c, 31, 32, 33, 34, 35, 36, 37, 38, 39, and 40).

By that time the idea was firmly grounded that efficient lithographic companies required specially designed buildings in order to operate. Pressrooms that could support the weight and withstand the vibration of the steam-powered machines, good power sources safely removed from the highly inflammable printing materials, well-equipped studios, all were necessary. Sarony, Major and Knapp, of New York, publicized their facility at 449 Broadway in the early 1860s:

> We occupy three floors, 200 feet in length by 25 wide, which afford sufficient space for all the various processes required. . . . The first floor contains some 40 lithographic presses, arranged side by side under

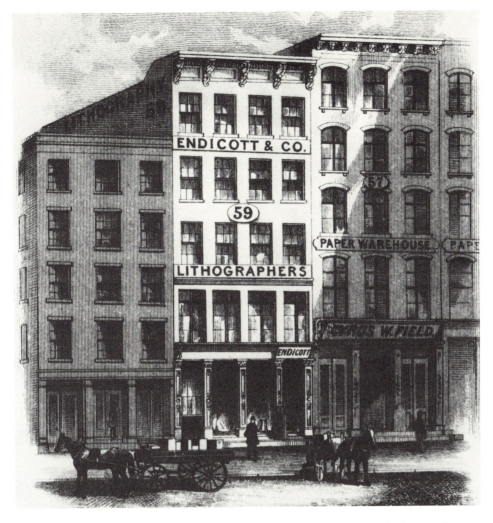

Figure 29. Detail of the building of Endicott and Company, Practical Lithographers, 59 Beekman Street, New York, c. 1862. Source: Leaflet printed on both sides, Warshaw Collection of Business Americana, National Museum of History and Technology, Smithsonian Institution, Washington, D.C.

an oblong sky-light, giving ample room and superior light for perfecting this very important branch of printing. Our upper floors are devoted to the preparing of stones, printing heavy work, and for artists' rooms, where the designs are wrought upon the stone.

In the front portion of our first floor, which is devoted to a Business Office and Specimens Room, are exhibited many beautiful specimens of our work.[30]

Louis Prang's Factory

Louis Prang's "printory," as he called it, in Roxbury, Massachusetts, was one of the earliest custom-built "factories," having been constructed in 1867 as the "largest . . . in the world, trebling in extent and facilities the largest chromo establishment in England" (Figure 41). The twenty-horsepower Corliss engine, forty-five presses (about twelve were steam-powered), and ninety workers were housed in a three-and-a-half-story building, measuring eighty by thirty-four feet and covered with a "French roof." In addition there were two annexes, each measuring twenty by thirty feet. Screw pas-

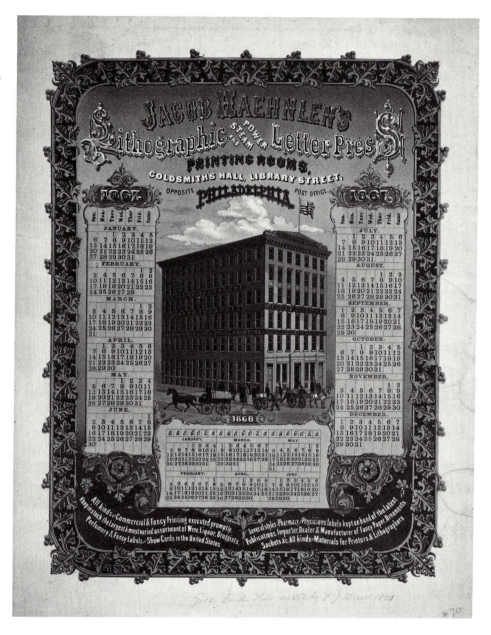

senger and freight elevators connected all floors. Unworked stones were stored on the ground level, while stones with artwork were kept in a fireproof vault. The second floor was the pressroom. There two rows of presses were supervised by a foreman, who worked out of a separate office. From his vantage point, noted one reporter, "he can sit and through the glass partition watch the swift-moving presses and the busy figures of the pressmen, or turning treat his eyes to a charming outlook of trees and sky and pleasant houses." As for orderliness, the reporter wrote, "Everything in the press-room is neat . . . and the work goes on as if by clockwork." On the third story were the main offices, Prang's private room, the art studio, and

STEAM POWER LITHOGRAPHIC AND
LETTER PRESS PRINTERS
Library Street, Goldsmith's Hall, Opp. Post Office,
PHILADELPHIA.

Figure 30b. Detail from a billhead of Lehman and Bolton, Philadelphia, 1874. The building is Goldsmith's Hall, on Library Street. In 1867 the building was owned by printer Jacob Haehnlen, who claimed it was the largest lithographic factory in America (Nicholas B. Wainwright, Philadelphia in the Romantic Age of Lithography, p. 90). The Haehnlen sign is visible in this view. Perhaps Lehman and Bolton simply rented "printing rooms" to produce their "chromos" (Lehman and Bolton trade card, Warshaw Collection). Location: Warshaw Collection of Business Americana, National Museum of History and Technology, Smithsonian Institution, Washington, D.C.

the famous picture gallery. On the half story above was the finishing room, where chromos were mounted, framed, sized, and varnished.[31]

Other printers quickly followed Prang's example.[32] The Strobridge firm in 1875 agreed to lease a custom-built factory, one that had not even been erected. The builders' proposal is described in the minutes of the board of directors:

> Wm. Sumner on the part of himself and John R. Wright proposed to erect a six story brick & stone building on the corner of Race & Burnets streets purposely adapted for the business of Strobridge Co.

Figure 30c. Detail from a billhead of Lehman and Bolton, 1875. Less than one year later, Goldsmith's Hall is shown with Lehman and Bolton's own sign. Location: Warshaw Collection of Business Americana, National Museum of History and Technology, Smithsonian Institution, Washington, D.C.

Figure 31. Trade card: factory of the Genesee Lithographic Company, n.d. Location: Warshaw Collection of Business Americana, National Museum of History and Technology, Smithsonian Institution, Washington, D.C.

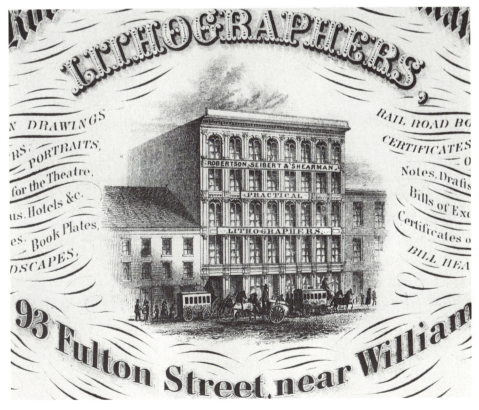

Figure 34. Trade card: detail from Hall and O'Donald Lithographic Company, of Topeka, n.d. Location: Warshaw Collection of Business Americana, National Museum of History and Technology, Smithsonian Institution, Washington, D.C.

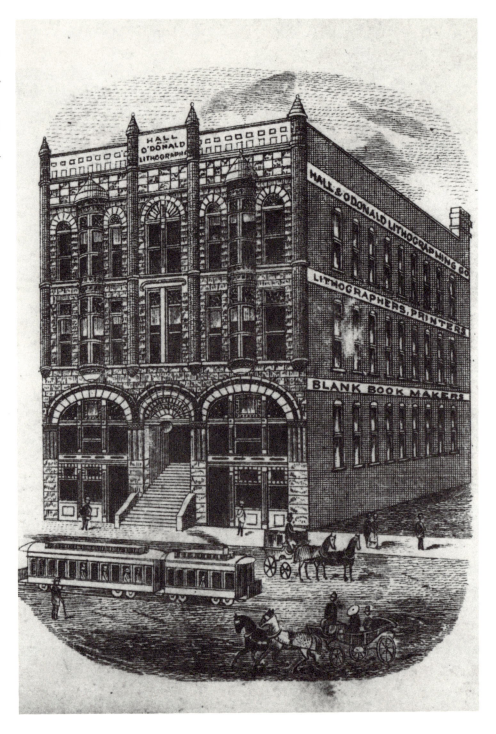

with all modern improvements including a boiler of large enough capacity . . . to supply the power for machinery & heating the entire building and including the necessary pipes in each story for that purpose & also to furnish a Hoisting Machine, Water Closets &c. . . . to agree to lease the entire building to said Strobridge Co. for a period of ten years at the rate of fifty-five hundred ($5500) Dollars per annum.[33]

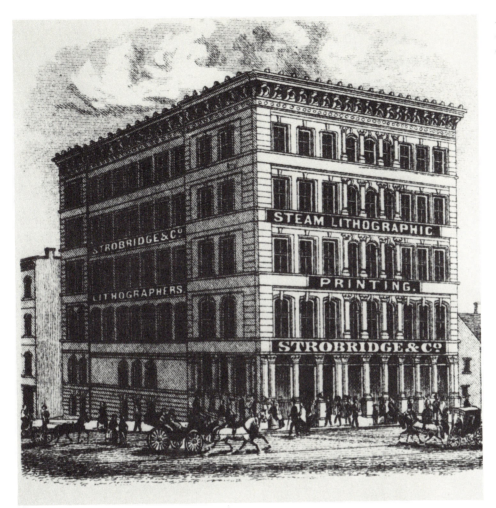

Figure 35. Detail from a billhead of Strobridge and Company, Cincinnati, 1872. Location: Warshaw Collection of Business Americana, National Museum of History and Technology, Smithsonian Institution, Washington, D.C.

All over the country newspapers, magazines, and urban-booster publications documented similar lithographic establishments. By the 1880s modern plants were well lighted—some sporting a few electric lamps—with large windows and swinging transoms. Steam heat, automatic sprinklers in case of fire, elevators, brass waterpipes, brick walls, and concrete cellar floors all contributed to the ideal facility.[34]

II. The Apprenticeship System and Its Decline

Thus, the trend from 1860 to 1900 was toward bigger factories, greater specialization, and massive corporate entities. A victim of this pervasive growth was the apprenticeship system, whose decline created the serious problem of how to train young would-be chromolithographers.

Before the Civil War the apprenticeship system had served to transfer skills from one generation to the next. Contracts varied in detail, but the scraps of surviving evidence indicate that most apprentices were at least fourteen years

Terms of Apprenticeship

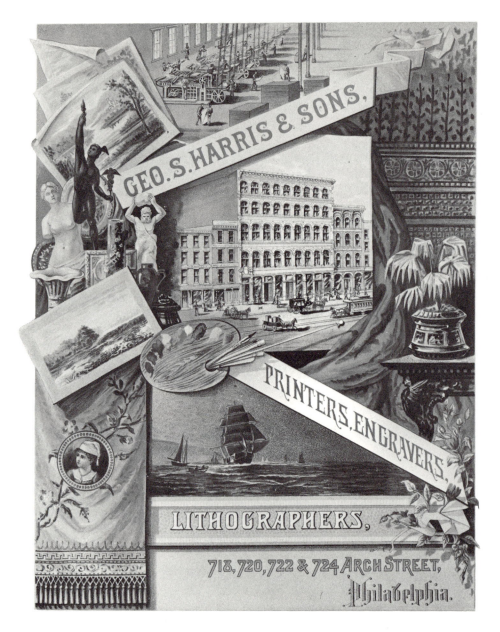

Figure 36. Advertisement of George S. Harris and Sons, Printers, Engravers, Lithographers, c. 1890. Location: Warshaw Collection of Business Americana, National Museum of History and Technology, Smithsonian Institution, Washington, D.C.

old; that they received room, board, and some general schooling; that some of them were paid from $50 to $300 a year; and that their term was four to five years. In return for working for the master, the apprentice received instruction in the secrets of lithography.[35] James Queen's contract with the Lehman and Duval Company, dated November 24, 1835, reads in part:

> James Queen, by and with the consent of his best friend Bernard Fitzsimmons, puts himself apprentice to George Lehman and P. S. Duval trading under the firm of Lehman and Duval, and to the survivor of them and in case of the disposition of said firm, then to the partner who shall be designated by them, to learn the art, trade, and mystery of Lithographic Draughtsmanship—four years, five months, and six days.

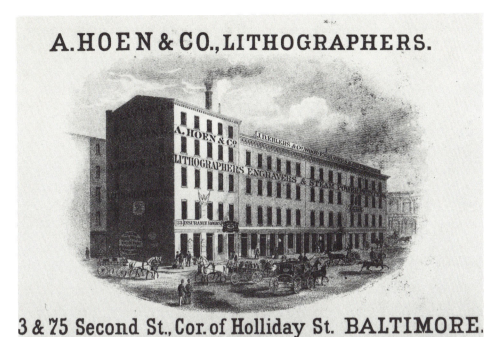

A.HOEN & CO., LITHOGRAPHERS.

3 & 75 Second St., Cor. of Holliday St. BALTIMORE.

Figure 37. Detail of the A. Hoen and Company building, Baltimore, as printed on an advertisement, c. 1877. Single sheet, printed both sides. Location: Warshaw Collection of Business Americana, National Museum of History and Technology, Smithsonian Institution, Washington, D.C.

Figure 38. Detail from the letterhead of the Henderson Lithographing Company, Cincinnati, 1897. Location: Warshaw Collection of Business Americana, National Museum of History and Technology, Smithsonian Institution, Washington, D.C.

. . . [They] will give him four quarters night schooling during said term and when finished will grant him a suit of freedom.[36]

This system survived the Civil War. A Strobridge contract from 1867 recalls Queen's of thirty years earlier:

Strobridge Co. agree to give Alfred Heyne such opportunity as is generally afforded in Similar Establishments to learn the art of Engraving on Stone, and give such instruction as will aid him in acquiring said art and agree further to pay him the Sum of one Dollar per week for the first

Postwar Apprenticeship

Figure 40. Detail from a billhead of the Forbes Lithograph Manufacturing Company, Boston, 1899. Location: Warshaw Collection of Business Americana, National Museum of History and Technology, Smithsonian Institution, Washington, D.C.

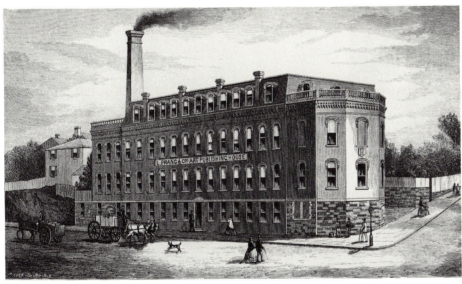

Figure 41. L. Prang and Company's factory in Roxbury, Mass. From The Aldine, *May 1869, p. 39. Location: Library of Congress, Washington, D.C.*

year of this agreement commencing Jany. 1, 1867 and for the second year three Dollars per week ending Dec. 31, 1868 and for the third year four Dollars per week ending Dec. 31, 1869 and for the fourth year Six Dollars per week ending Dec. 31, 1870 and for the fifth and last year Eight Dollars per week ending Dec. 31, 1871 provided said Alfred Heyne performs well and truly all that may be herein agreed to. . . .

Alfred Heyne on his part agrees and binds himself to make good use

of his time during said term of agreement in learning the art of Engraving, and rendering good service of his abilities to Strobridge Co. his Employers, and agrees to be at the shop at all times during business hours. . . .[37]

Strobridge made similar contracts until the 1880s.[38] Over the years the wages tended to increase and the term of apprenticeship to diminish, from five to three years.

Early in the 1820–1850 period, when most lithographers ran small, local businesses, apprenticeships probably grew out of personal contacts and community ties. By the 1870s, however, the most successful firms had outgrown their towns and cities and, as described, had begun to assume an impersonal corporate status. Consequently, apprentices might not even see the building in which they were to learn their trade until the day of their arrival. Like college freshmen groping for the cafeteria or gymnasium, they were probably at first disoriented and bewildered. The surviving records of the Strobridge company contain letters from parents seeking positions for their children. (Since by the seventies "Strobridge" was to millions of people merely a famous logo on a chromolithograph, many of the parents' letters are addressed, not to Hines Strobridge or any other individual, but blindly to "Messrs. Strobridge & Co.") Some of the letters are simple and direct, others are rather poignant, even desperate—a few contain odd bits of the human drama. William Downey, of Newark, Ohio, mailed samples of his son's drawings to Cincinnati, asked about wages, and pleaded for advice: the boy was cursed with a love of art, "having a talent for drawing and is willing to do nothing else."[39] The Downey child was one of many young Americans of the 1870s who, because of the dying system of apprenticeship and an undeveloped system of trade schools, were educationally abandoned.

Apprenticeship
Debated,
Declared Dead
After the Civil War the importance of the apprenticeship system was hotly debated. In the opinion of Louis Prang and others, the system had been declining for forty years and by 1890 was dead. He declared in February 1894, "Regular apprenticeship . . . has become obsolete." Why? "The work in the shops," wrote Prang, "has become so specialized that a boy entering it rarely has the opportunity of obtaining an insight in the underlying principles of the whole business."[40] Ten years earlier the *Inland Printer* had laid the blame on technological innovation, adding, "A number of the features which consumed the time of the apprentice and added to the length of his indenture, have disappeared, yet these very changes demand a higher order of intelligence and a thorough system of education."[41] Moreover, as lithography evolved between 1850 and 1890 it turned out not to be the apprenticeships that taught future chromolithographers, but rather the hundreds of highly-trained European immigrants who transplanted their skills to Ameri-

can companies. Prang observed in retrospect: "The lithographic establishments have hitherto had to depend largely on artists and printers educated in the old country, where a more thorough industrial education is provided for";[42] as late as 1898 more than a third of Chicago's lithographers were foreign-born.[43] To replace the old apprenticeship system, Prang, Julius Bien,[44] and others called for trade schools that would provide a "thorough industrial education," an "all-round education" giving, in Prang's words, "breadth of view."[45] Such schools did not appear during the chromo civilization— and in fact have not yet appeared.[46] Prang's statement has a contemporary ring: "Schools for lithography have been established for a number of years in London, Paris and Vienna; their success and influence is growing. Let us heed the signs of the times, or we may be left out of the race for supremacy which is run hard in this industrial era."[47]

*Call for
Trade Schools*

III. The Labor Unions

Specialization also influenced the union movement.

As early as 1843 in Philadelphia, and later in New York, lithographers formed societies that met on a regular basis for social, business, and beneficial purposes—they even had group insurance plans.[48] A ticket for the Philadelphia "Lithographic Printers Union Annual Ball" (Figure 42) of 1858 is evidence of one such organization, and various cards refer to another, New York's "Society Lithographia," founded in 1859.[49] One serious effort to organize was destroyed, according to teetotaler Charles Hart, by intemperance. His account was written more than fifty years after the fact:

Early Associations

> In 1850 the first lithographic society was formed.... [Our] place of meeting was in a room over a liquor saloon, the use of which was given to us free for the sake of the liquor the proprietor would sell....
>
> The evil effects of passing through the saloon and the occupancy of the room above it were soon made manifest, by the wrangles that continually occurred between the members—some of whom would bring their private disputes to be settled at the meetings.
>
> Very soon the meetings, instead of being for the interests of the trade, degenerated into a mere noisy and uninteresting debating society—for the gratification of a few gossiping old fellows.[50]

*Charles Hart
on Intemperance*

The need for a strong organization was dramatized several years later. In 1853 in New York a citywide strike by lithographers had developed out of a dispute in the house of Sarony and Major. The firm insisted "that many evil practices had grown up, consisting of time wasting by visiting

friends, and the drinking of beer and spirituous liquors during working hours." Sarony and Major posted rules designed to correct the abuses, and encouraged other companies to do the same. In response, workers from that firm, George Endicott, and other New York companies left their jobs and stayed out for weeks. The employers stood fast and gradually hunger won out over principles. Without a union to represent them, first a few lithographers quietly returned, then, according to one eyewitness, "a stampede" rushed back, desperate to regain their jobs.[51]

First National Union

By 1870 a fairly strong local union had developed in New York, and this served as the nucleus of a national lithographers' union chartered under the broad umbrella of the Knights of Labor in 1882. The unionization was impeded, however, by dissension within the lithographic work force: artists disliked being classed with pressmen, pressmen thought it below their station to associate with stone grinders, and so on down the labor line. Lithograph-

ers also established petty rivalries amongst themselves, from company to company and city to city, and many resented the idea that the fine skills of their craft could be lumped into a catchall labor organization. So while the Knights of Labor presented a national front, it was seldom supported by lithographic solidarity.

Thus, not until 1886 did the precursor of the National Lithographers' Association establish a charter that attempted to put the various specialists into a single body. This was a craft union, which concerned itself with workroom conditions, the reduction from ten to nine hours of the work day, minimum wages, and overtime policies. Changing its name frequently, it grew steadily, sprouting local chapters in most of the major cities of the United States and Canada.[52] As with so many labor unions, while its future lay in the twentieth century, its genesis was a response to the sudden increase in both size and specialization of industry in the 1880s.

National Lithographers' Association

IV. The Strobridge Efficiency Report

Growth and specialization altered the economics of producing chromolithographs, so that between the late 1870s and the '80s firms were compelled to change their work style. If in the 1850s printer P. S. Duval decided to bid on a job, he would undoubtedly first discuss with his artist Christian Schuessele the time it would involve and the estimated costs, and—if his bid was accepted—they each would work to stick to the projected figures: it was face-to-face, intra-office communication. Twenty years later, however, such close interaction between management and employees no longer took place. For example, in 1877 the Strobridge company was forced to appoint a fact-finding committee to determine where in its operations it was losing money—its profits at that time were dropping. Even by that relatively early date the production and business processes had become so compartmentalized that the art and sales workers were spiritually as well as physically disconnected, thus necessitating the formal investigation into how they functioned together. The committee responded:

Committee Investigates Operations

To the Board of Directors of Strobridge & Co.
Gentlemen:
 ... We ... find
 1st Many jobs have been taken at too low an estimate.
 2nd There has not been proper consultation by the Manager with the heads of the various departments before giving estimates.
 3rd In Artist Rooms more time and labor have been put upon jobs than the price received would warrant.

4th Much valuable time is lost in Artist Room because all orders are not sent up in writing. Too much annoyance from verbal orders, and personal directions from parties ordering, and not sending through the Office.

5th Hundreds of dollars have been lost yearly by men not working full time, some men coming late, some stopping before regular hours are completed.

6th Considerable money has been lost by giving credit to irresponsible parties.

To remedy the foregoing we have recommended the following Rules and directed an immediate application of the same.

1st The Foremen of the Different Departments are to be made responsible for their departments. They shall require every employee under their charge to be punctual to the minute, and spend the full hours of the stipulated time at work for the Company. No new hand shall be employed in any department without consulting the Foreman of the Department; nor shall the wages of any be advanced until after consultation with the Foreman of Department.

2nd A *careful estimate* shall be made of the cost of every job before it is taken, and no job taken unless such estimate shall show a profit.

3rd In *every case* after an estimate has been given and an order received, an entry shall be made in an Estimate Book ruled to show the following items:—"*Name of Party.*" "*Estimated cost of Artist Work*" "*Estimated cost of Transferring, Proving &c*" "*Estimated cost of Paper*" "*Estimated cost of printing*" "*Total Estimated Cost*" "*Price given to party*" "*Estimated Profit*"—All these items to be entered immediately on receiving order. The opposite page in each folio shall be ruled to show the *actual cost* &c of each job item, and shall be filled up after each job has been completed. By faithfully keeping this book, we may know the estimated profits of each day's, week's or month's business, and if any wrong estimate has been given, may be able to avoid a similar error in future estimates.

4th The Foreman in Artist Room should more generally be consulted in estimating cost of artist work. With every order sent to Artist Room should be given to the Foreman the estimated cost of the artist work, who will then be expected to execute the work within the prescribed cost. By observing this rule the Artist Room will not only pay expenses, but perhaps a moderate profit.

5th All business with the Artist Room should come through the Office, and every order for the Artist Room should be on an Order Sheet, containing explicit directions for Artists, Transferrers and Printers. This

Order Sheet to pass through the Different Departments, and have repeated visits to the Office.

6th The greatest care shall be used in giving credit. Persons regarded in financial circles as irresponsible should receive credit, if at all, only sparingly. Anxiety to obtain orders should not lead to our disregarding this rule.

7th No written or verbal contracts to be made for a year . . . without sanction of Board of Directors.

8th All experiments, involving expense of money should be referred to Directors before taking final action.

9th If possible an arrangement should be made among the principal lithographers of the city to no longer do engraving without charge in order to secure orders. If such an arrangement cannot be made, we recommend that our Co., very rarely do work of this kind without charge, and then only for responsible houses, where orders may be relied on for years to come.

10th Special efforts should be made to purchase paper and other material at lowest possible rates, and utmost economy enjoyed in every department.[53]

Typical? It is difficult to generalize from the procedures of the conservative Strobridge firm. What this report unequivocally makes clear is that chromolithography had moved out of the one-man print shop and into the twentieth-century world of the corporation.

NOVELTY IN A
CHROMO WORLD: FROM
ART TO ADVERTISING

I. Quantifying Creativity

The Strobridge recommendations for harnessing the energy of the art room dramatized an essential problem in the relationship of art to industry. How does one estimate the dollar value of creativity? For most chromolithograph-ers the solution was to concentrate on the tried and true, the popular prints that had been produced so often that their "creation" took a known amount *Lack of Originality* of time and their rate of consumption could be predicted. Stock items such as putti, scrolls, and flowers, the standard heart warmers of children and animals, and existing works of art that employed a proven style and genre guaranteed a healthy profit. Thus, as the lithographic art grew more and more into a high-stakes industry, few original images emerged from the chromo shop of the 1880s and '90s. Arresting works by men such as James Queen and F. Tuchfarber were the exception.

Artist and author Joseph Pennell touched on this while writing the draft for a proposed book on American illustration. In a combination hand-written and typescript copy, now located at the Library of Congress, he evaluated the American chromolithograph as "technically wonderful" but "artistically of very little importance." The chromo was just a "chapter in American commercial enterprise" because, Pennell continued, "any drawings made by an artist for [the lithographers] . . . were copied by professional draughts-men, and all the artist's work, all his feeling, all his execution was toned down to theirs." In addition, as the century approached its final decade the lithographic artists were increasingly being asked to toe the time line and to create according to a sales formula. By the nineties the old relation-ship of shop owner, lithographer, and artist working harmoniously and respectfully was considered a lost dream.

Lithographic artists became artisans and firms attempted to pay their regulars by piecework rather than by hourly rates.[1] It is depressing to read, in a letter written in 1893 by sports artist J. G. Tyler to Louis Prang, how far an individual could compromise his aesthetic values: "Sent off the picture this evening after having made all the changes you mentioned. While the picture may be prettier now I liked the desolate look it had before, but the blue in the sky, birds & c may make it sell better, even though those features are hackneyed."[2] Tyler had worked for Prang since the mideighties, his "Volunteer and Thistle" of the International Yacht Race (1887) being a fairly popular chromo. But the men's relationship subsequently soured. On November 15, 1893, Tyler again wrote to Prang complaining about his pictures being rejected outright or drastically altered, his being forced to work hurriedly, his failure to receive just compensation. "I cannot be made a fool of," protested a frustrated Tyler:

J. G. Tyler and Louis Prang

> I have been entirely above board with you ever since you asked me to be loyal to your house. You said it would be worth my while. I have not found it so—The man or men who said my boat was not correctly drawn only exhibit ignorance. . . . You sent me a photo taken broadside and stern. Why did you not send me one taken as my boat is. 2 pictures perfectly still to compare with mine under motion. What shows motion but the twisting and varrying [*sic*] of lines. I send you a photo taken while she was moving and I ask you to answer me if it is not exactly like mine. . . . I am pleased to be able to prove my work.[3]

On and on in a barrage of grievances, Tyler's letter was not unique. Little-known works, such as "Storming the Ice Palace" by the Pioneer Press of St. Paul, Minnesota, burst with originality and exuberance, but their exception proves the rule of the growing homogenization of popular art in chromolithography.

Plate 99.

II. Chicago's Louis Kurz and Others

Art-to-order is a highly competitive business at any time, but when tied to a large capital investment it usually militates against radical innovation or daring novelty. For that reason the few nude bathing scenes turned out by Louis Kurz in the 1880s are anomalies in the chromo story.

Louis Kurz (1835–1921), who late in life resembled Walt Whitman,[4] was born in Salzburg, Austria, and in 1848 he emigrated to America.[5] Establishing himself in the Midwest, where during the 1850s he became known as

Kurz as Muralist a mural painter, Kurz created views to decorate numerous entertainment spots in Chicago, including Crosby's Opera House (of "Starucca Valley" fame; see chapter two) and McVicker's Theatre.[6] Although he moved several times, Kurz became identified with Chicago.

Prewar Chicago In the decade before the Civil War Chicago was an active lithographic center, trailing only a step or two behind Cincinnati. Charles Shober, who first came on the scene in the partnership of Reen and Shober, and Edward Mendel were two of Chicago's prominent lithographers; Shober specialized in landscapes and "views,"[7] and by 1860 he was advertising that he could print in "Black and colors."[8] Meanwhile, during the fifties Kurz had been bitten by the lithography bug, and he practiced that art for several years in Milwaukee with Henry Seifert, a German-born and -trained lithographer.[9] Early in the sixties Kurz returned to Chicago. There in about 1864 he founded, with Otto Jevne, a Norwegian, Peter M. Almini, a Swede, and Edward Carqueville, the Chicago Lithographing Company. They promised "Every description of lithographic work done in the best style. . . ."[10] (Interior decorators specializing in frescoes,[11] Jevne and Almini's venture into lithography was in fact only a sideline.)[12]

Chicago Illustrated The major project of Kurz's new firm was a series of lithographs for a folio entitled *Chicago Illustrated*, to be financed by Jevne and Almini. The prospectus (located at the Chicago Historical Society) described a publication issued "in Monthly Parts, an Illustrated History of Chicago,—that is, a history of the more important and striking evidences of the City's improvement and enterprise." There would be twenty-five parts, each containing at least four "tinted" lithographs and each accompanied by a descriptive essay by James W. Sheahan, a Chicago journalist.[13] The subscription price was $1.50 per issue.

Made from original sketches by Louis Kurz, the first part appeared in January 1866. The series featured ornate monochromatic covers and many chromos. In promoting *Chicago Illustrated* the publishers described the Chicago Lithographing Company as composed of premier artists, "whose reputation . . . stands equal to that of any of the profession in this country," and indeed the printing of the series was consistently of high quality: "Pitts-

Plate 100. burgh, Fort Wayne and Chicago by Freight," "M.S. & N.I. & C. & R.I. & P.C.R.R. Dep.," and "The Great Central Depot Grounds" are all exquisite.[14] Nevertheless, the *Chicago Illustrated* was discontinued after thirteen monthly installments. It probably was failing to pay its costs.

In 1871 the city of Chicago came to a halt with one of America's most disastrous fires. Inevitably, the tragedy spawned more than one chromo, a particularly memorable one being sponsored by the Chicago Art Publishing Company. Copied from a painting by W. S. Churchill, this portrait of grief was supplemented with a numbered key detailing the conflagration: "18,000

Buildings burned. 100,000 Persons rendered houseless. $200,000,000 of Property destroyed. 2,000 acres burned over. 150 Miles of Sidewalk destroyed. 100,000 Volumes of Public Library burned." [15] The fire also ruined both Jevne and Almini and the Chicago Lithographing Company, scattering the partners. Edward Carqueville eventually joined Charles Shober to establish a new Chicago lithographic company, [16] and Louis Kurz headed for Milwaukee to found the American Oleograph Company.

Plate 101.

Not broadly employed in lithography (see chapter one), the word *oleograph* referred to the German variety of chromo that was printed in dark, thick inks and heavily coated with varnish. Currier and Ives ran "oleographed" under their horse-racing chromo "Young Fullerton" in 1888, and it did appear fairly regularly in the names of companies listed in the city directories. [17] In the cities with a strong German heritage, oleographs were imported from abroad. In Cincinnati, for example, William Donaldson and Company advertised in about 1880 twenty-six oleographs, "size 15 × 20 inches, recently imported and most entirely new and very excellent in design and execution." Perhaps Kurz considered *oleograph* a more comfortable-sounding word to the ears of Milwaukee's German citizens. His goal, as described by the *Milwaukee Sentinel* in 1872, was to print "chromos à la Prang." [18]

Oleographs

Despite his stated goal, while in Milwaukee, from about 1872 to 1878, Kurz produced only mediocre prints. Most were much too thinly inked to be correctly called oleographs, and virtually all were characterized by very poor registration and amateurish composition. The "Grange Chart and Photograph Family Record," "Canada Southern Railroad," "Centennial Mirror," and "I Feed You All"—all now in the Library of Congress—reflect the low level to which Kurz descended.

He returned to Chicago in about 1878 and in 1880 formed a new partnership, with Alexander Allison. This company survived as late as 1921. [19] In 1885 Kurz and Allison's specialty was described: "Their business consists in designing for large establishments of all kinds, and in originating and placing on the market artistic and fancy prints of the most elaborate workmanship." [20]

Kurz and Allison

Kurz and Allison called themselves "Art Publishers," a popular designation of the time, used notably by their competitor the Orcutt Lithographing Company, of Chicago. [21] Kurz and Allison chromoed a broad array of subjects, from portraits of Abraham Lincoln to railway advertisements, but two series were particularly popular. [22] During the late 1880s and early '90s they issued thirty-six battle scenes from the Civil War. Measuring 21½ by 28 inches, most of the chromos were published on or close to the twenty-fifth anniversary of the skirmishes they represented. [23] The Kurz and Allison scenes are characterized by a murallike rigidity, a simplicity in drawing style,

Plate 102.

and poorly delineated details. If Kurz himself drew the pictures (and he probably did), then these qualities could be attributed to his 1850s experience painting murals, an art form that aims at grand impressions easily perceived.[24]

For most of his career, Louis Kurz was a merchant of the ordinary. Although his artistic style was unusual—close in spirit, though not in execution, to James Queen's—his subjects were safe and predictable. Then suddenly in the mideighties out of the Kurz and Allison art-publishing shops emerged a bevy of bovine nymphs, naked amazons that the straight-faced Kurz called "Female Bathers, numbers one, two, three, and four." Thighs and buttocks like tree trunks, bellies like watermelons, and faces with mannequin expressions, the young damsels assume a variety of seductive poses, dip their toes in water, or sit serenely as the wind whistles through their ears. Drawn in the granite style of the Civil War scenes, the "Female Bathers" are most striking as novelties, for nudity was generally taboo in the democratic art. Prang alluded to it early in his career when he reproduced several European masters, and beer advertisers purveyed buxom sirens holding foaming glasses of lager, but most printers for the middle-class home could not afford to offend the tastes of the market so clearly defined by Catharine Beecher. Nudity on a parlor or dining-room wall would offend sentiment—it simply did not belong. It is not known just how the "Bathers" were received.

"Female Bathers"

Plate 103.

III. "On the Warpath": A Chromo from Detroit

American Indian

By the late 1870s the American Indian had apparently been dropped from the inventories of most chromolithographers. A common subject in the days of the hand-colored lithograph, the vanishing American was, for some mysterious reason, no longer considered desirable for sales. The case of the painter John Mix Stanley illustrates the point.

John Mix Stanley

John Mix Stanley was born in Canandaigua, New York, in 1814 and died in Detroit in 1872.[25] For most of his years he was consumed by a passion for art; his wife once wrote that she knew the subject of his dreams: "pictures, pictures, pictures."[26] During the 1840s and '50s he traveled throughout the West, painting portraits by the hundreds of its native inhabitants. In the preface to a catalogue of his works that were hanging in the Smithsonian Institution in 1852 he wrote: "The collection . . . comprises accurate portraits painted from life of forty-three different tribes of Indians, obtained at the cost, hazard, and inconvenience of a ten years' tour through the Southwestern Prairies, New Mexico, California, and Oregon."[27] One newspaper report observed: "The artist lived among the Indians till he almost became one of them—till he understood their habits and manners of

life as well as he did those of his own people."[28] During the fifties Stanley was a principal artist for the Pacific Railroad Survey; volume twelve, part one, of that government report is illustrated with his work. In 1864 he moved to Detroit as a permanent resident. Less than a year later most of his paintings were burned in the fire at the Smithsonian Institution. The loss was irretrievable. Works praised by Seth Eastman as "far superior to Mr. [George] Catlin's" had disappeared.[29]

Stanley continued to paint, but he had only a little more than seven years to live. He threw himself into the establishment of Detroit's Western Art Association—which eventually became the Detroit Institute of Arts—and shortly after the Civil War he jumped aboard the Chromo Special. In 1868 he sailed to Europe. The details of his doings are not known, but the broad pattern of his activity is discernible. In Berlin he arranged to have some of his new paintings chromolithographed, including, in reduced size, his most famous creation, *Trial of Red Jacket,* in which seventy-two Indians are portrayed (while on tour the painting was valued at $30,000). Other paintings he had chromolithographed were *The Young Chief, Uncas; Black-foot Cardplayers; The Snake in the Grass; Indian Telegraph; The Deer Slayers;* and *Gambling for the Buck.* The Detroit *Free Press* called "Stanley's Chromos" so good that they were "extremely hard to distinguish . . . from the original painting[s]." The colors in the chromos, continued the *Free Press,* "possess . . . all the brilliancy and richness of the original[s]. . . ."[30] His Berlin chromos are now quite rare, but Stanley's biographer wrote in 1942 that the "enthusiastic reception of documentary studies and his chromos put him in comfortable circumstances for the first time."[31] The volume sold may have been quite large, to judge from a Congressional bill of June 23, 1870, which waived all tariffs on Stanley's material coming in from Germany[32]—Stanley had been petitioning for compensation of his losses in the Smithsonian fire, but this temporary lifting of the ad-valorem duty was all he would receive.

Stanley also planned, in the late sixties, to publish a large portfolio of chromolithographs based on his paintings.[33] It would be similar in character to a famous series of hand-colored lithograph portraits produced in Philadelphia between 1837 and 1844, known as the McKenney and Hall series. Instead of simple portraits, however, it would be made up of fifty to a hundred pictures of "Indian customs, manners, occupations, and religious rites."[34] On April 21, 1872, two days after Stanley died, the Grand Rapids *Eagle* reported that the project had begun in 1869, when a Mr. Boothroyd of Detroit traveled to London with some of Stanley's art to find a publisher. He failed. Stanley then tried various American publishing companies including Lippincott, of Philadelphia, but they, like the Europeans, were wary of the huge cash outlay the project would have required. The *Eagle* con-

Stanley in Detroit and Berlin

Plate 104.

Stanley's Projected Portfolio

tinued: "The artist was deeply discouraged . . . and several times expressed . . . a fear that he might die before the labor of his life had been consummated." It was "A National Loss," the *Eagle* headlined, for in "addition to the artistic excellence of the drawings, which were to have been in oil and then chromoed, the letter-press would have embraced much myth and tradition that will now probably be lost to us."

"On the Warpath"

Plate 105.

There is only one chromo of Stanley's paintings that is known to have been produced in America: "On the Warpath," printed by Detroit's Calvert Lithographing and Engraving Company, appeared in 1872, shortly after Stanley's death. Stanley had painted the original in 1871 for the lithographic factories in Berlin, but its schedule had been interrupted by the Franco-Prussian War. The Calvert firm then offered to try their skills. They brought Robert T. Bishop from England to do the drawings and the color separations, and they sold the chromo by subscription. "On the Warpath" was large and unusually expensive: measuring 22¼ by 30 3/16 inches, it cost $20.[35] Reportedly, 300 copies were printed and more were intended, but a fire next door to the Calvert plant covered the stones with creosote and ruined the images. Calvert claimed a loss of $3,000 and "On the Warpath" became a limited edition.[36]

Thomas Calvert

Nothing is known of the artist Robert T. Bishop (except that he was paid fifty dollars a week), and only some rudimentary facts about Calvert have appeared. Born in Yorkshire, England, Thomas Calvert emigrated to America, made his way to Minnesota, and worked in "lumbering and merchantry" until 1860. Then he moved east and worked for a time in Buffalo with Sage, Sons and Company; at that time they had a booming business, claiming to be the largest lithographic house west of New York City. In 1861 Calvert moved west again, to Detroit, to form a partnership with John Gibson in the lithographic firm known as John Gibson and Company. Within about a year Calvert bought out Gibson (who later became a prominent lithographer in New York City) and worked alone until 1865, when he established the Calvert Lithographing and Engraving Company. This firm did business into the twentieth century.[37]

Judging from the city directories of the 1870s, Calvert had very little competition in Detroit.[38] He also established branch offices in other cities, including San Francisco.[39] Like most practical lithographers, Calvert promised "personal attention" for "lithographic work of every description." Taking a line from the old Sage, Sons and Company advertisements, Calvert boasted in 1874 that he operated "the largest artistic staff and most complete machinery of any lithographic establishment in the west."[40] At the time of the production of "On the Warpath" his steam presses were producing the usual variety of items, including a map of "Michigan and Wisconsin & parts of Iowa, Illinois & Minnesota," "Colored by Townships . . . Mounted on Canvass [*sic*], with Rollers."[41]

Looking at "On the Warpath" one can see that Stanley knew the chromolithographic style: clear outlines and bright colors depict an accessible subject. The scene could be an enlarged frame of film from a 1930s Western. The Detroit *Free Press* (May 6, 1871) exclaimed "that the beholder almost imagines himself standing face to face with the painted savage and listening to his guttural accents." The landscape, the placement of the figures, and the dramatic renderings combined to form a tense narrative that every American viewer could understand. (And for those who could not, Calvert also published a brochure, now located in the Library of Congress, that explained that the scene "is an army composed of representatives of all the Northern Tribes, en route to give battle to an insolent foe." The blurb also carried numerous testimonials and press notices.) The twenty stones used to print the colors created a rich impression, similar in feeling to the full chromos of Louis Prang and the oleographs from Germany. In the chromo world both the style and the content of "On the Warpath" made it special: its original subject matter interested knowledgeable buyers of art, but it was sufficiently conservative to satisfy the popular taste. And yet, curiously, no firm in the 1870s pursued the market that Calvert had defined.

IV. "Yankee Doodle": A Chromo from Buffalo

The herd instinct of most chromolithographers did not stop some mavericks from trying their luck at something new. One, J. F. Ryder, consciously went about this task at the time of America's hundredth birthday.

The Centennial year was a high point for chromolithographers. The major firms in Chicago, Cincinnati, Buffalo, Boston, New York, and Philadelphia were enjoying an economic boom. The rhetoric of the art promoters, the state of lithographic technology, the willingness of Americans to buy, and the patriotic spirit of 1876 combined to form a chromo buoyancy, which was to disappear soon after the party had ended. From their backbreaking beginnings, chromolithographers had always exploited patriotic themes to make their businesses prosper. Heroes from the Revolution and later from the Civil War were stock items, as were flags and eagles. *American* landscapes, *American* town views, and reproductions of *American* works of art made up the bulk of most *American Chromo* series. So when it came time to celebrate one hundred years of American freedom, the chromolithographers were only too ready to salute.

In the way of red-white-and-blue patriotism, the Centennial elicited a variety of chromo responses. "The Flag That Has Waved One Hundred Years" is a quiet, reverent scene, juxtaposing a small group raising a flag

Plate 106.

in the foreground against the Capitol in the rear. More than half of the chromo is a calm sky, which serves as an unobtrusive backdrop to the principal subject. Copyrighted in 1876 by J. M. Munyon, published by the National Chromo Company, and printed by E. P. and L. Restein, of Philadelphia, "The Flag" was advertised as an "OIL CHROMO," an ideal souvenir for visitors to the International Centennial Exposition being held in Philadelphia on the occasion of America's hundredth birthday.[42]

E. P. and L. Restein

Plate 107.

"Yankee Doodle 1776" was also a souvenir. Brash and proud, it has proved to be the most popular graphic image to come out of the 1876 celebration and one of the most pervasive scenes ever produced in America.[43] Today it is known as "The Spirit of '76," but that is a title it received in 1880, several years after its debut.

"The Spirit of '76"

"Yankee Doodle" was chromolithographed by the Buffalo firm of Clay, Cosack and Company after a painting by Archibald M. Willard, a Civil War veteran and former decorator of horse-drawn wagons.[44] Painting in 1874–75, Willard used photographs of his recently deceased father (the central figure), a fife player, and a young man named Henry Devereux to create the three generations of freedom fighters. The original was painted on a small scale (24 by 18 inches) and sent to Buffalo to be reproduced. A second, large version, measuring 10 by 8 feet, was begun in 1875 and finished in time to be exhibited at the Centennial Exposition.[45]

James F. Ryder

The entire "Yankee Doodle" project was the brainchild of James F. Ryder. This multitalented businessman, alert to all paths leading to a dollar, had the knack of deciphering public taste, anticipating fads, and selling anything. He wore many commercial hats: itinerant daguerreotypist, specialist in retouching and tinting negatives, "dealer in art goods,"[46] author, and chromo promoter first-class. Based in Cleveland, by the early 1870s he had picked up the profitable rhetoric of the democratic art. In the Cleveland *Leader* of February 1, 1873, he announced his new line of Prang chromos and then offered the standard philosophy: "When the common intellect became elevated, the genius of art sank down a step to meet it, and spreading out in steel engravings, photographs and chromos, gave everyone the means to adorn the most humble home."[47] In addition to art reproduction, Ryder dealt in mottoes and comic chromos, and it was the combination of these time-tested genres that sparked his business association with Archibald Willard.

Archibald M. Willard

Willard painted clever, humorous anecdotes, and Ryder used several of these in the early 1870s to poke fun at homely wisdom: "A Stitch in Time Saves Nine," "Contentment is Better than Riches," and the like.[48] Despite the popularity of the original mottoes, the satires were received as healthy antidotes to the glut of "God Bless Our Home" pieces, and they opened a vast market. Ryder moved quickly. In 1873 he had several Willard paint-

ings shipped up to Buffalo, where Clay, Cosack and Company were located, so that by Christmas two chromos of children in amusing circumstances were ready, and soon others followed. The first pair, "Pluck No. 1" and "Pluck No. 2," sold for $10. Since Clay, Cosack and Company charged only 17¢ for the printing of each, Ryder reaped a large profit. Apparently they sold well, for Ryder pursued this chromo muse with one lithograph after another.[49] It was this kind of chromo that, as mentioned in chapter one, he sent to London for a press review in 1875: the *Printing Times and Lithographer* described them as "four oleographs, as they would be called in this country—being printed in oil and embossed to imitate the irregularities of canvas."[50] *The Philadelphia Photographer,* writing about the two "Pluck"s, set its tongue firmly in its cheek: ". . . every one must buy the pair. They should by all means be hung in every photographic reception room, in order to put your sitters in good humor."[51]

Originally, "Yankee Doodle" had also been designed to make us laugh. Instead of tattered, tired patriots, Willard had meant to portray a joyous Fourth of July celebration. But, for whatever reason (several are given, but all are unconvincing), he altered the mode and steered himself and Ryder into an even richer bonanza. Measuring 24 by 18 inches, the "Yankee Doodle" chromo was produced in time for opening day of the Centennial Exposition. It first retailed for three dollars, but Ryder eventually lowered the price to two, with even greater discounts to dealers. It was distributed through both a large photographic supplier and the chromo network of Clay, Cosack and Company, which included representatives in numerous cities. By a combination of what Ryder called "Luck and Work," his chromo venture was an extraordinary success.[52]

Ryder's Promotion

Ryder had a powerful flair for promotion. His page-one advertisement in the Cleveland *Plain Dealer* (January 1, 1876) proclaimed: ". . . a good sun will rise HIGH IN THE HEAVENS, clear away the hanging mist and give a golden tinge of restored prosperity to all. . . . YANKEE DOODLE and a belief that AMERICA IS A SUCCESS [guarantee positive results]."

Ryder also had an ear for the English language. Writing in the *New England Magazine* (December 1895) twenty years after he had sent the original *Yankee Doodle* to Buffalo, he could still muster all the inspiration and symbolism used in his old sales spiels. Behind the chief figures

> . . . a few brave Continentals struggle up the hill, while by the side of a dismantled cannon lies a wounded soldier who raises himself on his elbow to give a last cheer to the stirring strains of "Yankee Doodle." The lines have evidently been forced back. The dying soldier and the broken cannon show where the line has stood. The other soldiers have been retreating. But the three musicians advance, and the sound of their

music thrills the retreating troops with new courage. Hats are in the air; the flag has turned; the threatened defeat is about to become a victory. The dying man raises himself to cheer. The trio of homespun musicians are discoursing with all their might that music whose shrill melody is so surcharged with patriotism. The old drummer in the centre, bareheaded, grand in his fearlessness . . . one sleeve rolled up as though he had turned from the plough to grasp the drumsticks, his white hair blown in the air, his eyes set close and defiant as though he saw the danger and feared it not, the sharp lines about his mouth showing a fixed determination,—all combine to make up that wonderful figure in our history which no rags could degrade nor splendor ennoble—the Continental soldier.

On the left of the brave old drummer is the fifer, who seems to have come to blow his fife, and he will do it as well here among the flying bullets as in the porch of his cottage. His eyes are fixed toward the sky as though reading the notes of his music on the clouds. Around his brow is a blood-stained handkerchief, which tells of the bullet which grazed yet spared him. His whole energy is poured into the reed at his lips, and one can almost hear the shrill notes of "Yankee Doodle" above the noise of battle.

On the right of the old man marches a boy, hardly in his teens, whose drum keeps time to the beat of the other. His face is upturned to the old man, perhaps his grandfather, as if to question perhaps the route or danger ahead, but still with a look of rapt inspiration. No shade of fear lurks in his calm eyes, while the "rub-a-dub" of his little drum sounds as clear and distinct as the heavier roll of the aged drummer. . . .

Yankee Doodle *Tours*

The imagery of Ryder's prose undoubtedly reflected the message of Willard's work as perceived by the populace. The painting was a hit wherever it toured. Displayed in Ryder's Cleveland store window, *Yankee Doodle* created such a sensation that, as Ryder wrote, "the crowds which gathered about it blockaded the entrance to the gallery and obstructed the sidewalk to such an extent that it was found necessary to remove it from the window to the rear of the store, where it was on exhibition for several days, during which time all business in the store was discontinued on account of the crowds." The scene was repeated at the exposition in Philadelphia, then in Boston's Old South Meetinghouse, in Washington's Corcoran Gallery of Art, in Chicago and San Francisco, and elsewhere.[53] The chromo copy could not fail.

V. The Buffalo Lithographers

The year that Ryder sent *Yankee Doodle* to Buffalo, 1875, there were at least five lithographic companies in his own city of Cleveland: Joseph Hartrath and Company, Herman Lentz, W. J. Morgan and Company, Peirce and Company, and Sanford and Company.[54] The Morgan firm even advertised a secret process for reproducing large pictures: "A reduction from the original by a mechanical process, known only to and used exclusively by this firm."[55] And yet, despite Cleveland's sophisticated lithography dating from at least the early 1850s, Ryder still chose Buffalo.[56]

Ryder's taking his business to Buffalo was not unusual in the annals of chromolithography, nor in the history of either city. Throughout the chromo civilization the publishers, artists, and printers of a single lithograph often worked in different cities. Moreover, though it is logical to assume that a chromo company would be most influential on its home turf and that its presence would be felt less and less as one moved away, nothing could be further from the truth. Instead of neat, exclusive circles on a map, a diagram of influence would show lines radiating from cities like the irregular patterns of the routes of commercial airlines, or the gigantic web of a mad spider. The free-enterprise philosophy of the chromo civilization did not call for rational distribution. Rather, it was an intense scramble for customers wherever they could be found: the traveling agent-peddlers, the direct-mail-order catalogues, the branch showrooms, and the fiercely competing premium systems of popular magazines all served to extend the reach of each center of lithography.

Such cross-fertilization among cities goes back at least to 1839, when a view of Cleveland was produced in Buffalo as one of Buffalo's earliest lithographs.[57] By the 1870s Buffalo had evolved into a major lithographic city and Ohioans, among others, continued to be attracted to it. As late as 1896 the chromo-poster division of Buffalo's Courier Lithograph Company was chosen to print the only original Toulouse-Lautrec lithograph in America.[58] The publisher was Cincinnati's Ault and Wiborg, an important manufacturer of inks and varnishes. They had imported the Lautrec image, "Au Concert," which had been drawn on zinc plates, reportedly by the artist himself (the plates are now in the Art Institute of Chicago). To produce the lithograph Ault and Wiborg could have hired their prestigious neighbor Strobridge or a New York firm, which would have been convenient, as Ault and Wiborg had a branch in that city. Nevertheless, Buffalo was chosen as the city for Toulouse-Lautrec.

Buffalo is only beginning to be understood as an important center of lithographic activity and of novel chromolithographs.[59] The first reference in the city directories to a lithographer appears in 1838. Several early firms,

Toulouse-Lautrec and Courier Lithograph Company

Plate 108.

including Hall and Mooney (who in the 1850s advertised "Lithographic Printing in Colors, as well done as in the Eastern Cities")[60] and Neitig and Buechner, survived the 1840s. Jewitt, Thomas and Company appeared in the early 1850s. Richard J. Compton,[61] the first substantial lithographic businessman in Buffalo, is recorded as being in various partnerships from 1849 until about 1856, when he was forced to sell out to his landlords, the music publishers J. Sage and Sons, for whom he had printed sheet music in the early 1850s. Eventually Compton moved on to St. Louis, where in 1886 he published the striking chromo (copyrighted by "Compton Lith. Co.") "Butchers Delight."

Plate 109.
J. Sage and Sons

J. Sage and Sons (later known as Sage, Sons and Company), "dealers in Piano Fortes, Melodeons, Musical Merchandise,"[62] turned into a major chromo enterprise. By 1869 they claimed on their billhead to be the "only complete printing house in America, combining every known process of en-

Plate 110.

graving & printing."[63] Their "Turn-out of the American Express Company" is a vivid chromo, revealing a high degree of technical competence. They also produced the usual assortment of hand-colored and chromoed sheet-music covers, cartoons, pictures of horses and game birds, views of ships, railroads, and buildings, and landscapes. Built on the foundation of Compton, the Sage company by 1866 operated nineteen lithographic presses and inventoried more than forty tons of lithographic stones. In 1871 Sage was sold to White and Brayley, having foundered on a family periodical, *For Everybody.* The magazine had been started, stopped, and started again, but it finally failed, bringing with its demise the entire business of Sage, Sons and Company.

Sage, Sons and Company was the training ground not only for Cincinnati's Adolph Krebs, as seen in chapter nine, but also for two immigrants,

Clay, Cosack
and Company

Hugh M. Clay, born in about 1834 in England, and Herman Cosack, of Danzig, Germany; born in 1826, Cosack arrived in New York City in 1853 and moved to Buffalo in 1856. The two men worked for Sage until 1864, when they opened their own business.[64] Clay was an artist, Cosack a printmaker, so that together they covered the various phases of lithographic production. For a little more than a decade the firm prospered, producing the

Plate 111.

Ryder chromos, a variety of advertisements, and one of the Centennial's monumental printing achievements, *Treasures of Art, Industry and Manufacture Represented At The International Exhibition 1876.*[65]

Treasures of Art

Issued in thirty-five parts between 1877 and 1878, each part of *Treasures of Art* contained four pages of text (in English and in French) and one chromolithograph, measuring 19½ by 14 inches. The price was $2 a part. The chromos depicted highlights from the International Centennial Exposition: Bohemian glass from Austria, marble statues from Italy, arms and fabrics from Tunis, woodcarvings from Egypt. Exhibits from twenty-two

countries were included, all, of course, "accurately reproduced" and exemplifying "the progress and success attained in chromo-printing in the United States."[66] The printing quality was actually inconsistent. In several instances, such as the "Porcelain Vase," the color registration is poor, while in others the crayonwork on the stone is coarse. But at least half of the pictures are competent and pleasing. The "Delft Smyrna Carpet" from New York is an extremely sophisticated plate in the tradition of Owen Jones's *Grammar of Ornament* (see chapter six). The "Embroidered Screen" from Japan brings together a collection of bizarre objects, all beautifully combined in a harmonious color arrangement.

Plate 112.

Plate 113.

At the eighteenth folio of the *Treasures* project, Clay and Cosack split up, with Cosack and Company completing the remaining eighteen chromos. Clay eventually took over the Buffalo concern of White and Brayley, while Cosack and Company established branch offices in New York, Chicago, Philadelphia, Boston, Cincinnati, St. Louis, Hartford, Pittsburgh, and Toronto.

Other flourishing Buffalo lithographers from 1860 to 1900 included the Courier firm, of Toulouse-Lautrec fame, and the French-born Charles Gies. Gies first appears as a lithographer in the Buffalo city directories in the 1860s. As was customary, he went through several partnerships and was still in business in the 1890s. He advertised in the city directory of 1875 his "Show Cards, Chromos, Portraits, Views, etc.," but his posters have the most charm. The classic landscape motif he used in the advertisement "Coates Hay & Grain Rake" wedded fine-art imagery with modern industrial products. An eclectic form, it marked the opening stages of an independent discipline that in the twentieth century would reign as "commercial art."

Charles Gies

Plate 114.

VI. San Francisco

The drift in chromolithography from art to advertising was not limited to Buffalo, but rather was common to almost all lithographic centers. In San Francisco, however, the evolution was different.

Almost from the beginning, lithography in San Francisco had been used primarily for stock certificates, labels, diplomas, factory or general commercial views, membership sheets for fraternities and other organizations, and letterheads and bill notices, such as those by Britton and Rey depicting California scenes.[67] Moreover, until the 1860s San Francisco lithography was either monochromatic or tinted. There were exceptions, to be sure, such as an occasional piece by Edward Bosqui, but his *Memoirs* (1904) indicate that even the early works "printed in colors" aimed at practical instead of artistic purposes. "San Francisco Blues," produced by B. F. Butler

Commercial Tradition

Plate 36.

and published, possibly before 1860, by C. C. Kuchel, is a beautiful small chromolithograph, yet it was designed to serve as a membership certificate. Seldom in the tradition of Louis Prang or Currier and Ives, the work of the Far West had a distinct business orientation. More often than not, when San Francisco print galleries sold fine-art reproductions they were dealing in Eastern goods.

The early lithographers in San Francisco were of two breeds: printers who had migrated from Eastern cities and Europeans who had landed directly on the West Coast. L. Nagel, for example, operated a shop in New York City before moving West,[68] while Max Schmidt, born near Danzig, Germany, first set eyes on the United States when he arrived in San Francisco in 1871.[69] A colorful individual, Schmidt eventually built a fairly large company: by 1884 his payroll was reported at $26,245 and ten years later at $70,141. Most of Schmidt's work was can labels, but he did produce the odd print for framing. "The Leading California Resorts," for instance, was put on stone by W. H. Byrnes and printed by the "Schmidt Label & Lithograph Co." in 1886. Intended as an illustrated supplement to *The Wasp,* one of the earliest American color cartoon papers, this chromolithograph depicts vignettes of such places as Hotel del Monte and Carmel-by-the-Sea.[70] Although not a fine-art reproduction, the "Resorts" does show an attempt at an artistic whole.

Since, unlike in the East, the chromo as fine art never gained a foothold on the West Coast, there was no old business philosophy to be discarded as the chromo industry grew. From the beginning the emphasis in San Francisco (later in Los Angeles) was on advertising and other commercial needs. This emphasis came to rule chromolithography throughout America.

12

ADVERTISING

I. A New Medium with
New Designs and Colors

The chromo as a reproduction of fine art began evolving slowly but early into the chromo as commercial art.[1] Beginning in the 1840s chromolithographers combined fine-art imagery with new industrial products and services. It was often an eclectic and uneasy union between classical forms and nineteenth-century inventions, but its purpose was to confer dignity, authority, and visibility to whatever was being purveyed.

The lithograph promoted goods in ways that were foreign to letterpress. While newspapers and magazines seldom broke their column rules to permit merchants to use large woodcuts or engravings—the two-inch-wide picture as an accompaniment to an advertiser's text was the standard format for the type press—lithography was a medium for freedom of design. Not bound by type metal, the alphabet could run riot in any style, size, and direction— and it did.[2] Traditionalists screamed as lettering and scrollwork became more and more intricate. One Englishman, A. J. Corrigan, wrote that lithographers "had no traditions. . . . They were not bound by any limitations, and could run their degeneracies in a diagonal or double diagonal, circle, pyramid, oval, or triangle as they pleased." In the opinion of some, the chromo advertisements destroyed the beauty of letterpress. The ferocity of such vandalism was described by the conservative Corrigan: "They out-hunned Attila!"[3] And, on top of this, the chromo brought the brightest, boldest color to printed advertising that had ever existed. Freed from type's constriction and armed with fine art and ink pots of rainbow hues, the chromolithographers created a new commercial language.

"Artistic designs to advertise" became such a common phrase in lithographers' notices that by the final decade of the nineteenth century the relationship between fine art and advertising was a public issue. The *Lithog-*

Lithography Free from Restrictions of Type Metal

raphers' Journal in October 1890 urged its readers to give "an art tone" to their advertisements by "reproducing celebrated works of art as specialties for advertising." The editor seemed not to realize, however, that this had actually been a tradition in the chromo world for almost fifty years.

II. Products and Methods

Lithographers Work for Advertisers

There was not a single chromolithographer of any significance who did not earn part of his income from creating or printing lithographic advertisements. Even Louis Prang, who is little known for this kind of work, produced a spectacular piece entitled "The Chicago Building of the Home Insurance Company of New York,"[4] and Currier and Ives often adapted their scenes to fit commercial needs.

Locomotive Advertisements

In the middle decades of the nineteenth century, lithographers aggressively sought the business of locomotive builders. When Bien and Sterner advertised in the *Railroad Advocate* (February 17, 1855), they emphasized accurate drafting ability: "These drawings will be faithfully rendered in outline and shade, from any ordinary sketches, made to scale; or if preferred, draughtsmen will be furnished to copy any machinery required either as it stands or from working plans."[5] It is not surprising, then, to see in these railroad posters that lithographers often isolated a locomotive, treating the machine like a work of art in the detailed rendering of a mechanical drawing. One of the earliest chromo examples is the "S. Meredith" (a locomotive built by Richard Norris and Son, of Philadelphia), which was drawn by L. Haugg and lithographed by Alphonse[6] Brett in about 1855. An early chromo printer, Brett had produced, with Thomas Sinclair, fifty-three brilliant plates for T. W. Gwilt Mapleson's *Pearls of American Poetry*, published in 1847.

Plate 115.

The Amoskeag Manufacturing Company, a large machine and tool works in New Hampshire, was another firm that at an early date commissioned chromo posters to sell their products. The "Outside Connected Passenger Engine" of about 1856 shows the locomotive in the foreground and the factory in the background—a composition that was probably dictated by the company to J. H. Bufford, of Boston, who chromoed the view.

Railroad Chromos

The chromo posters of locomotives occupied a special place midway between art and advertising. The dual functions of decoration and utility were stressed in the *Railroad Advocate* of November 8, 1856:

> The various locomotive builders are getting up very handsome colored lithographs of their machines, some of them showing only the engine, or engine and tender, and others embodying more or less landscape scenery.

The utility of these advertising cards is exactly in proportion to the elegance of their execution. When showy they attract attention, when accurate they give dimensions and details, and in all cases they constitute a better than a written history of the American Locomotive.

They are the appropriate adornments for the offices of every variety of business connected with railroads; they are consulted by master mechanics and locomotive buyers; they are the master-pieces in the parlors of many engineers of good taste; and everywhere, they tell their story just as the artist has made them.

Lithographs are not considered as mere pictures, as they once were, but in many cases as working drawings. They show all outside peculiarities of each builder's work, and are highly prized by the users of locomotives as an appropriate accompaniment—a key to each builder's work. . . .

Again, lithographs are now so common, that they are *expected* by all locomotive users. The builder who does not issue them is considered behind the times, and for this cause alone, loses at least a *little* favor with the *real buyers* of locomotives.[7]

In their work for railroad companies, as well as for others, Currier and Ives practiced a method of producing commercial art that was employed by many printers. One hand-colored Currier and Ives railroad view, entitled "American Express Train," was originally published, in 1855, as an art work, free of advertising. Later it was reissued with "The Adams Express Co." stamped on the sky and on the baggage car. The caption of another railroad lithograph, "The Danger Signal," was relettered to turn it into an advertisement for the United States Mutual Accident Association.[8] "A Prince of the Blood" and "An American Railway Scene . . ." are two of Currier and Ives's numerous chromo examples of standard decorative images on which advertising copy has been superimposed.

Currier and Ives

Plate 116.
Plate 117.

This practice was not unique to Currier and Ives. As late as 1897 the Henderson lithographic company, of Cincinnati, printed a bird's-eye view of the Tennessee Centennial Fair, leaving space in the margins for any client's individual message. Their flier to transportation firms was blunt in its appeal:

The success of the exposition means a large business for all the railroads in this country.

We would suggest you buying a quantity of these views with your ad lithographed across the top, and posting them in all your stations and prominent buildings, in each city through which your line runs. . . .

P.S. If you do not attend to the advertising please forward to the proper official.[9]

Early Compositions
of Advertisements

Plate 118.

Plate 119.

Plate 120.

Plate 121.

Advertising Genres

Plate 122.

Plate 123.

Employing the democratic art for American business, the early chromo-lithographers would either position a lithographic scene within an advertising framework or, the reverse, place the product in a chromo setting. In 1860 the New York chromo firm Robertson, Seibert and Shearman printed an advertisement for the Republic Fire Insurance Company that included the standard fire-insurance holocaust scene with the commercial information bordering the central view. The opposite approach was taken by the Boston lithographer Charles H. Crosby in his chromo advertisement of a fire engine for the Amoskeag Manufacturing Company. Here the product is placed on a grand veranda in front of a low horizon, suggestive of classical antiquity and late-seventeenth-century painting. The same approach was often used by Strobridge in its famous circus posters. The figures in "Tony Denier's Humpty Dumpty" appear as in a dream world, while the performers in "Venus of the Flying Rings" are suspended above a landscape that could have been copied from one of Julius Bien's Audubon chromos.

This joining of fine-art imagery and business appeals eventually led into the great poster period of 1890–1910, but even before that, signs of commercial art were clear. Sometimes the merging of forms resulted in a decorative picture that was designed to convey a commercial message. "The California Powder Works," an advertisement printed by San Francisco's Bosqui, could easily pass for a typical nineteenth-century view of a landscape with industry in it, much in the vein of George Inness's painting *Lackawanna Valley.* Slowly, however, totally new forms began to appear. Following neither the cut-and-paste tradition of the Republic Fire Insurance chromo, nor the style of Bosqui, firms such as Strobridge developed chromos that had no American precedents. The poster of a man catching a cannon-ball fired only ten feet away is a mixture of humor, insanity, and drama. Produced for W. W. Cole's New York and New Orleans Circus Museum and Menagerie, the chromo represented the new approach in posters, in which fine art for its own sake no longer played a part.

In this way, advertising posters proved that lithography was indeed a creative as well as a democratic medium. A lithographer from New York wrote in 1894:

> . . . People in these days seem to have gone picture-crazy. There never has been such a demand as there is now. They do not care so much for black and white as they used to—they want color; as realism seems to prevail, they want in their pictures the colors of nature, and the crude work of the chromo-lithographers of several years ago no longer satisfies them. True, our pictures are many of them for the soap manufacturers, the insurance companies, and the patent-medicine man; but we try in our way to be educators of the people, and to give them good

drawing and harmonious coloring. These business patrons of ours who use pictures for advertising purposes know that the public have become fastidious; hence they will only accept good designs. It is not so very long ago that advertising pictures invariably had hard, glaring backgrounds, and crude, contrasting colors . . . but that sort of work would find no sale now except in the back woods. . . .[10]

Taking pride in their creativity, many printers of the 1890s failed to understand that a large part of the chromo business as far back as the sixties had dealt with the production of original commercial artwork. Correspondence over the years from clients in the Strobridge files shows bankers, dry-goods salesmen, railroad executives, innkeepers, and others groping for the proper images to publicize their services, and sometimes they put their problem in the hands of the lithographic artists. DeVaney's Agricultural Works wrote to Strobridge in 1877: "We send you enclosed a sample of about-what-we-want—arrange it to your taste and send prices."[11] Other clients sent their own artwork to be redrawn and lithographed. George H. Knollenberg ("Dry Goods and Notions") mailed a photograph of his building, "now in the course of erection, of which I would like either a woodcut, steel-engraving or lithograph picture on a card about the size of the photograph."[12] Charles Newkirk, of Newark, Ohio, formerly a purveyor of "dry goods, millinery, cloaks, fancy goods, etc.," devised a stock scheme and drew up his own certificate (Figure 43), complete with instructions: "I shall want 1000 certificates not less in size than 7 inches by 9 inches inside the border, with a border about ⅝ inch wide. The border and words 'Series A' across face of certificates I wish of red bronze—the rest black—the whole to be bound in two books of 500 each. . . ."[13]

The Beginning of Commercial Art: Strobridge

Figure 43. Sketch by Charles Newkirk sent to Strobridge, November 24, 1877. Location: Strobridge Papers, Cincinnati Historical Society.

Custom-Work Difficulties Each job, each product, each contract between client and lithographer was different. Railway executives required one kind of poster while medicine peddlers demanded another. The potential for confusion in the lithographer's shop was high. After sending a proof of a custom print to a bank, Strobridge received a startled reply: "I very much regret to say that you have worked from the *wrong copy*."[14] The typical chromo company was involved in a spectrum of products: from simple show cards to multicolor posters to lavish chromos of oil paintings. In addition to business clients, much chromo work was also performed for volunteer associations, fraternal groups, and school boards. Usually ordering elaborate diplomas and certificates, these customers presented a special problem, because, with membership often disorganized and fickle, no one person ever seemed responsible for a project. After dealing with such an organization, a colorful Strobridge salesman named Wellington Jones vented his discontent: "the officers of Grand Lodge of Penna. . . . are old fossels [*sic*]. . . ."[15]

III. From Custer's Last Stand to Bernhardt's First American Tour

Two Great Posters Cap Chromo Civilization During the 1890s, as printers, artists, critics, and much of the public waved good-bye to the chromo civilization, two commercial interests gave the democratic art a short but exciting second life. The first involved the brewing company Anheuser-Busch, of St. Louis: in 1896 it published, as an advertisement, a chromolithograph depicting the defeat of George Custer above the Little Bighorn River, recalling in both subject and style the chromo past. The second project looked to the present. That same year a chromo of Sarah Bernhardt was printed by Strobridge after a picture by the French artist-lithographer Alphonse Mucha; produced as a poster, it advertised the actress's first American tour. Together, the Custer and Bernhardt chromos bracket the extremes of our story.

Numerous versions of Custer's Last Stand had been drawn, painted, engraved, etched, and lithographed since the disastrous day of June 25, 1876.[16] Of all the work, however, two paintings were most conspicuous: John Mulvany's *Custer's Last Rally* (1881) and Cassilly Adams's *Custer's Last Fight* (circa 1885).[17]

John Mulvany Mulvany was born in Ireland in about 1844 and emigrated to the United States sometime between 1855 and 1857. He picked up a little of his artist's skill at the National Academy of Design, in New York, and then, after the Civil War, studied at Düsseldorf, Munich, and Antwerp. Having learned the art of historical painting in Europe, he returned to America in the early *Plate 124.* seventies. Mulvany's painting *The Preliminary Trial of a Horse Thief—*

Scene in a Western Justice's Court was exhibited at the National Academy in 1876; it is considered his first major work.[18] Firmly drawn with solid local colors, the painting is in the Düsseldorf tradition but wedded to a purely American subject. It was magnificently chromolithographed from at least fifteen stones in 1877 by Clay, Cosack and Company, of Buffalo.

The same pattern appeared in *Custer's Last Rally*. Mulvany worked for two years on this mammoth piece, which, when he finally finished it, in 1881, measured 11 by 20 feet. He had visited the actual battlefield, studied both the Indian and the Seventh Cavalry dress and equipment, and obtained either portraits or descriptions of all the main participants. When first exhibited in Kansas City the painting proved a smashing success.[19] On to Boston and New York and more acclaim.[20] Walt Whitman reviewed it for the New York *Tribune* (August 15, 1881), confessing, "Sat for over an hour before the picture, completely absorb'd in the first view." To Whitman the painting represented the essence of American art:

<p style="margin-left:2em">

There are no tricks; there is no throwing of shades in masses; it is all at first painfully real, overwhelming. . . . Altogether a western, autochthonic phase of America, the frontiers, culminating, typical, deadly, heroic to the uttermost—nothing in the books like it, nothing in Homer, nothing in Shakespeare; more grim and sublime than either, all native, all our own, and all a fact. . . . There is an almost entire absence of the stock traits of European war pictures.

</p>

Then west to Louisville and Chicago. Some evidence suggests that the painting was also sent on a European tour. Finally, in about 1890 it was chromolithographed by Dominique C. Fabronius and published by the Chicago Lithographic and Engraving Company. A huge chromo, "Custer's Last Rally" measures 18½ by 34⅜ inches.

Mulvany struck a popular chord. While his life ended in drunkenness and suicide in 1906, his work lived to spawn a continued fascination with the Custer story, with no fewer than twenty artists following his theme. The most important was Cassilly Adams.

Born in Ohio in 1843, Cassilly Adams learned to paint at the Boston Academy of Arts and at the Cincinnati Art School. He then worked in St. Louis as an artist and engraver. Sometime in about 1885 he painted his own version of Mulvany's theme, calling it *Custer's Last Fight*. According to a contemporary pamphlet, the picture measured 12 by 32 feet and was valued at $50,000.[21] It toured the Midwest for a time before ending up on a barroom wall in St. Louis.[22] When the owner of the bar died, the business fell to creditors, one of whom was the brewing firm of Anheuser-Busch. They took the painting in lieu of cash and had it chromolithographed

Marginal notes:
Custer's Last Rally

Cassilly Adams

Plate 125.

Anheuser-Busch

in 1896 by the Milwaukee Lithographic Company. Even bigger than the Mulvany-Fabronius Custer chromo, the Adams chromo measured 32 by 41 13/16 inches. Lighter in color than Mulvany's, the presentation is particularly gory: men are being stripped and scalped, brains are being smashed, and whites and red alike are dying. Hardly a dining-room chromo in the Beecher tradition, it created a national sensation as it was distributed by the thousands. It seemed that every bar trading with Anheuser-Busch had a copy of the Adams chromo hanging on the wall.[23]

Adams's Chromo's Popularity

Since Adams's original picture was destroyed by fire in 1946, it cannot be compared with the chromo reproduction, although a photograph of the painting taken in 1886 shows many differences in the background, the action of Custer, and other details.[24] The changes in the print most likely appear because its model was a reduced version of the original, copied by the lithographic artist Otto Becker. At 24 by 40 inches the scaled-down copy presumably could not contain all the details of the original. But the changes in no way hurt the painting's appeal.[25] Historian Robert Taft called it the most popular picture in America. While on a bus trip in the Midwest in 1940, Taft experienced its drawing power at a watering hole:

> On one wall of the tavern, a busy rest stop for bus lines traveling east and west, was "Custer's Last Fight." Each bus that came to rest discharged its passengers, many of whom found their way into the tavern. As each group entered, someone was sure to see the Custer picture with the results that there were always several people—sometimes a crowd—around it, viewing it, commenting on it, and then hurrying on.[26]

With Anheuser-Busch's name printed as boldly as the legend, this chromo is a stunning example of the early tradition of advertising art, in which fine art was employed to publicize an unrelated product (beer, in this case).[27]

From this example of the older form of "artistic advertising," with its "great lot of muscular, tan-faced men,"[28] to a more fully integrated commercial art that featured gorgeous women, chromoed advertisements evolved. The image of Sarah Bernhardt was the other print that, with Custer, made the chromo's last stand.

Alphonse Mucha

Plate 126.

The same year that Otto Becker produced the Anheuser-Busch chromo, Cincinnati's Strobridge printed in bronze, blacks, and delicately blended pastels one of its finest pieces: a large (83⅞ by 32½ inches) chromo poster that advertised the first American tour of the great French actress Sarah Bernhardt. Painted originally by Alphonse Mucha in France, this was a work of art in its own right. The figure of lush, exotic, glittering Bernhardt redefined the American chromo. Unlike both Custer scenes, which sought to imitate oil paintings, the Strobridge-Mucha masterpiece was from the start

conceived and executed as an original design. It united the aspiration to fine *New Genre*
art with the commercial forces behind popularization to establish a new
genre. Stylistically, it combined the isolated colors of Duval's illuminated
chromos of the 1850s with the thorough color mixing of Louis Prang: there
are solid blocks of gold and black, as well as finely stippled tones. Feminine
without being cute, sexy without being bawdy, rich without being senti-
mental, the image of Sarah Bernhardt was a novelty.

The imagery, of course, came from France.[29] The artistic chromo poster
made for hanging outdoors was developed by Jules Cheret in the late 1860s,
and numerous entertainment posters after Mucha had been beautifully chro-
molithographed by F. Champenois, of Paris.[30] It was a familiar tale.
Throughout the chromo civilization until its very end, either the lithographic
art or the craft, or both, so often came from Europe.

It is not known whether the Strobridge lithographers worked from
Mucha's original, the French chromo, or images already drawn on plates
imported from Europe. The last case seems least likely. This was Strobridge's *Skilled Strobridge*
most artistic period, when its artists—Matt Morgan, Adolph Rimanoczy, *Artists*
Paul Jones, Harry Bridwell—together made up one of the most skilled shops
in America.[31] Their calendars from 1895 to 1910, for example, were works
of art: printed in bronze with elaborate borders, they have a delicate
aesthetic quality. Even a rare campaign poster, made for William Jennings
Bryan in 1900, was exquisitely designed and "printed in ten colors, including
silver and gold bronze."[32] The Strobridge advertising motto during these
years well suited its products: "It costs just as much to display a cheap and
ineffective poster as it does a Strong, Artistic One."[33] Chances thus are high
that the Strobridge artists themselves put the Mucha design on stones, but
whether they followed a French chromo or the original design cannot be
determined.

IV. Unity in Diversity

Comparing the old-fashioned Custer chromos with the forward-looking
Mucha poster is perhaps disconcerting but not absurd. These two strikingly
different kinds of prints have common elements. Both varieties appeared for
commercial purposes and were meant for public display. Both offered fine-
art images at dime-store prices. Both embodied romantic qualities that in-
spired the public. And technically, they were both gems, capping the fifty-
five-year tradition of chromolithography in America.

As they and similar posters appeared on walls, protests from various
groups arose: too much litter, too much seminudity, too much violence,
too much public art. Magazines such as *Brush and Pencil*[34] and *Art Inter-*

change returned the critical volleys, the editors of *Art Interchange* making fun of the objectors:

Every other field having received attention, there was nothing left, for some would-be reformers to turn to but the advertising posters to be seen about town. These pictorial sheets are charged with being inartistic, indecent, and wickedly demoralizing. . . .

It would be a matter of surprise to these good old ladies, and the public as well, if they but knew how many artists whose pictures are hung in our best exhibitions furnish designs to the lithographer's establishments for advertising purposes. In fact, this is one of the most hopeful artistic signs of the times and unless one took the trouble to compare the advertising work of a decorative and pictorial nature today with that produced ten years ago he would hardly credit the progress. . . .

There is still wide room for improvement. But it speaks well for public taste when artists are demanded for any work that is to meet the public eye, and the time, it is to be hoped, is not too distant when the artists' signatures will be affixed to any work put forth, be it a picture for the Academy walls or an advertising card or theatrical announcement. . . .[35]

FAMILIARITY
BREEDS CONTEMPT

ADVANCES IN PRINTING TECHNOLOGY and changes in public taste retired the chromolithograph. As we have seen, the American chromo had looked to a style of art inspired by the Düsseldorf Academy in Germany, but by the end of the nineteenth century the desire among Americans for Düsseldorf art had died. The French influence had intervened: now fresh, airy lithographs contrasted with the varnished chromos of the 1870s. The World's Columbian Exposition in Chicago, viewed as the cultural event of the 1890s, is a good place to look at the chromo as it neared the end of its life.

I. Chicago's Columbian Exposition

Chicago's salute in 1893 to the 400th anniversary of Columbus's discovery of America was the occasion of unprecedented cultural excitement in America. The fair, known as the White City, comprised 150 buildings in classical styles, designed by America's leading architects. Seventy-two countries participated and more than 27 million visitors attended. The creative energy it released affected all aspects of culture in the United States.

The event was hailed by America's lithographers. The entire lithographic trade had been undergoing a listless half decade, and the promise of the Chicago Fair stimulated printing activity. As early as March 1892 the *Lithographers' Journal* anticipated the coming year "as a most remarkable epoch in this remarkable age of printing," a period marked by the "most wonderful advance in the reproductive arts known to history or civilization." The Columbian Exposition was expected to "create the most stupendous demand for advertising matter, embracing catalogues, calendars, circulars, cards, posters and every conceivable variety and form of advertising specialty ever known in the history of the world."[1]

Economic Stimulant

*New Graphic-
Art Process*

Compared with Philadelphia's International Centennial Exposition, the Chicago Fair was portrayed in a much greater variety of graphic-art processes. This meant that the chromo faced stiff competition. To the lithographs, chromos, photolithographs, wood engravings, and photographs of 1876 were now added numerous photomechanical prints that reproduced original works of art. The "typogravure," for example, was used by George Barrie in Chicago to copy paintings by Felicien DeMyrback, Richard Jack, I. Marold, and Childe Hassam.[2] A popular process in France, where it was used extensively in illustrated papers,[3] typogravure involved the printing of halftone pictures from relief plates made by photography.

*Artists at the
Exposition*

The fair drew artists as well as printers: a variety of watercolorists and oil painters swarmed the grounds, including American Impressionists Childe Hassam and Theodore Robinson; landscapists Thomas Moran, R. Swain Gifford, and John Ross Key; illustrators Edwin H. Blashfield, Harry Fenn, and Thure de Thulstrup—at least thirty artists of middle or high reputation are known to have depicted the fair.[4]

Childe Hassam

Curiously, these artists' portrayal of the Chicago Fair has been all but ignored, as illustrated by the case of Childe Hassam. What little literature exists on this important painter and printmaker (that no adequate biography has been written is baffling) fails to mention his sojourn in Chicago. Hassam painted a number of watercolors of the fair that were published in 1893 as chromo supplements in the Chicago *Times:* "Manufacturers and Liberal Arts Building of the Chicago Fair of 1893" (August 13), ". . . Mining Building of the . . . Fair" (September 3), "The Agricultural Building" (September 10), "The United States Government Building" (September 24), and "The Electrical Building" (October 8) are five examples. These prints, which measured 7½ by 11 inches, were approximately half, or less, the size of the originals and—unlike the reproductions of the Philadelphia fair scenes of 1876—they did not attempt to duplicate the paintings.[5] The same is true of

Edwin Blashfield

prints made from the paintings of Edwin H. Blashfield. While his murals at the Chicago Fair earned him a national reputation and the opportunity to decorate the dome of the Library of Congress, his painting *West Portals of the Manufacturers Building* was reproduced at less than half the size of the original,[6] and the print did not attempt to be a precise copy. Charles

*Charles Courtney
Curran*

Courtney Curran's "The Administration Building, An Electric Fountain at Night" is a dramatic scene, reduced from the original's 18 by 21½ inches to 8 by 12.[7] Copyrighted by D. Appleton and Company in 1894, it too represented the new belief that color reproductions should not imitate oil paintings or watercolors, but rather capture the spirit of the original in their own language.

The new approach to art reproduction was in fact *illustration* of painting. There are several good examples of this trend away from the "facsimile." R.

Swain Gifford's painting *Jackson Park, October, 1891, The Sight of the Manufacturers Building* was photolithographed (by the Winters Art Lithographic Company) with no attempt at a representation of texture. Thure de Thulstrup, whose work Prang had chromoed in the previous decade, had his 1890s *Wedding Procession on Cairo Street* treated in a similar fashion. Other works thus reproduced are *The Administration Building, Evening* and *Ferris Wheel*, both by H. B. Nichols; *Agricultural Hall*, by H. R. Butler; *A Summer Day at the Fair*, by E. B. Child; and two scenes by J. D. Woodward, *Hall of Mining from the West Lagoon* and *The Great Dome of the Horticultural Hall*.[8]

Illustration Replaces Reproduction

The fascination with photogravure and photography, and the idea that reproductive pictures should not masquerade as originals, did not, however, completely displace the older chromo. One artist who had been extensively lithographed by Prang in the late 1870s was chromoed again in 1893: at least seven of John Ross Key's paintings were reproduced in the old tradition of re-creating the texture of the painted surface. "Court of Honor, Peristyle and Agricultural Building from Machinery Hall," printed by the Orcutt Company, of Chicago, was promoted as a chromo "from the original painting." Coming out in 1894, it appears today as a salute to the past.[9]

John Ross Key

Other chromos after Key were copyrighted in 1894 by the Werner Company, of Akron, Ohio; judging from an entry in the Cleveland city directory of 1887, Werner was a capable lithographer who proudly advertised with a "specimen of fine color printing."[10] The Werner Key chromos include "The Peristyle," "Administration, Mining and Electrical Buildings from Wooded Island," "Court of Honor from Peristyle," and "Golden Entrance to Transportation Building, and General View from Colonnade."[11] Their style, though different from that of the seventies, is certainly not in the vanguard of the nineties. Key's carefully outlined leaves are gone; now dashes of color represent leaves. People are occasionally represented by plops of paint, and the sky is suggested by loose brush strokes. The black key plate is not easy to see in the Werner chromos, which enhances the impression that the figures were molded from color rather than drawn first and colored afterward.[12]

New Kind of Chromos

Plate 127.

Charles Graham, a Chicago artist, also painted numerous scenes of the exposition, some of which were chromolithographed in the seventies style. His "Women's Building" and "Palace of Mechanical Arts" were reproduced, by an unknown chromolithographer, in an obvious attempt to imitate the paintings.[13] His striking chromo "The World Electricity Building" is smaller and somewhat darker in appearance than the original, but, with the exception of the space in the dome and the details at the bottom margin, the original and the chromo are close.[14] Of unknown origin, this chromo is a fine example of the pointillist, or stipple, technique used to achieve subtly graded colors. (Stipple in American chromolithography traditionally meant

Charles Graham

Plate 128.

Stipple

that ink or crayon was put on a stone dot by dot, and when several colors were thus applied to stones and then printed together, the dots mixed to create a blended hue. French chromolithographers were famous for their stipplework, and Louis Prang had used the technique on his more sophisticated— and expensive—chromos, for in mimicking the *process* of painting it stunningly achieved the effect of painting. At first done by hand, stippling was very slow, hence the expense, so that over the years many alternative methods of applying the colors to the stones were developed in both Europe and America. There was an American patent for "a plate provided with an embossed lithographic stipple," and there were English processes that used gelatin plates and German patents for transferring stipple effects from copperplates.[15] It is not known, however, to what degree these various techniques had been tried in the American chromo print shops by 1893.)

While the chromo was in decline by the 1890s, chromolithographic skills did not die. In fact, as late as the second and third decades of the twentieth century they survived in numerous commercial firms. The French-born American printmaker and painter Jean Charlot recalled a conversation with Ben Shahn, who had begun work as a commercial lithographer in 1913: "The commercial posters of old days were done by people with their eyes. They had an original and would mentally divide it into colors and would do their plates. When he was young, Ben Shahn would do that for a living...."[16] Yet, despite the flurry of chromolithography inspired by the Chicago Fair, the chromo as imitation of painting had all but disappeared by the end of the century. Why?

Chicago Fair as Teacher

Ironically, the Chicago Fair itself, which had engendered so much printing activity, was seen by many as the kiss of death of the popular chromo. A prominent magazine writer of the 1890s, James L. Ford, described the Columbian spectacle as a vast teaching machine that produced in Americans a more refined love of art than they had ever possessed. Visitors discovering the artistic styles from France and exciting ideas about form and color returned home determined to make use of their new information. "Chromos soon went into eclipse," wrote Ford. Such sentimental subject matter as "'I'm Grandmama now' and 'Fast Asleep' and 'Wide Awake' vanished from cottage walls."[17] To Ford and other social observers of the final decade, the change was overdue.

> The enormous benefit derived from this widespread growth of artistic taste cannot be overestimated, and it was all the greater because it was accomplished not by legislative enactment but through the voluntary efforts of each individual housekeeper. If the nation had been commanded by Congress to beautify its homes it would have resented the order just as many who never touch liquor rebel against Prohibition.[18]

There is no doubt as to where the organizers of the Chicago Fair stood on the matter of chromos, or indeed, on lithography in general. The lithographic displays at the exposition were classified in Department F, Group 75, otherwise known as Industrial Arts.[19] This was quite a comedown from the chromo's place at the Philadelphia Centennial, where, seventeen years earlier, it had been classified in Department IV, which included sculpture, painting, and engravings. Even though, by today's standards, the Chicago chromos are inferior to the earlier Philadelphia works, the *Lithographers' Journal* sputtered in disbelief. Lithography, the editor ranted, belonged in Department K, Fine Arts: the "classification . . . indicates condemnable ignorance on the part of those who so assigned it."[20] The lithographers who produced chromolithographs were fine artists, in the editor's opinion, because even though their work was "merely reproductive" it required a full range of art skills. The chromo

Industrial Art

> . . . presupposes such analytical power on the part of the one who executes it as can come only from exact knowledge of the original artist's methods and materials. The outlines must be traced, each tint and shade analyzed separately and shown exactly in its proper relationship, and in proper codes for superimposing the impressions. The original mental processes through which the original artist passed are thus retraced.[21]

No matter. The chromo was officially pronounced commercial art by the Columbian Exposition. The fair itself had assumed the chromo's former function of disseminating art to the people.

II. Enter the Critics

As we have seen, one of the most animated components of the story of the chromo was the debate it ignited and the reactions it loosed. From unbridled enthusiasm to utter disgust, the emotions and arguments echoed for nearly a century.

One can read the dazzling copy in the popular press and the excited promises broadcast in the advertising. Everyone would "live to see perfect facsimiles scientifically accurate in every detail of the great works of all the great masters of old, in every American City," proclaimed the Chicago print dealer Martin O'Brien in a broadside from about 1865. In the literary world the Louis Prangs and Catharine Beechers were perhaps the most visible philosophizers on the democratic art, but many other respected thinkers took up the cause. As early as the 1820s the art critic and novelist John Neal predicted:

The day is not far off when our doers of lithography will be more surprised at looking over what is now done, than they now are in looking over what was done five or six years ago; in other words, the day is not far off when the best of them will be astonished—whatever they may believe now—at the vigor and beauty of lithographic prints, and amazed at the hidden capacities of the art. Already we are beginning to hear of colored impressions in oil; to see the spirit, liveliness and strength of admirable chalk-drawings in the every-day workmanship of mere apprentices; and to hope for the fine, bold, sketchy manner, and glorious freedom of the old masters—of the men who used to throw off historical pictures, as people now-a-days are in the habit of throwing off advertisements, or letters, and to flash forth their divinest and most astonishing inspiration with the facility of unpremeditated eloquence.[22]

C. W. Webber on Rosenthal

C. W. Webber wrote in 1852 in the introduction to his best seller, *The Hunter-Naturalist*, that L. N. Rosenthal's chromos after Alfred Jacob Miller's paintings of the Plains Indians "brought to bear the latest discoveries of Science, in the application of mechanical forces to pictorial illustration, as to cheapen all their cost without any deterioration of artistic value; and bring the essential spirit of what have been heretofore as sealed books, from their excessive costliness, within the reach of the People."[23] *Graham's American Monthly Magazine* had stated in August 1832 that the "cheapness of lithographic prints brings them within the reach of all classes of society,"[24] and shortly after the Civil War the *Boston Daily Advertiser* wrote that chromolithography "promises to diffuse not a love of art merely among the people at large, but to disseminate the choicest masterpieces of art itself. It is art republicanized and naturalized in America."[25] The sentiments resembling these that are quoted throughout the pages of this book could make one think that, save for the occasional dissenting E. L. Godkin, the chromo was an unmitigated success.

James Parton

But *The Nation*'s E. L. Godkin was not alone. As early as 1869—the beginning of the chromo's reign—James Parton cautioned art promoters against expecting too much from color reproductions. In his "On Popularizing Art" in *The Atlantic Monthly* of March of that year, Parton wrote: "It is possible to overvalue the educating influence even of excellent pictures. In strengthening or in forming the intellect, they are of no more use than mothers' kisses or the smiling loveliness of a flower garden. . . ."[26] This warning was but a prelude to the hostility that would be vented on the chromo by critics ranging from intellectuals to curbside philosophers.

Charge of Deception

The most widespread criticism of the chromo—and the most serious—was the charge of deception. Throughout the chromo years lithographers saw it as a cause for pride that most viewers could not distinguish good chro-

molithographs from paintings. The critics nodded in agreement. The use of the paper in chromolithography serves to illustrate the point.

The large chromos, particularly those simulating oil paintings, seldom revealed the surface of the paper; even the color white would be printed on the white paper, just as green or blue were printed. This practice departed radically from the traditions of wood engraving and early lithography, in which artists and printmakers delighted in showing the viewer flakes of snow or flames in a fireplace by leaving the paper's surface exposed and merely outlining the image in black ink—the snow in C. C. Nahl's wood engraving "Old Block's Cabin" is nothing more than the naked paper showing through.[27] The significance of the traditional printing technique is that in being shown the paper the viewer is always made conscious of the medium: you know you are looking at ink on paper.

The vast majority of chromos, in covering every millimeter of surface, seemed to treat the paper like the family drunk—everyone knew he was there but no one wanted to acknowledge his presence. It was the fact of the concealed paper that Clarence Cook, self-proclaimed guardian of Victorian high culture, alighted on in an attack of the chromo in the *New York Daily Tribune* in 1866. He contended that Louis Prang's chromos were counterfeits, mere illusions of art.[28] When Prang sent Cook a copy of A. F. Tait's "Ducklings," the art critic pronounced "A clever imitation is nothing but an imitation after all."[29] Between 1866 and 1868 Prang and Cook waged a verbal war, passions rose, and Cook finally exploded. In response to Prang's chromo after J. Morviller (1868), Cook wrote: "Mr. Prang sends us a Winter Landscape, by a Mr. J. Morviller of whom, as we never heard his name before, we should have been glad to say, that we hope to hear of him very often in the future. But this we cannot say unless he paints something better than this Winter Landscape." That was just the beginning. Cook said that Morviller's trees looked like "frozen mops" and "old brooms," and that Prang's clever imitations were anathema: "As for the chromo-lithograph itself, the mechanical part of it, this is one of the poorest productions Mr. Prang's workshop has ever sent out. But we are not surprised to see that its excessive popularity is ruining the art of this country."[30]

Clarence Cook

The oft-quoted E. L. Godkin's *The Nation* printed in November 1870: "[The chromo] deludes those who do not know," it "disappoints even while it deceives," it is "bad art."[31] And twelve years later, English art-historical writer Philip Gilbert Hamerton added his opinion:

E. L. Godkin

Philip Gilbert Hamerton

> . . . the employment of chromolithography to imitate the synthetic colour of painters is one of those pernicious mistakes by which well-meaning people do more harm than they imagine. The money spent upon a showy chromo-lithograph which coarsely misrepresents some

great man's tender and thoughtful colouring might have purchased a good engraving or a good permanent photograph from an uncoloured drawing by the same artist. You will never meet with a cultivated painter who buys chromo-lithographs, the reason being that his eye is too well trained to endure them. Some of them, no doubt, are wonderful results of industry, but in a certain sense the better they are the worse they are, for when visibly hideous they would deter even an ignorant purchaser who had a little natural taste, whereas when they are almost pretty they allure him.[32]

Lewis Mumford In the twentieth century Lewis Mumford carried on Hamerton's protest: "The cheaper chromo-lithograph only increased the amount of futile work in the field, helping printers to flourish whilst it encouraged the original artists to starve."[33] Even as late as 1948 Sigfried Giedion took deadly aim. In *Mechanization Takes Command* he condemned the second half of the nineteenth century for its lack of fresh vision, its mania for reproducing every kind of art object, and its dedication to confusing the human environment through mechanization. The chromo publishers boasted that their works were "manufactured" in "factories": to Giedion and others this was cause for shame, not pride. In Giedion's mind, chromos and other fine-art reproductions reduced paintings and statues to anecdotes, and because of their massive numbers they led to a devaluation of art as a special human activity.[34]

Thus, to many nineteenth- and twentieth-century eyes the chromo was not an honest form of graphic art. It was a disfigured medium, forever trying to be something it never could be. When one looks at chromos one does not see a line or color on a piece of paper—rather, a clever illusion floats before the eyes. It is not the print as a work of art, but the print as a window on to something else. The enchantment is neither on the surface of the chromo nor in the relationship of ink and paper. It is something entirely different, an environment, a slice of magic that does not reflect an artist's point of view, but rather opens up to the masses the *idea* of art.

The protests of Cook, Godkin, Hamerton, Mumford, and Giedion were not necessarily triggered by a dislike of the populace that purchased chromos, but by a deeply rooted faith in culture, a belief that high aesthetic standards would ultimately serve a democracy best. *The Nation* of November 10, 1870, insisted: "It is not because of any cheap democracy of the 'chromo;' a certainly more democratic art, to which no aristocratic art objects, is the wood-cut."[35] *The Nation* expressed an honest state of mind.

But chromolithography was also an honest state of mind. Above all else, it saw itself as a commercial activity, rating itself in dollars and cents. In loftier moments it also was seen as a purveyor of refinement: a chromo was

an object to hang on the wall that at least alluded to a high ideal. And indeed it was the chromo's success at alluding to great art that brought about its execution by the critics for high deception.

Coupled with the crime of "deception" was the fact that in the latter years of the chromo era a great percentage of the work was overly sentimental or simply ugly. Some contemporary descriptions of chromos give an idea of the subject matter:

> A nice bit of genre in lithographic advertising is the Kinney Bros.' colored plate, showing a pretty girl in a coquettish winter costume, tobogganing down an ice-slope, while Cupid, with large snowshoes on his small feet, hovers about her shoulder and pushes her along. It is soft and mellow in color, nicely drawn and poetic in idea.[36]

And:

> F. S. Church's Christmas card shows a quaint procession, two pretty children and a harnessed robin red breast dragging a load of Christmas greens in the upper half, and in the lower, a long snowy branch of a tree laden with a row of alternate birds and chubby babies, with a holly bordering below at the edge of the card.[37]

Finally, familiarity had bred contempt. The saturation of the market with chromos, as described in earlier chapters, rendered them in the eyes of almost everyone valueless. The *Literary World* of December 1872 had predicted: "We believe in chromos; they do much to refine our homes, and to encourage a love for the beautiful, but under the present system of wholesale gratuitous distribution, their office will be degraded and they will rank as Sunday School picture cards."[38] And in 1896 *Braun's Iconoclast* clinched it: "No chromos, World's Fair Photos or A. H. Belo sewing machines go with the *Iconoclast*. We are running a magazine, not a plunder store."[39]

The demotion of the chromolithograph from its once high throne was such that by the 1890s—and up to this day—the very word *chromo* had come to mean "any person or object that is ugly or offensive."[40] As early as the 1860s the criticism had begun.[41] In France by the 1880s *chromo* meant "vulgar."[42] During the last quarter of the nineteenth century a phrase equivalent to "that takes the cake" was "that takes the chromo."[43] In the twentieth century, the comic strip *Little Orphan Annie* (Figure 44) had a frame that read: "HA! HA! HA! I know I'm just an old chromo—a has-been—a hag—go on, Annie—don't mind an old fool—laugh—." Damon Runyon, chronicler of New York low life, wrote in his *Take It Easy*, of 1938: "[His sister] is the chromo sitting behind him.... [She] is older than

Figure 44. Detail from Little Orphan Annie, *by Harold Gray, n.d. Reprinted by permission of the Chicago Tribune-New York News Syndicate, Inc.*

he is, and has a big nose, and a moustache."[44] New York saleswomen in the 1930s and '40s called a tough customer—one who looked but did not buy—a chromo.[45] And today in Australia a prostitute is called a chromo.[46]

III. The Momentum of Technological Change

The last quarter of the nineteenth century was a time of leaping technological advances, when a rapacity for the new struggled with a nostalgia for the old. The chromo symbolized that tug of war: it was a product of modern invention that was dedicated to the aesthetic values of the past. By 1880, however, the novelty of chromolithography had faded. Collotype, photolithography, and photo-engraving were displacing the older methods.

Technological Change

Throughout the 1880s and '90s numerous processes appeared for the "reproduction of oil paintings and colored pictures by the aid of photolithography in such a manner that while the result is more true to the original, the reproduction is effected at a less cost."[47] Progress, too, in the manufacture of coated papers and inks made constant news in the trade journals. One reporter was led to conclude: "within the last few years lithography in the United States has taken a new trend; it has turned from the tedious and irksome attempt to produce good results from cheap material and has called into its field all the best achievements."[48] Presses were also being improved. The many new models, with their larger beds, more exact inking rollers, and high-speed production capabilities, created the impression of a graphic-arts revolution: the *Lithographers' Journal* claimed that because of the technical improvements "it has been made possible for publishers to use a very much handsomer and more pretentious class of studies and illustrations than at former times and in larger quantities, thus giving the public an opportunity to own fac-similes of the work of famous foreign and American artists."[49] The *Lithographers' Journal*, which represented an estimated one third of the companies in the trade,[50] revered the new.[51] In October 1891 it theorized:

> If one were to group before him a complete variety of specimens executed by the lithographic art at different periods, he would obtain a very correct idea of the way in which human taste advances. The evolution in lithography from the clumsy and unsightly chromo, often garish in coloring and overburdened with decoration, to the choice scale of colors in a more modern piece of refined work, has been as rapid as the advance in . . . any of the realms of industrial art where beauty combined with usefulness now holds sway.[52]

And in September 1893 the *Journal* pronounced: "The chromo has given

place ... to innovation.... the garish in color and crude in form have been succeeded by the refined in both."[53]

Fueled by the shifting public taste, by the nineteenth-century faith in new machines and products as somehow better or more "refined," by the economic need for change, the *Lithographers' Journal* took the view that the past was junk. Its position gave the professional seal of approval to the growing legions of chromo haters.

At the same time, as a product of the growing machine-made culture, the chromo ran smack into the anti-machine sentiment, a grassroots version of E. L. Godkin's high-minded protest of the seventies. Oscar Lovell Triggs articulated the reaction against industrialization in an essay for *Brush and Pencil* in December 1897, in which the chromo is listed as one of the many items that were homogenizing taste and destroying individuality:

Anti-Technology Bias

> ... If beauty did not require the expression of the human soul, if beauty were simply a matter of the material, if beauty were merely a form, then the machine might populate the earth with objects of beauty. But the fact remains, that to have beauty in an object the human hand must touch the materials into shape, and the closer the object is to the soul the more beautiful it becomes in its ultimate form. The ugliness of the modern industrial product is we think, positively to be charged to the machine. What then shall we choose? Do we prefer infinite productivity, abounding things to wear, endless furniture, unlimited chromos, quick transportation for ... chromos, universal competency of a certain sort, universal cheapness—cheap goods and inexpensive men, or can we afford to deny ourselves the luxury of infinite cheap things, drive back the machine to do the work of drudgery and preserve some portion of the earth where a man can get with individual freedom, disport himself spontaneously and live according to human ideals? We cannot have both production and creation. If machines stay, beauty goes, if creations remain the machine is thrust aside....[54]

The chromo civilization ended, as it had lived, in debate. From 1840 to 1900 the pros and cons of the modest color print were pushed and pulled by lithographers, businessmen, housewives, artists, educators, and historians. The arguments have not yet died. This, then, is perhaps the chromo's real impact. In introducing paintings to the masses it forced Americans to grapple with the concept of culture for all, or art in a democracy.

EPILOGUE:
A PERSONAL VIEW

WOULD I HAVE a chromo copy of an oil painting on my dining-room wall today? Probably not, unless of course it was one of my favorites, listed below. I wouldn't because the modern attitude toward aesthetic refinement, which I have been raised on, is so different, so much more open, more confident, more commonly shared by the people at large than it was one hundred years ago. I do not need the chromo now. I get my art satisfaction in other ways.

In the American cities of today it is almost impossible to avoid art. From public sculpture to high billboard advertisements; television, movies, magazines, all channel an abundance of artistic images into the public's eye. Imperfectly perceived, dimly appreciated, unconsciously accepted or rejected, these images are nevertheless art, in incredibly diverse forms. The mass media of today could barely have been imagined by Americans of the chromo civilization. And fine art, in museums and art galleries and print clubs and picture dealers of every type, is available virtually everywhere. The American dream to democratize art, a driving force behind the success of the chromo, has resulted in the United States' taking its place today in the world of great art.

Because of our present sophistication, we find it difficult to sympathize with the needs of a society that was poor in fine-art resources. We forget that a little more than a hundred years ago the United States was rural, that travel was difficult, that even the largest cities did not have a professionally staffed public museum, that art schools were few, that art history was not offered on a regular basis at a single university, that most journalists and book writers described art and theorized about beauty without ever having seen the products of creative genius in Europe. What is perhaps most easy to forget is our predecessors' sense of inferiority about art. Many Americans felt the importance of fine art, yet they knew so little about it. It was over *there*, across the sea. It was a mysterious process. It was a product of venerable

cultures. It was the mark of sophistication. Oh, we wanted it here! We poured as much imagination and energy into the idea of art as many societies had done in creating it.

Thus, putting myself in our forebears' shoes, when I look at a chromo I see a colorful image through a public window. I see an attitude toward fine art that is articulated with a naïve enthusiasm. I see a valiant attempt both to learn about art and to spread its ineffable benefits as wide and as deep as possible.

Critics who hated the chromo were elitists who dreamed up foolish arguments. They were afraid that the populace might invent an idea or two about art that did not coincide with upper-class wisdom. Looking back, I simply do not see the motivation behind their insistence that chromos would corrupt our sensibilities, or that they were a debilitating force. Chromos designed to imitate paintings certainly were not the equal of the originals, but on their own terms many were expressive, creative, powerful.

In defending the chromo I don't mean to say that American chromolithography should go unquestioned. It would be interesting to speculate on the reasons why the American chromo is more often than not inferior to the European. Why, until the 1880s, were virtually all of the significant innovations made in lithographic shops in Europe? Why did the craft have to be imported? Words such as "tradition" and "training" do not entirely answer the question. I simply do not know.

And while I do admire the work of many of the chromolithographers— Duval, Bufford, Prang, Strobridge, Bosqui—I am forever aware that above all else they were businessmen. Profit was their goal. Their advertisements of the 1870s sound like the come-ons on modern cereal boxes: "Free!," "Discount!," "Premium!," "Latest!" pepper their copy. The often sensationalist verbiage appealed to passions that had little to do with art.

The broader issue of fine-art reproduction continues today to be controversial. Not just standard reprints, but films, videotapes, and thirty-five-millimeter slides of art works have their proponents and their detractors. When, for example, Walter H. Annenberg proposed to establish a communications center at New York's Metropolitan Museum of Art, for the purpose of reproducing and furnishing information on art and related areas, he encountered a variety of reactions. Most eloquent was Hilton Kramer's response. Asserting in *The New York Times* of March 27, 1977, that Annenberg's scheme was a "dubious proposal," Kramer sounded uncannily like the critic Clarence Cook, of a hundred years earlier: "Programs for 'disseminating' works of art to the 'broad masses' are always launched under the banner of increased democratization, and Mr. Annenberg's conforms to the pattern. But the effect is likely to be quite otherwise. For in the end it is not the experience of the work of art that the miracle of technology brings to

more and more people, but something quite different—a mechanical representation of someone else's experience of it." (What seemed most to irk Kramer, in fact, was that it was an art museum, not a commercial firm, that was flirting with the idea of a democratic art.)

No one can argue successfully that an original work of art is fully represented by a reproduction. Hilton Kramer and those who came before him were correct, in my opinion, when they described the confusion of illusion (an art reproduction) with reality (an original). But reproductions have their place in the world of art, as I discovered in my own education. Let me explain. Before I went to college I was a stranger to art museums. Indeed, art was something I had never even thought about. At college I encountered the Skira art books and the thirty-five-millimeter slide projector. Despite the false colors and homogenized sizes in these reproductions, they enchanted—haunted—me beyond description. On my first Christmas vacation I raced to the Frick Collection in New York to seek out Goya's painting of a forge. The original turned out to be nothing like the reproduction, and that helped me love the real thing even more. Now, to my eyes, the reproduction seems gross, but that's because I know the original. In leading me to the painting, the copy did its job.

When I finally got to Europe in 1973 I made a beeline for Florence. My passion was Botticelli's *Birth of Venus*. Wow! I couldn't believe it. It was so much bigger and lighter than I had imagined. I had to rethink the piece—to see it anew. I did. Like Goya, Botticelli is so much better in the flesh. To reiterate, those shoddy reproductions guided me to reality. They didn't shield the truth from me. Without them, I think I'd still be outside museum walls.

If a poll were ever taken, I'm convinced that many art lovers would turn out to have had my experience. I would guess that some who were turned on to art by reproductions probably now forget those initial feelings of excitement and how important these stimulants were. The art reproduction, thus, should not be judged solely by what it is, a copy. It must be judged by what it *does*. Those lucky enough to have been exposed to original art must not condemn the pedagogical tools used by the less privileged.

In sum, my position on the chromo is mixed. The mass-produced, aggressively marketed color print purveyed much that was aesthetically valueless. But in the process a chromo occasionally emerged that was a stunning work of art. Unquestionably, a great many of the chromo practitioners were mediocre, but some—Louis Prang, Julius Bien—were fascinating, creative men, whom one would have to call artists, businessmen though they also were. And in the end, the heightened awareness of art brought by the chromo, even if achieved through modest, inadequate prints, simply cannot be gainsaid.

Finally, which chromos do I consider the most important? The following list will come as no surprise, because it follows the organization of this book.

In the past, print scholars have noted their favorite works by Currier and Ives and others. Honoring that tradition, I offer the list below. Each print was chosen for either historical or aesthetic reasons, and together they compose the backbone of American chromolithography as I have interpreted it.

TITLE PAGE. "Prang's Chromos," by L. Prang and Company, because it is the most beautiful advertisement for chromos ever produced in America.

PLATE 2. "F. W. P. Greenwood," by William Sharp, because it is the first American chromolithograph.

PLATES 3 and 4. The illustrations for John F. Allen's *Victoria regia*, printed by Sharp and Son, because they represent the boldest use of colors by American lithographers before the Civil War.

PLATE 6. "View of Buffalo, N. Y.," by Francis Michelin after Edwin Whitefield, because Michelin was one of America's most skillful lithographers and Whitefield was a talented artist who sought to disseminate his art with the lithograph.

PLATE 7. "[Old Boston] Beacon Hill, from the Present Site of the Reservoir Between Hancock & Temple Sts.," by J. H. Bufford after John Rubens Smith, because Bufford was one of America's most talented and successful lithographers. This view is his tour de force. In addition, the original artist was considered a master in his day, and the print (coming long after his death) is a tribute to Boston's artistic heritage.

PLATE 11. "Lafayette," by P. S. Duval after Christian Schuessele, because it is representative of the work of Duval, an innovative lithographer, as well as a very successful businessman. It was promoted in 1851 as a landmark in printed color, and Schuessele, the lithographic artist, was proclaimed a master.

PLATES 15, 16, 17, 18, and 19. Illustrations for Henry R. Schoolcraft's *Historical and Statistical Information Respecting the . . . Tribes of the United States*, by Ackerman, P. S. Duval, and J. T. Bowen, because this was the federal government's first major use of chromolithography.

PLATE 22. "H. P. & W. C. Taylor Perfumers," by Thomas Sinclair after William Dreser, because it is an early example of the use of fine-art imagery for commercial advertising.

PLATE 24. "Henry's United Silver Cornet Band at Niagara Falls," by Wagner and McGuigan, because it is a quiet masterpiece.

PLATE 27. "The Volunteers in defense of the Government against usur-

pation," by P. S. Duval and Son after James Queen, because it is a bold, creative design, demonstrating Queen's ability to use chromolithography in an artistic way.

PLATE 31. "[Albany] of the Hudson River Day Line," by Endicott and Company, because it is a high-quality work, representative of one of New York City's most important lithographic companies.

PLATE 32. "A View of the Federal Hall of the City of New York . . . 1797," by Henry R. Robinson after John Joseph Holland, because it is a tasteful interpretation of an eighteenth-century watercolor by a nineteenth-century lithographer.

PLATE 35. "Volunteer," by Henry C. Eno, because it is a fine early example of a chromo horse portrait.

PLATE 36. "St. Julien," by E. Bosqui and Company, because it is an early example of skillful chromolithography from California.

PLATE 41. "View of the East Dorset Italian Marble Mountain and Mills," by Ferdinand Mayer and Sons, because it is beautifully printed and represents the use of fine art for advertising.

PLATE 42. "The Bummers," by Bencke and Scott, probably after Enoch Wood Perry, because it is a humorous genre piece by an important firm. Also, it is a good example of the Düsseldorf style, which was so compatible with the technical demands of chromolithography.

PLATE 43. "The Storming of Chapultepec Sept. 13th, 1847," by Sarony and Major after Henry Walke, because it is an extremely early use of chromolithography for a large, complex news print.

PLATE 44. "View of Norwich . . . ," by Sarony and Major after Fitz Hugh Lane, because it is an early example of a chromolithographic reproduction of a work by an important American painter.

PLATE 47. "The Court of Death," by Sarony, Major and Knapp after Rembrandt Peale, because it is the capstone of Peale's brilliant career as both a creative painter and a popularizer of art. The painting is historically important as a very popular touring picture.

PLATES 49, 50a, 50b, and 51. Prints from Audubon's *The Birds of America*, by Julius Bien, because this folio represents one of the most ambitious projects ever undertaken in American chromolithography. "Yellow Shank" is particularly important, because it demonstrates the transfer of aquatint impressions from the original etched plates made by Robert Havell, Jr.

PLATE 53. "American Speckled Brook Trout," by Currier and Ives after A.

F. Tait, because this is probably Currier and Ives's first chromolithograph. It is also one of the last Tait works they produced.

PLATE 56. "A Brush with Webster Carts," by Currier and Ives after J. Cameron, because it is well printed and lively, qualities most Currier and Ives chromos do not possess.

PLATE 57. "The Futurity Race at Sheepshead Bay," by Currier and Ives after Louis Maurer, because it is a large chromo after one of Currier and Ives's finest artists. Traditionally this large piece has been considered Currier and Ives's first chromo. It is not.

PLATE 62. "Group of Chickens," by L. Prang and Company after A. F. Tait, because this was Prang's first great success.

PLATE 64. "Hon. H. R. Revels," by L. Prang after Theodore Kaufmann, because it is a beautifully printed chromo and an interesting historical portrait.

PLATES 67, 69, 70, 71, and 72. Prints from F. V. Hayden's *The Yellowstone National Park*, by L. Prang and Company after Thomas Moran, because each chromo is a masterpiece. This is Prang's greatest work and represents the high tide of chromolithography in America.

PLATE 73. "Sunset: California Scenery," by L. Prang and Company after Albert Bierstadt, because in its day this was considered an important reproduction of a work by a master American painter. This chromo in the Düsseldorf tradition is a fine example of the ideal art style for lithography.

PLATE 79. "Haymaking in the Green Mountains," by L. Prang and Company after Benjamin Champney, because it is one of Prang's most polished pieces and its subject matter was of great interest to art purchasers of the 1870s.

PLATE 80. "The North Woods," by L. Prang and Company after Winslow Homer, because it is an extremely rare print.

PLATE 82. "Currants," by L. Prang and Company after Virginia Granbery, because it is a finely printed example of a "dining-room" still-life.

PLATE 86. "The Barefoot Boy," by L. Prang and Company after Eastman Johnson, because it was one of the most talked about chromos of the 1860s and '70s.

PLATE 91. "Edmund Dexter's Residence," by Ehrgott, Forbriger and Company, because it shows an unusually balanced treatment of pastel colors, and, surely, it was one of Cincinnati's finest.

PLATE 93. "Distinguished Masons of the Revolution," by Strobridge and Company, because it is a precise piece of lithographic printing and an artistic example of a commission by a noncommercial organization.

PLATE 94a. "Winter Sunday in Olden Times", by Strobridge and Company, after George Durrie, because it was a popular chromo that was sold to dealers who marketed it as their own. Its complex history, indicated by the different makers' names and various dealers' logos superimposed on the print, suggests the treasure-trove of mysteries surrounding the provenance of so many chromolithographs.

PLATE 97. "The Old Violin," by F. Tuchfarber and Company after William Harnett, because it was well printed, popular, and used by several lithographers for various purposes.

PLATE 98. "A Royal Flush," by F. Tuchfarber Company [sic], because its strange subject matter makes it unique in the history of American chromolithography.

PLATE 99. "Storming the Ice Palace," by Pioneer Press Lithography, because it is a rare example of a full chromo from a company of which little is known.

PLATE 100. From Chicago Illustrated, by the Chicago Lithographing Company, because this folio is made up of early, well-printed Chicago chromos that document the city just before the fire.

PLATE 105. "On the Warpath," by the Calvert Lithographing Company after John Mix Stanley, because it is the only chromo reproduction of Stanley's work produced in America. It is also the first chromolithograph printed in Detroit.

PLATE 106. "The Flag That Has Waved One Hundred Years," by E. P. and L. Restein, because it is simple in design and unique as a patriotic statement in chromolithography.

PLATE 107. "Yankee Doodle 1776," by Clay, Cosack and Company after Archibald M. Willard, because it was probably the most popular chromo image ever produced in America.

PLATE 110. "Turn-out of the American Express Company," by Sage, Sons and Company, because it exemplifies the high quality of chromolithography produced in Buffalo.

PLATE 122. "The California Powder Works," by Bosqui, because it is a good example of a fine-art view used for advertising.

PLATE 126. "Sarah Bernhardt[,] American Tour," by the Strobridge Lithographing Company, because it is probably the most exquisite piece of chromolithography used as an advertising poster to be produced in America.

APPENDIX 1

Examples of Color Formulas Used by Chromolithographers from 1860 to 1890

(From the *Lithographers' Journal*, January 1893, pages 6 and 8.)

"The chromolithographers will say, in reading what follows, that we are offering them an old tale; they will not be entirely wrong. Excepting a few passages, the greater part has already appeared in years past. But as we know nothing more enervating, at least in our opinion, than original investigations, the idea has occurred to us to gather into a single article what is found scattered in many. Our object is to facilitate the specialists' work.

"*Colors for Portraits.*—The shades for the flesh of women and children are made with silver white, saturn red (red lead), vermilion and a point of black, or better, of blue.

"For the flesh of men, use sienna earth, saturn red, white and a point of vermilion.

"The shaded parts are treated with burnt sienna earth, to which some black is often added. On some parts one is compelled to lay some light blue tints spread over white.

"Dead flesh is treated with saturn red, burnt sienna earth, white and black.

"The mouth is treated with orange lac for the flesh, and with carmine mixed with saturn red for the half-tints. It should be observed that the lower lip is brighter, and consequently saturn red and some violet tones are used for the shades. Sometimes the corners of the mouth are colored with pure carmine.

"It is extremely difficult to color the eyes properly, owing to the expression and nobility of this organ. A little vermilion and lac shall be added to the flesh color for the upper eyelids; the lower ones shall be grayish.

"The white of the eye is colored with a mixture of cobalt, lac and a slight point of chrome yellow.

"The pupil is colored with cobalt, prussian blue and burnt sienna earth.

"For the hair of a blonde use merita earth, mixed with sienna earth and 'still de grain' (brown pink), a little white for the lights and a little black for the shades. The chestnut hair with burnt sienna earth and black in proportions to suit the shade. The black hair with black and a little prussian or indigo blue.

"*Landscapes, Skies.*—For the skies use prussian blue, white, a little yellow lac and a point of black.

"For the night skies use indigo blue only.

"The effects of the sun on the skies, sunset and sunrise, are made with chrome yellow and carmine lac mixed; the orange and the saturn red produce the same effect.

"The misty skies, the offing, the vanishing parts without a fixed effect, are made with a mixture of black, reddish brown, white and blue; this tint, which is called neuter tint, varies in its proportions, but in no case should predominate the black.

"The stormy skies are effected with prussian blue, carmine lac, reddish brown and black.

"*The waters* in the background with prussian blue and white; in the intermediate planes with blue, white, reddish brown and black. Finally, on the fore-plane with blue and a little burnt sienna earth; sometimes a little black. To give more transparency and a greenish tint to the waters the sienna earth is replaced by some brown pink.

"*Trees, Trunks and Branches.*—Either use a mixture of black and sienna earth, or a mixture of these colors and prussian blue.

"*Leaves of Trees and Plants.*—Although almost always green, they present a great variety of shades, not only from one species to another, but on the same tree or plant.

"The base of all the greens is a mixture of yellow and blue; but owing to the proportions of these colors, the green undergoes great variations in shade. Ordinarily, the name of deep green is given to the mixture in which the blue predominates, and of light blue [*sic*] to that which contains more yellow than blue.

"The green has a series of very different shades, according to the kind of blue and yellow that are mixed. Thus, the chrome yellow and the indigo blue give a green that is not bright, while a mixture of yellow lac and cobalt produces a very bright green.

"The chrome yellow and the black produce a dull green, without any effect. This mixture offers very few combinations.

"The most extended combination for this color is that of yellow, blue

and a third color which modifies the tint. This third color may be carmine, orange and reddish brown for the bright leaves, as well as for the autumn leaves, in small quantity for the former and more or less predominant for the latter. The green at last disappears in the dead leaves, in which the yellow, the sienna earth, the reddish brown and the bistre predominate.

"The bluish greens, like those of certain cabbages, the carnation and other flower plants, are obtained with white, cobalt and a little merita earth or brown pink. Those of the hairy and bluish leaves with indigo, the same yellows and a large quantity of white.

"The following is the composition of the most used greens: As to the proportions we could not name them beforehand, they vary infinitely. Chrome yellow, cobalt and carmine lac; chrome yellow, black and indigo; chrome yellow and black; chrome yellow and prussian blue; chrome yellow and indigo; chrome yellow and cobalt; yellow lac and prussian blue; yellow lac and indigo; yellow lac, prussian blue and carmine or orange pigment.

"Sienna earth, carmine lac and prussian blue; sienna earth and indigo; earth of italy, reddish brown and a point of black; sienna earth and prussian blue; merita earth and cobalt; brown pink and cobalt; brown pink and prussian blue.

"*Soil, rocks,* and generally all the parts that receive the sun rays directly are painted with the colors peculiar to each object, but in which the vermilion predominates. The angular parts of the rocks, which abruptly break and separate the lights from the shades, and which present opposite surfaces, are tinted, on the light parts with warm tones, like those produced by the sienna earth, the saturn red, the orange; on the shady parts with a mixture of sienna earth, prussian blue, carmine lac and black; on some of the tones with black and sienna earth; on others with bluish or greenish tints.

"*Foreground.* —On the light parts with bright and free colors, such as the chrome yellow, the yellow lac and the fresh greens; on the shades with sienna earth and black mixed in the desired proportions.

"The mixture of colors for the shades is much more practical than theoretical; but many excellent examples may be taken from the work of Messrs. Berthiaul & Boitard on copper-plate printing in colors."

APPENDIX 2

George Munro's Chromos

The following are examples of chromos advertised by the New York print dealer George Munro in *The Fortnightly Review* of April 1880. It is typical in its appeal: portraits, landscapes, seascapes, nature, religion, history, adventure, satire, *sentiment*.

LIST OF NEW CHROMOS

Across the Sierra Nevada. Size 24 × 30. Price 40 Cents.

Autumn in the Alleghenies. Size 24 × 30. Price 40 Cents.

Autumn in the Catskills. Size 24 × 30. Price 40 Cents. A beautiful chromo representing these mountains.

Beatrice. Size 24 × 30. Price 40 Cents. After Guido's celebrated painting.

Bingen on the Rhine. Size 22 × 30. Price 40 Cents.

Camping on Lake Chautauqua. Size 24 × 30. Price 40 Cents.

Cascade in the Alps. Size 24 × 30. Price 40 Cents.

Crossing the Stream. Size 24 × 30. Price 40 Cents. After Cary's beautiful evening landscape and cattle picture.

Crown's Nest. Size 22 × 30. Price 40 Cents. After McCord's beautiful painting of Hudson River scenery.

Deer Stalking on the Mississippi River. Size 24 × 30. Price 40 Cents.

Easter Morning. Size 24 × 30. Price 40 Cents. A most beautiful Religious picture. Christ's ascension through a beautiful array of flowers.

Excelsior Fruit. Size 24 × 30. Price 40 Cents.

Finding of Moses. Size 22 × 30. Price 40 Cents.

Home in the Blueridge. Size 22 × 30. Price 40 Cents.

Home in the Country. Size 24 × 30. Price 40 Cents.

Home on the Wabash. Size 24 × 30. Price 40 Cents.

Holy Family. Size 22 × 30. Price 40 Cents. After Raphael's masterpiece.

Imperial Dessert Fruit. Size 22 × 30. Price 40 Cents.

Lake George. Size 24 × 30. Price 40 Cents. Beautiful lake and mountain. After John J. Zang.

Lakes of Killarney. Size 24 × 30. Price 40 Cents.

Last Supper. Size 24 × 30. Price 40 Cents. After Leonardo da Vinci.

Life on the Ocean Wave. Size 24 × 30. Price 40 Cents.

Life's Voyage. Size 24 × 30. Price 40 Cents. An interesting chromo. After John J. Zang.

Love's Reverie. Size 22 × 30. Price 40 Cents.

Mary Queen of Scots. Size 24 × 30. Price 40 Cents. A beautiful portrait of this celebrated Queen. After F. F. Martinez, a very fine painter.

Moonlight in Egypt. Size 24 × 30. Price 40 Cents.

Moonrise on the Nile. Size 24 × 33. Price 40 Cents.

Moses in the Bulrushes. Size 22 × 30. Price 40 Cents. A mate to Finding of Moses.

Old Homestead on the Susquehanna. Size 22 × 30. Price 40 Cents.

Old Kentucky Home. Size 24 × 30. Price 40 Cents. After the picture by Eastman Johnson, the most popular American figure painter.

Old Mill in Tyrol. Size 22 × 30. Price 40 Cents.

Old Oaken Bucket. Size 19 × 26 inches. Price 40 Cents. This is a chromo of world wide celebrity. After Wordsworth Thompson.

On the Scent. Size 24 × 30. Price 40 Cents. A dog picture.

Our New Friend. Size 24 × 30. Price 40 Cents. A charming out-of-door scene. Children feeding a beautiful large dog.

Pluck No. 1. Size 15½ × 21½. Price 40 Cents.

Pluck No. 2. Size 15½ × 21½. Price 40 Cents.

Rock of Ages. Size 22 × 30. Price 40 Cents. A copy of the famous American painting. The beautiful native work of Religious art.

Ruins of Neideck. Size 24 × 30. Price 40 Cents.

Summer in the Alps. Size 22 × 30. Price 40 Cents.

The Deacon's Prayer. Size 16 × 22½. Price 40 Cents.

The Deacon's Revenge. Size 16 × 22½. Price 40 Cents.

Valley of the Mohawk. Size 24 × 30. Price 40 Cents.

Vestal Virgin. Size 24 × 30. Price 40 Cents.

View on the Danube River. Size 24 × 33. Price 40 Cents.

Watch Meeting (New Year's Eve). Size 22 × 30. Price 40 Cents.

West Point. Size 24 × 30. Price 40 Cents. This is a picture of great beauty. Every household of taste should have one to be a representative of the historical beauty of their country. It is after John J. Zang.

Wet Sheet and Flowing Sea. Size 15½ × 25. Price 40 Cents. A beautiful marine picture. After M. F. H. de Haas.

Yacht Race. Size 22 × 30. Price 40 Cents. A handsome marine picture.

Any of the above chromos will admit being cut down to fit almost any size frame.

All of the above Chromos are first-class works of Art. They can be obtained of any newsdealer, or will be mailed (properly packed, single or in pairs), by us, on receipt of price.

GEORGE MUNRO, Publisher
17 to 27 Vandewater Street
NEW YORK.

NOTES

Preface

1. See, for example, Harriet Bridgeman and Elizabeth Drury, eds., *The Encyclopedia of Victoriana* (New York: Macmillan Co., 1975), which contains extremely useful texts covering furniture, clocks, photographs, sculpture, and so on, but not one word about chromolithography.

Chapter One

1. Allen Johnson and others, eds. *Dictionary of American Biography*, 21 vols. and 4 supplements (New York: Charles Scribner's Sons, 1929) 2: 129–135.
2. James Bryce, *Studies in Contemporary Biography* (New York: Macmillan Co., 1903), p. 372.
3. For a brief survey see Merle Curti, *The Growth of American Thought* (New York: Harper and Brothers, 1951), pp. 593–604. See also, Daniel J. Boorstin, *The Americans: The Democratic Experience* (New York: Vintage, 1974), pp. 478–514. See also Stephen Hess and Milton Kaplan, *The Ungentlemanly Art* (New York: Macmillan Co., 1968), p. 35.
4. See Ian M. G. Quimby and Polly Anne Earl, eds., *Technological Innovation and the Decorative Arts* (Charlottesville, Va.: Henry Francis duPont Winterthur Museum, 1974), particularly Cyril Stanley Smith, "Reflections on Technology and the Decorative Arts in the Nineteenth Century," pp. 1–64, and Jay E. Cantor, "Art and Industry: Reflections on the Role of the American Museum in Encouraging Innovation in the Decorative Arts," pp. 331–354. The classic account is Sigfried Giedion, *Mechanization Takes Command* (originally published in 1948, New York: W. W. Norton & Co., 1969).
5. Nicolette Gray, "The Nineteenth Century Chromo-Lithograph," *Architectural Review* 84 (October 1938):177–187.
6. Elizabeth McCausland, "Color Lithography," *Prints* 8 (December 1937):71–80, 120.
7. "Art-Lithographers of the United States," *Lithographers' Journal*, September 1893, p. 52.
8. Alois Senefelder, *A Complete Course of Lithography*, trans. A. S. (London: R. Ackermann, 1819), pp. 272–273.
9. "New Mode of Copying Oil Paintings, by Means of Lithography," *The Franklin Journal and American Mechanics' Magazine*, December 1827, p. 415.
10. See, for example, P. S. Duval's trade card, c. 1840, at the Historical Society of Pennsylvania, and the cover of the first issue of *Lithograph*, January 1, 1874.
11. Harry T. Peters, *America on Stone* (Garden City, N.Y.: Doubleday, Doran & Co., 1931), pp. 75–76.
12. See invitations and cards glued to pages in Charles Hart, "Lithography, Its Theory and Practice, Including a Series of Short Sketches of the Earliest Lithographic Artists, Engravers and Printers of New York," 1902 and several later inserts, Manuscript Division, New York Public Library. For modern celebrations see *Homage to Senefelder* (London: Victoria and Albert Museum, 1971).
13. Wilhelm Weber, *A History of Lithography* (London: Thames & Hudson, 1966), pp. 79–90; Michael Twyman, *Lithography, 1800–1850: The Techniques of Drawing on Stone in England and France and Their Application in Works of Topography* (London: Oxford University Press, 1970), pp. 160–163; and Garo Z. Antreasian and Clinton Adams, *The Tamarind Book of Lithography: Art and Techniques* (New York: Harry N. Abrams, 1971), pp. 163–225.
14. *The Literary Blue Book* (London: Marsh and

Miller), 1829, pp. 94–95.

15. "Autobiography of Louis Prang," as presented in typescript in Mary Margaret Sittig, "Louis Prang & Company, Fine Art Publishers" (master's thesis, George Washington University, 1970), pp. 123–156.

16. Broadside from Box 45, Warshaw Collection of Business Americana, National Museum of History and Technology, Smithsonian Institution, Washington.

17. Gustave von Groschwitz, "The Significance of Nineteenth Century Color Lithography," *Gazette des Beaux-Arts,* November 1954, p. 243. The author does admit parenthetically: "excellent chromolithographs were also produced during the middle and latter part of the nineteenth century," p. 243. See also André Mellerio, *La Lithographie originale en couleurs* (Paris: L'Estampe et l'affiche, 1898).

18. In my opinion, for American museums and libraries, *chromolithography* is a useful term when it is qualified. For example, "chromolithography: reproduction of oil painting . . . ," or "chromolithography: reproduction of a watercolor by Mr. So-and-So used as a calendar illustration," or "chromolithography: original design by artist So-and-So" seem suitable. The variety is endless. Nineteenth-century Americans used the word *chromo* in a loose manner, and I believe that this spirit should be maintained. The *application* of chromolithography should then be indicated in its catalogue subclassification. See Peter C. Marzio, "The Democratic Art of Chromolithography in America: An Overview," (Boston: Museum of Fine Arts, 1978), pp. 76–102. See also chapter fifteen, "Pictures, Designs, and Other Two-Dimensional Representations," *Anglo-American Cataloguing Rules* (Chicago: American Library Association, 1967), pp. 329–342.

19. Joseph Pennell and Elizabeth Robins Pennell, *Lithography and Lithographers* (London: T. Fisher Unwin, 1898), p. 217.

20. Ibid. p. 122.

21. Most critics felt that Pennell overstated his case. See *Art Interchange,* March 1899, p. 64; *Critic,* February 27, 1897, p. 153.

22. Calvin J. Goodman, *A Study of the Marketing of the Original Print* (Los Angeles: Tamarind Lithography Workshop, 1964), p. 8.

23. William John Stannard, *The Art-Exemplar, A Guide to Distinguish One Species of Print from Another with Pictorial Examples and Written Descriptions of Every Known Style of Illustration* (n.p., c. 1860), pp. 157–158, describes commercial lithography:

> With regard to Writing, commerce had no other method of multiplying and publishing its acts and transactions, but by having recourse to letter-press printing; and, notwithstanding the wonderful strides which typography has made of late, still it can never imitate writing and fac-similies [*sic*] of one's own handwriting, etc., with the same perfection and with the same facility as lithography. This art will always be found more elegant, more expeditious, and more ecomomical. Many of these examples of commercial lithography vie now with many of the happiest efforts of copper-plate writing engraving.

24. Advertisement, Box 45, Warshaw Collection. Also *Gopsill's Philadelphia . . . Directory for 1882,* p. 945: "Theo. Leonhardt & Son, commercial lithography. . . ."

25. *American Dictionary of Printing and Bookmaking* (New York: Howard Lockwood and Co., 1894), pp. 345–346. Not until the 1880s did the modern definition begin to evolve. The Strobridge company first used "commercial" as a bookkeeping entry in 1882, but even at that time it was not inclusive—omitting, for example, theatrical pieces and circus posters. And even by the 1890s the instinct was strong not to pull art and commerce apart. A. Hoen and Company, of Baltimore, advertised near the end of the century: "Fine Commercial Lithography a Specialty." See billhead for Potsdamer and Company, "Commercial Lithographers," 1880, Box 45, Warshaw Collection. Also, the Strobridge account book, 1867–86, Cincinnati Historical Society, p. 138.

26. The Warshaw Collection, Boxes 44 and 45, has numerous examples: Ferdinand Mayer and Company, John Wagner ("Successor to Endicott & Co."), Snyder and Black, Max Wolfensberger, Mayer and Korff all called themselves "practical lithographers." John H. Bufford supplied a similar listing: "Portraits, Labels, Landscapes, Drafts, Music, Titles, Checks, Show Cards, Printing Colors, Architectural Drawings, Maps, Plans, Bill Heads" (billhead, Box 45, Warshaw Collection). In *The New York Merchants' & Manufacturers' Advertising Business Directory for 1858–9* (New York: T. W. Barnum, 1858), pp. 166–167, the term appeared in a variety of ways: Charles Hart, "Practical Lithographer," of 99 Fulton Street, gave it a broad definition: "Show Cards, Portraits, Landscapes, Buildings, Views of Hotels, Music Titles, Labels, Maps, Plans, Fac Simile Circulars, Bill Heads, & c."; Henry Siebert and Brothers, "Practical Lithographers" on the same block of Fulton Street, were more pedestrian: "Railroad Bonds with Coupons, Certificates of Stocks, Notes, Checks, Drafts, Bill and Letter Headings, Maps, Plans, Labels, etc., etc." The Siebert offerings are probably the most common. The billhead for Mayer and Korff, of New York

City, (1880) listed "Bonds & Coupons, Certificates of Stock, Bills of Exchange, Billheads, Bills of Lading, Notes, Drafts, Checks, Circulars, Visiting & Business Cards, Cards Plain & Fancy, Labels, Maps &c. &c." Box 45, Warshaw Collection. To Hayward and Lepine, of New York's Pearl Street, practical lithography meant "all kinds of Commercial Blanks"; to Roby and O'Neill, on Liberty Street, "Labels of every description"; to Deutz Brothers, 197 William Street, no definition was offered: "Practical Lithographers" stood alone. (Box 44, Warshaw Collection.) Some companies, including A. Hoen, of Baltimore, (today, the oldest surviving lithographic house in America), retained in their advertising the term "practical lithographers" for much of their nineteenth-century existence, while others, including L. N. Rosenthal, of Philadelphia's Chestnut Street, adopted it as times and needs dictated (*Philadelphia Merchants and Manufacturers Business Directory 1856–57*, p. 251, and Rosenthal business card, Box 45, Warshaw Collection).

27. Billhead of Potsdamer and Company, Box 45, Warshaw Collection.
28. Billhead, Box 45, Warshaw Collection.
29. Ibid.
30. Ibid.
31. Gast Litho Company advertised "Special Offer In Handsome Chromo Advertising Cards, Only $1.50 per 1000." Johns and Company, of Cleveland, offered cards of little girls flying on the backs of birds, or hugging kittens, or gathering flowers, at 1,000 for $3.50. Mayer, Merkel and Ottoman, of New York: "Per Thousand, in 10,000 Lots . . . $3.00." All above from Box 45, Warshaw Collection.
32. See, for example, *San Francisco Directory* (Henry G. Langley, 1863), p. 624: R. W. Fishbourne, practical lithographer, "All orders in Crayon Work promptly attended to." William Donaldson, of Cincinnati, advertised: "in promptness of delivery we have no rival" (Box 44, Warshaw Collection). B. F. Corlies and Macy (c. 1870): "Lithographic Work of Every Description Executed with taste & Dispatch at low prices" (advertisement sheet, Box 44, Warshaw Collection).
33. *Geer's . . . Hartford City Directory . . . 1860–61*, p. 285.
34. *San Francisco Business Directory* (Crocker and Langley, 1901), opp. p. 328. See also Howard M. Nesmith and Tim Burger, of 36 Beekman Street, New York: "Artistic Designing and Lithographing" (Box 44, Warshaw Collection); Globe Lithographing and Printing Company (Chicago, 1893): "*Art Printing* a specialty" (Box 44, Warshaw Collection); C. Roth, of Brooklyn: "Designer on Stone" (Box 44, Warshaw Collection).

35. J. Fairbanks to Strobridge, April 19, May 17, 18, and 22, 1877, Cincinnati Historical Society.
36. In contradiction, Peters, *America on Stone* p. 364, calls the print a lithotint, meaning that all the colors were printed from a single stone, but he gives no evidence to substantiate his statement.
37. Bettina A. Norton, "William Sharp: Accomplished Lithographer," *Art and Commerce: American Prints of the Nineteenth Century* (Boston: Museum of Fine Arts, 1978). For the chronology on Sharp see Norton, "The Beginnings of Color Lithography in America: William Sharp in Boston" in *Books at Brown*, forthcoming.
38. The "Mr. Lane" referred to here is R. J. Lane, who reproduced lithographically many works by Landseer, Leslie, Lawrence, Gainsborough, and others: Clara Erskine Clement and Laurence Hutton, *Artists of the Nineteenth Century* (Boston and New York: Houghton Mifflin Co., 1894), pp. 37–38. The *Literary Blue Book*, 1829, pp. 79, 102, 109, 149.
39. *Stimpson's Boston Directory . . . 1840*, p. 369; Norton, "William Sharp," p. 67.
40. Hart, "Lithography," pp. 317–323.
41. See Sharp portrait of Daniel Webster, American Antiquarian Society, Worcester, Mass.
42. "The Battle Prayer" (n.p.: E. H. Wade, n.d.). "W. Sharp. Chromo Lith."
43. See, for example, "Tremont St., South," c. 1843, and "Tremont Street, 'Brimstone Corners'," before 1843, both after Philip Harry, located in the Boston Athenaeum and Massachusetts Historical Society, respectively. Original works of art by Sharp are located in the Museum of Fine Arts, Boston; Sawyer Free Public Library, Gloucester, Mass.; and the Massachusetts Historical Society, Boston. For tinted lithographic sheet-music covers by Sharp see the J. Francis Driscoll Collection, Newberry Library, Chicago.
44. Morris Mattson, *The American Vegetable Practice* (Boston: D. L. Hale, 1841) 1:xi.
45. Driscoll Collection. "Printed in Colours" by Bouvé and Sharp.
46. "Preface to the Third Number," *Transactions of the Massachusetts Horticultural Society,* 1847.
47. *The Boston Directory . . . 1852*, p. 229. Quotations taken from the print.
48. Norton, "William Sharp," pp. 50–75. Also, Sharp's son-in-law was a photographer, whose photograph of Boston from a balloon (c. 1860s) is a famous nineteenth-century image. See Sharp scrapbook, Print Department, Boston Public Library.
49. Hart, "Lithography," pp. 317–323.
50. George C. Groce and David H. Wallace, *The New-York Historical Society's Dictionary of Artists in America, 1564–1860* (New Haven: Yale University Press, 1957), p. 441.

51. "City of San Francisco," 1852. "From daguerreo-types taken on the spot . . . printed in tints by F. Michelin." Location: Prints and Photographs Division, Library of Congress. And "Utica, N.Y.," n.d., on stone by D. W. Moody. Location: Harry T. Peters "America on Stone" Lithography Collection, National Museum of History and Technology, Smithsonian Institution, Washington.

52. The date is difficult to read. A "7" appears to be written on the print—Whitefield apparently had left the space for the final digit blank, filling it in later. On a few occasions he also added or corrected titles. See Bettina A. Norton, *Edwin Whitefield, Nineteenth-Century North American Scenery* (New York: Barre Publishers, 1977), p. 130.

53. See Peters, *America on Stone*, pp. 281–284.

54. David Tatham, "John Henry Bufford, American Lithographer," *Proceedings of the American Antiquarian Society* (Worcester, Mass.: American Antiquarian Society, 1976), vol. 86, pt. 1, p. 51; Peters, *America on Stone*, p. 118.

55. For titles see Peters, *America on Stone*, pp. 118–127; Tatham, "Bufford," pp. 52–55.

56. Tatham, "Bufford," p. 57.

57. "Columbine Waltzes" (Boston: William H. Oakes, n.d.), "printed in colors" by Thayer and Company, Boston, and signed "Bufford."

58. Tatham, "Bufford," p. 58.

59. *Boston Evening Traveller*, p. 1.

60. The originals are located in the Print Room, Boston Public Library.

61. See Peter C. Marzio, *The Art Crusade* (Washington: Smithsonian Institution Press, 1976), pp. 18–23.

62. *Inland Printer*, November 1884, p. 73.

63. See the chromo "Gems of Art . . . Prosperity the Reward of Industry," in the Warshaw Collection.

64. See "Grace Darling" and a small, untitled shoreline scene at the Metropolitan Museum of Art, New York. Both are labeled "Bufford's Oil Chromo Boston."

65. "Chickering Waltz" (Boston: Oliver Ditson and Company, 1867), in the Driscoll Collection.

66. See Bufford trade cards and advertisements in Box 44, Warshaw Collection. See also, *New York City Business Directory . . . 1885*, p. 10: "We are the original mfrs in the US of advertising, birthday, Christmas, Easter, New Year, Scripture & Reward Cards, Folders, Orders of Dance, Satin and Shape Novelties, etc."

67. Advertisement of John H. Bufford's Lithographic Establishment, c. 1880, Box 45, Warshaw Collection.

68. Key located in the Library of Congress, Washington. It reads:

TWELVE TEMPTATIONS, or Passions, are represented by Twelve Lions. Daniel, with radiant brow and superhuman will, standing at the mouth of the den, seizes the strongest Lion, which is "APPETITE" (No. 1.) Angel, in background, is watching the conflict between APPETITE and Human Will. Will is king of faculties, as Lion is king of beasts. Daniel governed his appetite, drank no wine, nor tasted the king's meat.

II. —"INDOLENCE" reclines upon his back. He "don't care whether school keeps or not."

III. —"AMBITION" treads upon the necks of his fellows to mount to place. The prize is seen on the heights. It may be only a sheep, or it may be the White House.

IV. —Lions of "SUBMISSION" lick the feet of him that treadeth them down.

V. —"RAGE" was Submission's lion until he got his back up. He got no bone, but got hurt in the back-bone.

VI. —"HYPOCRISY" is a lion in sheep's clothing. Lambs frisk about unconscious of the deception. Black goat stands erect, as much as to say, "Who be you?"

VII. —"GREED" is a black lion, devouring widows and orphans.

VIII. —"REVENGE," wounded by an arrow, is furiously leaping upon his assailant.

IX. —Lion of "BACKBITING" is a member of the Sewing Circle. It assails Daniel a perte de vue.

X. —"PRESUMPTION" has gone one step too far; his foot slips, and down he goes!

XI. —Lions of "LOVE" are embracing each other, while "JEALOUSY" bites their heels.

XII. —"VANITY" is combing its locks in a mirror of water. "CURIOSITY" discovers its face in a polished shield, and is struck with delight. King Darius is anxiously watching Daniel's fate.

"The Chromo is splendid as an Allegory and work of Art, but it can convey but a faint idea of the thrilling Passions, Dialogues and Aphorisms of the Lecture."

69. For a more complete listing see Leeds Wheeler, "Armstrong and Company, Artistic Lithographers: 1872–1897, Checklist 1944," manuscript, Prints and Photographs Division, Library of Congress.

70. The lithographs and the text were bound into a book in 1882 by S. E. Cassino, Boston.

71. Original Sprague watercolors located in Department of Prints and Drawings, Museum of Fine Arts, Boston.

Chapter Two

1. *Philadelphia Public Ledger,* February 9 and 11, 1856. *McElroy's Philadelphia Directory . . . 1856* lists twenty entries under "Lithographers."

2. Nicholas B. Wainwright, *Philadelphia in the Romantic Age of Lithography* (Philadelphia: Historical Society of Pennsylvania, 1958), pp. 30–45, 61–74, gives the most reliable account of P. S. Duval. Not as reliable is Harry T. Peters, *America on Stone* (Garden City, N.Y.: Doubleday, Doran & Co., 1931), pp. 163–168.

3. George Lehman, a landscape painter, had been Childs's partner since 1833. Wainwright, *Philadelphia in the Romantic Age of Lithography,* pp. 10, 18–26.

4. Lithographs from the *Military Magazine* of 1839–42 carry the imprint "Huddy and Duval," a partnership that was limited to prints produced for the magazine. Duval did all his other work under his own name. Frederick P. Todd, "The Huddy & Duval Prints," *The Journal of the American Military Institute* 3 (1939), pp. 166–176.

5. See note 48, chapter eight.

6. See illustrations in John Edwards Holbrook, *North American Herpetology; or A Description of the Reptiles Inhabiting the United States,* 5 vols. (Philadelphia: J. Dobson, 1842).

7. *Journal of the Franklin Institute,* December 1844, p. 326; December 1848, p. 424.

8. Ibid. *Report of the Twentieth Exhibition of American Manufactures,* p. 17, follows the November 1850 issue.

9. George Dewey, "Christian Schuessele," *Sartain's Union Magazine of Literature and Art,* June 1852, pp. 462–463. Wainwright, *Philadelphia in the Romantic Age of Lithography,* p. 82, gives Schuessele's year of birth as 1826, but no source is cited.

10. Dewey, *Sartain's Union Magazine of Literature and Art,* June 1852, pp. 462–463.

11. J. Luther Ringwalt, ed., *American Encyclopaedia of Printing* (Philadelphia: Menamin & Ringwalt, 1871), p. 283. The entry "Lithography" is unsigned, but internal evidence points to Duval: "In 1849, the writer of this sketch engaged Mr. Schuessele . . . and introduced the chromo into his establishment in Philadelphia." Joseph Pennell and Elizabeth Robins Pennell, *Lithography and Lithographers* (London: T. Fisher Unwin, 1898), p. 218, say Schuessele "introduced colour work into America. . . ."

12. *Bulletin of the American Art-Union* (New York: George F. Nesbitt, 1850), pp. 26–27.

13. See letter dated January 3, 1916, in the Charles H. Taylor file at the American Antiquarian Society, which cites *Report of the Commissioner of Patents* (pt. 1):

> Mr. P. S. Duval of Philadelphia having been invited to furnish a fair specimen of machine painting, illustrative of the present state of chromo lithography in the United States, the subjoined beautiful sketch has been prepared and presented by him. This specimen is required to pass through the press nine times, and in order to render the process intelligible to those unacquainted with the modern art, a proof of each impression necessary to perfect the picture is inserted in a few copies of this report. A glance will suffice to show how the design is gradually brought out from the dark and dreamy shadows of No. 1 to the rich and glowing finish of No. 9.

A volume containing Duval's lithographic specimens is located in the Rare Book Room, Library of Congress, Washington.

14. *Philadelphia Public Ledger,* March 4 and October 8, 1852.

15. See, for example, the illustrations by Duval in [Henry Augustus], *Mitchell's New Universal Atlas* (Philadelphia: Charles De Silver, 1855). It is not known precisely when Duval and Schuessele stopped working together. *The Crayon* of March 1860, p. 92, notes the publication of a chromo, "Ocean Life," after C. Schuessele, and no mention is made of Duval. The original is probably *Underwater Marine Life,* a watercolor, now in the Metropolitan Museum of Art, New York.

16. Wainwright, *Philadelphia in the Romantic Age of Lithography,* p. 70.

17. See early P. S. Duval and Son advertisement, number 804, in the Langstroth Collection, Cincinnati Public Library.

18. John Sartain, *The Reminiscences of a Very Old Man* (New York: D. Appleton and Co., 1899), p. 250.

19. *Description of the Print Entitled Washington's Triumphal Entry, New York, Nov. 25, 1783* (Philadelphia: George T. Perry, 1861), p. 3.

20. Pennell and Pennell, *Lithography,* p. 218.

21. As early as 1859 Duval advertised his lithographic business as "The oldest . . . in the U. S." (*McElroy's Philadelphia City Directory . . . 1859,* p. 4).

22. *St. Louis Weekly Reveille,* July 31, 1848, as quoted in John Francis McDermott, ed., "A Journalist at Old Fort Snelling," *Minnesota History,* December 1950, p. 220. The standard source on Eastman is McDermott, *Seth Eastman: Pictorial Historian of the Indian* (Norman, Okla.: University of Oklahoma Press, 1961). See also McDermott, *The Art of Seth Eastman* (Washington: Smithsonian Institution, 1959).

23. H. R. Schoolcraft to Orlando Brown, February

13, 1850, in unbound general correspondence, Schoolcraft Papers, Library of Congress.

24. McDermott, *Seth Eastman: Pictorial Historian*, pp. 84–85.

25. See "The Collection of Watercolor Drawings of the North American Indian by Seth Eastman in the James Jerome Hill Reference Library, Saint Paul," 1954, by Frances Densmore, in the Library of Congress. Fifty-one watercolors in this collection were probably used in the Schoolcraft volume.

26. Orlando Brown to W. K. Sebastian, of the Committee on Indian Affairs, February 8, 1850, in unbound general correspondence, Schoolcraft Papers, Library of Congress.

27. Peters, *America on Stone*, p. 72. Ackerman appears in New York directories from 1845 to 1859.

28. Seth Eastman to Luke Lea, March 1851, in Miscellaneous files, Bureau of Indian Affairs, National Archives, Washington.

29. P. S. Duval to Luke Lea, April 5, 1851, Miscellaneous files, Bureau of Indian Affairs. For additional details of the financing, see: memorandum of a contract between Lippincott, Grambo & Co. and H. R. Schoolcraft, October 17, 1850; Schoolcraft account with Lippincott, Grambo & Co., 1851–53 (March 12, 1853); and miscellaneous estimates and memoranda from 1850. In unbound general correspondence, Schoolcraft Papers.

30. When Ackerman produced two lithographs, "printed in colours," (9 13/16 by 6¼ inches) for *Sartain's Union Magazine of Literature and Art*, January 1850, the editor wrote (pp. 100–101): "CHROMO-LITHOGRAPHY.— We give this month two fine specimens of this beautiful art. . . . The flower and title page are each produced by seven or eight successive impressions. . . . [The] advantages are numerous and obvious, especially in the case of very large editions being wanted."

31. Wainwright, *Philadelphia in the Romantic Age of Lithography*, p. 58, notes: "Bowen was too wedded to hand coloring to venture farther than the use of printed tints. . . ." The "Indian Offering Food to the Dead" is obviously an exception.

32. McDermott, *Seth Eastman: Pictorial Historian*, p. 81.

33. Lippincott, Grambo & Co. to Schoolcraft, January 9, 1851, in unbound general correspondence, Schoolcraft Papers.

34. Lippincott, Grambo & Co. to Schoolcraft, January 14, 1851, in unbound general correspondence, Schoolcraft Papers. See also in this correspondence Lippincott, Grambo & Co. to Schoolcraft, December 26 and 28, 1850; January 8, 18, and 20; February 3; and April 3 and 5,

1851. Also, Lippincott, Grambo & Co. to Luke Lea, January 22 and 31, and February 8 and 11, 1851.

35. Lippincott, Grambo & Co. to Schoolcraft, January 9, 1851, unbound general correspondence, Schoolcraft Papers.

36. Eastman to Schoolcraft, December 5, 1850, unbound general correspondence, Schoolcraft Papers.

37. Schoolcraft to Luke Lea, October 15, 1850, Miscellaneous files, Bureau of Indian Affairs. Note that as late as March 1851 Schoolcraft had not notified the publishers of his decision: "If you intend to have the illustrations in steel it is time we were engaging the engravers." Lippincott, Grambo & Co. to Schoolcraft, March 14, 1851, unbound general correspondence, Schoolcraft Papers. See also in this correspondence Schoolcraft to Lippincott, Grambo & Co., March 15, 1853.

38. Even as late as 1858 the Smithsonian Institution used hand-colored lithographs to illustrate Spencer F. Baird's beautiful *Catalogue of North American Birds*. Seventeen years later, however, Baird's *A History of North American Birds* was illustrated with sixty-four chromos. The important point to remember is that today we know that the chromo eventually won popular acceptance, but back in 1851, as the Schoolcraft project demonstrates, there was no sure future for this still experimental print technology. Baird, *Catalogue of North American Birds, Chiefly in the Museum of the Smithsonian Institution* (Washington: Smithsonian Institution, 1858), and Baird, T. M. Brewer, and Robert Ridgeway, *A History of North American Birds: Land Birds* (Boston: Little, Brown, and Company, 1874); the lithographer's name is not noted on the plates.

39. Sinclair's "Fort Massachusetts," by J. M. Stanley from a sketch by R. H. Kern, is a particularly fine tinted lithograph. Copy located in the Division of Graphic Arts, National Museum of History and Technology, Smithsonian Institution, Washington.

40. Wainwright, *Philadelphia in the Romantic Age of Lithography*, p. 49.

41. Trade card, Box 45, Warshaw Collection of Business Americana, National Museum of History and Technology.

42. See hand-colored lithograph "View of Inauguration of Gov. James Pollock," in the Prints and Photographs Division, Library of Congress.

43. "Seventy Two" (Philadelphia: Lee & Walker, n.d.), J. Francis Driscoll Collection, Newberry Library, Chicago.

44. Quoted in Wainwright, *Philadelphia in the Romantic Age of Lithography*, p. 82.

45. *Philadelphia Public Ledger*, September 17, 1851.

46. Another chromo of a similar style is "Philadelphia as it is in 1852," printed in colors. Located in the Print Room, New York Public Library.

47. Stefanie A. Munsing, *Made in America: Printmaking 1760–1860* (Philadelphia: The Library Company of Philadelphia, 1973), p. 50.

48. The firm appeared, under various minor changes in name, in the Philadelphia business directories until the late 1880s.

49. See *Edwards' Chicago Business Directory . . . 1866*, pp. 3–4.

50. William S. Talbot, *Jasper F. Cropsey, 1823–1900* (Washington: Smithsonian Institution Press, 1970), pp. 90–92. One small version of the painting is located in the Toledo Museum of Art.

51. Ibid., p. 81.

52. Seven Cropsey-Gambert lithographs are located in the Museum of Fine Arts, Boston. A label on the back of each chromo reads "Facsimiles of watercolor drawings and oil pictures by eminent artists, published by E. Gambert & Company."

53. Wainwright, *Philadelphia in the Romantic Age of Lithography*, pp. 82–85.

54. *Philadelphia Merchants and Manufacturers Business Directory . . . 1856–1857*, p. 15.

55. Wainwright, *Philadelphia in the Romantic Age of Lithography*, p. 85.

56. *McElroy's Philadelphia City Directory . . . 1859*, p. 9.

57. *Boyd's Washington & Georgetown Directory . . . 1865*, unpaginated.

58. See Peters, *America on Stone*, p. 23; Wainwright, *Philadelphia in the Romantic Age of Lithography*, pp. 70, 78, 86, 89.

59. For the first several years the firm was known as Kramer and Rosenthal. See "Sweet Briar Farm and Ice Compy. House," printed by Kramer and Rosenthal in the Atwater Kent Museum, Philadelphia.

60. These four other brothers were Max, Simon, Solomon, and Maurice.

61. R. A. Smith, *Philadelphia as It Is in 1852* (Philadelphia: Lindsay and Blakeston, 1852), p. 242. For the use of zinc in chromolithography see chapter five of this book.

62. See Wainwright, *Philadelphia in the Romantic Age of Lithography*, pp. 144, 153, 192.

63. Clipping "L. N. Rosenthal," Print Room, New York Public Library.

64. Boardman, Gray and Company piano advertisement in the Library Company of Philadelphia is particularly lush. See description in Munsing, *Made in America*, p. 56.

65. C. W. Webber, *The Hunter-Naturalist: Romance of Sporting; or, Wild Scenes and Wild Hunters* (Philadelphia: Lippincott, Grambo & Co., 1852), p. 7.

66. The original watercolor is located in the Historical Society of Pennsylvania, Philadelphia.

67. The firm vanished from the business directories in the early 1870s.

68. Peters, *America on Stone*, p. 329, spends about a hundred words on Queen and then notes: "His work is far more important than this brief sketch would seem to indicate."

69. Carl Malcolm Cochran, "James Fuller Queen: Artist and Lithographer" (master's thesis, University of Pittsburgh, 1954), pp. 5–6. Cochran published an article based on the thesis in 1958: "James Queen: Philadelphia Lithographer," *The Pennsylvania Magazine of History and Biography*, April 1958, pp. 138–174. George C. Groce and David H. Wallace, *The New-York Historical Society's Dictionary of Artists in America, 1564–1860* (New Haven: Yale University Press, 1957), p. 520, give Queen's year of birth as 1824 and state that he "learned lithography under Wagner & McGuigan."

70. Cochran, "James Fuller Queen," p. 6.

71. Ibid., pp. 7–10.

72. Duval to Newsam, August 30, 1864, the Library Company of Philadelphia.

73. See "Hibernia Fire Engine Co. No. 1 Assembling for Parade, Oct. 5, 1857," "Des." and "lith in colors" by James Queen, 29 by 19 inches, and "Shad Fishing," "from nature and on stone" by James Queen, "Printed in colors." Both prints located in the Historical Society of Pennsylvania.

74. For a check list see appendix in Cochran, "James Fuller Queen." Note, however, that the entire list must be consulted because lithographs "printed in colors" have been separated from "chromolithographs."

75. Printed in 1867 "in oil colors" by P. S. Duval; located in the Prints and Photographs Division, Library of Congress. See also "Washington as a Master Mason," 1870, P. S. Duval, Son and Company, Library of Congress.

76. Printed in 1872 by Duval and Hunter after a painting by William M. Chase, Prints and Photographs Division, Library of Congress.

77. Printed in 1871 by Duval and Hunter after a painting by A. L. Wyngaerot, Prints and Photographs Division, Library of Congress.

78. Printed in 1872 by Duval and Hunter, private collection.

79. *Hotel Rooms Business Directory . . . Philadelphia . . . 1870* (Philadelphia: Jules Bear, 1869), p. 32. "Chromo Publisher," Joseph Hoover, 804 Market Street.

80. The perennial champion, Louis Prang, won a medal for a fruit piece; A. Hoen and Company, of Baltimore, won one for "The Continentals"; and Joseph Hoover won medals for two entries, "The Changed Cross" and the "Faithful

Crowned." Located in the Prints and Photographs Division, Library of Congress, both Hoovers measure 28 by 21 inches; a third Hoover entry was entitled "Beautiful Snow." Prang was exhibiting the Moran Yellowstone series, in addition to other chromos. Hoen's award noted "their lithocaustic process in connection with lithographic engravings, being a new application of etching on stone, invented and patented by them." Other American chromolithographers and chromo dealers at the Centennial were M. Knoedler and Company (New York), A. and C. Kaufmann (New York), Bencke and Scott (New York), the National Chromo Company (Philadelphia), Edmund Foerster and Company (New York), Colton, Zahm and Roberts (New York), J. Latham and Company (Boston), W. J. Demorest (New York), Graf Brothers (Philadelphia), Thomas Hunter (Philadelphia), W. H. Perrine (Albion, Mich.), and Levi F. Smith (Philadelphia). *The United States Centennial Commission International Exhibition 1876 Official Catalogue . . . of Art* (Philadelphia, 1876), pp. 55–57; Francis A. Walker, ed., *United States Centennial Commission [,] International Exhibition 1876 [,] Reports and Awards [,] Group XXVII* (Philadelphia: J. B. Lippincott & Co., 1877), pp. 74, 112.

81. P. S. Duval having retired in 1869, his son, Stephen C., formed a partnership with Thomas Hunter. They operated approximately forty presses. The partnership dissolved in 1874, and Hunter remained in business alone. Wainwright, *Philadelphia in the Romantic Age of Lithography*, p. 74.

82. "Joseph Hoover," *Lithographers' Journal,* September 1893, p. 52.

83. All located in the Prints and Photographs Division, Library of Congress.

84. *Gopsill's Directory . . . 1876*, p. 256; . . . *1878*, p. 262. *Boyd's Philadelphia City Directory . . . 1879*, p. 174; . . . *1880*, pp. 149–150; . . . *1886*, p. 213. "Joseph Hoover," *Lithographers' Journal,* September 1893, pp. 52–53.

85. "Joseph Hoover," *Lithographers' Journal,* September 1893, p. 52. In the *Lithographers' Journal* of February 1894, p. 45, Hoover was again described as a man "who is always purchasing new paintings from the well-known artists of the United States. . . ."

86. *Lithographers' Journal,* September 1893, p. 52.

87. Ibid.

88. Ibid. Hoover produced a number of chromos of ocean-going ships. Copies are located in the Library Company of Philadelphia and the Prints and Photographs Division, Library of Congress. When Hoover's chromo of F. F. English's painting of a cruiser, *New York,* was published, the *Lithographers' Journal* of February 1894 (p. 45) noted: "The colors are excellent, and the reproduction one which will have a lasting interest. . . . Mr. Hoover has adhered faithfully to the tones and coloring of the artist's palette. The work . . . [defies] detection at a distance of a few feet from any water-color painting." For a later chromo by Hoover see "Autumn Blue Ridge," 1906, Cincinnati Museum of Art. As of January 1979 Joseph Hoover Sons is still in existence in Philadelphia. Unfortunately, neither the business papers nor many of the chromos are known to have survived from the time of the great-grandfather.

89. Wainwright, *Philadelphia in The Romantic Age of Lithography*, p. 68.

90. *Philadelphia Business Directory . . . 1863–64* (Hellier), unpaginated.

Chapter Three

1. "The Secretary's Report to the Members of the National Lithographers' Association," *Lithographers' Journal,* October 1891, p. 20.

2. Ibid., p. 33.

3. Ibid., p. 20.

4. Harry T. Peters, *America on Stone* (Garden City, N.Y.: Doubleday, Doran & Co., 1931), pp. 171–179.

5. Charles Hart, "Lithography, Its Theory and Practice . . . ," 1902 plus later inserts, Manuscript Division, New York Public Library; unpaginated section.

6. "The Enchantress" ("Lith and Printed in Colors," G. and W. Endicott), n.d. Located in the J. Francis Driscoll Collection, Newberry Library, Chicago. For slightly later covers see "LaVivandiere" and "Woodman! Spare That Tree!" (various editions), Driscoll Collection.

7. See "Sale in Massachusetts," printed in "chromo," 1854, in the Chicago Historical Society.

8. Located in Chicago Historical Society.

9. Peters, *America on Stone*, p. 176.

10. *Trow's New York City Directory . . . 1854–55*, p. 98.

11. *Wilson's New York City Directory . . . 1873–74*, pp. 400–401.

12. *Wilson's New York City Directory . . . 1879–80*, p. 478.

13. *Wilson's New York City Directory . . . 1886*, pp. 48–51.

14. Peter C. Welsh, "Henry R. Robinson: Printmaker to the Whig Party," *New York History,* January 1972, pp. 25–53.

15. Peters, *America on Stone*, pp. 13, 337–342.

16. George C. Groce and David H. Wallace, *The New-York Historical Society's Dictionary of*

Artists in America, 1564–1860 (New Haven: Yale University Press, 1957) p. 322. The lithographic stone used to print the black in this chromo is located in the Print Room, New York Public Library. Although the caption reads that the print was made expressly for D. W. Valentine's *Manual of the Corporation of the City of New York* (1841–70), it was never published. The stone was apparently sold in the late 1840s to Charles Currier (brother of Nathaniel), who also printed a chromo from it for D. W. Valentine's *Manual,* but neither did this print appear in the *Manual.* The Currier chromo is located in the Print Room, New York Public Library. A second curious chromo involving Robinson is also located at the New York Public Library: "The Government House," from an original drawing by W. J. Condit, copyright 1847 by H. R. Robinson and "Printed in Colours" by William Ells.

17. Peters, *America on Stone,* p. 183.
18. *Wilson's Business Directory of New York City* ... 1867–68, p. 324, and ... 1869–70, p. 348.
19. "U. S. Grant," New York, 1867, 15¾ by 19½ inches, "chromo lith." Located in the Prints and Photographs Division, Library of Congress, Washington.
20. He also, apparently, entered into at least one partnership, [Henry A.] Thomas and Eno. See broadside "Grover & Baker Sewing Machine Co.," Cincinnati Public Library.
21. "The Lurline Polka," 1860, Driscoll Collection.
22. "Nearest and Dearest," 1866, Driscoll Collection. See also "My Charmer," 1866, and "Sweet and Low: The Cradle Song From Tennyson's Princess," 1864, Driscoll Collection.
23. See "Beatrice Di Cenci," after a Guido Reni original, in the Cincinnati Museum of Art. Printed sometime after 1875.
24. Uncatalogued stacks of these cards exist in the Prints and Photographs Division, Library of Congress.
25. "Kauterskill Falls," after Herman Fuechsel, by Colton, Zahm and Roberts, was sold in this manner. Copy in the Old Print Shop, New York City, 1974.
26. The blurb, located at the Library of Congress, reads in full:

OIL CHROMO
of
ALEXANDER
CAMPBELL.
The most correct and life-like
PORTRAIT
Ever published, and a most
SPLENDID PICTURE
of the
Great Leader and Preacher!
The Publishers, R. W. CARROLL & CO.,

have spared no expense to produce the best picture yet issued, and now offer to the Christian Public a
FULL CHROMO
an exact fac-simile as to coloring, expression and likeness, of a portrait of
ALEXANDER CAMPBELL,
owned by his son, Alexander Campbell, of Bethany.
This splendid Picture presents
MR. CAMPBELL in
HIS PRIME
And shows him as he appeared at home. It is not a picture of the Preacher and Orator, so much as it is of
THE MAN
as he was known and loved by his family and friends.
THE PUBLISHERS
offer a Chromo, which, as prices go, would sell at $10, for the extremely low price of
$6.00!
Sent by mail, postpaid, or delivered by the Agent who may take the order.
AGENTS WANTED FOR THE
OIL CHROMO
OF ALEXANDER CAMPBELL!!
OIL CHROMO
OF ALEXANDER CAMPBELL!!
OIL CHROMO
OF ALEXANDER CAMPBELL!!
LARGE DISCOUNT TO AGENTS!
LARGE DISCOUNT TO AGENTS!
LARGE DISCOUNT TO AGENTS!
10,000 COPIES CAN BE SOLD!
10,000 COPIES CAN BE SOLD!
The likeness is so striking ...
the Chromo so cheap, that Agents will be able to coin money by selling it!

———————

The Publishers will be ready to deliver copies by the 15th of February. As the work is very nice, and requires great care, we can not rush it out, but must take time. Those who order first will get their pictures first.
Agents sending along with their application $6.00, will secure an early copy of the picture and a better chance to canvass to advantage.
We shall be able to begin to send specimens to Agents
EARLY IN FEBRUARY.
FIRST COME FIRST SERVED!
Size of Picture, 14 inches by 17 inches!
Mounted on Junk Board and ready for

framing. We can send the Chromo by mail with perfect security.

27. *Trow's New York City Directory . . . 1874–75,* "Commercial Register" section.

28. The set of six included: "Three Brothers [Rocky Mountains]," 1873, "Mirror Lake [California]," 1873, "Cathedral Rocks [California]," 1873, "Bridal Veil Falls [Rocky Mountains]," 1873, "Beverly Dock, Opposite West Point," 1871, "View on the Delaware Water Gap," 1871. 9⅛ by 12⅞ inches, "chromo-lithographed."

29. Groce and Wallace, *Dictionary of Artists in America,* p. 434.

30. On the two prints submitted for copyright the printed phrase "The True American" is faintly observable in the lower right corner. "The Bummers" is lettered by hand directly over the original title. Date and price noted on a printed label stuck to the back of the chromo. Prints and Photographs Division, Library of Congress.

31. Peters, *America on Stone,* p. 92; *Wilson's Business Directory of New York . . . 1869–70,* p. 348.

32. A third copy was advertised in *The Old Print Shop Portfolio,* December 1962, p. 84.

33. A brief account is given in Wend von Kalnein, "The Düsseldorf Academy," *The Düsseldorf Academy and the Americans,* ed. Donelson F. Hoopes (Atlanta: High Museum of Art, 1972), pp. 13–18. For a more detailed account see Wolfgang Hutt, *Die Düsseldorfer Malerschule, 1819–69* (Leipzig, 1964).

34. Quoted in Hoopes, *The Düsseldorf Academy and the Americans,* p. 19.

35. Henry T. Tuckerman, *Book of the Artists: American Artist Life* (New York: G. P. Putnam's Sons, 1867), p. 392.

36. *Art Amateur,* December 1894, p. 15.

37. Michael E. Moss, ed., *Robert W. Weir of West Point: Illustrator, Teacher and Poet* (West Point: United States Military Academy, 1976).

38. Hoopes, *The Düsseldorf Academy and the Americans,* p. 33. And it was in New York City where the early great feats in fine-art reproduction were achieved.

Chapter Four

1. Harry T. Peters, *Currier & Ives: Printmakers to the American People* (Garden City, N.Y.: Doubleday, Doran & Co., 1929), pp. 120–129; Charles Hart, "Lithography, Its Theory and Practice . . . ," 1902 plus later inserts, Manuscript Division, New York Public Library, pp. 343–344.

2. *New York Times,* November 10, 1896.

3. *Lithographers' Journal,* March 1892, p. 60. George C. Groce and David H. Wallace, *The New-York Historical Society's Dictionary of Artists in America, 1564–1860* (New Haven: Yale University Press, 1957), pp. 373, 558.

4. Hart, "Lithography," p. 341.

5. Ronnie C. Tyler, "Prints of the Mexican War as Historical Sources," *American Printmaking Before 1876: Fact, Fiction, and Fantasy* (Washington: Library of Congress, 1975), pp. 61–71. See "Victorious Bombardment of Vera Cruz," hand-colored lithograph, Sarony and Major, 1847, located in the Harry T. Peters "America on Stone" Lithography Collection, National Museum of History and Technology, Smithsonian Institution, Washington.

6. Tyler, "Prints of the Mexican War," p. 71.

7. Charles Hart, who was alive when Sarony and Major existed, notes that the firm relied heavily on Currier and Ives to sell its lithographs: "Lithography," pp. 341–344. A second lithograph (tinted) substantiates this point: "John Quincy Adams," "Sketch'd by Arthur J. Stansbury Esq. . . . A Few Hours Previous to the Death of Mr. Adams." "Copyright by Arthur J. Stansbury, Esq."; "Tinted Liths" by Sarony and Major; "Sold by N. Currier."

8. Hermann W. Williams, Jr., "Fitz Hugh Lane," *The Britannica Encyclopedia of American Art* (Chicago: Encyclopaedia Britannica Educational Co., 1973), p. 334; John Wilmerding, *Fitz Hugh Lane, 1804–1865: American Marine Painter* (Gloucester, Mass.: Peter Smith, 1967).

9. See clipping file, Print Room, New York Public Library; Wilmerding, *Fitz Hugh Lane,* p. 16.

10. See sheet-music cover for "The Seraglio Schottisch" (New York: Firth, Pond and Company, 1853), "Printed in Tints," Sarony and Major, in the J. Francis Driscoll Collection, Newberry Library, Chicago. See also the ten lithographs produced for the series *Graphic Scenes of the Japan Expedition* (New York: G. P. Putnam, 1856). Title cover reads "Executed in colours & tints by Sarony & Co." Corcoran Gallery of Art, Washington.

11. See sheet-music cover "Rainbow Schottisch" (New York: Firth, Pond and Company, 1853), located in the Driscoll Collection. These lithographs were sold both plain and colored. The Harry T. Peters collection of lithographs in the National Museum of History and Technology has numerous examples, including "Bird's Eye View of Boston," from nature and drawn on stone by J. Bachmann, hand-colored, 1850. Also the enormous (24¾ by 40½ inches) "Union Prisoners at Salisbury, N.C.," after Otto Boetlicker, 1863, which has tinted and hand-applied color.

12. Numerous editions located in the Driscoll Collection. Copies of the third edition show that the stones were overinked and the image was destroyed.

13. Rembrandt Peale to Tristram Coffen, July 3, 1860, Joseph Downs Manuscript Collection, Henry Francis duPont Winterthur Museum, Winterthur, Del.

14. For examples of his early work see Zerah Colburn and Alexander L. Holley, *The Permanent Way and Coal-Burning Locomotive Boilers* (New York: Holley & Colburn, 1858): fifty-one monochromatic plates, one hand-colored. A mid-1850s Bien advertisement is located in the Division of Graphic Arts, National Museum of History and Technology.

15. *The Work of Julius Bien: An Exhibition of Original Maps and Engravings* (Washington: Klutznick Exhibit Hall, B'nai B'rith Buildings, 1960), p. 2; *Who's Who in America, 1908–09,* s.v. "Bien, Julius"; Harry T. Peters, *America on Stone* (Garden City, N.Y.: Doubleday, Doran & Co., 1931), pp. 93–94; Allen Johnson and others, eds., *Dictionary of American Biography* 21 vols. and 4 supplements (New York: Charles Scribner's Sons, 1964) 1:249–250, s.v. "Bien, Julius"; *The Nation,* December 23, 1909, p. 635; and *National Lithographer,* January 1910.

16. Before the first plate of the Bien edition appeared, Americans had already seen a lithographed version of Audubon's *The Birds of America.* It was produced under Audubon's supervision between 1839 and 1844. Printed by J. T. Bowen, of Philadelphia, on sheets measuring 11 by 17 inches, it made up seven volumes and sold for approximately $100. Composed of hand-colored lithographs, it was promoted as an affordable version of the masterwork. It was a creditable job by American standards, and it even won the approval of a German visitor, who described it as "beautiful lithographic work and . . . brilliant lifelike coloring." But it was still intended as an inexpensive version of the large engravings. John James Audubon, *The Birds of America,* vols. 1–5 (New York: J. J. Audubon; Philadelphia: J. B. Chevalier, 1840–42); vols. 6 and 7 (New York: J. J. Audubon, 1843–44); Waldemar H. Fries, *The Double Elephant Folio: The Story of Audubon's Birds of America* (Chicago: American Library Association, 1973), pp. 353–354; C. L. Fleischmann, *Trade, Manufacture, and Commerce in the United States of America* (Stuttgart: Franz Kohler, 1852; trans. for Israel Program for Scientific Translations, Jerusalem, 1970), pp. 186–187.

17. The basic works on Audubon are Francis Hobart Herrick, *Audubon the Naturalist: A History of His Life and Time* (New York: D. Appleton–Century Co., 1938); *The 1826 Journal of John James Audubon,* edited and introduced by Alice Ford (Norman, Okla.: University of Oklahoma Press, 1967); and Fries, *The Double Elephant Folio.* For Havell see George Alfred Williams, "Robert Havell, Junior, Engraver of Audubon's 'The Birds of America,'" *The Print-Collector's Quarterly,* October 1916, pp. 225–257. Note: Havell engraved all but the first ten plates of *The Birds of America.* The first ten were done by William Home Lizars.

18. Fries, *The Double Elephant Folio,* pp. 355–359.

19. Quoted in Herrick, *Audubon* 2:389–390.

20. Lucy Audubon to Professor [Joseph] Henry, August 14, 1863, in the John James Audubon Collection, Princeton University Library, and Mrs. J. J. Audubon to Professor [Joseph] Henry, October 18, 1864, in record unit 26, Secretary, 1863–79, Incoming Correspondence, Smithsonian Institution Archives.

21. See Peter C. Marzio, "The Art Crusade" (Ph.D. dissertation, University of Chicago, 1969), pp. 168–197.

22. Quoted in Fries, *The Double Elephant Folio,* p. 75.

23. Alois Senefelder, *A Complete Course of Lithography* (New York: Da Capo Press, 1968), pp. 256–264.

24. See, for example, *McElroy's Philadelphia Directory for 1856,* 19th ed. (Philadelphia: Edward C. & John Biddle, 1856), p. 9. This is an advertisement for the printing firm of Wagner and McGuigan. It reads in part: "transferring from steel and copper plates, woodcuts, etc., this branch of their business is under their own immediate supervision, and having the assistance of the ablest workmen, enables them to produce work equal if not superior to any other establishment in the country." Julius Bien may have debated the claim!

25. Fries, *The Double Elephant Folio,* pp. 390–398.

26. An excellent description of the lithographic-transfer process is in Garo Z. Antreasian and Clinton Adams, *The Tamarind Book of Lithography: Art and Techniques* (New York: Harry N. Abrams, 1971), pp. 227–253.

27. Peters, *America on Stone,* pp. 93–94.

28. When lithography emerged as a promising print medium, from about 1810 through the 1820s, promoters dreamed of the day when lithographs would compete with aquatints in simulating watercolor paintings. To create a tonal system similar to that of an aquatint was the subject of articles and treatises in both Europe and America. The authors of the anonymous works *Lithographic Pen Drawings or Instructions for Imitating Aquatint on Stone* (English edition, 1824) and "Essay on Lithography: Imitation of Aqua-

Tints," *Journal of the Franklin Institute*, May 1828, both argued that if the aquatint effects could be achieved, then lithography would triumph, since lithographic stones generally yielded many more impressions than a soft copperplate.

29. Three progressive states are located in the Division of Graphic Arts, National Museum of History and Technology.

30. See the chromolithographs with additional hand-applied colors in Joseph Nash, *Views of the Interior and Exterior of Windsor Castle* (London: T. M. Lean, 1848).

31. Charles D. Childs, "Audubon's 'Birds of America,'" *The Magazine Antiques,* December 1934, pp. 226–228.

32. See, for example, Bien to Major J. W. Powell: August 24, 1877; November 27, 1874; and January 16, 1878. Letters located in John Wesley Powell correspondence, National Archives, Washington.

33. See the photomechanical-print collection in the Division of Graphic Arts, National Museum of History and Technology.

34. Peters, *America on Stone*, pp. 105–106.

35. Broadside located in the Division of Graphic Arts, National Museum of History and Technology.

36. Copy of the Bien lithograph is located in the Division of Graphic Arts, National Museum of History and Technology.

37. Frederic A. Conningham, *Currier & Ives Prints: An Illustrated Check List* (New York: Crown Publishers, 1949): the introductory essay comes the closest of all Currier and Ives treatments to the standards of professional historical writing. See also Groce and Wallace, *Dictionary of Artists in America*, pp. 159, 342.

38. Most of the exhibition and sales catalogues, for example, are only partially descriptive and are generally uncritical. The most influential have been *Best Fifty Currier & Ives Lithographs: Large Folio Size* (New York: The Old Print Shop, 1933) and *Best Fifty Currier & Ives Lithographs: Small Folio Size* (New York: The Old Print Shop, 1934). See also *A Selection of Lithographs Published by Currier and Ives* (Tarrytown, N.Y.: William Abbatt, 1929) and W. S. Hall, *The Spirit of America: Currier & Ives Prints* (London: The Studio Ltd., 1930).

39. Harry T. Peters Check List No. 1575. Conningham, *Currier & Ives Prints*, print number 3450, dates a Currier and Ives chromo, "The Trapper's Last Shot," after William T. Ranney, 1858. Bernard De Voto, *Across the Wide Missouri* (Boston: Houghton Mifflin Co., 1947), p. 451, dates it sometime after 1858.

40. Harry T. Peters, *Currier & Ives: Printmakers to the American People*, 2 vols. (Garden City: Doubleday, Doran & Co., 1929–31) 1:32–33. The persistence of this attitude can be seen in Colin Simkin, ed., *A Currier & Ives Treasury* (New York: Crown, 1955), foreword.

41. Russel Crouse, *Mr. Currier and Mr. Ives: A Note on Their Lives and Times* (Garden City, N.Y.: Doubleday, Doran & Co., 1930), p. 9: The prints of Currier and Ives "were not, as many believe, printed in color. They came off the presses plain and then went to a great center table where a dozen women, working from a model, added the greens and reds and blues."

42. Conningham, *Currier & Ives Prints: An Illustrated Check List*, p. vi.

43. Frederic A. Conningham, *Currier & Ives* (Cleveland: World Publishing Co., 1950), pp. 23–24.

44. Hart, "Lithography," insert after page 216.

45. Located in the Prints and Photographs Division, Library of Congress, Washington.

46. Ibid.

47. Ibid.

48. Conningham, *Currier & Ives Prints: An Illustrated Check List*, numbers 4476 and 4477, p. 194; "Mr. Currier & Mr. Ives," *The Kennedy Quarterly* vol. 10, no. 2, p. 93.

49. Peters, *Currier & Ives*, p. 32. More than a decade earlier (1877), Maurer's *Ready for the Trot* was "printed in oil colors" by Currier and Ives. Copy located in the Chicago Historical Society. Copies of the other chromos are located in the Harry T. Peters "America on Stone" Lithography Collection, National Museum of History and Technology.

50. Located in the Prints and Photographs Division, Library of Congress.

51. Ibid.

52. Ibid.

53. Groce and Wallace, *Dictionary of Artists in America*, p. 656. See also August P. Trovaioli and Toledano B. Roulhac, *William Aiken Walker: Southern Genre Painter* (Baton Rouge: Louisiana State University Press, 1972), and *Exhibition of Southern Genre Paintings by William Aiken Walker* (New York: Bland Galleries, 1940).

54. *The Kennedy Quarterly*, vol. 10, no. 2, pp. 99, 116, notes that the Walker chromos and others "were printed for Currier & Ives by outside specialist firms." No substantiation is given.

55. Original painting is in a private collection.

56. *Currier & Ives: Printmakers to the American People* (New York: New York Public Library, 1931), p. 4.

57. *Currier & Ives' Catalogue*, reproduced in Jane Cooper Bland, *Currier & Ives: A Manual For Collectors* (Garden City, N.Y.: Doubleday,

Doran and Co., 1931), p. 305.

58. Quoted from "Portraits of the Great Trotters, Pacers and Runners: Currier & Ives' Celebrated Cheap Popular Edition," reproduced in Bland, *Currier & Ives*, p. 319.

59. Quoted in Peters, *Currier & Ives*, figure 1. For subject-matter emphasis, see *Currier & Ives Prints: Clipper Ships* (London: The Studio Ltd., c. 1931) and *Currier & Ives Prints: Early Steamships* (London: The Studio Ltd., 1933).

60. James Ives died in 1895. His son, Chauncey, replaced him in the firm. The failure of Currier and Ives was owing to numerous interacting factors, and historians debate the importance of one above another. Lithographer Charles Hart listed four. He believed that lithographic companies did not usually survive a generational shift—the gift of Nathaniel Currier to perceive public taste was not part of his son's inheritance, nor was the dedication to business: "the early founders built up their establishments by industry and frugality. But these homely virtues were despised by those who inherited their places." Second, the firm became technologically out of date and was reluctant to establish the modern economies of production. Third, a change in public taste rendered the early, sentimental Currier and Ives imagery old-fashioned. And fourth, the rise of illustrated newspapers destroyed Nathaniel Currier's function as a purveyor of sensationalism: "the morning, the Evening and the Midday editions representing the daily and hourly events . . . [which] would in their times, have been a perfect bonanza to the firm of C & I. But alas the public could now buy for a few pennies and in a few minutes after its occurance [*sic*], all the horrors it wished to enjoy for its breakfast, dinner, or tea." Hart, "Lithography," insert after p. 216.

Chapter Five

1. The earliest supplier in Boston, the Pendletons, advertised: "[The Pendleton firm], being Agent for one of the German Quarries, has always on hand, an extensive assortment of the first quality lithographic stones polished on both sides. . . ." *Boston Monthly Magazine*, December 1825, pp. 378–384; single-sheet advertisement, Box 45, Warshaw Collection of Business Americana, National Museum of History and Technology, Smithsonian Institution, Washington. Data c. 1835. See also W. J. Burk, "Rudolph Ackermann, Promoter of the Arts and Sciences," *New York Public Library Bulletin*, October 1934, p. 808.

2. Charles Hart, "Lithography, Its Theory and Practice . . . ," 1902 plus later inserts, Manuscript Division, New York Public Library, p. 65.

3. Henry Edward; A. Rolker and Mollmann; John A. Tauber in *Trow's New York City . . . Directory, 1854–55*, pp. 13, 98; Frederic A. Schwarts and Company, Willy Wallach in *Wilson's Business Directory of New York City, 1855*, pp. 4, 246; Birkner and Wieland in *Wilson's Business Directory . . .* (1856), pp. 4, 251. See also Uffenheimer billhead: "importers of lithographic stones, color, and materials," Box 45, Warshaw Collection.

4. See advertisements in *Lithograph*, January 1 and March 1, 1874.

5. "Lithography," *History of American Manufacturers, 1800–1860* (Philadelphia: Edward Young & Co., 1860) 1:252; *Western Review* 1 (1820):59–60; "Lithography," *Encyclopedia Americana*, ed. Francis Lieber (Boston: Sanborn, Carter & Bazen, 1856); *The Analectic Magazine* 13 (1819):67–68; *Lithograph*, March 1, 1874, p. 4. Senefelder himself had a formula for what he called "stone paper."

6. "Lithographic Stone in North American Quarries," *Lithographers' Journal*, April 1894, pp. 86–87. See also "Litho-Stone in the United States," *Lithographers' Journal*, September 1891, p. 78: "At regular intervals for many years past, reports have appeared in various technical and popular journals, announcing the discovery of a deposit of stone in the United States adapted exactly to the requirements of lithographic work. When investigated, the 'find' has generally existed in the hope rather than in the fact. . . ."

7. Lithographs located in the Warshaw Collection.

8. As early as 1808 Americans began importing Solenhofen's best. "Dr. Mitchell of New York . . . ," reported the *National Intelligencer and Washington Advertiser* on February 8, "received . . . an account of a new discovery, denominated *Lithography*, or the art of multiplying copies of drawings and manuscripts, by means of a peculiar stone lately discovered. . . . Dr. Mitchell has in his possession one of these stones, together with a sample of the ink used; and we hope soon to be apprised of the result of the experiments which shall be tried."

9. According to *Appleton's Dictionary of Machines, Mechanics, Engine-work, & Engraving* (New York: D. Appleton & Co., 1852), s.v. "Lithography," the stones with the largest printing surface should also be the thickest: "In order to sustain the pressure used in taking impressions, a stone, 12 inches square ought not to be less than 1¼ inch thick, and this thickness should increase with the area of the stone." In short, the largest prints were to come from the thickest stones,

which were less likely to be cracked by the pressure of the scraper blade. For an excellent modern analysis of lithographic stones see "The Solenhofen Stone," *Lithopinion*, summer 1974, pp. 16–20.

10. Uffenheimer order in possession of the author. Each lithographer had his own method of testing the quality of a lithographic stone. One common practice was to wet the stone with a sponge: if the water was absorbed quickly, the stone was considered too soft; if, on the other hand, the water remained unabsorbed, the stone was too hard.

11. Strobridge account book, 1867, Cincinnati Historical Society, pp. 14, 23. *Wilson's Business Directory of New York City . . . 1859*, p. 281; . . . *1867–68*, p. 353.

12. See *Langley's San Francisco City Directories* for 1875 (p. 833) and 1877 (p. 986).

13. Fuchs and Lang to Strobridge, June 8, 1877. Cincinnati Historical Society.

14. Order of Herman Schmidt, loc. cit.

15. Hart, "Lithography," p. 55.

16. *Lithographers' Journal*, November 1893, p. 100.

17. Strobridge owned two Parker Stone Planing Machines in 1887. Insurance inventory of 1887, located in Cincinnati Historical Society. Pictures of stone planers are located in the files of the Division of Graphic Arts, National Museum of History and Technology.

18. Bufford and Sage billheads from Box 45, Warshaw Collection.

19. P. S. Duval to H. C. Baird, January 7, 1852, Edward Carey Gardiner Collection, Historical Society of Pennsylvania, Philadelphia.

20. "Lithographic Stones," *Lithographers' Journal*, June 1893, p. 136.

21. *Journal of the Franklin Institute*, September 1853, pp. 207–210; *The New American Cyclopaedia* (New York: D. Appleton, 1860), p. 571.

22. Strobridge account book, 1867, p. 23; 1886, p. 209.

23. Strobridge account book, July 1896.

24. *The New American Cyclopaedia*, p. 572. See also J. Luther Ringwalt, ed., *American Encyclopaedia of Printing* (Philadelphia: Menamin & Ringwalt, 1871), p. 285, for a description of preparing the zinc plate.

25. Nicholas B. Wainwright, *Philadelphia in the Romantic Age of Lithography* (Philadelphia: Historical Society of Pennsylvania, 1958), p. 86, notes that P. S. Duval's shop foreman, Frederick Bourquin, used zinc plates as early as 1849. See also L. N. Rosenthal's advertisement in R. A. Smith, *Philadelphia as It Is in 1852* (Philadelphia: Lindsay and Blakeston, 1852), p. 242, "Zincographic."

26. *The New American Cyclopaedia*, p. 572.

27. *Inland Printer*, December 1884, p. 124.

28. For a general account see W. Turner Berry, "Printing and Related Trades," *A History of Technology* (Oxford: At the Clarendon Press, 1958) 4:707.

29. "Rotary Printing From Zinc-Plates," *Lithographers' Journal*, September 1891, p. 6. Grained zinc was also sold by Milton Bradley Company, Springfield, Mass., and Mathiessen and Hegler Zinc Company, La Salle, Ill. *Cyclopaedia of the Manufactures and Products of the United States* (n.p., 1892), p. 749.

30. *Lithographers' Journal*, October 1893, p. 84. For an article that promotes zinc plates see "Stone versus Zinc for Lithographing," *Lithographers' Journal*, May–June 1894, pp. 116–117. See also *American Dictionary of Printing and Bookmaking* (New York: Howard Lockwood and Co., 1894), p. 344.

31. George Buday, *The History of the Christmas Card* (London: Spring Books, 1954), p. 75.

32. "Lithography and Zinc Plate Printing," *Art Interchange*, October 12, 1882, p. 76.

33. An article on Prang entitled "Chromo-Lithography," *The Paper World*, October 1880, p. 4, included:

> In the former days they [lithographic designs] were drawn on the lithograph stones, but a few years since it was discovered that a pen or brush drawing on zinc could be easily transferred to stone, by a simple process. . . . An important saving of storage room is also secured, as a hundred or more zinc plates take up no more space than a single stone. There are two vaults for this purpose. The smaller one, built in 1868, Mr. Prang supposed would hold as many stones as he should ever wish to preserve. It is now filled with zinc plates, and a much larger vault was built in 1872 at an expense of $10,000. Crayon work to be printed from the original is still drawn directly on stone.

At the end of the chromo civilization aluminum plates also came into existence. One firm in San Francisco in 1901 proudly illustrated an artist at work on a large plate, with the caption "Our new aluminum process." The history of aluminum, however, belongs to the twentieth century. *Langley's San Francisco Business Directory . . . 1901*, advertisement opp. p. 328; "Aluminum as a Substitute for Lithographic Stone," *Lithographers' Journal*, April 1894, p. 78; "Lithographic Printing with Aluminum Plates," *Lithographers' Journal*, p. 80.

34. Ringwalt, *American Encyclopaedia of Printing*, p. 286. For an early manufacturer's advertise-

ment see *Cincinnati Diary & Guide . . . 1856–7*, p. 89: Lay and Brother, manufacturer of lithographic ink.

35. See a typical advertisement of William Schaus, 1858, a New York dealer whose business served as the "Agency for the Principal European . . . Color Manufacturers." Box 44, Warshaw Collection. Also, H. Kohnstamm and Company (New York) to Messrs. Strobridge and Company, November 13, 1877: This is a price list from a firm that advertised itself as "importers of Ultramarine, English, French and German Colors, Anilines, & c." Cincinnati Historical Society.

36. See part seven of this chapter.

37. "Seventy-five Years of Lithographic Inks," *Lithographers' Journal*, September 1957, p. 26. The first foreign firm to build a major ink works in the United States was Jaenecke-Ullman, of Hanover, Germany: their American plant opened in Newark, N.J., in about 1892. For illustration of the plant see "Production of Fine Printing-Inks," *Lithographers' Journal*, April 1892, p. 89.

38. "Printing-Inks in Practical Lithography," *Lithographers' Journal*, April 1893, p. 78. Verified in Hart, "Lithography," p. 131.

39. The use of onions in hot linseed oil is described as early as 1683 in Joseph Moxon, *Mechanick Exercises on the Whole Art of Printing* (reprint of 1683 edition, London: Oxford University Press, 1958, p. 82): "for the process of making Inck being as well luborious to the Body, as noysom and ungrateful to the Sence, and by several odd accidents dangerous of Firing the Place it is made in." Hart, "Lithography," p. 65, gives the same procedure as Duval.

40. Ringwalt, *American Encyclopaedia of Printing*, p. 286.

41. *Cyclopaedia of the Manufactures and Products of the United States*, p. 749; *Inland Printer*, May 1885, p. 347.

42. See views in a broadside of Ault and Wiborg (Cincinnati, c. 1890) in Box 45, Warshaw Collection, and of George Mather's Sons' factory in the *Inland Printer*, October 1885, p. 2.

43. "Concerning Printing Inks," *Inland Printer*, October 1885, pp. 1–5. Charles Hart claimed to have taught George Mather the secret of making lithographic ink: Hart, "Lithography," p. 131.

44. Advertisement, *Inland Printer*, November 1884, p. 60.

45. See for example a bill from A. I. Uffenheimer and Company, Philadelphia, "Importers of Lithographic Stones, Colors and Materials . . . Dry Colors, Bronze powders, Metal Leaf." The items were: "½ lb. Vermillion, $.50; 5 lbs. Best Prussian Blue, $3.75; 1 pack metal leaf, $2.50; 1 oz. Bronze, $.50." Also, Strobridge inventory book,

January 1, 1868, Cincinnati Historical Society, included: "40 lbs. vermillion, $55.00; 2 lbs. Sienna, $2.00; 2 lbs. Florentine Lake, $4.20; 2 lbs. Milore Green, $2.80; 1½ lbs. Ultra Marine Blue, $4.87; 1¼ Carmine, $23.75; 1 14/15 lbs. Silver Bronze $9.38; ¼ lb. fine Bronze, $2.25; 7¼ lbs. Gold Bronze, $38.06; 15 lbs. or gallons of varnish, $8.25; 3 lbs. Burnt Sienna, $3.00; 4 lbs. Milon Blue, $7.20; ¾ lb. violet lake, $4.50; etc." Also, advertisement for Eagle Printing Ink Works in *Boyd's Philadelphia Directory . . . 1858:* "Special attention to lithographer's varnish. . . ." Advertisement (c. 1879) from Mayer, Merkel and Ottman, of New York: "Importers of Lithographic Stones, Dry Colors, Inks, Tools . . . Color Mills, Steam Presses. . . ." Box 44, Warshaw Collection. In the 1870s Strobridge often had barrels of varnish shipped from the East: See Gray's Ferry Printing Ink Works (Philadelphia) to Strobridge and Company, November 24, 1877: "in reference to the leakage in transportation of Barrell varnish sent you. . . . We credit your a/c for 8½ gallons @ 1.50– $12.75. . . ." And Excelsior Printing Ink Co. (New York) to Strobridge, February 9, 1877, regarding varnish. Cincinnati Historical Society.

46. "Practical Color Printing," *Lithographers' Journal*, February 1893, p. 42.

47. Strobridge insurance inventory of 1887. For illustration of R. W. Hartnett and Brothers "Ink Mill" see *Lithographers' Journal*, October 1891, p. 62.

48. W. D. Richmond, *The Grammar of Lithography* (London: Myers & Co., 1914), p. 126.

49. *Inland Printer*, February 1885, p. 223.

50. See a typical illustration of the Emmerich "Improved Bronzing and Dusting Machine," in five sizes. *Lithographers' Journal*, April 1892, p. 82.

51. *The Aldine*, May 1869, p. 39.

52. L. Gray-Gower, "How a Chromo-Lithograph is Printed," *Strand Magazine*, January 1904, pp. 33–39.

53. See, for example, Alois Senefelder, *The Invention of Lithography*, trans. J. W. Muller (New York: Fuchs & Lang Manufacturing Co., 1911), pp. 101–109; *Appleton's Dictionary*, s.v. "Lithography"; *The New American Cyclopaedia*, s.v. "Lithography"; *Encyclopaedia Americana*, s.v. "Lithography"; J. G. Heck, *Iconographic Encyclopaedia* (New York: Rudolph Garrigue, 1851), p. 172; Ringwalt, *American Encyclopaedia of Printing*, pp. 279–286. There were numerous recipes for a variety of lithographic crayons, writing and autographic inks, inks for lavis or wash effects, fine-line drawing inks, and chalks.

54. Until the late 1840s the secret was kept in Europe for making a roller that would properly distribute

ink across a lithographic stone, but in 1848 Samuel Bingham began manufacturing such a roller in America. Rollers continued to be imported, particularly from France, for several decades, but their manufacture became a full-fledged American industry by the late 1870s. "Printers' Rollers," *Inland Printer*, May 1885, pp. 329–332.

55. Ringwalt, *American Encyclopaedia of Printing*, p. 282.

56. *American Dictionary of Printing and Bookmaking*, p. 345. See also Richmond, *Grammar of Lithography*, p. 147.

57. Ringwalt, *American Encyclopaedia of Printing*, p. 286.

58. For illustration of a calendering machine see Fuchs and Lang advertisement in *Lithographers' Journal*, April 1892, p. 87, and Emmerich and Vonderlehr advertisement, *Lithographers' Journal*, May 1892, p. 112.

59. Ringwalt, *American Encyclopaedia of Printing*, p. 286. Henry Lindermeyer to Strobridge, January 10, 1877, and Louis Dejonge and Company to Strobridge, September 25, 1877. Cincinnati Historical Society. Paper cutters were common in lithographic shops. The Sanborn Cutter (New York) and the Acme Cutter (Boston) were widely advertised. See *Lithographers' Journal*, inside front cover, January 1892; March 1892, p. 56; and November 1891, p. 64. For early advertisement see *Inland Printer*, December 1884, p. 128.

60. See note in *American Dictionary of Printing and Bookmaking*, p. 345.

61. Daniel J. Boorstin, *The Americans: The Democratic Experience* (New York: Vintage, 1974), p. 356.

62. Peter C. Marzio, "American Lithographic Technology Before the Civil War," *Prints in and of America to 1850*, ed. John D. Morse (Charlottesville: University Press of Virginia, 1971). Stephen D. Tucker, *History of R. Hoe and Company, 1834–1885*, ed. Rollo G. Silver (Worcester, Mass.: American Antiquarian Society, 1973), p. 354. See also advertisement in *The Cincinnati Diary & Guide . . . 1856–57*, p. 96: James D. Foster and Company, "manufacturer of printing presses, lithographic presses. . . . Constantly on hand." In contradiction to Tucker, Hart, "Lithography," p. 295, notes that Hoe did not make hand presses until after 1840.

63. *The New American Cyclopaedia*, s.v. "Lithography."

64. Ibid.

65. Alois Senefelder, *The Invention of Lithography*, p. 101.

66. Michael Twyman, "The Lithographic Hand Press, 1796–1850," *Journal of the Printing Historical Society*, no. 3, 1967, pp. 3–50. See also the notice in the London *Art-Union*, October 1845, p. 322, of a steam press patented by M. Nicolle.

67. Ringwalt, *American Encyclopaedia of Printing*, p. 278, and *American Dictionary of Printing and Bookmaking*, p. 342.

68. Hart, "Lithography," p. 293; *Lithograph*, January 1 and March 1, 1874, advertisements.

69. See H. Voirin's "Sig. Ullman" advertisement in *Lithograph*, January 1, 1874, p. 6.

70. *Subject-Matter Index of Patents for Inventions Issued by the United States Patent Office from 1790 to 1873, Inclusive*, 3 vols. (Washington: Government Printing Office, 1874), pp. 11, 867: patent numbers 32,672; 43,796; 78,930; 92,276; 63,489; 89,997; 145,420; 111,749; 74,840; 116,335; 139,171; 31,818; 39,867; 92,765; 53,309; 113,276; 116,406; 87,950; 41,862; 46,390; 37,727; 42,125; and 22,519.

71. Edwin Freedley, *Leading Pursuits and Leading Men* (Philadelphia: Edward Young, 1856), p. 232; Carl M. Cochran, "James Queen: Philadelphia Lithographer," *The Pennsylvania Magazine of History and Biography*, April 1958, p. 144; Ringwalt, *American Encyclopaedia of Printing*, p. 279.

72. Broadside, "P. S. Duval's Colour Printing Lithographic Establishment," Box 45, Warshaw Collection.

73. Hart, "Lithography," pp. 283–289. For an example of Hart's own splendid work see chromo entitled "Standard Life Insurance Co." at the Metropolitan Museum of Art, New York.

74. Hart, "Lithography," pp. 283–311.

75. Ibid., p. 211.

76. See also *American Dictionary of Printing and Bookmaking*, p. 342: "Until 1860, or after, all lithographic work was done on hand-presses."

77. Hart, "Lithography," p. 291. Hart says that Major and Knapp operated three steam presses, but in "Mr. Joseph P. Knapp," *Lithographers' Journal*, March 1892, p. 60, the number is put at eight.

78. *Cyclopaedia of the Manufactures and Products of the United States* (1892), p. 508. For Scott see *Inland Printer*, January 1886, p. 249; for Campbell, *Inland Printer*, June 1885, p. 429; and Babcock, *Inland Printer*, November 1884, p. 81. Babcock advertised, *Inland Printer*, April 1885, p. 311: "This machine has no superior. It is very heavy, and has many improvements. . . . In Register, Speed, Distribution of Color and Water, Facility in making Changes, Stillness in Operation, it is ahead of all competitors."

79. Steam lithographic presses of the 1865–1900 era were generally categorized as number 1, 2, 3, 3½, 4, or 5: 1 was the smallest, 5 the largest. The model numbers did not refer, however, to standard-size beds or horsepower requirements,

or to impressions per hour. Each printing-press company had its own system of notation.

80. Strobridge account book, 1880, p. 123, and Strobridge inventory sheet for insurance estimate following fire of December 1, 1887; located in the Cincinnati Historical Society. The advertised price of the press in 1884 was $5,500. Advertisement, *Inland Printer*, October 1884, p. 52.

81. Tucker, *History of R. Hoe and Company*, p. 426.

82. *American Dictionary of Printing and Bookmaking*, p. 370.

83. Tucker, *History of R. Hoe and Company*, pp. 426–427.

84. Hart, "Lithography," pp. 293–294. For example, in 1887 Cosack and Company, of Buffalo, claimed to operate "the largest press-room in the United States." It was stocked exclusively with Hoe steam lithographic presses. These ran in a single line 147 feet long—the overall floor dimensions were slightly larger than a modern-day football field. And unlike the views of other plants, where all the power-transfer mechanisms are visible, the Cosack shop was without a "single post, partition, belt, shaft or pulley to obstruct the view or to impede the movements of the employees." All belts, pulleys, and shaftings were located in an 18-by-11-by-200-foot tunnel under the pressroom floor. *Buffalo Commercial Advertiser*, as quoted in Anne Marie Serio, "The Lithographers of Buffalo" (unpublished article, National Museum of History and Technology, 1977), p. 18.

85. *Inland Printer*, June 1885, p. 429. See also *R. Hoe & Co.'s Price List*, September 1870, Library of Congress.

86. Marinoni was one of the most celebrated press builders in Paris, holding more than "forty-five patents for inventions in typographic and lithographic presses." *American Dictionary of Printing and Bookmaking*, p. 370.

87. Strobridge account book, 1887, p. 95.

88. Advertisement, *Inland Printer*, October 1884, p. 52. Similar copy in *R. Hoe & Co.'s Catalogue of Printing Presses* (New York: R. Hoe & Co., 1881), pp. 30–31, located in the Franklin Institute, Philadelphia. It should also be noted that in addition to the Hoe machine, Strobridge purchased eight number-4 steam presses from C. Potter, Jr., and Company, of New York. The price for five, $30,000, was to be paid either in cash or with $10,000 down and two equal payments (including six-percent interest) after three and six months. The Potter was noted for its reliability; its form was virtually unchanged from the late 1870s through the '90s. The number 4 could carry a stone measuring 33 by 47 inches; the press itself measured 16 feet 11 inches long, 9 feet 3 inches wide, and 7 feet 4 inches high. C. Potter,

Jr., and Company's factory was in Plainfield, N.J. Strobridge account book, 1883, p. 155; Strobridge inventory sheet for insurance estimate following fire of December 1, 1887. Full-page advertisement, insert, *Lithographers' Journal*, January 1893. The smaller number-2 Potter accommodated a stone measuring 25 by 34 inches; it measured 14 feet 10 inches long, 8 feet wide, 6 feet high. The number 3 held a stone measuring 30 by 44 inches; it measured 10 feet 2 inches long, 8 feet 11 inches wide, and 7 feet 4 inches high.

89. The *Report* of 1870, p. 621, noted that all prints (lithographs, engravings, and so on) were produced on steam engines totaling 7,158 horsepower.

90. In addition to sources cited on Cincinnati see Lorin Blodget, *The Industries of Philadelphia* (Philadelphia: Collins, 1877), p. 23: 294 presses, 31 steam horsepower.

91. The 1881 Hoe catalogue, p. 33, described the Hand Lithographic Press in detail:

It is made of the best materials, is strong, simple, convenient, and works with great ease. The roller under the bed is geared in presses of large size, but is so arranged that it may be used with or without the gearing. The bed is made sufficiently long always to cover the roller, thus protecting it from dirt or grease from the scraper, and at the same time giving it more even movement. The toggles are adjustable so as to vary the elevation of the bed from one-eighth inch to five-eighths inch, as may be desired, thus permitting the use of any kind of printing apparatus.

92. H. P. Feisters's advertisement in *Lithographers' Journal*, October 1891, p. 58.

93. For example, in 1869 chromolithographer and ex–German forty-eighter F. Heppenheimer, of New York, purchased his first steam press from France after visiting the Paris Exposition. When it was installed in his plant it was surrounded by "eighty-five hand presses constantly running." And, naturally, it was described as "the first, or one of the first machines imported in the United States of the class." "F. Heppenheimer's Sons," *Lithographers' Journal*, February 1893, p. 28.

94. Quoted in *The Aldine*, May 1869, p. 39.

95. Single-sheet advertisement of L. Prang and Company's Art Publishing House, May 1870:

We have been applied to constantly, for some years past, to do the more elaborate and artistic class of illuminated commercial and publisher's work, but have always been compelled to decline, owing to the fact that our resources would hardly permit us to fill the orders for our own publications. —

Having however enlarged our establishment lately by the erection of new buildings and having increased our facilities by the addition of skilled artists and improved Steam machinery, we are at present enabled to offer our services for the best class of Chromolithographic work.

We shall make a speciality of fine Showcards and Circulars *in colors* for Machinery, Factories, etc. and your orders in this direction will receive prompt attention.

In Box 45, Warshaw Collection.

96. The tariff acts of the United States are printed in the following volumes:

Tariff of 1842: 27th Cong., Sess. II, Ch. 270, *The Public Statutes at Large* . . . (Boston: Little, Brown and Co., 1844), pp. 548–567.

Walker Tariff of 1846: 29th Cong., Sess. I, Ch. 74, *The Statutes at Large* . . . (Boston: Charles C. Little & James Brown, 1851), pp. 42–49.

Tariff of 1857: 34th Cong., Sess. III, Ch. 98, *The Statutes at Large* . . . (Boston: Little, Brown and Co., 1859), pp. 192–195.

Morrill Tariff of 1861: 36th Cong., Sess. II, Ch. 68, *The Statutes at Large* . . . (Boston: Little, Brown and Co., 1863), pp. 178–198.

Tariff of 1862: 37th Cong., Sess. II, Ch. 163, *The Statutes at Large* . . . (Boston: Little, Brown and Co., 1863), pp. 543–561.

Tariff of 1864: 38th Cong., Sess. I, Ch. 171, *The Statutes at Large* . . . (Boston: Little, Brown and Co., 1866), pp. 202–218.

Tariff of 1870: 41st Cong., Sess. II, Ch. 255, *The Statutes at Large* . . . (Boston: Little, Brown and Co., 1871), pp. 256–272.

Tariff of 1872: 42nd Cong., Sess. II, Ch. 315, *The Statutes at Large* . . . (Boston: Little, Brown and Co., 1873), pp. 230–258.

Tariff of 1875: 43rd Cong., Sess. II, Ch. 36, *The Statutes at Large* . . . (Washington: Government Printing Office, 1875), pp. 307–313.

Tariff of 1883: 47th Cong., Sess. II, Ch. 121, *The Statutes at Large* . . . (Washington: Government Printing Office, 1883), pp. 488–526.

McKinley Tariff of 1890: 51st Cong., Sess. I, Ch. 1244, *The Statutes at Large* . . . (Washington: Government Printing Office, 1891), pp. 567–625.

Wilson-Gorman Tariff of 1894: 53rd Cong., Sess. II, Ch. 349, *The Statutes at Large* . . . (Washington: Government Printing Office, 1895), pp. 509–570.

Tariff of 1897: 55th Cong., Sess. I, Ch. 11, *The Statutes at Large* . . . (Washington: Government Printing Office, 1899), pp. 151–213.

Payne-Aldrich Tariff of 1909: 61st Cong., Sess. I, Ch. 6, *The Statutes at Large* . . . (Washington: Government Printing Office, 1911), pp. 11–118.

For an early protest against low tariff rates see letter signed by Schumacher-Etthinger; Major, Knapp and Company; Julius Bien; Donaldson Brothers; and J. Ottmann to Charles Hart, November 1, 1887, Manuscript Division, New York Public Library.

97. *The Tariff and Its History* (Washington: Government Printing Office, 1934), p. 75.

98. Payne-Aldrich Tariff, p. 101. The term "lithograph" first appears in the tariff legislation of 1842 in connection with an anti-obscenity clause forbidding "the importation of all indecent and obscene prints, paintings, lithographs, engravings, and transparencies. . . ." The law was broadened in the 1880s: no "obscene . . . print . . . or any drug or medicine or any article whatever for the prevention of conception or for causing unlawful abortion. . . ." Tariff of 1842, pp. 566–567; of 1883, p. 489; of 1890, pp. 614–615; of 1894, p. 549; of 1897, p. 208.

99. Tariff of 1872, p. 236; of 1883, p. 519; of 1890, p. 607; of 1894, p. 541; of 1897, p. 199; of 1909, p. 77. See also bill of lading number 262, entered at the port of Philadelphia, April 9, 1888: "Lithographic Stones, not engraved, Free." Box 44, Warshaw Collection.

100. Tariff of 1862, p. 552; of 1890, p. 580; of 1894, p. 519; of 1897, p. 165; of 1909, p. 28.

101. Tariff of 1861, p. 190; of 1862, p. 547; of 1870, p. 264; of 1883, p. 493; of 1890, pp. 561–564; of 1894, pp. 508–511; of 1897, pp. 149–154; of 1909, pp. 14–16.

102. Tariff of 1842, p. 558; of 1846, p. 48; of 1861, p. 118; of 1862, p. 551; of 1864, p. 213; of 1872, p. 232; of 1883, p. 510; of 1890, p. 599. See bill of lading from Adolph Engel presented at the port of Philadelphia on July 30, 1877. Box

44, Warshaw Collection. The ten-percent reduction of the tariff of 1872 was repealed in 1876.

103. For example of classification see bill of lading, William Gerlack, presented at the port of Philadelphia, 1884. Also bill of lading for M. Bayersdorfer and Company, presented at the port of Philadelphia, 1873: "Chromos as printed matter." Box 44, Warshaw Collection.

104. Tariff of 1890, p. 599.

105. *Lithographers' Journal*, October 1891, p. 20. See also *Lithographers' Journal*, January 1894, pp. 3–4, 6–7; February 1894, pp. 38–40; March 1894, pp. 61–65; May–June 1894, p. 115.

106. Lithographic prints from either stone or zinc, bound or unbound (except cigar labels and bands, lettered or blank, music, and illustrations when forming a part of a periodical or newspaper and accompanying the same, or if bound in, or forming a part of printed books), on paper or other material not exceeding eight-thousandths of an inch in thickness, twenty cents per pound; on paper or other material exceeding eight-thousandths of an inch and not exceeding twenty-thousandths of an inch in thickness, and exceeding thirty-five square inches cutting size in dimensions, eight cents per pound; prints exceeding eight-thousandths of an inch and not exceeding twenty-thousandths of an inch in thickness, and not exceeding thirty-five square inches cutting size in dimensions, five cents per pound; lithographic prints from either stone or zinc on cardboard or other material, exceeding twenty-thousandths of an inch in thickness, six cents per pound; lithographic cigar labels and bands, lettered or blank, printed from either stone or zinc, if printed in less than ten colors, but not including bronze or metal leaf printing, twenty cents per pound; if printed in ten or more colors, or in bronze printing, but not including metal leaf printing, thirty cents per pound; if printed in whole or in part in metal leaf, forty cents per pound. Tariff of 1894, p. 532. These complex standards were enforced. See bill of lading, Carl Hirsch, presented at the Port of Philadelphia, 1896. Box 44, Warshaw Collection.

Lithographic prints from stone, zinc, aluminum or other material, bound or unbound (except cigar labels, flaps, and bands, lettered, or otherwise, music and illustrations when forming a part of a periodical or newspaper and accompanying the same, or if bound in or forming a part of printed books, not specially provided for in this Act), on paper or other material not exceeding eight one-thousandths of one inch in thickness, twenty cents per pound; on paper or other material exceeding eight one-thousandths of one inch and not exceeding twenty one-thousands [*sic*] of one inch in thickness, and exceeding thirty-five square inches, but not exceeding four hundred square inches cutting size in dimensions, eight cents per pound; exceeding four hundred square inches cutting size in dimensions, thirty-five per centum ad valorem; prints exceeding eight one-thousandths of one inch and not exceeding twenty one-thousandths of one inch in thickness, and not exceeding thirty-five square inches cutting size in dimensions, five cents per pound; lithographic prints from stone, zinc, aluminum or other material, on cardboard or other material, exceeding twenty one-thousandths of one inch in thickness, six cents per pound; lithographic cigar labels, flaps and bands, lettered or blank, printed from stone, zinc, aluminum or other material, if printed in less than eight colors (bronze printing to be counted as two colors), but not including labels, flaps and bands printed in whole or in part in metal leaf, twenty cents per pound. Labels, flaps and bands, if printed entirely in bronze printing, fifteen cents per pound; labels, flaps and bands printed in eight or more colors, but not including labels, flaps and bands printed in whole or in part in metal leaf, thirty cents per pound; labels, flaps and bands printed in whole or in part in metal leaf, fifty cents per pound. Books of paper or other material for children's use, containing illuminated lithographic prints, not exceeding in weight twenty-four ounces each, and all booklets and fashion magazines or periodicals printed in whole or in part by lithographic process or decorated by hand, eight cents per pound. Tariff of 1897, pp. 188–189.

107. Tariff of 1909, p. 78.

108. Tariff of 1872, p. 234; of 1883, p. 520; of 1890, p. 604; of 1894, p. 538; of 1897, p. 196.

109. Examples in Boxes 44 and 45, Warshaw Collection. See bill of lading, C. Wolf, presented at the port of Philadelphia, 1898. Bill of lading, appraiser's report, F. W. Steinhardt, presented at the port of Philadelphia, 1898: "Various samples of litho prints . . . of no commercial or dutiable value."

110. Tariff of 1909, p. 32.

111. Tariff of 1897, p. 167.

112. Tariff of 1842, p. 552; of 1846, p. 45; of 1857, p. 192; of 1861, p. 181; of 1862, p. 546; of 1864, p. 205; of 1872, p. 231; of 1883, p. 501; of 1890, p. 582; of 1894, p. 520.

113. Tariff of 1842, p. 560; of 1846, p. 49; of 1857, p. 193; of 1861, p. 196; of 1872, p. 234 ("professional books" only noted); of 1883, p. 521; of 1890, p. 609; of 1894, p. 543; of 1897, pp. 200–201; of 1909, p. 78.

114. *Lithographers' Journal*, March 1894, p. 62.

115. "An Open Letter," *Lithographers' Journal*, October 1893, p. 77.

116. "The National Lithographers' Association," *Lithographers' Journal*, January 1894, p. 3.

117. "Mass Meeting on the Tariff by Lithographic Employees," *Lithographers' Journal*, February 1894, p. 43.

118. *Lithographers' Journal*, March 1894, pp. 62–65.

119. *Lithographers' Journal*, April 1894, p. 93.

120. Ibid.

121. Ibid.

Chapter Six

1. *Lithographers' Journal*, February 1892, p. 36.

2. *Lithographers' Journal*, January 1892, p. 5.

3. Katharine Morrison McClinton, *The Chromolithographs of Louis Prang* (New York: Clarkson N. Potter, 1973), p. 194, cites the prices but does not indicate the source.

4. There are exceptions. Sometimes Prang paid a copyright fee to an artist (J. H. Beard to Prang, January 18, 1872, Hallmark Historical Collection, Kansas City, Mo.) and occasionally he paid royalties.

The earliest federal copyright statute in the United States was passed in 1790. For a useful survey of copyright in America see Benjamin W. Rudd, "Notable Dates in American Copyright: 1783–1969," *The Quarterly Journal of the Library of Congress*, April 1971, pp. 137–143.

5. Frederick Stuart Church to Prang, May 8, 1886, Corcoran Gallery of Art, Washington. (Not to be confused with the famous landscapist Frederic Edwin Church, Frederick Stuart Church was a student of Walter Shirlaw at the Chicago Academy of Design and of L. E. Wilmarth at the National Academy of Design, in New York.)

6. Louis Prang, "Chromo-Lithography the Handmaiden of Painting," *New York Daily Tribune*, December 1, 1866. This same analogy was made as late as 1890. See *The Critic*, October 24, 1896, p. 251. See also Prang's advertisement in Theodore Kaufmann, *Kaufmann's American Painting Book . . .* (Boston: L. Prang & Co., 1871):

Chromos "may safely be recommended . . . to the amateur artist who wishes to procure models from which to learn the practical application of the principles of art."

7. "Autobiography of Louis Prang," Mary Margaret Sittig, "L. Prang & Company, Fine Art Publishers" (master's thesis, George Washington University, 1970), p. 152. According to Sittig, p. 123, "The autobiography was written circa 1874 in pencil on 155 pages of yellow lined paper. The manuscript currently is in the possession of Prang's grand-daughter, Mrs. Louis Roewer, 71 Connant Street, Auburn, Maine. It was transcribed by Mrs. George Roewer of the same address, the daughter-in-law to Mrs. Louis Roewer, and used with her permission." Internal evidence dates the manuscript at c. 1890. It is possible that Prang's autobiographical sketch served as the outline for the biography that appeared in the *Lithographers' Journal*, January 1892, pp. 4–6. The structure and phrasing in both accounts are strikingly similar.

Regarding reproduction, other lithographers took more cautious positions. One admitted that if a "man's name signed to a canvas is sufficient to sell it whenever it is exhibited, it certainly would *not* pay him to paint for the lithographers; . . . it does pay [unknown] artists who wish to add to their names while waiting for fame to come to them." *Art Amateur*, January 1895, p. 50.

8. Reprint from the *Boston Commercial Bulletin* in *The Aldine*, May 1869, p. 39.

9. Louis Prang is the subject of two recent books: Larry Freeman, *Louis Prang: Color Lithographer* (Watkins Glen, N.Y.: Century House, 1971), and McClinton, *The Chromolithographs of Louis Prang*. Both contain useful illustrations and appear to be oriented toward the collector of American antiques. Neither contains either detailed notes or a full bibliography.

10. Departure date noted in Sittig, "L. Prang & Company," p. 134.

11. The spelling varies between Mayer and Meyer.

12. In his autobiography, Prang claimed that his first chromo was a simple bouquet of roses for a publication entitled *Ladies' Companion of 1857*. I have been unable to verify this statement.

13. Sittig, "Autobiography of Louis Prang," p. 145.

14. Ibid., p. 151.

15. See Box 3, Prang Collection, Boston Public Library, for fourteen Civil War prints and eleven maps. Box 4 contains four copies of Winslow Homer, "Our Jolly Cook," *Campaign Sketches* series.

16. Sittig, "Autobiography of Louis Prang," p. 149.

17. The chromos of Robert D. Wilkie are located in

the Print Room, Boston Public Library. See also *Yo-Semite Valley Photographic Views* (San Francisco, 1863).

18. The original is located in the Albany (N.Y.) Institute of History and Art.

19. Sittig, "Autobiography of Louis Prang," p. 153.

20. Excellent illustrations may be found in McClinton, *The Chromolithographs of Louis Prang*, pp. 27–118. Six of McClinton's ten chapters deal with these or related items.

21. These cards were composed by O. S. Whitney, "lovely artist whom I had employed for floral painting." Sittig, "Autobiography of Louis Prang," p. 153.

22. Ibid.

23. George Buday, *The History of the Christmas Card* (London: Spring Books, 1964). The Hallmark Historical Collection has a comprehensive archive.

24. *Prang's Chromo*, September 1868, p. 7.

25. Sittig, "Autobiography of Louis Prang," pp. 153–154. For samples of Prang Christmas cards see the large collections at the American Antiquarian Society, Worcester, Mass., the Society for the Preservation of New England Antiquities, Boston, and the Hallmark Historical Collection.

26. These dates come from McClinton, *The Chromolithographs of Louis Prang*, p. 74. Prang, in his autobiography, used 1874 for England and 1875 for America, p. 153.

27. *Art Amateur*, November 1881, p. 112.

28. Sittig, "Autobiography of Louis Prang," p. 154. Favorable notices of Prang's Christmas and Easter cards are in *Art Amateur*, June 1880, p. 110, and other issues.

29. See McClinton, *The Chromolithographs of Louis Prang*, pp. 73–90.

30. Sittig, "Autobiography of Louis Prang," p. 154.

31. Quoted in McClinton, *The Chromolithographs of Louis Prang*, p. 80.

32. Sittig, "Autobiography of Louis Prang," p. 154. *Art Interchange*, May 25, 1882, p. 113, editorialized:

> Upon excellent authority it is stated that Mr. Prang thinks seriously of abandoning his prize design competitions. All things considered, it is time that he should. Depending largely for their success on the fact that they represented a new idea, it is a plain inference that when that idea has ceased to be novel it is time to abandon the expectation that periodic recurrence will arouse public interest.... Mr. Prang has done exceedingly well at what he has attempted to do. Lithography has improved perceptibly under his stimulating efforts, and no one will deny that aside from his money interests he has had a

genuine wish to foster art works. For this he deserves thanks....

33. Sittig, "Autobiography of Louis Prang," p. 154.

34. *Lithographers' Journal*, January 1892, p. 5.

35. Ibid.

36. Whitman Bennett, *A Practical Guide to American Nineteenth-Century Color Plate Books* (New York: Bennett Book Studios, 1949), p. 109.

37. Jakob von Falke was vice-director of the Austrian Museum of Art and Industry at Vienna.

38. Peter C. Marzio, *The Art Crusade* (Washington: Smithsonian Institution Press, 1976), pp. 59–67.

39. Sittig, "Autobiography of Louis Prang," p. 154.

40. Ibid., p. 150.

41. *The New York Daily Tribune*, quoted in *Prang's Chromo*, January 1868, p. 8.

42. *The Aldine*, May 1869, p. 39.

43. A. F. Tait to Prang, August 9, 1866, from the collection of the Old Print Shop, New York. Quoted in Sittig, "Autobiography of Louis Prang," p. 70.

44. In addition to Harring, Prang imported other foreign lithographers into his shop. Charles Armstrong, who later began his own firm in Boston, worked for Prang from 1869 to 1871. Born in England and trained as an artist-lithographer, Armstrong, like Harring, brought a rich heritage with him; he represented Prang's determination to hire the finest craftsmen. See Leeds A. Wheeler, "Armstrong & Co., Artistic Lithographers, 1872–1897," typescript, Library of Congress, Washington.

45. Henry T. Tuckerman, *Book of the Artists, American Artist Life* (New York: G. P. Putnam's Sons, 1867), p. 497, wrote: Tait "has long been a popular animal painter, and many of his pictures have been widely circulated through chromolithographs."

46. There is an informative essay by Patricia C. F. Mandel in *A. F. Tait: Artist in the Adirondacks* (Blue Mountain Lake, N.Y.: Adirondack Museum, 1974), p. 16.

47. Clara Erskine Clement and Laurence Hutton, *Artists of the Nineteenth Century and Their Works* (Boston and New York: Houghton Mifflin Co., 1894), p. 281.

48. For examples of chromos based on Tait's work see "Group of Ducklings" in the Print Room, Boston Public Library and "Maternal Love," "Kluck! Kluck!," "Take Care," "The Intruder," and "Dash for Liberty" in the Hallmark Historical Collection. The Adirondack Museum, Blue Mountain Lake, N.Y., owns a set of progressive proofs for Prang's "Quails" after Tait.

49. *Prang's Chromo*, Christmas 1868, p. 8.

50. Located in the Prints and Photographs Division, Library of Congress.

51. All the above chromos located in the Prints and Photographs Division, Library of Congress.
52. *The New National Era,* October 20, 1870, p. 3. Price: $3.
53. Quoted in McClinton, *The Chromolithographs of Louis Prang,* p. 37.
54. The black stereotypes were particularly strong in the chromos of the 1880s. See lithographs of Currier and Ives, William Bruns (New York), and E. Eckstein (New York) in the Prints and Photographs Division, Library of Congress.
55 Quoted in McClinton, *The Chromolithographs of Louis Prang,* p. 37.
56. Copy in the Division of Graphic Arts, National Museum of History and Technology, Smithsonian Institution, Washington.
57. Copies in the Print Room, Boston Public Library.
58. Ibid.
59. Copy in the Prints and Photographs Division, Library of Congress.
60. Copies in the Hallmark Historical Collection.
61. Copy in the Print Room, Boston Public Library.
62. The Print Room of the Boston Public Library has several copies of Thure de Thulstrup's chromos. See, for example, "Sheridan's Ride," 1885, and "Battle of Fredericksburg—Laying the pontoon bridge." Originals for some of Thulstrup's works are located in the 7th Regiment Armory, New York City.
63. Copies of *Capture of Fort Fisher* and *The Encounter between the Monitor and the Merrimack* located in the Hallmark Historical Collection.
64. Noted in McClinton, *The Chromolithographs of Louis Prang,* p. 154.
65. "Base-Ball," 1887, in the Prints and Photographs Division, Library of Congress, and "Lawn-Tennis," in the Harry T. Peters "America on Stone" Lithography Collection, National Museum of History and Technology.
66. "Fine Arts: Color Printing from Wood and from Stone," *The Nation,* January 10, 1867, pp. 36–37.
67. To support its view *The Nation* quoted from the author of a work on illuminated manuscripts:
 When flat tints only were used, and the effect of light and shade was produced by consecutive bands of color, of increasing degrees of density, proceeding from pure white, the details of the composition being made emphatic by a surrounding of red or black lines, a close approximation to the original may be effected by means of the printing-press; but colors so produced can never have the solidity and richness of tone of those on which the hand and the brush alone have been employed. . . . The press has hitherto proved inadequate to the production of these refinements, and we can scarcely hope for any material improvement, as, independently of the difficulty of producing these gradations and blendings by machinery, some of the most beautiful pigments used in drawing are, when combined with the necessary varnish, of too thin a quality to be employed successfully in the process of printing.
68. *Sartain's Union Magazine of Literature and Art,* January 1850, pp. 100–101. Article signed by "J. S."
69. *The Nation,* January 10, 1867, p. 36.
70. Russell Sturgis to Prang, November 11, 1867, Hallmark Historical Collection. See also Sturgis, "The Conditions of Art in America," *The North American Review,* January 1866, pp. 1–24.
71. J. G. Tyler to Prang, March (or May) 13, 1895, Hallmark Historical Collection.
72. Sittig, "Autobiography of Louis Prang," p. 152.

Chapter Seven

1. The full title is *The Yellowstone National Park, and the Mountain Regions of Portions of Idaho, Nevada, Colorado and Utah* (Boston: L. Prang & Co., 1876). Quotation is from the London *Times,* as reported by *The Printing Times and Lithographer* (London), January 15, 1878, p. 13.
2. Moran went West many times. The Hayden book is "Illustrated By Chromolithographic Reproductions of Water-Color Sketches by Thomas Moran, Artist to the Expedition of 1871." For useful accounts of Moran see Thurman Wilkins, *Thomas Moran: Artist of the Mountains* (Norman, Okla.: University of Oklahoma Press, 1966), and Fritiof Fryxell, ed., *Thomas Moran: Explorer in Search of Beauty* (East Hampton, N.Y.: East Hampton Free Library, 1958).
3. Hayden, *The Yellowstone National Park,* preface.
4. Ibid.
5. Wilkins, *Thomas Moran,* p. 68.
6. Hayden, *The Yellowstone National Park,* preface.
7. Ibid.
8. *A Catalogue of the Complete Etched Works of Thomas Moran, N.A., and M. Nimmo Moran, S.P.E.* (New York: privately printed, 1889), p. 3.
9. Ibid., p. 5; Frank Weitenkampf, *American Graphic Art* (New York: Henry Holt and Co., 1912), pp. 18, 21.
10. Copies of both are located in the Print Room, New York Public Library. See also Clara Erskine Clement and Laurence Hutton, *Artists of the Nineteenth Century and Their Works* (Boston and New York: Houghton Mifflin Co.,1894), pp. 128–129.
11. Moran to Prang, December 22, 1873, cited in

Katharine Morrison McClinton, *The Chromo-lithographs of Louis Prang* (New York: Clarkson N. Potter, 1973), p. 200.

12. Moran to Prang, November 8, 1874, cited in McClinton, *The Chromolithographs of Louis Prang*, p. 200.

13. For a discussion of Moran's work in relation to theories of light as practiced by American landscape painters, see William H. Gerdts, *Thomas Moran* (Riverside, Calif.: University of California, 1963). For the definition of one overused word, "luminism," as related to theories of light, see Theodore Stebbins's entry "Luminism," *The Britannica Encyclopedia of American Art* (Chicago: Encyclopaedia Britannica Educational Co., 1973), pp. 354–355.

14. Quoted in W. H. Jackson, "With Moran in the Yellowstone: A Story of Exploration, Photography and Art," *Appalachia*, December 1936, p. 157.

15. Prang label in the Division of Graphic Arts, National Museum of History and Technology, Smithsonian Institution, Washington.

16. Hayden, *The Yellowstone National Park*, preface.

17. William H. Truettner, "'Scenes of Majesty and Enduring Interest': Thomas Moran Goes West," *Art Bulletin*, June 1976, pp. 241–259.

18. "Footnotes," *American Artist*, June 1948, p. 16. See also comments in introduction to *Memorial Exhibition: Paintings and Etchings by Thomas Moran, N.A.* (New York: Clinton Academy, 1928): "Moran was not a realist and he never entered the 'plein air' movement of France. . . . Moran was always seeing imaginative compositions." Copy of publication located in Archives of American Art, Smithsonian Institution.

19. The appearance of chromos does change with time, depending upon such environmental factors as light, dust, and humidity. At the Cincinnati Public Library, for example, a chromo of George Washington in "Warranted Oil Colors" (published in 1867 by Smith and Murray) was found stuck face in on the back of another copy of the same print. When removed, it appeared to be new. Compared with the copy that had been exposed to the air, the protected copy was free of dirt and of the pervasive yellow cast probably caused by oxidation of the varnish. The difference in appearance between the two is dramatic.

20. Wilkins, *Thomas Moran*, p. 163.

21. See *M. & M. Karolik Collection of American Water Colors and Drawings, 1800–1875*, 2 vols. (Boston: Museum of Fine Arts, 1962) 1:21.

22. A second Moran chromo, "On the Lookout—A Ute Camp, Utah," was produced by Louis Prang in 1881 (Amon Carter Museum of Western Art, Fort Worth, Tex.). See also "Prints Received,"

Art Interchange, December 22, 1881, p. 144, and "New Prints—Chromo-lithographs," *Art Interchange*, September 1, 1882, p. 47.

23. Moran became deeply involved, in the 1880s, in the use of etching as both a creative and a reproductive medium. His paintings, however, were still being chromoed as late as 1912. He died in 1926. See an untitled chromolithograph after Thomas Moran, printed in 1912, in the Cincinnati Art Museum. Printer unknown.

24. See six Colorado views after Mrs. J. A. Chain, published in 1876. They measure 5 by 7 inches and are unvarnished: "Grand Lake, Middle Park," "Bolder Park, Bolder Canyon" [*sic*] "Rainbow Falls," "Grey's Peak," "Pike's Peak," and "Twin Lakes," all located in the Print Room, Boston Public Library.

25. The year 1868 is suggested in Gordon Hendricks, *Albert Bierstadt: Painter of the American West* (New York: Harry N. Abrams and Amon Carter Museum of Western Art, 1974), but no reason for it is given.

26. *Prang's Chromo*, April 1869, p. 8.

27. Prang's catalogue for 1871.

28. Henry T. Tuckerman, *Book of the Artists: American Artist Life* (New York: G. P. Putnam's Sons, 1867), p. 392.

29. Another popular Prang chromo after Hill was "The Birthplace of Whittier." Copy in the Print Room, Boston Public Library. According to Prang's catalogue of 1871, Whittier wrote: "The chromo of Hill's picture seems to me one of the best specimens of the art. I cannot see how it could be better. It is the old homestead as it was when I left it thirty years ago." Size: 16⅞ by 26 inches. Price: $15. A third Hill-Prang chromo is "The Wayside Inn." Size: 18 by 26 inches. Price: $15. Offered in Prang's catalogue of 1871.

30. Quoted in Clement and Hutton, *Artists of the Nineteenth Century and Their Works*, p. 357.

31. *Catalogue of Mr. Louis Prang's . . . Paintings* (New York: Leeds Art Galleries, 1870), p. 26.

32. The facts on John Ross Key come from *Catalogue of a Collection of Oil Paintings and Drawings by the Late John Ross Key* (Washington: Smithsonian Institution, 1927). The *New York Times* obituary, August 2, 1920, mistakenly called him John *Francis* Key.

33. The other half chromos were: "Mount Diablo, California" (1873), "Lake Tahoe, Looking Southwest" (1873), "Sacramento Valley" (1873), "Santa Cruz Mountains, Monterey Bay" (1874), "Redwood Trees, Santa Cruz Mountains" (1874), "Big Trees, Calaveras Grove" (1874), "Yosemite Valley Looking East from the Mariposa Trail" (1874), "Yosemite Valley Looking West" (1875), "The Domes of the Yosemite Valley" (1874), "Bridal Veil Fall, Yosemite Valley"

(1874), and "Nevada Fall, Yosemite Valley" (1875). The Amon Carter Museum of Western Art owns one set. The Boston Public Library owns several, both varnished and unvarnished. For an unvarnished proof sheet of the full chromo "The Santa Clara Valley, California," see the copy in the Print Room, Boston Public Library. The companion to it is noted in McClinton, *The Chromolithographs of Louis Prang*, p. 157.

34. The *Boston Saturday Gazette* reviewed Key's exhibition in 1877 and noted: "Mr. Key's charcoal drawings are among the best ever shown in Boston; they are firm and masterly in drawing, strong in effect, and graceful in composition." Quoted in Clement and Hutton, *Artists of the Nineteenth Century*, p. 22.

35. Size: 4⅜ by 9 inches. Titles: "Souvenir of Lake George," "Twilight on Esopus Creek, N.Y.," "Sawyer's Pond, New Hampshire," "Mount Chocorua and Lake, New Hampshire," "On the Saco River, North Conway, New Hampshire," and "On the Hudson, Near West Point." Offered in Prang's catalogue of 1871.

36. Size: 16⅛ by 12⅞ inches. Titles: "Spring," "Summer," and "Autumn." The Boston Public Library owns both varnished and unvarnished copies.

37. "Scene near Cayuga Lake, N.Y.—Spring," "Scene near Stockbridge, Mass.—Summer," "Scene near Farmington, Ct.—Autumn," and "Scene near New Russia, N.Y.—Winter." Size: 9 by 16 inches. Price: $5 each. "Pastoral Scene" sold for $15. All offered in Prang's catalogue of 1871.

38. Size: 4½ by 9 inches. Price: $4.50 per set. Located in the Print Room, Boston Public Library.

39. Located in the Print Room, Boston Public Library.

40. Eighteen chromos measuring 5½ by 7 inches are located in the Print Room, Boston Public Library. Six were printed in a set after Robert D. Wilkie (1828–1902), entitled *Six Views in the Adirondacks*.

41. See, for example, "Sunlight in Winter," after J. Morviller (16⅜ by 24⅛ inches, $12), and "The Crown of New England," after George L. Brown (14⅞ by 23⅞ inches, $15). Offered in Prang's catalogue of 1869. Located in the Division of Prints and Photographs, Library of Congress.

42. See six views in the Boston Public Library: "Beverly," "Eagle Cliff," "Egg Rock," "Nahant," "Glouster [sic] Beach," and "Swamp Scott [sic] Beach."

43. "Lake George," after Hermann Fuechsel (15¼ by 26 inches, $12). Located in the Print Room, Boston Public Library.

44. "Harvest," 1869, after Benjamin Bellows Grant

Stone (14¼ by 18½ inches, $5). Located in the Print Room, Boston Public Library.

45. Quoted in Prang's catalogue of 1871.

46. As a boy, Champney watched the lithographers work in the Pendleton Lithographic Company, of Boston. Benjamin Champney, *Sixty Years' Memories of Art and Artists* (Woburn, Mass.: privately printed, 1900), p. 9.

47. Located in the Print Room, Boston Public Library.

48. Champney, *Memories*, p. 155.

49. *Art Interchange*, December 8, 1881, p. 125.

50. See the Harlow chromos in the Print Room, Boston Public Library. For example, "A Day in Autumn" (1889), "Winter By the Sea, A Windmill, Long Island" (1889), "Fishermen's Houses, Cape Cod" (1889), "A Misty Morning" (1889), "A River Path" (1888), "Thatcher's Island Lights" (1888), "Snowbound" (1888), "Gathering Seaweed" (1889), "Old Toll House, Martha's Vineyard" (1889), "Evening, On Cape Ann" (1889), "Old Houses, Vineyard Haven #1" (1889), "Old Houses, Vineyard Haven #2" (1889), "Morning, Martha's Vineyard" (1889), "Low Tide, Connecticut Coast" (1889), "A Marsh Twilight" (1887), "Nemasket River, Maine" (1887), "A Bit of Monhegan, Maine" (1887), "A Glimpse of the Sound, Connecticut" (1887), "Early Morning" (1887), "Castine, Maine" (1887), "Near Boothbay Harbor, Maine Coast, Evening Twilight" (1887), and "On The Connecticut Shore" (1890).

51. One of Prang's publications described Harlow's style: "He has studied the Dutch water-colorists to some purpose and followed their lines of development in remaining as truly American as they are Dutch." Publication reproduced in Larry Freeman, *Louis Prang: Color Lithographer* (Watkins Glen, N.Y.: Century House, 1971), p. 86.

52. Lloyd Goodrich, *Winslow Homer* (New York: Macmillan Co., 1944), p. 113. Apparently, Prang and Homer had discussed the possibility of color for *Campaign Sketches*. In December 1893 Homer wrote to Prang: "I have seen a copy of 'Campaign Sketches.' The cover is very neat and the pictures look better than they would in color, but why did you not get a copyright?" Goodrich, *The Graphic Art of Winslow Homer* (New York: Museum of Graphic Art, 1968), p. 10. See also Albert Ten Eyck Gardner, *Winslow Homer* (New York: Clarkson N. Potter, 1961), pp. 148–150.

53. Goodrich, *The Graphic Art of Winslow Homer*, pp. 13–14, 15–18. It is important to note that for Homer, etching was not a precious, creative medium, but rather a practical method of disseminating his oil paintings and watercolors. *The Life Line, Eight Bells, Perils of the Sea, Mending the Tears,* and *A Voice from the Cliffs* were

paintings that he translated into reproductive etchings. Homer had high hopes that his prints would become popular.

54. Homer to Prang, December 1893, quoted in Goodrich, *Winslow Homer*, p. 113.
55. Goodrich points out that the original title was *Playing Him*. Goodrich, *Winslow Homer* (New York: Whitney Museum of American Art, 1973), p. 139.
56. Advertisement on reverse side of *The Watch* [*Eastern Shore*] in the Metropolitan Museum of Art.
57. The original watercolor for *The Watch* [*Eastern Shore*] is in a private collection.
58. Quoted in Goodrich, *Winslow Homer* (1944), p. 113.
59. Proof book for several illustrations in this series located in the Corcoran gallery of Art, Washington.

Chapter Eight

1. Allen Johnson and others, eds., *Dictionary of American Biography* (New York: Charles Scribner's Sons, 1929), s.v. "Catharine Beecher," and Edward T. James, ed., *Notable American Women, 1607–1950* (Cambridge: Harvard University Press, 1971), s.v. "Catharine Beecher."
2. For a useful survey of design and decorating manuals see Harriet Bridgeman and Elizabeth Drury, eds., *The Encyclopedia of Victoriana* (New York: Macmillan Co., 1975), pp. 56–70.
3. Catharine E. Beecher and Harriet Beecher Stowe, *The New Housekeeper's Manual*, rev. title, (New York: J. B. Ford and Co., 1873), p. 19.
4. See Charles A. Beard and Mary R. Beard, *The Rise of American Civilization*, rev. ed., 2 vols in 1 (New York: Macmillan Co., 1937), 1:757.
5. See John A. Kouwenhoven, *The Arts in Modern American Civilization* (New York: W. W. Norton & Co., 1967), pp. 514–519, 526, 528–529.
6. Beecher and Stowe, *The New Housekeeper's Manual*, pp. 24, 25.
7. Ibid., pp. 84–85.
8. Ibid., p. 94. It may be difficult, today, to imagine what Beecher actually meant; but the Farnsworth Homestead in Rockland, Me., is a good possible example. The furniture is in place and chromos are on the walls—just as they were in the late nineteenth century.
9. Ibid., p. 92.
10. Ibid., pp. 91–92. The *New York Independent*, a journal that offered chromos as premiums (December 18, 1873), also published a pamphlet on how to frame chromos. Framing instructions may also be found in *Art Interchange*, November 19, 1885, p. 132.
11. Beecher and Stowe, *The New Housekeeper's Manual*, p. 85.
12. Samuel Langhorne Clemens, *A Connecticut Yankee in King Arthur's Court* (New York: Harper & Brothers, 1889), pp. 48–49.
13. *Prang's Chromo*, April 1868, p. 4.
14. William H. Gerdts and Russell Burke, *American Still-Life Painting*, (New York: Praeger, 1971), p. 69.
15. Harry T. Peters, *Currier & Ives: Printmakers to the American People*, 2 vols. (Garden City, N.Y.: Doubleday, Doran & Co., 1929–31), 1:110–116; Gerdts and Burke, *American Still-Life Painting*, p. 69.
16. For an exception see N. Currier's "American Feathered Game," 1854, a hand-colored lithograph after a painting by A. F. Tait; lithographic artist, O. Knirsch. Division of Graphic Art, National Museum of History and Technology, Smithsonian Institution, Washington.
17. The original painting measures 14 by 22 inches. It is signed and dated. Located in the Carl Otto von Kienbusch Angling Collection, Princeton University Library, Princeton, N.J.
18. *A. F. Tait: Artist in the Adirondacks* (Blue Mountain Lake, N.Y.: Adirondack Museum, 1974), p. 45.
19. Color reproduction of *Game Piece No. 1* in Katharine Morrison McClinton, *The Chromolithographs of Louis Prang* (New York: Clarkson N. Potter, 1973), color insert 2, opp. p. 183. See also L. Prang catalogue, 1876, Boston Public Library.
20. Clara Erskine Clement and Laurence Hutton, *Artists of the Nineteenth Century and Their Works* (Boston and New York: Houghton Mifflin Co., 1894), p. 32.
21. See the complete set of progressive proofs for Lambdin-Prang "Roses" chromo at the Prints and Photographs Division, Library of Congress, Washington.
22. Theodore E. Stebbins, Jr., *Martin Johnson Heade* (College Park, Md.: University of Maryland, 1969), unpaginated; Robert G. McIntyre, *Martin Johnson Heade, 1819–1904* (New York: Pantheon Press, 1948).
23. Quoted in Theodore E. Stebbins, Jr., *The Life and Works of Martin Johnson Heade* (New Haven and London: Yale University Press, 1975), p. 134.
24. Title page is pictured in McIntyre, *Martin J. Heade*, plate 24.
25. Quoted in Stebbins, *Martin Johnson Heade*, unpaginated.
26. Located in the Museum of Fine Arts, Boston, they are "Brazilian Hummingbird" "I," "II," "III," and "IV." I and II may be compared with the original paintings: since 1969 the original of I

has been owned by Mrs. George Metcalf and of II by Mr. and Mrs. Peter Benziger. Stebbins, *Martin Johnson Heade*, plates 18 and 19.

27. Quoted in McIntyre, *Martin Johnson Heade*, p. 30.

28. Clement and Hutton, *Artists of the Nineteenth Century and Their Works*, p. 340.

29. Other American artists also dealt with English lithographers. Conrad Wise Chapman's *Confederate Camp* was "chromolithographed by M & N Hanhart," of London, in 1871 (copy in the Prints and Photographs Division, Library of Congress). Jasper Cropsey sold oils to the English lithographer Gambert.

30. Robin Bolton-Smith, *Lilly Martin Spencer, 1822–1902: The Joys of Sentiment* (Washington: National Collection of Fine Arts, 1973).

31. *Prang's Chromo*, Christmas 1868, p. 8.

32. Bolton-Smith, *Lilly Martin Spencer*, p. 37. For addresses of Schaus see Harry T. Peters, *America on Stone* (Garden City, N.Y.: Doubleday, Doran & Co., 1931), pp. 357–358. Note, however, that while the Schaus name lasted into the 1890s the firm was owned by others. *Rand's New York City Business Directory . . . 1890–91, p.* 175, and *Trow's New York City Business Directory . . . 1899*, p. 46.

33. Prang broadside. Box 45, Warshaw Collection of Business Americana, National Museum of History and Technology, Smithsonian Institution.

34. Ibid.

35. *Wilson's New York City Business Directory . . . 1876–77*, p. 148; *Trow's New York City Business Directory . . . 1900*, p. 47.

36. The agreement between Spencer and Bencke is in the Lilly Martin Spencer Papers, Archives of American Art, Smithsonian Institution. Additional facts from Bolton-Smith, *Lilly Martin Spencer*, pp. 59–60, 183. Royalty contracts appear to have been the exception, not the rule; Prang had some with certain of his artists. J. G. Tyler to Prang, November 25, 1890, Hallmark Historical Collection, Kansas City, Mo.

37. Bolton-Smith, *Lilly Martin Spencer*, p. 49.

38. William Morris, ed., *The American Heritage Dictionary of the English Language* (Boston: Houghton Mifflin Company, 1976). See also "Sentimentalism," *Harper's New Monthly Magazine*, July 1860, pp. 203–211.

39. Patricia Hill, *Eastman Johnson* (New York: Clarkson N. Potter, 1972), and John I. H. Baur, *Eastman Johnson* (Brooklyn, N.Y.: Brooklyn Museum, 1940).

40. William Henry Hudson, *Whittier and His Poetry* (Norwood, Pa.: Norwood Editions, 1976), p. 18.

41. Prang's catalogue of 1871. Whittier to Prang, May 25, 1873, Archives of American Art, Smithsonian Institution.

42. Clement and Hutton, *Artists of the Nineteenth Century and Their Works*, p. 27.

43. All three located in the Print Room, Boston Public Library.

44. First exhibited at the National Academy of Design, New York, in 1868. Johnson made several artist's copies. Hill, *Eastman Johnson*, p. 49.

45. Quoted in Fred Lewis Pattee, *The Feminine Fifties* (New York: D. Appleton, 1940), p. 92.

46. *The Crayon*, July 1857, p. 213.

47. "Art-Lithographers of the United States," *Lithographers' Journal*, September 1893, p. 52.

48. Often confused with "tinted lithograph" in catalogue systems, the lithotint is a tonal lithograph printed from a single stone. The term was coined in 1840 by C. J. Hullmandel, one of its major promoters. It refers to the technique of applying washes of different strengths to a lithographic stone: after special preparation, the ink would print in varying shades, giving the lithograph the appearance of a watercolor. The lithotint in *Miss Leslie's* was described by the editor:

> In the month of December 1841, Mr. Richards, an artist of this city, saw several brilliant productions of Mr. Hullmandel in this new style; and although at that time ignorant of the composition of the chemical ink suitable for the purpose, and wholly unacquainted with the mode of application, he felt convinced that the discovery of these was worth his most strenuous efforts. . . .

P. S. Duval did the printing. The editor wanted the readers to recognize the importance of the print, so he described it as an art "hitherto unknown in the United States; and with a few exceptions unknown to the most skilful artists of Europe." That was no idle boast. The lithotint was new even in France in the early 1840s—the great printer R. J. Lemercier was experimenting with it in 1841 and '42 but it was still in its infancy in 1843. The work of both Richards and Duval, then, was quite extraordinary.

"Grandpapa's Pet" was described by *Miss Leslie's* as a product of both art and technology, a felicitous marriage referred to frequently in the promotion of chromolithography. The lithotint promised to abolish the "tame and mechanical elaboration of the Copyist" and replace it with the "spirit and refinement of the original artist." It was an unfulfilled promise, for it was difficult to make a lithotint, which required both too much time and too much artistic and technical skill. Writing almost thirty years later, Duval noted, in J. Luther Ringwalt's *American Encyclopaedia of Printing* (Philadelphia: Menamin & Ringwalt, 1871), that drawing by "*Lavis or Wash on Stone . . .* has never been fairly brought into practice as yet, but we will describe it, in the

hopes that some artist may be induced to try it." Few did. "The New Art of Lithotint," *Miss Leslie's Magazine*, April 1843, p. 113, and B. Rotch, "Hullmandel's Lithotint Process," *Journal of the Franklin Institute*, March 1844, pp. 215–216; Michael Twyman, *Lithography, 1800–1850: The Techniques of Drawing on Stone in England and France and Their Application in Works of Topography* (London: Oxford University Press, 1970), pp. 146–150, 214–215; Ringwalt, *American Encyclopaedia of Printing*, p. 282.

49. *Dictionary of American Biography*, s.v. "John S. Hart" (1810–77): once principal of the Central High School of Philadelphia, editor of the *Pennsylvania Common School Journal*, and from 1849 to 1851 co-editor of *Sartain's Union Magazine of Literature and Art*.

50. *The Iris: An Illuminated Souvenir*, ed. John S. Hart (Philadelphia: Lippincott, Grambo & Co., 1853), preface.

51. Ibid., p. xiii.

52. "Art in the House," *New York Times*, February 9, 1879.

53. *Farmers' Home Journal* to Strobridge, March 15, 1877, Cincinnati Historical Society.

54. *Christian Monitor* to Strobridge and Company, n.d. (1870s), Cincinnati Historical Society.

55. *Aurora Beacon* to Strobridge and Company, September 29, 1877, Cincinnati Historical Society.

56. Frank Luther Mott, *A History of American Magazines, 1865–1885* (Cambridge: Harvard University Press, 1938), p. 8. See also pp. 7, 191, 411, 425, 437, 442.

57. The blurb continued:

> The October number of DEMOREST'S MAGAZINE will present a feature which is wholly unique in magazine literature. Nothing of the kind has ever before been approached, or even thought of. The managers of American magazines are acknowledged to be the most progressive as well as the most indefatigable workers in the world; but DEMOREST'S for October will overtop the most brilliant of their achievements.
>
> It may not be known to everyone that Mrs. Benjamin Harrison is one of the best of American flower-painters. Since she has occupied her position of lady of the White House, however, her public duties have largely prevented the exercise of her artistic genius; but in that period she has found leisure to paint one of the loveliest representations of flower-life that ever came from an artist's brush,—a magnificent group of orchids on a porcelain panel. With that broad and kindly spirit which has marked her career, she has presented this single production of her scant leisure to the public, and DEMOREST'S MAGAZINE has the honor of being the medium through which this painting is offered "to the Mothers, Wives, and Daughters of America," to whom it is lovingly dedicated.
>
> This painting—remarkable for its intrinsic charm and value, and also for the reason that it is the only picture ever known to have been executed by a President's wife, to be given to the public—has been secured to DEMOREST'S MAGAZINE solely, and with every right reserved. No copy, reproduction, or representation of it can be obtained in any other way than with DEMOREST'S FAMILY MAGAZINE.
>
> Mrs. Harrison's painting has been reproduced in the highest style of art, of the same size as the original (11½ × 15 inches), and is an absolutely perfect counterpart in every particular, to the faintest tint of color, and even to the peculiar texture of the porcelain. This marvelous triumph of art has been accomplished by employing the most celebrated artisans in reproduction, and stimulating them by unstinted remuneration.
>
> With each copy of DEMOREST'S MAGAZINE for October one of these wonderful reproductions of "A WHITE-HOUSE ORCHID," PAINTED BY THE "PRESIDENT'S WIFE," will be PRESENTED FREE.
>
> Every person who desires to possess one of these pictures—and who will not?—may have it by purchasing the October Magazine. In the nature of things, such an opportunity cannot occur again. It is an event of a century. There is no taint of politics in it: it is simply the tribute of a good woman's love for the women of her nation, superbly expressed in color and form; the foremost woman of the Republic cementing, by means of her art, her sisterhood with all others of her sex in the land. DEMOREST'S MAGAZINE for October conveys this beautiful sentiment to the American people by a gift which would not be parted with on any terms, for it can be obtained in no other way, and will soon become so rare and valuable as to command almost any price.
>
> Remember, then, that you may get MRS. HARRISON'S ORCHID PICTURE with the October number of DEMOREST'S MAGAZINE, without extra charge.

58. *Art Interchange*, July 19, 1883, p. 13.

59. *Art Amateur*, September 1881, p. 68.

Chapter Nine

1. Joseph Pennell and Elizabeth Robins Pennell, *Lithography and Lithographers* (London: T. Fisher Unwin, 1898), p. 221. The Pennells misspelled "Strobridge" in this first edition. According to notes in the Museum of the City of New York from an interview with one James E. Strobridge in April 1971, the artists' anonymity was a result of specialization within the Strobridge company. Strobridge explained:

 > We used a crew of ten to fifteen men on each poster. That's why, with rare exceptions, Strobridge lithographs were never signed by any one artist. The key men of the crew were our "black artists," so called because they executed in black outlines all elements to be shown on a poster. Then, the so-called "yellow men" took over to execute those elements that called for yellow. And so on with the "red men," and "blue men" and on down the color spectrum. These men worked side by side. Consequently, their work could be done fairly quickly. Still other men specialized on lettering and borders.

2. See the collections of posters at the Ringling Museum of the Circus, Sarasota, Fla.; the Circus World Museum, at Baraboo, Wis.; and the Cincinnati Art Museum. See also at the Cincinnati Art Museum the note by Andrew Donaldson, Jr., "The Four 'Books' of Circus Posters."

3. D. J. Kenny, *Illustrated Cincinnati: A Pictorial Hand-Book of the Queen City* (Cincinnati: Robert Clarke & Co., 1875), p. 147.

4. "Street Lithography," *Art Age*, December 1884, p. 57.

5. An excellent overview of Cincinnati lithography may be seen in the T. A. Langstroth Lithography Collection at the Cincinnati Public Library. The parts I found most useful were: the separate prints, totaling nearly a thousand; a large volume entitled "History of Lithography But More Particularly in Cincinnati"; a volume of lithographed cigar bands; a volume of lithographed cigar labels; a volume of early color lithographs; a volume entitled "George D. Newhall: Cincinnati Music Publisher"; three volumes of tobacco labels; six volumes of lithographs, a volume entitled "Style of Printing of a Lithograph to Give a Three Dimensional Type Print"; and a volume of German lithographs.

6. Located in Cincinnati Public Library. Harry T. Peters says "Klauprech" began business in 1840. For titles of the lithographs of Klauprecht and Menzel see Harry T. Peters, *America on Stone* (Garden City, N.Y.: Doubleday, Doran & Co., 1931), p. 252.

7. George Stevens, *The Queen City in 1869* (Cincinnati: George S. Blanchard & Co., 1869), p. 72.

8. A useful source on Klauprecht is the pamphlet *Lithography in Cincinnati: To the Advent of the Steam Press* (Cincinnati: Young & Klein, 1956). Klauprecht's name appears in *Williams' Cincinnati Directory* for 1855.

9. The rest of the advertisement reads: "Lithographic printing for dispatch, neatness and economy, being very suitable for views, plans of estates, town plots, banker's checks, bills, attorney's law forms, merchant's invoice heads, circulars, chemist's and other labels, &c., &c. Merchants and others having their own copper or steel plates can have their bill heads printed and ruled to pattern at extremely low rates by the thousand."

10. The style of press is not known.

11. Gibson and Company became the Gibson Art Company in 1895. Throughout the 1860–1900 period they printed fancy stationery, patriotic scenes, school certificates, Valentine and Easter novelties, as well as single-sheet chromo reproductions of original art works. Earlier, before the Civil War, Charles Cist, *Sketches and Statistics of Cincinnati in 1859* (Cincinnati, 1859), p. 301, described their stock: "every variety of commercial and banking engraving, such as bonds, scrip, drafts, certificates of stock and deposit, notes, checks, bill and letter heads, show and business cards . . . every variety of drug, wine, liquor and perfumery labels; also, label books for druggists." Their chromos include "Mate to Le Grand Dessert," 1879, "Noon on the Juniata," n.d., "Venice—Pride of the Sea," 1877, and "Horse Trade #2," 1881, all located in the Cincinnati Public Library.

12. Located in the Cincinnati Public Library.

13. To avoid confusion the student of American prints should note that a minor error appears in I. N. Phelps Stokes and D. C. Haskell, *American Historical Prints* (New York: New York Public Library, 1932), p. 151, print number 1841-F-37: it says that "Cincinnati in 1841" is printed in four colors. It is not. It is hand-colored.

14. The firm was Middleton and Wallace until 1855, Middleton, Wallace, and Company until 1858, and Middleton, Strobridge and Company until 1865. See John W. Merten, "Stone by Stone Along a Hundred Years with the House of Strobridge," *Bulletin of the Historical and Philosophical Society of Ohio*, vol. 8, no. 1 (Cincinnati, January 1950), pp. 3–48; *Lithography in Cincinnati: To the Advent of the Steam Press*, chart; *Williams' Cincinnati Directory*, 1855, 1856, 1857, 1858, 1859, 1860.

15. Cited in Merten, "Stone by Stone," p. 5.

16. This estimate is based on surveys of Cincinnati

lithographs located in the Prints and Photographs Division, Library of Congress, Washington; Cincinnati Art Museum; Cincinnati Historical Society; Cincinnati Public Library; and the National Museum of History and Technology, Smithsonian Institution, Washington.

17. Cist, *Cincinnati in 1859*, p. 301:

> Middleton, Strobridge & Co., north-west corner Walnut and Third streets. In this establishment are embraced all kinds of lithographing, such as views of cities and buildings, landscapes, etc., in one or more colors; portraits, maps, bonds, certificates of stock, etc.; drafts, checks, etc., in all kinds of commercial work, almost equaling the finest engraving on steel. Value of work per annum, twenty-five thousand dollars. Hands employed, twenty.

For a fine early chromo by Middleton, Wallace, and Company, see "View of the City of Milwaukee, Wisconsin" (1856), at the Milwaukee Public Museum.

18. *Lithography in Cincinnati: To the Advent of the Steam Press* states that the firm was founded in 1856. The name Ehrgott and Forbriger appears in the *Cincinnati Guide and Business Directory* of July 1857.

19. Cist, *Cincinnati in 1859*, p. 301.

20. A note in the T. A. Langstroth Lithography Collection, Cincinnati Public Library, states, "Ehrgott, Forbriger, and Co., supplied most of the covers around the country for music published in such cities as New York, Philadelphia, Chicago, Cleveland, St. Louis and New Orleans. Nobody surpassed the beauty of the lithographed work done here [Cincinnati]." In my opinion this is an exaggeration, but even a cursory view of the sheet-music covers in the Library of Congress and the J. Francis Driscoll Collection, Newberry Library, Chicago, reveals the superb work of Ehrgott, Forbriger and Company. See also such Ehrgott and Forbriger chromos as "First Prize," 1869, a calendar for 1869, and advertisements of the Western Brass Works and Ohio White Sulphur Springs. All located in the Cincinnati Public Library.

21. *Lithography in Cincinnati: To the Advent of the Steam Press*, s.v. "Ehrgott & Forbriger."

22. Cist, *Cincinnati in 1859*, p. 301.

23. Ibid.

24. Note additional titles in Peters, *America on Stone*, p. 284.

25. J. Luther Ringwalt, *American Encyclopaedia of Printing* (Philadelphia: Menamin & Ringwalt, 1871), p. 283.

26. E. C. Middleton published with his chromos of George and Martha Washington a blurb from Edward Everett proclaiming them "accurate and spirited copies of the original paintings by Stuart."

27. The fire that burned the Strobridge company to the ground (they had been installed on the second floor of Pike's Opera House Building) was immortalized by Strobridge in a lithograph commissioned by the Aetna Fire Insurance Company.

28. John W. Merten, "Stone by Stone," p. 15.

29. Copy located in the Cincinnati Public Library.

30. Max, Jacoby, & Zeller to Strobridge, November 27, 1877, Cincinnati Historical Society.

31. *Wilson's New York Directory, 1873–74,* p. 141.

32. Samuel Little to Strobridge and Company, July 13 and 20 and August 6, 1877, Cincinnati Historical Society. There are numerous bulk orders for the pair of Washingtons.

33. "Office of Strobridge & Co. Steam Lithographic Printers, Engravers and Fine Art Publishers, 1877, Price List." Cincinnati Historical Society.

34. Letter located at Cincinnati Historical Society.

35. Strobridge price list, 1877, Cincinnati Historical Society.

36. Note the entry for F. Gleason in Peters, *America on Stone*, p. 196: "Unknown 1½ Tremont Row. Publisher of a typical 'Life and Age of Man,' n.d. small. . . . Also other small prints of this type, which were probably all copies." A. E. Eilers and Company (which became M. A. Coudy) advertised itself as "publishers of English & German marriage, baptism, catechism, confirmation certificates, chromos, pictures, prints, Sunday school cards, etc." Eilers to Strobridge, January 23, 1877, Cincinnati Historical Society.

37. Stamped on back of "Winter Sunday in Olden Times," Division of Graphic Arts, National Museum of History and Technology. Original painting is in the White House Collection, Washington. See also chromo "Old Oaken Bucket," F. Gleason, 1875, Cincinnati Public Library.

38. Printed intent to file a petition in bankruptcy, F. Gleason to Strobridge, May 31, 1877, Cincinnati Historical Society.

39. J. Latham and Company to Strobridge, June 1, 1877, Cincinnati Historical Society.

40. J. Latham and Company to Strobridge, July 7 and August 7, 1877, Cincinnati Historical Society.

41. See Ryder advertisement in *Cleveland City Directory, 1889,* p. 650.

42. Durkee to Strobridge, [n.d.] 1877; Kelly to Strobridge, [n.d.] 1877. Cincinnati Historical Society. The competition among chromo dealers in Chicago must have been fierce. See entries in *Classified Business Directory . . . Chicago, 1879,* p. 137. See also Richter and Hushe—"dealer in chromos . . . Canal Street, Chicago"—to Strobridge, May 5 and 12, 1877, Cincinnati Historical Society.

43. William W. Kelly and Company to Strobridge, October 17, 1877, Cincinnati Historical Society. In part: "175.00 is a good figure for 500 chromos. Can now buy Hoover's Dogs at 28¢, so you see I am offering you 7¢ more than I can get a good selling picture [sic]. Yours is the best executed however and if you can accept the $175.00 send them by Express C.O.D. at once." See a similar letter, National Chromo Company (927 Chestnut Street, Philadelphia) to Strobridge, September 17, 1877, Cincinnati Historical Society.

44. Letter located at Cincinnati Historical Society.

45. Letter located at Cincinnati Historical Society.

46. Letter located at Cincinnati Historical Society.

47. Letter located at Cincinnati Historical Society.

48. A. J. Dittenhoefer, attorney and counsel, New York City, to Strobridge, 1886–1891, Cincinnati Historical Society.

49. *Vickery's Fireside Visitor* was begun in 1874 and survived for more than thirty years. According to magazine historian Frank Luther Mott, it was representative of a "whole brood of mail-order papers" that appeared in Augusta, Me. Mott, *A History of American Magazines, 1865–1885* (Cambridge: Harvard University Press, 1938), pp. 37–38.

50. Vickery to Strobridge Company, December 20, 1877, Cincinnati Historical Society.

51. Inventory book, number one, of the Strobridge company, 1867–86, p. 101, Cincinnati Historical Society. The inventory of chromos was $29,000 in January 1879.

52. Copy in the Prints and Photographs Division, Library of Congress. See Dorothy Miller, *The Life and Work of David G. Blythe* (Pittsburgh: University of Pittsburgh Press, 1950), pp. 86–87.

53. Located in the Prints and Photographs Division, Library of Congress. For additional titles see Peters, *America on Stone*, pp. 169–170.

54. *Lithography in Cincinnati: To the Advent of the Steam Press*, s.v. "Adolph Krebs"; frontispiece following p. xxvi of *Directory for 1856–57, of Pittsburgh and Allegheny Cities* (Pittsburgh: George H. Thurston, 1856) is a picture and advertisement for A. Krebs and Brother.

55. *William Gillespie Armor, 1834–1924* (Pittsburgh: Historical Society of Western Pennsylvania, 1974). See "The Hunter's Funeral," chromolithograph by Armor, Gillespie, and Company, 1880 (19½ by 13 inches), Historical Society of Western Pennsylvania, Pittsburgh.

56. See a gorgeous single-sheet chromo advertisement for Ehrgott and Krebs (1871) at the Cincinnati Public Library.

57. Kenny, *Illustrated Cincinnati*, p. 147. See also billhead of Krebs Lithographing Company, May 8, 1875, Box 45, Warshaw Collection of Business Americana, National Museum of History and Technology.

58. George Moerlin, *A Trip Around the World* (Cincinnati: M. & R. Burgheim, 1880). Note also that Adolph Krebs died in 1884. The later history of the company is recorded in *Lithography in Cincinnati: To the Introduction of the First Offset Press* (Cincinnati: Young & Klein, 1959).

59. Andrew Morrison, *The Industries of Cincinnati* (Cincinnati, 1888), as quoted in *Lithography in Cincinnati: To the Introduction of the First Offset Press*, unpaginated. By 1893 the firm had been reincorporated under the name Henderson-Achert Krebs, and it reportedly operated ten steam presses and employed 135 workers. *Lithographers' Journal*, June 1893, p. 126.

60. *Williams' Cincinnati Directory*, 1895, p. 1918.

61. Tuchfarber won first prize at the World's Columbian Exposition in the category "Iron and Glass Showcards," *Lithographers' Journal*, February 1894, p. 37.

62. Kenny, *Illustrated Cincinnati*, p. 172.

63. Alfred Victor Frankenstein, *After the Hunt: William Harnett and Other American Still Life Painters, 1870–1900*, rev. ed. (Berkeley and Los Angeles: University of California Press, 1969), p. 74. It should be noted that *The Old Violin* does not appear in the catalogue for the Cincinnati exhibition. Frankenstein quotes, pp. 75–76, from the *Cincinnati Commercial Gazette* of September 16, 1886: "The little collection of pictures secured by Commissioner Mehner a little too late to be catalogued, are now being placed in position and attracting great attention. One of these pictures especially, a study of still life, by W. H. Harnett [sic], of New York City, is a remarkable bit of realism. It is called 'The Violin.'"

64. Frankenstein, *After the Hunt*, pp. 74–75.

65. Ibid.

66. Lewis Alexander Leonard, *Greater Cincinnati and Its People* (Cincinnati: Lewis Historical Publishing Co., 1927), 3:50–53.

67. Frankenstein, *After the Hunt*, p. 76. A Tuchfarber chromo on glass is located at the Yale University Art Gallery.

68. Ibid.

69. See proof marks in copy at Cincinnati Art Museum.

70. The Donaldson name is found in various Cincinnati firms: Donaldson and Elmes (1863), William M. Donaldson (1872), Donaldson, Mach and Company (1873), Donaldson Lithographing Company (1880), William M. Donaldson and Company (1883). The name is charted in *Lithography in Cincinnati: To the Introduction of the First Offset Press*.

71. For a number of amusing stories about Tuchfarber's chromo, see Frankenstein, *After the Hunt*, pp. 77–78.

72. Tuchfarber seemed to specialize in lithographic novelties. For example, in 1882 it printed a decalcomania after Defregger's painting *Ready for the Dance*. The decal was transferred to glass from paper and backed with milk glass to give the illusion, when illuminated, of great depth.

Chapter Ten

1. Charles Hart, "Lithography, Its Theory and Practice . . . ," 1902 plus later inserts, Manuscript Division, New York Public Library, p. 36.

2. *American Dictionary of Printing and Bookmaking* (New York: Howard Lockwood and Co., 1894), p. 345.

3. Ibid.

4. A second series of views of Wagner and McGuigan's shop are printed on a trade card owned by Mrs. Joseph Carson, of Philadelphia. Nicholas Wainwright, *Philadelphia in the Romantic Age of Lithography* (Philadelphia: Historical Society of Pennsylvania, 1958), p. 234, dates the card c. 1851.

5. *McElroy's Philadelphia Directory . . . 1857* (Philadelphia: Edward C. & John Biddle, 1857), p. 72.

6. This division of labor was also described by *Wide Awake Magazine*, December 1884, p. 63, after a reporter's visit to the Prang plant.

7. "Prominent Lithographers of the United States," *Lithographers' Journal*, February 1894, pp. 28–29.

8. As early as 1867 the Strobridge company was buying furniture—tables and stools—for its "artists room" and its "printing room." Strobridge inventory book, July 1, 1867, p. 23.

9. As late as 1894 the *Lithographers' Journal*, February, p. 38, wrote: "No accurate statistics of the lithographic industry in the United States exist, so far as we are aware. . . ."

10. For an analysis see Meyer H. Fishbein, *The Censuses of Manufactures, 1810–1890* (Washington: General Services Administration, 1973).

11. *Abstract of the Statistics of Manufactures According to the Returns of the Seventh Census* (Washington, 1858), p. 139; *Manufactures of the United States in 1860; Compiled from the Original Returns of the Eighth Census* (Washington: Government Printing Office, 1865), pp. CXI, CXLi; *The Statistics of the Wealth and Industry of the United States . . . from the Original Returns of the Ninth Census* (Washington: Government Printing Office, 1872), p. 621; *Report of the Manufactures of the United States at the Tenth Census* (Washington: Government Printing Office, 1883), pp. 12, 13, 54; and *Report on Manufacturing Industries in the United States at the Eleventh Census* (Washington: Government Printing Office, 1895), pp. 236–237, 272–273, 764–765, 962.

12. "Statistics on the Proposed Tariff Legislation," *Lithographers' Journal*, February 1894, p. 38.

13. John W. Merten, "Stone by Stone Along a Hundred Years with the House of Strobridge," *Bulletin of the Historical and Philosophical Society of Ohio*, vol. 8, no. 1 (Cincinnati, January 1950), pp. 25–26.

14. Strobridge account book, p. 127.

15. Ibid., p. 118. See also contract between Emil Rothengatter and the Strobridge Lithographing Company. Cincinnati Historical Society.

16. See Strobridge contracts in the Cincinnati Historical Society.

17. Strobridge account book, p. 169. Even pressmen did not receive uniform wages from Strobridge. In 1883 three different such workers respectively earned fifteen, eighteen, and twenty dollars a week: memoranda of agreement between Strobridge and J. Ryan, December 1, 1883; Strobridge and James Muir, December 1883; and Strobridge and J. A. Langenbahn, December 1883. See also contracts between Strobridge and M. Kenealy, December 1883, and Strobridge and Albert Thompson, December 1883. All located at the Cincinnati Historical Society.

18. Hart, "Lithography," p. 261.

19. Ibid., p. 265.

20. See billhead of Joseph Hoover, April 8, 1882, Box 45, Warshaw Collection of Business Americana, National Museum of History and Technology, Smithsonian Institution, Washington.

21. *Lithographers' Journal*, February 1893, p. 28. For additional examples see advertisement of Clinton and Company, of North Haven, Conn., n.d., in Box 44, Warshaw Collection.

22. Letter dated January 3, 1879. Box 45, Warshaw Collection.

23. *Lowell* (Mass.) *Daily Courier*, May 5, 1885.

24. Numerous letters in the Strobridge papers (late 1870s) at the Cincinnati Historical Society complain of damaged chromos.

25. See three chromos of the American Chromo Company (New York) at the Prints and Photographs Division, Library of Congress, Washington: "Right Medicine" (7⅝ by 6½ inches), 1867; "Wrong Medicine" (7⅝ by 6½ inches), 1867; "Chauty," artist's proof copy, 1872.

26. Strobridge account book under years 1876 and 1886.

27. For chromos by the American Lithographic Company see the collection at the Prints and Photographs Division, Library of Congress.

28. *Langley's San Francisco Business Directory . . . 1868*, p. 77, advertisement for Nile and Durney, ". . . engravings, chromos & lithographs . . . Steam factory."

29. *Merchants & Manufacturers' Business Directory of New York City . . . 1873–4*, p. 215.

30. Trade card, Box 45, Warshaw Collection.

31. *The Aldine*, May 1869, p. 39.

32. See the description in the *Lowell (Mass.) Daily Courier*, May 5, 1885.

33. Strobridge account book, 1875, p. 88.

34. "The Providence Lithographic Company," *Lithographers' Journal*, September 1891, pp. 6–7. Strobridge account book, 1880, pp. 113, 124: purchase of "Brush Electric Light" machine; 1886, pp. 191, 206: "automatic sprinklers."

35. See Hart, "Lithography," no page number. Also, David Tatham, "John Henry Bufford: American Lithographer," *Proceedings of the American Antiquarian Society*, vol. 86, pt. 1 (Worcester, Mass.: American Antiquarian Society, 1976), p. 62.

36. Apprenticeship agreement of James Queen and Lehman and Duval, as quoted in Carl M. Cochran, "James Queen: Philadelphia Lithographer," *The Pennsylvania Magazine of History and Biography*, April 1958, p. 140.

37. Apprenticeship agreement between F. W. Heyne, Alfred Heyne, and Strobridge Company, November 30, 1867. Original copy in the Cincinnati Historical Society.

38. See agreements with John Shobe, March 31, 1869; John Reilly, May 5, 1873; Anthony Smith, February 7, 1873; Charles Schmidt, October 8, 1883; and Theodore A. Brewer, March 5, 1885. Cincinnati Historical Society.

39. Letter of William Downey to Strobridge, December 13, 1877. Cincinnati Historical Society.

40. "Lithographic Employees and Technical Schools," *Lithographers' Journal*, February 1894, pp. 30–31.

41. *Inland Printer*, October 1884, p. 15.

42. Ibid., p. 30.

43. Fred C. Munson, *History of the Lithographers' Union* (Cambridge, Mass.: Amalgamated Lithographers of America, 1963), p. 3.

44. "National Lithographers' Association," *Lithographers' Journal*, October 1891, p. 18.

45. "Lithographic Employees and Technical Schools," p. 30.

46. The trade-school issue remained unresolved and troublesome into the twentieth century. See *National Lithographer*, January 1911, p. 30.

47. "Lithographic Employees and Technical Schools," p. 32.

48. Munson, *Lithographers' Union*, p. 1.

49. Cards glued to pages in Hart, "Lithography."

50. Hart, "Lithography," pp. 261–267. Hart's dates are often incorrect. This may have occurred in 1856, when New York lithographers tried to establish a national union: Munson, *Lithographers' Union*, pp. 1–2.

51. Hart, "Lithography," p. 346; *New York Times*, May 4, 1853. Hart incorrectly wrote 1850 as the year of the strike.

52. Munson, *Lithographers' Union*, pp. 1–23. See also H. E. Hoagland, *Collective Bargaining in the Lithographic Industry* (New York: Columbia University, 1917), pp. 17–47.

53. Strobridge Report, Cincinnati Historical Society.

Chapter Eleven

1. The Strobridge contracts in the Cincinnati Historical Society show piecework on the rise in the 1880s.

2. J. G. Tyler to Louis Prang, August 7, 1893, Hallmark Historical Collection, Kansas City, Mo.

3. Tyler to Prang, November 15, 1893. See also Tyler to Prang, December 3, 1893, and Tyler to Prang, November 25, 1890. Hallmark Historical Collection.

4. Photographs in the Chicago Historical Society.

5. George C. Groce and David H. Wallace, *The New-York Historical Society's Dictionary of Artists in America, 1564–1860* (New Haven: Yale University Press, 1957), p. 378; Ulrich Thieme and Felix Becker, *Allgemeines Lexikon der Bildenden Künstler*, 37 vols. (Leipzig: Wilhelm Engelmann, 1907–50), 22:136. See also *New York Times*, March 24, 1921, p. 5.

6. *History of Chicago* (Chicago: A. T. Andreas Co., 1885), p. 489.

7. *D. B. Cooke & Co.'s Directory of Chicago . . . 1858*, pp. 16, 49.

8. *D. B. Cooke & Co.'s Chicago City Directory . . . 1861–62*, p. 312.

9. Alan E. Kent, "Early Commercial Lithography in Wisconsin," *Wisconsin Magazine of History*, vol. 36 (summer 1953):247–251. Milwaukee enjoyed an active chromolithography business, and it deserves detailed investigation. For an excellent work on Milwaukee city views, see Thomas Beckman, *Milwaukee Illustrated* (Milwaukee: Milwaukee Art Center, 1978).

10. *T. A. Holland & Co.'s Business Directory of Chicago . . . 1866*, p. 118. See also two historical sheets written by C. M. Jevne, a nephew, 1928. Chicago Historical Society. Note a print in addition—in the Division of Graphic Arts, National Museum of History and Technology, Smithsonian Institution, Washington—signed "Louis

Kurz, Milwaukee, 1864": "Camp Randall, Madison, Wis."

11. Paul M. Angle, "Views of Chicago, 1866–1867," *Antiques*, January 1953, pp. 60–61.

12. *Edwards' Chicago Business Directory*, opp. p. 30. Neoclassical-style advertisement for Chicago Lithographing Company under "Chromos."

13. Lithographed hand-written vita on James Sheahan is located in the Chicago Historical Society.

14. See back cover, *Chicago Illustrated*, pt. 1. Also, promotional broadside, 1867. Chicago Historical Society.

15. Copy of the key located in the Chicago Historical Society.

16. A sample of their work is the sheet-music cover "Favorite Songs of Jessie Bartlett Davis" (Chicago: Chicago Music Co., 1884), located in the J. Francis Driscoll Collection, Newberry Library, Chicago.

17. See, for example, *Smith & DuMoulin's Chicago Directory for . . . 1860*, pp. 185–186: Hesler's Gallery of Art under "Oleographs." The chromo "Young Fullerton" is located in the Harry T. Peters "America on Stone" Lithography Collection, National Museum of History and Technology, Smithsonian Institution, Washington.

18. Trade card, Box 44, Warshaw Collection of Business Americana, National Museum of History and Technology. Quotation from Beckman, *Milwaukee Illustrated*, introduction.

19. The assets of Kurz and Allison were purchased by the firm Daleiden and Company in 1921. In a Daleiden and Company catalogue of 1923 are three pages of "Famous Kurz and Allison Pictures . . . Pictures for the School Room and Hall." Newspaper clipping, Chicago Historical Society.

20. *History of Chicago*, p. 489.

21. *Lakeside Annual . . . 1886–87*, p. 1818.

22. Harry T. Peters, *America on Stone* (Garden City, N.Y.: Doubleday, Doran & Co., 1931), pp. 259–260, for titles. Chromolithograph of Abraham Lincoln by Kurz and Allison was located in the Old Print Shop, New York City, 1974.

23. Other chromo firms—including Louis Prang, with his Thure de Thulstrup copies, and Cosack and Company, with its "Battle of Shilo" (1885) — were printing similar historical pieces. Cosack chromo (27 by 37 inches) published as a premium for the McCormick Harvest Machine Company, after a panorama painting being exhibited in Chicago. Chicago Historical Society.

24. Other titles include "Battle of Missionary Ridge," 1886, "Battle of Kenesaw Mountain," 1891, "Battle of New Orleans," 1890, and "Battle Between the Monitor & the Merimac," 1889. Located in the Harry T. Peters "America on Stone" Lithography Collection, National Museum of History and Technology. See reprint, *Battles of the Civil War* (Birmingham, Ala.: Oxmoor House, 1976).

25. David I. Bushnell, Jr., "John Mix Stanley, Artist-Explorer," *Annual Report of the Smithsonian Institution*, 1924, p. 507. Obituary in *Detroit Daily Post*, April 11, 1872, as quoted in *New York Times*, April 14, 1872. See also clippings in vertical file, Library of National Collection of Fine Arts, Smithsonian Institution.

26. Quoted in William Vernon Kinietz, *John Mix Stanley and His Indian Paintings* (Ann Arbor: University of Michigan Press, 1942), p. 9.

27. "Portraits of North American Indians, with Sketches of Scenery, etc., Painted by J. M. Stanley," *Smithsonian Miscellaneous Collections*, vol. 2 (Washington, 1852), p. 3.

28. "Stanley's Chromos," *Detroit Free Press*, September 19, 1869.

29. Quoted in Kinietz, *John Mix Stanley*, p. 17.

30. "Stanley's Chromos," *Detroit Free Press*, September 19, 1869. Each chromo is explained in the news account.

31. Kinietz, *John Mix Stanley*, p. 9. It may or may not be significant that Stanley petitioned the Smithsonian for an allowance of $100 per year, the money to pay the interest on a loan. Stanley had hoped he would not have to sell his paintings. *Annual Report of the Smithsonian Institution for 1864* (Washington, 1872), p. 119.

32. *Resolved . . .* That certain printed chromos of Indian paintings belonging to John M. Stanley, not exceeding twenty-one thousand copies, shall be admitted free of duty, under such rules and regulations as the Secretary of the Treasury may prescribe:
Provided, That the permit so granted to John M. Stanley shall be in full settlement of all claims against the United States for the destruction by fire, of certain Indian paintings belonging to him, in January, 1864 at the time of the burning of the building of the Smithsonian Institution, in the city of Washington.

33. Frederick Webb Hodge, "A Proposed Indian Portfolio by John Mix Stanley," *Indian Notes*, Heye Foundation, vol. 6, no. 4 (1929), pp. 259–367.

34. *Grand Rapids Eagle*, April 12, 1872.

35. "On the Warpath," *Detroit Free Press*, May 6, 1871; "The Warpath," *Detroit News-Tribune*, February 14, 1897; and James Bartlett, "*On the War Path*, by John Mix Stanley," *Antiques*, September 1976, pp. 520–521.

36. Copy in the Prints and Photographs Division, Library of Congress, includes a price printed on a label on reverse side. See also entry in *Catalogue*

of Lithographic Prints, Books, Etc., in the Art Gallery of the Fuchs and Lang Manufacturing Company, New York, 1913, p. 42.

37. "Mr. Calvert and The Calvert Lithographing Company," Lithographers' Journal, May 1893, p. 102. Cover includes a portrait of Thomas Calvert.

38. Hubbell & Weeks' Annual City Directory ... 1872–3 (Detroit: Hubbell & Weeks, 1872). Their only competition, apparently, was Corrie's Detroit Lithographing Company.

39. Crocker-Langley San Francisco Directory, p. 1856.

40. J. W. Weeks & Co.'s Annual City Directory ... 1873–4 (Detroit: J. W. Weeks & Co., 1873), opp. p. 185.

41. Charles F. Clark & Co.'s Annual City Directory ... 1871–2 (Detroit: Charles F. Clark & Co., 1871), between pp. 153 and 154. Note: Proofs from ten stones of a Calvert lithograph are located in the Cincinnati Public Library.

42. E. P. Restein died in December 1890. Lithographers' Journal, October 1891, p. 24. E. P. and L. Restein appears first in Gopsill's Philadelphia City and Business Directory ... 1867–8. Peters, America on Stone, p. 332, says "I have never seen a print by the Resteins." "Othello," a chromolithograph done in 1859, is located in the Harry T. Peters "America on Stone" Lithography Collection, National Museum of History and Technology. Peters says Edmund P. Restein was born in France in 1837 and worked with the French-born P. S. Duval in Philadelphia. The Restein firm survived into the twentieth century. See Boyd's Co-Partnership & Residence Business Directory ... 1902. The National Chromo Company, of Philadelphia, was a dealer; in 1876 it was located at 927 Chestnut Street. See Boyd's Philadelphia City Directory ... 1876–7, under "Chromos."

43. The history of "Yankee Doodle" is told in an excellent article by Thomas H. Pauly, "In Search of 'The Spirit of '76,'" American Quarterly, fall 1976, pp. 445–464. Pauly corrects many of the errors found in earlier accounts, particularly Anne Colver, Yankee Doodle Painter (New York: Alfred A. Knopf, 1955); Alberta Thorne Daywalt, "The Spirit of '76," Antiques, July 1911; "The Spirit of '76," American Heritage, August 1901; Henry Kelsey Devereux, The Spirit of '76 (Cleveland: privately printed, 1926); James F. Ryder, "The Painter of 'Yankee Doodle,'" New England Magazine, December 1895; and E. O. Roberts, "The Spirit of '76," Illinois Farm Bureau Magazine, July 1973.

44. Judging by the proof marks on the copy in the Prints and Photographs Division, Library of Congress, the chromo was printed from eighteen separate plates. There are several oil paintings of the "Spirit of '76." The chromo was probably copied from a 24-by-18-inch copy owned by Winthrop L. Brown, Topsham, Me.

45. International Exhibition 1876 Official Catalogue: Art Gallery and Annexes (Philadelphia, 1876), p. 40, entry number 866. Willard apparently painted other copies of Yankee Doodle. See Pauly, "The Spirit of '76," p. 446.

46. Cleveland City Directory ... 1889, p. 650.

47. Quoted in Pauly, "The Spirit of '76," p. 452.

48. Peters, America on Stone, p. 348, notes the uniqueness of the Ryder-Willard prints.

49. For titles see Pauly, "The Spirit of '76," pp. 454–455.

50. Printing Times and Lithographer, July 15, 1875, pp. 13–14.

51. Quoted in Pauly, "The Spirit of '76," p. 453.

52. James F. Ryder, Voigtlander and I: In Pursuit of Shadow Catching (Cleveland: Cleveland Printing & Publishing Co., 1902), p. 236.

53. Ryder, "The Painter of 'Yankee Doodle,'" pp. 489–494.

54. W. S. Robinson & Co.'s Cleveland Directory ... 1875, p. 757.

55. Ibid., p. 444.

56. Spears, Denison & Co. Cleveland City Directory ... 1856, unpaginated. The Cleveland Almanac & Business Man's Directory ... 1857: Peirce & Co. advertised, p. 3: "Lithographing. This art is being brought to the highest state of perfection, and is scarcely inferior to steel engraving, while it costs materially less. . . . We are prepared to furnish . . . landscapes . . . executed in the highest style of the art."

57. "Cleveland" was drawn by H. Park, put on stone by Hall, and published by "Oliver G. Steele's Lith. Press," Buffalo; located in the Buffalo and Erie County Historical Society.

58. Gustave von Groschwitz, "The Significance of Nineteenth Century Color Lithography," Gazette des Beaux-Arts, November 1954, pp. 253–254.

59. Anne Marie Serio, "The Lithographers of Buffalo" (Unpublished article. Washington: National Museum of History and Technology, 1977).

60. Peters, America on Stone, p. 203. Peters lists some of the Hall and Mooney prints.

61. Ibid., p. 145.

62. Buffalo City Directory ... 1856.

63. Sage, Sons and Company billhead, Box 45, Warshaw Collection.

64. Lithographers' Journal, May 1892, p. 124; Buffalo Morning Express, April 5, 1864.

65. Peters, America on Stone, pp. 142–143, notes additional titles.

66. "Wine Cooler," in C. B. Norton, ed., Treasures of Art, Industry and Manufacture, pt. 7 (Philadelphia: S. T. Souder & Co., 1877), preface.

67. The Harry T. Peters "America on Stone" Lithography Collection has examples of Britton and Rey material. Harry T. Peters, *California on Stone* (Garden City, N.Y.: Doubleday, Doran & Co., 1935), s.v. "Britton & Rey."

68. For an early Nagel chromolithograph printed in San Francisco see "Private Signals of the Merchants of New York & San Francisco," reproduced as plate number 81 in Peters, *California on Stone*.

69. Elford Eddy, *The Log of A Cabin Boy* (San Francisco: privately printed, 1922), pp. 1–41.

70. Described in a sales catalogue issued by Victoria Keilus Dailey, Los Angeles, 1975.

Chapter Twelve

1. The standard history of advertising is Frank Presbrey, *The History and Development of Advertising* (Garden City, N.Y.: Doubleday, Doran & Co., 1929). See pp. 490–511.

2. Clarence P. Hornung, *Handbook of Early Advertising Art, Mainly from American Sources: Pictorial Volume*, 2nd ed. (New York: Dover, 1953), pp. 40–45.

3. Ibid.

4. Copy located at the Chicago Historical Society.

5. Quoted in John H. White, Jr., "Locomotives on Stone," *The Smithsonian Journal of History* 1 (1966): 50.

6. Also spelled "Alphonze" and "Alphonso," Nicholas B. Wainwright, *Philadelphia in the Romantic Age of Lithography* (Philadelphia: Historical Society of Pennsylvania, 1958), p. 86. The "Bien" in this firm is Julius Bien, of Audubon fame.

7. Quoted in White, "Locomotives on Stone," pp. 49–50.

8. Frederic Arthur Conningham, *Currier & Ives* (Cleveland: World Publishing Co., 1950), p. 18.

9. Flier of the Henderson Lithographing Company, January 12, 1897, Box 45, Warshaw Collection of Business Americana, National Museum of History and Technology, Smithsonian Institution, Washington.

10. *Art Amateur*, December 1894, p. 15.

11. George DeVaney to Strobridge, January 3, 1877, Cincinnati Historical Society.

12. George H. Knollenberg to Strobridge, August 25, 1877, Cincinnati Historical Society.

13. Charles H. Newkirk to Strobridge, November 24, 1877. For similar directions see W. R. Houghton, of Indiana State University, to Strobridge, December 22, 1877; E. R. Egnew, proprietor of Saint Charles Hotel, to Strobridge, January 13, 1877. Cincinnati Historical Society.

14. First National Bank to Strobridge, May 3, 1877, Cincinnati Historical Society.

15. Wellington Jones to Strobridge, October 30, 1877, Cincinnati Historical Society.

16. Robert Taft, "The Pictorial Record of the Old West. IV. Custer's Last Stand—John Mulvany, Cassilly Adams, and Otto Becker," *Kansas Historical Quarterly* vol. 14 (November 1946): 385–390; Don Russell, "Sixty Years in Bar Rooms," *Westerners Brand Book*, November 1946, pp. 61–68.

17. The date for Adams's work has been estimated in Robert Taft, *Artists and Illustrators of the Old West, 1850–1900* (New York: Charles Scribner's Sons, 1953), pp. 143, 335. See also Taft, "Custer's Last Stand," pp. 385–390.

18. Taft, *Artists and Illustrators*, pp. 135, 332.

19. *Kansas City* (Mo.) *Daily Journal*, March 2, 1881.

20. *Boston Evening Transcript*, June 30, 1881.

21. *Custer's Last Fight* (St. Louis: John G. Furber, 1886). See also Taft, *Artists and Illustrators*, pp. 143, 335.

22. *Kansas City Gazette*, August 11, 1903.

23. Taft, *Artists and Illustrators*, pp. 129–130. Taft's description gets to the heart of the matter: From 1896 to 1946 "it has been viewed by a greater number of the lower-browed members of society—and by fewer art critics—than any other picture in American history."

24. Ibid., pp. 145–146.

25. Harold C. Evans, "Custer's Last Fight," *The Kansas Magazine*, 1938, pp. 72–74.

26. Ibid., p. 130.

27. Anheuser-Busch has issued a number of chromos, photolithographs, and halftones, in addition to the Custer piece. Examples are in the Prints and Photographs Division, Library of Congress, Washington.

28. Walt Whitman, "Mulvany's 'Custer's Last Rally,'" *New York Tribune*, August 15, 1881.

29. Numerous French chromos after Mucha are located in the Cincinnati Art Museum.

30. Henri Beraldi, *Les Graveurs du XIXe Siècle* (Paris: Librairie L. Conquet, 1888), p. 187n. Brian Reade, *Art Nouveau and Alphonse Mucha* (London: Her Majesty's Stationery Office, 1963), pp. 1–34, plate 3.

31. For short biographies of several Strobridge artists see John W. Merten, "Stone by Stone Along a Hundred Years with the House of Strobridge," *Bulletin of the Historical and Philosophical Society of Ohio*, vol. 8, no. 1 (Cincinnati, January 1950), pp. 24–28.

32. Copy owned by John Lentz, Sarasota, Fla. The full caption reads: "This lithograph printed in ten colors, including silver and gold bronze, embossed on very heavy plate paper. 20 × 30 inches

in size, will be mailed to any part of the United States on receipt of 25 cents, or sent by express at the following prices: 100 for $15.00; 200 for $25.00; 500 for $60.00; 1,000 for $100."

33. From a calendar, 1910, Box 45, Warshaw Collection.
34. *Brush and Pencil*, September 1897, p. 14.
35. *Art Interchange,* November 1894, p. 129.

Chapter Thirteen

1. "Answering an Inquiry," *Lithographers' Journal,* March 1892, p. 66.
2. See "Central Pavilion of the Horticultural Building," "The South Entrance of Electricity Building," "The Golden Door," and "An Autumn Day in the North Stand," all at the Chicago Historical Society.
3. *American Dictionary of Printing and Bookmaking* (New York: Howard Lockwood and Co., 1894), p. 564.
4. In addition to works cited in subsequent notes all original paintings are located in the Chicago Historical Society: *North Lagoon,* by Theodore Robinson; *Eastern Veranda of the Woman's Building,* by Francis Coates Jones; *The Woman's Pavilion,* by William John Whittemore; *The Administration Building,* by Charles Graham; *The East End of the Grand Basin,* by Charles Courtney Curran; *The Fisheries,* by Childe Hassam and others.
5. The prints and the watercolors are located in the Chicago Historical Society. Note that the *Times* was not unique. The *Chicago Tribune* also published supplements of chromos, printed by the Winters Art Lithographic Company, of Chicago. One included the Official "Birds-eye View of the World's Columbian Exposition," after a painting by Charles Graham. There were also chromo cards, measuring 4½ by 7 inches, depicting buildings and scenes.
6. The print measures 13¾ by 9¾ inches, the painting 29½ by 21½ inches. Both are located at the Chicago Historical Society.
7. Painting and print are located at the Chicago Historical Society.
8. Paintings and prints located at the Chicago Historical Society.
9. Located at the Chicago Historical Society. A second Key-Orcutt chromo was "Liberal Arts, Electricity, and Administration Buildings from Corridor of Woman's Building."
10. *The Cleveland City Directory . . . 1887,* opp. page 720. It is conceivable that Werner and Orcutt were working together, but no single chromo that I have seen credits one as printer, the other as publisher.

11. Located at the Chicago Historical Society and the Amon Carter Museum of Western Art, Fort Worth, Tex.
12. Armstrong and Company, of Boston, also printed chromos of the Chicago Fair, for Hubert H. Bancroft in 1893. These were copied after paintings by Jules Guerin, H. N. Nichols, Louis K. Harlow, and F. Hopkinson Smith.
13. The painting of the Woman's Building measures 24 by 37 inches. Painting and prints are located at the Chicago Historical Society.
14. The painting measures 20 by 32 inches, the print 17 by 27½ inches. Both at the Chicago Historical Society.
15. "Substitute for Lithographic Stone," *Lithographers' Journal,* January 1893, p. 10; "Color-Plates for Chromolithography," *Lithographers' Journal,* July 1893, p. 8; W. D. Richmond, *The Grammar of Lithography* (London: Myers & Co., 1914), p. 171.
16. Quoted in Peter Morse, *Jean Charlot's Prints: A Catalogue Raisonné* (Honolulu: University of Hawaii Press, 1976), p. viii.
17. "Fast Asleep" and "Wide Awake" were two English chromolithographs widely circulated in the 1870s as premiums for American magazines.
18. James L. Ford, *Forty-Odd Years in the Literary Shop* (New York: E. P. Dutton & Co., 1921), pp. 76–77.
19. "Authorized Official Classification at The World's Fair," *Lithographers' Journal,* March 1892, p. 78.
20. "Lithography at the World's Fair," *Lithographers' Journal,* November 1891, pp. 76–77.
21. Ibid., p. 77.
22. John Neal, *Observations on American Art,* ed. Harold Edward Dickson (State College, Pa.: Pennsylvania State College, 1943), p. 40.
23. C. W. Webber, *The Hunter-Naturalist: Romance of Sporting; or, Wild Scenes and Wild Hunters* (Philadelphia: Lippincott, Grambo & Co., 1852), p. 3.
24. *Graham's American Monthly Magazine,* August 1832, p. 359.
25. *Prang's Chromo,* January 1868, p. 1.
26. James Parton, "On Popularizing Art," *Atlantic Monthly,* March 1869, pp. 349–357.
27. Alonzo Delano, *Old Block's Sketch-Book* (Sacramento, Calif.: James Anthony & Co., 1856).
28. "Fine Arts Items," *New York Daily Tribune,* April 27, 1866; Clarence Chatham Cook, "Fine Arts," *New York Daily Tribune,* November 20, 1866; Clarence Chatham Cook, "A New Chromo," *New York Daily Tribune,* October 22, 1868.
29. Clarence Chatham Cook, "Fine Arts," *New York Daily Tribune,* November 20, 1866.
30. Clarence Chatham Cook, "A New Chromo,"

New York Daily Tribune, October 22, 1868.

31. "Autotypes and Oleographs," *The Nation*, November 10, 1870, pp. 317–318.

32. Philip Gilbert Hamerton, *The Graphic Arts* (London: Seeley, Jackson, and Halliday, 1882), p. 375.

33. Lewis Mumford, *The Brown Decades: A Study of the Arts in America, 1865–1895*, 2nd rev. ed. (New York: Dover, 1971), pp. 35–36.

34. Sigfried Giedion, *Mechanization Takes Command*, originally published in 1948 (New York: W. W. Norton & Co., 1969), pp. 344–364.

35. *The Nation*, November 10, 1870, p. 317.

36. See *Art Age*, April 1884, p. 93; September 1884, p. 14; January 1885, p. 84; April 1885, p. 146; and June 1885, p. 179.

37. *Art Interchange*, September 1, 1882, p. 47.

38. *Literary World*, December 1872, p. 104.

39. Quoted in Frank Luther Mott, *A History of American Magazines, 1885–1905* (Cambridge: Harvard University Press, 1957), p. 18.

40. Harold Wentworth and Stuart Berg Flexner, eds., *The Dictionary of American Slang* (New York: Thomas Y. Crowell, 1960).

41. See numerous entries in Frank Luther Mott, *A History of American Magazines, 1865–1885* (Cambridge: Harvard University Press, 1938).

42. Henri Beraldi, *Les Graveurs du XIXe Siècle* (Paris: Librairie L. Conquet, 1888), p. 186n.

43. Mitford M. Mathews, ed., *A Dictionary of Americanisms* (Chicago: University of Chicago Press, 1951).

44. Damon Runyon, *Take It Easy* (New York: Frederick A. Stokes Co., 1938), p. 282.

45. Interview with Mrs. J. Clifford Harden, Sarasota, Fla., December 14, 1976.

46. *A Supplement to the Oxford English Dictionary* (Oxford: At the Clarendon Press, 1972) 1:519.

47. "Photolithography and the Reproduction of Oil-Paintings," *Lithographers' Journal*, May 1892, p. 124. Virtually every month for three years the *Journal* ran a column on photolithography.

48. Ibid.

49. "O. D. Gray and the Gast Lithography Company," *Lithographers' Journal*, September 1892, p. 60.

50. "The Lithographic Industry in the United States," *Lithographers' Journal*, February 1894, p. 38.

51. *Lithographers' Journal*, September 1892, p. 60; "Art Specialties," *Lithographers' Journal*, October 1891, p. 39.

52. "Art Specialties," p. 39.

53. *Lithographers' Journal*, September 1893, p. 52.

54. "Arts and Crafts," *Brush and Pencil*, December 1897, pp. 47–48.

BIBLIOGRAPHY

A Note About Sources

So little recent scholarship has dealt with American chromolithography that this survey was written chiefly from primary documents. I have attempted to provide notes on all factual information and to furnish a bibliography that will assist the interested reader in reviewing my sources.

In the entries that follow, several basic concepts reign. First, the format is generally according to Kate L. Turabian's *A Manual for Writers*. Second, whenever a source is fully cited in the body of the text it is not repeated in the note. Third, sources cited in the text, notes, and picture captions exclusively for their illustrations are not listed in the bibliography. Fourth, the periodicals in the bibliography are cited by the span of months or years that I read through; the dates do not mean that every issue appears in the notes. Fifth, I found it difficult on occasion to identify precisely the type of evidence I was citing: invoices, trade cards, letters, and so on of lithographic firms often are found in the "Miscellaneous" box of a historical society or museum. And even during the time I was researching this book I found that a document discovered one year in one place sometimes was not there the next; usually, it had been arbitrarily shifted to some other category. Sixth, city directories are listed in the notes but not in the bibliography. Useful as they are, they simply blur any list of references with their continual changes in title, publisher, and periodicity. Directories for Boston, New York, Philadelphia, Pittsburgh, Cincinnati, Chicago, and San Francisco were thoroughly reviewed; other city directories were sampled in the holdings of the Library of Congress.

An enormous amount of research in this field is still to be accomplished, and I hope that this bibliography will be of help to historians and others who pursue the subject.

Archives and Unpublished Manuscripts

Carey, John Thomas. "The American Lithograph from Its Inception to 1865, With Biographical Considerations of Twenty Lithographers and a Checklist of Their Works." Ph.D. dissertation, Ohio State University, 1954.

Chicago. Newberry Library. J. Francis Driscoll Collection.

Cincinnati. Cincinnati Historical Society. Strobridge Lithographic Company account books, correspondence, and records, 1867–1900.

Cincinnati. Public Library of Cincinnati and Hamilton County. T. A. Langstroth Lithography Collection.

Cochran, Carl Malcolm. "James Fuller Queen: Artist and Lithographer." Master's thesis, University of Pittsburgh, 1954.

Densmore, Frances. "The Collection of Watercolor Drawings of the North American Indian by Seth Eastman in the James Jerome Hill Reference Library, Saint Paul." Xeroxed copy, Library of Congress, 1954.

Erlich, George. "Technology and the Artist: A Study of the Interactions of Technological Growth and the Nineteenth-Century Pictorial Art." Ph.D. dissertation, University of Illinois, 1960.

Hart, Charles. "Lithography, Its Theory and Practice, Including a Series of Short Sketches of the Earliest Lithographic Artists, Engravers and Printers of New York." Manuscript Division, New York Public Library, 1902 and several later inserts.

Marzio, Peter C. "The Art Crusade." Ph.D. dissertation, University of Chicago, 1969.

New York. New York Public Library. Print Room, vertical file.

Philadelphia. Historical Society of Pennsylvania. Edward Carey Gardiner Collection.

Prang, Louis. "Autobiography." Manuscript included as an appendix to Sittig thesis (q.v.).

Serio, Anne Marie. "The Lithographers of Buffalo." Unpublished article, typescript. National Museum of History and Technology, Smithsonian Institution, Washington, 1977.

Sittig, Mary Margaret. "L. Prang & Company, Fine Art Publishers." Master's thesis, George Washington University, 1970.

Washington. Archives of American Art, Smithsonian Institution.

Washington. Corcoran Gallery of Art. Archives.

Washington. Library of Congress. H. R. Schoolcraft Papers.

Washington. National Archives. File of Bureau of Indian Affairs.

Washington. National Archives. John Wesley Powell correspondence.

Washington. National Collection of Fine Arts, Smithsonian Institution. Vertical file.

Washington. National Museum of History and Technology, Smithsonian Institution. Division of Graphic Arts, vertical file.

Washington. National Museum of History and Technology, Smithsonian Institution. Warshaw Collection of Business Americana.

Washington. Smithsonian Institution. Archives.

Wheeler, Leeds. "Armstrong and Company, Artistic Lithographers: 1872–1897, Checklist 1944." Manuscript, Prints and Photographs Division, Library of Congress, Washington.

Winterthur, Del. The Henry Francis duPont Winterthur Museum. Joseph Downs Manuscript Collection.

Worcester, Mass. The American Antiquarian Society. Charles H. Taylor file.

Contemporary Periodicals

The Aldine: The Art Journal of America, 1868–79.
The Analectic Magazine, 1818–20.
Appleton's Journal (New York), 1869–81.
Art Age (New York), 1884.
Art Amateur, 1880–95.
Art Interchange (New York), 1878–1900.
Art Union (London), 1845.
The Atlantic Almanac, 1873.
The Atlantic Monthly (Boston), 1857–90.
Boston Evening Transcript, 1881.
Boston Evening Traveller, 1864.
Boston Monthly Magazine, 1825.
British Lithographer, 1892.
Brush and Pencil, 1897.
Buffalo Morning Express, 1864.
Bulletin of the American Art-Union, 1849–50.
Chicago Times, 1893.
Chicago Tribune, 1893–94.
Cleveland Leader, 1873.

The Crayon, 1857.
Critic, 1888–1900.
Decorator and Furnisher (New York), 1882–98.
Demorest's Family Magazine, 1870–95.
Detroit Free Press, 1869–73.
Detroit News-Tribune, 1897.
Everybody's, 1899–1910.
Fortnightly Review, 1880.
Graham's American Monthly Magazine, 1832.
Grand Rapids Eagle, 1872.
Harper's New Monthly Magazine, 1860.
Inland Printer (Chicago), 1884–1900.
Journal of the Franklin Institute, under various titles, (Philadelphia), 1826–90.
Kansas City (Mo.) Daily Journal, March 2, 1881.
Kansas City (Mo.) Gazette, August 11, 1903.
Ladies' Home Journal (under various titles), 1883–1910.
Literary World, 1872.
Lithograph (New York), 1874.
The Lithographer and Printer, 1884–86.
Lithographers' Journal (Philadelphia), 1891–1900.
Lowell (Mass.) Daily Courier, 1885.
McClure's Magazine, 1893–1910.
Military Magazine, 1839–42.
Miss Leslie's Magazine, 1843.
The Nation, 1867–1910.
National Intelligencer and Washington Advertiser, 1808.
National Lithographer, 1910.
The New National Era, October 20, 1870.
Newton's London Journal of Arts, Sciences, and Manufactures . . . , 1855–66.
New York Daily Tribune, 1860–83.
New York Herald, 1860–80.
New York Independent, 1873.
New York Times, 1860–1930.
The North American Review, 1866–80.
Once a Week, 1866.
The Paper World, 1880.
The Pennsylvanian, 1840.
Philadelphia Public Ledger, 1856.
Prang's Chromo: A Journal of Popular Art, 1868–69.
The Printing Times and Lithographer (London), 1875–90.
Railroad Advocate, 1855–56.
Sartain's Union Magazine of Literature and Art, 1850–52.
Smithsonian Miscellaneous Collections, vol. 2.
Strand Magazine (London), 1904.
Western Review (Lexington, Ky.), 1820.
Wide Awake Magazine, 1884.

Contemporary Books and Reports

Abstract of the Statistics of Manufactures According to the Returns of the Seventh Census. Washington, 1858.

Allen, John F. *Victoria regia; or, The Great Water Lily of America.* Boston: Dutton and Wentworth, 1854.

American Dictionary of Printing and Bookmaking. New York: Howard Lockwood and Co., 1894.

Annual Report of the Smithsonian Institution for 1864. Washington, 1872.

Appleton's Dictionary of Machines, Mechanics, Engine-work, and Engraving. 2 vols. New York: D. Appleton & Co., 1852.

Artistic Houses, Being a Series of Interior Views of a Number of the Most Beautiful and Celebrated Homes in the U.S. 2 vols. New York: D. Appleton & Co., 1884.

Audubon, John James. *The Birds of America.* Vols.: 1–5, New York: J. J. Audubon; Philadelphia: J. B. Chevalier; 1840–42. Vols. 6 and 7, New York: J. J. Audubon, 1843–44.

———. *The 1826 Journal of John James Audubon.* Edited by Alice Ford. Norman, Okla.: University of Oklahoma Press, 1967.

[Augustus, Henry]. *Mitchell's New Universal Atlas.* Philadelphia: Charles De Silver, 1855.

Bainard, Frederick Augustus Porter. *Art Culture: Its Relation to National Refinement and Morality.* New York: D. Van Nostrand, 1864.

Baird, Spencer F. *Catalogue of North American Birds. . . .* Washington: Smithsonian Institution, 1858.

Baird, Spencer F.; Brewer, T. M.; and Ridgeway, Robert. *A History of North American Birds: Land Birds.* Boston: Little, Brown, and Company, 1874.

Beaux, Cecilia. *Background with Figures.* Boston and New York: Houghton Mifflin Co., 1930.

Beecher, Catharine E., and Stowe, Harriet Beecher. *The New Housekeeper's Manual* (title of revised *The American Woman's Home,* 1869). New York: J. B. Ford and Co., 1873.

Benjamin, Samuel Greene Wheeler. *Art in America: A Critical and Historical Sketch.* New York: Harper and Brothers, 1880.

Beraldi, Henri. *Les Graveurs du XIXe Siècle.* Paris: Librairie L. Conquet, 1888.

Blodget, Lorin. *The Industries of Philadelphia.* Philadelphia: Collins, 1877.

Bosqui, Edward. *Memoirs.* San Francisco: privately printed, 1904.

Bowman, Henry, and Cowther, J. S. *The Churches of the Middle Ages.* 2 vols. London: G. Bell, 1857.

Boys, Thomas Shotter. *Picturesque Architecture in Paris, Ghent, Antwerp, Rouen.* London, 1839.

Catalog of an Exhibition Illustrating the Technical Methods of the Reproductive Arts: From the Fifteenth Century to the Present Time, with Special Reference to the Photo-Mechanical Processes. Boston, 1892.

Catalogue of a Collection of Oil Paintings and Drawings by the Late John Ross Key. Washington: Smithsonian Institution, 1927.

Catalogue of Lithographic Prints, Books, Etc., in the Art Gallery of the Fuchs and Lang Manufacturing Company, New York. 1913. Located in Print Room, New York Public Library.

Catalogue of Mr. Louis Prang's . . . Paintings. New York: Leeds Art Galleries, 1870.

Catalogue of Rare Historical Engravings and Lithographs. Trenton, N.J.: Edward Boker Sterling, 1893.

A Catalogue of the Complete Etched Works of Thomas Moran, N.A., and M. Nimmo Moran, S.P.E. New York: privately printed, 1889.

Champney, Benjamin. *Sixty Years' Memories of Art and Artists.* Woburn, Mass.: privately printed, 1900.

"Chromo-Lithography," *The Paper World,* October 1880.

Cist, Charles. *Sketches and Statistics of Cincinnati in 1859.* Cincinnati, 1859.

Clemens, Samuel Langhorne. *A Connecticut Yankee in King Arthur's Court.* New York: Harper & Brothers, 1889.

Colburn, Zerah, and Holley, Alexander L. *The Permanent Way and Coal-Burning Locomotive Boilers.* New York: Holley and Colburn, 1858.

Cook, Clarence. *The House Beautiful.* New York: Scribner, Armstrong and Co., 1878.

Cowdrey, Mary Bartlett. *George Henry Durrie, 1820–1863: Connecticut Painter of American Life.* Hartford: Wadsworth Atheneum, 1947.

Custer's Last Fight. St. Louis: John G. Furber, 1886.

Cyclopaedia of the Manufactures and Products of the United States. 1892 (no other information available). Located in National Museum of History and Technology Library, Smithsonian Institution.

Delano, Alonzo. *Old Block's Sketch-Book.* Sacramento, Calif.: James Anthony & Co., 1856.

Dunlap, William. *History of the Rise and Progress of the Arts of Design in the United States.* 2 vols. New York: George P. Scott & Co., 1834.

Early Proceedings of the American Philosophical Society. Philadelphia: American Philosophical Society, 1884.

Eighty Years' Progress of the United States. New York: L. Stebbins, 1861.

Encyclopaedia Americana. Edited by Francis Lieber. Boston: Sanborn, Carter & Bazin, 1856.

Every Man His Own Printer, or Lithography Made Easy. London: Waterlow and Sons, 1854.

Fleischmann, C. L. *Trade, Manufacture, and Com-*

merce in the United States of America. Stuttgart: Franz Köhler, 1852. Translated for Israel Program for Scientific Translations, Jerusalem, 1970.

Ford, James L. Forty-Odd Years in the Literary Shop. New York: E. P. Dutton & Co., 1921.

Freedley, Edwin. Leading Pursuits and Leading Men. Philadelphia: Edward Young, 1856.

Frémont, John Charles. Report of the Exploring Expedition to the Rocky Mountains in the Year 1842, and to Oregon and North California in the Years 1843–44. Washington, 1845.

———. A Report on an Exploration of the Country Lying Between the Missouri River and the Rocky Mountains. . . . Senate document no. 243, 27th Congress, 3rd Session, 1843.

Hamerton, Philip Gilbert. The Graphic Arts. London: Seeley, Jackson, and Halliday, 1882.

Hayden, F. V. The Yellowstone National Park and the Mountain Regions of Portions of Idaho, Nevada, Colorado and Utah. Boston: L. Prang and Co., 1876.

Heck, J. G. Iconographic Encyclopaedia. New York: Rudolph Garrique, 1851.

Henry Bankes's Treatise on Lithography. 1813 and 1816. Reprint. London: Printing Historical Society, 1976.

Hesse, Friedrich. Die Chromolithographie. N.p.: Wilhelm Knapp, 1896.

History of American Manufacturers, 1800–1860. Vol. 1. Philadelphia: Edward Young & Co., 1860.

History of Chicago. Chicago: A. T. Andreas Co., 1885.

Holbrook, John Edwards. North American Herpetology; or A Description of the Reptiles Inhabiting the United States. 5 vols. Philadelphia: J. Dobson, 1842.

Hooper, E. J. Hooper's Western Fruit Book. 3rd ed. Cincinnati: Moore, Welstock, Keys & Co., 1858.

International Exhibition 1876 Official Catalogue: Art Gallery and Annexes. Philadelphia, 1876.

The Iris: An Illuminated Souvenir. Edited by John S. Hart. Philadelphia: Lippincott, Grambo & Co., 1853.

Jarves, James Jackson. The Art-Idea: Sculpture, Painting and Architecture in America. Boston: Houghton Mifflin, 1864.

Kaufmann, Theodore. Kaufmann's American Painting Book: The Art of Painting or of Imitating the Effects of Color in Nature. Boston: L. Prang & Co., 1871.

Kenny, D. J. Illustrated Cincinnati: A Pictorial Handbook of the Queen City. Cincinnati: Robert Clarke & Co., 1875.

The Literary Blue Book. London: Marsh and Miller, 1829.

Lithographic Pen Drawings or Instructions for Imitating Aquatint on Stone. English edition. N.p., 1824.

Lodge, Henry Cabot. "Colonialism in the United States," Studies in History. Boston: Houghton, Mifflin and Co., 1884.

Manufactures of the United States in 1860; Compiled from the Original Returns of the Eighth Census. Washington: Government Printing Office, 1865.

Mattson, Morris. The American Vegetable Practice. Vol. 1, introduction. Boston: D. L. Hale, 1841.

Meadon, Joseph. The Graphic Arts and Crafts Year Book. Hamilton, Ohio, 1907.

Mellerio, André. La Lithographie originale en couleurs. Paris: L'Estampe et l'affiche, 1898.

Moerlin, George. A Trip Around the World. Cincinnati: M. & R. Burgheim, 1880.

Moxon, Joseph. Mechanick Exercises on the Whole Art of Printing. Originally published in 1683. London: Oxford University Press, 1958.

Nash, Joseph. Views of the Interior and Exterior of Windsor Castle. London: T. M. Lean, 1848.

Neal, John. Observations on American Art: Selections from the Writings of John Neal (1793–1876). Edited by Harold Edward Dickson. State College, Pa.: Pennsylvania State College, 1943.

The New American Cyclopaedia. New York: D. Appleton, 1860.

Norton, C. B., ed. Treasures of Art, Industry and Manufacture. Philadelphia: S. T. Souder & Co., 1877.

On the War Path. Detroit: Calvert Lithographing Co., 1872.

Pennell, Joseph, and Pennell, Elizabeth Robins. Lithography and Lithographers. London: T. Fisher Unwin, 1898.

The Penny Cyclopaedia of the Society for the Diffusion of Useful Knowledge. London: Charles Knight & Co., 1839.

Pettit, James S. Modern Reproductive Graphic Processes. New York: D. Van Nostrand, 1884.

R. Hoe & Co.'s Price List. 1870. Located in Franklin Institute, Philadelphia.

Report of the Manufactures of the United States at the Tenth Census. Washington: Government Printing Office, 1883.

Report on Manufacturing Industries in the United States at the Eleventh Census: 1890. Washington: Government Printing Office, 1895.

Reports of the Commissioner of Patents from the years 1838 to 1900.

Ringwalt, J. Luther, ed. American Encyclopaedia of Printing. Philadelphia: Menamin & Ringwalt, 1871.

Runyon, Damon. Take It Easy. New York: Frederick A. Stokes Co., 1938.

Ryder, James F. Voigtlander and I: In Pursuit of

Shadow Catching. Cleveland: Cleveland Printing & Publishing Co., 1902.

Sartain, John. *The Reminiscences of a Very Old Man, 1808–1897.* New York: D. Appleton and Co., 1899.

Schoolcraft, Henry R. *Historical and Statistical Information Respecting the History, Condition and Prospects of the Indian Tribes of the United States.* 6 vols. Philadelphia: J. B. Lippincott & Co., 1851–57.

Senefelder, Alois. *A Complete Course of Lithography.* Originally published in 1818. Translated by A. S. London: R. Ackermann, 1819.

———. *A Complete Course of Lithography.* New York: Da Capo Press, 1968.

———. *The Invention of Lithography.* Originally published in 1818. Translated by J. W. Muller. New York: Fuchs & Lang Manufacturing Co., 1911.

Sheldon, G. W. *American Painters.* Enl. ed. New York: D. Appleton, 1881.

Simpson, G. Wharton. *On the Production of Photographs in Pigments . . . Swan's Patent Carbon Process.* London: Thomas Piper, 1867.

Smith, R. A. *Philadelphia as It Is in 1852.* Philadelphia: Lindsay and Blakeston, 1852.

Southward, J. *Progress in Printing and the Graphic Arts During the Victorian Era.* London: Simpkin, Marshall, Hamilton, Kent & Co., 1897.

Spooner, Sheeryashub. *An Appeal to the People of the United States, in Behalf of Art, Artists, and the Public Weal. . . .* New York: J. J. Reed, 1854.

Sprague, Isaac. *Flowers from the Field and Forest.* Boston: S. E. Cassino, 1882.

Stannard, William John. *The Art-Exemplar: A Guide to Distinguish One Species of Print from Another, with Pictorial Examples and Written Descriptions of Every Known Style of Illustration.* N.p., c. 1860.

The Statistics of the Wealth and Industry of the United States . . . from the Original Returns of the Ninth Census. Washington: Government Printing Office, 1872.

The Statutes at Large. . . . Boston: Charles C. Little & James Brown, 1851; Boston: Little, Brown & Co., 1854, 1859, 1863, 1866, 1871, 1873; Washington: Government Printing Office, 1875, 1883, 1891, 1895, 1899, 1911.

Stevens, George. *The Queen City in 1869.* Cincinnati: George S. Blanchard & Co., 1869.

Subject-Matter Index of Patents for Inventions Issued by the United States Patent Office from 1790 to 1873, Inclusive. 3 vols. Washington: Government Printing Office, 1874.

Transactions of the American Art-Union for the Year 1847. New York: G. F. Nesbitt, 1848.

Transactions of the Massachusetts Horticultural Society. Boston: Dutton and Wentworth, 1847.

Tucker, Stephen D. *History of R. Hoe and Company, 1834–1885.* Edited by Rollo G. Silver. Worcester, Mass.: American Antiquarian Society, 1973.

Tuckerman, Henry T. *Book of the Artists: American Artist Life.* New York: G. P. Putnam's Sons, 1867.

The United States Centennial Commission International Exhibition 1876 Official Catalogue . . . of Art. Philadelphia, 1876.

Valentine, D. T. *Manual of the Corporation of the City of New York.* Various titles and compilers. 1841–70.

von Bezold, Wilhelm. *Theory of Color in its Relation to Art and Art-Industry.* Translated by S. R. Koehler. Boston: L. Prang & Co., 1876.

von Falke, Jakob. *Art in the House.* Boston: L. Prang & Co., 1879.

Walker, Francis A., ed. *United States Centennial Commission[,] International Exhibition 1876[,] Reports and Awards[,] Group XXVII.* Philadelphia: J. B. Lippincott & Co., 1877.

Webber, C. W. *The Hunter-Naturalist: Romance of Sporting; or, Wild Scenes and Wild Hunters.* Philadelphia: Lippincott, Grambo & Co., 1852.

Woods, J. G. *Our Living World.* New York: Selmar Hess, 1885.

Wyatt, Matthew Digby. *The Industrial Arts of the Nineteenth Century.* London, 1851.

Yo-Semite Valley Photographic Views. San Francisco, 1863.

Young, Edward. *Leading Pursuits and Leading Men.* Philadelphia: Edward Young & Co., 1856.

Historical Articles

Angle, Paul M. "Views of Chicago, 1866–1867." *Antiques,* January 1953.

Bartlett, James. "*On the War Path,* by John Mix Stanley." *The Magazine Antiques,* September 1976.

Baur, John I. H. "Unknown American Painters of the Nineteenth Century." *College Art Journal* 6 (summer 1947).

Benjamin, S. G. W. "A Painter of the Streets." *Magazine of Art* 5 (1882).

Berry, W. Turner. "Printing and Related Trades," *A History of Technology,* vol. 4. Oxford: At the Clarendon Press, 1958.

Burk, W. J. "Rudolph Ackermann, Promoter of the Arts and Sciences." *New York Public Library Bulletin,* October 1934.

Bushnell, David I., Jr. "John Mix Stanley, Artist-Explorer." *Annual Report of the Smithsonian Institution,* 1924.

———. *Seth Eastman: The Master Painter of the North American Indian.* The Smithsonian Insti-

tution, Publication 3136, 1932.

Carpenter, Frederic I. "The Genteel Tradition: A Reinterpretation." *Readings in Intellectual History*. Edited by James McFarland. New York: Random House, 1970.

Childs, Charles D. "Audubon's 'Birds of America.'" *The Magazine Antiques*, December 1934.

Cochran, Carl M. "James Queen: Philadelphia Lithographer." *The Pennsylvania Magazine of History and Biography*, April 1958.

Cooke, Hereward Lester. "Winslow Homer's Water Color Technique." *The Art Quarterly*, summer 1961.

Cooper, Jeremy. "Victorian Furniture: An Introduction to the Sources." *Apollo*, February 1972.

Corcoran Gallery of Art. "Five American Genre Painters." *Bulletin*. October 1963.

Cowdrey, Mary Bartlett. "The Discovery of Enoch Wood Perry." *The Old Print Shop Portfolio*, April 1945.

———. "Lilly Martin Spencer, 1822–1902: Painter of the American Sentimental Scene." *American Collector*, August 1944.

Daywalt, Alberta Thorne. "The Spirit of '76." *Antiques*, July 1911.

Decatur, Stephen. "Alfred Jacob Miller: His Early Indian Scenes and Portraits." *American Collector*, December 1939.

Durrie, Mary Clarissa. "George Henry Durrie." *Antiques*, July 1933.

Eckhardt, George C. "Early Lithography in Philadelphia." *Antiques*, December 1935.

Evans, Harold C. "Custer's Last Fight." *The Kansas Magazine* 33 (1938).

"Footnotes." *American Artist*, June 1948.

Gandy, Lewis Cass. "The Story of Lithography." *Supplement to the Lithographers' Journal*, February 1940.

Gray, Nicolette. "The Nineteenth Century Chromo-Lithograph." *Architectural Review* 84 (October 1938).

Harris, Elizabeth M. "Miscellaneous Map Printing Processes in the Nineteenth Century." *Five Centuries of Map Printing*. Edited by David Woodward. Chicago: University of Chicago Press, 1975.

Haverstock, Mary Sayre. "The Tenth Street Studio." *Art in America*, September–October 1966.

Hendricks, Gordon. "A Wish to Please and a Willingness to Be Pleased." *American Art Journal*, spring 1970.

Hodge, Frederick Webb. "A Proposed Indian Portfolio by John Mix Stanley." *Indian Notes*. Heye Foundation, vol. 6, no. 4 (1929).

Jackson, W. H. "With Moran in the Yellowstone: A Story of Exploration, Photography and Art." *Appalachia*, December 1936.

Kainen, Jacob. "The Development of the Halftone Screen." *Annual Report, Smithsonian Institution, 1951*. Washington: Government Printing Office, 1952.

Kaplan, Abraham. "The Aesthetics of the Popular Arts." *The Journal of Aesthetics and Art Criticism*, September 1966.

Kaplan, Milton. "Music Covers." *Library of Congress Quarterly Journal of Current Acquisitions*, December 1961.

Kent, Alan E. "Early Commercial Lithography in Wisconsin." *Wisconsin Magazine of History*, summer 1953.

Keyes, Homer Eaton. "A. F. Tait in Painting and Lithography." *Antiques*, July 1933.

Kimball, Fiske. "Victorian Art and Victorian Taste." *Antiques*, March 1933.

McCausland, Elizabeth. "Color Lithography." *Prints* 8 (December 1937).

McClinton, Katharine M. "L. Prang and Company." *Connoisseur*, February 1976.

McDermott, John Francis, ed. "A Journalist at Old Fort Snelling." *Minnesota History*, December 1950.

Marzio, Peter C. "American Lithographic Technology Before the Civil War." *Prints in and of America to 1850*. Edited by John D. Morse. Charlottesville: University of Virginia Press, 1971.

———. "The Democratic Art of Chromolithography in America: An Overview," *Art and Commerce: American Prints of the Nineteenth Century*. Boston: Museum of Fine Arts, 1978.

———. "Mr. Audubon and Mr. Bien: An Early Phase in the History of American Chromolithography." *Prospects*. Edited by Jack Salzman. New York: Burt Franklin & Co., 1975.

Mastai, M. L. D'Otrange. "The World of William Aiken Walker." *Apollo*, June 1961.

Merten, John W. "Stone by Stone Along a Hundred Years with the House of Strobridge." *Bulletin of the Historical and Philosophical Society of Ohio*, January 1950.

Morrill, Edward. "Louis Prang: Lithographer." *Hobbies Magazine*, August 1940.

"Mr. Currier and Mr. Ives." *The Kennedy Quarterly*, vol. 10, no. 2.

Norton, Bettina A. "William Sharp: Accomplished Lithographer." *Art and Commerce: American Prints of the Nineteenth Century*. Boston: Museum of Fine Arts, 1978.

Novak, Barbara. "American Landscape: Changing Concepts of the Sublime." *The American Art Journal*, September 1972.

Ostroff, E. "Etching, Engraving and Photography." *The Journal of Photographic Science* 17 (1969).

Pauly, Thomas H. "In Search of 'The Spirit of '76.'"

American Quarterly, fall 1976.

"Portraits of North American Indians, with Sketches of Scenery, etc., Painted by J. M. Stanley." *Smithsonian Miscellaneous Collections.* Vol. 2. Washington, 1852.

"Prang Was in the Limelight." *Hobbies: The Magazine for Collectors,* December 1941.

Richardson, Edgar P. "Charles Willson Peale's Engravings in the Year of the National Crisis, 1787." *Winterthur Portfolio One,* 1964.

Roberts, E. O. "The Spirit of '76." *Illinois Farm Bureau Magazine,* July 1973.

Rosenberg, Manuel. "Billing 'The Greatest Show on Earth.'" *The Artist and Advertiser,* February 1931.

Rudd, Benjamin W. "Notable Dates in American Copyright: 1783–1969." *The Quarterly Journal of the Library of Congress,* April 1971.

Russell, Don. "Sixty Years in Bar Rooms." *Westerners Brand Book,* November 1946.

Ryder, James F. "The Painter of 'Yankee Doodle.'" *New England Magazine,* December 1895.

Sadik, Marvin. "The Negro in American Art." *Art in America,* June 1964.

"The Solenhofen Stone." *Lithopinion,* summer 1974.

"The Spirit of '76." *American Heritage,* August 1901.

Taft, Robert. "The Pictorial Record of the Old West. IV. Custer's Last Stand—John Mulvany, Cassilly Adams, and Otto Becker." *Kansas Historical Quarterly,* November 1946.

Tatham, David. "John Henry Bufford: American Lithographer." *Proceedings of the American Antiquarian Society.* Worcester, Mass.: American Antiquarian Society, 1976.

———. "The Pendleton-Moore Shop: Lithographic Artists in Boston, 1825–1840." *Old-Time New England,* October–December 1971.

Todd, Frederick P. "The Huddy & Duval Prints." *The Journal of the American Military Institute* 3 (1939).

Truettner, William H. "'Scenes of Majesty and Enduring Interest': Thomas Moran Goes West." *Art Bulletin,* June 1976.

Twyman, Michael. "The Lithographic Hand Press, 1796–1850." *Journal of the Printing Historical Society,* no. 3 (1967).

Viele, Chase. "Four Artists of Mid–Nineteenth Century Buffalo." *New York History,* January 1962.

von Groschwitz, Gustave. "The Original Lithograph in Color in the Nineteenth Century." *Marsyas* 6 (1954).

———. "The Significance of Nineteenth Century Color Lithography." *Gazette des Beaux-Arts,* November 1954.

Wainwright, Nicholas B. "Augustus Kollner, Artist." *The Pennsylvania Magazine of History and Biography,* July 1960.

———. "Lithographic Note." *The Pennsylvania Magazine of History and Biography,* October 1959.

Welsh, Peter C. "Henry R. Robinson: Printmaker to the Whig Party." *New York History,* January 1972.

White, John H., Jr. "Locomotives on Stone." *The Smithsonian Journal of History* 1 (1966).

Williams, George Alfred. "Robert Havell, Junior, Engraver of Audubon's 'The Birds of America.'" *The Print-Collector's Quarterly,* October 1916.

Historical Books

A Catalogue of the Complete Etched Works of Thomas Moran, N.A., and M. Nimmo Moran, S.P.E. New York: privately printed, 1889.

Adams, Adeline. *Childe Hassam.* New York: American Academy of Arts and Letters, 1938.

A. F. Tait: Artist in the Adirondacks. Blue Mountain Lake, N.Y.: Adirondack Museum, 1974.

American Printmaking Before 1876: Fact, Fiction, and Fantasy. Washington: Library of Congress, 1975.

Amon Carter Museum of Western Art: Catalogue of the Collection, 1972. Fort Worth, Tex.: Amon Carter Museum of Western Art, 1973.

Anglo-American Cataloguing Rules. Chicago: American Library Association, 1967.

Antreasian, Garo Z., and Adams, Clinton. *The Tamarind Book of Lithography: Art and Techniques.* New York: Harry N. Abrams, 1971.

Barker, Virgil. *American Painting: History and Interpretation.* New York: Macmillan Co., 1950.

Battles of the Civil War. Birmingham, Ala.: Oxmoor House, 1976.

Baur, John I. H. *American Painting in the Nineteenth Century: Main Trends and Movements.* New York: Frederick A. Praeger, 1953.

———. *Eastman Johnson.* Brooklyn, N.Y.: Brooklyn Museum, 1940.

Beam, Philip C. *Winslow Homer at Prout's Neck.* Boston: Little, Brown & Co., 1966.

Beard, Charles A., and Beard, Mary R. *The Rise of American Civilization.* Rev. ed. (2 vols. in 1). New York: Macmillan Co., 1937.

Beckman, Thomas. *Milwaukee Illustrated.* Milwaukee: Milwaukee Art Center, 1978.

Bénézit, Emmanuel. *Dictionnaire critique et documentaire des peintres, sculpteurs, dessinateurs et graveurs.* 7 vols. N.p.: Librairie Gründ, 1962.

Bennett, Whitman. *A Practical Guide to American Nineteenth-Century Color Plate Books.* New York: Bennett Book Studios, 1949.

Bermingham, Peter. *Jasper F. Cropsey, 1823–1900:*

A Retrospective View of America's Painter of Autumn. College Park, Md.: University of Maryland Art Gallery, 1968.

Best Fifty Currier & Ives Lithographs: Large Folio Size. New York: The Old Print Shop, 1933.

Best Fifty Currier & Ives Lithographs: Small Folio Size. New York: The Old Print Shop, 1934.

Bigmore, E. C., and Wyman, C. W. H. *A Bibliography of Printing.* New York: Philip C. Duschnes, 1945.

Bland, Jane Cooper. *Currier & Ives: A Manual For Collectors.* Garden City, N.Y.: Doubleday, Doran & Co., 1931.

Boas, George, ed. *Romanticism in America.* Baltimore: Johns Hopkins Press, 1940.

Bolton, Theodore. *American Book Illustrators.* New York: R. R. Bowker Co., 1938.

Bolton-Smith, Robin. *Lilly Martin Spencer, 1822–1902: The Joys of Sentiment.* Washington: National Collection of Fine Arts, 1973.

Boorstin, Daniel J. *The Americans: The Democratic Experience.* New York: Vintage, 1974.

Born, Wolfgang. *Still-Life Painting in America.* New York: Oxford University Press, 1947.

Bridgeman, Harriet, and Drury, Elizabeth, eds. *The Encyclopedia of Victoriana.* New York: Macmillan Co., 1975.

The Britannica Encyclopedia of American Art. Chicago: Encyclopaedia Britannica Educational Co., 1973.

Brown, Bolton. *Lithography for Artists.* Chicago: University of Chicago Press, 1930.

Brown, Herbert Ross. *The Sentimental Novel in America, 1789–1860.* New York: Pageant Books, 1959.

Bryant, Lorinda Munson. *American Pictures and Their Painters.* New York: John Lane, 1917.

Bryce, James. *Studies in Contemporary Biography.* New York: Macmillan Co., 1903.

Buday, George. *The History of the Christmas Card.* London: Spring Books, 1954.

Burroughs, Alan. *Limners and Likenesses: Three Centuries of American Painting.* Cambridge: Harvard University Press, 1936.

Caffin, Charles H. *The Story of American Painting: The Evolution of Painting in America from Colonial Times to the Present.* New York: Frederick A. Stokes, 1907.

Cantor, Jay D. *The Landscape of Change.* Sturbridge, Mass.: Old Sturbridge Village, 1976.

Cate, Phillip Dennis, and Hitchings, Sinclair Hamilton. *The Color Revolution: Color Lithography in France, 1890–1900.* New Brunswick, N. J.: Rutgers University, 1978.

Childe Hassam, 1859–1935. Tucson, Ariz.: University of Arizona Museum of Art, 1972.

Clement, Clara Erskine, and Hutton, Laurence. *Artists of the Nineteenth Century and Their Works.* Boston and New York: Houghton Mifflin Co., 1894.

Clipper Ships: Currier & Ives Prints No. 3. London: The Studio Ltd.; New York: W. E. Rudge, 1932.

Collison, Robert Lewis, ed. *Encyclopedias: Their History Throughout the Ages.* New York: Hafner Publishing Co., 1966.

Colver, Anne. *Yankee Doodle Painter.* New York: Alfred A. Knopf, 1955.

The Compact Edition of the Oxford English Dictionary. 2 vols. Oxford: At the Clarendon Press, 1971.

Comstock, Helen C. *American Lithographs of the Nineteenth Century.* New York: M. Barrows & Co., 1950.

Conningham, Frederic A. *Currier & Ives.* Cleveland: World Publishing Co., 1950.

———. *Currier & Ives Prints: An Illustrated Check List.* New York: Crown Publishers, 1949.

Constable, W. G. *Art Collecting in the United States: An Outline of a History.* London: Unwin, 1964.

Crosby, Everett Uberto. *Chromos.* Nantucket, Mass.: Tetaukimmo Press, 1954.

Cross, Barbara M., ed. *The Educated Woman in America: Selected Writings of Catharine Beecher, Margaret Fuller, et al.* New York: Columbia University Press, 1965.

Crouse, Russel. *Mr. Currier and Mr. Ives: A Note on Their Lives and Times.* Garden City, N.Y.: Doubleday, Doran & Co., 1930.

Currier & Ives Lithographs in Color. New York: Parke-Bernet Galleries, 1942.

Currier & Ives: Printmakers to the American People. New York: New York Public Library, 1931.

Currier & Ives Prints: Clipper Ships. London: The Studio Ltd., c. 1931.

Currier & Ives Prints: Early Steamships. London: The Studio Ltd., 1933.

Curti, Merle. *The Growth of American Thought.* New York: Harper and Brothers, 1951.

Darrell, Margery, ed. *Christmas in the Country.* Princeton, N.J.: Pyne Press, 1974.

Devereux, Henry Kelsey. *The Spirit of '76.* Cleveland: privately printed, 1926.

De Voto, Bernard. *Across the Wide Missouri.* Boston: Houghton Mifflin Co., 1947.

Dickson, Harold E. *Arts of the Young Republic: The Age of William Dunlap.* Chapel Hill: University of North Carolina Press, 1968.

Dorra, Henri. *The American Muse.* New York: Viking Press, 1961.

Early Steamships: Currier & Ives Prints No. 4. London: The Studio Ltd.; New York: The Studio Publications, 1933.

Eddy, Elford. *The Log of A Cabin Boy.* San Francisco: privately printed, 1922.

Eliot, Alexander. *Three Hundred Years of American Painting.* New York: Time Inc., 1957.

Emory, William Helmsley. *Notes of a Military Reconnaissance, from Fort Leavenworth, in Missouri, to San Diego, in California.* Washington: Wendell & Von Benthuysen, 1848.

Exhibition of Southern Genre Paintings by William Aiken Walker. New York: Bland Galleries, 1940.

Fine Art Reproductions: Old and Modern Masters. New York: New York Graphic Society, 1954.

Fink, Lois Marie, and Taylor, Joshua C. *Academy: The Academic Tradition in American Art.* Washington: Smithsonian Institution Press, 1975.

Fishbein, Meyer H. *The Censuses of Manufactures, 1810–1890.* Washington: General Services Administration, 1973.

Flexner, James Thomas. *American Painting: First Flowers of Our Wilderness.* Boston: Houghton Mifflin, 1947.

————. *American Painting: The Light of Distant Skies, 1760–1835.* New York: Harcourt, Brace, 1954.

————. *Nineteenth Century American Painting.* New York: G. P. Putnam's Sons, 1970.

————. *That Wilder Image: The Painting of America's Native School from Thomas Cole to Winslow Homer.* Boston: Little, Brown, 1962.

Frankenstein, Alfred Victor. *After the Hunt: William Harnett and Other American Still Life Painters, 1870–1900.* Rev. ed. Berkeley and Los Angeles: University of California Press, 1969.

Frederic Edwin Church. Washington: Smithsonian Institution Press, 1966.

Freeman, Larry. *Louis Prang: Color Lithographer.* Watkins Glen, N.Y.: Century House, 1971.

Fries, Waldemar H. *The Double Elephant Folio: The Story of Audubon's Birds of America.* Chicago: American Library Association, 1973.

Fryxell, Fritiof, ed. *Thomas Moran: Explorer in Search of Beauty.* East Hampton, N.Y.: East Hampton Free Library, 1958.

Gardner, Albert Ten Eyck. *Winslow Homer.* New York: Clarkson N. Potter, 1961.

Gerdts, William H. *Thomas Moran.* Riverside, Calif.: University of California, 1963.

Gerdts, William H., and Burke, Russell. *American Still-Life Painting.* New York: Praeger, 1971.

Giedion, Sigfried. *Mechanization Takes Command.* Originally published in 1948. New York: W. W. Norton & Co., 1969.

Goodman, Calvin J. *A Study of the Marketing of the Original Print.* Los Angeles: Tamarind Lithography Workshop, 1964.

Goodrich, Lloyd. *The Graphic Art of Winslow Homer.* New York: Museum of Graphic Art, 1968.

————. *Winslow Homer.* New York: Macmillan Co., 1944.

————. *Winslow Homer.* New York: Whitney Museum of American Art, 1973.

Gowans, Alan. *The Restless Art: A History of Painters and Painting, 1760–1960.* Philadelphia: J. B. Lippincott Co., 1966.

Graphic Arts. Garden City, N.Y.: Garden City Publishing Co., 1936.

Groce, George C., and Wallace, David H. *The New-York Historical Society's Dictionary of Artists in America, 1564–1860.* New Haven: Yale University Press, 1957.

Groseclose, Barbara S. *Emanuel Leutze, 1816–1868: Freedom Is the Only King.* Washington: Smithsonian Institution Press, 1975.

Hall, W. S. *The Spirit of America: Currier & Ives Prints.* London: The Studio Ltd., 1930.

Hamilton, Sinclair. *Early American Book Illustrators and Wood Engravers, 1670–1870.* Princeton, N.J.: Princeton University Library, 1958.

Harris, Neil. *The Artist in American Society.* New York: George Braziller, 1966.

Hartmann, Sadakichi. *A History of American Art.* Rev. ed. 2 vols. Boston: L. C. Page, 1902.

Hendricks, Gordon. *Albert Bierstadt: Painter of the American West.* New York: Harry N. Abrams and Amon Carter Museum of Western Art, 1974.

Herrick, Francis Hobart. *Audubon the Naturalist: A History of His Life and Time.* New York: D. Appleton–Century Co., 1938.

Hess, Stephen, and Kaplan, Milton. *The Ungentlemanly Art.* New York: Macmillan Co., 1968.

Hill, Patricia. *Eastman Johnson.* New York: Clarkson N. Potter, 1972.

Hoagland, H. E. *Collective Bargaining in the Lithographic Industry.* New York: Columbia University, 1917.

Holland, Vyuyan. *Hand Coloured Fashion Plates.* London: Batsford, 1955.

Homage to Senefelder. London: Victoria and Albert Museum, 1971.

Hoopes, Donelson F., ed. *The Düsseldorf Academy and the Americans.* Atlanta: High Museum of Art, 1972.

Hornung, Clarence P. *Handbook of Early Advertising Art, Mainly from American Sources.* 2 vols. New York: Dover, 1953.

Houghton, Walter E. *The Wellesley Index to Victorian Periodicals, 1824–1900.* Toronto: University of Toronto Press, 1966.

Hudson, William Henry. *Whittier and His Poetry.* Norwood, Pa.: Norwood Editions, 1976.

Huntington, David C. *The Landscapes of Frederic Edwin Church: Vision of an American Era.* New York: George Braziller, 1966.

Hutson, Martha Young. *George Henry Durrie.* Santa Barbara, Calif.: Santa Barbara Museum of Art, 1977.

Hutt, Wolfgang. *Die Düsseldorfer Malerschule,
1819–69.* Leipzig, 1964.

Isham, Samuel. *The History of American Painting.*
New York: Macmillan Co., 1905.

James, Edward T. *Notable American Women, 1607–
1950.* 3 vols. Cambridge: Harvard University
Press, 1971.

Johnson, Allen, and others. *Dictionary of American
Biography.* 21 vols. and 4 supplements. New
York: Charles Scribner's Sons, 1928–74.

Kauffer, E. McKnight. *The Art of the Poster.* New
York: Albert & Charles Boni, 1928.

King, Roy, and Davis, Burke. *The World of Currier
& Ives.* New York: Random House, 1968.

Kinietz, William Vernon. *John Mix Stanley and His
Indian Paintings.* Ann Arbor: University of
Michigan Press, 1942.

Kouwenhoven, John A. *The Arts in Modern Ameri-
can Civilization.* Originally published under the
title *Made in America* in 1948. New York:
W. W. Norton & Co., 1967.

Kynett, Harold Havelock. *Illusion: Rambles Away
from Reality.* Philadelphia: privately printed,
1937.

Larkin, Oliver W. *Art and Life in America.* New
York: Holt, Rinehart & Winston, 1960.

Laver, James. *Manners and Morals in the Age of
Optimism, 1848–1914.* New York: Harper &
Row, 1966.

Leonard, Lewis Alexander. *Greater Cincinnati and
Its People.* 4 vols. Cincinnati: Lewis Historical
Publishing Co., 1927.

Lipman, Jean. *American Primitive Painting.* New
York: Oxford University Press, 1942.

*Lithography in Cincinnati: To the Advent of the
Steam Press.* Cincinnati: Young & Klein, 1956.

*Lithography in Cincinnati: To the Introduction of
the First Offset Press.* Cincinnati: Young &
Klein, 1959.

*M. & M. Karolik Collection of American Water
Colors and Drawings, 1800–1875.* 2 vols.
Boston: Museum of Fine Arts, 1962.

MacKellar, Thomas. *The American Printer.* Phila-
delphia: MacKellar, Smiths & Jordan, 1878.

Marzio, Peter C. *The Art Crusade.* Washington:
Smithsonian Institution Press, 1976.

Mason, Lauris, compiler. *Print Reference Sources:
A Select Bibliography, Eighteenth–Twentieth
Centuries.* Millwood, N.Y.: Kraus-Thomson
Organization, 1975.

Mathews, Mitford M., ed. *A Dictionary of Ameri-
canisms.* Chicago: University of Chicago Press,
1951.

Mayor, A. Hyatt. *American Printmaking: The First
150 Years.* Washington: Smithsonian Institution
Press, 1969.

McCauley, Lois B. *Maryland Historical Prints, 1752
to 1889.* Baltimore: Maryland Historical Soci-
ety, 1915.

McCausland, Elizabeth. *A. H. Maurer.* New York:
Walker Art Center, 1951.

McClinton, Katharine Morrison. *The Chromolitho-
graphs of Louis Prang.* New York: Clarkson N.
Potter, 1973.

McCoubrey, John W. *American Tradition in Paint-
ing.* New York: George Braziller, 1963.

McCracken, Harold. *Portrait of the Old West.* Fore-
word by R. W. G. Vail. With a biographical
check list of Western artists. New York:
McGraw-Hill, 1952.

McDermott, John Francis. *The Art of Seth Eastman.*
Washington: Smithsonian Institution, 1959.

———. *The Lost Panoramas of the Mississippi.*
Chicago: University of Chicago Press, 1958.

———. *Seth Eastman: Pictorial Historian of the
Indian.* Norman, Okla.: University of Oklahoma
Press, 1961.

McIntyre, Robert G. *Martin J. Heade, 1819–1904.*
New York: Pantheon Press, 1948.

McMurtrie, Douglas C., ed. *The Invention of Print-
ing.* New York: Burt Franklin, 1942.

*Memorial Exhibition: Paintings and Etchings by
Thomas Moran, N.A.* New York: Clinton
Academy, 1928.

Miller, Dorothy. *The Life and Work of David G.
Blythe.* Pittsburgh: University of Pittsburgh
Press, 1950.

Miller, Lillian B. *Patrons and Patriotism: The En-
couragement of the Fine Arts in the United
States, 1790–1860.* Chicago: University of
Chicago Press, 1966.

Morris, William, ed. *The American Heritage Dic-
tionary of the English Language.* Boston:
Houghton Mifflin Company, 1976.

Morse, Peter. *Jean Charlot's Prints: A Catalogue
Raisonné.* Honolulu: University of Hawaii Press,
1976.

Moss, Michael E., ed. *Robert W. Weir of West Point:
Illustrator, Teacher and Poet.* West Point:
United States Military Academy, 1976.

Mott, Frank Luther. *A History of American Maga-
zines, 1865–1885.* Cambridge: Harvard Uni-
versity Press, 1938.

———. *A History of American Magazines, 1885–
1905.* Cambridge: Harvard University Press,
1957.

Mr. Currier & Mr. Ives: An American Phenomenon.
New York: Kennedy Galleries, 1970.

Mumford, Lewis. *The Brown Decades: A Study of
the Arts in America, 1865–1895.* New York:
Dover, 1971.

Munsing, Stefanie A. *Made in America: Printmaking
1760–1860.* Philadelphia: The Library Com-
pany of Philadelphia, 1973.

Munson, Fred C. *History of the Lithographers'
Union.* Cambridge, Mass.: Amalgamated Li-

thographers of America, 1963.

Norton, Bettina A. *Edwin Whitefield, Nineteenth-Century North American Scenery.* New York: Barre Publishers, 1977.

Novak, Barbara. *American Painting of the Nineteenth Century: Realism, Idealism, and the American Experience.* New York: Frederick A. Praeger, 1969.

Pattee, Fred Lewis. *The Feminine Fifties.* New York: D. Appleton, 1940.

Peters, Fred Joseph. *Clipper Ship Prints.* New York: Antique Bulletin Publishing Co., 1930.

———. *Railroad, Indian and Pioneer Prints by N. Currier and Currier & Ives.* New York: Antique Bulletin Publishing Co., 1930.

———. *Sporting Prints by N. Currier and Currier & Ives.* New York: Antique Bulletin Publishing Co., 1930.

Peters, Harry T. *America on Stone.* Garden City, N.Y.: Doubleday, Doran & Co., 1931.

———. *California on Stone.* Garden City, N.Y.: Doubleday, Doran & Co., 1935.

———. *Currier & Ives: Printmakers to the American People.* 2 vols. Garden City, N.Y.: Doubleday, Doran & Co., 1929–31.

Pictorial History of American Battle Scenes. Watkins Glen, N.Y.: Century House, 1961.

Pinckney, Pauline A. *Painting in Texas: The Nineteenth Century.* Austin: Amon Carter Museum of Western Art and the University of Texas Press, 1967.

A Portfolio of Currier and Ives. Garden City, N.Y.: Doubleday, Doran & Co., 1931.

Pratt, John Lowell. *Currier & Ives Chronicles of America.* Maplewood, N.J.: Hammond, 1968.

Presbrey, Frank. *The History and Development of Advertising.* Garden City, N.Y.: Doubleday, Doran & Co., 1929.

Quimby, Ian M. G., and Earl, Polly Anne, eds. *Technological Innovation and the Decorative Arts.* Charlottesville, Va.: Henry Francis duPont Winterthur Museum, 1974.

Ralph Albert Blakelock, 1847–1919. New York: M. Knoedler & Co., 1973.

Ralph Albert Blakelock, 1847–1919. Lincoln, Nebr.: University of Nebraska, 1975.

Ralph Albert Blakelock: Centenary Exhibition. New York: Whitney Museum of American Art, 1947.

Rathbone, Perry T., ed. *Westward the Way: The Character and Development of the Louisiana Territory as Seen by Artists and Writers of the Nineteenth Century.* St. Louis: City Art Museum, 1954.

Reade, Brian. *Art Nouveau and Alphonse Mucha.* London: Her Majesty's Stationery Office, 1963.

The Red Indian: Currier & Ives Prints No. 2. London: The Studio Ltd.; New York: W. E. Rudge, 1931.

Reps, John W. *Cities on Stone.* Fort Worth, Tex.: Amon Carter Museum of Western Art, 1976.

Richardson, Edgar P. *American Romantic Painting.* New York: E. Weyhe, 1944.

———. *Painting in America: From 1502 to the Present.* New York: Thomas Y. Crowell Co., 1965.

Richmond, W. D. *Colour and Colour Printing as Applied to Lithography.* London: Myers & Co., 1912.

———. *The Grammar of Lithography.* London: Myers & Co., 1914.

Romaine, Lawrence B. *A Guide to American Trade Catalogs 1744–1900.* New York: R. R. Bowker Co., 1960.

Ross, Marvin C. *The West of Alfred Jacob Miller.* Norman, Okla.: University of Oklahoma Press, 1968.

Rutledge, Anna Wells. *Artists in the Life of Charleston, Through Colony and State from Restoration to Reconstruction.* Philadelphia: American Philosophical Society, 1949.

———. *Cumulative Record of Exhibition Catalogues. . . .* Philadelphia: American Philosophical Society, 1955.

Sears, Clara Endicott. *Highlights Among the Hudson River Artists.* Boston: Houghton Mifflin, 1947.

A Selection of Lithographs Published by Currier and Ives. Tarrytown, N.Y.: William Abbatt, 1929.

Simkin, Colin, ed. *Currier and Ives' America.* New York: Crown Publishers, 1952.

———, ed. *A Currier & Ives Treasury.* New York: Crown Publishers, 1955.

Sitwell, Sacheverell. *Narrative Pictures: A Survey of English Genre and Its Painters.* London: B. T. Batsford, 1969.

Smith, Henry Nash, ed. *Popular Culture and Industrialism, 1865–1890.* New York: Random House, 1967.

The Spirit of America, Currier & Ives Prints. London: The Studio Ltd.; New York: W. E. Rudge, 1930.

Stebbins, Theodore E., Jr. *The Life and Works of Martin Johnson Heade.* New Haven and London: Yale University Press, 1975.

———. *Martin Johnson Heade.* College Park, Md.: University of Maryland, 1969.

Steegman, John. *Victorian Taste.* Cambridge, Mass.: M.I.T. Press, 1971.

Stokes, I. N. Phelps, and Haskell, D. C. *American Historical Prints.* New York: New York Public Library, 1932.

———. *American Historical Prints: Early Views of American Cities.* New York: New York Public Library, 1933.

A Supplement to the Oxford English Dictionary. Oxford: At the Clarendon Press, 1972.

Taft, Robert. *Artists and Illustrators of the Old West,*

1850–1900. New York: Charles Scribner's Sons, 1953.

———. *Photography and the American Scene*. New York: Macmillan Co., 1942.

Talbot, William S. *Jasper F. Cropsey, 1823–1900*. Washington: Smithsonian Institution Press, 1970.

Tarbell, Ida M. *The Tariff in Our Times*. New York: Macmillan Co., 1911.

The Tariff and Its History. Washington: Government Printing Office, 1934.

Taylor, Joshua C. *To See Is to Think*. Washington: Smithsonian Institution Press, 1975.

Thieme, Ulrich, and Becker, Felix. *Allgemeines Lexikon der Bildenden Künstler*. 37 vols. Leipzig: Wilhelm Engelmann, 1907–50.

Tomsich, John Michael. *A Genteel Endeavor: American Culture and Politics in the Gilded Age*. Stanford: Stanford University Press, 1971.

Trachtenberg, Alan, ed. *Democratic Vistas, 1860–1880*. New York: George Braziller, 1970.

Trovaioli, August P., and Toledano, Roulhac B. *William Aiken Walker: Southern Genre Painter*. Baton Rouge: Louisiana State University Press, 1972.

Twyman, Michael. *Lithography, 1800–1850: The Techniques of Drawing on Stone in England and France and Their Application in Works of Topography*. London: Oxford University Press, 1970.

Van Nostrand, Jeanne, and Coulter, Edith M. *California Pictorial: A History in Contemporary Pictures, 1786 to 1859*. Berkeley and Los Angeles: University of California Press, 1948.

Viola, Herman J. *The Indian Legacy of Charles Bird King*. Washington: Smithsonian Institution Press and Doubleday & Co., 1976.

Wainwright, Nicholas B. *Philadelphia in the Romantic Age of Lithography*. Philadelphia: Historical Society of Pennsylvania, 1958.

Walsh, S. Padraig. *Anglo-American General Encyclopedias: A Historical Bibliography, 1703–1967*. New York and London: R. R. Bowker Co., 1968.

Weaver, Peter. *The Technique of Lithography*. New York: Reinhold Publishing Co., 1964.

Weaver, Warren A. *Lithographs of N. Currier and Currier & Ives*. New York: Holport Publishing Co., 1925.

Weber, Wilhelm. *A History of Lithography*. London: Thames & Hudson, 1966.

Weisendanger, Martin, and Weisendanger, Margaret. *Louisiana Painters and Paintings: A Catalogue of the Collection of W. E. Groves*. New Orleans: W. E. Groves Gallery, 1971.

Weitenkampf, Frank. *American Graphic Art*. New York: Henry Holt and Co., 1912.

Wentworth, Harold, and Flexner, Stuart Berg, eds. *The Dictionary of American Slang*. New York: Thomas Y. Crowell, 1960.

Wiborg, Frank B. *Printing Ink*. New York and London: Harper & Brothers, 1926.

Wilkins, Thurman. *Thomas Moran: Artist of the Mountains*. Norman, Okla.: University of Oklahoma Press, 1966.

William Gillespie Armor, 1834–1924. Pittsburgh: Historical Society of Western Pennsylvania, 1974.

Williams, Hermann Warner, Jr. *The Civil War: The Artists' Record*. Boston: Beacon Press, 1961.

———. *Mirror to the American Past*. Greenwich, Conn.: New York Graphic Society, 1973.

Wilmerding, John. *Fitz Hugh Lane, 1804–1865: American Marine Painter*. Gloucester, Mass.: Peter Smith, 1967.

Winslow Homer at Prout's Neck. Brunswick, Me.: Bowdoin College Museum of Art, 1966.

The Work of Julius Bien: An Exhibition of Original Maps and Engravings. Washington: Klutznick Exhibit Hall, B'nai B'rith Buildings, 1960.

Young, William, ed. *A Dictionary of American Artists, Sculptors and Engravers*. Cambridge, Mass.: William Young and Co., 1968.

Ziff, Larzar. *The American 1890s: Life and Times of a Lost Generation*. New York: Viking Press, 1966.

PLATES

The illustrations that follow were gathered from numerous museums, libraries, historical societies, and private collections throughout the country. The location in the caption is by no means exclusive; often copies of the print can be found in several institutions. My citation is intended to guide the reader to the particular picture used by me in preparing this book. In measurements, height precedes width and dimensions refer to the page size, including caption—they are not restricted to the image itself. The term *artist* refers to the person who put the image on the stone. When the caption indicates that the picture was printed in color or chromolithographed, I have quoted it.

PLATE 1.
"Hôtel De Cluny, Paris." Artist,
Thomas Shotter Boys, after his own
painting. Printed by C. J. Hull-
mandel, London, 1839. 21½ × 14⅜
inches. Source: Thomas Shotter Boys,
Picturesque Architecture . . . 1839,
Rare Book Room, Library of Con-
gress, Washington, D.C.

PLATE 2.
"F. W. P. Greenwood." Artist,
William Sharp. Printed by William
Sharp, Boston, 1840. "Printed in
Colours." 24 × 18 inches. Location:
Harry T. Peters "America on Stone"
Lithography Collection, National
Museum of History and Technology,
Smithsonian Institution, Washing-
ton, D.C.

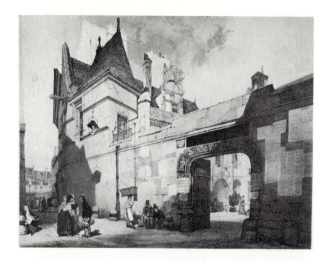

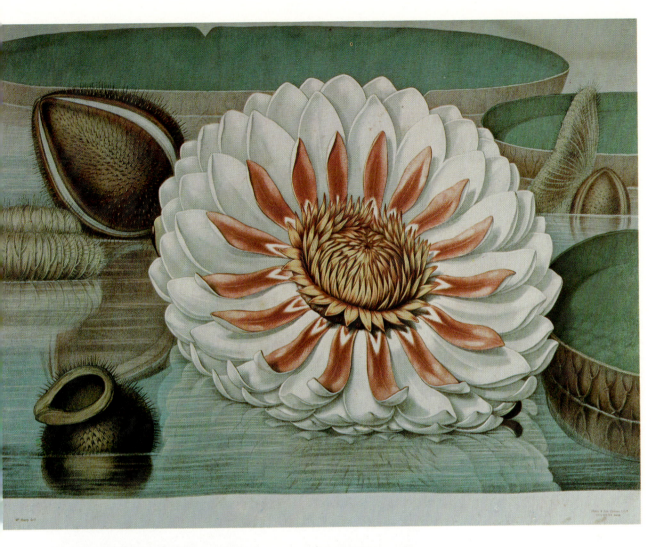

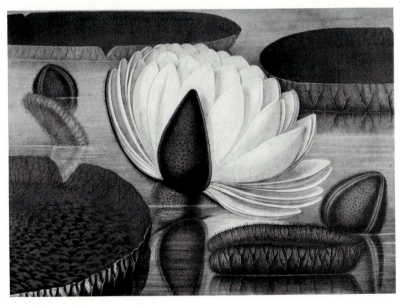

PLATE 3.
"American Water Lily." Artist, William Sharp, after his own painting. Printed by Sharp and Son, Dorchester, Mass., 1854. "Chromo lith'd." 21¼ × 27¼ inches. Source: John F. Allen, *Victoria regia; or, The Great Water Lily of America* (Boston: Dutton and Wentworth, 1854), The Library Company of Philadelphia.

PLATE 4.
"American Water Lily." Artist, William Sharp, after his own painting. Printed by Sharp and Son, Dorchester, Mass., 1854. "Chromo lith'd." 21¼ × 27¼ inches. Source: John F. Allen, *Victoria regia; or, The Great Water Lily of America* (Boston: Dutton and Wentworth, 1854), The Library Company of Philadelphia.

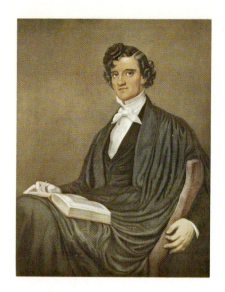

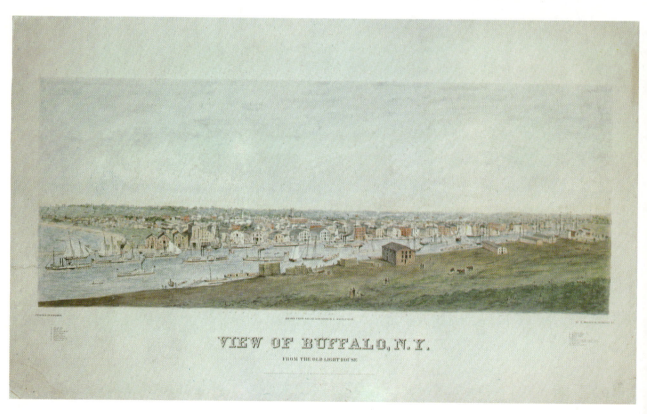

VIEW OF BUFFALO, N.Y.

FROM THE OLD LIGHT HOUSE

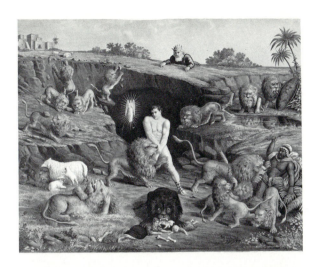

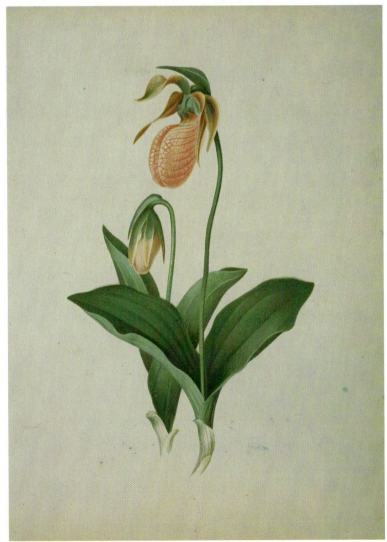

PLATE 5.
"W. M. Rogers." Artist, probably William Sharp. After a portrait by F. Alexander. Printed by Sharp and Son, Boston, 1852. "Chromo Lith." 15¾ × 12¾ inches. Location: Prints and Photographs Division, Library of Congress, Washington, D.C.

PLATE 6.
"View of Buffalo, N. Y. from the Old Lighthouse." Artist, Edwin Whitefield, after his own painting. Printed by Francis Michelin, New York, 1847. "Printed in Colors." 24¼ × 40¾ inches. Location: Harry T. Peters "America on Stone" Lithography Collection, National Museum of History and Technology, Smithsonian Institution, Washington, D.C.

PLATE 7.
"[Old Boston] Beacon Hill, from the Present Site of the Reservoir Between Hancock & Temple Sts." Artist unknown. After a drawing by John Rubens Smith. Printed by J. H. Bufford Lithographing, Boston, 1858. 16 × 15⅝ inches. Location: Prints and Photographs Division, Library of Congress, Washington, D.C.

PLATE 8.
"Twelve Temptations; Daniel in the Lions' Den." Artist unknown. After a painting by H. Schoff. Printed by J. H. Bufford's Sons, Boston, 1877. "Oil Chromo." 16 × 20 inches. Location: Prints and Photographs Division, Library of Congress, Washington, D.C.

PLATE 9.
"The Moccasin Flower." Artist unknown. After a watercolor by Isaac Sprague. Printed by Armstrong and Company, Boston, c. 1880–82. 12½ × 9½ inches. Location: Division of Graphic Arts, National Museum of History and Technology, Smithsonian Institution, Washington, D.C.

PLATE 10.
"The Iris Souvenir for 1851." Artist, Christian Schuessele. Printed by P. S. Duval, Philadelphia, 1851. "Printed in Color. . . ." 9 × 6 inches. Location: Rare Book Room, Library of Congress, Washington, D.C.

PLATE 11.
"Lafayette." Artist, Christian Schuessele. Printed by P. S. Duval, Philadelphia, 1851. "Printed in colours." 22⅝ × 17¼ inches. Location: Prints and Photographs Division, Library of Congress, Washington, D.C.

PLATE 12.
"Washington's Triumphal Entry into New York, Nov. 25th, 1783." Artist, Christian Inger. Printed by P. S. Duval and Son, Philadelphia, 1860 (on some copies of this print the date appears to read 1850, but 1860 is the correct date). "Printed in oil colors." 35-1/16 × 46½ inches. Location: The Library Company of Philadelphia.

PLATE 13.
"Washington's Grand Entry into New York, Nov. 25th, 1783." Artist unknown. After a drawing by Alphonse Bigot. Printed by Thomas Sinclair, Philadelphia, 1860. "Chromo Lith." Location: Prints and Photographs Division, Library of Congress, Washington, D.C.

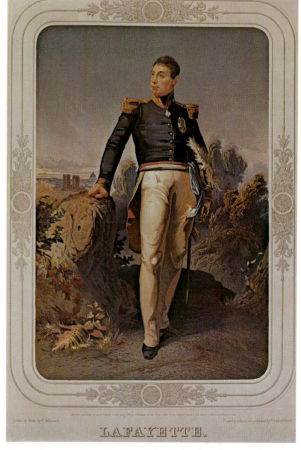

LAFAYETTE.

WASHINGTON'S TRIUMPHAL ENTRY INTO NEW YORK, NOV. 25TH 1783.

Washington's Grand Entry into New York, Nov. 25th 1783.

PLATE 14.
"Wabeno Songs." Artist unknown. After a drawing by Seth Eastman. Printed by Ackerman Lithography, New York, 1851. 9½ × 13 inches. Source: Henry R. Schoolcraft, *Historical and Statistical Information Respecting the History, Condition and Prospects of the Indian Tribes of the United States*, 1851, volume 1, Library, National Museum of Natural History, Smithsonian Institution, Washington, D.C.

PLATE 15.
"Copper Wrist Bands." Artist unknown. After a drawing by Seth Eastman. Printed by Ackerman Lithography, New York, 1851. 13 × 9½ inches. Source: Henry R. Schoolcraft, *Historical and Statistical Information Respecting the History, Condition and Prospects of the Indian Tribes of the United States*, 1851, volume 1, Library, National Museum of Natural History, Smithsonian Institution, Washington, D.C.

PLATE 16.
"Symbolic Petition of Chippewa Chiefs." Artist unknown. After a drawing by Seth Eastman. Printed by P. S. Duval, Philadelphia, 1851. 9½ × 13 inches. Source: Henry R. Schoolcraft, *Historical and Statistical Information Respecting the History, Condition and Prospects of the Indian Tribes of the United States*, 1851, volume 1, Library, National Museum of Natural History, Smithsonian Institution, Washington, D.C.

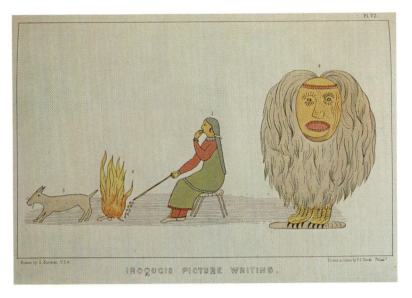

IROQUOIS PICTURE WRITING.

RUINS OF AN ANTIQUE WATCH TOWER
Parr's Point, Grave Creek Flats.

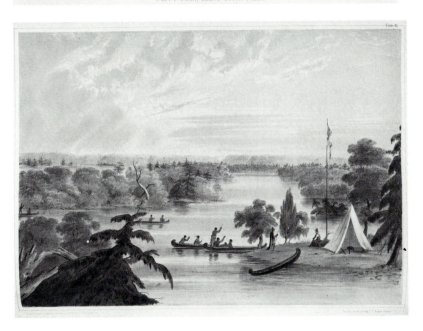

PLATE 17.
"Iroquois Picture Writing." Artist unknown. After a drawing by Seth Eastman. Printed by P. S. Duval, Philadelphia, 1851. "Printed in Colors." 9½ × 13 inches. Source: Henry R. Schoolcraft, *Historical and Statistical Information Respecting the History, Condition and Prospects of the Indian Tribes of the United States*, 1851, volume 1, Library, National Museum of Natural History, Smithsonian Institution, Washington, D.C.

PLATE 18.
"Ruins of an Antique Watch Tower." Artist, Christian Schuessele. After a painting by Seth Eastman. Printed by P. S. Duval, Philadelphia, 1851. "Printed in Colors." 9½ × 13 inches. Source: Henry R. Schoolcraft, *Historical and Statistical Information Respecting the History, Condition and Prospects of the Indian Tribes of the United States*, 1851, volume 1, Library, National Museum of Natural History, Smithsonian Institution, Washington, D.C.

PLATE 19.
"Itasca Lake." Artist unknown. After a drawing by Seth Eastman (who copied a sketch by H. R. Schoolcraft). Printed by J. T. Bowen, Philadelphia, 1851. "[Hand-] colored." 9½ × 13 inches. Source: Henry R. Schoolcraft, *Historical and Statistical Information Respecting the History, Condition and Prospects of the Indian Tribes of the United States*, 1851, volume 1, Library, National Museum of Natural History, Smithsonian Institution, Washington, D.C.

PLATE 20.
"The Rivals." Artist unknown.
Printed by Thomas Sinclair, Phila-
delphia, 1869. 6¾ × 8½ inches.
Location: Prints and Photographs
Division, Library of Congress,
Washington, D.C.

PLATE 21.
"Improved Order of Red Men."
Artist, William Dreser, after his own
design. Printed by Thomas Sinclair,
Philadelphia, n.d. 13⅜ × 10 inches.
Location: Prints Division, The New
York Public Library, Astor, Lenox,
and Tilden Foundations.

PLATE 22.
"H. P. & W. C. Taylor Perfumers."
Artist, William Dreser, after his own
design. Printed by Thomas Sinclair,
Philadelphia, c. 1851. "Printed in
Colors." 17-15/16 × 23⅝ inches.
Location: The Library Company of
Philadelphia.

PLATE 23.
"American Autumn, Starucca Valley, Erie R. Road." Artist, William Dreser. After an oil painting by Jasper F. Cropsey. Printed by Thomas Sinclair, Philadelphia, 1865. "Chromo Lith." 22 × 31⅞ inches. Location: Amon Carter Museum of Western Art, Fort Worth, Tex.

PLATE 24.
"Henry's United Silver Cornet Band at Niagara Falls." Artist unknown. Printed by Wagner and McGuigan, Philadelphia, 1855. "Printed in colors." 11¼ × 12¼ inches. Location: The Library Company of Philadelphia.

PLATE 25.
Scene from C. W. Webber, *The Hunter-Naturalist*. Artist unknown. After a drawing by Alfred Jacob Miller. Printed by L. N. Rosenthal, Philadelphia, c. 1852. "Chromo Lith." 6⅛ × 9⅛ inches. Location: Rare Book Room, Library of Congress, Washington, D.C.

PLATE 26.
"Interior View of Independence Hall, Philadelphia." Artist, Max Rosenthal, after his own watercolor. Printed by L. N. Rosenthal, Philadelphia, 1856. "Printed in Colors." 13 × 18½ inches. Location: Prints Division, The New York Public Library, Astor, Lenox, and Tilden Foundations.

PLATE 27.
"The Volunteers in defence of the Government against usurpation." Artist, James Queen. Printed by P. S. Duval and Son, Philadelphia, 1861. "Printed in Oil Colors." 21¾ × 13½

inches. Location: Harry T. Peters "America on Stone" Lithography Collection, National Museum of History and Technology, Smithsonian Institution, Washington, D.C.

INTERIOR VIEW OF INDEPENDENCE HALL, PHILADELPHIA.

PUBLISHED BY STAYMAN & BROTHER, 210 CHESNUT ST. PHILa

THE VOLUNTEERS

in defence of the Government against usurpation

—— 1861 ——

Published by James Queen at P.S.Duval & Son's Lithographic Office 22, 24 & 5 St. Phil.

PLATE 28.
"View of the Philadelphia Volunteer
Refreshment Saloons." Artist, James
Queen. Printed by Thomas Sinclair,
Philadelphia, 1861. "Printed in Col-
ors." 23¾ × 29½ inches. Location:
Harry T. Peters "America on Stone"
Lithography Collection, National
Museum of History and Technology,
Smithsonian Institution, Wash-
ington, D.C.

PLATE 29.
"Buildings of the Great Central
Fair." Artist, James Queen. Printed
by P. S. Duval and Son, Philadelphia,
1864. "[Printed in oil colors]" (see
Nicholas B. Wainwright, *Philadel-
phia in the Romantic Age of Lithog-
raphy*, p. 106). 18 × 23¼ inches.
Location: Prints Division, The New
York Public Library, Astor, Lenox,
and Tilden Foundations.

PLATE 30.
"The Bright Little Teacher." Artist,
James Queen. After a work by D. R.
Knight. Printer: unknown, 1869.
"Hoover's Philadelphia Chromos."
19¼ × 15 inches. Location: Prints
and Photographs Division, Library
of Congress, Washington, D.C.

PLATE 31.
"[Albany] of the Hudson River Day
Line." Artist unknown. Printed by
Endicott and Co., New York, 1880.
20-3/16 × 28⅜ inches. Location:
Prints and Photographs Division, Li-
brary of Congress, Washington, D.C.

A VIEW OF THE FEDERAL HALL OF THE CITY OF NEW YORK.
as appeared in the year 1797. with the Adjacent buildings thereto

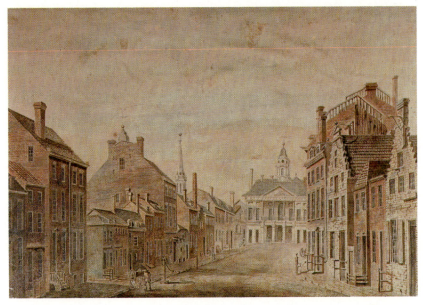

PLATE 34.
"Autumn Fruits." Artist, Dominique C. Fabronius. After a painting by W. M. Brown. Printed by Fabronius, Gurney and Son, New York, 1868. "Chromo-Lithographed." 19½ × 15¾ inches. Location: Prints and Photographs Division, Library of Congress, Washington, D.C.

PLATE 35.
"Volunteer." Artist unknown. After a painting by Charles S. Humphreys. Printed by Henry C. Eno, New York, 1864. "Printed in Colors." 14¾ × 19¾ inches. Location: Harry T. Peters "America on Stone" Lithography Collection, National Museum of History and Technology, Smithsonian Institution, Washington, D.C.

PLATE 36.
"St. Julien." Artist, William Harring. Printed by E. Bosqui and Co., San Francisco, 1880. 22⅛ × 29¾ inches. Location: Harry T. Peters "America on Stone" Lithography Collection, National Museum of History and Technology, Smithsonian Institution, Washington, D.C.

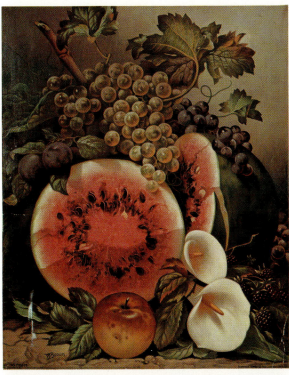

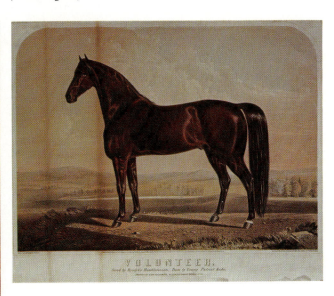

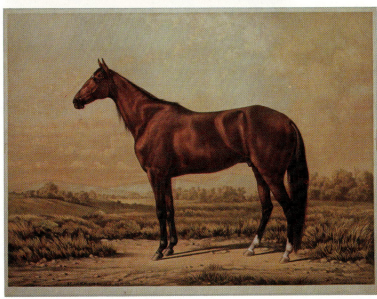

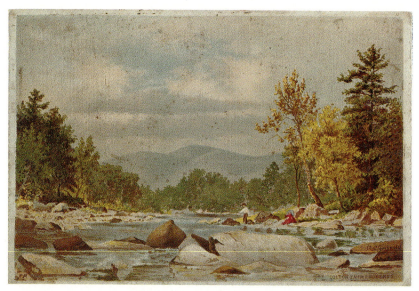

PLATE 37a.
"View on Esopus Creek, N. Y." Artist unknown. After a painting by Casimier Clayton Griswold. Printed by Colton, Zahm and Roberts, New York, 1869. "Chromo-Lithographed." 5⅛ × 7½ inches. Location: Division of Graphic Arts, National Museum of History and Technology, Smithsonian Institution, Washington, D.C.

PLATE 37b.
Label from reverse side of Plate 37a.

PLATE 38.
"The Arrival of Hendrik Hudson in the Bay of New York, September 12, 1609." Artist unknown. After a painting by Frederic A. Chapman. Printed by Colton, Zahm and Roberts, New York, 1868. About 13⅛ × 17-5/16 inches. Location: Prints and Photographs Division, Library of Congress, Washington, D.C.

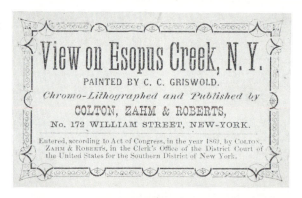

PLATE 39.
"Alexander Campbell." Artist unknown. Printed by Colton, Zahm and Roberts, New York, 1872. "Chromo Portrait." 17-7/16 × 14-7/16 inches. Location: Prints and Photographs Division, Library of Congress, Washington, D.C.

PLATE 40.
"View on the Delaware Water Gap." Artist unknown. After a painting by Max Eglau. Probably printed by Edmund Foerster and Company, New York, 1871. "Chromo-Lithographed." 9⅛ × 12⅞ inches. Location: Prints and Photographs Division, Library of Congress, Washington, D.C.

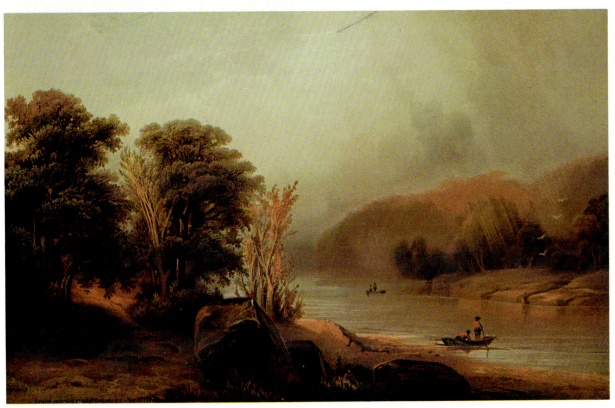

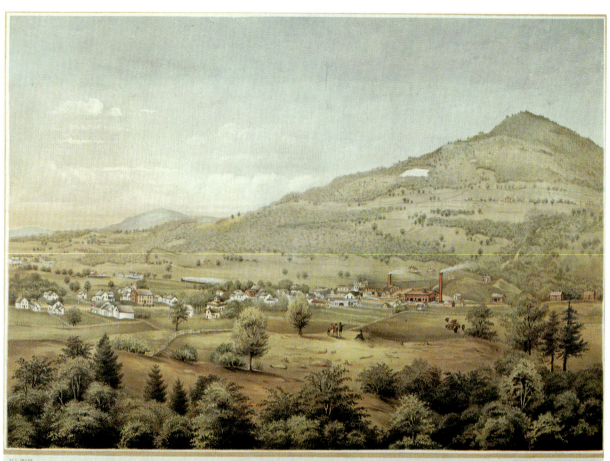

VIEW OF THE EAST DORSET.
Italian Marble Mountain & Mills.

PLATE 41.
"View of the East Dorset Italian
Marble Mountain and Mills." Artist
unknown. After a painting by F.
Childs. Printed by Ferdinand Mayer
and Sons, New York, n.d. 19 × 24
inches. Location: Prints Division,
The New York Public Library, Astor,
Lenox, and Tilden Foundations.

PLATE 42.
"The Bummers." Artist unknown.
After a painting probably by Enoch
Wood Perry. Printed by Bencke and
Scott, New York, 1875. 16¾ × 22¾
inches. Location: Division of Graphic
Arts, National Museum of History
and Technology, Smithsonian In-
stitution, Washington, D.C.

PLATE 43.
"The Storming of Chapultepec Sept. 13th, 1847." Artist unknown. After a painting by Henry Walke. Printed by Sarony and Major, New York, 1848. "Printed in Colours." 28 × 37⅞ inches. Location: Amon Carter Museum of Western Art, Fort Worth, Tex.

PLATE 44.
"View of Norwich, From the West Side of the River." Artist unknown. After a sketch by Fitz Hugh Lane. Printed by Sarony and Major, New York, 1849. "Printed in Colors." 14 × 17¾ inches. Location: Harry T. Peters "America on Stone" Lithography Collection, National Museum of History and Technology, Smithsonian Institution, Washington, D.C.

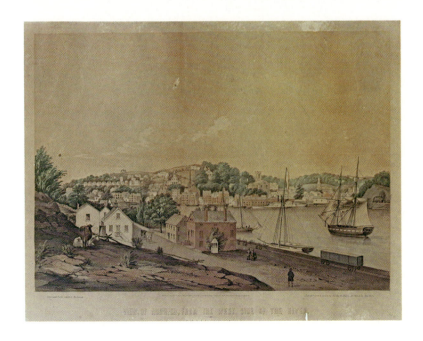

PLATE 45.
"Philadelphia from Camden, 1850."
Artist unknown. Printed by Sarony,
New York, c. 1850. "Printed in
tints." 28⅞ × 41¾ inches. Loca-
tion: The Library Company of
Philadelphia.

PLATE 46.
"Old Sachem Bitters, Wigwam
Tonic." Artist unknown. Printed by
Sarony, Major and Knapp, New
York, c. 1859. 24 × 19¼ inches. Lo-
cation: Prints and Photographs Divi-
sion, Library of Congress, Washing-
ton, D.C.

PLATE 47.
"The Court of Death." Artist
unknown. After an oil painting by
Rembrandt Peale. Printed by Sarony,
Major and Knapp, New York,
c. 1859. About 18½ × 26-15/16
inches. Location: Division of Graphic
Arts, National Museum of History
and Technology, Smithsonian Insti-
tution, Washington, D.C.

PLATE 48.
Half-year calendar for 1866. Artist
unknown. Printed by Major and
Knapp, New York, 1866. 14 × 11
inches. Location: Warshaw Collec-
tion of Business Americana, National
Museum of History and Technology,
Smithsonian Institution, Washing-
ton, D.C.

PLATE 49.
"American Flamingo, Old Male."
Artist unknown. After a painting by
John James Audubon and an engrav-
ing by Robert Havell, Jr. Printed by
Julius Bien, New York, 1860. "Chro-
molith d." 40 × 27 inches. Location:
Division of Graphic Arts, National
Museum of History and Technology,
Smithsonian Institution, Wash-
ington, D.C.

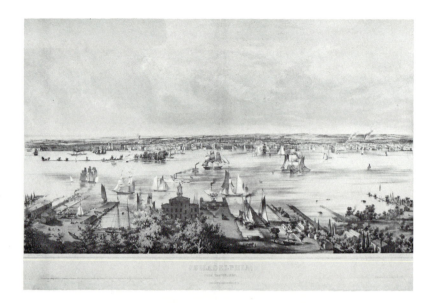

THE COURT OF DEATH.

FROM THE ORIGINAL PAINTING BY REMBRANDT PEALE.

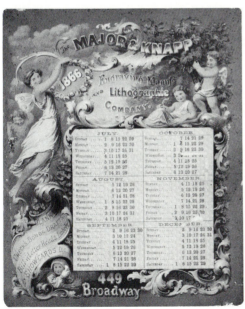

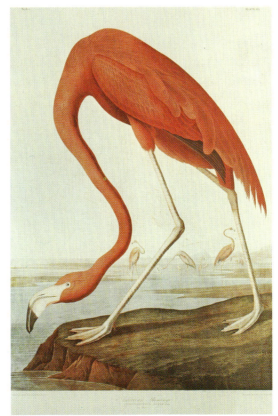

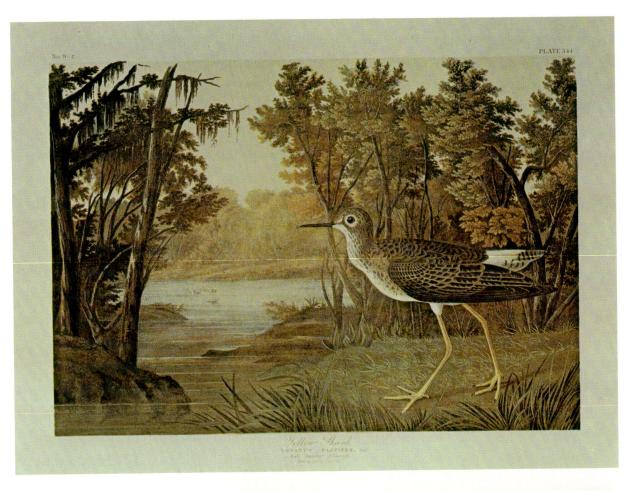

PLATE 50a.
"Yellow Shank." Artist unknown. After a painting by John James Audubon and an engraving, with aquatint, by Robert Havell, Jr. Printed by Julius Bien, New York, 1860. "Chromolith d." 13½ × 20 inches. Location: Division of Graphic Arts, National Museum of History and Technology, Smithsonian Institution, Washington, D.C.

PLATE 50b.
Detail from Plate 50a, showing transferred aquatint impression.

PLATE 51.
"Wild Turkey, Male." Artist unknown. After a painting by John James Audubon and an engraving by W. H. Lizars. Printed by Julius Bien, New York, 1858. "Chromolith'd." 40 × 27 inches. Location: Division of Graphic Arts, National Museum of History and Technology, Smithsonian Institution, Washington, D.C.

PLATE 52.
"Pembroke Iron." Artist unknown. Printed by L. H. Bradford, Boston, n.d. 16⅛ × 20 inches. Location: Division of Graphic Arts, National Museum of History and Technology, Smithsonian Institution, Washington, D.C.

AMERICAN SPECKLED BROOK TROUT.

PLATE 53.
"American Speckled Brook Trout."
Artist, Charles R. Parsons. After an
oil painting by A. F. Tait. Printed by
Currier and Ives, New York, 1864.
"Chrom Lith. . . ." 19⅞ × 25¾
inches. Location: Division of Graphic
Arts, National Museum of History
and Technology, Smithsonian Insti-
tution, Washington, D.C.

THE ALARM.

CHROMO IN OIL COLORS.

FROM THE ORIGINAL PAINTING BY A. F. TAIT.

Published by CURRIER & IVES,

152 NASSAU STREET, N. Y.

Entered according to Act of Congress, A. D. 1808, by CURRIER & IVES, in the Clerk's
Office of the District Court of the United States for the Southern District of N. Y.

PLATE 54a.
"The Alarm." Artist unknown. After
a painting by A. F. Tait. Printed by
Currier and Ives, New York, 1868.
"Chromo in Oil Colors." 10 × 14
inches. Location: Division of Graphic
Arts, National Museum of History
and Technology, Smithsonian Insti-
tution, Washington, D.C.

PLATE 54b.
Label attached to reverse side of Plate
54a.

PLATE 55.
"Night Scene at an American Railway Junction. Lightning Express, Flying Mail and Owl Trains, 'On Time.'" Artists: Charles R. Parsons and Lyman W. Atwater. Printed by Currier and Ives, New York, 1876. 25¼ × 37¼ inches. Location: Amon Carter Museum of Western Art, Fort Worth, Tex.

PLATE 56.
"A Brush with Webster Carts." Artist unknown. After a painting by J. Cameron. Printed by Currier and Ives, New York, 1884. "Printed in Oil Colors." 25¼ × 33¼ inches. Location: Prints and Photographs Division, Library of Congress, Washington, D.C.

A BRUSH WITH WEBSTER CARTS.

PLATE 57.
"The Futurity Race at Sheepshead Bay." Artist unknown. After a painting by Louis Maurer. Printed by Currier and Ives, New York, 1889. "Printed in Oil Colors." 27 × 39 inches. Location: Division of Graphic Arts, National Museum of History and Technology, Smithsonian Institution, Washington, D.C.

PLATE 58.
"Thistle." Artist unknown. Printed by Currier and Ives, New York, 1887. "Printed in Oil Colors." 31-9/16 × 24¾ inches. Location: Amon Carter Museum of Western Art, Fort Worth, Tex.

PLATE 59.
"The Levee–New Orleans." Artist unknown. After a painting by William Aiken Walker. Printed by Currier and Ives, New York, 1884. "Reproduced in Oil Colors." 23-13/16 × 33-1/10 inches. Location: Amon Carter Museum of Western Art, Fort Worth, Tex.

PLATE 60.
"A Cotton Plantation on the Mississippi." Artist unknown. After a painting by William Aiken Walker. Printed by Currier and Ives, New York, 1884. "Printed in Oil Colors." 25¼ × 34⅝ inches. Location: Amon Carter Museum of Western Art, Fort Worth, Tex.

PLATE 61.
"Early Autumn on Esopus Creek, N. Y." Artist, William Harring. After a painting by Alfred Thompson Bricher. Printed by L. Prang and Company, Boston, 1866. 9½ × 18⅝ inches. Location: Print Department, Boston Public Library.

THE LEVEE - NEW ORLEANS.

A COTTON PLANTATION ON THE MISSISSIPPI.

PLATE 62.
"Group of Chickens." Artist, William Harring. After an oil painting by A. F. Tait. Printed by L. Prang and Company, Boston, 1866. 10 × 12 inches. Location: Division of Graphic Arts, National Museum of History and Technology, Smithsonian Institution, Washington, D.C.

PLATE 63.
"Henry Ward Beecher." Artist unknown. Printed by L. Prang and Company, Boston, 1870. "Chromo." 17-7/16 × 14⅛ inches. Location: Prints and Photographs Division, Library of Congress, Washington, D.C.

PLATE 64.
"Hon. H. R. Revels." Artist un-
known. After a painting by Theodore
Kaufmann. Printed by L. Prang and
Company, 1870. "Chromo-Litho-
graphed . . ." 14 × 11¾ inches.
Location: Prints and Photographs
Division, Library of Congress, Wash-
ington, D.C.

PLATE 65.
"Ludwig Von [sic] Beethoven." Art-
ist unknown. After a painting by
Ferdinand Schimon. Printed by
L. Prang and Company, 1870.
14⅜ × 11¼ inches. Location: Prints
and Photographs Division, Library
of Congress, Washington, D.C.

PLATE 66.
Toquerville, S. Utah. Artist, Thomas
Moran. Medium, pencil on paper.
3⅞ × 7-5/16 inches. Location: Na-
tional Collection of Fine Arts, Smith-
sonian Institution, Washington,
D.C. Gift of Dr. William H. Holmes.

PLATE 67.
Lower Yellowstone Range. Water-
color by Thomas Moran, c. 1874.
14 × 19-13/16 inches. Location:
Division of Graphic Arts, National
Museum of History and Technology,
Smithsonian Institution, Washing-
ton, D.C.

PLATE 68.
"Lower Yellowstone Range." Artist
unknown. After a watercolor by
Thomas Moran. Printed by L. Prang
and Company, Boston, 1875. 14 ×
19-13/16 inches. Location: Amon
Carter Museum of Western Art, Fort
Worth, Tex.

PLATE 69.
"Lower Yellowstone Range." Artist
unknown. After a watercolor by
Thomas Moran. Printed by L. Prang
and Company, Boston, 1875.
14 × 9-13/16 inches. Location:
Division of Graphic Arts, National
Museum of History and Technology,
Smithsonian Institution, Wash-
ington, D.C.

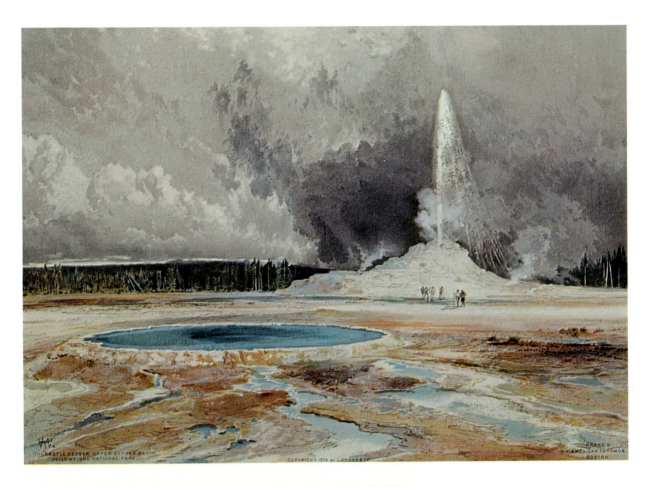

PLATE 70.
"The Castle Geyser, Upper Geyser Basin, Yellowstone National Park." Artist unknown. After a watercolor by Thomas Moran. Printed by L. Prang and Company, Boston, 1874. "Prang's American Chromos." 9-11/16 × 14 inches. Location: Library, National Museum of History and Technology, Smithsonian Institution, Washington, D.C.

PLATE 71.
"Mosquito Trail, Rocky Mountains of the Colorado." Artist unknown. After a watercolor by Thomas Moran. Printed by L. Prang and Company, Boston, 1875. "Prang's American Chromos." 9-13/16 × 14 inches. Location: Library, National Museum of History and Technology, Smithsonian Institution, Washington, D.C.

PLATE 72.
"Cliffs of the Upper Colorado River, Wyoming Territory." Artist unknown. After a watercolor by Thomas Moran. Printed by L. Prang and Company, Boston, 1881. 12-3/10 × 7-1/16 inches. Location: Amon Carter Museum of Western Art, Fort Worth, Tex.

PLATE 73.
"Sunset: California Scenery." Artist unknown. After an oil painting by Albert Bierstadt. Printed by L. Prang and Company, Boston, 1868. "Prang's American Chromos." 12 × 18 inches. Location: Prints and Photographs Division, Library of Congress, Washington, D.C.

PLATE 74.
[Domes of the Yosemite]. Artist unknown. After a painting by Albert Bierstadt. Printed by Breidenbach and Company, Düsseldorf, n.d. "Oeldruck." 22½ × 33¼ inches. Location: Amon Carter Museum of Western Art, Fort Worth, Tex.

PLATE 75.
"Yosemite Valley." Artist, William Harring. After a painting by Thomas Hill. Printed by L. Prang and Company, Boston, c. 1873. 15¾ × 26 inches (trimmed composition). Location: Print Department, Boston Public Library.

PLATE 76.
"Harvesting Near San Jose, California." Artist unknown. After a painting by John Ross Key. Printed by L. Prang and Company, Boston, 1874. "Prang's American Chromos." 7 × 14⅛ inches. Location: Amon Carter Museum of Western Art, Fort Worth, Tex.

PLATE 77.
"Pastoral Scene." Artist, William Harring. After a painting by James M. Hart. Printed by L. Prang and Company, Boston, c. 1870. 13¾ × 24¼ inches. Location: Print Department, Boston Public Library.

PLATE 78.
"North Conway Meadows." Artist unknown. After a painting by Benjamin Champney. Printed by L. Prang and Company, Boston, 1870. 15 × 24 inches. Location: Print Department, Boston Public Library.

PLATE 79.
"Haymaking in the Green Mountains." Artist unknown. After a painting by Benjamin Champney. Printed by L. Prang and Company, Boston, 1871. 15 × 24 inches. Location: Print Department, Boston Public Library.

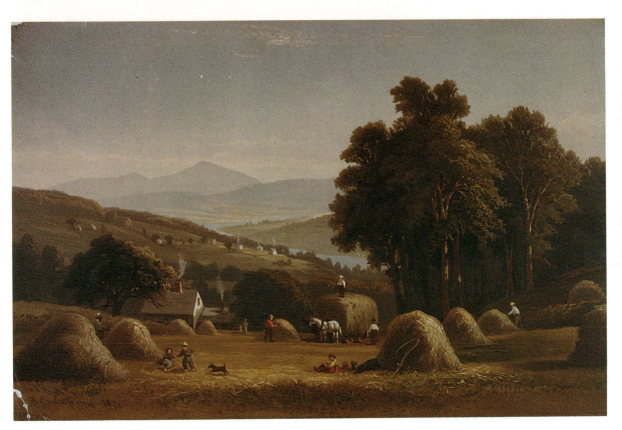

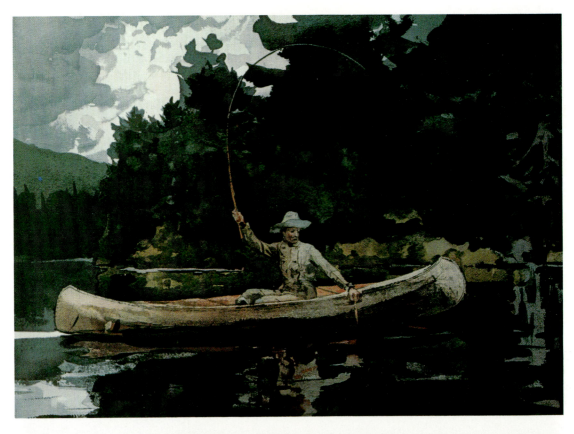

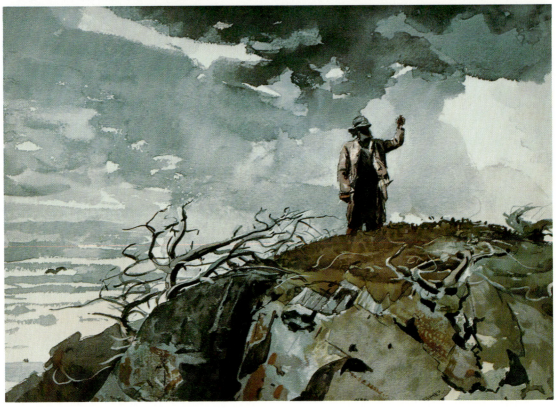

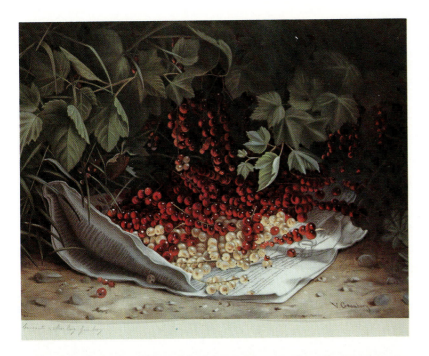

PLATE 80.
"The North Woods." Artist unknown. After a painting by Winslow Homer. Printed by L. Prang and Company, Boston, c. 1894. 16¾ × 23-7/16 inches. Location: The Metropolitan Museum of Art, Harris Brisbane Dick Fund, 1927, New York City.

PLATE 81.
"The Watch," or "Eastern Shore." Artist unknown. After a watercolor by Winslow Homer. Printed by L. Prang and Company, Boston, c. 1896. "Prang's Water Color Facsimile." 15 × 21-5/16 inches. Location: The Metropolitan Museum of Art, Harris Brisbane Dick Fund, 1927, New York City.

PLATE 82.
"Currants." Artist unknown. After a painting by Virginia Granbery. Printed by L. Prang and Company, Boston, 1869. "Chromo." 13½ × 18⅜ inches. Location: Print Department, Boston Public Library.

PLATE 83.
"Kitchen Bouquet." Artist, William Harring, after his own painting. Printed by L. Prang and Company, Boston, 1868. "Chromo." 12⅞ × 17⅝ inches. Location: Print Department, Boston Public Library.

PLATE 84.
"Dessert #6." Artist unknown. After a painting by Carducius Plantagenet Ream. Printed by L. Prang and Company, Boston, c. 1871–75. "Chromo." 25-5/16 × 25-9/16 inches. Location: Print Department, Boston Public Library.

PLATE 85.
"Maud Muller." Artist unknown. After a painting by John G. Brown. Printer unknown. 24¾ × 17¾ inches. Location: Prints and Photographs Division, Library of Congress, Washington, D.C.

PLATE 86.
"The Barefoot Boy." Artist unknown. After a painting by Eastman Johnson. Printed by L. Prang and Company, Boston, 1867. 12⅞ × 9-9/16 inches. Location: Print Department, Boston Public Library.

PLATES 319

PLATE 87.
"The Boyhood of Lincoln." Artist
unknown. After a painting by East-
man Johnson. Printed by L. Prang
and Company, Boston, 1868. 21 ×
16¾ inches. Location: Print Depart-
ment, Boston Public Library.

PLATE 88.
"The Garland, or Token of Friend-
ship 1848." Artist unknown. Printed
by Sharp, Peirce and Company,
1848. 9 × 6 inches. Location: War-
shaw Collection of Business Ameri-
cana, National Museum of History
and Technology, Smithsonian Insti-
tution, Washington, D.C.

PLATE 89.
"Indian Courtship." Artist, Christian
Schuessele. After a drawing by Seth
Eastman. Printed by P. S. Duval,
Philadelphia, 1852. "Chromolith."
9 × 6 inches. Source: *The Iris*, 1852,
Rare Book Room, Library of Con-
gress, Washington, D.C.

MOUNT HOOD, OREGON.

PLATE 90.
"Mount Hood, Oregon." Artist unknown. Printed by the West Shore Litho. and Engraving Company, Portland, Ore., 1886. 14 × 20¼ inches. Source: Supplement to *The West Shore*, Prints and Photographs Division, Library of Congress, Washington, D.C.

PLATE 91.
"Edmund Dexter's Residence." Artist unknown. Printed by Ehrgott, Forbriger and Company, Cincinnati, c. 1861–69. Caption: "Lith. & Print, in Colors. . . ." 15¾ × 20¼ inches. Location: Cincinnati Art Museum, Gift of Mrs. William M. Chatfield.

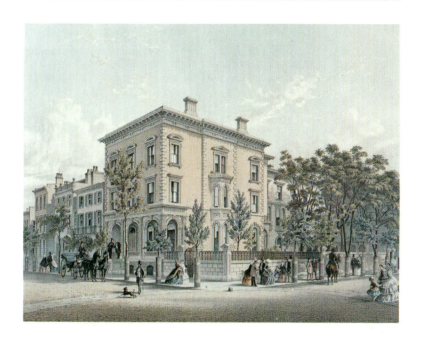

PLATE 92.
"The Gladiators." Artist unknown.
After a painting by Jean-Léon
Gérôme. Printed by Strobridge and
Company, Cincinnati, c. 1874–79.
"Strobridge & Co. Chromo. . . ."
13 × 25 inches. Location: Cincinnati
Art Museum, Gift of Theodore A.
Langstroth.

PLATE 93.
"Distinguished Masons of the Revo-
lution." Artist unknown. Printed by
Strobridge and Company, Cincin-
nati, 1876. "Executed in Oils. . . ."
23-15/16 × 18⅞ inches. Location:
Prints and Photographs Division,
Library of Congress, Washington,
D.C.

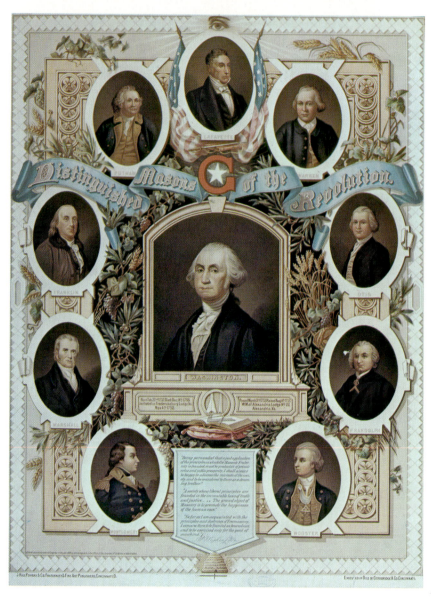

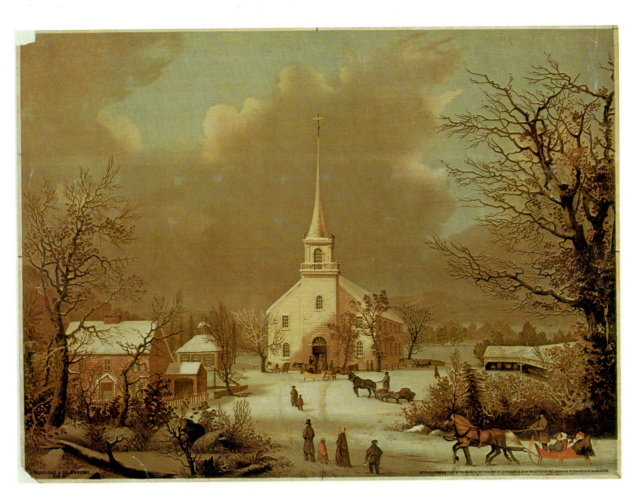

PLATE 94a.
"Winter Sunday in Olden Times". Artist unknown. After an oil painting by George Durrie. Printed by Strobridge and Company, Cincinnati, 1874. "Strobridge & Co. Chromo. . . ." 16-5/16 × 22⅜ inches. Location: Prints and Photographs Division, Library of Congress, Washington, D.C.

PLATE 94b.
Stamped label on reverse of "Winter Sunday in Olden Times." Gleason (dealer), Boston, 1875.

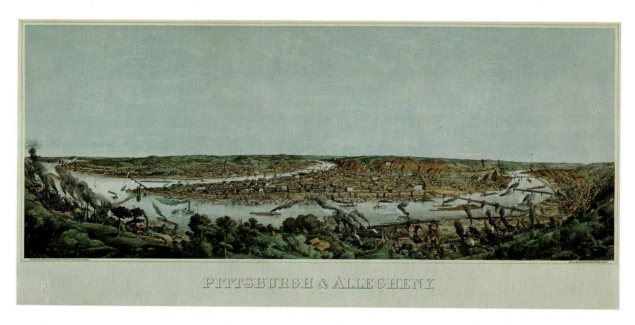

PITTSBURGH & ALLEGHENY

PLATE 95.
"Pittsburgh & Allegheny." Artist,
Otto Krebs. Printed by Otto Krebs,
Pittsburgh, 1871. 23 × 48¾ inches.
Location: Amon Carter Museum of
Western Art, Fort Worth, Tex.

PLATE 96.
"Pork Packing in Cincinnati." Artist,
H. F. Farny. After "the Cartoons
exhibited by the Cincinnati Pork
Packers' Association, at the Inter-
national Exposition at Vienna."
Printed by Ehrgott and Krebs, Cin-
cinnati, 1873. "Chromo-litho-
graph. . . ." 26¼ × 37½ inches.
Location: Prints and Photographs
Division, Library of Congress, Wash-
ington, D.C.

PLATE 97.
"The Old Violin." Artist unknown.
After an oil painting by William
Harnett. Printed by F. Tuchfarber
and Company, Cincinnati, 1887.
34-9/16 × 22-15/16 inches. Loca-
tion: Amon Carter Museum of West-
ern Art, Fort Worth, Tex. Note:
Copy in the Division of Graphic
Arts, National Museum of History
and Technology, Smithsonian In-
stitution, reads "Donaldson Art Sign
Co. Publishers, Cov., Ky."

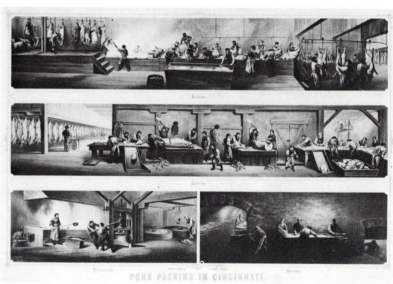

PORK PACKING IN CINCINNATI.

PLATE 98.
"A Royal Flush." Artist unknown.
Printed by F. Tuchfarber Company,
Cincinnati, c. 1899. 16 × 21 inches.
Location: Cincinnati Art Museum.

PLATE 99.
"Storming the Ice Palace." Artist un-
known. Printed by Pioneer Press
Litho., St. Paul, Minn., 1886. 20⅞ ×
28-3/16 inches. Location: The Li-
brary Company of Philadelphia.

PLATE 100.
"M. S. & N. I. & C. & R.I. & P.C.R.R.
Dep. [Michigan Southern & North-
ern Indiana & Chicago & Rock
Island & Pacific Railroad Com-
pany]." Artist, probably Louis Kurz.
Printed by Chicago Lithographing
Company, Chicago, 1866. 11¾ ×
14 inches. Source: *Chicago Illus-
trated, Part II*, Rare Book Room,
Library of Congress, Washington,
D.C.

PLATE 101.
"Compliments of the Season 1884."
Artist unknown. Shober and Carque-
ville Litho. Company. 3 × 7 inches.
Location: Warshaw Collection of
Business Americana, National Mu-
seum of History and Technology,
Smithsonian Institution, Washing-
ton, D.C.

PLATE 102.
"Battle of Lookout Mountain." Art-
ist, probably Louis Kurz. Printed by
Kurz and Allison, Chicago, 1889.
22⅛ × 28 inches. Location: Harry
T. Peters "America on Stone" Lithog-
raphy Collection, National Museum
of History and Technology, Smith-
sonian Institution, Washington, D.C.

BATTLE OF LOOKOUT MOUNTAIN.

PLATE 103.
"Female Bathers No. 3." Artist,
probably Louis Kurz. Printed by
Kurz and Allison, Chicago, 1886.
18 × 23¼ inches. Location: Prints
and Photographs Division, Library of
Congress, Washington, D.C.

PLATE 104.
"Trial of Red Jacket." Artist un-
known. After a painting by John Mix
Stanley. Printer, Storch and Kramer,
Berlin, 1871. 23½ × 36 inches.
Location: Amon Carter Museum of
Western Art, Fort Worth, Tex.

PLATE 105.
"On the Warpath." Artist, R. T.
Bishop. After an oil painting by John
Mix Stanley. Printed by Calvert
Lithographing Company, Detroit,
1872. "Chromo Artist." 22¼ ×
30-13/16 inches. Location: Prints and
Photographs Division, Library of
Congress, Washington, D.C.

PLATE 106.
"The Flag That Has Waved One
Hundred Years." Artist unknown.
Printed by E. P. and L. Restein, Phil-
adelphia, 1876. "Oilchromo." 22 ×
17¼ inches. Location: Harry T.
Peters "America on Stone" Lithog-
raphy Collection, National Museum
of History and Technology, Smith-
sonian Institution, Washington, D.C.

PLATE 107.
"Yankee Doodle 1776." Artist un-
known. After a painting by Archibald
M. Willard. Printed by Clay, Cosack
and Company, Buffalo, 1875–76.
24 × 18 inches. Location: Prints and
Photographs Division, Library of
Congress, Washington, D.C.

THE FLAG THAT HAS WAVED ONE HUNDRED YEARS.

PLATES 331

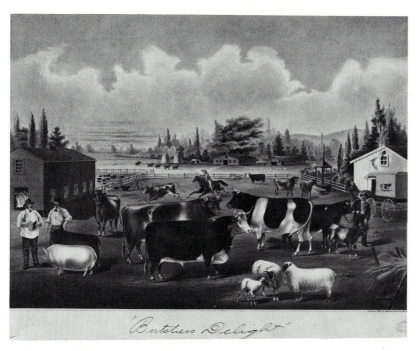

"Butchers Delight"

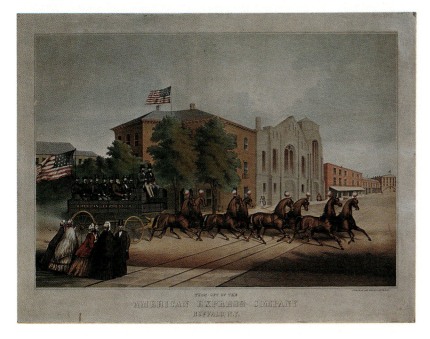

TURN-OUT OF THE
AMERICAN EXPRESS COMPANY
BUFFALO, N.Y.

PLATE 108.
"Au Concert." Artist, Henri de Toulouse-Lautrec, after his own design. Printed by Courier Lithograph Company, Buffalo, 1896. Location: Charles F. Glore Collection, The Art Institute of Chicago.

PLATE 109.
"Butchers Delight." Artist unknown. Printed by Compton's Lithographic Company, St. Louis, 1886. 21¾ × 28 inches. Location: Prints and Photographs Division, Library of Congress, Washington, D.C.

PLATE 110.
"Turn-out of the American Express Company, Buffalo, N. Y." Artist unknown. Printed by Sage Sons and Company, Buffalo, n.d. 21¾ × 29 inches. Location: Harry T. Peters "America on Stone" Lithography Collection, National Museum of History and Technology, Smithsonian Institution, Washington, D.C.

PLATE 111.
"The Flight of the Fast Mail on the Lake Shore and Michigan Southern Ry." Artist, H. M. Clay. Printed by Clay, Cosack and Company, Buffalo, 1875. 30 × 23 inches. Location: Harry T. Peters "America on Stone" Lithography Collection, National Museum of History and Technology, Smithsonian Institution, Washington, D.C.

PLATE 112.
"Delft Smyrna Carpet, P. Centemeri, New York." Artist unknown. Printed by Cosack and Company, Buffalo, 1877. "Chromo-Lith." 19½ × 14 inches. Source: *Treasures of Art, Industry and Manufacture Represented at the International Exhibition, 1876*, Division of Graphic Arts, National Museum of History and Technology, Smithsonian Institution, Washington, D.C.

PLATE 113.
"Embroidered Screen, Bronze & Porcelain Manufactures, Japan." Artist unknown. Printed by Clay, Cosack and Company, Buffalo, 1877. "Chromo-Lith." 19½ × 14 inches. Source: *Treasures of Art, Industry and Manufacture Represented at the International Exhibition, 1876*, Division of Graphic Arts, National Museum of History and Technology, Smithsonian Institution, Washington, D.C.

PLATE 114.
"Coates Hay & Grain Rake." Artist unknown. Printed by Gies and Company, Buffalo, n.d. 25¼ × 20 inches (trimmed composition). Location: Langstroth Collection, Public Library of Cincinnati and Hamilton County, Ohio.

PLATE 115.
"Outside Connected Passenger Engine, Amoskeag Manufacturing Co." Artist unknown. Printed by J. H. Bufford, Boston, c. 1856. 27 × 36 inches. Location: Division of Transportation, National Museum of History and Technology, Smithsonian Institution, Washington, D.C.

PLATE 116.
"A Prince of the Blood." Artist unknown. Printed by Currier and Ives, New York, 1893. 32 × 25¼ inches. Location: Division of Graphic Arts, National Museum of History and Technology, Smithsonian Institution, Washington, D.C.

PLATE 117.
"An American Railway Scene, at Hornellsville, Erie Railway." Artists, Charles R. Parsons and Lyman W. Atwater. Printed by Currier and Ives, New York, 1874. 23⅞ × 35¼ inches. Location: Amon Carter Museum of Western Art, Fort Worth, Tex.

PLATE 118.
"Republic Fire Insurance Co." Artist unknown. Printed by Robertson, Seibert and Shearman, New York, 1860. "Lith in Colors." 19 × 24 inches. Location: Prints and Photographs Division, Library of Congress, Washington, D.C.

PLATE 119.
"[Fire engine] Built by the Amoskeag Manufacturing Co." Artist unknown. Printed by Charles H. Crosby, Boston, c. 1860. 20 × 24⅛ inches. Location: Division of Transportation, National Museum of History and Technology, Smithsonian Institution, Washington, D.C.

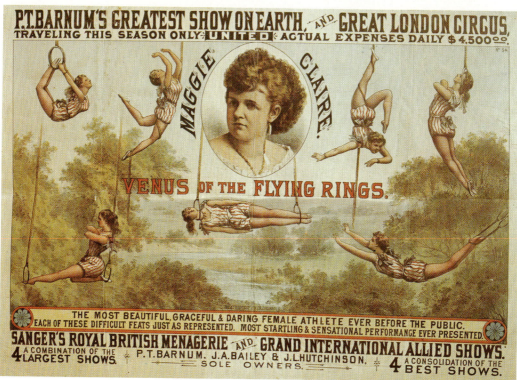

PLATE 120.
"Tony Denier's Humpty Dumpty."
Artist unknown. Printed by Stro-
bridge Lithographing Company,
Cincinnati, n.d. 30 × 38¾ inches.
Location: Ringling Museum of the
Circus, Sarasota, Fla.

PLATE 121.
"Venus of the Flying Rings, P. T.
Barnum's Greatest Show on Earth
and Great London Circus." Artist
unknown. Printed by Strobridge
Lithographing Company, Cincinnati,
n.d. 20 × 29¼ inches. Location:
Ringling Museum of the Circus,
Sarasota, Fla.

PLATE 122.
"The California Powder Works."
Artist unknown. Printed by Bosqui,
San Francisco, n.d. 21½ × 26¾
inches. Location: Amon Carter Mu-
seum of Western Art, Fort Worth,
Tex.

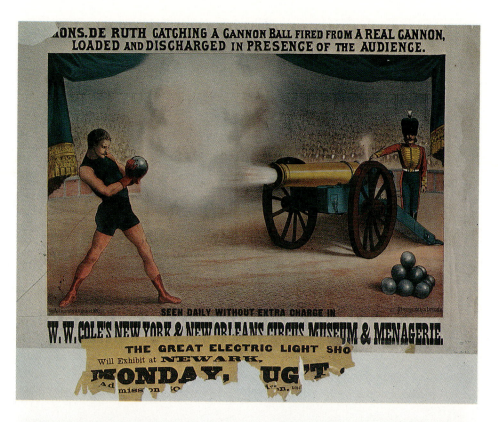

CUSTER'S LAST FIGHT.
The Original Painting has been Presented to the Seventh Regiment U.S. Cavalry
BY ANHEUSER BUSCH BREWING ASSOCIATION,
ST. LOUIS. MO. U.S.A.

PLATE 123.
Advertisement for W. W. Cole's New York & New Orleans Circus Museum & Menagerie. Artist unknown. Printed by Strobridge and Company, Cincinnati, 1879. 20 × 30⅛ inches. Location: Harry T. Peters "America on Stone" Lithography Collection, National Museum of History and Technology, Smithsonian Institution, Washington, D.C.

PLATE 124.
"Preliminary Trial of a Horse Thief in Kansas City." Artist, John Mulvany, after his own painting. Printed by Clay, Cosack and Company, Buffalo, 1877. 23½ × 30⅛ inches. Location: Harry T. Peters "America on Stone" Lithography Collection, National Museum of History and Technology, Smithsonian Institution, Washington, D.C.

PLATE 125.
"Custer's Last Fight." Artist, Otto Becker. After a painting by Cassilly Adams. Printed by Milwaukee Lithographic and Engraving Company, 1896. 32 × 41-13/16 inches. Location: Amon Carter Museum of Western Art, Fort Worth, Tex.

ADMINISTRATION, MINING AND ELECTRICAL BUILDINGS FROM WOODED ISLAND.

PLATE 127.
"Administration, Mining and Electrical Buildings from Wooded Island." Artist unknown. After a painting by John Ross Key. Printed probably by Werner Company, Akron, Ohio, 1894. 17 × 27½ inches. Location: Chicago Historical Society.

PLATE 128.
"[Chicago World's Columbian Ex-
position] Women's Building." Artist
unknown. After a watercolor by
Charles Graham. Printer unknown,
1893. 17 × 27½ inches. Location:
Chicago Historical Society.

INDEX

Ackerman, James, 30, 31, 51, 284
Ackermann, Mrs. Arthur, 99
Adams, Cassilly, 196, 197–198, 341
"Administration, Mining and Electrical Buildings from Wooded Island" (Werner-Key), 203, 343
advertising: "artistic," 198; of chromolithography, 5, 21, 24, 32, 34, 40, 42, 45, 61–62, 88, 131, 179, 205, 213, 237nn.14, 24, 256n.56, (Prang) 11, 119–120, 125, (Strobridge) 139, 140; chromolithography used in, 5, 21, 33, 35, 37, 51, 99, 179, 180, 189–190, 194, 209 (see also posters, below); and "commercial art," 189, 191–200, 205, 215; lithographers' influence on, 5; of lithographic suppliers, 79; posters, 13, 130–131, 143, 147, 156, 189, 192–200 passim, 219, 339, 340, 342; "practical" lithography and, 16; railroad, 147, 192–193
Agnew's Repository of the Arts, 102
Ain't She Pretty? (Bencke-Spencer), 122
air conditioning developed (1902), 79
"Alarm, The" (Currier and Ives-Tait), 60, 120, 303
"[Albany] of the Hudson River Day Line" (Endicott), 43, 216, 291
album cards, 98–99, 100
Alcott, Louisa May, 103
Aldine, The (journal), 96
Allen, John Fiske, 18, 215, 279, 280
Allison, Alexander, 179–180
Almini, Peter M., 178, 179
aluminum plates, 240n.33.
American Antiquarian Society, 74
American Art Galleries (New York), 94
"American Autumn, Starucca Valley" (Sinclair-Cropsey), 33, 36, 287

American Chromo Company (New York), 156
American Chromos, see Prang, L., and Company
American Dictionary of Printing and Bookmaking, 14, 82, 149
American Encyclopaedia of Printing (Ringwalt), 27, 82
"American Express Train" (Currier and Ives), 193
"American Farm Life" (Currier and Ives-Willis), 60
"American Flamingo, Old Male" (Bien-Audubon), 299. See also Audubon, John James
"American Fruit" (Hoover-Queen), 39
American Lithographic Company (New York), 13, 51, 156–157
American Oleograph Company (Milwaukee), 10, 179
"American Railway Scene, An" (Currier and Ives), 193, 336
American Scenery series (Gambert-Cropsey), 33
"American Speckled Brook Trout" (Currier and Ives-Tait), 59, 120, 216–217, 302
American Vegetable Practice, The (Mattson), 17
"American Water Lily" (Sharp), 18, 215, 279, 280
American Women's Home, The (Beecher and Stowe), 116–118, 123, 125
American Yachts (Cozzens), 22
Amon Carter Museum of Western Art (Fort Worth), 110
Amoskeag Manufacturing Company, 192, 194, 335, 337
Anheuser-Busch Inc., 196, 197–198
Annenberg, Walter H., 213
apprenticeship system, 26, 37, 42, 64, 108, 130, 149, 150; age of ap-

prentices, 165–166; decline of, 59, 170–171; under Strobridge, 130, 167, 169–170
aquatints, 53–54; Audubon, 54–57, 132, 216, 299–301
Armor, William G., (Pittsburgh), 146
"Armoured Steel Cruiser—N.Y.—U.S. Navy" (Currier and Ives), 61
Armstrong, Charles, 21, 247n.44.
Armstrong and Company (Boston), 21–22, 143, 144, 281
art, see advertising; "democratic" art; fine art; industrial art
Art Age (magazine), 131
Art Amateur (magazine), 128
Art Institute of Chicago, 187
Art Interchange (magazine), 71, 114, 128, 199–200
Art in the House (Falke), 101
artist fees, 108. See also copyright
"Artist's Brook" (Prang-Champney), 113
Art Journal, 48
art unions, 5, 122
Arundel Society (England), 123
Atlantic Monthly, The, 75, 96, 206
Atwater, Lyman W., 304, 336
"Au Concert" (Courier-Lautrec), 187, 333
Audubon, John James, 12; The Birds of America, 54–58, 132, 194, 216, 299–301
Audubon, John Woodhouse, 55, 56
Audubon, Lucy (Mrs. John James), 56
Ault and Wiborg (Cincinnati), 187
"Autumn Fruits" (Fabronius-Brown), 44, 293

Babcock Manufacturing Company, 84
Babies' Lullaby Book (Pratt), 100
"Baby, The" (Prang-Bouguereau), 104
Bacon, Henry, 124–125

Baltimore: chromolithography in, 66
"Baltimore From Federal Hill, View
 of" (Sarony and Major-Lane), 50
"Baltimore, Md. from Federal Hill,
 View of" (Whitefield), 19
Barefoot Boy (Johnson), 48, 75, 77,
 95, 96, 118, 121, 124, 125, 217, 318
Barnum and Bailey, 130
Barrie, George (Chicago), 202
"Battle of Lookout Mountain" (Kurz
 and Allison), 327
Beacon Hill, *see* Boston, Mas-
 sachusetts
Becker, Otto, 198, 341
Beecher, Catherine Esther, 116–118,
 123, 125, 180, 198, 205
Beecher, Henry Ward, 1, 103, 307
Beethoven, Ludwig van, 104, 309
Bencke, Herman, 45, 122
Bencke and Scott (New York),
 45–46, 216, 296
Bennett, Whitman, 101
Berger Brothers (New York), 10
Bernhardt, Sarah: Mucha chromo of,
 196, 198–199, 219, 342
Bethune, Rev. George W., 125
Bezold, Wilhelm von, 101
Biele, C., 121
Bien, Julius, 14, 42, 51, 53, 64, 139,
 171, 214; Audubon chromos by,
 54–58, 132, 194, 216, 299–301;
 as "forty-eighter," 52, 59, 97;
 heads National Lithographers' As-
 sociation, 41, 59, 92; and photog-
 raphy, photolithography, 18, 54,
 58
Bien and Sterner, 192
Bierstadt, Albert, 47, 48, 96, 111–
 113, 118, 217, 312
Bigelow and Company (New York),
 16
Bigot, Alphonse, 27, 172
Bingham, Dodd and Company
 (Hartford), 16
Birds of America, The (Audubon),
 54–58, 132, 194, 216, 299–301
Birkner, J. (New York), 66
"Birthplace of Whittier" (Prang-Hill),
 95, 249n.29
Bishop, Robert T., 182, 329
Bispham, C., 135, 140
"Blackberries in a Vase" (Prang-
 Spencer), 122
Blackfoot Cardplayers (Stanley), 181
Blashfield, Edwin H., 202
"Blue Beard" (Sharp), 18
"Blue Point Oysters" (Prang-Homer),
 94

Blythe, David G., 145
book illustrations, 18, 22, 35, 36, 53,
 178, 188–189, 215, 218, 232n.38,
 279, 288; *Birds of America* (Au-
 dubon), 54–58, 132, 216, 299–
 301; "gift-books," 24, 126–127;
 Picturesque Architecture . . .
 (Boys), 6, 9–10, 279; Prang and,
 95, 100–101, 107–111, 115, 217;
 Schoolcraft (Indian) project,
 28–31, 215, 284–285
Book of the Artists (Tuckerman), 112
Bosqui, Edward, 189
Bosqui, E., and Company (San Fran-
 cisco), 44, 194, 213, 216, 218, 293,
 339
Bossett, G., 121
Boston, Massachusetts, 15, 44, 183,
 189; Beacon Hill chromos, 20, 215,
 281; and "Boston style," 21–22,
 28, 40; dealers, 139, 140; earliest
 work in, 6, 8, 12, 17–22; litho-
 graphic suppliers, 66, 72, 239n.1;
 photograph of, from balloon
 (1860s), 229n.48; steam presses in,
 82, 89
Boston Academy of Arts, 197
Boston *Commercial Bulletin*, 89
Boston Daily Advertiser, 206
Boston Evening Traveller, 20
Boston Public Library, 74
Bouguereau, Adolphe William, 104
Bourquin, Frederick, 240n.25
Bouvé, Ephraim W., 17
Bowen, J. T., 30, 237n.16, 285
"Boyhood of Lincoln" (Prang-
 Johnson), 95, 96, 125, 320
Boys, Thomas Shotter, 6, 9, 279
Bradford, Lodowick H., 58, 301
Braun's Iconoclast (magazine), 209
"Breezy Day, A" (Queen), 38–39
Breidenbach and Company (Düssel-
 dorf), 111, 313
Brett, Alphonse (Philadelphia), 192
Bricher, Alfred Thompson, 44, 94,
 101–102, 112, 113, 306
Bridwell, Harry, 199
"Bright Little Teacher, The"
 (Hoover-Queen), 39, 291
Britton and Rey (San Francisco), 189
[Broad Street, Wall Street, and the
 City Hall, A View of] (Holland),
 292
"Brooklyn, L.I. from U.S. Hotel,
 View of" (Whitefield), 19
Brown, George L., 250n.41
Brown, John G., 94, 95, 122, 124,
 318

Brown, W. M., 44, 293
Bruns, William, 10
Brush and Pencil (magazine), 199,
 211
"Brush with Webster Carts, A" (Cur-
 rier and Ives), 61, 217, 304
Bryan, William Jennings, 199
Bryce, James, 2
Bucks County (Pa.) *Intelligencer*, 121
Buffalo, New York, 28, 44, 72, 89,
 197, 218; earliest chromolithog-
 raphy in, 19, 187–189; and "Yan-
 kee Doodle," 183–186. *See also*
 Sage, J., and Sons
"Buffalo, N.Y. from the Old Light-
 house, View of" (Michelin-
 Whitefield), 19, 215, 280
Bufford, John H., 67, 123–124, 192,
 213, 215, 281, 335; Homer em-
 ployed by, 12, 114–115; partner-
 ships and business changes of,
 19–21
"Buildings of the Great Central Fair"
 (Duval-Queen), 38, 290
Bulk, G. H., and Company (New
 York), 156
*Bulletin of the American Art-Union,
 The* (1850), 26
"Bummers, The" (Bencke and Scott-
 Perry), 45–46, 216, 296
Burke, Russell, 119
Bushnell, S. W., 115
business cards, 34, 81, 95, 98–99,
 100
"Butcher's Delight" (Compton), 188,
 333
Butler, B. F., 189
Butler, H. R., 203
Byrnes, W. H., 190
"By the Sea Shore" (Currier and
 Ives-Rossiter), 60

calendar art, 21, 199; half-year calen-
 dar for 1866 (Major and Knapp),
 299
"California Powder Works, The"
 (Bosqui), 194, 218, 339
Calvert, Thomas, 182, 183
Calvert Lithographing and Engraving
 Company (Detroit), 182, 218, 329
Cameron, J., 217, 304
Campaign Sketches (Prang-Homer),
 114
Campbell, Alexander, 45, 295
Campbell Printing Press Company,
 84
"Canada Southern Railroad" (Kurz),
 179

Carqueville, Edward, 41–42, 178, 179
Carrier, Willis H., 79
Carroll, R. W., and Company (Cincinnati), 45
Case and Green billhead, 79
Cass, George Nelson, 121
Cassatt, Mary, 13
"Castle Geyser, The" (Prang-Moran), 111, 311
Catlin, George, 181
Celebrated Dogs of America, The: Imported and Native (Pope), 22
Celebrated Horses (collected paintings), 22
"Celebrated Trotting Horse Trustee, The" (Currier and Ives), 60
Centennial Exposition (Philadelphia), 3, 39, 48, 65; Chicago Fair compared to, 202, 205; patriotic chromos for, 183–184, 185, 186; *Treasures of Art* of, 188–189; Weir's *Report* of, 112
Centennial Fair, Tennessee, 193
"Centennial Mirror" (Kurz), 179
certificates, 32, 37, 132, 189, 195, 286. *See also* diplomas
Chain, Mrs. J. A., 249n.24
Champenois, F. (Paris), 199
Champney, Benjamin, 19, 47, 94, 111, 113, 217, 315
Chapman, Conrad Wise, 252n.29
Chapman, Frederic A., 45, 294
Charlot, Jean, 204
Cheret, Jules, 199
"Cherries in a Basket" (Prang-Granbery), 119
Chicago, Illinois: Art Institute, 187; chromolithography in, 21, 72, 177–179, 183, 189; dealers, 140, 142; fire (1871), 33, 178–179; steam presses in, 41, 82
Chicago Art Publishing Company, 178
"Chicago Building of the Home Insurance Company of New York, The" (Prang), 192
Chicago Fair (Columbian Exposition, 1893), 3, 201–205
Chicago Historical Society, 178
Chicago Illustrated (Chicago Lithographing Company), 178, 218
Chicago Lithographic and Engraving Company, 197
Chicago Lithographing Company, 178, 179, 218, 327
"[Chicago World's Columbian Exposition] Women's Building", 344

"Chickering Waltz" (Bufford), 21
Child, E. B., 203
Childs, Cephas G. (Philadelphia), 23
Childs, F., 45, 216, 296
Chittenden, H. M., 109
Christmas cards, *see* greeting cards
chromistes, 73–74. *See also* color techniques
"chromo" as term, 11, 42, 63, 103, 209–210; "half chromos," 103, 112; "oil chromo," 184
chromo civilization, 211; "chromo realism" and, 47 (*see also* style[s]); concept of, as democratic symbol, 3; European influence on, 199, 201 (*see also* England; France; Germany); as term of contempt, 1, 47
"chromolithographie," "chromalithography," invention of term, 6
chromolithographs and chromolithography: as a business, 4–6, 8, 21, 59, 98, 127–129, 149–165, 173–190, 194–196, 208, 213 (*see also* advertising; prices, chromo); commercialism in, 13, 21, 176–177, 189, 208, 213 (*see also* industrial art); cost of producing, 13, 18, 20, 26, 29–31, 33, 88, 100, 108, 111, 143, 185; criticisms of, 1–2, 5, 13, 47, 105–106, 205–210, 211, 213; custom-made, 61, 139; defined, 9–12; distinguished from color lithography, 11–12 (*see also* lithographs and lithography); distribution of, 5–6, 20, 26, 40 (*see also* premiums); European, *see* England; France; Germany; as fine art, *see* fine art; financing of, 121, 139 (*see also* cost of producing, *above*); first U.S., 17, 53, 215, 279; government contracts for, *see* United States; historical role of, 5; immigrant influence on, *see* immigrants; invention of, 6; "largest ever executed" (1861), 27; as "new" art, 10; origin of term, 6–7; technical complexity of, 9, 13, 16, 26, 53, 176, 203–204 (*see also* specialization); technical limitations of, 105, 239n.60; technique described, 9, 20, 56–57 (*see also* color techniques). *See also* Civil War chromos; dealers; quality of chromolithography; style(s)
"chromo realism," 47–48. *See also* style(s)
Church, Frederic Edwin, 103, 246n.5
Church, Frederick Stuart, 95, 209

Churchill, W. S., 178
Cincinnati, Ohio: chromolithography in, 19, 40, 44, 45, 72, 82, 130–140, 143–148, 151, 179, 183, 187, 189, 193 (*see also* Strobridge and Company); Industrial Exposition (1886), 147; Symphony Orchestra, 147
Cincinnati *Commercial Gazette*, 147
Cincinnati Historical Society, 143, 154
circus posters, *see* advertising
Cist, Charles, 132, 134
City and Suburban Architecture (Sloan), 36
Civil War chromos, 33, 37–39, 43, 98, 103, 104, 145, 179, 215–216, 288, 290. *See also* journalism
Clay, Hugh M., 120, 188, 334
Clay, Cosack and Company (Buffalo), 120, 184, 185, 189, 197, 218, 330, 334, 340
Cleveland, Ohio, 10, 140, 184–187
Cleveland *Leader*, 184
Cleveland *Plain Dealer*, 185
"Cliff House, San Francisco" (Prang-Key), 112
"Cliffs of the Upper Colorado River" (Prang-Moran), 111, 312
"Coates Hay & Grain Rake" (Gies), 189, 335
Cole, Thomas, 12
Cole, W. W., Circus Museum and Menagerie of, 194, 340
Collins, John (Philadelphia), 32
collotype, 210. *See also* photomechanical printing
Colman, Samuel, 60, 99
color techniques: in Audubon prints, 57–58, 132, 216; and "chromistes," 73–74; color formulas (1860–1890), 221–223; and color variation (piece to piece), 46, 50–51, 81, 110; and effect of time on colors, 110; hand-coloring, 30, 32, 50, 54, 122, 131, (combined with printed color) 42, 57, 58, (Currier and Ives and) 59–60, 63 (*see also* aquatints; lithographs and lithography); limitations of (mechanical), 105; metallic powders, use of, 34, 64, 72–73, 74, 199; old style (isolated color) vs. new (overlapping, blending), 9–11, 18, 24–32 *passim*, 36, 47, 57, 102, 108, 114, 119, 132, 199; and paper, 207; patent on, 6; pigments, 71–73 (*see also* inks); processes described,

9, 56–57, 74–78; progressive proofs (printing sequence), 26, 57, 74–78, 150; "redefined," 199; registration, 5, 9, 20, 44, 50, 74, 78, 110, 115, 132, 179, 189; specialization in, 254n.1; stippling (pointillism), 32, 199, 203–204; in watercolor reproduction, 20, 32, 114; in Yellowstone folio, 107, 109, 111–112. *See also* lithographic stones; style(s)

Colton, Zahm and Roberts, 44, 45, 135, 294, 295

Columbian Exposition, *see* Chicago Fair

"Columbine Waltzes" (Bufford), 20

commercial art, *see* advertising

Complete Course of Lithography, A (Senefelder), 6, 74

"Compliments of the Season 1884" (Shober and Carqueville), 327

Compton, Richard J., and "Compton Lith. Co." (Buffalo, St. Louis), 188, 333

Conningham, Frederic A., 60

"Contentment is Better than Riches" (Ryder-Willard), 184

Cook, Clarence, 207, 208, 213

Cooman, Joseph, 104

"Copper Wrist Bands" (Ackerman-Eastman), 30, 284

copyright: international, 41; of pictures sold to lithographers, 95; and royalty agreements, 95, 102, 122

Corcoran, William Wilson, and Corcoran Gallery of Art, 101, 186

Corn Husking Bee (Johnson), 124

Correggio, 96, 104

Corrigan, A. J., 191

Cosack, Herman, 188

Cosack and Company (Buffalo), 189, 243n.84, 259n.23, 334

Cosmopolitan Art Association, 122

"Cotton Plantation on the Mississippi, A" (Currier and Ives-Walker), 61, 306

Cottrell, C. B., and Sons (New York), 84

Courier Lithograph Company (Buffalo), 187, 189, 333

"Court of Death" (Sarony, Major and Knapp-Peale), 51, 216, 299

Cozzens, Frederic S., 22

"'Crack' Sloop, A, in a Race to Windward" (Currier and Ives-Parsons), 61

Cranberry Pickers, The (Johnson), 124

Cropsey, Jasper F., 33, 36, 287

Crosby, Charles H. (Boston), 194, 337

Crosby, Uranus H., 33, 177

Curran, Charles Courtney, 202, 262n.4

"Currants" (Prang-Granbery), 119, 217, 317

Currier, Charles, 235n.16

Currier, Edward West, 63

Currier, Nathaniel, 19, 49, 63, 102, 120, 235n.16, 239n.60; as agent for Sarony and Major, 50; joined by Ives, 59–61

Currier and Ives (New York), 42, 64, 102, 216–217, 302, 303, 306; and advertising, 190, 192, 193; "commercial" prints of, 14; and hand-coloring, 59–60, 63, 102, 120; horse-racing prints of, 60–61, 179, 217, 305; railroad prints of, 60, 304, 336; sentimentality of, 32, 61; uniqueness of, 59–62

Currier & Ives (Peters), 59–60

Currier Gallery of Art (Manchester, N.H.), 115

Custer's Last Fight (Adams), 196, 197–198, 199, 341

Custer's Last Rally (Mulvany), 196, 197, 198, 199

Daeschler, C., 65

daguerreotypes, *see* photography

Daleiden and Company (Chicago), 259n.19

"Dandelion Time" (Bencke-Spencer), 122

"Danger Signal, The" (Currier and Ives), 193

D. Appleton and Company, 202

Davidson, Julian O., 104

Davies, Arthur B., 13

Davis, Jefferson, 104

Dawes, A. G., 20

deadlines, 16, 30–31

dealers, 50, 59, 122, 135, 138–145, 205, 224, 323

Deer Slayers, The (Stanley), 181

de Haas, M. F. H., 113

Delaroche, Paul, 24

"Delaware Water Gap, View on the" (Foerster-Eglau), 295

"Delft Smyrna Carpet" (Cosack and Company), 189, 334

"democratic" art, 1–6, 19, 26–27, 35, 40, 46, 64, 127, 184, 205–211; in the home, 2, 5, 20, 48, 61, 101, 104, 116–129, 204; posters as, 131, 194; Prang and, 102, 104, 106, 115. *See also* advertising; popular taste

DeMyrback, Felicien, 202

"Dessert #6" (Prang-Ream), 318

"Dessert Table, The" (Queen), 38

Detroit, 182, 218

Detroit *Free Press*, 181, 182

Detroit Institute of Arts, 181

Deutz Brothers (New York), 66

Devereux, Henry, 184

Dickman Jones Company (San Francisco), 154

"Dining-Room Pictures," 119–122, 217, 317, 318

diplomas, 16, 37, 189, 196. *See also* certificates

"Distinguished Masons of the Revolution" (Strobridge), 139, 218, 322

"Doctor, The" (Prang-Bacon), 124

Donaldson, William, and Company (Cincinnati), 134, 179, 256n.70

"Donaldson Art Sign Co. Publishers, Cov., Ky.," 148, 325

Donaldson Brothers (Brooklyn), 156

Doughty, Thomas, 12

Douglass, Frederick, 104

Downey, William, 170

drawing manuals, 101

Dreser, William, 33, 35, 215, 286, 287

Duff, J. B. (Pittsburgh), 146

Durand, Asher Brown, 94, 98

Durkee, Albert, and Company (Chicago), 140

Durrie, George, 140, 218, 323

Düsseldorf Academy and style, 46–48, 61, 111–113, 124, 196–197, 201, 216, 217

Duval, Peter S., 37, 39, 67, 89, 155, 173, 216, 227n.10, 240n.25, 260n.42, 288; career and influence of, 23–27, 40, 51, 213; and "chromo" as term, 11, 42, 63; lithotint published by, 126; rivals of, 34, 35; and Schoolcraft Indian project, 30, 215, 284–285; -Schuessele prints, 26, 31, 50, 126, 134, 215, 282, 285, 320; and technical procedures, 32, 71–72, 74, 78, 82. *See also* Lehman and Duval

Duval, P. S., and Son (Philadelphia), 26, 27, 37, 38, 39, 139, 282, 290

Duval, Stephen C., 26, 234n.81

Duval and Hunter (Philadelphia), 39

"Early Autumn" (Currier and Ives-Shattuck), 60

"Early Autumn on Esopus Creek,

N.Y." (Prang-Bricher), 113, 306
"Early Winter in the Highlands of
Upper Bavaria" (Hoover-Queen),
39
"East Dorset Italian Marble
Mountain and Mills, View of"
(Mayer-Childs), 45, 216, 296
Eastern Shore, see Watch, The
Eastman, Seth, 29–31, 127, 181,
284–285, 320
"Éclat du Jour" (Prang-Mucha), 104
"Edmund Dexter's Residence"
(Ehrgott and Forbriger), 132–133,
145, 217, 321
education, 3; of taste, see popular
taste; and trade schools, 59, 171.
See also apprenticeship system
Eglau, Max, 45, 113, 295
Ehrgott, Peter, 132, 146
Ehrgott and Forbriger (Cincinnati),
132–133, 134, 145, 217, 321
Ehrgott and Krebs (Cincinnati), 146,
324
Eilers, A. H. (St. Louis), 139
Embers (Johnson), 124
"Embroidered Screen" (Clay,
Cosack), 189, 334
"Encampment of 17th Reg.t National
Guard, N.Y.S.A. at Camp
Schuyler . . . 1845" (Michelin), 19
Enchanted Monarch, The (Church),
95
Encyclopaedia Americana (Lieber),
65
Endicott, George (New York), 19, 42,
44, 64, 149, 172
Endicott, William, 42
Endicott and Company (New York),
42, 43, 159, 216, 291
Engelmann, Godefroy, 6, 12
Engelmann and Graf (Europe), 24
England: chromolithography in,
6–8, 10, 53, 100, 102, 114, 118,
133; as pigment source, 71
engraving processes: copper and
steel, 27, 31, 53–54, 56, 67, 133,
228n.23; etching, 53–54, 108,
115; photomechanical, 18, 202–
203, 210; skill in, compared to
lithography, 73; wood engraving,
27, 29, 53–58 passim, 114, 115,
202, 207. See also aquatints
Engues (French engineer), 82
Eno, Henry C., 44, 216, 293
"Esopus Creek, N.Y., View on" (Col-
ton, Zahm and Roberts), 44, 135,
294; Strobridge and Prang also
publish, 135, 306

etching, see engraving processes
"evolution," 3. See also education

Fabronius, Dominique C., 44, 45,
197, 198, 293
Fabronius, Gurney and Son (New
York), 293
Falke, Jakob von, 101
"Falling Spring, Va." (Currier and
Ives-Colman), 60
"Family Scene in Pompeii, A" (Prang-
Cooman), 104
Farmer's Home Journal, 127
"Fast Asleep," 204
"Federal Hall of the City of New
York . . . 1797, A View of"
(Robinson-Holland), 44, 45, 216,
292
Feister, H. P. (Philadelphia), 89
"Female Bathers, numbers one, two,
three, and four" (Kurz), 180, 328
Fenn, Harry, 202
Ferguson, Henri A., 113
fine art: availability of (present-day),
212; chromolithography as, 14,
190, 191; "debased" by
chromolithography, 1–2, 12–13,
177; and "Düsseldorf" style, 46
(see also Düsseldorf Academy and
style); European, 135; mass pro-
duction of, 4, 208; popularization
and dissemination of, 2–4, 8, 10,
43, 96, 101, 104, 122, 131, 190. See
also popular taste; reproduction(s)
of painting or watercolor
"Fine Art Publishers," 21, 139, 148
fire: Chicago Fire (1871), 33, 178–
179; danger of, 72, 158; losses by,
26, 34, 134, 146, 181, 182, 198
"[Fire engine] Built by the Amoskeag
Manufacturing Co." (Crosby),
194, 337
Fiske, John, 3
"Flag, The, That Has Waved One
Hundred Years" (Restein), 183–
184, 218, 330
"Flight of the Fast Mail, The, on the
Lake Shore and Michigan Southern
Ry." (Clay, Cosack), 334
"Floral Year, The" (Sharp), 11
"Flowers of Hope" (Prang-Heade),
121
Foerster, Edmund and Company
(New York), 45, 295
Forbes Lithograph Manufacturing
Company (Boston), 169
Forbriger, Adolph, 132, 145
Ford, James L., 204

For Everybody (periodical), 188
"forty-eighters," see immigrants
frames and framing, 39, 103, 118,
135, 142
France: chromolithography in, 6, 9,
10, 32, 114, 118, 122, 133, 199;
February Revolution (1848) in, 26;
and French influence in U.S., 8, 11,
23, 38, 146, 201, 202; as pigment
source, 71; stipplework in, 204
Frankenstein, Alfred, 147
Franklin Institute (Philadelphia), 27;
awards by, 24, 32, 34
Franklin Journal, The, and American
Mechanics' Magazine, 6
Freedley, Edwin, 82
Fuchs and Lang (New York), 66
Fuechsel, Hermann, 250n.43
"Futurity Race at Sheepshead Bay"
(Currier and Ives-Maurer), 61, 217,
305

"Galt House" (Klauprecht), 131
Gambert, E., and Company
(England), 33
Gambling for the Buck (Stanley), 181
Game Birds of America (Sage-Clay),
120
Game Fishes of the United States
(Kilbourne), 22
"Garland, The, or Token of
Friendship" (Sharp, Peirce), 320
Gazette des Beaux-Arts, 11
Gems of Brazil (Heade), 121
Genesee Lithographic Company, 162
George Mather's Sons (New York),
72
Gerdts, William H., 119
Germany: chromolithography in, 6,
9, 10, 51, 57, 100, 114, 118, 181,
182; and German-born printers in
U.S., 8, 51, 65, 93, 97–98, 101,
131, 145, 146, 153–154, 178, 179,
188, 190, 243n.93; as lithographic
supply source, 65–66, 71. See also
Düsseldorf Academy and style;
oleograph(s)
Gérôme, Jean-Léon, 135, 322
"Gettysburg Battlefield, Plan of"
Endicott), 42
Gibson, George, and Company (Cin-
cinnati), 131, 134; renamed Gibson
Art Company, 254n.11
Gibson, John, and Company (New
York), 66, 182
Giedion, Sigfried, 208
Gies, Charles (Buffalo), 189, 335
Gifford, R. Swain, 202, 203

"gift-books," *see* book illustrations
Giles Company (New York), 156
Gillespie, Charles (Pittsburgh), 146
Gilpin, Thomas, 78
Glackens, William, 13
"Glade, The, Allegheny Mountains, Maryland" (Prang-Key), 112
"Gladiators, The" (Strobridge-Gérôme), 135, 322
Gleason, F. (Boston), 139, 140, 323
Godkin, Edwin Lawrence, 1–2, 3, 5, 47, 105, 115, 206, 207, 208, 211
Going to Church, see "Winter Sunday in Olden Times"
Golden Evening (Prang-Spitzweg), 104
"Golden Gate, The, Looking West" (Prang-Key), 112
Gothic Revival, *See* style(s)
Goupil, Vibert and Company (France), 122
Graham, Charles, 262nn.4, 5
Graham's American Monthly Magazine, 206
Grammar of Ornament (Jones), 104, 189
Granbery, Virginia, 119, 120, 217, 317
Grand Canyon of the Yellowstone, The (Moran), 108; Prang-Moran chromo, 111
"Grand Display of Fireworks and Illuminators, The, at the Opening of the Great Suspension Bridge between New York and Brooklyn" (Currier and Ives), 61
"Grandpapa's Pet" (Duval-Richards), 126
Grand Rapids *Eagle*, 181–182
"Grange Chart and Photograph Family Record" (Kurz), 179
Grant, Benjamin Bellows, 250n.44
Grant, Ulysses S., 44, 103, 134
"Great Blue Spring of the Lower Geyser Basin" (Prang-Moran), 111
"Great Central Depot Grounds, The" (Chicago Lithographing Company), 178
Greek Vases: Their System of Form and Decoration (Lau), 100
Greenwood, F. W. P.: Sharp chromos of, 17, 18, 20, 215, 279
greeting cards, 95, 99, 100; Christmas cards, 21, 114, 99–100, 209
Griswold, Casimier Clayton, 294
Groschwitz, Gustave von, 11
"Group of Chickens" (Prang-Tait), 95, 102, 103, 105, 217, 307
"Group of Ducklings" (Prang-Tait), 95, 207

Haehnlen, Jacob (Philadelphia), 160, 161
Hale, Edward Everett, 103
Hall and Mooney (Buffalo), 188
Hall and O'Donald Lithographic Company (Topeka), 164
Hamerton, Philip Gilbert, 207, 208
Hamlin, A. C., 100
"hanging" print, 10, 18, 19, 20, 39, 45, 95, 123, 129, 134, 190. *See also* reproduction(s) of painting or watercolor
Hani, A. (Pittsburgh), 146
"Harbor of Charleston with Fort Sumter" (Prang), 98
Harlow, Louis K., 114
Harnett, William, 147, 148, 218, 325
Harring, William, 101, 102, 113, 293, 306, 307, 313, 314; "The Kitchen Bouquet," 119–120, 317
Harris, George S., and Sons (Philadelphia), 156, 166
Harrison, Mrs. Benjamin, 128
Hart, Charles, 17, 149, 236n.7, 239n.60; on lithographic labor and "union," 153–154, 171; on lithographic supplies and machinery, 64, 66, 83, 84, 87
Hart, James M., 113, 314
Hart, John Seely, 126
Hartford, Connecticut, 16, 155, 189
Hartrath, Joseph, and Company (Cleveland), 187
"Harvesting Near San Jose, California" (Prang-Key), 112, 314
Hassam, Childe, 202
Haugg, L., 192
Havell, Robert, Jr., 55, 56, 57, 216, 299-301
Hayden, Ferdinand Vandeveer, 107–111, 217, 310–312
"Haymaking in the Green Mountains" (Prang-Champney), 113, 217, 315
Hazen, Edward, 150
"Head and Head at the Winning Post" (Currier and Ives), 61
Heade, Martin Johnson, 94, 121
Henderson-Achert Krebs (Cincinnati), 256n.59
Henderson Lithographing Company (Cincinnati), 193
"Hendrik Hudson, The Arrival of, in the Bay of New York . . ." (Colton, Zahm and Roberts-Chapman), 45, 294
Henry, Joseph, 56
"Henry's United Silver Cornet Band at Niagara Falls" (Wagner and McGuigan), 34, 215, 287
Heppenheimer, Otto, 154
Heppenheimer and Maurer (New York), 154
Heppenheimer's Sons, F., 156, 243n.93
Hill, Thomas, 94, 95, 111, 112, 249n.29, 313
Historical and Statistical Information Respecting . . . the Indian Tribes of the United States (Schoolcraft), 28–31, 215, 284–285
Hoe, R., and Company, 79, 86–88; *History of, 1834–1885* (Tucker), 84
Hoe, R. M., 85
Hoen, A., and Company (Baltimore), 15, 228n.25, 229n.26, 233n.80
Holland, John Joseph, 44, 45, 216, 292
home, the, *see* "democratic" art; popular taste
Homer, Winslow, 11, 12, 94, 114–115, 217, 246n.15, 317
"Home, Sweet Home" (Queen), 38
Hooper's Western Fruit Book, 132
Hoover, Joseph (Philadelphia), 15, 39–40, 61, 139, 140, 250n.43; *American Chromos* of, 103
horse-racing prints, *see* Currier and Ives
"Hot Springs of Gardeners River" (Prang-Moran), 111
Howard Iron Works (Buffalo), 88
Huber Rotary Zincographic Printing Press, 69–70
Huddy and Duval (Philadelphia), 231n.4
Hughes and Kimber (New York), 66, 82
Hullmandel, Charles, 6–8, 9, 17, 19, 279; coins term "lithotint," 252n.48
Humphreys, Charles S., 293
Hunt, Richard Morris, 99
Hunt, William Morris, 12, 46
Hunter, Thomas, 234n.81. *See also* Duval and Hunter
Hunter-Naturalist, The (Webber), 35, 206, 288

"I Feed You All" (Kurz), 179
Ilg, Gus, 148
illuminated style, *see* style(s)
Illustrated Cincinnati (Kenny), 131, 146
"I'm Grandmama now," 204
immigrants, 8, 17, 32, 34–35, 44, 49, 178, 188, 196; vs. apprenticeship system, 170–171; "forty-eighters," 51, 59, 93, 97, 177, 243n.93; and tariff law, 92; on West Coast, 190. *See also* England; France; Germany
"Improved Order of Red Men" (Sinclair-Dreser), 32, 286
"Independence Hall, Philadelphia, Interior View of" (Rosenthal), 35, 288
"Indian Courtship" (Duval-Schuessele), 320
"Indian Offering Food to the Dead" (Bowen-Eastman), 30
Indians, American: Schoolcraft volumes on, 28–31; as subject, 30, 181–183, 206, 320
Indian Telegraph (Stanley), 181
industrial art, 105, 115, 189, 205, 210. *See also* advertising
Industrial Arts of the Nineteenth Century, The (Wyatt), 69
Industries of Cincinnati, The, 145
Inger, Christian, 282
inks, 64, 111, 179, 187; and inking process, 74, 75–77, 80, 81, 110; preparation of, 71–73, 75; tariffs on, 91; transparent/translucent, 9, 24; and varnishes, 64, 71–72, 91, 132, 179, 187; and watercolor reproduction, 115. *See also* color techniques
Inland Printer (journal), 69, 72, 170
Inness, George, 121, 194
intaglio, *see* engraving processes
Iris, The (annual), 126–127
"Iris Souvenir for 1851, The" (Duval-Schuessele), 282
"Iroquois Picture Writing" (Duval-Eastman), 30, 284
"Itasca Lake, Source of the Mississippi River, View of" (Bowen-Eastman), 30, 285
Ives, Chauncey, 239n.60
Ives, James, 59, 61, 239n.60. *See also* Currier and Ives

Jack, Richard, 202
Jacoby, Max, and Zeller (New York), 135, 140

"Jer Falcon" (Bien-Audubon), 57
Jevne, Otto, 178, 179
Jewitt, Thomas and Company (Buffalo), 188
J. H. Bufford companies, 15, 19–21. *See also* Bufford, John H.
Johnson, Eastman, 11, 19, 47, 94, 123, 124; *Barefoot Boy*, 48, 75, 77, 95, 96, 118, 121, 124–125, 217, 318; *Boyhood of Lincoln*, 95, 96, 125, 320
Jones, Francis Coates, 262n.4
Jones, Owen, 104, 189
Jones, Paul, 199
Joseph Hoover Sons (Philadelphia), 234n.88. *See also* Hoover, Joseph
journalism, 37, 49, 63, 131. *See also* Civil War chromos; magazines; newspapers
Judge (magazine), 32, 78

Kaufmann, Theodore, 101, 104, 217, 307
Kellogg, E. B. and E. C. (Hartford), 155
Kelly, William W., and Company (Chicago), 140, 142
Kenny, D. J., 131, 146
Ketterlinus, E., 27
Ketterlinus Printing House (Philadelphia), 152
Key, John Ross, 94, 111–113, 202, 203, 314, 343
Kidder Press Manufacturing Company (Boston), 89
Kilbourne, S. A., 22
"Kitchen Bouquet, The" (Prang-Harring), 119–120, 317
Klauprecht, Emil (Cincinnati), 131
Knapp, Joseph, 51. *See also* Sarony, Major and Knapp
Knapp Company (New York), 156
Knight, D. R., 291
Knights of Labor, 172–173
Koehler, Silvester, 101
Koerner, H. T., 149, 150
Kramer, Hilton, 213–214
Kramer and Rosenthal (Philadelphia), 233n.59. *See also* Rosenthal, L. N.
Krebs, A., and Brother (Pittsburgh), 145, 146
Krebs, Adolph (Cincinnati), 134, 145, 146, 188, 324
Krebs, Otto (Pittsburgh), 145, 146, 324
Krebs Lithographing Company (Cin-

cinnati), 146, 151
Kuchel, C. C., 190
Kurz, Louis (Chicago), 14, 177–180, 327, 328
Kurz and Allison (Chicago), 179–180, 327, 328

labor unions, 171–173. *See also* specialization
Lackawanna Valley (Inness), 194
La Farge, John, 12, 99
Lafayette, Marquis de: chromo of, 26, 31, 134, 215, 282
Lafosse, Jean Baptiste Adolphe, 122
Lambdin, George Cochran, 121
Lane, Fitz Hugh, 19, 50, 216, 297
Lane, R. J., 17
Latham, J., and Company (Boston), 140
Lau, G. T., 100
"Leading California Resorts, The" (Schmidt), 190
Leading Pursuits and Leading Men (Freedley), 82
Lehman, George, 23
Lehman and Bolton, 161, 162
Lehman and Duval (Philadelphia), 23, 37, 166
Lemercier, R. J. (France), 252n.48
Lentz, Herman (Cleveland), 187
Leonhardt, Theodore, and Son (Philadelphia), 15
Leslie, Frank, 153
Leutze, Emanuel, 46, 47, 124
"Levee, The—New Orleans" (Currier and Ives-Walker), 61, 306
Library of Congress, 45, 46, 74, 176, 179, 183, 202
Lieber, Francis, 65
Life in Camp (Prang-Homer), 114
Lincoln, Abraham, 131; as subject, 95, 96, 103, 125, 134, 179
Linder, Eddy and Clauss (New York), 156
Lion in Love (Church), 95
Lippincott, J. B., and Company (Lippincott, Grambo & Co.), 30, 31, 181
Literary Blue Book, The (London), 7, 17
Literary World, The (periodical), 209
"Lithographer" (Prang), 150
Lithographers' Journal, 6, 40, 67, 70, 72, 152, 191–192; color formulas from, 221–223; quoted, 94–97 *passim*, 100, 125–126, 201, 205, 210–211; tariff stand of, 92

lithographic industry: buildings designed for, 158–165; difficulty in documentation of, 43, 44; growth of, 3, 4, 43, 64, 122, 133, 145, 153–154, 176; tariff legislation for, 59, 71, 90–93; wages in, 152–154, 167, 169–170, 176. *See also* apprenticeship system; inks; paper; presses, lithographic; specialization

Lithographic Plate Manufacturing Company, 69

lithographic stones, 13, 14; cost of (and tariff on), 65, 66, 74, 75, 83, 91; damage to, 83, 84; drawing directly on, 8, 10, 16, 20, 37, 75, 113, 150, 159, (apprentices and) 167, ("chromistes" and) 73–74, (by original artist) 12, 14, 29, 33, 35, 37, 50, 126; in first U.S. chromolithograph, 17; numbers used, 9, 17–20 *passim*, 24, 26, 44, 45, 49, 75–78, 183, 197, 252n.48; ownership of, 31, 67, 148; preparation of, 67–68; quality test of, 240n.10; size of, 66, 67, 68–69, 87, 243n.88; source of supply for, 64–67, 91, 134; storage of, 68–69, 160, 188; zinc plates as substitute for, 35, 69–71, 187

lithographs and lithography: and advertising, 191–200 (*see also* advertising); artistic, "revival" of, 13; bias against, 12–13, 101, 128, 191; changeover from, to metal plates, 31, 54 (*see also* engraving processes); color, distinguished from chromolithography, 11–12; commercial, 12–13, 14, 130, 176; compared to steel engravings, 133; custom orders, 16, 61; different types of, 8–9, 59–63; on glass, 157; hand-coloring in, 9, 30, 32, 42, 102, 120, 122, 178, 181, 188, 189, 232n.38, 237n.16 (*see also* color techniques); invention of, 6; and journalism, 37, 49, 63, 131; "original print," 14; and photolithography, 54, 58, 202, 210 (*see also* photography); "practical," 14–17, 61, 88, 99, 132, 134, 143, 146; process described, 8–9, 16, 67–90, (lithographic-transfer) 56–57 (*see also* lithographic stones); speed of production, 80, 87–88, 111, 210; "street" (posters), *see* advertising; techniques of, underestimated, 56, 73

"lithotints," 23, 229n.36; first U.S., 126

"Little Bo-Peep" (Prang-Brown), 95, 124

Little Orphan Annie (comic strip), 209

"Little Red Riding Hood" (Hoover-Queen), 39

"Live Woodcock" (Hoover-Queen), 39

London *Art-Journal*, 9

London *Times*, 107

Longfellow, Henry Wadsworth, 103

Louis Philippe, king of France, 26

"Lower Yellowstone Range" (Prang-Moran), 109, 110, 310

McGuigan, James (Philadelphia), 34, 91, 108. *See also* Wagner and McGuigan

McKenney and Hall portrait series, 181

magazines, 53, 116, 188; chromo advertising in, 24; chromo illustrations for, 32, 34, 37, 126; chromos as premiums for, 126–128; discussions of chromolithography in, 65, 73, 75–78, 82, 96, 114, 124, 128, 131, 199–200, 206, 211; and dissemination of information, 3–4. *See also* journalism

Major, Henry B., 49

Major, Richard, 49

Major and Knapp (New York), 49, 51, 84, 299. *See also* Sarony, Major and Knapp

Mann, Horace, 3

Mapleson, T. W. Gwilt, 192

Marinoni, Auguste Hippolyte, 85, 86–87

Marold, I., 202

Mather, George (New York), 72

Mattson, Morris, 17

"Maud Muller" (Prang-Brown), 122, 318

Mauger, Victor E., 82, 84

Maurer, Louis, 61, 217, 305

Mayer, Constant, 44

Mayer, Ferdinand, and Company (New York), 45, 163, 216, 296

Mayer, Julius, 98

Mayer, Robert, and Company, 65

Mayer and Sons (New York), 45

Mechanization Takes Command (Giedion), 208

Medcalf, William L., 262n.4

Memoirs (Bosqui), 189

Mendel, Edward (Chicago), 178

Menzel, Adolph, 131

metal: chromolithographs printed on, 147; engraving, *see* engraving processes; and metallic powders, *see* color techniques

Metropolitan Museum of Art (New York), 46, 115, 213

Mexican War, 49

Michelin, Francis, 17, 19, 215, 280

"Michigan and Wisconsin & parts of Iowa, Illinois & Minnesota" (map, Calvert), 182

Middleton, Elijah C., 132, 134

Middleton and Wallace; Middleton, Strobridge and Company; Middleton, Wallace and Company (Cincinnati), 132, 134, 254n.14, 255n.17

Miller, Alfred Jacob, 35, 206, 288

Milwaukee, Wisconsin, 10, 178, 179

Milwaukee Lithographic Company, 198, 341

Milwaukee Sentinel, 179

"Moccasin Flower, The" (Armstrong-Sprague), 281

Modern Painters (Ruskin), 110

Moerhlin, George, 146

Moody, John E., 19

Moore, Clement C., 100

Moore, Thomas, 19

Moradei, Arturo, 104

Moran, Thomas, 94, 99, 107–114, 202, 217, 309–312

Morgan, Matt, 153, 199

Morgan, W. J., and Company (Cleveland), 187

Morrill Land-Grant College Act (1862), 3

Morviller, J., 207, 250n.41

"Mosquito Trail" (Prang-Moran), 111, 311

Mott, Frank Luther, 128, 256n.49

"Mount Chocorua," "Mount Kearsarge" (Prang-Champney), 113

"Mount Hood, Oregon" (West Shore Litho. and Engraving Company), 321

"M.S. & N.I. & C. & R.I. & P.C.R.R. Dep." (Chicago Lithographing Company), 178, 327

Mucha, Alphonse, 104, 196, 198–199, 342

Mulvany, John, 196–197, 198, 340

Mumford, Lewis, 208

Munro, George, 139, 224–226

Munyon, J. M., 184

Nagel, L. (San Francisco), 190

Nahl, C. C., 207
Nation, The, 47, 103, 105, 106, 206, 207, 208; moralism of, 1–2
National Academy of Design (New York, 124, 196, 197
National Chromo Company (Philadelphia), 140, 156, 184
National Lithographers' Association, 41, 53, 59, 91, 92, 149, 153, 173; *Journal* of, quoted, 5. *See also Lithographers' Journal*
Neal, John, 205
Negro stereotypes, 104
Neitig and Buechner (Buffalo), 188
New American Cyclopaedia, The, 80
New Bonnet (Johnson), 124
New England Lithographic Company, 21, 155–156. *See also* Bufford, John H.
New England Magazine, 185
Newsam, Albert, 37
newspapers, 53; German-language (in U.S.), 131. *See also* journalism; magazines
"New Ulm, Minnesota, Ansicht von [view of]" (Ehrgott and Forbriger), 132–133
New York City: chromolithography in, 8, 10, 14–21 *passim*, 28, 29, 40, 72, 183, 187, 189, 190; dealers in, 135, 140; as lithographic center of U.S., 41–46, 48, 51, 53, 64, 66, 82
New York Daily Tribune, 102, 197, 207
New York *Evening Post*, 99
New York *Herald*, 156
New York Lithographic, Engraving and Printing Company, 58
New York Times, The, 1, 49, 127, 213
Nichols, H. B., 203
"Night Scene at an American Railway Junction" (Currier and Ives), 60, 304
Norris, Richard, and Son, 192
North American Lithographic Stone and Asbestos Company, 65
"North Conway Meadows" (Prang-Champney), 113, 315
"North Woods, The" (Prang-Homer), 94, 115, 217, 317
"Norwich, View of, From the West Side of the River" (Sarony and Major-Lane), 50, 216, 297
nudity, *see* popular taste

Oakes, William H., 18
Oakley, F. F., Lithographic Company

billhead, 80, 150
O'Brien, Martin, 205
Official Report of the American Centennial Exposition of 1876 (Weir), 112
"Ohio River, from the Summit of Grave Creek Mound" (Ackerman-Eastman), 31
"oil portraits," *see* reproduction(s) of painting and watercolor
"Old Block's Cabin" (Nahl), 207
Old Kentucky Home (Johnson), 124
"Old Man's Reminiscences, An" (Prang-Durand), 98
"Old Sachem Bitters" (Sarony, Major and Knapp), 51, 298
"Old Violin, The" (Tuchfarber-Harnett), 147–148, 218, 325
oleograph(s): German, 10, 111, 179, 183; as term, 10–11, 179, 185
"On the Warpath" (Calvert-Stanley), 182, 183, 218, 329
Orcutt Lithographing Company (Chicago), 179, 203
Oriental Ceramic Art (Bushnell), 100–101, 115
"original print" defined, 14. *See also* lithographs and lithography
Otis, Bass, 12, 65
"Our Father" (Ehrgott and Forbriger), 145
"Outside Connected Passenger Engine" (Bufford), 192, 335

Pacific Railroad surveys, 32, 53, 181
Palmer, Fanny, 120
Panorama of Professions and Trades, The (Hazen), 150
paper, 58, 64, 72, 78–79, 111, 207; "stone paper," 239n.5
Park, H., 260n.57
Parsons, Charles R., 61, 120, 302, 304, 336
Parton, James, 75, 96, 103, 206
"Pastoral Scene" (Prang-Hart), 113, 314
patents: *Report of the Commissioner of* (1849), 26. *See also* color techniques; presses, lithographic
Peale, Rembrandt, 12, 51, 216, 299
Pearls of American Poetry (Mapleson), 192
Peirce and Company (Cleveland), 187
Pelletreau and Raynor (New York), 43, 158
"Pembroke Iron" (Bradford), 58, 301
Pendleton, John, 12
Pendleton, William S., 12, 19, 50

Pendleton firm (Boston), 12, 239n.1
Pennell, Joseph, 12, 13, 27, 130, 176
Pennsylvania Academy of the Fine Arts, 26
Perry, Enoch Wood, 45–48, 216, 296
Perry, George T., 27
Peters, Harry T., 59–60
Philadelphia, Pennsylvania: chromolithography in, 8, 15, 18, 19, 23–28, 29, 32, 34–40, 66, 72, 74, 82, 89, 108, 126, 132, 152, 183, 184, 189; dealers in, 139, 140; Exposition at, *see* Centennial Exposition
Philadelphia as It Is in 1852 (Smith), 35
"Philadelphia from Camden" (Sarony and Major), 50, 298
Philadelphia Photographer, 185
Philadelphia *Public Ledger*, 26, 32
Phillips, Wendell, 103
Phoenix Lithographic Company (Buffalo and Chicago), 156
photography, 98, 202, 203, 229n.48; chromolithography "evolution" into, 18, 27, 49; daguerreotype, 34, 184, 230n.51; and photolithography, 54, 58, 202, 210
photomechanical printing, 18, 202–203; collotype and photoengraving, 210. *See also* engraving processes
Picturesque Architecture in Paris, Ghent, Antwerp, Rouen (Boys), 6, 9, 279
pigments, 71–73. *See also* color techniques; inks
Pinkerton, E. J., 34
Pinkerton, Wagner and McGuigan (Philadelphia), 24, 34. *See also* Wagner and McGuigan
Pioneer Press (St. Paul), 177, 218, 326
Pittsburgh, Pennsylvania: chromolithography in, 19, 44, 145–146, 189
"Pittsburgh, Fort Wayne and Chicago by Freight" (Chicago Lithographing Company), 178
"Pittsburgh & Allegheny" (Krebs), 146, 324
Playing Mother (Brown), 95
"Pluck No. 1," "Pluck No. 2" (Clay, Cosack-Willard), 185
Pollice Verso, see "Gladiators, The"
Pope, A., Jr., 22
popular taste, 46, 122, 139, 183; changes in, 143, 210–211; Currier and Ives and, 59, 61–62; education

of, 5, 20, 40, 96, 100–102, 106, 116–117, 126, 206; and nudity as taboo, 177, 180, 199; Prang and, 96, 100–102, 105–106, 119–120 (*see also* Prang, Louis); sentimentality, 21, 32, 39, 46, 61, 102, 104, 121, 123–124, 180, 239n.60; stock items, 38, 62, 99, 102–103, 112–113, 119–127 *passim*, 135, 175, 183–186, 198, 204; and "suitability" of subject, 123–125, 180, 198, 199; women and, 125–127, 128

"Porcelain Vase" (Clay, Cosack), 189

"Pork Packing in Cincinnati" (Ehrgott and Krebs), 146, 324

posters, *see* advertising

Potter, C., Jr., and Company (New York), 243n.88

Powers, J. Hale, and Company, 139

Prang, Louis, 61, 120, 179, 190, 213, 214; and advertising, 119–120, 192; album, greeting and Christmas cards "invented" by, 98–100; on apprenticeship, 170–171; as art patron, 40, 94–96; and "chromo" as term, 11, 63, 103; as "forty-eighter," 51, 93, 97; and free trade, 92–93; "Hints on Framing," 103, 118; as popularizer of art and tastemaker, 96–97, 99–101, 102, 104–106, 116, 117, 119, 125, 129, 205; quality of work of, 18, 21, 44, 77, 111, 134, 148, 183, 207, 233n.80; technical innovations by, 70–71, 89–90, 204

Prang, L., and Company (Boston), 21, 98, 135, 139, 177, 184, 203, 307, 309; *American Chromos*, 89, 103, 106, 111, 122, 215, 314; "dining-room" pieces by, 119–122, 217, 317, 318; Eastern landscape views by, 113, 314–315, 317; European paintings reproduced by, 101, 104; historical pieces by, 259n.23; Key chromos by, 112, 314; *Oriental Ceramic Art*, 115; *Prang's Chromo: A Journal of Popular Art*, 103, 118; prices of, 135, 143; "printory" of, 159–161, 169; specialization at, 154; *Trades and Occupations* series ("Lithographer"), 150; and watercolor chromos (Winslow Homer), 114–115, 217, 317. *See also* "Barefoot Boy"; "Birthplace of Whittier"; "Boyhood of Lincoln"; "Group of Chickens"; "Sunset: California Scenery"; "Yellowstone National

Park, The"; "Yosemite Valley"

Pratt, Charles S., 100

Preliminary Trial of a Horse Thief, The (Clay, Cosack-Mulvany), 196–197, 340

premiums: chromolithographs as, 5, 127–128, 142, 143, 209, 213, 259n.53, 262n.17

"President Lincoln Writing the Proclamation of Freedom" (Ehrgott and Forbriger-Blythe), 145

presses, lithographic, 132, 188; "Bronstrup," 89; cost of, 84, 243n.88; hand, 79, 82–84, 88; patents on, 82, 84, 85–86, 204; speed of, 80, 87–88, 111, 210; steam-powered, 53, 60, 69–70, 72, 80, 81–90, 133, 134, 158, 159, 182; steam-powered, denounced, 83–84

prices, chromo, 178; compared to price of original art, 75, 96; competition and, 44–45; and credit terms, 15; "high," 101–104 *passim*, 111, 112–113, 118, 182, 204; "low," 4, 5, 20, 53, 185, 199, 229n.31; Munro's 1880 list, 224–226; quantity and, 59, 61–62; Strobridge 1877 list, 135–139, 143; variation in, 30, 135; wholesale, 135, 142, 143

"Pride Polka" (Sarony and Major), 50

"Primavera, La" (Prang-Moradei), 104

"Prince of the Blood, A" (Currier and Ives), 61

printing, *see* chromolithographs and chromolithography; engraving processes; inks; lithographic industry; lithographic stones; lithographs and lithography; paper; presses, lithographic

Printing Times and Lithographer, The (London), 10, 185

Providence Lithographic Company, 69–70, 155

P. S. Duval, *see* Duval, Peter S.

Puck (magazine), 32

"Pumpkin Time" (Prang-Champney), 113

quality of chromolithography: attention to, 5, 44, 77, 135, 178; awards for, 24, 32, 34, 53, 233n.80; decline in, 20–21; inferiority to European, 213; and price, 44; variation in, 18, 21, 24, 26, 30–36 *passim*, 40, 50, 58, 81, 134, 179,

189, 207. *See also* color techniques; reproduction(s) of painting and watercolor; style(s)

Queen, James, 14, 166, 167, 176, 180; Civil War pieces of, 33, 37–39, 215–216, 288, 290; post-Civil War "clichés" of, 38–39, 291

Queen of the Woods (Brown), 95

Railroad Advocate (periodical), 192

"Raspberries" (Prang-Granbery), 119

"Reading Magdalen" (Prang-Correggio), 104

Ream, Carducius Plantagenet, 121, 318

Rease, W. H., advertising sheet, 68

Reem and Shober (Chicago), 178

Reinhart, B. F., 125

reproduction(s) of painting or watercolor, 18–22, 24, 26–27, 33, 34, 36, 51, 147, 185; "for advertising," 192 (*see also* advertising); Audubon project, 54–58; cost of, 101–102; criticisms of, 13, 105–106, 207, 213–214; by Currier and Ives, 61, 63; debate on value of, to artist, 95–96, 102; as "ideal work" (Prang), 98; "no artistic merit," 13; "oil portraits," 103, 134–135, 146; oleographs as, 10–11; "precision," "perfection" of, 6, 13, 21, 26, 40, 104, 109, 111, 113, 121, 181, 205, 236n.38 (*see also* quality of chromolithography); process described, 75–78; trend away from, 202–203; "typogravure process" of, 202 (*see also* photography); and watercolor facsimiles, 22, 29, 57, 108–109, 114–115, 217, 317, 237n.28. *See also* "hanging" print; popular taste

"Republic Fire Insurance Co." (Robertson, Seibert and Shearman), 194, 337

Restein, E. P. and L. (Philadelphia), 184, 218, 330

Revels, Hiram R., 104, 217, 309

"Rêverie du Soir" (Prang-Mucha), 104

Richards, John H., 126

Ringwalt, J. Luther, 27, 82

"Rivals, The" (Sinclair), 285

Robertson, Seibert and Shearman (New York), 163, 194, 337

Robinson, Henry R., 43, 44, 45, 49, 216, 292

Robinson, Theodore, 202

"Rodman's Red Cling—Natural

Size" (Middleton, Wallace and Company), 132
Roe Lockwood and Son (New York), 55
Rogers, Rev. W. M., 18, 280
"Roman Beauty, The" (Prang-Cooman), 104
Rosenthal, Lewis, 34
Rosenthal, L. N. (Philadelphia), 23, 34–36, 39, 42, 206, 229n.26, 240n.25, 288
Rosenthal, Max, 35–36, 288
Rossiter, Thomas P., 60
Rowse and Scherer (Cincinnati), 145
"Royal Flush, A" (Tuchfarber), 147, 148, 218, 326
royalty agreements, see copyright
"Ruins of an Antique Watch Tower" (Duval-Eastman), 30, 285
Runyon, Damon, 209
Ruskin, John, 105, 110
Russell, Benjamin, 21
Russian-born printers in U.S., 8, 34. See also immigrants
Ryder, J. F. (Cleveland), 10, 140, 183–187, 188

Sage, J., and Sons (later Sage, Sons and Company, Buffalo), 15, 67, 182, 188, 218, 333; Game Birds of America, 120
"St. Julien" (Bosqui), 44, 216, 293
St. Louis, Missouri, 72, 139, 188, 189, 197
Samuelson and Rogers (Philadelphia), 40
Sandham, Henry, 104
Sanford and Company (Cleveland), 187
San Francisco, California, 44, 66, 72, 154, 168, 182, 189–190, 194, 240n.33, 257n.28
"San Francisco Blues" (Butler), 189
"Santa Clara Valley, California" (Prang-Key), 112
Sarony, Napoleon, 18, 49–51
Sarony, Major and Knapp (New York), 14, 42, 49–51, 64, 155, 216, 298, 299; factory described, 158–159
Sarony and Company (New York), 49
Sarony and Major (New York), 49–50, 51, 133, 216, 297, 298; strike at, 171–172
Sartain, John, 105
Sartain's Union Magazine of Literature and Art, 24, 232n.30

Schaus, William (New York), 122, 139
Schimon, Ferdinand, 104, 309
Schmidt, Max, 190
Schmidt Label and Lithographic Company (San Francisco), 168, 190
Schoff, H., 21, 281
Schoolcraft, Henry Rowe, 28–31, 215, 284–285
Schuchman, William (Pittsburgh), 146
Schuessele, Christian, 24–26, 35, 38, 173; -Duval chromos, 26, 31, 50, 126, 134, 215, 282, 285, 320
Schumacher and Ettlinger (New York), 156
Schurz, Carl, 51
science: popularization of, 2–4
Scientific American (magazine), 82
Scott, Julian, 104
Scott, Walter, and Company (New Jersey), 84
Seifert, Henry, 178
Senefelder, Alois, 11, 44, 69, 80, 239n.5; as inventor of lithography, 6, 12, 68, 74
Senefelder Lithographic firm (Boston), 6
sentimentality, see popular taste
Shahn, Ben, 204
Sharp, Philip T., 17–18
Sharp, William, 8, 18, 23, 50, 280; and "chromo" as term, 11, 42; "F.W.P. Greenwood," (first U.S. chromolithograph), 17, 20, 215, 279; partnerships of, 17, 19
Sharp, Peirce and Company, 320
Sharp and Son (Boston), 18
Shattuck, A. T., 60
Sheahan, James W., 178
sheet music covers, 17–21 passim, 32, 37, 42, 44, 50, 133, 188, 229n.43, 259n.16
Shober, Charles, 178, 179
Shober and Carqueville Litho. Company (Chicago), 179, 327
Siebold, H., and Company (New York), 66
Siegel, Franz, 51
Sigl (Austrian inventor of steam press), 82
Silver, Rollo G., 84
Sinclair, Thomas, 24, 32, 33, 34, 39, 192
Sinclair, Thomas, and Company (Philadelphia), 15, 23, 27, 37, 38, 172, 286, 290; style and quality of, 32–33, 215

Sinclair, Thomas, and Son, 33, 36, 285, 287
Sloan, Samuel, 36
"Small Green Crested Flycatcher" (Bien-Audubon), 57
"S. Meredith" (Brett-Haugg), 192
Smith, John Rubens, 20, 215, 281
Smith, R. A., 35
Smith, William, 26–27
Smithsonian Institution, 45, 46, 56, 74, 110, 180, 232n.38; fire at, 181
Snake in the Grass, The (Stanley), 181
Snyder and Black business card, 81
Solenhofen quarries and stone, 65, 66, 68, 69, 91. See also lithographic stones
"Solitude" (McGuigan-Moran), 108
"South Shore of Lake Superior" (Moran), 108
specialization: of labor, 16, 53–54, 72, 122, 149–156, 170, 171–175, 254n.1; of product, 5, 21, 27, 37
Spencer, Lilly Martin, 121, 122
"Spirit of '76, the" (Clay, Cosack-Willard), 10; as "Yankee Doodle 1776," 184, 185–186, 187, 218, 330
Spitzweg, C., 104
Sprague, Isaac, 22, 281
"Spring" (Prang-Bricher), ii, iii, 101
Stanley, John Mix, 47; Indian paintings by, 180–183, 218, 328, 329
"Starucca" chromos (Sinclair-Cropsey), 33, 36, 177, 287
steam-powered printing press, see presses, lithographic
Steele, Oliver G., Lith. Press (Buffalo), 260n.57
"Stitch in Time, A, Saves Nine" (Ryder-Willard), 184
stock certificates, 189, 195
stock items, see popular taste
"stone paper," 239n.5. See also paper
stonerooms, 68. See also lithographic stones
Storch and Kramer (Berlin), 328
"Storming of Chapultepec . . . , The" (Sarony and Major-Walke), 49–50, 216, 297
"Storming the Ice Palace" (Pioneer Press), 177, 218, 326
Stowe, Harriet Beecher, 103, 116, 123, 125
Strand Magazine (England), 73
"Strawberries in a Basket" (Prang-Granbery), 119
Strobridge, Hines, 61, 132, 140

Strobridge and (later Strobridge Lithographing) Company (Cincinnati) (mentioned), 103, 134, 165, 187, 195, 196, 213, 218, 228n.25, 240n.17, 322, 323; and apprentices, 130, 167, 169–170; building plans of, 161, 164; and chromos as premiums, 127–128, 143; and dealers, 139–140, 142–145; diploma production by, 16; inventory records of, 66, 69, 89, 144, 241n.45, 242n.88; name changes of, 132; "oil portraits" by, 134–135; posters by, 130–131, 143, 156, 194, 198–199, 219, 339, 340, 342 (see also advertising); prices of, 135–139, 143; and profits, 156, 173, 174, 176; specialization at, 154, 173–175; steam presses used by, 84, 88, 89, 134; wages paid by, 153

Sturgis, Russell, 105–106

style(s): attention to detail, 109–110, 113; comparison of (1881), 114; "crayon," 18; Dutch, 250n.51; European, see England; France; Germany; evolution of, 9–11, flamboyant trend of (1850s), 34, 38, 51; illuminated (Gothic Revival), 24–25, 26, 34, 126–127; "illustration" of original art, 114, 202–203; individual city, 28; murallike, 179–180; national, 28; "old" vs. "new," 9–11, 26, 32, 35–36, 37, 132; pointillist, or stipple, 32, 199, 203–204; "printed in tints," 50; realism, 47–48, 102, 109–110, 114, 194. See also color techniques; Düsseldorf Academy and style; reproduction(s) of painting and watercolor

Sumner, Charles, 103

"Sunny Day" (Prang-Spitzweg), 104

"Sunset: California Scenery" (Prang-Bierstadt), 48, 96, 111–112, 113, 217, 312

"Sunset on the Coast" (Prang-de Haas), 113

Swett, Moses (New York), 42

"Symbolic Petition of Chippewa Chiefs" (Duval-Eastman), 30, 284

"Syn Chronological Chart or Map of History" (Strobridge and Company), 134

Taft, Robert (historian), 198

Tait, Arthur Fitzwilliam, 94, 108;

Currier and Ives prints, 59, 60, 120, 216–217, 302, 303; Prang prints, 95, 102, 103, 105, 207, 217, 307

Take It Easy (Runyon), 209

Tamarind Lithographic School and Shop, 14

tariffs and tariff legislation, 59, 71, 90–93, 181

Taylor Perfumers, H. P. and W. C.: advertisement for, 33, 215, 286

Tennessee Centennial Fair, 193

Thayer, Benjamin W., 19

Theory of Color (Bezold), 101

"Thistle" (Currier and Ives), 61, 305

"Three Celebrated Dogs—Don, Peg & George" (Strobridge-Bispham), 135, 140

Thulstrup, Thure de, 104, 202, 203, 259n.23

Thurwanger, Martin, 35

Tilton, Theodore, 1

"Tony Denier's Humpty Dumpty" (Strobridge), 194, 339

Toquerville, S. Utah (Moran), 309

Toronto, Ontario, 189

Toulouse-Lautrec, Henri de, 187, 189, 333

Tourmaline, The (Hamlin), 100

Trades and Occupations series (Prang), 150

trade schools, see education

Transactions of the Massachusetts Horticultural Society, 18

Treasures of Art, Industry and Manufacture . . . (Centennial publication), 188–189

Trial of Red Jacket (Stanley), 181; chromo of (Storch and Kramer), 328

Triggs, Oscar Lovell, 211

Trip Around the World, A (Krebs-Moerhlin), 146

"Trotting Stallion Phallas" (Currier and Ives), 61

Trouvelot, E. L.: *Astronomical Drawings of*, 22

Troy Lyceum, New York, 65

"True American, the," see "Bummers, The"

Trumbull, John, 109

Tuchfarber, F. (Frank) (Cincinnati), 134, 146–148, 176, 218, 325, 326

Tucker, Stephen D., 84, 86

Tuckerman, Henry, 47, 112

Turner, Joseph, 73, 110

"Turn-out of the American Express

Company" (Sage), 188, 218, 333

Twain, Mark, 119

"Twelve Temptations; Daniel in the Lions' Den" (Bufford-Schoff), 21, 281

Tyler, J. G., 177

"typogravure," 202. See also photomechanical printing

Uffenheimer, A. I., Company, 65, 240n.10, 241n.45

Ullman, Sigmund, 72

"Union Volunteer Refreshment Saloon of Philadelphia" (Sinclair-Queen), 33, 38, 290

United States: first chromolithograph produced in, 17, 53, 215, 279; government contracts for chromolithography, 28, 31, 32, 53, 58, 181, 215; immigrant influence on lithography in, see immigrants; and national chromolithographic style, 28; social upheaval in, 2

United States Coast and Geodetic Survey, 112

United States Geological Survey, 53

U.S. Military Magazine, 37

United States Mutual Accident Association, 193

United States Pacific Railroad Expedition and Survey, 32, 53, 181

Upland Game Birds and Water Fowl of the United States (Pope), 22

varnish, see inks

Vedder, Elihu, 99

"Venus of the Flying Rings" (Strobridge), 194, 339

"Veteran, The" (Hoover-Queen), 39

Vickery, P. O., 143–145

Victoria, queen of England, 126

Victoria regia; or The Great Water Lily of America (Allen), 18, 215, 279, 280

Vienna International Exhibition (1873), 98

Villas on the Hudson (Bien), 58

Visit from St. Nicholas, A (Moore), 100

"Volunteer" (Eno), 44, 216, 293

"Volunteer and Thistle" (Prang-Tyler), 177

"Volunteers in defence of the Government against usurpation" (Duval-Queen), 37–38, 215–216, 288

Vore, George W., 138–139

"Wabeno Songs" (Ackerman-Eastman), 30, 284
wages, *see* lithographic industry
Wagner, Thomas S., 34
Wagner and McGuigan (Philadelphia), 23, 24, 37, 39, 126, 237n.24; factory, 34, 150
Walke, Henry, 49–50, 216, 297
Walker, William Aiken, 61, 306
Walker Tariff, 90. *See also* tariffs and tariff legislation
Wallace, W. R., 132
Wallach, Willy, 66
Washington, George, 103, 134, 135; Duval-Schuessele chromo of, 26, 31
Washington, Martha, 103, 255n.26
"Washington as a Mason" (Queen), 38
"Washington's Grand Entry into New York, Nov. 25th, 1783" (Sinclair), 27, 282
"Washington's Triumphal Entry into New York" (Duval), 27, 282
Wasp, The (cartoon paper), 190
"Watch, The", or "Eastern Shore" (Prang-Homer), 94, 115, 317
watercolors, *see* reproduction(s) of painting or watercolor
"Water Jump, The" (Currier and Ives), 61
Watkins, Carleton E., 98
Weaver, Matthias S., 32
Webber, C. W., 35, 206, 288
Webster, Daniel, 134
Wedding Procession on Cairo Street (Thulstrup), 203

Weir, Julian Alden, 13
Weir, Robert, 48, 112
Werner Company (Akron), 203, 343
Western Review (magazine), 65
West Shore Litho. and Engraving Company (Portland, Oregon), 321
Whistler, James A. M., 13
White, Stanford, 99
White and Brayley (Buffalo), 188, 189
Whitefield, Edwin, 19, 215, 280
Whitman, Walt, 177, 197, 261n.28
Whitney, O. S., 121, 247n.21
Whittemore, William John, 262n.4
Whittier, John Greenleaf, 96, 103, 124, 249n.29
Whittredge, Worthington, 47
"Wide Awake," 204
Wild Flowers of America, The (Sprague), 22
"Wild Fruit" (Prang-Lambdin), 121
"Wild Turkey, Male" (Bien-Audubon), 57, 301
Wilkie, Robert D., 98, 120, 250n.40
Willard, Archibald M., 184–185, 218
William Endicott and Company (New York), 42
Willis, A. O. Van, 60
Willis, Nathaniel Parker, 125
Winters Art Lithographic Company, 203
"Winter Sunday in Olden Times" (Strobridge-Durrie), 140, 218, 323
Witsch and Schmidt (New York), 156
women: and chromos for the home, 116–129. *See also* "democratic" art; popular taste
"Women's Pavilion" (Bien), 58

wood engraving, *see* engraving processes
Woodville, Richard Caton, 47
Woodward, J. D., 203
W. T. Walters Collection of Oriental Ceramic Art (Bushnell), 100–101, 115
Wyatt, Matthew Digby, 68–69

"Yankee Doodle 1776," *see* "Spirit of '76, The"
"Yellow Shank" (Bien-Audubon), 57, 216, 300
"Yellowstone Lake" (Prang-Moran), 111
Yellowstone National Park, The (Hayden; Prang-Moran), 107–111, 114, 217, 310–312
Y.M.C.A.'s, Y.W.C.A.'s, 3
"Yosemite Valley" (Prang-Hill), 95, 112, 313
Yosemite Valley views: Bierstadt, 313; Hoover, 103; Prang-Watkins, 98
Youmans, Edward, 3
Young Chief, Uncas, The (Stanley), 181
"Young Commodore" (Prang-Reinhart), 125
"Young Fullerton" (Currier and Ives), 179
"Young Rogues, The" (Hoover-Queen), 39

zinc plates, 35, 41, 69–71, 187

THE DEMOCRATIC ART
was designed by Richard Hendel,
typeset by G&S Typesetters, Inc., Austin, and
composed in Sabon, a typeface designed by Jan Tschichold.
In 1960 Tschichold was commissioned by a group of German
master printers to make drawings for a new typeface designed to meet
specific technical requirements. It had to be suitable for production in
identical form for mechanical composition by Linotype and Monotype and
for hand composition in foundry types, so that type set by any of the methods
would be indistinguishable. Sabon, named after Jacques Sabon, the Lyons type
founder, is really a version of Garamond; its originality lies in the subtle
alterations that Tschichold skillfully developed to suit mechanical
composition. Easy to read and appealing to the eye, Sabon
is suitable for all printing purposes.
The text of the book has been printed by Hart Graphics,
Austin, on Mead Moistrite Matte, and the plates
have been printed on Champion Javelin.
The book was bound by
Universal Book Bindery,
San Antonio.